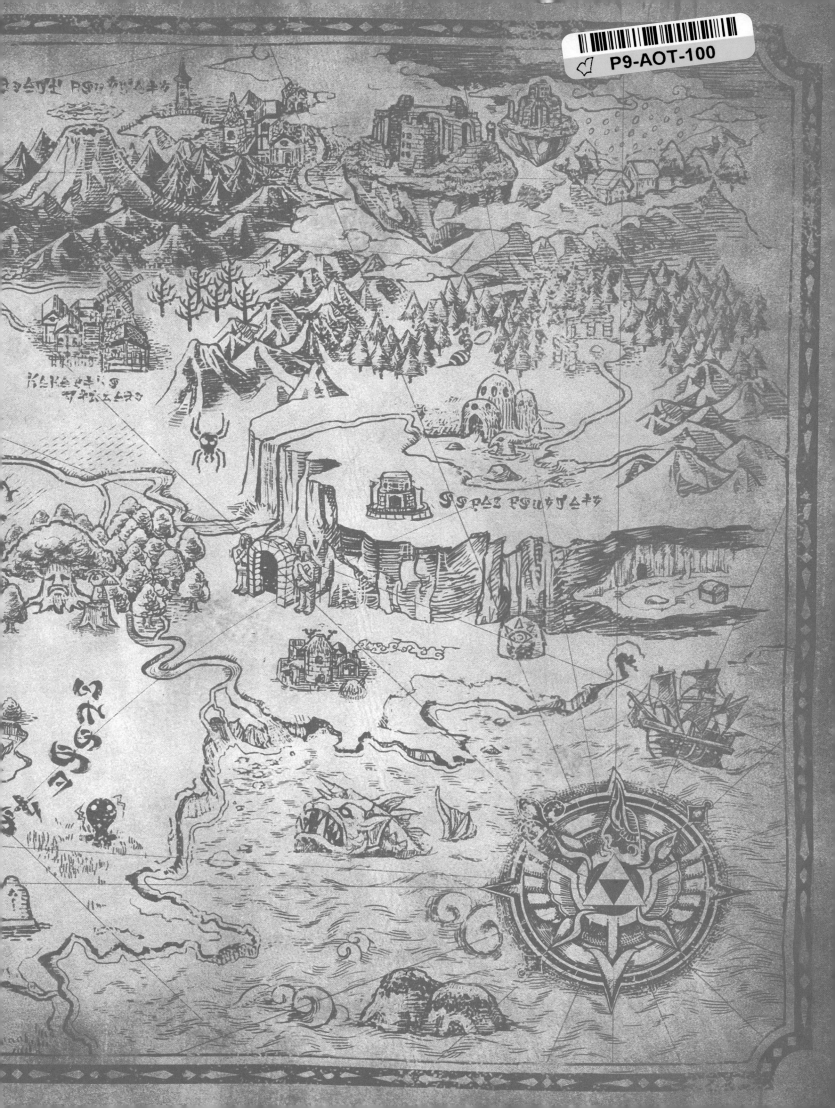

HYRULE ENCYCLOPEDIA

Publisher **TAKASHI YAMAMORI**	*Photographer* **SHOJI NAKAMICHI**
Editor in Chief **KAZUYA SAKAI**	*Editing Collaborators* **DAISAKU SATO** **KIMIKO KANMURI** **HARUE KANMURI** **TAKENOSUKE** **TAKASHI OKAZAWA**
Editors **MIKA KANMURI** **NAOYUKI KAYAMA** **YUKARI TASAI**	
Writers **AKINORI SAO** **GINKO TATSUMI** **CHISATO MIKAME**	*Supervision and Collaboration* **NINTENDO CO., LTD.** *Design* **FREEWAY LTD.**
Data/Material Production **MASATO FURUYA** **NOBUO TAKAGI** **YUTA MORO**	*Art Director* **SHION SAITOU**

ENCYCLOPEDIA

Publisher **MIKE RICHARDSON**	*Design Assistance* **JUSTIN COUCH** **LIN HUANG** **SARAH TERRY**
Editor **PATRICK THORPE**	*Digital Art Technicians* **CARY GRAZZINI** **CHRIS HORN** **CHRISTINA McKENZIE**
Assistant Editor **DAKOTA JAMES**	
Writer (English) **BEN GELINAS**	*Cover Design* **CARY GRAZZINI**
Designer **CARY GRAZZINI**	

The Legend of Zelda: Hyrule Encyclopedia was published by Ambit Ltd. First edition: March 2017.

Special thanks to Eiji Aonuma, Akira Himekawa, Yasushi Nakahara, Dave Marshall, Nick McWhorter, Michael Gombos, and Annie Gullion.

Neil Hankerson Executive Vice President • *Tom Weddle* Chief Financial Officer • *Dale LaFountain* Chief Information Officer • *Tim Wiesch* Vice President of Licensing • *Matt Parkinson* Vice President of Marketing • *Vanessa Todd-Holmes* Vice President of Production and Scheduling • *Mark Bernardi* Vice President of Book Trade and Digital Sales • *Randy Lahrman* Vice President of Product Development • *Ken Lizzi* General Counsel • *Dave Marshall* Editor in Chief • *Davey Estrada* Editorial Director • *Chris Warner* Senior Books Editor • *Cary Grazzini* Director of Specialty Projects • *Lia Ribacchi* Art Director • *Matt Dryer* Director of Digital Art and Prepress • *Michael Gombos* Senior Director of Licensed Publications • *Kari Yadro* Director of Custom Programs • *Kari Torson* Director of International Licensing

Published by Dark Horse Books
A division of Dark Horse Comics LLC
10956 SE Main Street
Milwaukie, OR 97222

DarkHorse.com

Library of Congress Cataloging-in-Publication data is available.

First English edition: May 2018
ISBN 978-1-50670-638-2

Deluxe English edition: May 2018
ISBN 978-1-50670-740-2

9 10
Printed in China

THE LEGEND OF ZELDA™ ENCYCLOPEDIA

Translation Partner
ULATUS

Translator
KEATON C. WHITE

Reviewer
SHINICHIRO TANAKA

*All concept illustrations that originally
contained handwritten notes in Japanese have been
translated into English for this book.*

DARK HORSE BOOKS

CONTENTS

HISTORICAL RECORDS
THE WORLD OF *THE LEGEND OF ZELDA* THROUGH THE AGES

TRADITIONS & HISTORY .. 10
History of Hyrule .. 11
The Goddesses & the Creation Myth | The Goddess Hylia 12
The Triforce ... 13
Origin of Hyrule & the Hylians 14
The Kingdom of Hyrule .. 15
Zelda, Princess of Legend .. 16
Link, the Chosen Hero .. 18
Ganondorf, King of Evil .. 20
Spirits ... 22
Fairies .. 23
The Sacred Realm & the Sages 24
The Temple of Time .. 26

OTHER LANDS & REALMS ... 28
Dark World .. 29
The Twilight Realm .. 30
Lorule ... 32
Holodrum .. 34
Labrynna .. 35
Termina ... 36
Koholint Island .. 38
World of the Ocean King ... 39
New Hyrule .. 40
Hytopia ... 42

THE DIFFERENT RACES ... 44
The Sheikah ... 44
The Gerudo .. 45
The Gorons .. 46
The Zora .. 48
The Kokiri | Deku Scrubs .. 50
Koroks | The Rito ... 51
The Minish | The Wind Tribe 52
The Oocca ... 53
Ancient Peoples ... 54
Other Races ... 55

GEOGRAPHY & NATURE .. 56
Maps Across Timelines ... 57
Animals ... 62
Plants ... 64
Fish .. 65
Insects .. 66

LIFE & CULTURE .. 68
Hyrule Castle ... 70
Castle Town ... 72
Ranches ... 73
Food .. 74
Language .. 76
Kakariko Village .. 78
Fishing ... 79

WEAPONS & EQUIPMENT .. 80
 Swords... 80
 The Master Sword ... 82
 Four Sword ... 83
 Shields... 84
 Armor & Accessories... 86
 Bows & Arrows ... 88
 Bombs .. 90
 Hookshots .. 92
 Other Equipment ... 93
 Rupees ... 94
 Musical Instruments & Melodies 96
MONSTERS & DEMONS... 98
 The Origin of Evil .. 99
 Blins ... 100
 Stals .. 102
 Octos... 104
 Chuchus... 105

DATABASE
AN ALPHABETICAL ARCHIVE OF INFORMATION

 Towns & Villages .. 108
 Items .. 115
 Dungeons.. 144
 Enemies & Monsters.. 162

ARCHIVES
INFORMATION AND NOTES ON EACH GAME

 The Legend of Zelda .. 218
 The Adventure of Link 222
 A Link to the Past ... 226
 Link's Awakening .. 231
 Ocarina of Time .. 236
 Majora's Mask .. 242
 Oracle of Seasons ... 248
 Oracle of Ages .. 252
 The Wind Waker .. 256
 Four Swords .. 262
 Four Swords Adventures 264
 The Minish Cap ... 268
 Twilight Princess... 274
 Phantom Hourglass... 280
 Spirit Tracks ... 286
 Skyward Sword.. 292
 A Link Between Worlds.................................... 298
 Tri Force Heroes ... 303
 Still More Legends .. 308
 Promotional Materials 316
 Revising Expectations in *The Legend of Zelda* 322

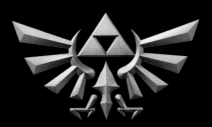

PREFACE

For well over a generation, stories of Link, hero of Hyrule, have been passed down in sacred text, cartridge, and disk. They began with *The Legend of Zelda*, released on a golden cart in the summer of 1987. The revolutionary top-down dungeon crawl defined the action-adventure genre and spurred a series of beloved games appearing on nearly every Nintendo console to date.

To celebrate thirty years of the series many just call *Zelda*, Nintendo teamed with Ambit to create the book you now hold in your hands. First published in the year leading up to *Breath of the Wild* and now translated into English for the first time, this encyclopedia collects the myriad characters, creatures, locales, and key moments that make *Zelda* truly a legend.

TIMELINE OF
KEY RELEASES

The main-series *Legend of Zelda* titles sold in North America and Japan presented in the order that they were released in North America.

8.22.1987 | 2.21.1986 (JP)
The Legend of Zelda
Nintendo Entertainment System
Famicom Disk System

12.1.1988 | 1.14.1987 (JP)
Zelda II: The Adventure of Link
Nintendo Entertainment System
Famicom Disk System

4.13.1992 | 11.21.1991 (JP)
The Legend of Zelda: A Link to the Past
Super Nintendo Entertainment System
Super Famicom

8.6.1993 | 6.6.1993 (JP)
The Legend of Zelda: Link's Awakening
Game Boy

2.19.1994 (JP)
The Legend of Zelda (Japan-only rerelease)
Famicom

11.23.1998 | 11.21.1998 (JP)
The Legend of Zelda: Ocarina of Time
Nintendo 64

12.15.1998 | 12.12.1998 (JP)
The Legend of Zelda: Link's Awakening DX
Game Boy Color

10.26.2000 | 4.27.2000 (JP)
The Legend of Zelda: Majora's Mask
Nintendo 64

5.14.2001 | 2.27.2001 (JP)
The Legend of Zelda: Oracle of Seasons & Oracle of Ages
Game Boy Color

12.2.2002 | 3.14.2003 (JP)
The Legend of Zelda: A Link to the Past & Four Swords
Game Boy Advance

3.24.2003 | 12.13.2002 (JP)
The Legend of Zelda: The Wind Waker
Nintendo GameCube

6.7.2004 | 3.18.2004 (JP)
The Legend of Zelda: Four Swords Adventures
Nintendo GameCube

1.10.2005 | 11.4.2004 (JP)
The Legend of Zelda: The Minish Cap
Game Boy Advance

11.19.2006 (Wii), 12.11.2006 (GC) | 12.2.2006 (JP)
The Legend of Zelda: Twilight Princess
Nintendo GameCube | Wii

10.1.2007 | 6.23.2007 (JP)
The Legend of Zelda: Phantom Hourglass
Nintendo DS

12.7.2009 | 12.23.2009 (JP)
The Legend of Zelda: Spirit Tracks
Nintendo DS

6.19.2011 | 6.16.2011 (JP)
The Legend of Zelda: Ocarina of Time 3D
Nintendo 3DS

11.20.2011 | 11.23.2011 (JP)
The Legend of Zelda: Skyward Sword
Wii

9.20.2013 | 9.26.2013 (JP)
The Legend of Zelda: The Wind Waker HD
Wii U

11.22.2013 | 12.26.2013 (JP)
The Legend of Zelda: A Link Between Worlds
Nintendo 3DS

2.13.2015 | 2.14.2015 (JP)
The Legend of Zelda: Majora's Mask 3D
Nintendo 3DS

10.23.2015 | 10.22.2015 (JP)
The Legend of Zelda: Tri Force Heroes
Nintendo 3DS

3.4.2016 | 3.10.2016 (JP)
The Legend of Zelda: Twilight Princess HD
Wii U

*T*he *Legend of Zelda* endures across vast periods of time and great distances both within the land of Hyrule and well beyond its borders. There are multiple timelines, chronicling different outcomes in an eternal struggle for courage, power, and wisdom.

What follows is an encyclopedic guide to the events in the *Legend of Zelda* series to date, framed by key settings, figures, creatures, and cultures. These pages will unearth old memories for many and deepen the lore behind the various tales of Link told over the years.

The world of *Zelda* has evolved, growing in scope and complexity with leaps forward in technology. Some elements at play behind early titles were not spoken of at the time of release, and interpretations of these first adventures of Link in Hyrule have evolved to include the context of later games.

This section covers both original and remake versions of key titles in the series, including HD releases, using the same names where referenced generally. It draws from in-game content as well as developmental and promotional materials, connecting the stories and worlds presented in each title as naturally as possible. Where necessary, the writers of this book added their own interpretations and expanded upon the games' stories. It should be noted that the events described here are also subject to revision, as new trials may await the people of Hyrule in ages to come.

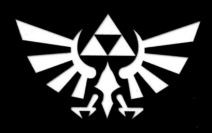

Historical Records

The World of *The Legend of Zelda* through the Ages

TRADITIONS & HISTORY

To better know the world of *The Legend of Zelda*, it is crucial to know about Hyrule's creation, its history, the connections between its eras, the chosen hero, Zelda and the goddess Hylia, and the battle of good and evil that seems doomed to be repeated.

The diagram on the right shows the connected timelines of seventeen key stories in the *Zelda* series (the details of each story begin on page 217). Following the events of *Ocarina of Time*, the timeline was divided into three distinct paths. This section presents the history of Hyrule using this chronology as a foundation.

Ocarina of Time takes place over seven years and serves as a fork in the path of Hyrulean history.

A

Creation.

Skyward Sword　　　　　　　(#15)

Emergence and sealing of the Demon King.
Goddess Hylia reborn as Zelda.
Master Sword is forged.

Banishment of the Twili.
Sacred Realm is sealed.
Kingdom of Hyrule founded.

The Minish Cap　　　　　　　(#11)

Four Sword born from the blade of Picori legend.
The rise and sealing away of the demon Vaati.

Four Swords　　　　　　　　(#9)

Revival of Vaati, sealed once again by the Four Sword.

Hyrulean Civil War.

Ocarina of Time　　　　　　　(#5)

Ganondorf, King of Thieves, enters Sacred Realm.
The Triforce splits.
Ganondorf transforms into Ganon, the Demon King.

READING THE TIMELINE

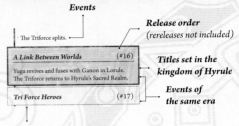

See the next page for a more in-depth explanation of the events of the timeline.

In Ocarina of Time, Ganon is sealed away by the Seven Sages, including Princess Zelda.

THE HERO IS DEFEATED

The Seven Sages seal away Ganon, King of Evil.

B　Imprisoning War.

A Link to the Past　　　　　　(#3)

King of Evil Ganon revives, then is exterminated.
The Triforce returns to Hyrule Castle.

Link's Awakening*　　　　　　(#4)

Oracle of Seasons & Oracle of Ages　(#7)

The Triforce splits.

A Link Between Worlds　　　　(#16)

Lorule invades Hyrule.
The Triforce returns to Hyrule's Sacred Realm.

Tri Force Heroes　　　　　　(#17)

The royal family uses the Triforce.
Prosperity gives way to decline, with Hyrule reduced to a small, regional power.

The Legend of Zelda　　　　　(#1)

Ganon returns but is defeated.
The hidden Triforce of Wisdom is located.

The Adventure of Link　　　　(#2)

The ancient Princess Zelda returns.
The hidden Triforce of Courage is found.

THE HERO IS TRIUMPHANT

C　CHILD TIMELINE:
GANONDORF'S PLOT IS STOPPED

Majora's Mask　　　　　　　(#6)

Twilight Princess　　　　　　(#12)

Ganondorf, King of Thieves, is banished to the Twilight Realm.
The Twili invade the kingdom of Hyrule.
Ganondorf returns but is defeated by Link.

Four Swords Adventures　　　(#10)

Ganondorf is reincarnated as Demon King Ganon.
The demon Vaati returns but is defeated.
Link seals away Ganon using the Four Sword.

D　ADULT TIMELINE:
GANON IS SEALED AWAY

Hyrule is sealed and then flooded.

The Wind Waker　　　　　　(#8)

Ganondorf is revived and defeated by Link.
The Triforce is united.
Hyrule is washed away. Its people set out for a new land.

Phantom Hourglass　　　　　(#13)

Kingdom of Hyrule is founded in a new land.

Spirit Tracks　　　　　　　(#14)

Demon King Malladus is revived and then defeated.
Lokomo guardians return to the heavens.

A new age dawns in Spirit Tracks.

*Attentive readers may note that the timeline shown here differs slightly from the one found in *Hyrule Historia*.
The timeline can be interpreted in a number of ways, and may change depending on new discoveries that have come to light and on the players' imaginations.

HISTORY OF HYRULE

This brief summary contains Hyrule's history, as we currently understand it, and follows the timeline on the left-hand page.

A HYLIA & THE HERO OF TIME

Creation of the World: The three Golden Goddesses create the land that will come to be known as Hyrule and leave behind the Triforce (page 13), golden triangles bearing the goddesses' power, courage, and wisdom.

The Goddess Hylia: Evil appears from beneath the land. The goddess Hylia, entrusted with the Triforce and the protection of the world, seals away Demise. She knows that Demise will come again and she will be powerless to stop him. A goddess cannot use the Triforce, so she gives up her divine form to unlock the power of the Triforce for her and a chosen hero so that they might defeat Demise.

Skyward Sword: Guided by a spirit, a young man tempers the Goddess Sword into the Master Sword and takes his place as the chosen hero. The power of the Triforce destroys Demise.

Banishment of the Twili: The world remained at peace for many years, but a group wielding strong magical powers desires the Triforce and fights to obtain it. The goddesses send spirits of light, which banish this group to the Twilight Realm (page 30).

Sealing the Sacred Realm: The sage Rauru builds the Temple of Time and seals the entrance to the Sacred Realm (page 24).

Founding of the Kingdom of Hyrule: The kingdom of Hyrule is founded in the land watched over by Hylia (page 12).

The Minish Legend: The Minish (page 52) gift the Hero of Men with the powerful Picori Blade, and the royal family with the sacred Light Force. The hero seals away the evil plaguing Hyrule.

The Minish Cap: The Light Force is targeted by the demon Vaati. The Four Sword (page 83) is forged from the legendary sword of the Picori, and Vaati, having become a demon, is sealed.

Four Swords: After being tricked by Ganon into drawing the Four Sword and releasing Vaati, Link defeats both Vaati and, with the help of Princess Zelda, Ganon, to once again seal them both.

Hyrulean Civil War: Conflict among the different races continues ceaselessly across the land. The king of Hyrule quells the war and unifies the Hyrulean people under him.

Ocarina of Time: The thief Ganondorf (page 20) invades the Sacred Realm. He touches the Triforce, and the Triforce splits into three. The youth chosen as the Hero of Time wields the Master Sword and, traveling across seven years, awakens the Seven Sages.

A Battle for Time: The Triforce of Power that remained with Ganondorf, the Triforce of Wisdom within Princess Zelda, and the Triforce of Courage within the Hero of Time, Link, reunite once more in a decisive battle. The fate of Hyrule changes depending on the outcome.

B THE HERO IS DEFEATED

Sealing Ganon: The hero fails. Ganondorf steals the Triforces of Wisdom and Courage and transforms into the Dark Beast Ganon. The Seven Sages, including Princess Zelda, seal the unified Triforce and Ganon in the Sacred Realm.

The Imprisoning War: Fighting erupts in the Sacred Realm. The Seven Sages seal the entrance to the Sacred Realm and Ganon in it.

A Link to the Past: Ganon, sealed in the Sacred Realm, transformed into the Dark World, plots his revival in the Light World. A boy descended from a clan of knights defeats Ganon. He recovers the Triforce, and peace returns to the world.

Link's Awakening: The hero departs on a training journey and washes ashore on Koholint Island.

Oracle of Seasons and Ages: A young man visiting Hyrule Castle is whisked away to realms of trials known as Holodrum and Labrynna, guided by the Triforce. He becomes a hero and stops the complete revival of Ganon.

The Triforce Separates: The Triforce pieces separate and reside within the souls of the legendary hero, Princess Zelda, and Ganon.

A Link Between Worlds: The sorcerer Yuga (page 32), from a parallel world known as Lorule, targets the Triforce. Yuga awakens the soul of Ganon in Lorule, but Link manages to defeat their combined form and unify the Triforce once more.

Tri Force Heroes: Hytopia (page 42) gathers heroes. They save Princess Styla, who was cursed by the Drablands Witch.

A Kingdom of Prosperity: The king of Hyrule uses the Triforce to make the kingdom prosperous. When the king dies, Princess Zelda refuses to tell her unworthy brother the location of the Triforce of Courage. She is then put into a cursed slumber (page 17).

The Kingdom Declines: The kingdom declines and its borders recede.

The Legend of Zelda: While Hyrule is small and vulnerable, Ganon awakens. The Triforce of Power is stolen. Princess Zelda splits the Triforce of Wisdom into eight pieces and hides them. A young hero gathers the pieces and defeats Ganon.

The Adventure of Link: The boy who defeated Ganon takes on a series of trials left by the old king. He obtains the Triforce of Courage, hidden in the Great Palace, and awakens the sleeping Princess Zelda. The three pieces of the Triforce are unified in the kingdom of Hyrule.

C CHILD TIMELINE

Return of the Hero: Princess Zelda and the rest of the Seven Sages seal away Ganondorf and the Triforce of Power. Link, having returned to his original time along with Princess Zelda, stops Ganondorf's ambitions before they can take shape. At this time, Link possesses the Triforce of Courage.

Majora's Mask: The Hero of Time, searching for his fairy partner, Navi, wanders into the world of Termina (page 36).

The Failed Execution of Ganondorf: The kingdom of Hyrule attempts to execute Ganondorf as a traitor. However, since he was chosen by the Triforce of Power and had been blessed with the power of the goddesses, it was impossible to execute Ganondorf. He could only be banished to the Twilight Realm (page 30) by the sages.

Twilight Princess: Ganondorf, a spirit in the Twilight Realm, manages to return to the Light World. He attempts to regain his former power, only to be destroyed by the hero.

Four Swords Adventures: Ganondorf reincarnates. He obtains the evil Trident and becomes Demon King Ganon, breaking the seal on the demon Vaati. The hero obtains the Four Sword, defeats Vaati, and seals away Ganon.

D ADULT TIMELINE

Sealing Ganon: Ganon is sealed along with the Triforce of Power. The Hero of Time disappears, having returned to his original time. With the hero gone, the Triforce of Courage splits into eight pieces and scatters.

Hyrule Submerged: Ganon returns. The hero does not. To prevent the destruction of the world, the goddesses submerge and seal Hyrule, along with Ganon, beneath the Great Sea.

The Wind Waker: Ganondorf revives again. The ancient king of Hyrule guides Link and Princess Zelda, and they once again unite the Triforce. The king uses the Triforce to bury both Ganon and Hyrule beneath the ocean (page 15).

Phantom Hourglass: Princess Zelda and her crew depart for a new land. They continue their voyage while becoming caught up in the Temple of the Ocean King, freeing it from the grips of the monster known as Bellum (page 39).

Founding the Nation of Hyrule: They arrive at the land of the Spirits of Good and make peace with the Lokomo tribe there (page 40).

Spirit Tracks: The Demon King, Malladus, sealed long ago, returns. Princess Zelda and Link defeat the demon. The Lokomo guardians return to the heavens, and the new land is entrusted to the people of Hyrule.

THE GODDESSES & THE CREATION MYTH

When all was chaos and nothing yet existed, it is said that three goddesses created the world. Din, the Goddess of Power, created the land. Nayru, the Goddess of Wisdom, created order. And Farore, the Goddess of Courage, created all life. When the creators departed the world, they left behind three golden triangles symbolizing their power: the Triforce, which grants the wish of anyone who touches it. Upon their departure to the heavens, the three goddesses entrusted another goddess, Hylia, and a legion of spirits and fairies (page 22) with protecting the land they had created.

Why the goddesses left the Triforce behind is shrouded in mystery. Many have tried to obtain it; many have fought to keep it. For ordinary people, the Triforce is a symbol of faith, but when the world faces great calamity, its great power can be unlocked.

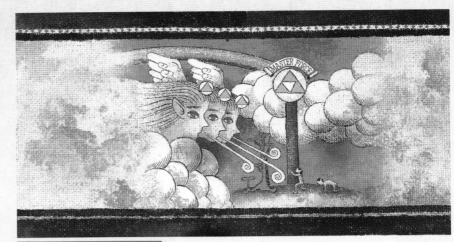

Din (power) Nayru (wisdom) Farore (courage)

The crests of the three goddesses. They are found in places or upon objects to indicate their power.

The Tower of the Gods, a trial faced by Link in The Wind Waker.

THE GODDESS HYLIA

After the three goddesses departed, the Triforce and the world were entrusted to the goddess Hylia.

Hylia's great responsibility was soon tested as evil beings emerged from beneath the ground, seeking the Triforce. Called demons (page 98), they served an evil power so great it was known only as "Demise."

Without the power to fight, Hylia's people could only cry out for help to the goddess. She answered, cutting out a portion of their land and, along with the Triforce, moving her people to safety high above. The land and the sky were then separated by a sea of clouds.

After a ferocious battle, Demise was sealed away. However, it became apparent that the seal would not last long against Demise's great power. Hylia knew that her power alone was not enough to stop Demise and that her only hope was to unlock the power of the Triforce. Since a goddess cannot wield the power of the Triforce, Hylia sacrificed her divinity. Reborn as a Hylian and working together with Link, the goddess destroyed Demise. Eternally reborn, she lives among her people as a Hylian in the kingdom now known as Hyrule.

For her selfless acts to protect the Hylians who bear her name, Hylia is among the most praised and beloved deities in all of Hyrule.

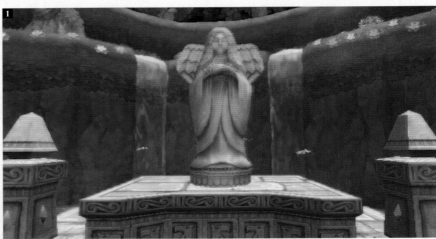

1 The Earth Spring, which is connected to Hylia. By praying to the goddess statue, Zelda regains her memories of when she was the goddess. **2** The goddess Hylia as seen in a wall mural. **3** Skyloft, the island raised into the sky by the goddess. The island where the Triforce rests is known as the Isle of the Goddess. The ancient lands have become a myth, passed down orally. **4** Hylia (Zelda), who put herself to sleep for several thousand years to secure the seal.

THE TRIFORCE

The Triforce is the ultimate force behind all things. It is capable of granting the wish of those who lay hands on it, but only the first person to touch it will have their wish granted; it is said that their wish will hold true until the user dies.

The three triangles of the Triforce, which represent wisdom, courage, and power, have at times been split into pieces and scattered for fear of misuse.

The Triforce does not discriminate between good and evil desires, but a balance of power, wisdom, and courage is required to unlock its full force, and one must demonstrate these qualities through sacred trials. If someone unworthy touches it, the three parts will separate, with only the piece best representing the one who touched it remaining. The remaining two pieces will reside in those chosen by the goddesses, and a triangular mark will appear on the back of their hand. To obtain its true power, one must acquire all three pieces of the Triforce. As the separate pieces of the Triforce draw near each other, they will resonate as they try to become one.

In *Ocarina of Time*, Ganondorf (page 20) touches it, and it splits apart. All that remains in him is the Triforce of Power, while Wisdom resides within Princess Zelda and Courage within Link, a boy who will become the Hero of Time.

The battle over the Triforce has waged since its creation, and shall continue without end for all eternity.

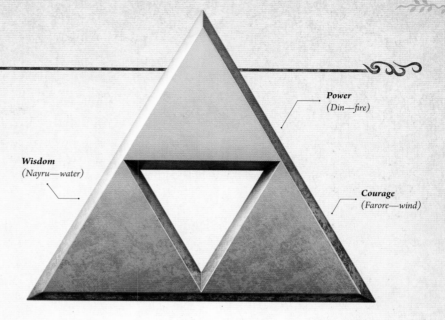

Wisdom
(Nayru—water)

Power
(Din—fire)

Courage
(Farore—wind)

TIMELINE OF THE TRIFORCE

COMPLETE FORM
The Triforce with all three pieces united

Skyward Sword
COMPLETE FORM Skyloft
To eliminate the source of evil, Zelda and the hero gain the capability to wield the Triforce. They wish for the elimination of Demise.
COMPLETE FORM The Sealed Grounds

Conflicts over the Triforce occur, and the entirety of the Sacred Realm is sealed.
COMPLETE FORM Sacred Realm of Hyrule (Temple of Light)

Ocarina of Time
The Triforce splits into three after Ganondorf touches it.
POWER Ganondorf
WISDOM Princess Zelda
COURAGE Link

The Hero of Time is defeated. Ganondorf steals the Triforces of Courage and Wisdom and becomes Dark Beast Ganon. Ganon is sealed away by the sages in the Dark World, formerly the Sacred Realm.
COMPLETE FORM Dark World (formerly Sacred Realm)

Ganondorf is defeated and sealed away.
POWER Sealed along with Ganondorf
WISDOM Princess Zelda
COURAGE Link

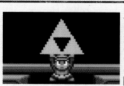

A Link to the Past
Ganon, sealed in the Dark World, possesses the Triforce, until he is defeated and it is reclaimed. Link touches it and asks to undo the damage Ganon has done.
COMPLETE FORM Hyrule Castle

Oracle of Seasons & Oracle of Ages
COMPLETE FORM Hyrule Castle
A boy with the qualities of a hero is bestowed with a set of trials by the Triforce. Once both are completed, the Triforce ascends into the sky, transforms into birds, and flies away.
Split.
POWER Ganondorf (sealed) **WISDOM** Princess Zelda **COURAGE** Link

The Hero of Time returns to his original timeline, but since he was in possession of the Triforce of Courage, this influences the Triforce in the Sacred Realm. Three individuals chosen by fate come to possess the three pieces of the Triforce.
POWER Ganondorf
WISDOM Princess Zelda
COURAGE Link

The Hero of Time returns to his original era, and the Triforce of Courage splits into eight fragments and scatters. Later, Ganon revives, and Hyrule is sunk under the Great Sea.
POWER Ganondorf (sealed)
WISDOM Split into two, and the king of Hyrule (sealed) and the princess (later, Tetra) continue to inherit it
COURAGE Sinks, along with Hyrule, under the waves

A Link Between Worlds
The Triforce is desired by Lorule (page 32) after their own Triforce was destroyed. The hero and Princess Zelda touch Hyrule's Triforce, wishing for Lorule's to return.
COMPLETE FORM Hyrule Sacred Realm

A great king uses the Triforce and makes the kingdom prosperous. After his death a spell is cast so that a triangular mark would appear on the back of the hand of one bearing the qualities of the Triforce, and the Triforce of Courage is hidden in the Great Palace.
POWER **WISDOM** Princess Zelda **COURAGE** Great Palace

The Legend of Zelda
The Triforce of Power is stolen by Ganon, and the Triforce of Wisdom is split into eight pieces and hidden by Princess Zelda. Link and Zelda defeat him and reclaim it.
POWER **WISDOM** The kingdom of Hyrule
COURAGE Great Palace

Twilight Princess
It dwells within one possessing the necessary qualities, bringing forth various powers. Ganondorf seeks its complete form but loses to Link, and his mark fades.
POWER Ganondorf (eliminated)
WISDOM Princess Zelda
COURAGE Link

The Wind Waker
POWER Ganondorf
WISDOM Princess Zelda
COURAGE Gathered by Link
The Triforce is united. The King of Red Lions wishes for Ganondorf to be submerged with Hyrule under the Great Sea. The Triforce vanishes, its whereabouts unknown.
COMPLETE FORM Unknown

The Adventure of Link
Seeking the Triforce of Courage, Link takes on the Great Palace. He awakens the ancient Zelda with the power of the Triforce.
COMPLETE FORM The kingdom of Hyrule

ORIGIN OF HYRULE & THE HYLIANS

The world created by the three goddesses and protected by the goddess Hylia is known as Hyrule. It is a beautiful land, surrounded by mountains and forests.

THE ROYAL FAMILY CAN TRACE THEIR ROOTS DIRECTLY TO THE GODDESS HYLIA

Hylians were the first race to establish civilization in ancient Hyrule. When the goddess Hylia took on a mortal form, she chose to live among the Hylians. Because of their close relationship to Hylia, it is said that their long ears are intended to hear the voice of the goddess.

In the past, Hylians were able to wield magic of considerable might, but, over time, that ability has faded. However, because they are of Hylia's bloodline, the royal family, especially its princesses, is still strong in magic. Hylia's power has manifested whenever Hyrule is in danger.

Both in the present and throughout history, some sages and shrine maidens have also been able to use magic (page 24), an ability that has brought them considerable honor in Hylian society.

1 The Triforce descended to Hyrule, a gift of power from the goddesses that is protected by the goddess Hylia, reborn as a Hylian princess, Zelda. **2** Princess Zelda has a prophetic vision in her dreams. **3** Maidens abducted by Ganondorf. To search for Princess Zelda, Ganondorf kidnapped all maidens with pointed ears.

A map depicting key locations of historical significance in Hyrule.

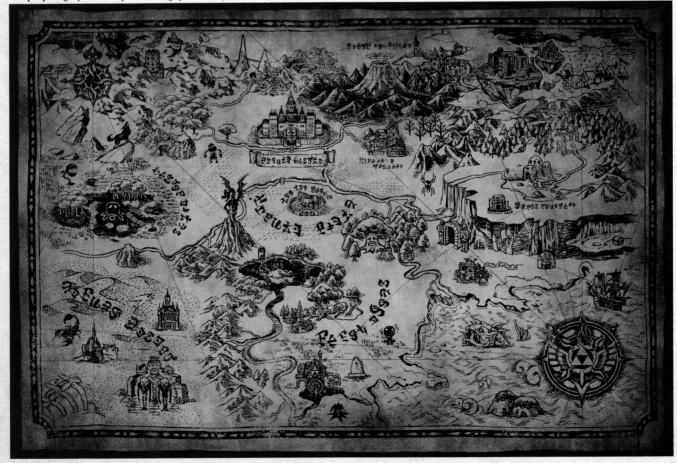

THE KINGDOM OF HYRULE

At the heart of Hyrule is its kingdom, whose faithful people are called to keep the world at peace. The kingdom of Hyrule reigns over land that has been called the "Country of the Gods," largely for the wealth and prosperity it enjoys from its divine protection.

The Triforce is traditionally under the care of Hyrulean sages or the royal family. It is their duty to keep it from the clutches of heartless and evil beings who desire its power.

When wars break out, those bearing the rightful lineage of Hylia are called to the kingdom of Hyrule to keep chaos at bay.

The kingdom is often threatened by demons (page 98), and this has created a cycle of prosperity and decline. Over time, Hyrule's history has been defined by periods of great conflict and oppression between the races who call the world home. Various traditions and legends have been born from strife, and if one path leads the kingdom of Hyrule to a diminished state, another sees it rise from the ashes, sometimes in new lands (page 40).

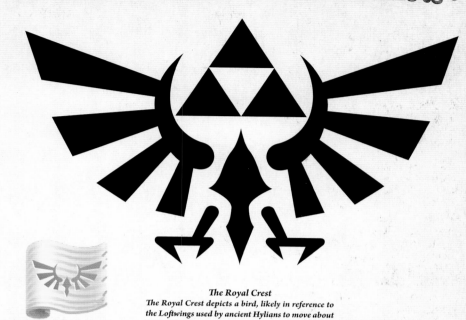

The Goddess Crest

The Royal Crest
The Royal Crest depicts a bird, likely in reference to the Loftwings used by ancient Hylians to move about in Skyloft. There is a similar engraving in the ancient Temple of Time (page 26).

HYLIAN ROYALS

Although there are many legends regarding Princess Zelda (page 16), few records of other Hylian royals survive. King Daltus in *The Minish Cap*, King Daphnes in *The Wind Waker*, and the ancient King Gustaf are often cited as rulers of particular importance.

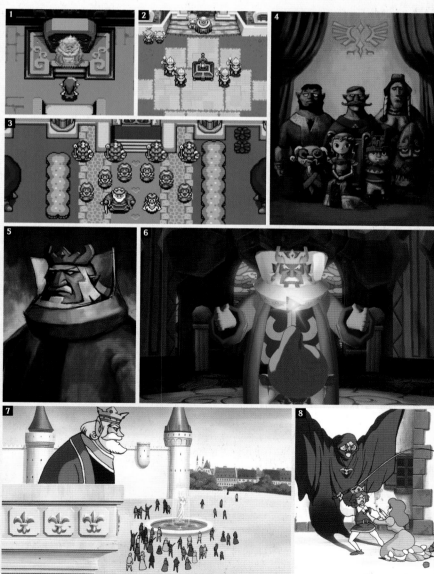

1 The Royal Crypt from *The Minish Cap*, where the remains of King Gustaf rest. **2** King Daltus from *The Minish Cap*—who, as a member of the royal family, knows the secret of the Minish (page 52)—oversees the Picori Festival. **3** The king of Hyrule from *A Link to the Past* (bottom left) is assassinated without realizing the true identity of the wizard Agahnim. His life is restored with the power of the Triforce through the work of the hero. **4** A portrait of the princess and her retainers, who were chosen as the bodyguards of the successor princess when Hyrule was sealed. Escaping the seal, their descendants formed Tetra's pirate crew. Even in the new kingdom of *Spirit Tracks*, some of these descendants are present and swear allegiance to the royal family. **5** The king who left the greatest mark on history: Daphnes Nohansen Hyrule. The king was guided by the goddess to seal Hyrule. Awakening in response to Ganon's revival in *The Wind Waker*, he transferred his soul to a small boat known as the King of Red Lions and guided the hero. To end the cycle of conflict, he used the power of the Triforce to submerge Hyrule. **6** Bringing together the fragments of the Triforce of Wisdom, Daphnes reveals to Tetra that she is Princess Zelda. **7** The old king of Hyrule who led the nation to greatness using the Triforce. He hid the Triforce of Courage in the Great Palace to ensure proper use. The Great Palace and guardians in *The Adventure of Link* were created by this king and a trusted wizard. **8** The old king's son, unable to wield the Triforce, questioned Princess Zelda about its location. Because she would not give up the information, Princess Zelda was placed into an eternal slumber by a palace wizard. So as to never forget this fateful error on his part, the regretful prince decreed that all future princesses shall be named "Zelda."

ZELDA, PRINCESS OF LEGEND

Like "Link," "Zelda" is a name that has been given to many individuals over time. The fabled princess of Hyrule has played a key role in ensuring balance is maintained in Hyrule throughout history. She is the goddess Hylia reborn, and wields great power that she uses to keep evil in check.

KEEPER OF THE LIGHT FORCE

Princess Zelda was turned to stone by the Wind Mage Vaati, who was attempting to steal the Light Force within her. Link reverses the spell and defeats Vaati. Zelda uses the Mage's Cap and the Light Force to undo the damage Vaati had done.

FOUR SWORD PROTECTOR, BELOVED EVEN BY DEMONS

Princess Zelda is tasked with protecting the Four Sword in its sanctuary. The blade sealed the demon Vaati in the past. When Vaati returns to Hyrule, the demon attempts to make the princess his bride, stealing her away to the Palace of Winds. Link uses the Four Sword to save her.

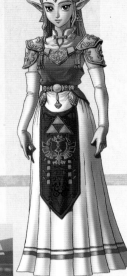

THE REBORN GODDESS HYLIA

Before the kingdom of Hyrule and the royal family exist, the goddess Hylia is reborn as a mortal to the headmaster of the Knight Academy. She regains the power of the ancient goddess, awakens the hero, Link, and bears the fate of protecting the world from demons.

MASTER OF DISGUISE WHO MANIPULATES TIME

Zelda learns in a dream that the thief Ganondorf is targeting the Triforce and that a boy from the forest will become the hero who saves the world. However, unable to convince her father, the king, she takes matters into her own hands, granting the boy of legend a sacred ocarina that manipulates time. Zelda's nurse Impa arranges to disguise her as a Sheikah boy (page 44) and saves her from Ganondorf's clutches when the Gerudo storm the castle.

Seven years later, Ganon is sealed and Zelda sends Link back to the world of seven years ago. This event would have a significant influence on the makeup of the world, fracturing the further adventures in Hyrule into three distinct timelines.

THE LEGENDS OF ZELDA

Though the series bears her name, Zelda is not in every *Legend of Zelda* game. She does not appear in *Tri Force Heroes* or *Link's Awakening*. And while she is in *Majora's Mask*, it is only in a memory.

The Legend of Zelda The Adventure of Link A Link to the Past

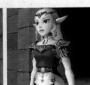
Ocarina of Time

Ocarina of Time 3D

Majora's Mask

Majora's Mask 3D

Oracle of Seasons & Oracle of Ages

The Wind Waker

The Wind Waker HD

Four Swords

Four Swords Adventures

The Minish Cap

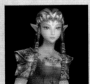
Twilight Princess

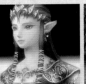
Twilight Princess HD

Spirit Tracks

Skyward Sword

A Link Between Worlds

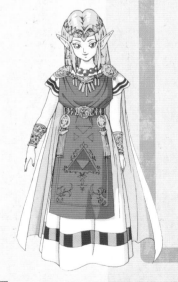

TRIFORCE GUIDE

Captured by a wizard plotting to revive Ganon, Zelda reaches out telepathically to Link, who carries the spirit of a hero. Along with the maidens who carry the blood of the Wise Men, she guides the hero to the Triforce.

LEADER TO A NEW WORLD

Tetra, a pirate captain sailing the Great Sea, proves the true successor of the old kingdom of Hyrule. Guided by fate, she awakens as the princess.

Zelda, setting sail with Tetra's pirate crew on the sea that submerged old Hyrule, founds the new nation.

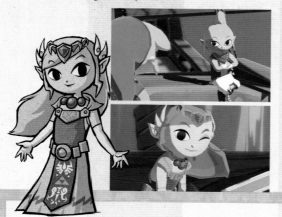

SPIRIT WHO FOUGHT ALONGSIDE LINK

The Zelda of *Spirit Tracks* is the great-great-grandchild of Tetra, founder of the new nation of Hyrule. When Zelda's body is stolen as a vessel for the revival of the Demon King Malladus, Zelda manages to keep her soul. Able to possess the armor of Phantoms and fight, she journeys alongside Link to stop Malladus from bringing terror to Hyrule.

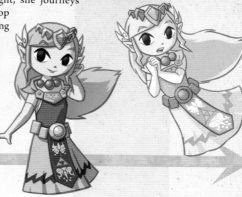

PEACEMAKER WITH TWILIGHT

While Hyrule is invaded by the army of the Twilight Realm (page 30), Zelda is asked to choose between surrender and the destruction of her people. The princess chooses to surrender in order to save her people. Accepting subjugation, she wears a black robe. She comes to meet the princess of the Twilight Realm, Midna. Together, they overcome the ancient grudges between the Light World and the Twilight Realm to help Link stop Ganondorf, with Zelda and Midna both nearly sacrificing themselves in the process.

LIGHT OF THE KINGDOM

The demon Vaati escapes his seal and works to revive Ganon. The hero, wielding the Four Sword, fights to defeat Vaati and a primal form of Ganon with the aid of Zelda's magic.

A PRINCESS AS BEAUTIFUL AS A PAINTING

The Triforce of Wisdom dwells within Zelda. Taken away to the parallel world of Lorule (page 32), the princess is turned into a painting in a plot to possess the power she holds. Zelda is freed, and together with the hero, she saves both Hyrule and Lorule from a darker path.

THE LEGEND OF THE ANCIENT PRINCESS ZELDA

Princess Zelda guarded the secret location of the Triforce of Courage, and because she would not reveal the location was cast into an eternal sleep by magic. It is said that all Hylian princesses to come would inherit the name "Zelda" in her honor.

When the ancient Princess Zelda is awakened by Link's heroism, the world enters a time when there are actually two Princess Zeldas.

HOPE OF HER PEOPLE

Princess Zelda is the symbol of hope for the people of the kingdom of Hyrule. When Zelda is threatened, the Flame of Despair is lit (page 34).

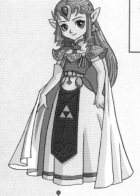

KEEP THE POWER OF THE GODDESSES AWAY FROM THE HANDS OF EVIL

The great King of Evil, Ganon, captures Zelda, hoping she will reveal to him where she has hidden the Triforce of Wisdom. Zelda sends Impa to seek out a hero to put an end to Ganon's ambitions. Protecting the Triforce from evil is the role of the royal family in Hyrule, one Zelda takes very seriously.

LINK, THE CHOSEN HERO

In *The Legend of Zelda*, what defines a hero? Is it the name "Link"? The green cap he wears? The Master Sword he wields often with his left hand? Perhaps the Triforce of Courage on the back of that hand?

These signs may help define what it means to be the hero of Hyrule, but Link is not just one individual; he is the hero reborn to many homes, over the course of many lifetimes, chosen by the goddesses with a singular purpose: to stand up and fight when evil descends upon Hyrule.

Most incarnations of Link are little more than ordinary Hylians who, through fate and a moment of courage, reawaken as the chosen hero.

In the history of *Zelda*, there have been ages where a single hero saved the world more than once. However, it's more common that a new version of the hero will arise when Hyrule needs them most to restore balance and become legend, only to be reborn again when evil threatens.

Before they embrace their destiny, these young men often need time to mature into the chosen hero. In each era, Link has to endure a series of trials that will test the balance of wisdom, courage, and power within him. These tests unlock the potential within him as he rises to the challenge of each new trial.

No matter his beginnings, because he has the spirit of the hero, Link always embraces his destiny, not for his own ego or personal mastery, but for the sake of others. He is looked upon as a symbol of the courage hidden within every person. This is why people will continue to pass down the inspirational legends of heroes for all time.

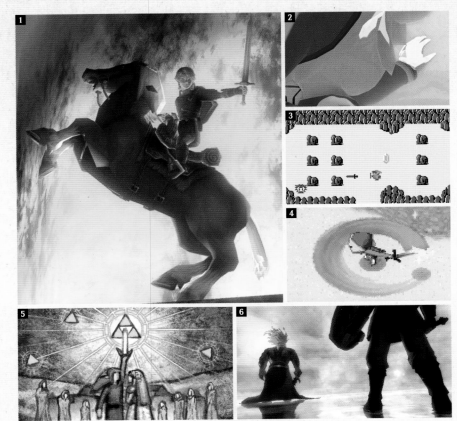

1 Link on horseback has become an iconic image of his role in protecting Hyrule. Here Link rides Epona. **2** A Triforce on Link's hand proves he is chosen by the goddesses. **3** Here he launches a sword beam. **4** Here he practices a Spin Attack. **5** This painting of the hero Link and Princess Zelda has survived for ages. **6** The climactic battle between the hero and Demise early in the history of Hyrule. After several thousand years, from a people who could only lament and were unable to fight, the first hero was born.

THE MANY LINKS OF HYRULE

Seen side by side, the heroes of many *Zelda* stories are clearly cut from the same green cloth. Each Link has realized his potential in his youth, often as a young adult. In *Ocarina of Time*, we met a younger Link, just a child when Ganondorf first sought the Triforce—courageous of spirit, but too young to confront the leader of the Gerudo. Even then, Link's courage was legendary.

The Legend of Zelda *The Adventure of Link* *A Link to the Past* *Link's Awakening*

*Ocarina of Time** *Ocarina of Time** *Ocarina of Time 3D** *Ocarina of Time 3D** *Majora's Mask* *Majora's Mask 3D* *Oracle of Seasons & Oracle of Ages*

The Wind Waker *The Wind Waker HD* *Four Swords* *Four Swords Adventures* *The Minish Cap* *Twilight Princess* *Twilight Princess HD*

Phantom Hourglass *Spirit Tracks* *Skyward Sword* *A Link Between Worlds* *Tri Force Heroes*

*Link appears as both a child and a young adult in *Ocarina of Time*.

THE PATHS OF A HERO

The origins and fates of Link vary from adventure to adventure. Taken together, it is easy to see the impact the many heroes named Link have had on Hyrule's storied history.

This chart contains some key information about the hero from each era.

A

Skyward Sword

UPBRINGING A student of the Knight Academy. Childhood friend of fellow student Zelda, who plays the part of the goddess Hylia for that year's Wing Ceremony.

PATH The hero is chosen by the goddess Hylia. He tempers the Master Sword, guided by Fi, the spirit of the sword, and seals away Demise.

CLOTHING He dons the provided knight uniform. The year's color is green.

FATE It's believed he decides to settle on the Surface.

The Minish Cap

UPBRINGING/OCCUPATION A childhood friend of Princess Zelda and an apprentice blacksmith.

PATH Link wears Ezlo, a Minish who was transformed into a cap, on his head. Wielding the Four Sword, he battles Vaati to save Princess Zelda. In the end, Ezlo gifts Link a green cap shaped like himself, which becomes a symbol of the hero.

Four Swords

PATH Using the Four Sword, Link splits into four versions of himself and defeats the demon Vaati.

CLOTHING The four versions of Link wear matching green, red, blue, and purple tunics.

Ocarina of Time

UPBRINGING Link is born to a Hylian family during a time of war. During the war, his mother was driven from their home and, clutching her baby, fled into the forbidden forest. The Great Deku Tree proclaimed that the child was fated to save the world, and Link was raised as a Kokiri (page 50) in the Kokiri Forest.

PATH He sets out on a journey with the fairy Navi and becomes the "Hero of Time" who carries the Triforce of Courage. After seven years of sleep, Link battles Ganon with the Master Sword in hand.

CLOTHING The standard green clothing worn by all Kokiri.

FATE **B** Defeat. The sages seal Ganon. **C D** Link defeats Ganon and returns to his original time.

B DEFEAT

A Link to the Past

UPBRINGING A descendant of the Knights of Hyrule who guard the royal family, Link lives together with his uncle.

PATH He defeats Ganon with the Master Sword and wishes for the Triforce to return things as they were.

FATE Link sets out on a journey of training.

Link's Awakening

UPBRINGING Same hero as A Link to the Past.

PATH The ship runs ashore on Koholint Island in a storm. Link is caught up in an adventure to wake the Wind Fish.

Oracle of Seasons & Oracle of Ages

UPBRINGING Same hero as A Link to the Past.

PATH Link travels to the realms of Labrynna and Holodrum. He thwarts Twinrova's attempts to fully revive Ganon.

FATE He sets sail for training.

A Link Between Worlds

OCCUPATION Apprentice blacksmith.

PATH Using his ability to enter walls, Link recovers the Triforce from Lorule.

CLOTHING Blacksmith's work clothing.

FATE Link travels to the kingdom of Hytopia.

Tri Force Heroes

UPBRINGING Same hero as A Link Between Worlds.

PATH Link becomes the legendary Tri Force Hero, lifting Lady Maud's curse on Princess Styla.

CLOTHING Changes from the "bear" minimum to a soldier's outfit.

The Legend of Zelda

OCCUPATION The youth who travels the kingdom of Hyrule.

PATH Link seeks out the hidden Triforce of Wisdom and defeats Ganon.

CLOTHING Ordinary traveling clothes.

The Adventure of Link

UPBRINGING Same hero as The Legend of Zelda. At the age of 16, the mark of the Triforce appears on the back of Link's hand.

PATH He solves the mystery of the Great Palace, obtains the Triforce of Courage, and awakens the ancient Princess Zelda.

C CHILD TIMELINE

Majora's Mask

UPBRINGING Same hero as Ocarina of Time.

PATH Link returns to his original time with the Triforce of Courage. He strays from the forest into a parallel world called Termina while searching for Navi. He saves Termina, along with the fairy Tatl, but no record of his deeds after remains.

FATE After dying, he becomes the Hero's Spirit and seeks a successor for his sword techniques.

Twilight Princess

UPBRINGING/OCCUPATION A ranch hand from Ordon Village, Link is fascinated by swordsmanship and horse riding. He inherits the Triforce of Courage from the Hero of Time.

PATH Transforms into a wolf. With help from Midna, princess of the Twilight Realm, Link obtains the Master Sword and defeats Ganon.

CLOTHING Ordinary clothes typical of Ordon villagers. Link's classic green tunic and cap are given to him by the Spirits of Light and inherited from an ancient hero. Link also dons sumo attire.

FATE He returns to Ordon along with the children of the village.

Four Swords Adventures

UPBRINGING A childhood friend of Princess Zelda.

PATH Using the Four Sword and splitting into four, he defeats the demon Vaati.

D ADULT TIMELINE

The Wind Waker

UPBRINGING A boy who grew up on Outset Island. He lives with his grandmother and younger sister.

PATH Link boards a talking boat, the King of Red Lions. He obtains the Triforce of Courage, which had sunk to the bottom of the sea, and battles Ganondorf, earning the title "Hero of Winds."

CLOTHING Link normally wears blue clothes with a lobster pattern. Link's green clothing is worn, in honor of an ancient hero, as part of a tradition to celebrate his birthday.

FATE Seeking a new kingdom, he sets sail with Tetra's pirate crew.

Phantom Hourglass

UPBRINGING Same hero as The Wind Waker.

PATH Link gets caught up in the mystery of a Ghost Ship. The adventure with the fairy Ciela, the Spirit of Time and Courage, unfolds in the Temple of the Ocean King. In regular time, Link's adventure only lasts ten minutes.

FATE Tetra's pirates discover a new continent. It is unclear whether Link settles there.

Spirit Tracks

OCCUPATION Engineer in training.

PATH Riding on the Spirit Tracks, Link defeats the Demon King Malladus with the help of Princess Zelda's disembodied spirit.

CLOTHING Link first wears the clothes of an engineer before borrowing from Zelda the green tunic and cap of a Hylian soldier.

FATE It is said that Link became an engineer as planned, but also that he became a swordsman to protect Princess Zelda.

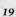

GANONDORF, KING OF EVIL

Ganon, the King of Evil who has repeatedly sought the Triforce and threatened balance in Hyrule, began his life as Ganondorf, a leader of Gerudo thieves west of Hyrule Castle (page 45).

There is a tradition among the Gerudo that the sole boy born to them every hundred years shall be king, and so Ganondorf is raised as a king.

As he matured, Ganondorf's unquenchable ambitions became more and more apparent. He opposed his people's lowly status in Hyrule and sought more. This led him to commit dark acts in the name of the Gerudo, killing and stealing from the weak. His rare ability to use magic made Ganondorf a powerful thief. Some even called him the King of Thieves.

After the Hyrulean Civil War, the Gerudo Desert region came to be governed by the kingdom of Hyrule. As leader of the Gerudo, Ganondorf was expected to swear fealty to the Hyrulean king. He did so in order to gain the king's trust, which allowed him to move freely until the moment he could acquire the Triforce—a moment that was realized when he followed Link into the Sacred Realm. When Ganondorf touched the sacred triangles, they separated. The Triforce of Power remained with him, while the other pieces scattered. In battle with Link for the other two pieces, Ganondorf tested the limits of his Triforce of Power and transformed into a demon in the form of the Dark Beast, Ganon.

Defeated and sealed away by the Seven Sages (page 24), Ganon has repeatedly returned to wage a seemingly eternal battle for the Triforce, only to be thwarted each time by the chosen hero of the goddesses.

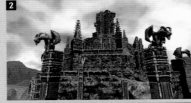

1 The Triforce is split into three when Ganondorf touches it. He takes the Triforce of Power. **2** The ruined Hyrule Castle, now Ganon's Castle, following the defeat of young Link. **3** Ganon awaits the arrival of the hero at the top of Ganon's Tower, playing an organ. **4** The parents who raised Ganondorf, the twin witches Kotake and Koume. **5** One of many demons Ganondorf has created in his own image. This one was known as Phantom Ganon.

```
Skyward Sword

The Minish Cap        [ ] = Titles in which Ganon/
                            Ganondorf appears
Four Swords
                      [ ] = Titles in which his
Ocarina of Time             reincarnation appears

A Link to the Past    Majora's Mask        The Wind Waker
Link's Awakening
                      Twilight Princess    Phantom Hourglass
Oracle of Seasons
                      Four Swords Adventures   Spirit Tracks
A Link Between Worlds
Tri Force Heroes

The Legend of Zelda
The Adventure of Link
```

THE MANY FORMS OF GANON/GANONDORF

Depending on the title, Ganondorf may only appear as Ganon, transform from his Gerudo form into a beast, or not transform at all. Chronologically, *Ocarina of Time* is when Ganondorf first appears, as he was not yet born during the events of *Four Swords*, *The Minish Cap*, and *Skyward Sword*. It could be argued, however, that some aspect of Demise (page 99), the source of evil in Hyrule, resembles Ganondorf.

The Legend of Zelda
Ganon pursued the Triforce in a pig-like form, commanding an army of demons.

A Link to the Past
Ganon plotted his revival from the Dark World. Sages spoke then of a time when he was once a man.

Ocarina of Time
The thief Ganondorf obtained the Triforce of Power and transformed into Dark Beast Ganon before being sealed away.

Oracle of Seasons & Oracle of Ages
Twinrova revived him. Since the rite was incomplete, Ganon was mindless and full of rage.

The Wind Waker
Awakening from his divine seal, Ganondorf sought out Princess Zelda, the inheritor of the Triforce of Wisdom. He was defeated and did not transform into the Dark Beast Ganon.

Four Swords Adventures
The reborn Ganondorf broke the law of the Gerudo by stealing the Trident, and becomes Ganon, King of Darkness.

Twilight Princess
Ganondorf, banished to the Twilight Realm, uses Zant to return to Hyrule. Obtaining the Triforce, he possesses Zelda and becomes the Dark Beast before Link impales him with the Master Sword.

A Link Between Worlds
The sorcerer Yuga of Lorule used the descendants of the Seven Sages to summon and then fuse with Ganon's soul.

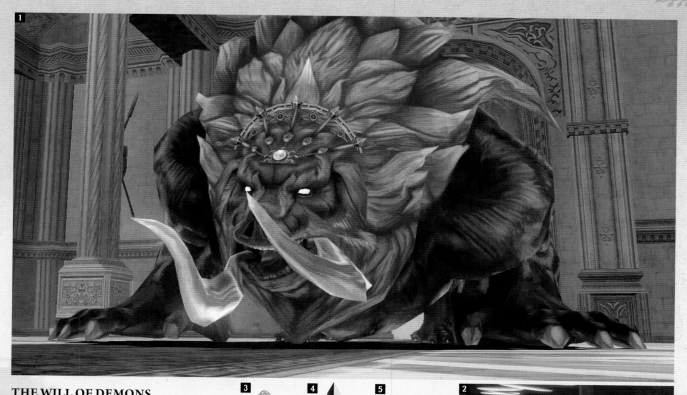

THE WILL OF DEMONS, A MAN OF DARKNESS

As a Demon King, Ganon's dark powers were truly terrible, but that focus on the darkness meant he was weak against light and silver arrows. Facing Link, who wielded the Master Sword and possessed the spirit of the hero, Ganondorf was sealed away. His soul overflowed with malice toward Princess Zelda and Link, and his will was strong enough to repeatedly break the seal. Plotting to overrun the world with demons, he continued to seek the power of the Triforce. No matter the state in which Ganon would return to Hyrule, demons seemed drawn to his side. Their allegiance to his cause was all but absolute.

Before his final confrontation with Link in *The Wind Waker*, Ganondorf, keeping his Gerudo form, let slip something telling, something that suggested his will was deeper than just power. "My country lay within a vast desert," he said. "When the sun rose into the sky, a burning wind punished my lands, searing the world. And when the moon climbed into the dark of night, a frigid gale pierced our homes. No matter when it came, the wind carried the same thing . . . death. But the winds that blew across the green fields of Hyrule brought something other than suffering and ruin. I coveted that wind, I suppose."

In defeat, he was freed from his unceasing, demonic desire to obtain the Triforce, which had clung to him like a curse.

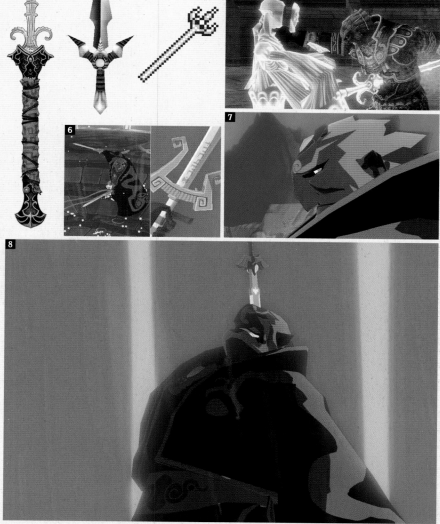

1 Dark Beast Ganon. **2** At the execution grounds in *Twilight Princess*, the Triforce of Power awakens and shatters Ganondorf's restraints. He then kills the water sage. **3** He takes possession of the sword used in the execution and wields it. The sheath is wrapped in cloth with a Gerudo pattern. **4** This is the weapon Dark Beast Ganon used in *Ocarina of Time*. It is decorated with topazes, Ganondorf's favorite gem. **5** The emblematic weapon of Dark Beast Ganon is the Trident, a three-pronged spear. **6** In *The Wind Waker*, Ganondorf wields two swords. Each is engraved with a name: "Kotake" and "Koume," respectively. **7** **8** In *The Wind Waker*, Ganondorf recalls the harsh environment of his home and reflects on his desire to take Hyrule. He is struck in the forehead with the Master Sword and is turned to stone by its power. He disappears with Hyrule beneath the waves of the Great Sea.

SPIRITS

Spirits in *The Legend of Zelda* possess unique powers and have an astral form different from physical matter. While their true form is technically invisible, they can reveal themselves and communicate by living within or taking on material forms.

It is not uncommon for a spirit's appearance to change depending on who they choose to appear to and when. Many spirits visible to people take the form of animals like turtles or whales. While many act as guides, spirits have at times been known to forge bonds of friendship with Hylians and others like them.

Rare spirits like the Ocean King (page 39) watch over entire worlds. Commanded by the goddesses, these and other spirits serve as a connection between people and their creators, and even come to be worshiped as protective deities.

In Hyrule, you can often see symbolic marks or names related to Din, Nayru, and Farore.

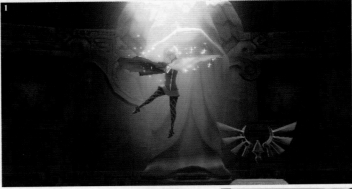

1 The sword spirit, Fi. Conveying the words of the goddess to the hero, she was created by the goddess Hylia to serve as a guide. She appears in a metallic form, awakening as needed and returning to sleep once her duty is complete.
2 Levias, the Spirit of the Sky from *Skyward Sword*. Here he sings the Song of the Hero, together with the three dragons.
3 A seedling born from the roots of the withered Deku Tree in the Adult Era of *Ocarina of Time*. One of its roles is to tell Link about his past. By the time of *The Wind Waker*, it has grown significantly.

THE THREE ANCIENT DRAGONS

In the time of *Skyward Sword*, three spirit dragons watched over the Surface: the water dragon, Faron, guardian of forests and sources of water; the fire dragon, Eldin, overseer of volcanic lands; and the thunder dragon, Lanayru, who had domain over the deserts. In addition to being entrusted with the land by the goddess Hylia, alongside the sky spirit Levias, their role was to pass on the four parts of the Song of the Hero to the hero. Each possessed the power of the land they were in, such as the ability to flood entire forests and set off volcanoes. The thunder dragon controlled the Ancient Robots (page 54) of the era by way of Timeshift Stones hidden beneath the desert that bears his name.

Faron *Eldin* *Lanayru*

SPIRITS OF LIGHT

Sent by the goddesses, the Spirits of Light sealed away the magical power of a group targeting the Triforce and banished them to the Twilight Realm (page 30). Their magical power was sealed in a Fused Shadow, split into four, and guarded in separate locations.

Just like the dragons, the names of these spirits were the same as the lands they protected: Ordona, Faron, Eldin, and Lanayru. Although they lived in spirit fountains, these spirits did not normally show themselves to people. They appeared to the hero as animals: a goat, monkeys, a bird, and a snake.

In *Twilight Princess*, after fulfilling their roles and disappearing, the spirits' springs become fairy springs, continuing to grant life energy to anyone who might happen upon them.

Spirit of Light *A spring after the spirit has left*

GUARDIAN DEITIES OF VARIOUS LANDS

The Great Deku Tree in *Ocarina of Time* nurtured the forest and the Kokiri (page 50). Lord Jabu-Jabu, an enormous whale-like guardian deity, was enshrined in the home of the Zora (page 48) at the source of their water. Both were spirits beloved as guardian deities. Residing within the Fire Temple in *Ocarina of Time*, Volvagia was a wicked dragon defeated by Link; in essence, it was the spirit of Death Mountain.

The Great Deku Tree *Lord Jabu-Jabu*

THE PEARL GUARDIANS

In *The Wind Waker*, the Deku Tree, spirit of the forest, was connected to the fire spirit Valoo and the water spirit Jabun. These great spirits of nature were a part of the daily lives of the people. They awaited the reincarnation of the hero, Link, and guarded the pearls of Farore, Din, and Nayru.

The Deku Tree *Valoo* *Jabun*

FAIRIES

Fairies are spirits that bestow life force to those in need. The especially powerful Great Fairies gather the smaller fairies to watch over the many corners of Hyrule. Above the Great Fairies, there exists a Fairy Queen who possesses enormous power. Throughout Link's many adventures, there have been multiple Fairy Queens.

Though the fairies are scattered all over, many live near fountains, bestowing life force to anyone who may wade into their healing waters.

One of the roles of fairies is to lend their power to Link whenever the order of the world is threatened.

If one places and keeps a small fairy in a bottle, it will give them life when their strength fails them. Because of this, fairies are sometimes captured using nets and sold in shops.

The Kokiri Forest in *Ocarina of Time* was also called the Fairy Woods. The spirit of the forest, the Great Deku Tree, watched over the Kokiri (page 50) with the aid of the fairies. In *Majora's Mask*, a man known as Tingle (page 57), who believed he was the reincarnation of a fairy, awaited the coming of his own fairy partner.

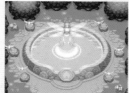
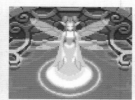

1 A fairy fountain. Many small fairies may be found floating together, waiting to restore the health of anyone who wades into the spring. **2** The fairy Navi from *Ocarina of Time*. At the behest of the Great Deku Tree, Navi guides Link, a boy raised by the Kokiri who becomes the Hero of Time. **3** A Great Fairy, in her extravagant fountain, grants Link powers. By playing a specific melody at the pedestal of the Triforce, she appears with a signature burst of laughter. **4** The fairy twins from *Majora's Mask*. The older sister, Tatl, casts a golden light, while her younger brother, Tael, casts a black light. **5** In *A Link to the Past*, fairies are captured with nets.

GREAT FAIRIES OF LEGEND

Over the course of Hyrulean history, a great many Great Fairies and Fairy Queens have aided Link in his quests, there to restore life and grant power when he needs it most.

For smaller fairies that can be bottled, please see page 122.

Majora's Mask *The Minish Cap* *The Wind Waker*

A Link to the Past
The Great Fairy (left) and the Fairy Queen, known as Venus, the goddess of the Pond of Happiness (right).

The Great Fairies encountered in various lands are all unique. Their appearances differ by their region.

Link's Awakening
Great Fairies exist on Koholint Island too. This one restores the hero's strength.

Ocarina of Time
The Great Fairies of *Ocarina of Time* received the divine protection of the three goddesses. They grant the power of magic in various locations.

Majora's Mask
Great Fairies in *Majora's Mask* exist in each region, but their bodies are scattered, and they wander as Stray Fairies (bottom right).

Oracle of Seasons & Oracle of Ages
Other than the fairies, Great Fairies, and Fairy Queen who lend their power to Link, there are also prankster fairies (bottom right).

The Wind Waker
The Great Fairy (left) and the Queen of the Fairies (right), the latter of which takes a childlike form.

Four Swords
The Great Fairies of *Four Swords* award visitors gold, silver, and Hero's Keys.

Four Swords Adventures
If Link saves the Fairy Queen (right), who was split in two by monsters, the Great Fairies (left) will also lend their aid.

The Minish Cap
The Great Butterfly Fairy, the Great Dragonfly Fairy (pictured), and the Great Mayfly Fairy. The hero answers their questions at the Adventurer's Spring.

Twilight Princess
The Great Fairy is found in the Cave of Ordeals and reigns over all fairies as their queen.

A Link Between Worlds
In addition to Great Fairies (left), there is also a Great Rupee Fairy (right) who desires tribute.

THE SACRED REALM & THE SAGES

When the goddesses descended and gave life to the world, they left the Triforce behind, and where it came to rest became known as the Sacred Realm. Those who guard the Sacred Realm with the royal family are called sages. The mysterious power of the early Hylians has largely been lost as eras have passed, but the sages and their descendants still possess this sacred power.

Each time the world falls into certain crisis, a new group of chosen sages awaken to combat evil.

The location of the Sacred Realm had long been a mystery, but when it was discovered, war broke out. The ancient sage Rauru placed the Triforce of the Sacred Realm in the Temple of Light and constructed the Temple of Time (page 26) on the other side to conceal its entrance. The key that joined the Temple of Light to the Temple of Time was the Blade of Evil's Bane, the Master Sword (page 82).

The towering Door of Time, at the heart of the Temple of Time, was erected to prevent anyone but a chosen hero from approaching the Master Sword's pedestal. The door was sealed, and would not open without a song from the royal family's Ocarina of Time, and Spiritual Stones of forest, fire, and water, each entrusted to a race swearing loyalty to the royal family.

When young Link opened the door and drew the Master Sword, Ganondorf was right behind him. The Gerudo thief invaded the Sacred Realm and used the Triforce of Power to become the King of Evil. Link, the Hero of Time, was thrust forward in time to awaken the sages and, together with their leader, Princess Zelda, seal Ganon away.

In the timeline where the Hero of Time failed to stop Ganondorf, a war over the Sacred Realm broke out. Vile demons poured out of the Sacred Realm, which had been turned into the Dark World (page 29) by Ganon's evil heart. The Seven Sages of that era sealed the realm in a ferocious battle known as the Imprisoning War. The clan of knights tasked with guarding the sages was nearly wiped out in the process.

No matter the timeline, Hyrule's sages and their descendants are fated to be targeted by Ganon and the forces of evil.

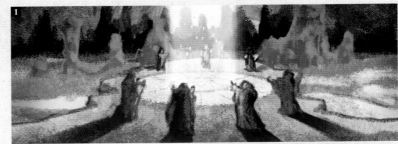

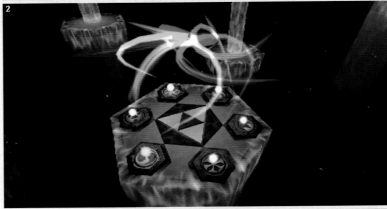

1 The sealing of the Sacred Realm. **2** In *Ocarina of Time*, the Seven Sages, including Zelda, seal Ganon away. **3** The Temple of Time from *Ocarina of Time*. A connection is made to the Sacred Realm with the Master Sword. **4** The ceremony to revive Ganon in *A Link Between Worlds*. Those who carry the blood of the Seven Sages are gathered.

THE SAGES & MAIDENS OVER THE AGES

A Link to the Past
Agahnim kidnapped seven maidens who descended from the sages, sacrificing all but Zelda to the Dark World.

Ocarina of Time
The six sages here were each represented by a different group: Hylian, Kokiri, Goron, Zora, Sheikah, and Gerudo, with Rauru at the head of the six. Zelda is the seventh sage and their leader.

Oracle of Seasons & Oracle of Ages
Maidens with the same names as the goddesses Din, Nayru, and Farore guard the order of seasons and time.

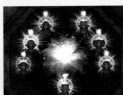

The Wind Waker
With the Sages of Earth and Wind murdered by Ganondorf's servants, Link must find new sages to take up their cause.

Four Swords Adventures
Vaati was sealed in the Elemental Sanctuary by Link and Zelda, and watched over by seven maidens, including Zelda, who were all descended from the sages.

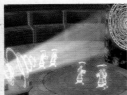

The Minish Cap
Ezlo, a sage turned into a bird-like cap, carries the knowledge of the Minish.

Twilight Princess
Ganondorf's execution fails. Breaking free of his chains, Ganondorf kills one of the sages. The others continue to protect the Twilight Mirror.

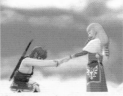

Spirit Tracks
The Seven Sages of the Lokomo protect the Spirit Tracks that sealed the Demon King Malladus (page 41).

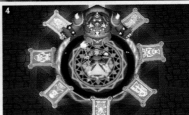

Skyward Sword
Zelda, born to the headmaster of the Knight Academy, doesn't realize that she is the goddess Hylia reborn. She happens to play the role of the goddess Hylia during a Knight Academy ceremony.

A Link Between Worlds
Yuga kidnaps the Seven Sages and brings them to Lorule in an attempt to revive Ganon and merge with him.

THE SEVEN SAGES & THEIR SYMBOLS

In eras when the Seven Sages awake to fight evil, there are also eras when, within the seven, there are six sages associated with particular symbols and Zelda is the seventh sage and their leader.

The symbols that are the crests of six of the Seven Sages in the era of the Hero of Time can be seen in the most ancient of times, adorning the Temple of Hylia in the era of *Skyward Sword*. Information about those symbols has been lost to time, but in the era of the Hero of Time, there is a legend passed down among the Sheikah that states, "When evil rules all, an awakening voice from the Sacred Realm will call those destined to be sages. Together with the Hero of Time, the awakened ones will bind the evil and return the light of peace to the world."

As foretold, during the events of *Ocarina of Time*, the Seven Sages, including Princess Zelda, awaken, sealing Ganon away, fulfilling their duty to bind evil.

Each of the sages in *Ocarina of Time* and *Twilight Princess*, with the exception of Princess Zelda, their leader, is associated with a crest that shows their particular element: forest, fire, water, spirit, shadow, or light.

The Seven Sages have awoken in Hyrule's darkest times in multiple timelines, including the Imprisoning War. Those sages passed the secret of the Sacred Realm and the Triforce on to their descendants, who were not sages themselves but carried the blood of the sages, and were therefore the key to breaking the ancient seal to the Sacred Realm, corrupted by Ganon's heart into the Dark World.

1 The ceiling of the Temple of Hylia (*A* on the timeline to the left). The goddess Hylia split the Triforce when she raised it into the sky, but it is possible to confirm the six crests. **2** Stained glass images of the sages around the pedestal of the Master Sword in Hyrule Castle, keeping watch. In this era (*C* on the left timeline), two sages place their power in the Master Sword. **3** The crests of the sages are lined up on either side of the throne inside Hyrule Castle (*B* on the timeline chart). **4** The Arbiter's Grounds, where judgment is passed down by the sages. The sages' tower marks it as a place of significance (*B* on the timeline chart). **5** The Seven Sages in *A Link Between Worlds* all stand on pedestals marked by their initials rather than the traditional crests (*D* in the timeline chart). Unlike other times, Zelda is not among these seven.

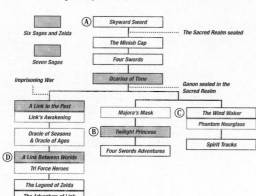

[Timeline chart]

Six Sages and Zelda

Seven Sages

Imprisoning War

(A) Skyward Sword — — — — — *The Sacred Realm sealed*

The Minish Cap

Four Swords

Ocarina of Time — — — — *Ganon sealed in the Sacred Realm*

A Link to the Past
Link's Awakening

Oracle of Seasons & Oracle of Ages

(D) A Link Between Worlds
Tri Force Heroes

The Legend of Zelda
The Adventure of Link

Majora's Mask — (C) The Wind Waker
(B) Twilight Princess — Phantom Hourglass
Four Swords Adventures — Spirit Tracks

Forest	Fire	Water	Spirit	Shadow	Light

THE SAGE OF LIGHT WHO BECAME AN OWL

Owls are symbols of wisdom. Protectors of knowledge. Perhaps this is why the ancient sage Rauru chose to appear to Link as the owl-like bird Kaepora Gaebora: he knew what Link would have to do to stop Ganon.

. . .

By the time the ancient sage Rauru constructed the second Temple of Time in the Era of Chaos to seal the Sacred Realm and the Triforce within, the events of *Skyward Sword* had faded into legend. It was said that the Master Sword had been used by a hero who traveled between two times and that there was a temple called the Temple of Time.

Borrowing the name of legend, Rauru constructed the new Temple of Time on the ruins of the Sealed Temple, and made the Master Sword a key for passage into the Sacred Realm. Since only someone worthy could pull the sword from its pedestal, it would keep those unworthy of the Triforce from entering the Sacred Realm.

Rauru then secluded himself in the Sacred Realm in the Chamber of Sages along with the Triforce.

The Sheikah inherited the secret of the realm and Master Sword, while Rauru's name was all but forgotten.

A great length of time passed before the Triforce was targeted by Ganondorf. A young boy from the Kokiri Forest, Link, emerged, another hero able to travel between two times, and he was destined to become the Hero of Time.

. . .

Although the events of *Skyward Sword* took place long before Rauru existed, the legacy of those events and of the hero who first wielded the Master Sword set the events that took place in *Ocarina of Time* in motion.

The legend of the Hero of Time was told and celebrated by the people for ages to come, and the name of Rauru, the Sage of Light, along with it.

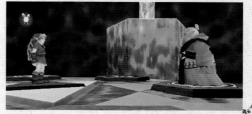

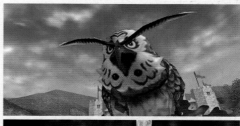

THE TEMPLE OF TIME

The temples of Hyrule are not only places for the faithful to gather and worship the goddesses. They are also built to protect sacred treasures and items, which is why temples often have mechanisms in place to stop intruders.

The temple regarded with the most reverence has always been the Temple of Time. The form of the temple changed over the eras, but it has always housed the Master Sword (page 82), which has served as a key to traverse time. Even in eras where the temple has decayed and fallen into ruin, the Master Sword, in its pedestal, remains.

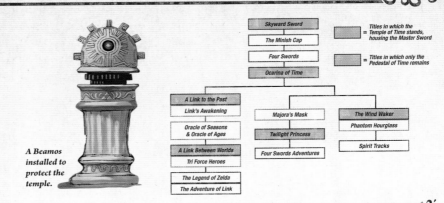

A Beamos installed to protect the temple.

Skyward Sword	
The Minish Cap	
Four Swords	
Ocarina of Time	

= Titles in which the Temple of Time stands, housing the Master Sword

= Titles in which only the Pedestal of Time remains

A Link to the Past		
Link's Awakening		
Oracle of Seasons & Oracle of Ages	Majora's Mask	The Wind Waker
A Link Between Worlds	Twilight Princess	Phantom Hourglass
Tri Force Heroes	Four Swords Adventures	Spirit Tracks
The Legend of Zelda		
The Adventure of Link		

THE TWO GATES OF TIME
Skyward Sword

Two Gates of Time stood as a means for traversing time in early eras. In *Skyward Sword*, Link found one gate in the old Temple of Time in the Lanayru Desert, and another in the Sealed Temple—once the Temple of Hylia.

Each gate operated by way of the divine force that dwells within the Master Sword. The Temple of Time was destroyed after Link and Impa escaped Ghirahim through it, the Goddess's Harp in tow. The Sealed Temple did not survive the ages, but Rauru's Temple of Time was built where it once stood.

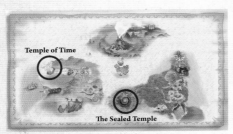

Location of the two Gates of Time: the Sealed Temple and the Lanayru Desert.

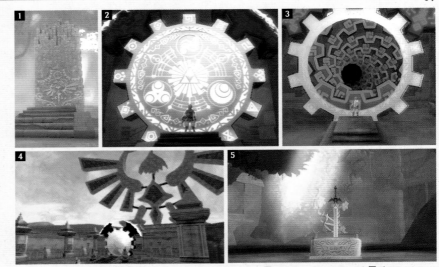

1 The Gate of Time in the Sealed Temple before being activated. **2** The gate when activated. **3** The gate in use. **4** The Temple of Time in the Lanayru Desert. It sat at the heart of what was once a thriving civilization where Ancient Robots were used to mine for Timeshift Stones. **5** The Master Sword in its pedestal in the Sealed Temple.

THE DOOR OF TIME
Ocarina of Time

During the era of the Hero of Time, the Temple of Time, built on the ruins of the Sealed Temple, was quite close to Hyrule Castle.

The temple itself was dignified and sat in the middle of a well-maintained garden. At the rear of its towering, echoing main hall stood the sealed Door of Time. Beyond that, the Blade of Evil's Bane and key to the Sacred Realm (page 24), the Master Sword, sat in the Pedestal of Time.

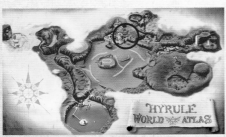

Location of the Temple of Time near Hyrule Castle and Castle Town.

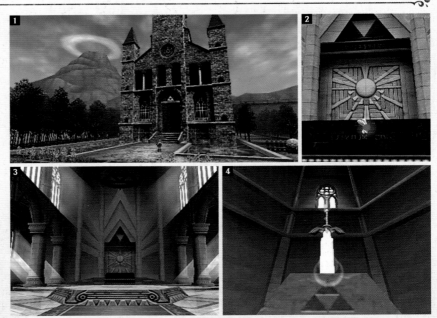

1 Unlike the lively town down the road, the grounds of the temple are quiet and serene. **2** The Door of Time would only open for the right person. **3** The inside of the Temple of Time is awe inspiring. **4** The pedestal of the Master Sword sits beyond the Door of Time. Removing it would open the entrance to the Sacred Realm.

THE PEDESTAL OF TIME

In *Twilight Princess* a dense forest prevents access to the ruins of the Temple of Time, but in the remains of the temple, the Master Sword still sleeps.

Link journeys to the sacred grove that has grown in place of the decayed temple. Using the Master Sword as a key, the descendant of the Hero of Time is able to walk into the past, where the temple still stands in all its grandeur and contains the technology of the Oocca. Additionally, the crest of the Sage of Light is everywhere.

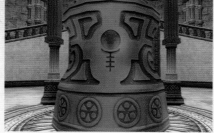

The Temple of Time made in ancient times bears crests thought to signify the Temple of Light.

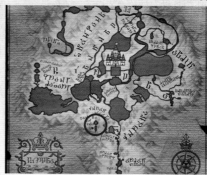

Location of the Sacred Grove.

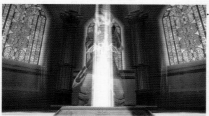

The key to the depths of the temple is the Master Sword. Many traps were built using the technology of ancient sky beings known as the Oocca. The Dominion Rod was enshrined there, to be carried by the messenger to the heavens, chosen by the royal family.

COMPARISON OF THE PAST & PRESENT

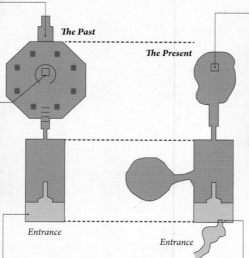

The Past

The Present

Entrance

Entrance

The area around the Master Sword's pedestal is in ruins. There are few hints of the temple's past splendor.

The Pedestal of Time. The mark of the Sage of Light is etched into the floor, and the windows are decorated with beautiful stained glass.

Descending the staircase through this massive entryway leads directly to the room with the Pedestal of Time. Stone statues guard the entrance.

Even with the temple in ruins, the guardian statues continue to protect the Master Sword. The path to the Master Sword will open when the puzzle is solved.

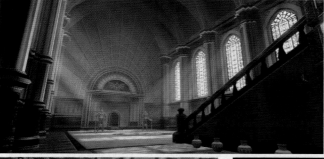

Past

Path leading to the Sacred Grove.

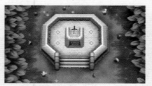

Present

THE PEDESTAL

The Master Sword is traditionally placed with its blade in gray stone atop a fine pedestal. In *A Link to the Past*, the game that established the tradition, Link found this pedestal in a grove deep within the forest. In *The Wind Waker*, it was inside the austere, temple-like bowels of Hyrule Castle.

A Link to the Past
The Sacred Grove deep within the Lost Woods. Extracting the sword will clear the surrounding fog.

A Link Between Worlds
The Sacred Grove deep within the Lost Woods. Removing the sword attracts small birds and animals.

The Wind Waker
Deep within Hyrule Castle. When the sword is extracted, time once again moves forward.

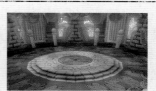

OTHER LANDS & REALMS

The adventures of Link are not confined to Hyrule. In many legends, the hero takes up the sword to smite evil in far-flung lands and strange other realms.

This section covers lands other than the kingdom of Hyrule and its Sacred Realm, and explains the relationship between those places and Hyrule.

To learn more about the people who call these and other lands home, please see page 217.

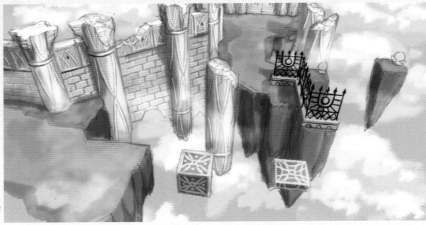

The Drablands that connect to Hytopia. Many mysterious worlds exist within and well beyond Hyrule.

BEYOND HYRULE

Though Hyrule is the land that is most associated with the *Legend of Zelda* series, there are many other lands that populate the legends.

Some exist independently of Hyrule and the world that it occupies, while others can be seen as photo negatives of Hyrule, or, if Hyrule and that world were two sides of the same coin, Hyrule would face the light, while the other side would be in the shadow. They are counterparts and form a pair, with Hyrule being situated in the Light World and its parallel counterpart existing in places called the Dark World or the Twilight Realm, demonstrating their relationship to one another.

Additionally, Lorule is a parallel world that acts as the opposite side of Hyrule, but also has its own separate history and Triforce.

These worlds do not ordinarily come in contact with one another, but, occasionally, some kind of trigger breaks down the barriers between them.

There are also illusory worlds that exist only in the dreams of great beings, or for only moments of time.

Kingdoms like Hytopia are connected to Hyrule by land and can be reached by conventional means—on foot or on horseback.

The skies over Hyrule have held their share of lands as well. Skyloft was created when the goddess Hylia raised islands of land off of the surface of the world to protect her people and the Triforce from evil. The Oocca's City in the Sky and the Wind Tribe's Palace of the Winds have also occupied the clouds in one era or another.

In the Adult timeline, where the Hero of Time disappears back to his rightful time, Hyrule is submerged beneath the Great Sea to seal Ganon and his evil forces. The Great Sea is connected to the neighboring world of the Ocean King by water. Beyond that is open sea that leads to the land of the Spirits of Good, which would become the land where Tetra founds the new kingdom of Hyrule.

The chart below illustrates one way of looking at the relationships between these various lands. Only the lands that serve as settings of the known legends are covered here, but it is certain that there are more yet to be discovered.

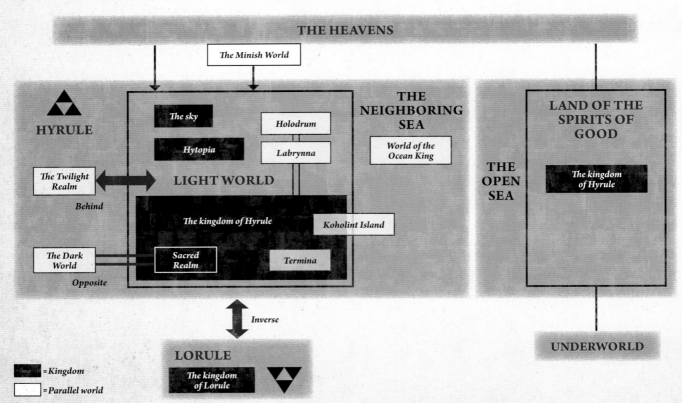

DARK WORLD: RUINS OF THE SACRED REALM

The Dark World is a kind of second Hyrule, born of Ganon's avarice. It exists in parallel to the Light World, a mirror that reflects a world full of gloom and despair, standing in opposition to all that is good.

It was originally the Sacred Realm (page 24), where the Triforce was kept safe.

It has been said that the Triforce grants the wish of whoever touches it, while also acting as a mirror of their heart. By invading the Sacred Realm and touching the Triforce, Ganondorf transforms the realm into the Dark World. It overflows with malice and becomes the domain of monsters.

The invasion of the Sacred Realm occurs in *Ocarina of Time*. Link then enters and explores the Dark World extensively in *A Link to the Past*.

LINK IN THE DARK WORLD

Ganondorf, transformed into Ganon, is sealed in the Sacred Realm with the Triforce. There, he plots his return.

Due to the actions of the dark wizard Agahnim, Ganon is able to make his move: sending the Light World into chaos by opening portals to the Dark World throughout Hyrule.

Those who set foot in the Dark World cannot maintain their form, and are transformed into the form that best represents who they are in their hearts.

Link turns into a rabbit, requiring an artifact known as the Moon Pearl to keep his Hylian form. Another artifact, the Magic Mirror, allows him to pass freely between Light and Dark. With these artifacts in hand, he defeats Ganon, then wishes for the Triforce to return the world back to the way it was before Ganon's chaos.

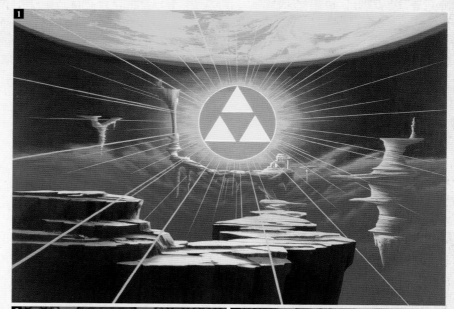

1 The Sacred Realm, transformed in the Dark World by the power of the Triforce. **2 3** The same meadow as it appears in the Light and Dark Worlds. **4** Link as a rabbit in the Dark World. **5** The Cursed Fairy, as she appears in the Dark World.

Magic Mirror *Moon Pearl*

MONSTERS IN LIGHT & DARK

Every living being changes in the Dark World: people, monsters, and creatures alike. Some differences are subtle, others extreme.

Light World: Octorok Dark World: Slarok

Light World: Crow Dark World: Dacto

Light World: Rope Dark World: Skullrope

Light World: Zora Dark World: Ku

Light World: Poe Dark World: Hyu

MORE DARKNESS

There have been other times when a hero named Link entered the Dark World. In *Four Swords Adventures*, portals to the Dark World open. And in *Spirit Tracks*, Link enters a parallel world called the Dark Realm that acts much the same.

Four Swords Adventures

A dark mirror casting its reflection on Hyrule, the Dark World can be entered through Moon Gates by way of the Moon Pearl. Shadows in the Light World are made physical in the Dark.

Spirit Tracks
The Dark Realm is the domain of Malladus and exists in the Underworld connected to the new Hyrule.

THE TWILIGHT REALM: WHERE THE ANCIENT TWILI DWELL

In *Twilight Princess*, Link is introduced to the Twilight Realm: a domain of shadows where the goddesses, by way of the four Light Spirits, banished the Interlopers, who sought to establish dominion over the Sacred Realm.

Unable to return to the Light World, the inhabitants of this realm eventually evolved into a race known as the Twili.

The sun does not shine in the Twilight Realm. Instead, there are glowing spheres of light and power known as Sols that give the realm life.

ORIGIN OF THE TWILIGHT REALM & THE TWILI

The origin of the Twili dates back to an ancient battle among Hylians over the Triforce of the Sacred Realm.

The Twili were once people of Hyrule with powerful magical abilities. Using this magic, they attempted to take control of the Triforce.

The goddesses sent the Light Spirits to the Sacred Realm to stop these would-be usurpers of the Triforce's power. Using the Mirror of Twilight, the Light Spirits banished the usurpers to the Twilight Realm and sealed their most powerful magic in Fused Shadows. Barred from returning to the Light World, they became the Twili, forever living in Hyrule's shadow.

Though they lost their most powerful abilities, the Twili still possess some magical power, and the strongest of them can even teleport.

They built a leadership structure around those with the strongest magical abilities. Until Ganondorf's interference in *Twilight Princess*, they lived in relative peace for ages, their hearts said to be purified in the gentle evening glow of a beautiful, if lonely, realm.

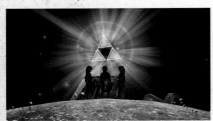

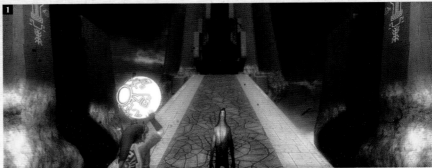

1 The Twilight Realm and Sols. The Sols, along with serving as the power source for activating mechanisms used in the Palace of Twilight, repel dark magic with their light. **2 3** Midna, the Twilight Princess and rightful ruler of the Twili. Unique clan patterns are embroidered in her black robes.

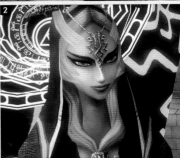

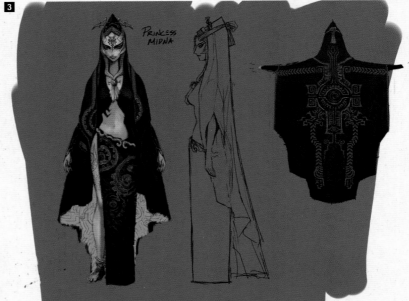

PRINCESS MIDNA

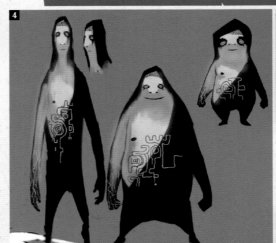

4 Typical Twili. They rarely speak, and most only communicate with other Twili. Note the distinct patterns on their chests, signifying their clans. **5** Zant's Hand guards the Sol in the Palace of Twilight.

Crest of the Twili

THE REBELLION OF ZANT

Even in the peaceful glow of twilight, dark ambitions can fester. Such was the case with Zant, who felt oppressed by the Light World for banishing his tribe to the Twilight Realm.

Zant served in the royal household of the Twilight Realm, believing that he would be the next to rule. Instead, rule went to Princess Midna.

Just as Zant's hatred is about to boil over, Ganondorf, banished to the Twilight Realm, grants Zant power, using him as a pawn in a greater scheme.

Zant incites a rebellion, transforming the Twili into monsters and making them his vanguard. He curses Princess Midna, steals her powers, and makes himself the self-proclaimed King of Twilight.

After Zant gains control of the realm, and with the help of Ganondorf, he begins an invasion of the Light World. He seizes control of Hyrule Castle, steals the light of the Light Spirits of each province, and expands the domain of shadow.

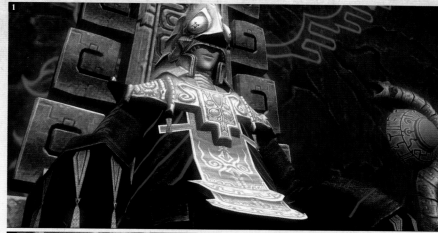

1 Zant was made king with Ganondorf's power. He worshiped Ganondorf as a god, his devotion made clear by the pattern on his robes. **2** Hyrule was fused with Twilight. As the spirits' light was stolen, the provinces protected by the Light Spirits became part of the Twilight Realm. The people of the Light World became soul shadows in the Twilight, but they were not aware of the change. Creatures became strange shadow monsters.

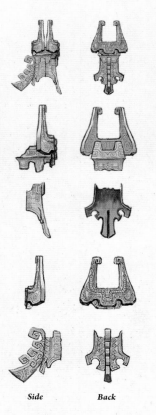

Side **Back**

Fused Shadows
The ancient magic of the Twili is sealed within a magic stone known as the Fused Shadow. After is is divided by the four Light Spirits, three pieces are placed under the care of Faron, Eldin, and Lanayru. The fourth is passed down among the leaders of the Twili. Together, the pieces take the shape of a face, and grant extraordinary power.

Mirror Chamber
The Mirror of Twilight, entrusted to the people of the Light World, was hidden in the Arbiter's Grounds in what was once Gerudo territory.

Mirror of Twilight
The Mirror of Twilight is a divine treasure that provides passage between the Light World and the Twilight Realm. It is entrusted to the people of Hyrule by the goddesses who forbade the usurpers from ever returning to the Light World. Zant attempts to destroy the mirror, and its pieces are scattered across Hyrule.

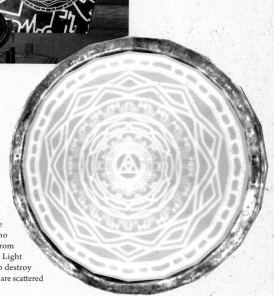

THE HERO WHO BECAME A WOLF

One of the legends passed down among the Twili for generations states, "In our world, we've long believed that the hero would appear as a divine beast."

It is said that the soul of the hero, in which dwells the power of the goddess, is endowed with the spirit of a noble beast. When Zant and Ganondorf rise to power in *Twilight Princess*, Hyrule is controlled by twilight. A wolf of shining gold appears. This wolf had been known long ago as the Hero of Time, his soul remaining to pass on skills only one with the hero's soul can utilize.

The young boy named Link from Ordon Village, who is the hero reborn, becomes a dark gray wolf inside the Twilight Realm. He possesses the courage recognized by the goddesses and obtains the Master Sword, just as prior versions of himself did.

Further recognized by the guardian deities of the Twilight Realm, Link gains additional power for the Master Sword and becomes their savior of legend: a true hero who brings together light and shadow and defeats both Zant and Ganondorf.

The Hero of Time appeared as a gold wolf.

Lorule: A Second Triforce

Lorule is the inverse of Hyrule. Its people, terrain, and even customs mirror Hyrule's. Lorule even possesses its own Triforce—until it is destroyed.

Like the Triforce in Hyrule, Lorule's has enormous power and will grant a wish to anyone who touches it. This sows greed within some, driving vicious conflict. Amid the turmoil, the king destroys the Triforce, seeing it as the root of the violence. But the Triforce is the foundation of the world itself. Without it, the world is doomed to decay and eventually die. On a steady march toward ruin, Lorule hatches a plan to steal Hyrule's Triforce and save itself.

The crest of the kingdom of Lorule

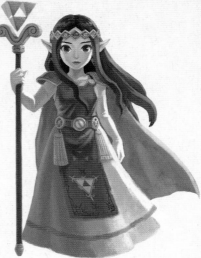

Princess Hilda, ruler of Lorule

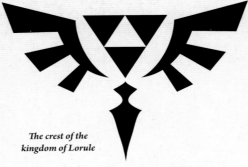

THE TRIFORCE LOST, A WORLD BEGINS TO DIE

Life without a Triforce makes for a miserable existence in Lorule. A great gloom settles over its people.

Without the Triforce's protection, thick, dark clouds form, blocking the sun. Great rifts grow in a land literally tearing itself apart. Animals turn into monsters.

Resources are soon exhausted and become increasingly scarce. Some people resort to banditry, and looting grows rampant. Still, few in Lorule feel any particular hatred toward the royal family. The king did what he thought was right by destroying the Triforce.

Over time, however, desperation sets in. Many begin to envy the monsters. They seem to have a happier life. The Masked Elder puts it thus: "Though we have seen the world crumble before us, we must not give in to the corruption of thievery! Monsters can keep you strong! They are your only salvation, my son. Don the mask. Don the mask!"

This is why some of Lorule's people wear monster masks, chanting and hoping for the day when they become monsters themselves.

1 The Triforce of Lorule. **2** Lorule Castle, somehow standing on collapsed ground. **3** The entrance to Hyrule is discovered by the priest Yuga. **4** The Triforce of Lorule. Princess Zelda and Link return its power to Lorule.

LIFE IN HYRULE

People seek salvation by donning monster masks.

A discolored and distorted house. Rubble is strewn all over the place.

HYRULE & LORULE

Lorule was once a world overflowing with light, much like Hyrule, but after losing its Triforce, it comes to resemble the Dark World (page 29) of legends past. In the absence of a Triforce, Lorule's people grow increasingly aggressive and grim.

Hyrule **Lorule**
A Hylian and her Lorulean counterpart.

Hyrule

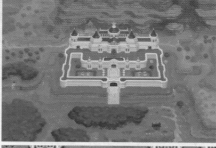

Lorule

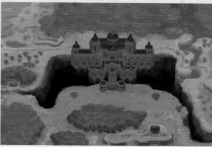

The same location in Hyrule and Lorule. In Lorule, the bridge has collapsed into the abyss. The castle teeters on the brink of a rift tinged with mysterious light.

The milk bar in Hyrule is full of customers and run by a kind owner. The bards play gentle songs. In Lorule, the bar is run by a shady owner and many customers find it intimidating or uncomfortable. The bards play sad music.

THE ADVENTURE OF RAVIO

Much as Link served Princess Zelda, a cowardly young man in Lorule serves Princess Hilda. His name is Ravio: a greedy, lazy merchant who covets rupees more than life itself.

Ravio watches as Hilda frets over her decaying kingdom. He sees her hatch a plan to steal the Triforce from Hyrule to return Lorule to greatness. While Ravio knows this is wrong, he mostly fears for his princess and the dark path she is taking.

Unable to muster the courage to do something about this himself, Ravio flees Lorule in search of someone who can help. Together with his bird Sheerow, he picks up the tools of his trade and sets out for Hyrule. There, in a land overflowing with light and life, he arrives at the home of a young man named Link, who is to become this story's hero.

Ravio gives Link a bracelet he treasured for many years in exchange for room and board. The bracelet smells unpleasant. Moldy. To a Hylian, it seems almost worthless. To Ravio, it is priceless: a reminder of the home he left behind.

Safe in Hyrule, Ravio decides to make himself comfortable, if not useful. He sets up an item rental shop and turns a handsome profit, largely by the patronage of Link, whom he comes to call "Mr. Hero."

After all of Ravio's items sell out, he has nothing to do but laze about, cheering on Mr. Hero.

Ravio isn't trying to save the world when he seeks help from Link. He is only trying to save Hilda's heart. But Ravio's items are essential in Link's quest. When Link and Princess Zelda bring the power of the Triforce back to Lorule, it is in no small part thanks to Ravio, a cowardly hero, but a hero all the same.

A diary is found in Ravio's house in Lorule, revealing Ravio's thoughts before he set out on his journey.

Ravio opens his rental shop after coming to Hyrule.

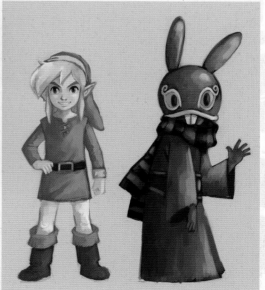

Link, hero of Hyrule, and Ravio, Lorule's coward.

Holodrum is the land where Link faces a trial bestowed upon him by the Triforce in *Oracle of Seasons*. It is governed by the spirits of the four seasons: spring, summer, autumn, and winter, in Season Towers. Din, the Oracle of Seasons, ensures their stability.

When Din is sealed away, Link must seek out the eight Essences of Nature, trade the essences for a Huge Maku Seed with the Maku Tree, and use the seed to take down the barrier at General Onox's Castle in Holodrum's northern reaches and save Din.

Beneath Holodrum is Subrosia, home to secretive Subrosians.

ESSENCES OF NATURE

Fertile Soil: Seeds are scattered across the bountiful lands of Holodrum and nourished in it.
Gift of Time: It allows seeds to sprout and seasons to change.
Bright Sun: Young shoots grow quickly under its warm rays.
Soothing Rain: Bathed in its drops, shoots grow into saplings.
Nurturing Warmth: It helps balmy days build strong saplings.
Blowing Wind: Sweet fruit is born when pollen is carried by it.
Seed of Life: Life begins anew when birds carry it to new lands.
Changing Seasons: Scattered seeds sprout in spring, grow in summer, bear fruit in fall, and sleep through winter. It is an endless cycle of life . . .

1 The Spirit of Spring.
2 Winter in Holodrum.
3 The Maku Tree, guardian of Holodrum, appears as an old man.
4 The Subrosians.

The Huge Maku Seed

STOPPING GANON'S REVIVAL

There are actually three oracles. Beyond Din and Nayru is Farore, Oracle of Secrets. Together the three share the names of the goddesses who created Hyrule. Link meets Farore over the course of his adventures in both Holodrum and Labrynna.

As Link works to restore the ages and seasons, the witches Twinrova are behind the scenes, plotting to resurrect Ganon. Their ritual requires three flames: the Flame of Destruction, ignited by the chaos of Holodrum; the Flame of Sorrow, stoked by the grief of Labrynna; and the Flame of Despair, lit by kidnapping Princess Zelda, a symbol of hope for her people.

After succeeding in lighting the flames, the twin Gerudo witches plot to offer Zelda as a holy sacrifice to complete the ritual, but Link stops them. The enraged Twinrova instead sacrifice their own bodies to revive Ganon.

The Ganon that is revived is incomplete due to Twinrova's unworthiness as a vessel: a mindless, raging beast. Link, having overcome the trials of both seasons and ages, defeats Ganon and fulfills his destiny.

The spirit of the Triforce has guided Link since the age of *A Link to the Past*. With its guidance, Link has fought his way through countless trials and legendary acts of heroism, like those faced in Holodrum and Labrynna.

It is said that after these trials, the Triforce took the form of birds that soared skyward and headed in different directions. This would account for its splitting prior to A Link Between Worlds.

1 The tower that Queen Ambi forced the people to build.
2 The Maku Tree, guardian of Labrynna, appears as a young girl.
3 The courtyard from Ambi's Palace in the past.
4 The Tokay, who live on the shores of Crescent Island.

If Holodrum is the domain of the seasons, Labrynna is the domain of time. In *Oracle of Ages*, Link is transported to Labrynna by the Triforce and must face another trial: correcting the flow of time by saving the Oracle of Ages, Nayru, after she is possessed by Veran, the Sorceress of Shadows.

Link must travel between past- and present-day Labrynna, seeking out the eight Essences of Time. He must then trade these with the Maku Tree for another Huge Maku Seed.

In ancient times, the land of Labrynna was ruled by Queen Ambi, who had her subjects construct the giant Black Tower that still stands there.

Labrynna is also home to the Zora, who live in the Zora Seas, and the Tokay, who call the shores of Crescent Island home.

ESSENCES OF TIME

Eternal Spirit: Even after life ends, it speaks across time to the heart.
Ancient Wood: It whispers only truth to closed ears from out of the stillness.
Echoing Howl: It echoes far across the plains to speak to insolent hearts.
Burning Flame: It reignites wavering hearts with a hero's burning passion.
Sacred Soil: All that lies sleeping in the bosom of the earth will know its nourishing warmth.
Lonely Peak: It is a proud, lonely spirit that remains stalwart, even in trying times.
Rolling Sea: The mystical song of the sea roars into a crashing wave that sweeps heroes out into adventure.
Falling Star: The eternal light of this heavenly body acts as a guide to the other essences.

The Huge Maku Seed

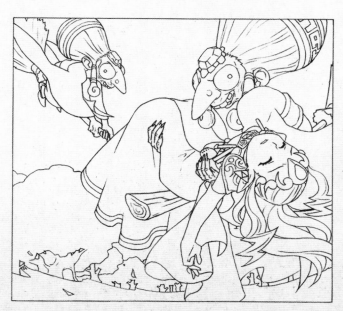

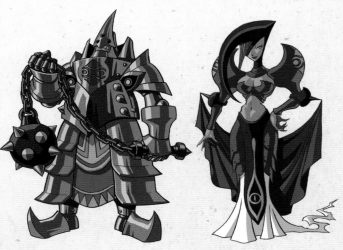

Servants of Twinrova: the General of Darkness, Onox, and the Sorceress of Shadows, Veran. The pattern of the Gerudo decorates their clothing and armor.

TERMINA: THE WORLD OF MAJORA'S MASK

In *Majora's Mask*, young Link wanders into Termina. The entrance to this parallel world is deep within a forest in Hyrule and leads to Clock Town, Termina's central hub.

Much like Hyrule, Termina has great bodies of water, towering mountains, and deep canyons—and the people who call these areas home resemble their Hyrulean counterparts.

Hyrule and Termina join in the center of a dim forest. Passing through, the hero emerges underneath the tower at the center of Clock Town.

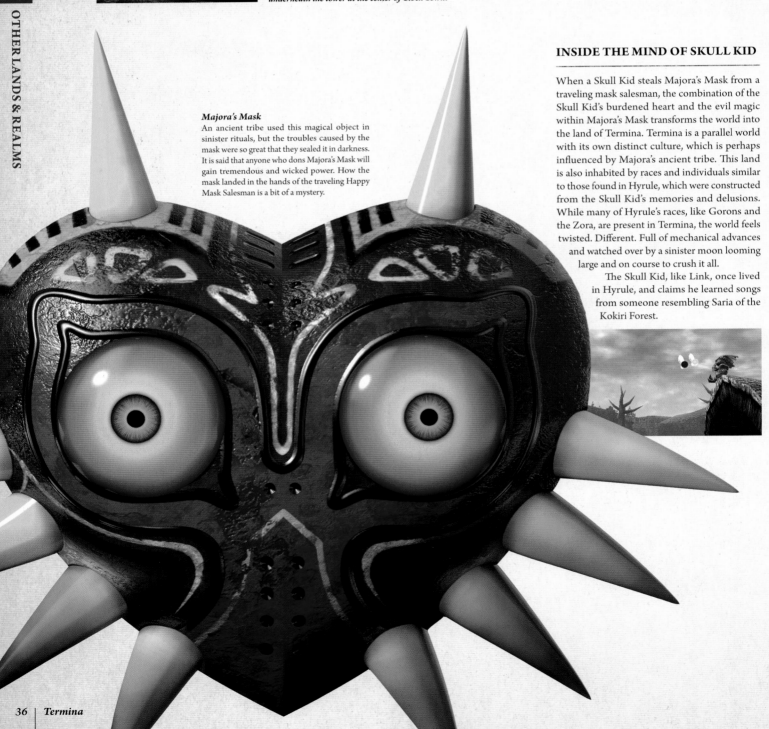

Majora's Mask

An ancient tribe used this magical object in sinister rituals, but the troubles caused by the mask were so great that they sealed it in darkness. It is said that anyone who dons Majora's Mask will gain tremendous and wicked power. How the mask landed in the hands of the traveling Happy Mask Salesman is a bit of a mystery.

INSIDE THE MIND OF SKULL KID

When a Skull Kid steals Majora's Mask from a traveling mask salesman, the combination of the Skull Kid's burdened heart and the evil magic within Majora's Mask transforms the world into the land of Termina. Termina is a parallel world with its own distinct culture, which is perhaps influenced by Majora's ancient tribe. This land is also inhabited by races and individuals similar to those found in Hyrule, which were constructed from the Skull Kid's memories and delusions. While many of Hyrule's races, like Gorons and the Zora, are present in Termina, the world feels twisted. Different. Full of mechanical advances and watched over by a sinister moon looming large and on course to crush it all.

The Skull Kid, like Link, once lived in Hyrule, and claims he learned songs from someone resembling Saria of the Kokiri Forest.

A TALE OF FOUR GIANTS & A FALLING MOON

In Clock Town, at the heart of Termina, there is a story passed down telling of four guardian giants (depicted in the bottom right image). According to this story, the giants once lived together in harmony with the town, and there's also mention of a mischievous imp . . . the Skull Kid. The four giants were spirit friends of the Skull Kid who, much like Termina itself, were created in a new form by the power of Majora's Mask. As for the Skull Kid's past deeds . . . they are now legend among the people of Termina.

As the legend continues, the giants are sealed away, and Termina is fated to be destroyed by the swiftly falling moon. Luckily, the Hero of Time appears to defeat Majora's wicked embodiment and break the curse of Majora's Mask. While the hero's pure heart allows the world of Termina to momentarily revel in its salvation, as soon as he departs, that world ceases to exist. Having learned his lesson, the Skull Kid makes amends with his friends the giants, and thus the world in his heart also finds peace and is able to greet the dawn of a new day.

THE CARNIVAL OF TIME

Each year, the season of harmony begins when the sun and moon are in alignment. Paying homage to the way that both nature and time are tirelessly in the process of progressing. The Carnival of Time is when the peoples of the four worlds celebrate that harmony and request fruitfulness for the next year.

For ages, people have worn masks resembling the giants who are the gods of the four worlds. Now, it has become a custom for each person to bring a handmade mask to the Carnival of Time. It is said that if a couple united on the day of the festival and dedicated a mask as a sign of their union, it would bring luck.

The centerpiece of the carnival is the Clock Tower, and on the eve of all the festivities, the doors to its roof are opened. From atop the Clock Tower roof, a ceremony to call the gods is held and an ancient song is sung.

All of these festivities for the Carnival of Time are held so that we may ask the gods for a rich harvest in the year to come!

—Legend as told by Anju's Grandmother

Masks are closely tied to the livelihood of residents in Termina. These are masks used for weddings: a groom's Sun Mask and a bride's Moon Mask.

THE FOUR GIANTS

This tale's from long ago when all the people weren't separated into four worlds like they are now. In those times all the people lived together, and the four giants lived among them. On the day of the festival that celebrates the harvest, the giants spoke to the people.

"We have chosen to guard the people while we sleep. 100 steps north, 100 steps south, 100 steps east, 100 steps west. If you have need, call us in a loud voice by declaring something such as 'The mountain blizzard has trapped us.' or 'The ocean is about to swallow us.' Your cries shall carry to us . . ."

Now then . . . there was one who was shocked and saddened by all this. A little imp. The imp was a friend of the giants before they had created the four worlds.

"Why must you leave? Why do you not stay?" The childhood friend felt neglected, so he spread his anger across the four worlds. Repeatedly, he wronged all people. Overwhelmed by misfortune, the people sang the song of prayer to the giants who lived in each of the four compass directions.

The giants heard their cry and responded with a roar. "Oh, imp. Oh, imp. We are the protectors of the people. You have caused the people pain. Oh, imp, leave these four worlds! Otherwise, we shall tear you apart!"

The imp was frightened and saddened. He had lost his old friends. The imp returned to the heavens, and harmony was restored to the four worlds. And the people rejoiced and they worshiped the giants of the four worlds like gods.

And they lived happily . . . ever after . . .

—Legend as told by Anju's Grandmother

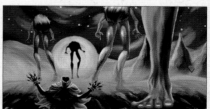

It can be theorized that the giants of the four worlds truly exist, that the imp is the Skull Kid, and the heavens are Hyrule.

KOHOLINT ISLAND: THE DREAM OF THE WIND FISH

Not far from the kingdom of Hyrule, there lives a sky spirit known as the Wind Fish. Massive and powerful, the Wind Fish is said to control the wind—and within its dreams lie an entire world. This is where the subtropical Koholint Island resides, in the dream of a great whale in the sky. The island is a peaceful domain of song-loving people who know nothing of existence beyond its shores.

It is said that life on the island began with a giant egg. The island formed around it, and on the island, people and animals were born. Beyond being surrounded by water, Koholint's geography closely resembles that of Hyrule.

During the events of *Link's Awakening*, the island has become the target of Nightmares attempting to overtake the dream world. The Wind Fish is unable to wake, its soul fading. It creates a version of itself inside its dream in the form of an owl, awaiting the arrival of a hero who will wake it. As it slumbers, the wind around it kicks up, creating a massive storm. Link, the very same hero from *A Link to the Past*, is caught in the storm and marooned on Koholint. The Wind Fish guides Link on a quest to awaken himself.

If the Wind Fish is woken up, this world will vanish. To the parasitic Nightmares living off the dream, this means destruction. To avoid the destruction of the world, the Nightmares began creating monsters. So long as they do not relinquish the musical instruments of awakening, they can obstruct the hero. Ultimately, the hero wakes the Wind Fish and escapes the island. Koholint Island vanishes into the sea.

Though the world was an illusion, Link's memories remain. It could be said that the memories themselves are the world of Koholint Island.

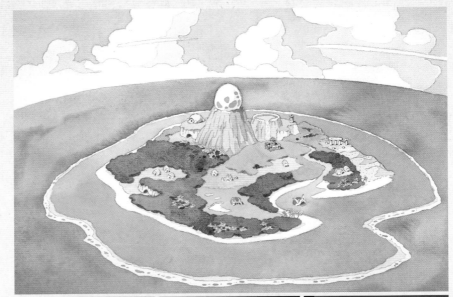

1 A storm rages in the seas not far from Hyrule. Link awakens to find himself marooned on Koholint Island. **2** A mural left for the one who will solve the mystery of the island. **3** The giant egg on top of the mountain. Here, the Wind Fish sleeps, waiting to be awakened by song.

LINKS ACROSS SEA & TIME

The Wind Fish and the Ocean King are both emissaries of wisdom, and both take the form of whales. In addition to being leeched off by monsters, Koholint Island and the world of the Ocean King share many other elements.

Incidentally, "Ballad of the Wind Fish" is the name of a song played by the Zora band the Indigo-Go's (page 49). The melody is different, however. Additionally, Captain Linebeck, who was dragged into the world of the Ocean King, has a grave in *Spirit Tracks*, as well as a grandson, so it is certain that he arrived in the land of the Spirits of Good (page 40).

THE WIND FISH

His form is that of a giant white whale. It is a spirit of the wind that flies through the skies and controls the wind.

THE OCEAN KING

His form is that of a giant white whale. He possesses incredible power and is the great spirit of the sea.

When Link left the world of the Ocean King, it is said that he saw Linebeck's ship in the distance.

WORLD OF THE OCEAN KING: ANOTHER LIFE AT SEA

Phantom Hourglass

The waters beyond Hyrule are the domain of a great spirit known as the Ocean King. Many people live on islands that dot the vast seas beyond the kingdom.

It is a parallel world that the hero Link wanders into in *Phantom Hourglass*. The world of the Ocean King, though in another realm, appears very much like the Great Sea of Link's world. There are numerous islands, including some inhabited by Gorons and Anouki, races found in old and new Hyrule. The Ocean King's world has also received the divine protection of three goddesses, similar to Hyrule, and is full of life force. Leaf, the Spirit of Power; Neri, the Spirit of Wisdom; and Ciela, the Spirit of Courage, serve the Ocean King, and their stronghold is the Temple of the Ocean King on Mercay Island in the southwest.

The flow of time in this parallel world is vastly different from Hyrule's, as the Ocean King and the Spirit of Courage have the power to control it.

The Ocean King's life force is stolen by a demon known as Bellum in *Phantom Hourglass*, and the possessed Ocean King is dragged into the depths of his temple. Bellum, usurping the temple, absorbs the great spirit's life force and uses it to create guardian Phantoms to prevent anyone from drawing near. To gather more life force, Bellum creates a Ghost Ship, spreading rumors of treasure to lure and trap prey in the world of the Ocean King. The spectral vessel terrorizes the seas, claiming the lives of many sailors.

As rumors spread of a Ghost Ship, Tetra's pirate crew are passing through in search of a land to replace old Hyrule, submerged in the end of *The Wind Waker*.

The Ghost Ship lures the pirates and Link, the Hero of Winds, into the world of the Ocean King. But Link's ready, having tangled with bigger fish. He defeats Bellum and revives the Ocean King.

With Bellum gone, his Ghost Ship vanishes.

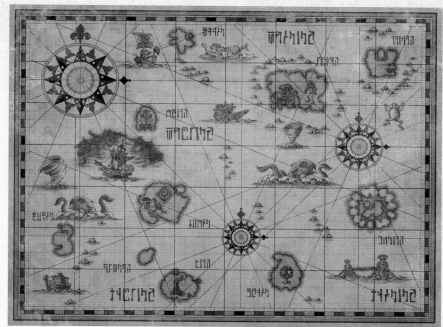

1 Bellum and the monsters he created with the stolen life force. **2** Bellum's Ghost Ship. **3** Captain Linebeck, one of the people lured into the world of the Ocean King. **4** The entrance to the Temple of the Ocean King. **5 6** Spirits are sealed in various temples: pictured is Leaf, the Spirit of Power. The crest of the three goddesses is present in the locations where the spirits are sealed away.

TALKING WITH SPIRITS

The Wind Fish and the Ocean King both create surrogates in order to communicate with the heroes who come to their aid. The owl that appears to Link on Koholint Island speaks for the Wind Fish, while the Ocean King takes the form of a man named Oshus, who is able to move freely in search of ways to fight off the monsters that plague his world.

DREAM & LIFE EATERS

The dream-eating Nightmares and the life force–consuming Bellum. Both are parasitic monsters.

PARALLEL ERAS

```
              Skyward Sword
                   |
             The Minish Cap
                   |
              Four Swords
                   |
             Ocarina of Time
          _____|_____
         |         |         |
  A Link to the   Majora's    The Wind Waker
     Past         Mask        Phantom Hourglass
  Link's Awakening  |              |
         |      Twilight      Spirit Tracks
  Oracle of Seasons Princess
  & Oracle of Ages
         |          |
  A Link Between  Four Swords
     Worlds      Adventures
  Tri Force Heroes
         |
  The Legend of Zelda
  The Adventure of Link
```

Though the events of *Link's Awakening* and *Phantom Hourglass* occur across separate histories, both happen at similar times: while at sea after the defeat of a revived Ganon.

THE SPIRIT OF THE SKY

Another spirit takes the form of a whale in *Skyward Sword*. Levias is a great spirit that guards the skies at Thunderhead. Like the Wind Fish and the Ocean King, Levias becomes plagued by a parasitic monster, in his case the Bilocyte.

There is a land far from the ancient kingdom of Hyrule governed by the Spirits of Good and home to the Lokomo tribe.

When old Hyrule was flooded, this was the land where Tetra's pirate crew founded a new kingdom. Tetra, revealed to be Princess Zelda in *The Wind Waker*, became this New Hyrule's ruler and founder.

A new castle and bustling Castle Town were built near the Tower of Spirits, off an inlet on the southern coast.

A complicated network of Spirit Tracks, already present after a prolonged war with the demon Malladus, allowed faster travel across vast stretches of land.

One hundred years after its founding, this world became the setting for *Spirit Tracks*.

In a land so dependent on trains, engineers here have coveted positions, and it is Princess Zelda, Tetra's descendant, who handles their appointment. The hero of this era begins his adventure as one such engineer.

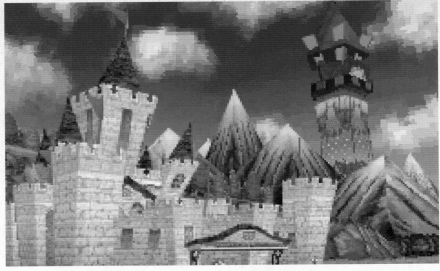

An engineer's certificate. It states: "I hereby recognize our newest royal engineer. Work hard, for we all rely on you."

The crest of the new kingdom of Hyrule. The King of Red Lions, pirate's swords, and the symbol of the Spirits of Good serve as motifs. The Triforce, lost at sea at the end of *The Wind Waker*, is not present.

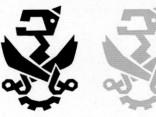

1 A stained glass window of Tetra in the audience chamber of Hyrule Castle. **2** Princess Zelda's office. The teacher takes care of her needs. **3** Soldiers. Their uniforms are based on the green outfit worn by the Hero of Winds. **4** The Royal Engineer Alfonso. A former swordsman, his ancestor was Gonzo, a member of Tetra's pirate crew. **5** A passenger train.

THE FOUNDING OF THE NATION BY TETRA

When Tetra and her pirate crew first arrive in the land of the Spirits of Good, they encounter Anjean, the Lokomo guardian of the Tower of Spirits.

To Anjean, these pirates are an obnoxious bunch, but over time she and Tetra grow close, becoming good friends.

Anjean possesses the Spirit Flute, an instrument. Tetra takes a liking to it, and after she pesters Anjean incessantly, Anjean finally agrees to give it to Tetra,

provided she uses its power to protect the land and its people.

The strong-willed Tetra has no reason to refuse. With the flute in hand, she creates a new kingdom of Hyrule, and with it, great prosperity.

One hundred years later, the descendants of the immigrant Hyruleans, alongside the Lokomo and other races in farther reaches, have built a nation to rival the Hyrule of old.

THE LOKOMO GUARDIANS & THE SPIRIT TRACKS

With a new land comes a new manifestation of evil. Ages before the Hyruleans arrived, the Spirits of Good sealed away the powerful Demon King Malladus in a protracted war.

The divine seal that trapped the demon spread Spirit Tracks across the land, which the Lokomo used to carry life force to the Tower of Spirits. After so many years of war, guardians were chosen among the Lokomo to pray in each corner of the land in order to maintain peace.

Since that war, there have been no monsters to speak of, and beyond the odd minor skirmish, peace has been kept, even after the arrival of the Hyruleans.

But even in this distant land and in the absence of the Triforce, Princess Zelda still holds her mysterious powers. Chancellor Cole, a kingdom official, plots to use these powers to revive Malladus.

Zelda and a brave engineer named Link travel together to defeat the revived Malladus. The Lokomo guardians, fulfilling their duty to protect the seal, entrust their land to the people of Hyrule.

From here, a new history of the kingdom of Hyrule begins.

1 An image depicting the Demon King's seal via the Tower of Spirits and the Spirit Tracks. **2** The guardian Anjean. Her duty ends with the defeat of the Demon King, and her soul ascends to the heavens along with her apprentice Byrne, whose hands were steeped in evil.

THE TOWER OF SPIRITS & THE SPIRIT TRACKS

The Tower of Spirits acts as a hub for the Spirit Tracks, which extend into the four main realms of Hyrule. The Spirit Train uses life force to run from the tower to each of the realms, and that force makes its wheels shine brilliantly. The tower itself is decorated with the colors and elements of each realm.

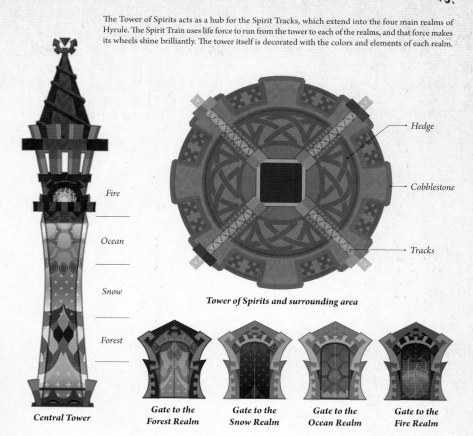

Fire

Ocean

Snow

Forest

- Hedge

- Cobblestone

- Tracks

Tower of Spirits and surrounding area

Central Tower

Gate to the Forest Realm

Gate to the Snow Realm

Gate to the Ocean Realm

Gate to the Fire Realm

The Spirit Train

The symbol of the Spirits of Good

THE GUARDIANS OF THE REALMS

In addition to Anjean, Lokomo guardians are tasked with the protection of shrines across the realms. They connect and maintain the Spirit Tracks using various instruments.

Gage, guardian of the Forest Realm

Steem, guardian of the Snow Realm

Carben, guardian of the Ocean Realm

Embrose, guardian of the Fire Realm

Rael, guardian of the Sand Realm

HYTOPIA: THE FASHION-FORWARD KINGDOM

North of the kingdom of Hyrule is Hytopia, a land governed by everything fashionable. The differences in language and traditions between the two kingdoms are minor, but an emphasis on fashion over swordsmanship defines the culture of Hytopia like nowhere else.

LINKS ACROSS SEA & TIME

Hytopian fashion is known for its bold designs and costume-like flourishes. The town's outlets, and in particular, Madame Couture's tailor shop, are famous the world over. Many people interested in fashion travel to Hytopia to shop and see what people are wearing in any given season. Princess Styla, Hytopia's beloved ruler, is particularly admired for her style, and is the perennial talk of the fashion elite.

The fashion of Hytopia isn't all about appearances. It's also about function. The climate in the north gets a bit chilly, so many in Hytopia don hats and clothing with frills and fringes. Sometimes, the outfits donned by Hytopians are designed to also aid in battle, particularly for those brave enough to enter the dangerous Drablands nearby.

When Princess Styla is cursed by Lady Maud, the Drablands Witch, her entire body is trapped in tights that she cannot remove. Styla shuts herself in her room, and the kingdom falls into deep despair. A rumor begins to spread that being fashionable will get you cursed.

Hytopia, so reliant on its fashion industry, finds itself in serious trouble.

The king sends out an announcement calling for heroes to lift the princess's curse and return Hytopia to its former glory.

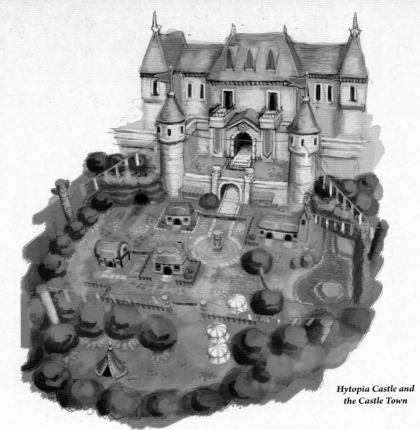

Hytopia Castle and the Castle Town

Madame Couture's logo

1 Madame Couture. She became famous for the mysterious powers that dwell in the clothes she makes, and receives orders from around the world. Her boy apprentice is not from Hytopia, but came to the kingdom for the love of fashion. **2** Princess Styla talks to her subjects about fashion. **3** The language of Hytopia is the same spoken in the kingdom of Hyrule. **4** The soldier at the entrance to Hytopia's coliseum is the captain from *A Link Between Worlds*. He has quite a high rank for someone who got transferred midcareer.

PASSAGE TO THE DRABLANDS

It is possible to instantly transport to the dangerous Drablands in Hytopia called the Triforce Gateway. Use of the pedestal is usually prohibited, since the Drablands it leads to are filled with monsters.

There are a great many kinds of terrain in the Drablands, from forests to swamps, volcanoes, and even areas high in the sky. Each contains enormous ruins.

It's clearly not a place where many people can live safely. Somehow, it is where Lady Maud, rival to Madame Couture, makes her home.

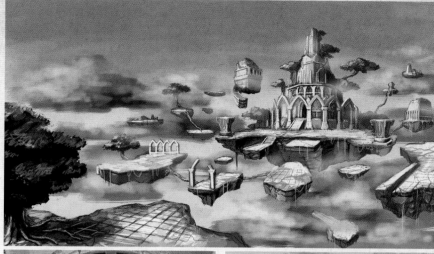

The pedestal known as the Triforce Gateway. The only entrance to the Drablands. It will only open in the presence of three people.

Ruins of the Drablands. Even after studying the symbols used here, it is not possible to identify its era or people.

LEGEND OF THE TRI FORCE HEROES & THE WITCH'S TRUE FORM

When Princess Styla is cursed by Lady Maud, the king, in accordance with the legend, gathers heroes to lift the spell.

The three marks of a hero in Hyrule are power, wisdom, and courage; but in Hytopia, proof of a hero is having "pointy ears, truly epic sideburns, and side-parted hair." In this era, the hero who saves the day has all of these qualities.

With the aid of two other heroes of similar character, he heads through the Triforce Gateway to the Drablands, where Maud awaits. The heroes of Hytopia wear various outfits made by Madame Couture to better survive what proves to be a perilous journey.

Before she was known as the Drablands Witch, Lady Maud was a designer from Hytopia. Similar to her sister Madame Couture's clothing, the outfits Maud made were imbued with magical powers. But unlike Madame Couture, Maud's skills went unrecognized. Ever confident in her abilities, Maud exiled herself to the Drablands, hoping to find appreciation for her unique sense of style among the monsters there.

To hear Maud tell it, she trapped Princess Styla in tights out of concern for her appearance. Maud felt Styla's style of dress didn't suit her, so she decided to send the princess a more fitting outfit. She selected the materials, adjusted the measurements, and created the ultimate tights to fit her body. "A perfect outfit for a perfect princess," Maud said.

Maud truly believed the outfit was the pinnacle of fashion, clothing that made all other clothing seem inferior, and so she placed a spell on the tights, preventing Styla from ever removing them.

LEGEND OF THE TRI FORCE HEROES

When three heroes heroically gather, the Triforce gate will open. So it is written. Right here. You just read it.

Hytopia's fated heroes shall embody the Three Noble Attributes of Courage.

Pointy ears that reach skyward, ever alert for the call of friends in need . . .

Attractive yet ethereal sideburns that inspire allies to greatness . . .

And perfectly parted hair that smells of lavender and friendship.

The bond between the three is such that they can communicate thoughts and emotions without a word.

They will totem. They will triumph. They will overcome all hardships.

That is why they are the three of legend . . . The Tri Force Heroes.

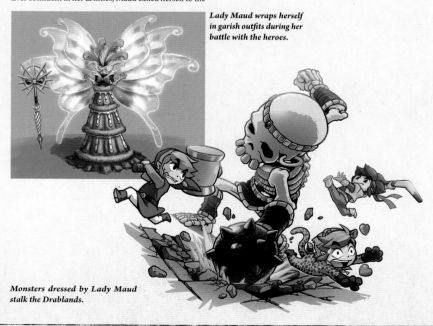

Lady Maud wraps herself in garish outfits during her battle with the heroes.

Monsters dressed by Lady Maud stalk the Drablands.

THE DIFFERENT RACES

Hyrule and the lands beyond its borders are not only the domain of Hylians; many races coexist with Hylians and spirits. Even among the Hylians, there are a variety of peoples of different cultures and ethnicities.

The relationships between various races and those living in the kingdom of Hyrule can be close or sources of great conflict.

There is an even wider variety of races when other realms and parallel worlds are considered.

This section examines the cultures and histories of other prominent peoples in *The Legend of Zelda*.

In an era that has become legend, it is said that the Hyrulean races fought demons alongside the goddess Hylia.

THE SHEIKAH: SHADOWS OF HYRULE

The Sheikah tribe have served the royal family of Hyrule since the age of creation. Born with the singular purpose of guiding and guarding the royal family, they protect and pass down the traditions of Hyrule and its leaders.

While there are few physical distinctions between Sheikah and Hylians, the Sheikah are known to excel in mobility and jumping, can use magic, and specialize in hand-to-hand combat. They have enhanced their technical capabilities with a variety of research and create tools unique to their tribe.

The existence of the Sheikah is typically a secret to all but members of the royal family and those close to them. Their tribe best fulfills its duty when acting in secret, as shadows of Hyrule.

In eras of war, they are essential agents of the royal family, handling all manner of duties, from combat to intelligence gathering. No matter how dark or perilous the task, they will do what is necessary to keep the kingdom from harm.

There was a time where they existed in great numbers. But as a relative peace comes over Hyrule, the role of the Sheikah becomes less important and their ranks dwindle. At certain points in Hyrule's history, encountering a Sheikah is a rare thing.

LINKS ACROSS SEA & TIME

Beyond their duty to protect the secrets of the royal family, the Sheikah historically act as guardians of the Triforce. This is why, over many eras, Sheikah have come out of the shadows to help the hero Link and Princess Zelda in times of need.

A woman named Impa is one such Sheikah, fated to aid the hero in his quest to stop Ganondorf from obtaining the Triforce.

In *Ocarina of Time*, Impa is born and raised in Kakariko Village (page 78), a hidden village of the Sheikah, and serves as Princess Zelda's attendant. When Ganondorf attacks the capital, Impa flees with Princess Zelda and guides the Hero of Time as the Sage of Shadow.

Sheikah women named Impa, all chosen to protect Zelda and help Link, have appeared as early as the earliest known story in the timeline, *Skyward Sword*.

Era upon era, the Sheikah have lived in the shadows, quietly carrying the absolute trust of the royal family on their shoulders while keeping a fragile peace.

Lens of Truth **Mask of Truth**

Sheikah Stone **Wood Statue**

The crest seen on items related to the Sheikah. It is in the shape of an eye, open wide to seek truth. The Sheikah live as shadows of the royal family and go to any lengths to achieve a goal. Knowing this, the eye on the crest sheds a single tear.

Crest of the Sheikah

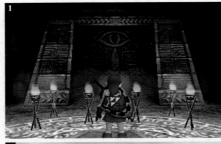

1 The Shadow Temple, located in the Kakariko Village graveyard. It is a place where the Sheikah, entrusted with the lives of Hyrule's royal family, have historically taken enemies of the royal family to be interrogated or worse. Because it stands as a symbol of Hyrule's dark history, it is taboo for the royal family to speak of this temple and its horrific purpose. **2** A forgotten village in *Twilight Princess*. The Hidden Village of the Sheikah is abandoned, but Impaz, the inheritor of the clan's lineage, remains to fulfill her role of guiding the messenger from the royal family to the heavens. **3** Impa, an old woman serving as Princess Zelda's attendant. In *The Legend of Zelda* and *The Adventure of Link*, she finds the boy who will become that era's hero, passes on the Triforce of Wisdom, and guides Link with stories of legends past. **4 5** Impa from *Skyward Sword* is brought to this world as a servant of the goddess. She maintains an absolute commitment to guarding the Sealed Grounds.

THE GERUDO: NOBLE THIEVES OF THE DESERT

The Gerudo people live in a harsh, unforgiving desert that bears their name. In this group made up entirely of women, traditionally only one boy is born to the Gerudo every hundred years, and he is fated to become their king.

Sweltering days and bitterly cold nights in the Gerudo Desert mean that the Gerudo are as tough as they are resourceful. Thievery is a livelihood. They compete in horse riding and archery. On the rare occasion that they make the trip to Castle Town, it is often in the pursuit of courtship.

In *Ocarina of Time*, Ganondorf is the boy born to the Gerudo and raised to lead them. He rises up to take control of all Hyrule, becoming the King of Evil. His Gerudo second in command, Nabooru, becomes leader of their people. Nabooru is brainwashed by Kotake and Koume, the witches who raised Ganondorf, and carries out cruel acts of banditry on his behalf.

Kotake and Koume, about four hundred years old at the time of Ganondorf's rise, are said to maintain their long lives by way of powerful magic.

Once Ganondorf is sealed, the world becomes peaceful and the Gerudo return to their lives of noble thievery.

When Ganondorf is then executed in *Twilight Princess*, the Gerudo are driven out of the desert altogether. They find a new home in the Desert of Doubt in *Four Swords Adventures*, and work to foster a more positive relationship with the Hylians, condemning the actions of their former leader.

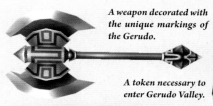

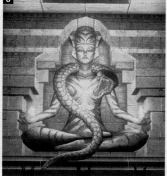

Crest of the Gerudo
The Gerudo crest depicts the back of a poisonous king cobra.

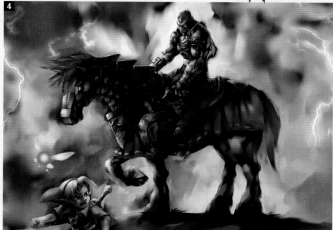

A weapon decorated with the unique markings of the Gerudo.

A token necessary to enter Gerudo Valley.

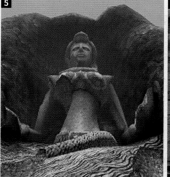

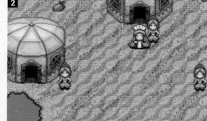

1 A Gerudo swordswoman. **2** The Gerudo village in *Four Swords Adventures*. The elder unites the clan while guarding their independence, but is also cooperative with Link. **3** Gerudo Fortress in *Ocarina of Time*. A Gerudo token is necessary for entry. **4** A Gerudo horse, characterized by its jet-black coloring, mounted by their leader, Ganondorf. **5** Beyond Gerudo Fortress and past the Haunted Wasteland are a goddess statue and the Spirit Temple. Because of differences in religion, the people of Hyrule say the Desert Colossus depicts an evil deity. Thieves loyal to Ganondorf and Nabooru use it as a base of operations, and experiments in brainwashing using magic are conducted there. **6** The era of *Twilight Princess*, where the Gerudo have left the kingdom of Hyrule after losing their leader Ganondorf. Within the desert now stands an execution ground governed by the kingdom. Inside stands a statue wrapped in a snake as well as Gerudo writing. The grounds are connected to the Spirit Temple. **7** The Gerudo alphabet. Their language is different from that of the Hylians.

THE GORONS: BODIES LIKE BOULDERS

A HISTORY AS OLD AS ROCKS

The rock-like, rock-eating Hyrulean race known as Gorons have a longer history than just about any race in the known world. They have been called "rock people" since ancient times, when the goddess Hylia ruled—and have long held close ties with the Hyrulean royal family.

Compared with Hylians, Goron bodies are larger, with some growing as big as mountains. They are heavy and solid, with a rock-like shell that runs from the top of their heads all the way down their backs. Goron legs are short, especially in comparison to their much longer arms. This is perfect for shielding their face when they roll into a ball for protection.

Gorons not only resemble rocks; they eat them too and typically build villages in volcanic regions where they can excavate the highest quality stone.

Despite their intimidating size and strength, most Gorons are relatively relaxed and friendly. Those who become chiefs are both powerful and wise, uniting their people through respect and trust, rather than by force.

GORON CULTURE & TRADITION

Gorons tend to live in relative isolation but will regularly trade with Hyruleans and other friendly races. They are especially gifted in bomb making and smithing.

Though Gorons eat rocks, they tend to be somewhat selective about the quality. Rock Sirloin extracted from Dodongo's Cavern is especially appetizing to Gorons. Some of them also occasionally enjoy milk after a soak in a hot spring.

Gorons are famous for their love of entertainment, singing, and dancing. Most styles of dance incorporate their sizable stature, rather than emphasizing finesse.

It is also customary for Gorons to paint their bodies. The patterns change with each era, and are often drawn in a manner deemed fashionable at the time, rather than adhering to any traditional symbols or greater meaning.

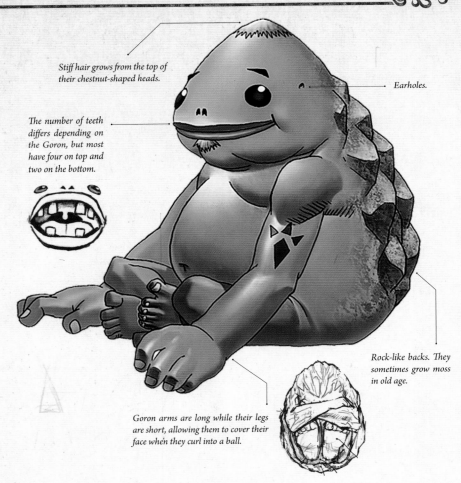

Stiff hair grows from the top of their chestnut-shaped heads.

Earholes.

The number of teeth differs depending on the Goron, but most have four on top and two on the bottom.

Rock-like backs. They sometimes grow moss in old age.

Goron arms are long while their legs are short, allowing them to cover their face when they curl into a ball.

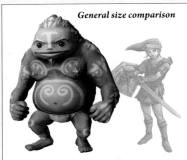
General size comparison

Child and elder

Hot spring

Rock Sirloin

This Goron has painted three lines on his back to be seen while rolling.

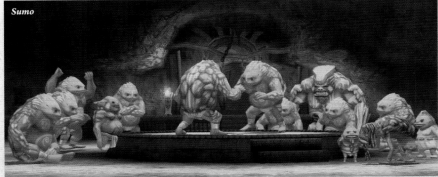
Sumo

OF STONE & CREST

The ancient Goron race has a deep, trusting relationship with the royal family of Hyrule.

When the Sacred Realm was sealed (page 24), it was the Gorons who were entrusted with guarding the Spiritual Stone of Fire, which is passed down among their leaders. The Spiritual Stone of Fire is also called Goron's Ruby, and its shape resembles that of the Goron crest. The crest has a long history and is a popular pattern when body painting.

A RESILIENT PEOPLE

Gorons have lived for ages weathering a great deal of change without changing too much themselves. They have the capability to thrive in any environment, and in times of crisis, have survived by migrating to different climes.

In the *Wind Waker* era, there are still Gorons around even after their Hyrule home is submerged.

Their relationship with the royal family of Hyrule wiped clean, they cross the seas, settle, and soon build a village in a distant land, beginning life anew alongside the Hylians.

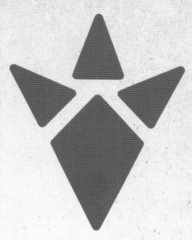

Crest of the Gorons

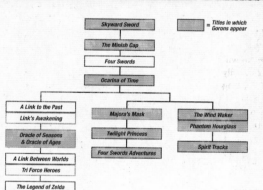

1 Gortram the entrepreneur attempted to start a coaster business in *Skyward Sword*. Ever resourceful, no challenge is too big for a Goron. **2** The ancient dragon Volvagia, revived by Ganondorf in *Ocarina of Time*, is a dragon that once devoured Gorons. The Goron leader Darunia descends from the great hero who first defeated it. **3** Wandering Goron merchants pop up in *The Wind Waker*. They hide their faces so as not to stand out, but they are Gorons. **4** A Goron as big as a mountain in *The Minish Cap*. Mountain-sized Gorons have appeared in multiple titles, with mountain-sized names like Biggoron and Medigoron.

Skyward Sword		= Titles in which Gorons appear
The Minish Cap		
Four Swords		
Ocarina of Time		

A Link to the Past	Majora's Mask	The Wind Waker
Link's Awakening	Twilight Princess	Phantom Hourglass
Oracle of Seasons & Oracle of Ages	Four Swords Adventures	Spirit Tracks
A Link Between Worlds		
Tri Force Heroes		
The Legend of Zelda		
The Adventure of Link		

GORONS OVER THE AGES

Darunia from Ocarina of Time
Chief of the Gorons in Hyrule during the adventures of the Hero of Time, Darunia famously loves singing and dancing, though he gets serious when it comes to ceremonies. Darunia affectionately calls those he trusts "brother." He awakened as the Sage of Fire to help defeat Ganondorf.

Ocarina of Time

Majora's Mask

Oracle of Seasons

Oracle of Ages

Darmani the Third in Majora's Mask
Hero of the Gorons, Darmani notices the change in the mountain and, sadly, perishes while investigating.

Darbus from Twilight Princess
A chief proud of his strength, Darbus and four elders unite many of the Gorons in the era of *Twilight Princess*.

The Wind Waker

Four Swords Adventures

The Minish Cap

Twilight Princess

Phantom Hourglass

Spirit Tracks

Skyward Sword

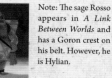

Note: The sage Rosso appears in *A Link Between Worlds* and has a Goron crest on his belt. However, he is Hylian.

THE ZORA: PROTECTORS OF WATER

The Zora are a race of Hyruleans uniquely adapted to thrive in water. Their features resemble those of Hylians, but with characteristics not unlike some fish. Zora have large fins on their arms and flippers on their feet, enabling them to swim freely in the rivers and lakes they call home. Zora primarily subsist on fish and other marine life, and many are skilled fishers.

Though Zora mainly live in freshwater, some eras have seen them find homes in oceans and seas. The territory of the Zora is limited only by where water flows, but all pledge allegiance to a single royal family who call Zora's Domain home.

Zora take pride in a strong sense of duty and respect for the history, laws, and leadership of their people. They do not often stray far from water, so interaction with other races tends to be limited. This is especially true of Zora's Domain. Typically, the only Hylians allowed in this central hub are official messengers of the Hyrulean royal family.

The Zora have maintained positive relations with their Hylian counterparts since ancient times. However, in the timeline of Hyrule's decline, that bond gradually fades.

The Zora, along with Hylians and Gorons, have often been called to watch over Hyrule.

Women of their royal family have been given the crucial role of sages in times of need. And when the Sacred Realm was sealed, the Zora were entrusted with guarding the Spiritual Stone of Water.

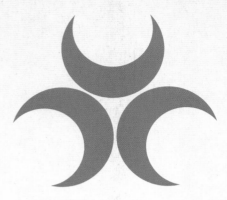

Crest of the Zora
Scales allude to their connection to water.

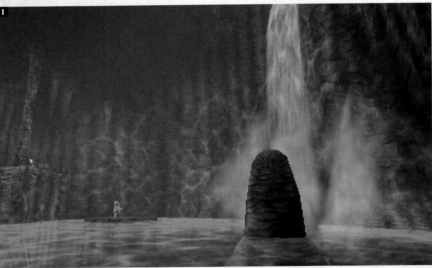

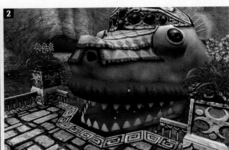

1 Zora's Domain. Zora villages tend to be small and remote, and are often found at water sources. **2** The giant fish Lord Jabu-Jabu, a water spirit, is revered as a guardian deity of the Zora. The royal family are tasked with Jabu-Jabu's care. **3** Zora can swim against the current and even up waterfalls.

ZORA OF LEGEND

Ruto from Ocarina of Time
The princess and daughter of the king. She inherits Zora's Sapphire, the Spiritual Stone of Water, from her mother as an engagement ring passed among the Zora, and later awakens as the Sage of Water, granting her power to the Hero of Time.

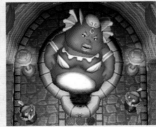

Queen Oren from A Link Between Worlds
The queen who rules over the Zora, Oren becomes bloated without her Smooth Gem. She later awakens as a sage.

The Legend of Zelda *The Adventure of Link* *A Link to the Past* *Link's Awakening*

Ocarina of Time *Majora's Mask* *Oracle of Seasons* *Oracle of Ages*

Four Swords Adventures *Twilight Princess* *A Link Between Worlds*

EVOLUTION OF THE ZORA

As Hyrule changes, so do the Zora. The three-way split in time alters the scope and direction of these changes greatly, with the Zora either maintaining their proud monarchy, evolving to fly instead of swim, or becoming monstrous sea creatures that threaten Link rather than help him.

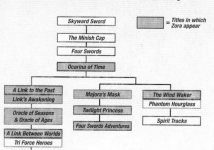

After sealing Ganon, the Zora Laruto becomes the Sage of Earth, offering prayers to the Master Sword. In this era of *The Wind Waker*, Hyrule has been flooded under the Great Sea. Due to the unnatural properties of the sea (page 69), it is inhospitable to the Zora. They evolve over the span of a century into the Rito, who possess the ability to fly. Laruto passes her sage abilities and duties to the Rito girl Medli, her descendant.

THE SPLIT

The Zora in *Ocarina of Time* maintain a strong relationship with the royal family of Hyrule, and guard the Spiritual Stone of Water, a key to the Sacred Realm. Known as Zora's Sapphire, it has been passed down within the royal family, used by generations of princesses as a sign of betrothal. The Zora king of this era is Zora De Bon XVI.

In the era of *Twilight Princess*, the Zora monarchy continues to reign in prosperity. They are equipped with spears and helmets to serve as guards to their Lakebed Temple at Lake Hylia.

When Queen Rutela is killed during the invasion from the Twilight Realm, the absence of a ruler throws the Zora into chaos. When Link thwarts Ganondorf, the queen's son Ralis assumes the throne, despite his young age.

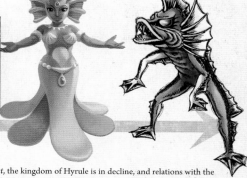

By the era of *A Link to the Past*, the kingdom of Hyrule is in decline, and relations with the Zora have soured greatly. Their bodies change from blue to green and they become increasingly aggressive toward outsiders, going so far as to spit fireballs at anyone who dares tread near their waters.

In *A Link Between Worlds*, Queen Oren attempts to rule over the Zora, but they split, with half pledging loyalty to her and half rebelling in violent fashion. Despite the queen's attempts to return the Zora to their former glory, this hostile faction of Zora grow stronger over time, and by the era of *The Adventure of Link*, the Zora are outright monsters.

CHARACTERISTICS

In the parallel world of Termina, a place called Zora Hall flourishes, with the popular band the Indigo-Go's regularly performing to enthusiastic crowds. Lulu, the lead singer, lays seven eggs. Zora eggs take one to three days to hatch after being laid, need to be kept together, and are sensitive to changes in water temperature. The eggs hatch and teach Link the New Wave Bossa Nova.

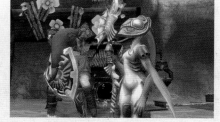

Zora navigate the waters of Hyrule better than any other beings, protect temples long submerged and forgotten, and keep hidden passages a secret to allow discreet travel not possible over land.

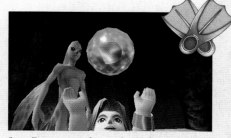

Some Zora items can bestow the Zora's aquatic powers to others. Over the course of his adventures, Link dons flippers that allow him to swim freely in water, a Silver Scale to dive for long periods, and a tunic that lets him breathe underwater.

THE KOKIRI: FAIRY PEOPLE OF THE FOREST

Deep within the Kokiri Forest live a people protected by the Great Deku Tree. It is said that the Kokiri never age, maintaining their childlike forms eternally. They all wear the same green outfit, and become a true Kokiri when partnered with a fairy. The Kokiri maintain almost no contact with the other peoples of Hyrule, though they are known among the Hylians, who often refer to them as "forest fairies."

In truth, the Kokiri are also Hylians. They trace their roots back to a time when the Hylians were first developing their civilization, building cities and relying on a less natural way of life. The Kokiri decided to distance themselves from the Hylians, exiling themselves to the forest to make their own way of life closer to nature.

The Kokiri are told that they will die if they leave the forest, but that is because they will age in places the Deku Tree's power does not reach. After the Sage of Forest revives and the child of the Deku Tree is born, they become able to venture outside of the forest they had been confined to for so long.

In a later era, a Kokiri serves alongside the king as the Sage of Wind, offering prayers to the goddesses.

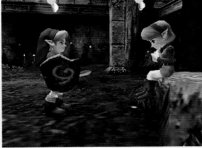

Crest of the Kokiri

The Kokiri Saria, playing the ocarina in the Sacred Forest Meadow. In Ocarina of Time, she senses the change in the Forest Temple and later awakens as a sage.

Fairy Slingshot *A Kokiri shield*

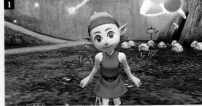

1 Their roots are Hylian and they appear very similar. **2** The Great Deku Tree and Spiritual Stone of the Forest, also known as the Kokiri's Emerald. Like the Gorons and the Zora, the Kokiri are entrusted with one of the three Spiritual Stones, keys to the Sacred Realm (page 24). **3** Where Hyrule Field and the forest meet. Hylians who wander into the Lost Woods turn into monsters: adults into Stalfos and children into Skull Kids. **4** The Kokiri use many things found in the forest in their everyday lives, like using Deku Seeds as slingshot ammo, and make their homes in trees.

NOTEWORTHY KOKIRI

Mido from Ocarina of Time
A bossy Kokiri who takes it upon himself to guard the Great Deku Tree, and later the path to the Sacred Forest Meadow.

Fado from The Wind Waker
An ancient sage who offered prayers in the Wind Temple, Fado awakens his descendant Makar as a sage.

DEKU SCRUBS: FOREST TROUBLEMAKERS

The Deku Scrubs of Hyrule make trouble in the forests and swamps. Unlike the Kokiri or spirits of the forest, they are a monstrous bunch. Their bodies are made of nuts and leaves, and they are characterized by glowing eyes and round mouths.

Deku Scrubs are extremely wary of other beings and live reclusive lives, hiding in the ground and spitting Deku Seeds at anyone who approaches.

Though they are more hostile than not, they have been known to trade with Hylians. It is said that the disposition of a Deku Scrub differs greatly based on the type of tree they are born from.

In the parallel world of Termina, Deku Scrubs build their own kingdom in the swamp.

Deku Scrubs' appearances and dispositions differ.
Some Deku Scrubs may be taller than others and many have different-colored leaves. Some, like Mad Scrubs, are especially aggressive.

In Four Swords Adventures, the Deku Scrubs of the Lost Woods try to gain Ganon's favor through flattery.

A Business Scrub doing business.

The Deku Kingdom of Termina and its crest (upper right). In Termina, Deku Kings reign and are bound to guard a temple deep in the swamp.

KOROKS: THE FOREST GUARDIANS

The Koroks are spirits of the forest. In *The Wind Waker*, they are led by the Great Deku Tree of Forest Haven. Koroks are made of light wood and make a jingling sound when they walk. Once a year, they gather at their home in Forest Haven and hold a ceremony to obtain seeds from the Great Deku Tree, which they use to grow forests on islands all over the world.

The roots of these strange forest dwellers lie in the Kokiri from *Ocarina of Time*. When old Hyrule was submerged, it is said that the Kokiri evolved, gaining the ability to fly above the waves to different islands.

NOTEWORTHY KOROK

Makar from The Wind Waker
The Korok in charge of the musical performance at the annual ceremony, Makar later awakens as a sage through Link's guidance, as well as the guidance of Makar's ancestor, the Kokiri Fado.

1 Koroks wear leaf masks of different shapes and colors. Their personalities may differ greatly, and are often reflected in their masks. **2** Koroks are able to fly long distances using a Deku Leaf imbued with magical power. **3** The Koroks, who cross the sea and scatter to various lands, plant seeds on islands and watch over their growth. A mysterious power dwells within the Great Deku's seeds created during their annual ceremony, and they must all be planted simultaneously or they will wither.

THE RITO: AN AVIAN TRIBE

The Rito are a race of bird-like Hyruleans. They have beaks and they can transform their arms into wings, allowing them to fly. In *The Wind Waker*, the Rito build a village on Dragon Roost Island and consider the dragon Valoo, who sits at the summit of the volcano, to be a guardian deity.

Their roots lie in the Zora from *Ocarina of Time*. They evolved to survive after Hyrule was submerged under the sea.

They are not born with the ability to fly, and only those Rito who have proven themselves as adults can receive a scale from Valoo and obtain their wings.

NOTEWORTHY RITO

Medli from The Wind Waker
Valoo's attendant awakens as the Sage of Earth through the guidance of Link and her Zora ancestor Laruto.

Komali from The Wind Waker
When Link first meets Komali, the son of the chieftain, the Rito prince is coming of age and nervous about his responsibility.

1 When Rito children reach a certain age, they enter Dragon Roost's volcano and meet Valoo, their guardian deity. They are recognized as adults and grow wings after being granted one of the great dragon's scales. **2** Rito that gain the ability to fly operate a mail delivery service between the islands of *The Wind Waker*. **3** The spirit Valoo and the Rito. Rito women serve as the dragon's attendants and interpret the ancient Hylian when Valoo speaks to visitors.

THE MINISH: SAVIORS FROM THE SKY

The Minish (whom the Hylians refer to as Picori) are a tiny race of beings about the size of a thumb. It is said that long ago they descended from the sky and granted a golden light, or Light Force, and a single blade to a hero. Only once every hundred years do the Minish visit, and only children can see them.

In *The Minish Cap*, there is a village of Minish in the Minish Woods. Its very existence is a secret to all but those with close ties to the royal family.

The Minish use different words than Hylians, a language slightly different from that of the original Minish of legend. They live in towns and the like, peering in on Hylian lives and culture, sometimes even lending a hand in secret.

1 2 The Minish Village. The Minish here speak a language slightly different from that of the Minish Realm, and they do not understand Hylian language. **3 4** A Minish home. In addition to leaves, mushrooms, and other bits from nature, they also use Hylian shoes and pots. **5** Some Minish live in secret inside Hylian homes. **6** The entrance to the Minish Realm, which opens once every hundred years. It is connected to Hyrule Castle.

THE WIND TRIBE: HEARING WHISPERS OF THE WINDS

The Wind Tribe are a remote people who have mastered living with wind. Together with the Palace of Winds, they rose up to make a life in the sky. In homes above the cloud tops, they harness the power of wind, walk on top of clouds, and are able to travel freely between the sky and the surface.

In *The Minish Cap*, the tribe guards the Wind Element, which sleeps in the Palace of Winds. They guard the entrance, forbidding anyone from the surface from entering.

The leader of the Wind Tribe knows everything happening on the surface by listening to rumors carried by the wind.

Since ancient times, this tribe has passed down the legends of a sacred sword and the four Elements that are the key to unlocking its potential.

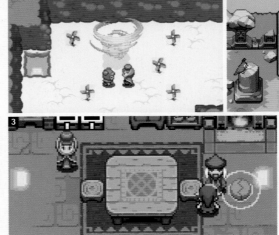

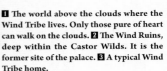

1 The world above the clouds where the Wind Tribe lives. Only those pure of heart can walk on the clouds. **2** The Wind Ruins, deep within the Castor Wilds. It is the former site of the palace. **3** A typical Wind Tribe home.

AN ANCIENT WORLD IN THE SKY

Long before the kingdom of Hyrule, the floating island of Skyloft was raised up by the goddess Hylia. People traveled the skies on giant birds called Loftwings. Faith in the goddess took root then, and those who left the sky for the Surface could be called the ancestors of the Hylians (pages 12, 68).

The Oocca are said to have interacted with the kingdom of Hyrule in ancient times. It is said the City in the Sky prospered because of their advanced technology. There is also a theory that they are actually the ancestors of the Hylians, and the closest people to the goddess.

The Wind Tribe also make their home in the skies, and guard the Palace of Winds. They protect the Wind Element, which is a necessary piece of the Four Sword (page 83).

There have been many peoples and cultures who have made the skies above Hyrule their home.

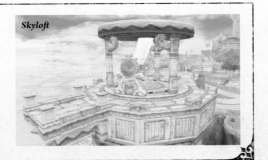

Skyloft

THE OOCCA: ADVANCED ANCIENTS

The striking Oocca are an ancient race with bodies like birds but heads similar to those of people. They have wings, are able to glide for a short time, and live in an enormous city floating high above the kingdom of Hyrule.

Oocca are extremely intelligent and use a different language than the surface world, called Sky Writing. However, some of the Oocca can speak surface languages.

It is said that they prospered in the time before the Hylians, achieving unique developments using magic and building an advanced civilization in the clouds. The City in the Sky stands as a testament to this advancement; tales persist of them using their unparalleled technology to lift the entire city from the surface into the sky.

The Sheikah tell stories of Oocca guiding messengers, and of an Ancient Sky Book, written in Sky Writing.

Symbol of the Oocca

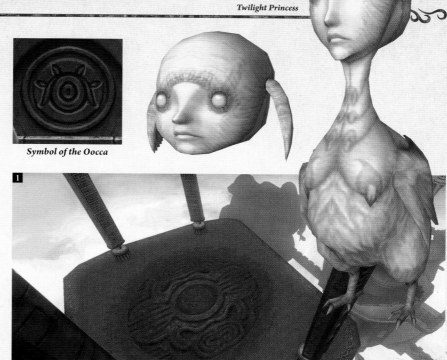

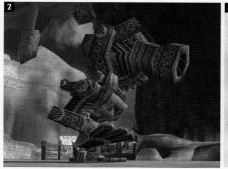

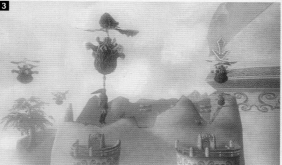

1 Towers in the City in the Sky, which flies using propellers. **2** The Oocca glide to the City in the Sky from the surface using cannons. **3** A home in the City in the Sky. The building is shaped like a broken egg. **4** The Oocca live in this city made of machines, walk vertically up walls, and use the wind to glide.

The Oocca are pale, and the bridge of their nose crosses their oval-shaped face. Their expressions do not change much.

Their heads are shaped like eggs and have distinct patterns.

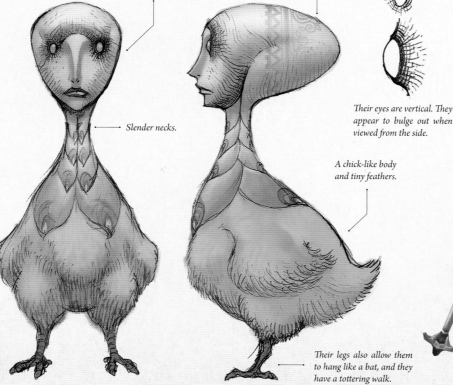

Slender necks.

Their eyes are vertical. They appear to bulge out when viewed from the side.

A chick-like body and tiny feathers.

Their legs also allow them to hang like a bat, and they have a tottering walk.

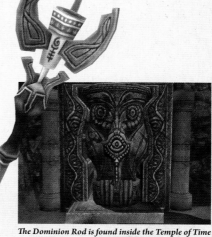

The Dominion Rod is found inside the Temple of Time and is necessary for Link to find the Sky Cannon to allow him passage to the City in the Sky. It also allows him to activate and move owl statues that are found near pieces of the Ancient Sky Book.

Ancient Peoples

Five races other than Hylians existed during the age of the goddess Hylia. Those five races stood with the goddess Hylia to fight the demon hordes and the Demon King Demise and remained on the surface after he was sealed away.

With the exception of the Ancient Robots, these early people lived nomadic lives. Tribes formed according to the lands they called home—in forests, deserts, and volcanoes. Unlike the peoples of later eras, they did not form villages.

Of the ancient peoples, the Hylians and Gorons (page 46) can be seen in nearly every era since, and have not changed significantly.

The Gorons are an ancient race. In Skyward Sword, they explore ruins in search of secrets.

THE KIKWI

The Kikwi are an herbivorous race that live in the woods of Faron Province. Buds on their backs hide plants of various types. By lying on the ground and revealing this plant, they can disguise themselves.

Their bodies are covered in thick, bushy hair. Most are only as high as a person's knees, but they grow bigger as they mature, and some are more than twice the size of a person.

They are normally gentle; some can be outright timid. Kikwi tend to be named for kinds of tea.

THE MOGMA

The Mogma are a mole-like people from Eldin Province. They have prominent claws, perfect for digging and burrowing freely beneath the earth. Not much is known of their way of life, as they spend much of their time underground where others cannot go.

Often, Mogma are obsessed with collecting rupees and treasure; many work as treasure hunters in Eldin.

A greedy sort, Mogma have been known to put themselves in peril for the sake of treasure, and can often be found exploring dangerous areas where others would fear to tread. Perhaps it helps that they can avoid dangers by burrowing underground.

Mogma are named for types of ore.

THE PARELLA

Deep within a cave at the back of Lake Floria dwell the aquatic Parella, a race that resembles jellyfish crossed with seahorses. A distinctive coral grows from the tops of their heads.

The Parella idolize the water dragon Faron, and live alongside her inside their cave. Parella rarely if ever leave Faron's cave, but maintain a healthy curiosity for what lies in the forest beyond the lake.

In general, Parella do not have individual names.

ANCIENT ROBOTS

Long ago, when the arid Lanayru Province was lush and green, it was the domain of an ancient race of mechanical robots.

Under the guidance of the thunder dragon Lanayru (page 22), the Ancient Robots engaged in the maintenance and excavation of Timeshift Stones that possess the unique magical power to control time.

These robots have since fallen into disrepair, but they can be reactivated through the Timeshift Stones they mined from the desert.

Most Ancient Robots were mass-produced as part of the LD-301 series, with curved bodies and hands that could be swapped out for claws better suited for excavation. Some, like LD-301S, nicknamed Scrapper, specialized in transport operations, using propellers to travel greater distances by air.

Controlling time with a Timeshift Stone makes it possible to see parts of the past. It shows that the desert domain of the Ancient Robots was once in part a sea. The robot Skipper protected Nayru's flame in this galleon.

OTHER RACES

Many other races make their homes in Hyrule and lands well beyond. Smaller groups have existed over the many eras of history and in myriad other realms. All are well adapted to their living environments, with unique customs and cultures. For every group that is friendly to Hylians and other races, there is another that lives in isolation or outright hostility.

In most cases, the peoples of Hyrule and beyond share a language with Hylians and can communicate and understand one another.

HISTORICAL RECORDS THE DIFFERENT RACES

THE TWILI

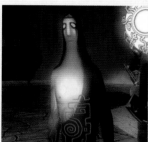

Twilight Princess
Twili were once a group of criminals who sought the power of the Triforce using magic and were banished from the Light World to the Twilight Realm (page 30). They maintain a monarchy much like those in Hyrule, and their leaders are generally those with the strongest magical power.

THE LOKOMO

Spirit Tracks
The Lokomo are indigenous to the land of the Spirits of Good, where the new kingdom of Hyrule is built (page 40). Among the Lokomo, those blessed by the Spirits of Good with power are known by Hylians as sages. They are tasked with watching over the seals in the Tower of Spirits and each of the realms.

THE ZUNA

Four Swords Adventures
The Zuna descend from a tribe that built a pyramid to seal the dark power of a trident eventually wielded by Ganon. The green-skinned inhabitants of the Desert of Doubt keep a rich oral history and pass down stories of the pyramid's construction and significance.

THE MAIAMAI

A Link Between Worlds
Maiamai are an aquatic race of shelled creatures that vaguely resemble Octoroks. As Maiamai grow, the large shells that sit atop their heads become small by comparison. Mother Maiamai arrives in Hyrule after a long journey and loses her children. She implores Link to help find them, and in turn, helps him in his adventures.

THE ANOUKI

Phantom Hourglass/Spirit Tracks
Anouki reside in cold climes and have antlers similar to a reindeer's. They tend to be frivolous, prickly, and hard to please. They are not aggressive, but do not have much interest in the other groups, preferring an isolated life.

THE YOOK

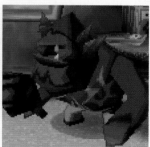

Phantom Hourglass
Yook are a race of large, monkey-like creatures that live on the Isle of Frost. Though their large stature can at first appear intimidating, they are a peaceful people who seek to establish friendly bonds with the Anouki who share the island.

THE SUBROSIANS

Oracle of Seasons
The Subrosians are a mysterious, sub-terranean people who live in Subrosia, a world below Holodrum (page 34). An easygoing, peaceful people, they cover themselves in hoods and skip as they move.

THE TOKAY

Oracle of Ages
The Tokay make their home on Crescent Island in Labrynna (page 35) and resemble bipedal lizards. They are notoriously crafty and known to steal from outsiders who visit their island home.

CHANGES IN THE RACES

The races of Hyrule and beyond have adapted over multiple eras to survive. Some have only appeared in certain periods, while others that once enjoyed prosperity have dwindled. Depending on the timeline, races may altogether evolve, as seen with the Zora and Rito as well as the Kokiri and Koroks.

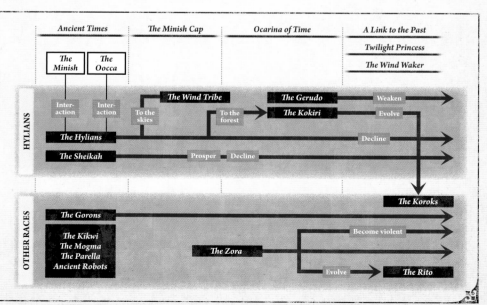

GEOGRAPHY & NATURE

The geography of Hyrule has changed over the ages, sometimes drastically, with old Hyrule being submerged in *The Wind Waker*, but, in other ages, the kingdom has been composed of similar geographical features that tend to include a body of water, a treacherous mountain, a forest, and an oppressive desert.

This section explores the geography and natural features of Hyrule and other lands featured in the *Legend of Zelda* series. More maps can be found in the Archives (page 217).

The terrain beyond the areas Link explores in Ocarina of Time is treacherous, high-reaching, and impassible.

FORESTS

The forests of Hyrule are particularly mystical places, and often the domain of spirits and fairies. The Minish are found in the Minish Woods of *The Minish Cap*, while the Kokiri of *Ocarina of Time* live under the protection of the Great Deku Tree in the forest that shares their name. The Lost Woods of multiple eras protect the Sacred Grove and its Master Sword.

Few other people call forests home. Deku Scrubs often live there. Monkeys and other animals too. But unless you know the woods well, it can be easy to get lost—even trapped. They are best explored with a sword in hand.

A portion of the forest in Twilight Princess. Giant trees grow in striking formations.

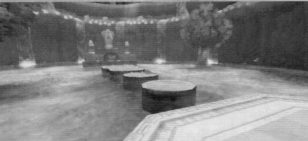

A thick mist makes navigating difficult in the Lost Woods of A Link to the Past, protecting the Master Sword from falling into the wrong hands.

MOUNTAINS

The mountains that have existed in Hyrule over the ages are especially perilous places in an already perilous land. This is why few beyond the hard-skinned Gorons live there, and why Death Mountain, an active volcano, is named after the death it most certainly brings to those who scale it irresponsibly.

Some mountains stretch high enough that snow collects on their frigid peaks, as in *Twilight Princess*'s Snowpeak. Others are steep and rocky summits where dust covers the ground.

A ring of clouds circles the peak of Death Mountain in Ocarina of Time.

In the Light World of A Link to the Past, the Tower of Hera stands at the summit of Death Mountain. In the Dark World, it is Ganon's Tower.

LAKES & SPRINGS

Clear streams flow from fountainheads into the great blue lakes of Hyrule, which in turn feed its many mighty rivers and streams. The Zora live at the sources of the water and are often tasked as its guardians. In ancient times, they say, the goddess Hylia purified her body in Hyrule's springs. These springs now give life to the ailing and weak.

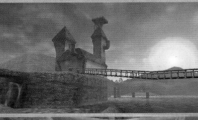

Lake Hylia, named for the goddess, as it appears in Ocarina of Time. It connects to Zora's Domain upstream.

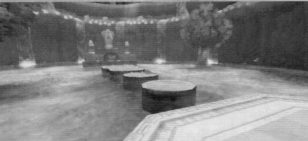

Skyview Spring. A spring rises from Hyrule's rich water sources, with underground streams connecting to the lake.

DESERTS

The deserts of Hyrule and beyond are desolate lands characterized by scorching winds in the day and biting cold at night. Ruins of past eras peek out from beneath the dunes and it is said that there once was a great sea here.

The Gerudo Desert is home to the Gerudo, a band of noble thieves who thrive in the harsh conditions. After Ganondorf's rise and fall, his people leave the desert. In Twilight Princess, Ganondorf faces execution in the long-abandoned place of his birth.

The ancient sea can be observed through the use of a Timeshift Stone in the Lanayru Sand Sea in Skyward Sword.

MAPS ACROSS TIMELINES

A study of the many maps of Hyrule over multiple eras shows just how much the world has changed. While the perspectives of each map may shift, there is a rough symmetry when comparing them to one another. Many areas and landmarks share the same names as time moves forward and then splits.

The following pages lay out the maps of certain eras with shared locations and connect those locations with red lines. This does not necessarily mean that these are the exact same places in a different era, but due to their similarities, it is reasonable to conclude that they likely are.

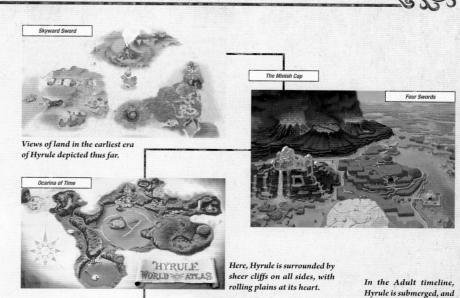

Skyward Sword

The Minish Cap

Four Swords

Views of land in the earliest era of Hyrule depicted thus far.

Ocarina of Time

Here, Hyrule is surrounded by sheer cliffs on all sides, with rolling plains at its heart.

In the Adult timeline, Hyrule is submerged, and only the tallest points on the map remain visible— islands in a great sea.

All roads lead to Hyrule Castle at the center of the map.

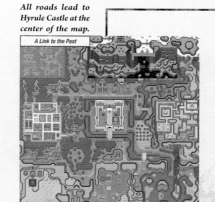

A Link to the Past

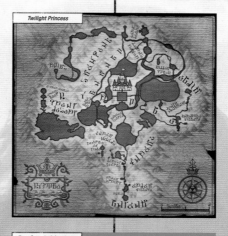

Twilight Princess

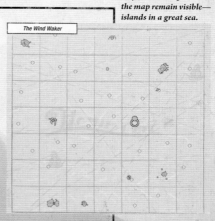

The Wind Waker

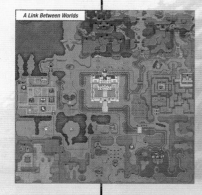

A Link Between Worlds

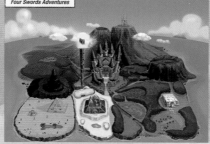

Four Swords Adventures

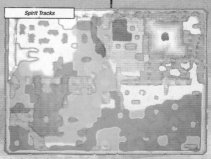

Spirit Tracks

As seen on this map, the Hyrule of this era is surrounded by an ocean instead of mountains.

The land of the Spirits of Good, home to the Lokomo, is an altogether new location where a new Hyrule is founded (page 40).

The Legend of Zelda

The Adventure of Link

In The Adventure of Link, Link explores further into the Western and Eastern Continents.

TINGLE THE MAP SELLER

It's hard to talk about maps without mentioning the map merchant of Termina: Tingle. He floats in the air using red balloons, drawing and selling maps.

Tingle believes that he is a reincarnated fairy, and despite being a thirty-five-year-old, he wears green tights and talks about how his fairy has not yet arrived (see "The Kokiri," page 50). His catch phrase, which he calls his "magic words," is "Tingle, Tingle, Kooloo-Limpah!"

For reasons beyond understanding, adults like this have appeared across multiple eras as far back as *The Minish Cap*.

Purlo, a scam artist in Twilight Princess, *dresses in a manner similar to Tingle.*

Majora's Mask

Oracle of Ages

The Wind Waker

Four Swords Adventures

The Minish Cap

THE CORNERS OF HYRULE OVER TIME

In the era of *Skyward Sword*, Hylians lived on islands in the sky, and other races populated the wild and largely undeveloped Surface. At some point in time after that, the Hylians joined the other races on the Surface, and, after a protracted civil war, formed a unified kingdom of Hyrule, as seen in *Ocarina of Time*. Eras later, the map from *Twilight Princess* shows that the landscape has changed slightly. Though separated by time, all three maps show similarities to the other eras, as demonstrated by the charts to the right.

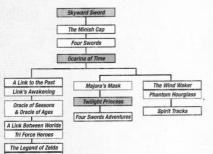

Pirate stronghold

Lanayru Sea

The Lanayru Sea predates the events of Skyward Sword.

The top two maps share the locations of a desert, mountain, water source, and forest. Only the lake's position differs significantly. Many areas during the era of *Skyward Sword* were undeveloped, since it was in the distant past. It's interesting to note that each map shares the same desert but, in ancient times, that desert was a vast ocean, illustrating how much the landscape can change over time.

Faron Woods

Key locations that persist across multiple eras:
• Kokiri Forest: Called "Faron Woods" in *Skyward Sword* and *Twilight Princess*. The Kokiri crest can be seen in the Forest Temple in *Twilight Princess*.
• Gerudo Desert: The Arbiter's Grounds contain a statue that resembles the Desert Colossus (page 45).
• The Sacred Grove, with the pedestal that holds the Master Sword. In later eras, the pedestal is known as the Pedestal of Time.
• Zora's Domain, Kakariko Village, and Death Mountain are major centers for the Zora, Hylians, and Gorons, respectively, that persist across multiple eras.

Great rifts form

The map from *Twilight Princess* is more spread out than the maps of the other eras. Large cracks in the earth are visible signs that the ground has shifted and expanded to the point where it splits open.

Since older provinces like Faron, Eldin, and Lanayru have retained their names over the ages, it is possible to speculate that the southern area in *Skyward Sword* expanded as well, forming the lands that became Ordona Province.

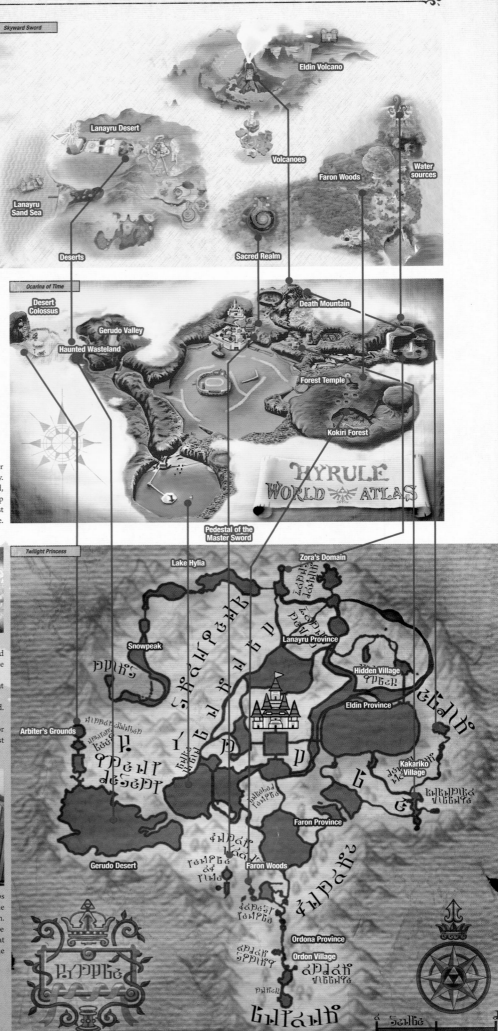

Skyward Sword

Eldin Volcano

Lanayru Desert

Volcanoes

Faron Woods

Water sources

Lanayru Sand Sea

Deserts

Sacred Realm

Ocarina of Time

Desert Colossus

Death Mountain

Gerudo Valley

Haunted Wasteland

Forest Temple

Kokiri Forest

HYRULE WORLD ATLAS

Pedestal of the Master Sword

Twilight Princess

Lake Hylia

Zora's Domain

Snowpeak

Lanayru Province

Hidden Village

Arbiter's Grounds

Eldin Province

Kakariko Village

Faron Province

Gerudo Desert

Faron Woods

Ordona Province

Ordon Village

Skyward Sword

The Minish Cap

Four Swords

Ocarina of Time

A Link to the Past / Link's Awakening

Oracle of Seasons & Oracle of Ages

A Link Between Worlds / Tri Force Heroes

The Legend of Zelda / The Adventure of Link

Majora's Mask

Twilight Princess

Four Swords Adventures

The Wind Waker / Phantom Hourglass

Spirit Tracks

HYRULE UNDERWATER

In *The Wind Waker*, where Hyrule is submerged under the Great Sea, only islands dot the surface, showing no trace of the vast land it once was. Guardian spirits watch over three of those islands until Ganondorf destroys Greatfish Island.

It is on these scattered islands that pieces of Hyrule as it appeared in *Ocarina of Time* remain, inhabited by survivors of the flood.

To adapt to a world composed mostly of water, the Kokiri became the Koroks. Knowing this, it can be extrapolated that the Great Deku Tree is the same Great Deku Tree from the era of the Hero of Time, and that the Kokiri Forest has become Forest Haven.

From there, it is possible to link these other locations that remain above the waves.

• Zora's Domain became Dragon Roost Island.
• The people of Hyrule Castle Town and the nearby Kakariko Village are on Windfall Island.
• Lake Hylia, connected to Zora's Domain through an underwater passage, is Greatfish Isle, former home of Jabun.
• The Gerudo Fortress in the desert is now the Forsaken Fortress, fittingly occupied by Ganondorf.

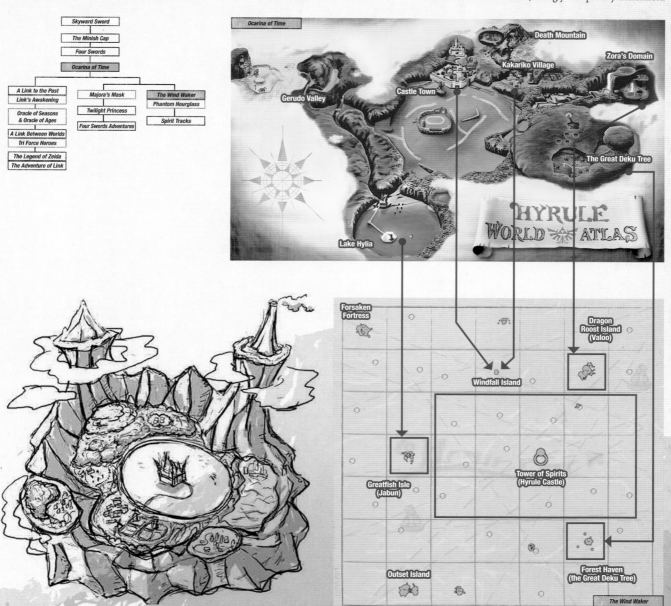

In The Wind Waker, it is said that before Hyrule sank, there was a castle in the center surrounded by mountains.

Forest Haven, Dragon Roost Island, and Greatfish Isle form the corners of a triangle. Each protected a Goddess Pearl named for Din, Farore, or Nayru.

OUTSET ISLAND & ORDON VILLAGE

Though many parts of *The Wind Waker* and *Ocarina of Time* can be connected in ways that make sense, there are some areas that do not have such obvious parallels.

One is the remote Outset Island, a far-flung paradise where the hero of *The Wind Waker* is born. No place like Outset Island exists in *Ocarina of Time*. However, *Twilight Princess* is a different story. The Link of *Twilight Princess* grows up on the southern tip of a rural area near Ordon Village, another place that doesn't appear on Hyrulean maps from earlier eras. *The Wind Waker* and *Twilight Princess* happen in similar eras in different timelines, just as Outset Island and Ordon Village are similar places in very different worlds.

Outset Island

Ordon Village

HYRULE IN AN ERA OF DECLINE

In the timeline where Link fails to defeat Ganon in *Ocarina of Time* and the King of Evil is sealed away instead by the sages, the kingdom of Hyrule shrinks to a small, regional power. The maps of games set during this decline illustrate how Hyrule changes.

Ocarina of Time

Pedestal of the Master Sword

Forests

Water sources (home of the Zora)

Lake

Graveyard

HYRULE WORLD ATLAS

The map of Hyrule from Ocarina of Time is somewhat offset when compared to A Link to the Past. Tilting it slightly makes it easier to line up parallel points on each map. Even then, the location of the forest has changed dramatically.

Skyward Sword

The Minish Cap

Four Swords

Ocarina of Time

A Link to the Past / Link's Awakening

Oracle of Seasons & Oracle of Ages

A Link Between Worlds / Tri Force Heroes

The Legend of Zelda

The Adventure of Link

Majora's Mask

Twilight Princess

Four Swords Adventures

The Wind Waker

Phantom Hourglass

Spirit Tracks

Forests

Deserts

A Link to the Past

A Link Between Worlds

The forests, deserts, water sources, and mountain passes of A Link to the Past and A Link Between Worlds are largely the same, right down to the location and appearances of individual buildings.

Overlaying the maps of A Link to the Past and A Link Between Worlds shows the subtle ways the kingdom of Hyrule has changed through time.

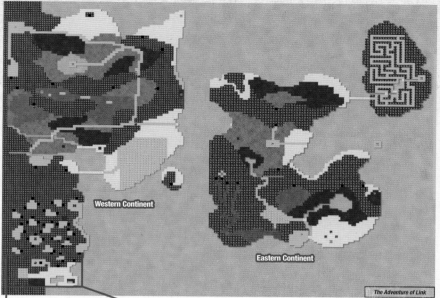

Western Continent

Eastern Continent

The Adventure of Link

*The map from **The Legend of Zelda** is only a small portion of a much greater land to the north, and a second continent to the northeast, where **The Adventure of Link** takes place.*

TOWNS NAMED FOR SAGES

Most towns in *The Adventure of Link* are named for sages of eras past, specifically the Era of the Hero of Time. There's Saria, named for the Sage of the Forest and friend to the Hero of Time, and Rauru, Sage of Light, who has influenced past heroes since the Era of Chaos, when the Sacred Realm was sealed. The town Kasuto is named for a sage who has not appeared in any story yet told, while Mido is the only town not named for a sage, instead immortalizing the self-proclaimed Kokiri leader in *Ocarina of Time*. The presence of these two names alongside the names of the sages invites speculation as to what took place in eras not yet explored.

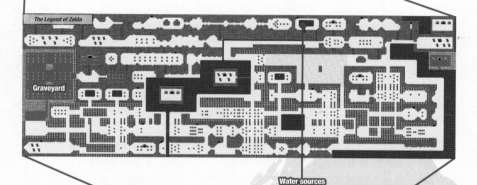

The Legend of Zelda

Graveyard

Water sources

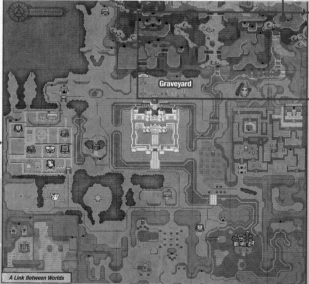

Graveyard

A Link Between Worlds

*In **The Legend of Zelda**, Link's quest to defeat Ganon takes place in a fraction of the space seen in this map of **A Link Between Worlds**. By lining up the source of water flowing from the mountain, you can see that they share Death Mountain to the north and a graveyard to the west.*

*You cannot see Hyrule Castle or the villages in **The Legend of Zelda** but it is possible that people live south of where the map ends. Another difference is that the water in **A Link Between Worlds** flows into a lake, but in **The Legend of Zelda** it flows into a sea.*

HYTOPIA IN THE NORTH

In the shared era of *A Link Between Worlds* and *Tri Force Heroes*, Hytopia (page 42) is located to the north of Hyrule. Just as *The Adventure of Link* explores the area north of Death Mountain, so does *Tri Force Heroes*, and, in fact, it may be possible to see Hytopia's legacy in the era of *The Adventure of Link*. There were powerful magic users in Hytopia and there are still people who can use magic in *The Adventure of Link*. You may also note that the people in the north in *The Adventure of Link* are noticeably fashionable.

Less clear is the fate of the Drablands from *Tri Force Heroes*. There are ruins, temples, and the Valley of Death found in *The Adventure of Link* which share commonalities with the Drablands.

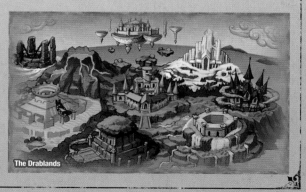

The Drablands

Animals

Animals make their homes in Hyrule and beyond, from the land of the Spirits of Good to parallel worlds. Even in the realms of monsters.

Many enjoy close relationships with people and have been domesticated, living in villages and on ranches (page 73). A rare few, like some monkeys, can even speak.

Here are a few animals common in various corners of the world and in the darker places that mirror it.

In A Link to the Past and A Link Between Worlds, there are open spaces deep in the woods where animals gather. You can find rare animals there like rabbits that were thought to be extinct in the era of Ocarina of Time.

Cuccos may become aggressive if harassed and will call upon other cuccos to retaliate and protect their own. They are said to be among the toughest animals in the world.

ANCIENT TIMES

EARLY SKY & SURFACE CREATURES

There are a great many ancient and unusual animals in *Skyward Sword*. There are differences between the animals found in Skyloft and those that live on the Surface. For example, because Skyloft has very little land, large animals like cows are not present there.

Loftwings
The goddess Hylia allowed these great birds to be partners with the Hylians of Skyloft. Loftwings arrive in Skyloft each Wing Ceremony to bond with a young Hylian rider. Crimson Loftwings, a uniquely powerful and legendary breed, were thought to be extinct.

Chirris
Birds that live on the Surface. Their bodies are too small for them to fly very high, so they are not seen around Skyloft.

Remlits
Remlits are raised as pets in parts of Skyloft. They become violent at night under the influence of demonic energies there.

Ringers
A flying squirrel. They will gather in the air to form a ring.

Frogs
Various species of frogs, including the staring Eyeball Frogs, live in the rivers and springs of Hyrule, and have been known to gather together to sing songs. Frogs are especially useful as an ingredient in some medicinal potions.

Furnix
Beautiful birds that nest in Surface ruins, with distinct tail feathers.

THE KINGDOM OF HYRULE

DOMESTICATED BEASTS

Hylians have long domesticated animals for companionship, travel, and food. Dogs and cats are common pets, while horses are raised to be ridden or to pull carts. Cows and cuccos are also kept, often to produce milk and eggs, respectively.

In the past, there were many wild rabbits in the fields, but they were hunted to the point of near extinction.

Cats
Cats have been bred to be kept as pets by Hylians in many eras.

Dogs
Dogs in Hyrule are often kept as pets or raced for entertainment. Other dogs are wilder creatures, sometimes dangerous to approach.

Cows
Cows are raised on Hyrulean farms, often for their milk, and can sometimes be found living in holes in fields.

PARALLEL WORLDS

ANIMALS MORE LIKE PEOPLE

In the dream world of *Link's Awakening*, there is a village where animals live much like people. In *Oracle of Ages* and *Oracle of Seasons*, animals like Ricky the kangaroo, Moosh the bear, and Dmitri the Dodongo speak and aid Link in his adventures.

Over the course of many eras, a number of animals have spoken in a manner similar to Hylians and many more will happily aid Link and others.

Mutts
Wilder canines are prone to growl if approached.

Snakes
While many snakes are wild and dangerous, some may be charmed and kept as pets.

Monkeys
Monkeys have been known to play pranks on those who tread in their territory.

Turtles
The giant turtles of Lorule, like Mama Turtle, are good for hitching rides.

Cuccos
Cuccos are domesticated fowl commonly raised by Hyrulean villagers and farmers. Over the eras, a number of varieties have been bred for various characteristics and colors.

Cuccos left out of their enclosures will often wander. Grabbing onto their feet enables the holder to glide.

Pigs
Oinking animals raised on Outset Island.

Seagulls
Seagulls are waterbirds often found near oceans. They can be summoned with a Hyoi Pear.

THE NEW WORLD

NEW LAND, NEW CREATURES

When the Hylians settle in New Hyrule, they encounter many new and strange beasts. Often, they are variations on animals found in old Hyrule, adapted to live in a very different climate.

Whip Birds
Whip Birds carry wooden bars and will often let people hang on to be transported.

Bullbos
These boar-like animals will charge if approached, making them dangerous.

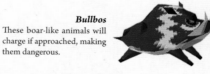

Doves
Doves are small, cooing birds. They will gather if the Song of Birds is played.

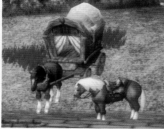

Horses
Horses are valuable livestock in Hyrule and beyond, coveted for their ability to travel broad fields in a short amount of time and pull heavy loads. Hylians will sometimes form deep bonds with their mounts. Such is the case with Link and Epona.

Squirrels
Squirrels scurry about in forests, foraging and chattering.

Findols
Many creatures live in the sea, including golden findols.

Moinks
Moinks are strange cows that resemble pigs or maybe the other way around.

Hawks
The hawks of Hyrule use sharp claws on their feet to snatch objects and attack their prey. They are exceptionally smart and may be trained to come when called with a grass whistle.

Goats
Some villages, like Ordon, raise goats, but they are notoriously stubborn and liable to escape.

Rabbits
Rabbits are far more numerous in New Hyrule, appearing in various colors depending on the realm they call home.

PLANTS

Bountiful plants of various types grow throughout Hyrule and well beyond. In addition to the grasses, trees, and flowers seen commonly, rare plants unique to certain eras or regions are also found.

Some, like the Great Deku Tree, provide materials useful to Hylians for making tools and weapons, such as sticks, nuts, and leaves. There are many other types of plants and fruits with a variety of uses.

Plants and fungi flourished in the era when the Hylians lived on islands in the sky.

Ancient Flower
A flower that bloomed in the distant past, when the desert was still a sea.

Spiral Ivy
An ivy that wraps around ancient trees, with its tips hanging in spirals.

Jabber Nut
Jabber Nuts, grown by the Minish, allow people to understand the languages of other peoples if consumed.

Heart Flower
Heart Flowers, grown in Skyloft, help recover health.

Bomb Flower
Bomb Flowers are a unique and dangerous plant often found in areas of high elevation. Despite this, they prefer the shade and do not tolerate sunlight well. They have explosive properties and should be picked with great care.

Various trees

Octo Grass
A common type of grass in Hyrule. Coincidentally, in Lorule (page 32), its blades are reversed.

Spike Grass
This spiky grass is rarer than most. Despite their sharp appearance, the blades are soft and do not hurt when touched.

Exotic Flower

Hawk Grass
It can be made into a grass whistle that can be blown to call hawks.

Horse Grass
It can be made into a grass whistle that can be blown to call horses.

Sea Flower

Many flowers are cultivated and pruned in pots to decorate homes and public places.

Town Flower

Flower Grass
Grass that flowers.

Flutter Grass
This tall grass may conceal rupees, hearts, fairies, and even enemies.

Peahat
Floats in the air with leaves like a propeller. Link can latch onto them with his Clawshot while they are in flight to catch a ride.

Tufted Grass

Item Flowers
Mysterious flowers that, when opened, contain items.

FISH

Water originating from high springs flows down mountains and into ponds and lakes that dot the land and are home to many varieties of freshwater fish. Hylians have been known to go fishing in those still places (page 79).

The vast oceans of *Phantom Hourglass* and *Spirit Tracks* are located in a broad subtropical zone with many types of migratory fish. The Great Sea in *The Wind Waker* is an illusory ocean created by a torrential downpour from the heavens. Its ethereal "water" is unlike the water natural to Hyrule, and so only monsters and Fishmen are able to live there.

Eelie
An ancient eel. Its body is narrower than most water creatures, allowing it to fit in tight spots and slip away easily.

Waroana
An ancient fish that grows to enormous sizes. Its eyeballs look upward so that it can eat bugs that fall onto the surface of the water.

Hyrule Bass
A common fish in Hyrule and a staple of fishing holes.

Loovar
A sought-after fish that lives in the open ocean. It is seen as a delicacy in Papuchia Village.

Toboni
A common fish in the Ocean Realm of the land of the Spirits of Good.

Hylian Loach
A legendary fish that the Fishing Pond Man aspires to catch in *Ocarina of Time*. Many conditions need to be fulfilled to catch it, as it is very particular. It prefers summer days.

Stowfish
A rather strange fish that lives in the ocean. Its stomach is a suction cup, and it attaches itself to larger fish and lives off them.

Greengill
A small fish common in nearly all bodies of water.

Ordon Catfish
A freshwater fish native to the waters near Ordon Village.

Rusty Swordfish
Living well out in the ocean, the Rusty Swordfish can reach lengths of more than 1.5 meters. It is characterized by its long, sharp upper jaw.

Hylian Pike
An edible fish that can be found from the head of Zora's River all the way to Lake Hylia. It travels upstream by jumping.

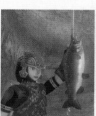

Reekfish
A fish with a powerful odor that only lives in Zora's Domain in Hyrule. Good for soups.

Water sources are protected by the Zora, and many fish live in their clear waters.

The same species of fish live in the world of the Ocean King and the Ocean Realm. In expansive seas, exceptionally large fish have plenty of room to swim. Here, various sizes of fish are compared to a findol at the center.

CATCHABLE FISH

Ocarina of Time	Majora's Mask 3D		Twilight Princess	Phantom Hourglass
Fishing Pond (Lake Hylia)	**Swamp Fishing Hole**	**Ocean Fishing Hole**	**Outside Fishing Holes**	**Ocean**
Hyrule Bass	Groovy Carp	Termina Seabass	Greengill	Skippyjack
Hylian Loach	Termina Bass	Goodta Goby	Ordon Catfish	Toona
	Termina Loach	Ambrosial Amberjack	Hyrule Bass	Loovar
	Mooranha	Bashful Angler	Hylian Pike	Stowfish
	Postal Salmon	Skullfish	Hylian Loach	Rusty Swordfish
	Ancient Fish	Dancing Sea Bream	**Zora's Domain**	Neptoona
	Fragrant Reekfish	Ninja Flounder	Reekfish	
	Sweet Ranchfish	Nuptuna	**Lakebed Temple**	
	Cuccofish	Fairy Fish	Skullfish	
	Ferocious Pirarucu	Savage Shark	Bombfish	
	Colossal Catfish	Grand Swordfish		
	Lord Chapu-Chapu	Great Fairy Fish		

Termina Seabass

Fairy Fish
There are numerous kinds of fish in Termina, many of which Link is able to catch. They come in breeds both common and rare in Hyrule, but many in Termina have unique and memorable names, such as the Ninja Flounder, the Bashful Angler, and the Fairy Fish.

INSECTS

Insects and other bugs creep and crawl all over the world. Some fly. Others hide in grass and sting anyone who disturbs them.

In *Skyward Sword*, it is possible to capture a wide variety of insects. Captured insects can be used as ingredients for medicines. These are ancient bugs, many with distinctive, swirling patterns on their bodies.

In *Twilight Princess*, there are glimmering, rare insects throughout Hyrule known as Golden Bugs. A bug-loving girl named Agitha is looking for them; each bug has a male and a female counterpart.

A variety of bug specimens decorate Agitha's home.

Bees

Bees are among the most common insects, found across most eras and regions. Hylians commonly eat the bee larvae and honey from their nests. Bees are liable to sting if approached or provoked.

Hylian Hornets

Living primarily in forests, Hylian Hornets make giant nests on treetops. They can be quite dangerous. In addition to having a venomous stinger, they will attack in groups if provoked. The larvae that come from nests are prized as bait for fishing.

Deku Hornet

Deku Hornets make nests in the large trees of Faron Woods. The woods are teeming with life, so these hornets have plenty of prey and in turn grow quite large. The venom in their stingers is particularly dangerous. Deku Hornets can be used as an ingredient for a variety of recovery medicines.

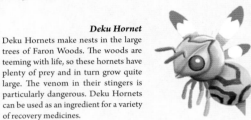

Blessed Butterfly

A butterfly common in multiple regions. It can be identified by its beautiful blue wings. People call this butterfly "blessed" because it has a habit of appearing in curious places.

Gerudo Dragonfly

A species of dragonfly that commonly lives in the Lanayru Desert. They see moving enemies with their compound eyes and can fly around quickly, but they have difficulty identifying anything that moves slowly. Gerudo Dragonflies have eyes like gemstones and beautiful wings as clear as glass.

Dragonfly

A type of Golden Bug found in Zora's Domain and upstream around Zora's River. Golden Dragonflies lay eggs in water when breeding and spend their larval period in fresh water. They are especially attracted to the clear waters of Zora's River.

Fabled Butterfly

A rare butterfly with lace-like wings that some say is a myth. It lives in Hytopia, and is said to only appear before those with outstanding valor.

Butterfly

A Golden Bug found in Lanayru Province. The Golden Butterfly lives off flower nectar. Like other lepidopterans, its golden wings are covered in scales. It prefers to live near the blooming flowers in Hyrule Field and is exceptionally beautiful when dancing around these flowers at night.

Sand Cicada

A cicada that lives in the Lanayru Desert. It makes a distinctive noise. Larval periods for the Sand Cicada are extremely long, taking up to ten years underground, but the bug's life once it matures is actually very short. In addition to spending limited time aboveground, it is sensitive to even minute sounds and will flee if startled. This makes the Sand Cicada difficult to catch.

Mantis

A Golden Bug found around the Great Bridge of Hylia above Lake Hylia. The Golden Mantis has long, slender limbs and is characterized by its large, spiked, sickle-shaped forelimbs.

Grasshopper

Another Golden Bug that makes its home in Hyrule Field. The Golden Grasshopper appears in open, grassy areas where there are few obstructions like trees or large rocks. When attacked, it jumps away quickly using its hind legs.

Faron Grasshopper

A grasshopper that lives in the Faron Woods. It jumps about quickly with considerable power from its large hind legs. Like many grasshoppers, it reproduces in great numbers; every ten years or so, great swarms are born ready to devour plant life in the region, doing considerable damage to the forest ecosystem.

Skyloft Mantis

A mantis found throughout Skyloft. It takes cover and ambushes its prey, pierces insects that get near with its sharp arms, and quickly devours them. It prefers darkness and often hides inside pots.

Sky Stag Beetle

A blue-bodied stag beetle frequently seen around the trees and shrubs of Skyloft. It has a scissor-like jaw, a distinctive appearance that makes it popular with children. This is in spite of the fact that the Sky Stag Beetle's pincers are powerful, to the point where even adults find getting pinched unbearable.

Woodland Rhino Beetle

A brown and yellow beetle with a large horn not unlike a rhino's. It lives in the Faron Woods. The hard shell of the Woodland Rhino Beetle protects it from harm but causes it to move slowly. It trades speed for exceptional strength; the Woodland Rhino is among the strongest of any insects in Faron Woods.

Beetle

A species of Golden Bug that lives near the woods of Hyrule Field. Only the male has a long horn, a key trait of this particular type of beetle. Golden Beetles enjoy eating tree sap, and it is relatively common for bug collectors to find both varieties feeding on a tree.

Stag Beetle

A type of Golden Bug found north of Hyrule Field. The male Golden Stag Beetle uses its jaw, which is more developed than the female's, to fight for territory and over prospective partners during mating season.

Ladybug

A type of Golden Bug found south of Hyrule's Castle Town, near the gate to Hyrule Field. Like most ladybugs, it has a distinctive pattern on its back. What makes Golden Ladybugs of this region special is that their pattern resembles an inverted Triforce.

Volcanic Ladybug

This volcano-dwelling insect is often spotted in groups. It eats red volcanic ore, giving its body a vivid red color all the more brilliant as it reaches maturity. Volcanic Ladybugs are typically docile and often remain still.

Golden Insect

Not to be confused with the Golden Bugs of *Twilight Princess*, the valuable Golden Insect calls the desert of Hytopia home. Used in armor, its dazzling gleam is said to be worth more than solid gold.

Starry Firefly

Living only in areas with clean running water, the Starry Firefly emits a bright light at night. The varieties found only in Skyloft have a distinctive pattern on their wings.

Dayfly

One of the Golden Bugs, the dayfly has a long, frail body with large wings. Most dayflies live near bodies of water such as rivers or lakes, but the Golden Dayfly manages to live without much water at all in the Gerudo Desert.

Lanayru Ant

An ant that rarely separates from its colony, the Lanayru Ant builds and lives in underground nests in the Lanayru Desert, subsisting off water sources deep underground.

Ant

A type of Golden Bug commonly found in Kakariko Village and the neighboring graveyard. Since the Golden Ant eats almost anything, it lives near Hylian homes where food is abundant. Females tend to be larger, while males have wings.

Eldin Roller

A dung beetle that lives on Eldin Volcano. Dung beetles make animal droppings their food, rolling the dung up to move it. However, it's unknown what materials the Eldin Roller has balled up. It is often present in soft soil. Digging up the ground will cause it to leap out and flee while rolling its ball.

Pill Bug

Found around Hyrule Field in Eldin Province, this Golden Bug's body has many joints that curl in when threatened, forming a ball to protect itself.

Snail

A Golden Bug native to the Sacred Grove. Golden Snails are a type of land-dwelling gastropod with soft bodies and shells. Snails are hermaphroditic, so their coloration is arbitrary.

Phasmid

A Golden Bug with a long, thin body that can disguise itself as a twig. It can be found around Kakariko Gorge.

LIFE & CULTURE

The history of Hyrule is long. It spans thousands, perhaps even tens of thousands, of years, and is marked by periods of great prosperity and decline.

This section observes changes in the cultures and lifestyles of its people over the eras, as well as the many commonalities that persist throughout the ages.

Skyward Sword (prehistory)

ERA OF HYLIA

The people of Lanayru Province use robots to mine Timeshift Stones, using them to build an advanced civilization. By the time of *Skyward Sword* all that remain of this ancient civilization are ruins covered in sand.

Skyward Sword

SKY ERA

The Hylians of the Sky Era live on airborne islands, with Skyloft as a central hub. Travel through the air and between islands is made possible by riding giant birds called Loftwings.

The winds are strong in the sky, so Hylian clothes are thick and durable. The colors of clothes and buildings are especially vivid in the Sky Era. The color of the tunics bestowed upon new knights changes each year.

Birds are used as a motif in almost everything from heraldry to jewelry, a sign of just how important they are to early Hylians.

Knights keep the peace in Skyloft, and the youth study at the Knight Academy to become knights.

Land of any kind is scarce in the sky, so there is little room for farming or ranching. Hylians largely subsist off crops like pumpkins grown in small patches.

A variety of machines were used in Hyrule's early history, including robots that excavated and processed Timeshift Stones.

Ocarina of Time

ERA OF THE HERO OF TIME

The Era of the Hero of Time directly follows the dramatic Hyrulean Civil War that saw many in Hyrule perish before its people united under a single crown.

After the war, the Zora, Gorons, and Kokiri are rarely seen in central hubs like Karariko Village. Contact is generally limited to matters of diplomacy between the various peoples and the royal family. Many regions are not accessible without the royal family's permission, and cultural exchange is essentially nonexistent.

While Hyrule's Castle Town flourishes, their culture is not nearly as advanced as that of the people who created the Ancient Robots. This is even less the case in Kakariko Village, where the poorer people of Hyrule work to build a better life for themselves.

In general, the lives of the people in this era are nothing extravagant, leaning more toward a kind of pastoral simplicity. Most keep meager possessions made from materials that can be grown or found in nature. Hylians raise cuccos and cows, and the latter animal's milk is popular. Horses are in high demand as a means of transportation and for pulling carriages.

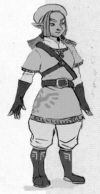
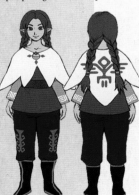

Practical attire for bird riding **Uniform of the Knight Academy**

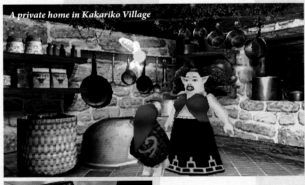

A private home in Kakariko Village

The Knight Academy and its crest

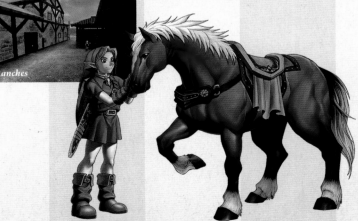

Ranches

ERA OF THE GREAT SEA

When Hyrule is submerged to seal away Ganondorf and his army, its people make new homes for themselves on the scattered islands that remain.

Life in this era is markedly peaceful. Children go to school. Sailing is a popular pastime and the primary means of travel.

Outset Island is particularly idyllic. The people there raise pigs and keep small seaside homes. It stands in contrast with the relative bustle of Windfall Island, where business is booming and some are wealthy enough to have large villas.

The clothing of this era reflects the warmer island lifestyle of its people, with an emphasis on lightweight, comfortable outfits.

The Zora, unable to live in the Great Sea's ethereal waters, evolved into the Rito (page 51), who are able to fly through the skies. They deliver letters and serve to connect the islands to each other.

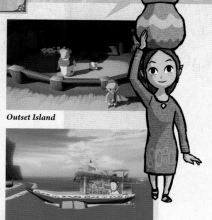

Outset Island

Windfall Island

A merchant ship. There is no fishing in the Great Sea due to a lack of fish.

ERA OF HYRULE'S REBIRTH

After settling in a new land, the Hyruleans adapt to a life built around the railroad that crisscrosses great distances.

Trains make it possible to move lumber from Whittleton, where the lumberjacks live, deliver fish while they're fresh, and transport ice between four villages that deal in materials unique to each region. Despite how easy it is to travel between Castle Town and the most remote points on the map, the people of each area cherish their individual identity and strive to maintain their own unique ways of living.

The people of the Ocean Realm (left) and the Forest Realm (right).

TWILIGHT ERA

Few eras in the history of Hyrule are marked with as much disparity between rich and poor as the Twilight Era.

The wealthy of Hyrule wear beautiful, fashionable clothing, often with elaborate stitching and bold accessories. They dress in a variety of materials, from silks to fur and leather, using precious metals and gems as accents.

The markets reflect this demand for excess. In addition to daily necessities, flowers and luxury goods are sold in Hyrule Castle Town, and Hot Springwater is in demand for its health benefits.

In contrast, the people of Ordon Village live simple lives, earning enough to subsist through ranching and farming—in turn, supplying Hyrule Castle Town with goods.

Others in Hyrule are still less well off. Some struggle just to survive.

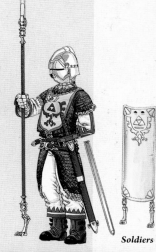

The Rich　*The Villagers*
Fashions among Hylians of the Twilight Era favor free-flowing clothing and bold hairstyles.

Soldiers

Castle Town

Entrance to the castle

ERA OF LIGHT & DARK

The Imprisoning War ushers in an era of impoverishment across Hyrule, its people and resources largely spent warring over the Sacred Realm.

A sanctuary is built, and historical documents are stored in its library to ensure history is kept and studied.

Unlike in the Twilight Era, Hyrule's Castle Town does not prosper. The people of Hyrule live frugally in order to survive, and fill their days with distractions like bars and simple amusements.

ERA OF DECLINE

Lack of an heir in the royal family who possesses the characteristics of power, wisdom, and courage ushers in the Era of Decline. Since no one appears who is able to wield the Triforce, Hyrule is reduced to a small regional kingdom. When the demons appear, some merchants and elders hide themselves in caves away from any town.

HYRULE CASTLE: A NOBLE & BEAUTIFUL PALACE

High, white outer walls. A tended garden. Flowing red carpets with gold trim. Brilliant stained glass. Hyrule Castle, home of the royal family and the seat of Hyrule's government, is the most beautiful palace in the kingdom. Over multiple eras, it has stood at the heart of Hyrule, a beacon of strength and residence of Princess Zelda.

However, Hyrule Castle's fortifications make it especially dangerous in the hands of its enemies. In multiple eras, the castle has been captured by hostile forces, rendering it a formidable dungeon and casting a shadow on the light the castle represents. Time and time again, it has fallen to Link to reclaim the great castle's labyrinthine halls from those who seek ultimate power over Hyrule and its people.

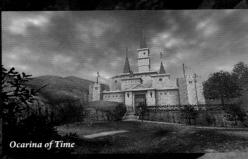

Ocarina of Time

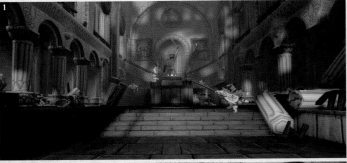

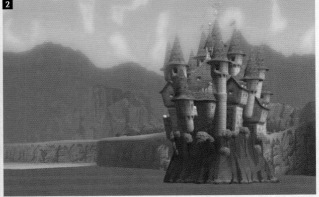

1 2 In *The Wind Waker*, the castle is submerged along with most of Hyrule—frozen in time and standing precariously at the heart of a lake that has formed around it. After Link obtains the Master Sword from within the castle, time flows again, the monsters within come to life, and Link frees the castle of any lingering evil. **3** Inside Hyrule Castle in *Twilight Princess*, armor and shields give an air of authority, while beautiful paintings stretch to the ceiling. **4** Hyrule Castle is an architectural marvel. Note the figure for scale. **5** Princess Zelda's quarters in *A Link Between Worlds*.

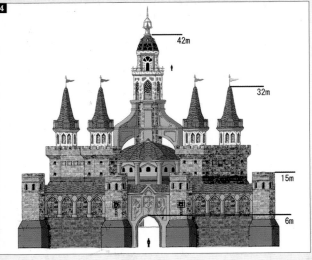

42m

32m

15m

6m

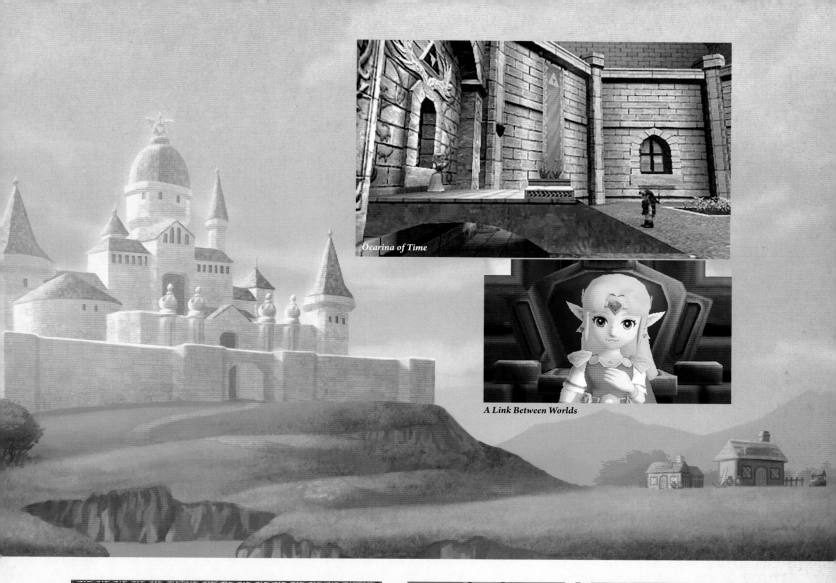
Ocarina of Time

A Link Between Worlds

HYRULE CASTLE OVER THE ERAS

Hyrule Castle often plays an important role in Link's adventures. When nefarious forces take the castle, it becomes a formidable dungeon (page 144). Here is a brief overview of the appearances of Hyrule Castle over the course of the *Legend of Zelda* series.

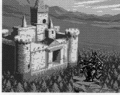

A Link to the Past
When the castle is captured and Zelda imprisoned, Link frees her from the dungeon and they escape using a secret passage behind the throne that leads to the sanctuary.

Ocarina of Time
At the urging of the Great Deku Tree, Link seeks out the "Princess of Destiny" by sneaking into Hyrule Castle's courtyards through a hole in the moat and then sneaking past the guards.

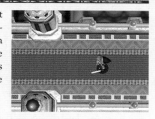
Oracle of Seasons & Oracle of Ages
Hyrule Castle appears in the opening of both *Oracle of Seasons* and *Oracle of Ages*. Link enters the castle, and the Triforce which is housed there sends him to either Holodrum or Labrynna. If both adventures are completed, Princess Zelda will be seen on the terrace during the ending.

The Wind Waker
Link finds Hyrule Castle in stasis at the bottom of the sea, frozen in time by the goddess's seal. Here Tetra learns she is Princess Zelda and Link finds the Master Sword.

Four Swords Adventures
Link finds the Four Sword, used to seal Vaati, in Hyrule Castle. The castle is overrun with demons and becomes a dungeon.

The Minish Cap
In a secret room, stained glass tells the legend of the Minish, known to Hylians as Picori. Vaati transforms it into Dark Hyrule Castle.

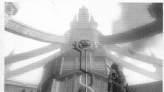
Twilight Princess
Hyrule Castle has been invaded by Zant. Bokoblins and Bulblins have overrun the courtyard. Link must take it back.

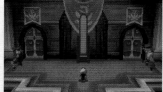
Spirit Tracks
Link meets Princess Zelda at the Engineer Graduation Ceremony held at the castle. At Zelda's request, he sneaks her out afterward.

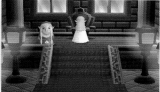
A Link Between Worlds
Paintings of ancient legends decorate the castle. Princess Zelda notes that other paintings herald the reawakening of evil in the land.

CASTLE TOWN

Throughout Hyrule, from its quaint villages to its far-flung grottoes and highest peaks, all roads lead to Castle Town.

High walls built to protect the castle also keep the town and its people safe. This means that Castle Town is where Hyrule goes to let its hair down. Across almost every era, the lively entertainment hub is home to many of the region's biggest festivals and most colorful characters.

Among the amusements in Castle Town are the many games, both of skill and of chance. Some owners operate them as much for their own amusement as the amusement of customers. Whereas beyond the walls, smaller challenges are limited to horse riding or fishing (page 79), in Castle Town, entertainment means anything from bowling to defeating enemies. For a price, there's all sorts of fun to be had here.

Twilight Princess
The Castle Town depicted in *Twilight Princess* is especially opulent. Lavishly decorated, the town's market sells a variety of fine apples, bread, and even flowers. To be able to sell one's wares in the market is considered a great privilege.

The Minish Cap
The Picori Festival is held in the colorful Hyrule Town, where colorful flowers are in full bloom and the roofs are colorful too. There are many shops, from bakeries to cafés.

Ocarina of Time
The Castle Town in the Era of the Hero of Time is heavily fortified, surrounded by both walls and a moat. The castle gate is a drawbridge, and it is closed at night to prevent monsters from getting in. Houses and shops circle the plaza in the center of town, and it is full of people during the day. It becomes quiet at night, and dogs wander about. After Ganondorf seizes control, it is destroyed by the monsters pouring out of the Sacred Realm. The residents flee to Kakariko Village (page 78).

BOUNTY OF AMUSEMENTS

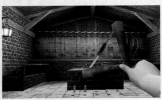

Shooting Gallery
The shooting gallery in *Ocarina of Time* challenges players to target rupees with a slingshot. There is also one that uses a bow and arrow.

Bombchu Bowling Alley
Players at this colorful bowling alley from *Ocarina of Time* win prizes by carefully placing Bombchus to avoid obstacles while aiming at the target.

Treasure Chest Shop
In this luck-based game in *The Minish Cap* and *Ocarina of Time*, players receive the mystery contents of the treasure chest they choose.

STAR Game
This game, playable in the Castle Town from *Twilight Princess*, challenges players to collect all the glowing orbs before the time runs out.

Fruit Pop Flight Challenge
There are games to be played outside of Castle Town too. In *Twilight Princess*, players fly around Lake Hylia, attempting to pop as many balloons as possible.

Cucco Ranch
In *A Link Between Worlds*, players are challenged to dodge flying cuccos. The time and amount of cuccos increase with each level of difficulty.

Clean Cut
On Bamboo Island in *Skyward Sword*, players must swing their sword quickly to cut through a towering bamboo stalk as many times as possible.

Mail Sorting
Players who take a part-time job at the Island Postal Service in *The Wind Waker* are challenged to sort envelopes with their corresponding icon on the shelf as quickly as possible.

RANCHES

For generations, ranches have supported the daily lives of many in Hyrule. They raise cuccos, cattle, and other livestock.

In *Ocarina of Time*, Lon Lon Ranch breeds horses, and through its dairy farm, is also tasked with supplying milk to Hyrule Castle and nearby towns.

Far away from Castle Town, in *Twilight Princess*'s Ordon Village, they raise goats. The entire village's livelihood is closely tied to the Ordon Ranch.

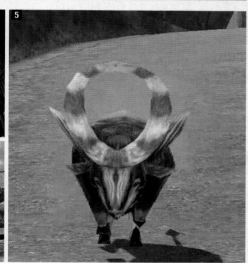

1 2 Lon Lon Ranch in *Ocarina of Time*. It's here that Link first meets Epona. Many animals on the ranch enjoy Malon's songs. **3 4** Romani Ranch from *Majora's Mask*. Pictured is Cremia, who is in charge of delivering milk to the town. Doggy Racetrack is located just south of the ranch. **5** An Ordon Goat from *Twilight Princess*. Their milk, skins, and horns are used for a variety of items. The goats sometimes escape and roam Ordon Village.

HYRULEAN RANCHES OVER MULTIPLE ERAS

Ranches play key roles in many eras, but none is more enduring than Lon Lon Ranch, which shows up in many different eras, and is run by its manager Talon and his daughter Malon.

Perhaps the most recognizable Lon Lon Ranch appears in *Ocarina of Time*, where the Hero of Time meets Epona, and Malon's employee Ingo usurps the ranch after Ganondorf's rise to power.

Though many ranches, like Romani Ranch, are big enough to have names, some are smaller, and may be as simple as a fenced-in area where cuccos are raised.

Dodge enough cuccos at the Cucco Ranch in A Link Between Worlds and Link will be able to meet the Giant Cucco.

Lon Lon Ranch (Ocarina of Time)
Talon, the owner of Lon Lon Ranch when Link is young, habitually drinks Lon Lon Milk. The ranch's close proximity to Castle Town means it gets a fair number of visitors.

Romani Ranch (Majora's Mask)
The Romani Ranch is run by sisters Romani and Cremia, who inherited it from their father. They raise Romani-bred cows that produce the milk for the Milk Bar's popular Chateau Romani.

Gorman Track (Majora's Mask)
The Gorman brothers train horses at their track. They also cause trouble for the competing Romani Ranch, selling watered-down milk and committing other underhanded deeds.

Lon Lon Ranch (Four Swords Adventures)
Talon is the owner of Lon Lon Ranch in *Four Swords Adventures*. He raises horses together with his only daughter, Malon. Talon stocks plenty of carrots, which the horses love.

Lon Lon Ranch (The Minish Cap)
Talon and his daughter Malon run Lon Lon Ranch. Malon is tasked with selling milk in Hyrule Town.

Ordon Ranch (Twilight Princess)
The goats raised on Ordon Ranch have distinct, circular horns.

FOOD

As the terrain of Hyrule changes over the eras, so too does the food grown and consumed by its people. Regardless of era, Hylians tend to favor simple food preparation over complex meals.

Twilight Princess
A kitchen in rural Ordon Village.

VEGETABLES

While a great many vegetables are cultivated in Hyrule, pumpkins are by far the most plentiful and popular.

Grown in patches from the Sky Era on, pumpkins are often used as the primary ingredient in soup. The great spirit Levias loves pumpkin soup, and people present it to him as an offering.

In the Twilight Era, Ordon Village is famous for the Ordon Pumpkin that shares its name.

Skyward Sword
Pumpkins are so common in the Sky Era that there are entire shops dedicated to their sale.

Twilight Princess
A variety of colorful vegetables and fruits are sold in Castle Town's bustling market.

MUSHROOMS

Mushrooms, considered by some to be a blessing of the forest, are more often used in medicines than in food. When people do cook with them, however, mushrooms with strong smells are particularly valuable.

FRUIT

Apples are among the most popular and plentiful fruits in Hyrule. They grow on trees all over Hyrule. The most common varieties are red.

*Apples can be knocked out of trees in **A Link to the Past** and **A Link Between Worlds**. In the latter game, it is possible to find rare green apples.*

*Chestnuts, known as Wood Hearts, are found in both **Phantom Hourglass** and **Spirit Tracks**, though it is unclear if they are edible.*

FISH

In many eras, the ocean is a good distance from the Hylian people, so they fish in the freshwater rivers, ponds, and lakes.

Due to the unnatural creation of the Great Sea in *The Wind Waker*, there aren't any fish or other seafood to harvest and eat.

When the displaced Hylians settle in the land of the Spirits of Good, fish are plentiful and can be seen being transported by train to the various realms.

MEAT

In most eras, meat does not make up a large portion of the average Hylian's diet. However, in more prosperous eras like the Twilight Era, meat is one of the more popular foods and can be found in the markets and bars of the Castle Town.

The Legend of Zelda
Meat is sometimes used as bait for monsters.

BREAD

Bread is a staple of Hylian cuisine and can often be found in the bustling Castle Towns of different eras.

In The Minish Cap, a variety of breads are available to buy in the bakery of Wheaton and Pita. They put Kinstones in random cakes to attract customers.

A stall selling bread in the Castle Town from Twilight Princess.

Twilight Princess
Telma's bar, where large helpings of meat are on display and popular with customers. Telma even serves processed and cured meats like ham.

EGGS & DAIRY PRODUCTS

Ranches play a key role in feeding many in Hyrule (page 73). Eggs, laid by cuccos, are a common meal, as is milk from cows. Many people drink milk daily due to its nutritious nature. Milk is occasionally served at cafés and bars.

Twilight Princess
Ordon Goat cheese. Made from the Ordon Goat's milk, this regional cheese is shaped into a pattern similar to the goat's distinctive horns. It has a pleasant, if acquired, taste.

Majora's Mask
In the Castle Town of *Majora's Mask*, there is a popular establishment known as the Milk Bar. It caters to adults and sells superior-quality milk known as "Chateau Romani," obtained from Romani cows on the nearby ranch. The milk is known for maximizing one's magical potential for three days.

THERE'S NOTHING LIKE A BOTTLE OF SOUP

When Hylians cook, there are few dishes more popular than soup. It is easy to make, can be prepared in great quantities, and travels well, especially when put in bottles.

A wide variety of ingredients can go into a soup, and it's a common sight to see a pot simmering on the stove in many homes in Hyrule.

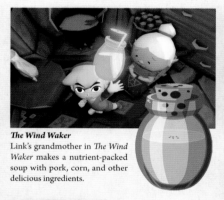

The Wind Waker
Link's grandmother in *The Wind Waker* makes a nutrient-packed soup with pork, corn, and other delicious ingredients.

Skyward Sword
Pumpkin soup. Best eaten hot.

Twilight Princess
Yeto's Superb Soup uses Reekfish for stock, Ordon Pumpkins as the main ingredient, and Ordon Goat's cheese to bring out the flavor. It is made by a yeti, but it's delicious and nutritious for Hylians as well.

A Link Between Worlds
A common setup for a meal, with a soup bowl, spoon, and milk.

Ocarina of Time
The carpenters cook soup in a large pot outdoors.

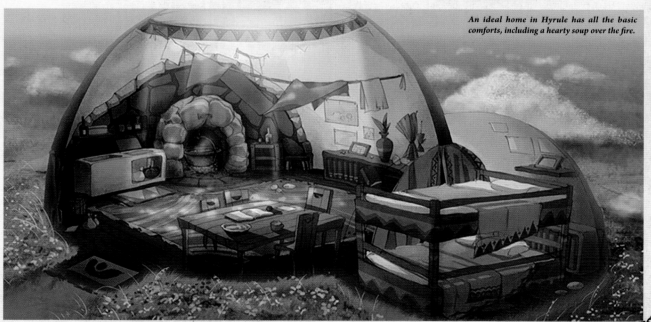

An ideal home in Hyrule has all the basic comforts, including a hearty soup over the fire.

LANGUAGE

The Hylian language has been used by the people of Hyrule since ancient times, expressed visually using a handful of different alphabets or syllabic character sets. One of the earliest Hylian alphabets on record appears in *Skyward Sword*.

In *Ocarina of Time*, an expanded syllabary is used.

When the timeline splits, three more scripts are introduced, each with its own style and nuances. This section outlines each in the context of its corresponding era.

LIFE & CULTURE

HISTORICAL RECORDS

A Skyward Sword
The Minish Cap
Four Swords
B Ocarina of Time

A Link to the Past
Link's Awakening
Oracle of Seasons & Oracle of Ages
C *A Link Between Worlds*
Tri Force Heroes
The Legend of Zelda
The Adventure of Link

Majora's Mask
D Twilight Princess
Four Swords Adventures

E The Wind Waker
Phantom Hourglass
Spirit Tracks

Titles with decipherable text are marked A–E, and releases that share an alphabet have the same color.

OTHER ALPHABETS

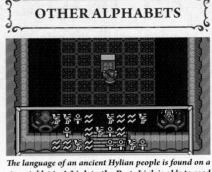

The language of an ancient Hylian people is found on a stone tablet in A Link to the Past. *Link is able to read this indecipherable language only after obtaining the Book of Mudora.*

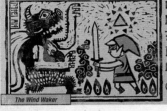

The Wind Waker

Four Swords Adventures

The Hylian character set from The Wind Waker, *though predominantly appearing in the Adult timeline, is found in surprising places outside of that timeline.*

The Sky Writing used by the Oocca (page 53) is found throughout the provinces of Twilight Princess.

A SKYWARD SWORD

A	B	C	D	E	F	G	H

I	J	K	L	M	N	O	P

Q	R	S	T	U	V	W	X

Y	Z

One of the earliest known alphabets appears in *Skyward Sword*. It is believed to have existed as far back as the Era of the Goddess Hylia, and can be found on ancient ruins throughout explorable lands. While it is possible to read these letters by matching them to the English alphabet, D and W, E and K, G and Q , O and Z, and P and T all share the same letters, complicating any translations.

The large letters are G-A-T-E-O, suggesting the message reads "Gate O(pen)."

B OCARINA OF TIME

A	I	U	E	O		HA	HI	FU	HE	HO

KA	KI	KU	KE	KO		MA	MI	MU	ME	MO

SA	SHI	SU	SE	SO		RA	RI	RU	RE	RO

TA	CHI	TSU	TE	TO		YA	YU	YO

NA	NI	NU	NE	NO		WA	WO	N

This simple alphabet appears in the Era of the Hero of Time. Each thick, squarish character can be deciphered using the Japanese syllabary. However, not everything written is necessarily readable, as the characters are often used aesthetically rather than to convey any particular meaning.

Note that the Gerudo of this era have their own alphabet (page 45).

Lon Lon Ranch sign from Ocarina of Time.

This character set is also found in Termina.

C A LINK BETWEEN WORLDS

Though many years separate the eras of *A Link Between Worlds* and *Skyward Sword*, their alphabets share some letters, and others are very similar. Like the Sky Era alphabet, several letters in this alphabet share the same characters. Those include D and G, E and W, F and R, J and T, and O and Z.

A B C D E F G H

I J K L M N O P

Q R S T U V W X

Y Z

The people of Hytopia in Tri Force Heroes *use the same alphabet as the people of* A Link Between Worlds, *which takes place in the same era.*

D TWILIGHT PRINCESS

The Hylian alphabet of the Twilight Era, though roughly corresponding to the twenty-six letters of the English alphabet, differs significantly from the alphabets of *Skyward Sword* and *A Link Between Worlds*.

The curves and emphasis make these letters well suited to exaggerated script and signs. This alphabet's distinguishing trait is the inclusion of ●s and ▲s into the line work.

These letters are present on ancient ruins as well, but the meaning is often unclear when trying to decipher them.

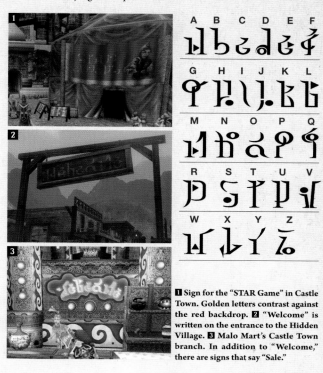

A B C D E F

G H I J K L

M N O P Q

R S T U V

W X Y Z

1 Sign for the "STAR Game" in Castle Town. Golden letters contrast against the red backdrop. **2** "Welcome" is written on the entrance to the Hidden Village. **3** Malo Mart's Castle Town branch. In addition to "Welcome," there are signs that say "Sale."

E THE WIND WAKER

The most commonly used alphabet is seen as far back in the timeline as *The Minish Cap*, and is widely used in the Adult timeline, persisting from the Era of the Great Sea to after Hylians relocate to New Hyrule in *Spirit Tracks*. It can also be found in different timelines, most notably in the Shadow Era seen in *Four Swords Adventures*.

It is possible to decipher it by matching the letters to the Japanese syllabary. However, Japanese modifiers like the small "ya" are written at full size and not differentiated.

A I U E O

KA KI KU KE KO

SA SHI SU SE SO

TA CHI TSU TE TO

NA NI NU NE NO

HA HI FU HE HO

MA MI MU ME MO

YA YU YO

RA RI RU RE RO

WA WO N

GA GI GU GE GO

ZA JI ZU ZE ZO

DA DI DU DE DO

BA BI BU BE BO

PA PI PU PE PO

1 2 3 4 5

6 7 8 9 0

This common alphabet is also used to address envelopes. This one reads, "To 415-000 Hokotate-cho, Ofukuro he" (ofukuro means "mother").

Valoo speaks Hylian in an archaic dialect that the King of Red Lions understands.

A gravestone from Kakariko Village in Twilight Princess. *This portion reads: "In addition to the army of the people . . ."*

Even in Ocarina of Time, *where alphabet B is commonly used, alphabet E is visible on the carpet of the Temple of Time.*

KAKARIKO VILLAGE: RECLAIMED VILLAGE OF THE SHEIKAH

Kakariko Village exists in many of the *Legend of Zelda* video games. In most eras, it is a place where people live in peace—raising cuccos, working as carpenters, and the like.

In *Ocarina of Time* it is located at the foot of Death Mountain. Its most prominent feature is a large windmill. It was originally a hidden village of the Sheikah (page 44), and concealed dark secrets. Later, during a more peaceful time, Impa, the leader of Kakariko Village and Zelda's attendant, opened the doors to the common people.

In *A Link to the Past*, it is home to Sahasrahla, village elder and descendant of the Seven Sages.

Titles in which
▢ = Kakariko Village
appears

Skyward Sword
The Minish Cap
Four Swords
Ocarina of Time
A Link to the Past
Link's Awakening
Oracle of Seasons & Oracle of Ages
A Link Between Worlds
Tri Force Heroes
The Legend of Zelda
The Adventure of Link

Majora's Mask
Twilight Princess
Four Swords Adventures

The Wind Waker
Phantom Hourglass
Spirit Tracks

1 2 Kakariko Village as it appears in *Ocarina of Time*. The large house is Impa's, its rooms packed with miscellany.
3 Kakariko Village, located in the volcanic Eldin Province in *Twilight Princess*. Elde Inn is famous for its access to the Kakariko Hot Spring, attracting many visitors, including Gorons. Farther in is a graveyard.

KAKARIKO VILLAGE OVER THE ERAS

In the Dark World of *A Link to the Past* and Lorule in *A Link Between Worlds*, Kakariko's parallel village is overrun with thieves. It is much the same in *Four Swords Adventures*, where portions of the village are burned, and its people are mostly thieves hostile to outsiders.

In *Ocarina of Time*, a graveyard rests in the rear of the village. A monument to those who pledged loyalty to the royal family serves as the entrance to the Shadow Temple.

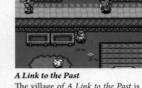

A Link to the Past
The village of *A Link to the Past* is a stone's throw from Hyrule Castle. Elder Sahasrahla resides there.

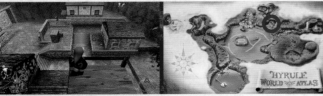

Ocarina of Time
In the Hero of Time's youth, Kakariko Village is in the midst of an expansion. After Impa opens the town to outsiders, new houses are built and the village grows. It takes in still more people when Castle Town is overrun by monsters during the rise of Ganondorf. Some villagers relocate their shops from Castle Town to Kakariko Village.

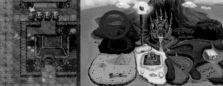

Four Swords Adventures
The village is swallowed by darkness in *Four Swords Adventures*. Its once-peaceful townspeople resort to thievery and Kakariko Village becomes a dangerous place.

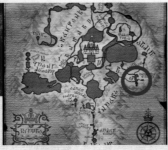

Twilight Princess
In this era, Kakariko Village has fallen into disrepair. The grave of King Zora can be found in its graveyard.

A Link Between Worlds
A new elder that shares the name Sahasrahla lives here. While the town is simple, one can find a variety of diversions here and talk to interesting people.

FISHING

It takes considerable skill and patience to catch a fish, and trying is a common pastime in Hyrule—done for sport.

Fishing is most popular at dedicated fishing holes, where many compete to catch the rarest, biggest, or most elusive types. There are often rewards for catching specific fish. In addition to lures, bait like bee larvae and worms can be used.

In *Twilight Princess*, fishing plays a significant role in daily life, and fishing poles are common equipment.

Coral earrings

Fishing rod

The sinking lure

1 Spring at the fishing hole in *Twilight Princess*. **2** A tank for holding captured fish. **3** Battling a stubborn fish in *Majora's Mask*.

The Trading Post from Majora's Mask has all the trappings of a fishing hole, but it isn't actually possible to fish there.

FISHING HOLES IN HYRULE & BEYOND

Regardless of the era, there always seem to be people in Hyrule with a passion for fishing. Browsing the in-store collections of the fishers and operators of Hyrule's various fishing spots can be almost as much fun as actually catching a fish.

For a list of catchable varieties, see page 65.

Link's Awakening
The fishing hole on Koholint Island is located northwest of Mabe Village. The man who tends to the spot gives out rupees depending on the size of the fish caught there.

Ocarina of Time
In *Ocarina of Time*, there is a fishing hole connected to Lake Hylia where people enjoy bass fishing with lures. Caught fish are released rather than eaten. When Link visits as an adult, the fish have grown larger. Under specific conditions, and using the prohibited sinking lure, it is possible to catch a rare Hylian Loach here.

Twilight Princess
If there's a fish in the water in *Twilight Princess*, Link can try to catch it with a bobber. There is a fishing hole in Upper Zora's River, and a variety of lures are available there. Every time the hero enters this beautiful area, the season changes. Hena, the owner, takes visitors to the spot with a boat.

Phantom Hourglass
Fish appear as shadows from the deck of Link's boat. Link can try to catch the legendary Neptoona.

Majora's Mask 3D
Link can take time out to fish at the swamp and ocean fishing holes in *Majora's Mask*. There are many types of fish to catch, each with its own characteristics. Depending on the type of fish, it may be necessary to attract them by wearing specific masks.

WEAPONS & EQUIPMENT

In Hyrule's darkest corners and deepest dungeons, it's dangerous to go alone.

A sword and shield are standard equipment when fighting the many monsters that lurk in the dark, but Link requires a variety of items in his adventures. A map and a compass are vital to seeing his way through a dungeon, while other tools like boomerangs and Hookshots are indispensable, both in a tough fight and when solving tougher riddles.

This section looks at the iconic equipment Link has wielded over the eras, from weapons (starting with swords) to tunics, shields, and other essentials like bombs. For more item data, please see page 115.

SWORDS

It's hard to imagine beginning any adventure without even the simplest sword in hand. Some, like the Master Sword (page 82), also known as the Blade of Evil's Bane, and the Four Sword (page 83), which splits Link into four, are legendary. The hero has also utilized other swords of great power, including the White Sword and Magical Sword, both found in Hyrule, as well as the Phantom Sword and Lokomo Sword, which are found in other lands.

Swords will at times grow in power along with their bearer; some have even changed their names to reflect this, like when the Goddess Sword became the Goddess Longsword.

The hero is able to have a blacksmith temper the Razor Sword into the Gilded Sword by providing Gold Dust.

WHITE SWORD

Over the eras, many swords of significant power have been called the "White Sword." In some instances, a White Sword imbued with greater power becomes the Master Sword, as is the case with the Goddess White Sword of the Sky Era. In *Oracle of Ages* and *Oracle of Seasons*, it is called a Noble Sword, but the blade still shines a distinctive white.

The Legend of Zelda
The White Sword is obtained from an old man in a cave. Not just anyone can use it.

Oracle series
The sword stands in a forest pedestal in *Oracle of Seasons*, while a similar blade is restored from broken pieces in *Oracle of Ages*.

Having the blacksmith temper the broken Picori Blade turns it into the White Sword. Ultimately, it becomes the legendary Four Sword.

MAGICAL SWORD

The Magical Sword is the most powerful blade in an era when the Master Sword's whereabouts are unknown. Imbued with magical power, it is a rare blade. Wielding the Magical Sword requires a great degree of experience and skill.

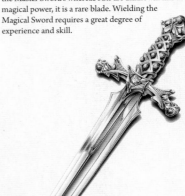

The Adventure of Link
A sword containing powerful magic, the Magical Sword is awarded to Link by an old man in the cemetery in *The Legend of Zelda*. The hero continues to use it in *The Adventure of Link*.

MASTER SWORDSMITHS

Blacksmiths can repair broken swords, improve a blade's cutting ability, and sometimes even reforge a sword into something better. These are some of the most notable blacksmiths throughout the eras, including Biggoron, who makes the powerful Biggoron's Sword that bears his name and constitution.

Majora's Mask
The Mountain Smithy's shop in *Majora's Mask* is run by Zubora and his assistant, Gabora. Zubora is lazy, but Gabora is a diligent smith with a skilled hand.

"Zubora Gabora" is engraved on the sword wielded by Phantom Ganon in The Wind Waker.

A Link to the Past
The Dwarven Swordsmiths of the Smithery, just outside Kakariko Village in *A Link to the Past*, are skilled enough to temper even the Master Sword.

The Minish Cap
Master Smith of the kingdom of Hyrule is quite talented in his own right, but it is Melari, a Minish smith, who assembles the broken pieces of the Picori Blade to forge the White Sword.

Phantom Hourglass
The blacksmith Zauz of *Phantom Hourglass* lives alone on an island that shares his name. He is exceptionally skilled, forging the blade necessary to craft the Phantom Sword.

A Link Between Worlds
Stubborn smiths in both Hyrule and Lorule work with their families, forging blades in parallel with exceptional skill.

IMPORTANT SWORDS OVER THE ERAS

Below is a chart that details swords that the hero known as Link wields over many adventures and periods of history.

Master Sword Variants

Four Sword Variants

 = First sword obtained in that title.

= Strongest sword in that title.

Item Name	The Legend of Zelda	The Adventure of Link	A Link to the Past	Link's Awakening	Ocarina of Time	Majora's Mask	Oracle series	The Wind Waker	Four Swords	Four Swords Adventures	The Minish Cap	Twilight Princess	Phantom Hourglass	Spirit Tracks	Skyward Sword	A Link Between Worlds	Tri Force Heroes
Sword	■		■	■													■
White Sword (Noble Sword)*	■						■				■						
Magical Sword	■	■															
Master Sword			■		■		■	■		■		■			■	■	
Kokiri Sword					■	■											
Giant's Knife					■												
Broken Giant's Knife					■												
Biggoron's Sword					■												
Great Fairy's Sword						■											
Razor Sword						■											
Gilded Sword						■											
Wooden Sword						■											
Hero's Sword								■									
Smith's Sword											■						
White Sword (Two Elements)											■						
White Sword (Three Elements)											■						
Four Sword									■	■	■						
Wooden Sword											■						
Ordon Sword												■					
Oshus's Sword													■				
Phantom Sword													■				
Recruit's Sword														■			
Lokomo Sword														■			
Practice Sword															■		
Goddess Sword															■		
Goddess Longsword															■		
Goddess White Sword															■		
True Master Sword															■		
Forgotten Sword																■	

THE MASTER SWORD: THE BLADE OF EVIL'S BANE

There is a legend that states when Hyrule is in crisis, only one who is pure of heart shall be able to draw the Master Sword from its pedestal. Those whose hearts are tainted cannot claim it.

The Master Sword, also known as the Blade of Evil's Bane, has the power to seal both demons and the darkness they serve. It is also used as a key to the Sacred Realm, protecting it from would-be trespassers (page 24).

The True Master Sword, blessed by the goddess Hylia in *Skyward Sword*, possesses the Light Force that is the source of all life in the world. Held aloft, it gathers heavenly energy and becomes able to fire a beam of light known as a "Skyward Strike."

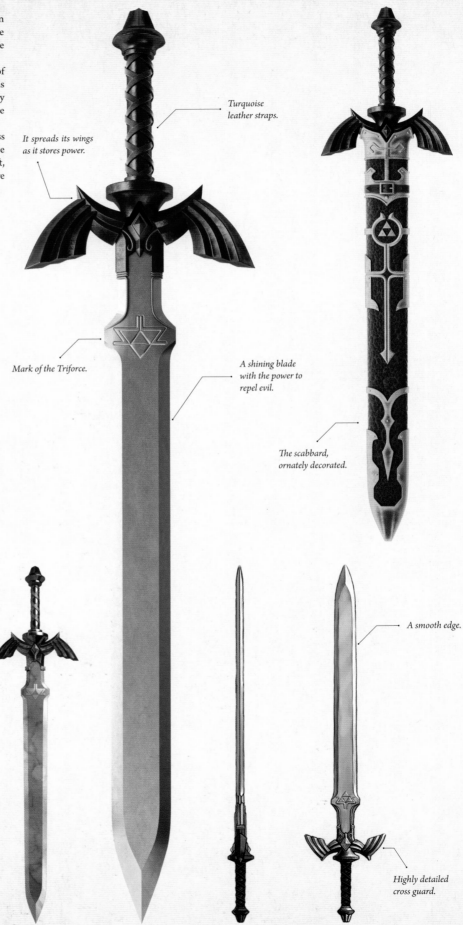

It spreads its wings as it stores power.

Turquoise leather straps.

Mark of the Triforce.

A shining blade with the power to repel evil.

The scabbard, ornately decorated.

A smooth edge.

Highly detailed cross guard.

A Link to the Past & Four Swords

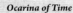

Ocarina of Time **Twilight Princess** **Skyward Sword**

HISTORY OF THE MASTER SWORD

The Master Sword is originally a blade known as the Goddess Sword, created by Hylia to help protect the people of the world from evil.

Fi, the spirit of the sword, guides a hero she calls "Master" in *Skyward Sword*. The blade they forge with the three sacred flames becomes the Master Sword of legend. Ultimately, it is set in a divine pedestal (page 26) to be passed down to the chosen hero.

Over the course of history, the Master Sword has spent a great many years lying dormant, waiting for a worthy hero to take up its blade in the name of the goddess and her legacy of peace. In certain timelines, the blade waits so long that the temple built around its pedestal falls into disrepair and even rots away.

Despite its long life, the Blade of Evil's Bane is not eternal; to maintain it requires sacred power from spirits, Great Fairies, and sages. Over the years, worthy smiths temper the Master Sword with unique materials, changing its color and shape ever so slightly.

Forged and improved over multiple phases in the Sky Era, the Goddess Sword becomes the True Master Sword. In its final phases, it is exposed to sacred flames, a blessing, and branded with the mark of the Triforce.

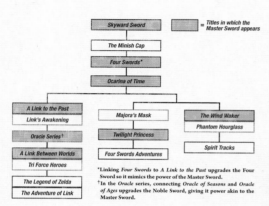

Skyward Sword
The Minish Cap
*Four Swords**
Ocarina of Time

= Titles in which the Master Sword appears

A Link to the Past
Link's Awakening
Oracle Series†
A Link Between Worlds
Tri Force Heroes
The Legend of Zelda
The Adventure of Link

Majora's Mask
Twilight Princess
Four Swords Adventures

The Wind Waker
Phantom Hourglass
Spirit Tracks

*Linking *Four Swords* to *A Link to the Past* upgrades the Four Sword so it mimics the power of the Master Sword.
†In the *Oracle* series, connecting *Oracle of Seasons* and *Oracle of Ages* upgrades the Noble Sword, giving it power akin to the Master Sword.

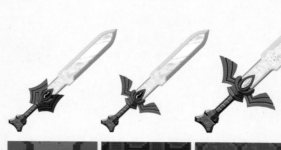

In The Wind Waker, *Link restores the Master Sword's ability to repel evil by offering songs of prayer with the sages. The shape of the sword changes as its power is restored.*

The Master Sword can be tempered in A Link to the Past *and other titles to make its edge sharper and the light filling it more colorful.*

FOUR SWORD: POWER SPLIT FOUR WAYS

The legendary Four Sword has the power to split its holder into four bodies with four blades. Like the Master Sword, it is enshrined in a pedestal in a sanctuary and is used over multiple eras to quell those who seek power over others for their own nefarious gains. Also like the Master Sword, the Four Sword can be used to seal evil away.

The Four Sword Sanctuary is guarded by Princess Zelda and the six other Shrine Maidens.

The Four Sword is said to be inseparable from Light Force, the source of all life energy.

HISTORY OF THE FOUR SWORD

It was the tiny Minish people, known to Hylians as Picori (page 52), who created the Picori Blade which would become the Four Sword. After Vaati destroys the Picori Blade in *The Minish Cap*, the fragments are reforged into the White Sword. Once the blade is infused with the four Elements (fire, earth, wind, and water), it becomes the Four Sword.

The Four Sword is used to seal Vaati on several occasions after *The Minish Cap*.

In *Four Swords Adventures*, Link uses it to finally defeat Vaati for good, and in the process, the sword also seals away a mindless incarnation of Ganon (page 20), after Ganondorf's rebirth.

The blade has lain dormant in its sanctuary ever since.

The stained glass of Hyrule Castle in The Minish Cap *shows how, in ancient times, the Picori Blade and Light Force were given to the Hero of Men by the Minish.*

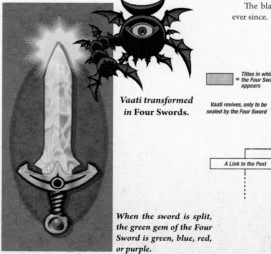

Vaati transformed in Four Swords.

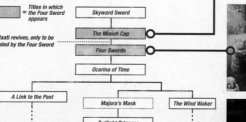

Titles in which = the Four Sword appears

Skyward Sword
The Minish Cap
Vaati revives, only to be sealed by the Four Sword
Four Swords
Ocarina of Time
A Link to the Past
Majora's Mask | *The Wind Waker*
Twilight Princess
Four Swords Adventures

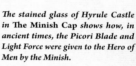

In The Minish Cap, *the Picori Blade becomes the Four Sword when strengthened by the four Elements.*

The sanctuary is moved and watched over by Princess Zelda across multiple generations, its place in the pedestal serving to seal Vaati away.

The Four Sword is extracted from its pedestal, resurrecting Vaati. Princess Zelda and the maidens stop him and seal Ganon, who used the Minish mage to attempt his own rebirth in the land of Hyrule.

When the sword is split, the green gem of the Four Sword is green, blue, red, or purple.

SHIELDS

What's a sword without a shield? If a sharp blade smites evil, it's a solid shield that protects against it. From the distinctive blue of the Hylian Shield to the blinding gleam of the Mirror Shield, few things in *The Legend of Zelda* are more iconic than Link exploring a dungeon or fighting off monsters with a sword in one hand and a shield in the other.

Shields emblazoned with the symbol of the Triforce are often standard issue for knights in the kingdom of Hyrule, and they carry them with pride. But rarer shields, many with specific uses, have emerged over the eras to aid Link in the hero's more challenging trials.

Magical Shield
The Legend of Zelda

Shield
Link's Awakening

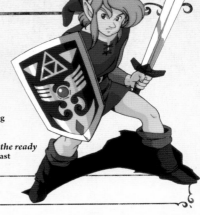

Link with a shield at the ready
A Link to the Past

HYLIAN SHIELD

The Hylian Shield, said to be filled with the hero's power, has existed since the Era of the Goddess Hylia. The bird-like design that is painted to look as though it is protecting the Triforce is the mark of the goddess Hylia and also depicts the brilliant red Loftwing once ridden by the hero.

A shield of great strength with this design has been carried by heroes from the Sky Era onward, but unlike the Master Sword, there is more than one.

In *Ocarina of Time*, the Knights of Hyrule all carry shields that share the same design. Link discovers his in the graveyard in Kakariko Village, and it is possible to buy the same model in Castle Town. Some of the birds are more vivid than others, since the design is painted and may fade or scratch over time and with heavy use.

The Hylian Shield is big—broad enough for a child to curl up and hide underneath it. Though it is made of steel,

it is light and sturdy, an optimal weight for a fighter with a one-handed weapon.

Shields of this style, that depict the legends of the past, become less common in later eras, but in the kingdom of Lorule (page 32), a parallel world to Hyrule, similar shields are made and are very effective.

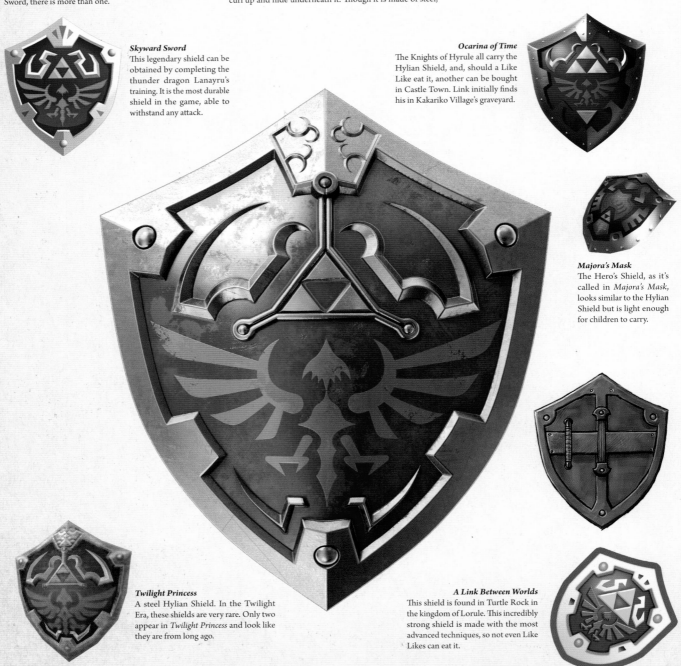

Skyward Sword
This legendary shield can be obtained by completing the thunder dragon Lanayru's training. It is the most durable shield in the game, able to withstand any attack.

Ocarina of Time
The Knights of Hyrule all carry the Hylian Shield, and, should a Like Like eat it, another can be bought in Castle Town. Link initially finds his in Kakariko Village's graveyard.

Majora's Mask
The Hero's Shield, as it's called in *Majora's Mask*, looks similar to the Hylian Shield but is light enough for children to carry.

Twilight Princess
A steel Hylian Shield. In the Twilight Era, these shields are very rare. Only two appear in *Twilight Princess* and look like they are from long ago.

A Link Between Worlds
This shield is found in Turtle Rock in the kingdom of Lorule. This incredibly strong shield is made with the most advanced techniques, so not even Like Likes can eat it.

WOODEN SHIELDS

Light and easy to handle, wooden shields are common in every era. However, they break easily and have a tendency to catch fire and burn away, making wooden shields less than ideal for long or dangerous journeys.

Deku Shield (Ocarina of Time)
A shield engraved with the mark of the Kokiri. It is sold in the shop in Kokiri Forest, and like anything Kokiri, is small enough for a child to use.

Wooden Shield (Twilight Princess)
A wooden shield sold in stores during the Twilight Era. They have metal trimming and a winged design painted on the face, but are functionally identical to the Ordon Shield.

Ordon Shield (Twilight Princess)
This shield is branded with the signature horns of the Ordon Goat.

Wooden Shields (Skyward Sword)
A light and easy-to-use shield from Skyloft can be upgraded to the more durable Banded Shield (center) and Braced Shield (right).

Small Shield (The Minish Cap)
The Small Shield of *The Minish Cap* is won by Princess Zelda in a game she plays during the Picori Festival. She gives it to Link, who carries it for much of his adventure with Ezlo. Similar shields are sold in Castle Town. The shield is made of steel, a favorite metal for Gorons to eat. If Link gives it to a Goron to "nibble on," the shield will be returned to him as the Mirror Shield.

Hero's Shield (The Wind Waker)
This shield hangs in Link's home on Outset Island, and is said to have been carried by an ancient hero. The design on its face, of a winged beast and Triforce, is the same as the one carried by Link in *The Minish Cap*. It's possible they are one and the same.

Shield of Antiquity (Spirit Tracks)
It is said the Hero of Winds used this shield one hundred years prior to the events of *Spirit Tracks*. Niko, a member of Tetra's crew, treasures it dearly. The shield used by the Hero of Winds in *Phantom Hourglass* below is indeed the same.

Shield (Phantom Hourglass)

Shield (Spirit Tracks)
This shield carries the triangular symbol of the life force in the form of a gold Force Gem and the bird-like symbol of the spirits.

THE MIRROR SHIELD

Many shields over the course of Link's adventures in Hyrule bear the name "Mirror Shield," largely due to their reflective qualities. The surface of these shields reflects magic and light, a necessary feature for battling some monsters and solving some dungeon puzzles. It is also quite powerful—a rare treasure that is sometimes the strongest shield the hero uses.

Shield (Oracle series)
The Wooden Shield of *Oracle of Ages* and *Oracle of Seasons* can be tempered to become the Iron Shield by using Hard Ore.

Iron Shield (Skyward Sword)
A shield made of iron is more durable than wood, but care is necessary around electricity. The Iron Shield of the Sky Era can be upgraded into the Reinforced Shield (center) and Fortified Shield (right).

Mirror Shield (The Wind Waker/The Minish Cap)
In *The Wind Waker*, Link finds the Mirror Shield in the Earth Temple. It bears a striking resemblance to the Mirror Shield in *The Minish Cap*, but it is not clear whether or not they are the same shield.

Mirror Shield (Ocarina of Time)
The Mirror Shield carried by the Hero of Time is discovered in the Spirit Temple. It bears the crest of the Gerudo. Used together with Sun Switches, the shield must be used to solve the temple's riddles. Like other shields in past and future eras, it reflects the light of the sun. Although it has the ability to reflect magical attacks, it cannot block projectiles.

Mirror Shield (Majora's Mask)
The Mirror Shield in the parallel world of Termina has a face-like pattern, and the light it reflects carries the same image. It is hidden at the bottom of a well in Ikana Canyon and is required to explore Ikana Castle. It seems that the king of Ikana, who died in battle long ago, sought true light in death, and that cry carried over into this shield.

Mirror Shield (A Link to the Past)
The Mirror Shield of *A Link to the Past* lies in the Dark World. Much like the others, it is a sturdy shield that can withstand and reflect magic and lasers.

Sacred Shield (Skyward Sword)
The Sacred Shield is not very durable, but repairs itself over time. It can repel curses and will terrify some monsters. It can be upgraded to the Divine Shield (center) and Goddess Shield (right).

Armor & Accessories

Bringing the right equipment when exploring can save a hero's life. There's protective gear like clothing, gloves, or shoes; accessories like masks and capes; and jewelry like bracelets and rings that may give Link added abilities, allow him to blend in or access otherwise inaccessible areas, or just look a little more fashionable.

This kind of equipment broadly fits into one of two categories: items that are equipped immediately and are always active, and those that can be swapped and used freely. Even if their appearances and equipping methods differ, there are a few items that grant similar powers, such as heat resistance. There are also instances where they can be equipped freely and grant an ability, but doing so may have negative effects, such as increasing damage taken.

Donning outfits of different colors and styles may also allow Link to gain special abilities, like red for fire resistance or blue to breathe underwater. But outfits may also simply be cosmetic, as is the case when Link wields the Four Sword and splits into multiple versions of himself.

Though Link's starting outfit and boots have no real effects, they are well made and well suited to adventuring.

When Link eventually dons the signature green of heroes past in The Wind Waker, *the change is purely cosmetic.*

1 An example of a clothing color swap in *The Adventure of Link*. Here, Link's outfit changes from green to red when its defense is increased through magic. There are similar effects when equipping a red outfit in other titles. **2** When an item with a greater effect is obtained, it overwrites the weaker item, enabling Link to do a multitude of incredible feats, like lifting massive objects. **3** There are many armors that are suited for specific environments, like those that enable breathing underwater or provide heat resistance. **4** Some items of clothing, like masks, have special abilities unique to a specific task and only need to be worn for a short time. **5** Link can safely glide down from great heights using the Sailcloth.

BLUE OUTFITS

Blue Mail
A Link to the Past
Magical clothing that reduces damage. The Red Mail, which has even higher defense, can be found in the Dark World.

Zora Tunic
Ocarina of Time
The Zora Tunic worn by Link as a young adult enables him to breathe underwater.

Zora Armor
Twilight Princess
A treasure kept safe for Link by King Zora. It allows the wearer to stay submerged for long periods of time.

When Link draws the Four Sword, he is split into four. The four versions of Link wear green, red, blue, and purple, respectively. However, there is no apparent difference in strength or ability based on the color of their clothing. The difference represents the four Elements that give the Four Sword its power (page 83).

RED OUTFITS

Red Clothes
Link's Awakening DX
Red Clothes double Link's damage. Blue Clothes halve damage taken. Link can choose blue or red in the Color Dungeon.

Goron Tunic
Ocarina of Time
A fire-resistant tunic made by the Gorons. It is strong against heat and will not catch fire.

Red Mail
A Link Between Worlds
This outfit is stronger than the Blue Mail and reduces damage taken by three-quarters. It is the strongest armor in Lorule.

Goron Garb & Zora Costume
Tri Force Heroes
A discussion of clothing would be woefully incomplete without something from the fashion-forward kingdom of Hytopia. These are outfits made by Madame Couture that are inspired by the Gorons and Zora. The wearer is granted that race's abilities. The Goron Garb allows them to swim in lava, while the Zora Costume improves their ability to swim.

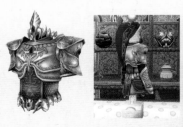 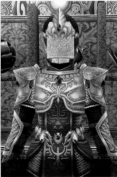

Magic Armor
Twilight Princess
Magical armor that makes the wearer invulnerable by draining rupees from their wallet. If the rupees run out, the armor becomes a hindrance. The set is sold in one of the higher-end shops in Castle Town.

HEAD

Bunny Hood
An adorable hood with ears that bounce and sway like a rabbit's. It's designed to be worn on the top of the head but is classified as a mask. Wearing it in *Majora's Mask* brings forth the power of the wild, enabling the hero to run faster.

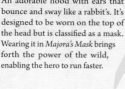
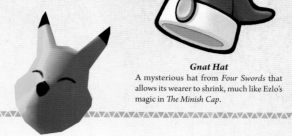

Gnat Hat
A mysterious hat from *Four Swords* that allows its wearer to shrink, much like Ezlo's magic in *The Minish Cap*.

FACE

Fireshield Earrings
A sacred gift from the goddess to the hero who will save the world. These earrings protect the wearer from heat, making activity in volcanic or lava-filled areas possible for long periods of time.

Masks
Masks in *Ocarina of Time* are used as fun diversions. In *Majora's Mask*, there is a great variety of masks, and they are more personal objects, sometimes used in ceremonies. Masks in Termina have the power to transform their wearers, imbuing them with special skills.

BACK

Sailcloth
After Link wins the Wing Ceremony, Zelda takes this Sailcloth from her shoulders and rewards him with it, as per the ancient tradition in Skyloft. It is used to safely glide down from high places.

Magic Cape
A cape full of magical power. Donning it makes the wearer invisible and immune to any attack. It is hidden in the graveyard in the Light World of *A Link to the Past*.

Roc's Cape
The wearer of this cape can make large jumps and glide at will, soaring through the air like a bird. There is another item with similar, though lesser, properties known as Roc's Feather.

WRISTS

Power Bracelet
Equipping one of these magical bracelets allows the wearer to draw out hidden strength, enabling them to lift and carry objects that are otherwise far too heavy.

Power Glove Titan's Mitt Silver Gauntlets Golden Gauntlets
Upon equipping any of these gloves, Link is able to lift and carry heavy objects with ease. Their names change over the eras, but the golden version can always carry more than the silver.

Goron's Bracelet
A secret treasure possessed by the Goron chief that enables the hero to pull up Bomb Flowers in mines.

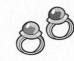

Digging Mitts, Mogma Mitts & Mole Mitts
These gloves are used to dig through soft dirt. They resemble the claws of the Mogma, a tribe of mole people who lived in the Sky Era.

Magnetic Gloves
Equipping them creates an enormous magnetic field, which has the power to draw in all sorts of things, as long as they are magnetic.

Ravio's Bracelet
A bracelet that enables its wearer to become a painting and merge into walls at will. Ravio of Lorule gives it to Link and it counteracts Yuga's magic in *A Link Between Worlds*.

HANDS

Magical Rings
These rings from *Oracle of Seasons* and *Oracle of Ages* are made from seeds containing mysterious, magical powers. The effects differ by the type of seed used. In all, there are sixty-four.

Rings (Red/Blue)
These magic rings increase defensive power, reduce damage taken, and simultaneously change the hero's clothes to a pale blue or red.

FEET

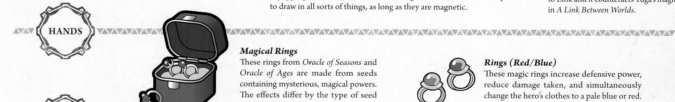

Pegasus Boots
The Pegasus Boots enable the wearer to dash at great speeds in a straight line. They are so fast that it is nearly impossible for the wearer to stop themselves unless they run into a solid object.

Iron Boots
These boots are covered in heavy iron, allowing the wearer to sink to the bottom of a body of water rather than float. When they are paired with the Zora Tunic, it is possible for Link to walk underwater.

Hover Boots
Gusts that shoot out from the bottom of these boots make it possible to walk on air for a short time. The trade-off? It can be difficult to find stable footing.

Flippers (Zora's Flippers)
Wearing these flippers improves Link's swimming abilities. He will no longer drown in water too deep for his feet to reach the ground.

BOWS & ARROWS

Bows and arrows go together like Gorons and rocks. There are few tools that can get the job done better than a well-aimed arrow. Mainly used as a long-range weapon, a bow and arrow is an effective method of attacking enemies too far away to reach with a sword. They can also be used to activate distant switches.

Often, bows are hidden in dungeons or temples, and beyond the more common ones are rare or even legendary weapons like the Hero's Bow of multiple eras or the Fairy Bow in *Ocarina of Time*.

Arrows are consumable, but they tend to be easy to find out in the world or they can be purchased in shops. It is possible to increase the maximum number of arrows the hero can carry, either by increasing the size of the quiver, or through the power of the Great Fairies.

MAGIC ARROWS CARRY THE POWER OF FIRE & LIGHT

In addition to ordinary arrows used for shooting distant enemies or targets, there are also magic arrows that hold sacred power. Wrapped in fire or ice, they are an essential tool for solving the puzzles in temples, creating platforms to proceed, and exploring labyrinths. Using them consumes magic power.

There are also Light Arrows. Much like the Master Sword, they repel evil. Light Arrows often play a large role in the hero's final showdown with evil.

A standard bow and Silver Arrows from The Legend of Zelda. *The Silver Arrows carry sacred power and are used to fire the finishing blow at Ganon.*

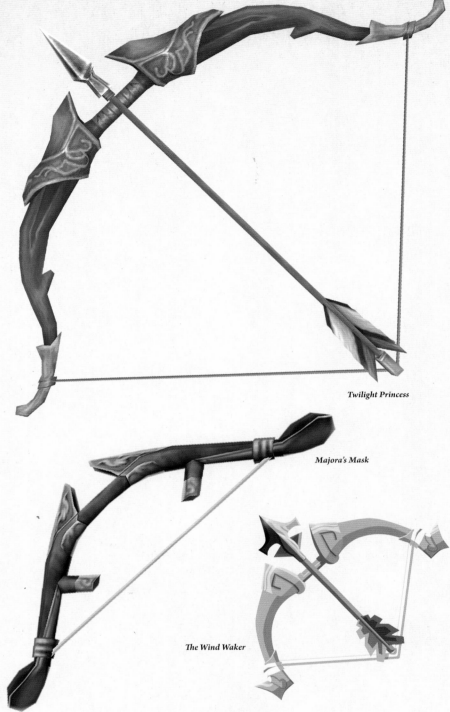

Twilight Princess

Majora's Mask

The Wind Waker

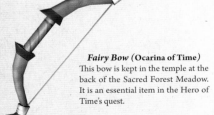

Fairy Bow (Ocarina of Time)
This bow is kept in the temple at the back of the Sacred Forest Meadow. It is an essential item in the Hero of Time's quest.

Hero's Bow
The Hero's Bow is said to have been first used in ancient times by a hero who saves the world. The bow has since been used by heroes with causes of similar gravity.

In *Twilight Princess*, the Hero's Bow is a Goron treasure said to have been bequeathed by an ancient hero to the mountain people. It is passed down through the generations and awarded to the Link of the Twilight Era.

In *Majora's Mask*, the bow is in Woodfall Temple, a site of great importance for the Deku.

In *The Wind Waker*, it is in the Tower of the Gods.

Wooden Bow
Skyward Sword

Iron Bow
Skyward Sword

Sacred Bow
Skyward Sword

Bow and Arrows
The Minish Cap

Bow
A Link to the Past

Bow and Arrows
Phantom Hourglass

Bow and Arrows
Spirit Tracks

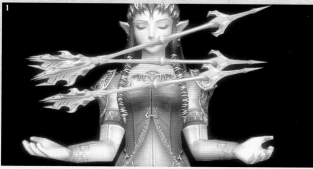

1 In *Twilight Princess*, Zelda summons Light Arrows and the Bow of Light from the Light Spirits. They are essential in the fight against the King of Evil, Ganondorf. **2** A Light Arrow from *Ocarina of Time*. While the arrows look like any other, they bear great power when fired. The light these arrows carry is not only Ganondorf's weakness, but the weakness of many monsters that stalk Hyrule by his bidding. **3** An ordinary bow and arrow. They can be used to activate switches, in addition to targeting enemies.

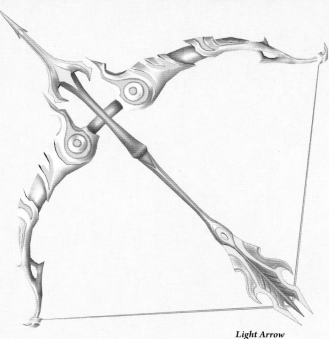

Fire Arrow

An arrow carrying the power of fire. They not only burn targeted enemies, but can also melt ice and light distant torches.

Ice Arrow

An arrow carrying the power of ice. With a powerful chill, they will momentarily freeze a struck target solid. They are also useful for creating frozen platforms to walk across water.

Light Arrow

An arrow that conceals the sacred power to destroy evil. It boasts the greatest strength of all the magic arrows, and, in the era of *The Wind Waker*, is capable of defeating an enemy in a single shot. It is the weapon of choice for Hyrule's princess of certain eras as she fights alongside the chosen hero.

QUIVERS OF VARIOUS SHAPES & SIZES

Arrows are carried in quivers of varying size and quality. It is possible to obtain more arrows by buying them from shops and collecting them from defeated enemies. The number and type of arrows Link can carry changes greatly depending on the quiver he uses.

Ocarina of Time **Majora's Mask** **The Wind Waker** **The Minish Cap**

Twilight Princess **Phantom Hourglass** **Spirit Tracks** **Skyward Sword**

Arrows for sale in a shop. The number and cost vary by bundle.

LEVEL/SIZE TITLE	LEVEL 1	#	LEVEL 2	#	LEVEL 3	#	LEVEL 4	#
*A Link to the Past**	—	30	—	70				
Link's Awakening	—	30	—	60				
Ocarina of Time	Quiver	30	Big Quiver	40	Biggest Quiver	50		
Majora's Mask	Quiver	30	Large Quiver	40	Largest Quiver	50		
The Wind Waker	Quiver	30	Quiver	60	Quiver	99		
The Minish Cap	Quiver	30	Large Quiver	50	Large Quiver	70	Large Quiver	99
Twilight Princess	Quiver	30	Big Quiver	60	Giant Quiver	100		
Phantom Hourglass	—	20	Quiver	30	Quiver	50		
Spirit Tracks	—	20	Quiver	30	Quiver	50		
Skyward Sword†	Quiver	20	Small Quiver	+5	Medium Quiver	+10	Large Quiver	+15

Note: A dash denotes that no name is provided for the quiver in this title.
*In *A Link to the Past*, for every 100 rupees, Venus will increase the number of arrows Link is able to carry by 5.
† It is possible to carry up to 65 arrows with a fully upgraded quiver in *Skyward Sword*.

BOMBS

This spherical tool with a fuse can be lit to cause a delayed explosion. Carried in a special bomb bag, they are used to destroy rocks, walls, and even sturdy doors. They can also be effective in combat against especially powerful enemies.

People originally used the naturally growing Bomb Flower for its explosive properties, but eventually perfected a synthetic version for portability.

The Gorons tend to be on the forefront of bomb development and improvement, which makes sense since the mountains they call home are often the only places that Bomb Flowers grow.

There are bomb specialty shops and research centers in various eras, where they continue to develop a variety of unique specialty bombs.

A Link Between Worlds

Majora's Mask

Four Swords

Skyward Sword

Twilight Princess

The Wind Waker

Big Bomb Outfit
With this outfit from *Tri Force Heroes*, a bomb or Bomb Flower turns into a Big Bomb, enhancing its attack power and range.

1 2 3 Sometimes walls or rocks will have suspicious cracks, suggesting something may be hidden behind them. **4** There are times when it is possible to destroy a faraway object by attaching a bomb to an arrow, creating a Bomb Arrow. **5** The Clock Town Bomb Shop from *Majora's Mask*. In addition to stocking and selling bombs, the shopkeeper is also responsible for the carnival's fireworks. He is devising a way to travel to the moon using the propulsive power of his bombs. **6** Barnes, the Bomb Shop owner from *Twilight Princess*. He sells dangerous bombs he develops himself and is completely devoted to his craft. Gunpowder and other volatile materials are piled up in his shop, so open flames are prohibited.

BOMBS OF ALL SHAPES & SIZES

Sometimes Link needs more than just a bomb.

Maybe the bomb needs to explode underwater or remotely.

Maybe the explosion needs to be bigger. Giant, even.

A multitude of strange bombs are at Link's disposal over the eras, including the memorable Bomblings, Bombfish, and Bombchus. At times, Link's even been able to make explosions without using a bomb at all.

Super Bomb
A powerful explosive capable of destroying rocks much too big for regular bombs. Super Bombs are sold in the Dark World of *A Link to the Past*. Rather than being carried, they will follow their user around until detonated on command.

Big Bomb Flower
A Bomb Flower that has grown to an enormous size. It is the subject of much research by the residents of Lorule. Like the Super Bomb, it will follow its owner around and can destroy boulders regular bombs cannot.

Giant Bomb
A massive bomb used by Shadow Link in *Four Swords Adventures*. Like the skull painted on the side suggests, this bomb causes great harm if detonated. It is too large for Link to handle.

Bomb Flower
While Bomb Flowers grow in a variety of areas, they are most commonly found in mountainous regions. They will ignite soon after being picked and explode within a few seconds. Bomb Flowers are used to make synthetic bombs and have similar destructive power. They prefer places with minimal sun and grow in clumps in caves.

Powder Keg
Only Gorons can handle these gigantic bombs.

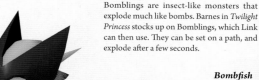

Bombchu
These mouse-like bombs run forward while wobbling left and right. They can climb up walls, making them ideal for hitting hard-to-reach targets.

Their development took inspiration from the exploding mouse monster known as the Real Bombchu.

Bomblings
Bomblings are insect-like monsters that explode much like bombs. Barnes in *Twilight Princess* stocks up on Bomblings, which Link can then use. They can be set on a path, and explode after a few seconds.

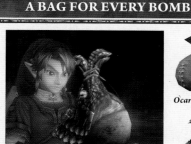

Bombfish
A bomb developed for use underwater by Barnes in *Twilight Princess*.

Blast Mask
This mask enables its wearer to conjure explosions at will. The downside? Safety is not guaranteed. The Blast Mask is very dangerous.

A BAG FOR EVERY BOMB

Bombs are best carried in durable bags made from the stomachs of especially monstrous beasts—such as the Dodongo's stomach used in *Ocarina of Time*.

The number of bombs that Link is able to carry depends on the size of the bag, and it can be increased by obtaining a larger bag or via a Great Fairy's power. These bags do not tend to have particular names; most are simply called "Bomb Bag."

The number and types of bombs each bag can carry are listed below.

In Twilight Princess, *the number of bombs the bag can hold varies by bomb type.*

Ocarina of Time	*Majora's Mask*	*The Wind Waker*	*The Minish Cap*
Twilight Princess	*Phantom Hourglass*	*Spirit Tracks*	*Skyward Sword*

LEVEL/SIZE TITLE	LEVEL 1	#	LEVEL 2	#	LEVEL 3	#	LEVEL 4	#
The Legend of Zelda	—	8	—	12	—	16		
*A Link to the Past**	—	10	—	50				
Link's Awakening	—	30	—	60				
Ocarina of Time	Bomb Bag	20	Big Bomb Bag	30	Biggest Bomb Bag	40		
Majora's Mask	Bomb Bag	20	Big Bomb Bag	30	Biggest Bomb Bag	40		
Oracle series	—	10	—	30	—	50		
The Wind Waker	Bomb Bag	30	Bomb Bag	60	Bomb Bag	99		
The Minish Cap	Bomb Bag	10	Big Bomb Bag	30	Big Bomb Bag	50	Big Bomb Bag	99
Twilight Princess	Bomb Bag	30	Giant Bomb Bag	60				
	Bomb Bag (Bombfish)	15	Giant Bomb Bag (Bombfish)	30				
	Bomb Bag (Bomblings)	10	Giant Bomb Bag (Bomblings)	20				
Phantom Hourglass	(Bombs)	10	Bomb Bag	20	Bomb Bag	30		
	(Bombchu)	10	Bombchu Bag	20	Bombchu Bag	30		
Spirit Tracks	Bomb Bag	10	Medium Bomb Bag	20	Big Bomb Bag	30		
Skyward Sword†	Bomb Bag	10	Small Bomb Bag	+5	Medium Bomb Bag	+10	Large Bomb Bag	+15

Note: A dash denotes that no name is provided for the Bomb Bag in this title.

*In *A Link to the Past*, for every 100 rupees, Venus will increase the number of bombs Link is able to carry by 5.

†*Skyward Sword* allows a standard Bomb Bag and the Adventure Pouch set with Small, Medium, and Large Bomb Bags (up to three), for a maximum of 55 bombs.

HOOKSHOTS

The Hookshot is an essential tool in many of Link's adventures that launches an arrowhead with a chain attached. The arrowhead sticks into distant objects and uses the force of retracting the chain to pull the object toward Link. If it sticks to a fixed target or post, Link can use the Hookshot to pull himself forward. This can be useful when crossing over cliffs or other gaps.

A well-aimed Hookshot can also be used to deal a small amount of damage to enemies.

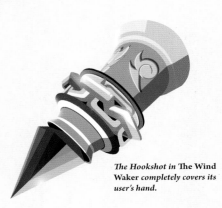

The Hookshot rented from Ravio in A Link Between Worlds. *Upgrading it to the Nice Hookshot increases the speed of the chain.*

Precision is key when using a Hookshot. It will only stick to certain, often small targets.

In Ocarina of Time, *there is also a Longshot that shoots twice as far as the Hookshot, allowing Link to reach even farther places.*

The Hookshot in The Wind Waker *completely covers its user's hand.*

SIMILAR TOOLS

Switch Hook
This hook swaps the position of the struck target and its user, making it possible to cross significant gaps.

Grappling Hook
The Grappling Hook is used similarly to the Whip and can be used to span gaps, fight weak monsters, or steal treasure from more hearty monsters.

Gripshot
A robotic arm is attached to the end, in place of a hook. The design means it can safely latch onto people as well as objects.

Clawshot
A claw on the head of the Clawshot allows Link to latch onto ivy and netting. Upgrading to Double Clawshots equips one to each arm, allowing Link to move between multiple targets without ever touching the ground.

Whip
Whips can be used to latch onto posts, swing across gaps, pull objects nearer, and operate levers and switches.

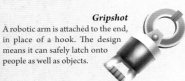

MAXIMUM REACH OF EACH HOOKSHOT

This chart shows the approximate length of the Hookshots across multiple games. The Hookshot in *Majora's Mask* is roughly the same length as the Longshot in *Ocarina of Time*, making it the farthest-reaching Hookshot to date by about five meters.

Note: The values are estimated using step distance in each title relative to Link's height.

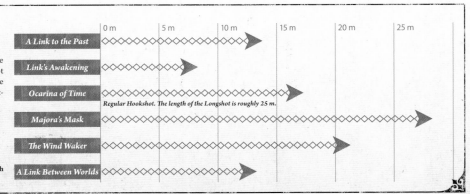

	0 m	5 m	10 m	15 m	20 m	25 m
A Link to the Past						
Link's Awakening						
Ocarina of Time	Regular Hookshot. The length of the Longshot is roughly 25 m.					
Majora's Mask						
The Wind Waker						
A Link Between Worlds						

OTHER EQUIPMENT

Over the course of his adventures, Link has had need of many tools and other equipment to get the job done. Some are common implements, like shovels and slingshots. Others are rarer, more magical items, like the Gust Bellows and rods. All serve an essential purpose.

For more information on which games each item has appeared in, see page 115.

Slingshots

With small nuts or larger seeds as ammunition, a slingshot uses the tension on its leather band to fire at enemies a short distance away. It is a simple, short-range substitute for a bow that does less damage, and is often a primary weapon for younger adventurers. The Fairy Slingshot is a favorite weapon of the Kokiri.

Boomerangs

When thrown, a boomerang moves along a quick and cutting arc before returning to its owner's hand. It will stun most monsters if it connects, and has a variety of other uses, like picking up faraway items and activating switches.

The Fairy of Winds is said to dwell within the legendary Gale Boomerang, giving it the power to generate wind.

Hammers

A hammer is a powerful weapon, ideal for a heavy strike against foes and breakable objects.

Link has many types of hammers at his disposal including Magic Hammers and the Megaton Hammer, a Goron treasure.

Hammers can be used to smash down posts blocking paths or springs that propel Link to higher areas.

Gust Bellows

The Gust Bellows is a container that can suck in air and blast it out again with force. It can be used to clear away sand or dust.

Nets

A well-timed swing with a net can snatch up a bee, bug, fairy, or even rabbit. There are even records of them repelling magic attacks when shaken vigorously enough. In *Skyward Sword*, Link must skillfully wield his net in order to catch many types of bugs.

Rods

Rods are colorful staves that hold magical powers. Often they are legendary items imbued with miraculous abilities, like the Cane of Somaria and Rod of Seasons. Others wield the elements, like the Ice Rod, Fire Rod, and Lightning Rod. Some even project sand or overturn objects through great force.

Beetle

The Beetle is a machine of an ancient civilization that flies freely when launched from the wrist; it can cut strings as well as grab and carry objects.

Shovel

A shovel allows Link to turn up the earth, revealing hidden items or holes.

Lantern or Lamp

The darkest depths of Hyrule are illuminated with a lantern or lamp in hand. They can be used to light torches, melt ice, or even damage enemies.

Bottles

Link can use a bottle to reliably catch and carry water, potions, milk, and even bugs or fairies. Similar to the net, they even have the power to repel magic.

RUPEES: CURRENCY THAT SHIMMERS LIKE A GEM

Glittering like gems in brilliant colors, the rupee is broadly used as a currency in the kingdom of Hyrule, neighboring countries, and even other worlds. A rupee's value changes depending on its size and color, and can be traded for goods in stores and with other merchants.

Rupees are found just about anywhere: by cutting down tall grasses and breaking pots, in treasure chests, and in the purses of defeated enemies. Sometimes people will offer rupees as a reward for helping them.

Rupees may fit in the palm of one's hand or be big enough that they require two hands to hold.

There is evidence that coins were once used as currency, but the era is unknown.

THE RUPOOR

Not all rupees are currency. Sometimes they may be used more like tokens in games or puzzles, such as the silver rupees in *Ocarina of Time*.

Then there's the Rupoor, a black rupee that actually drains Link's supply of rupees rather than adding to it. And that's a little sad.

Silver rupees that appear in a dungeon in Ocarina of Time *cannot be used as currency, but are instead gathered to solve a dungeon puzzle.*

Silver rupees are among the most highly valued in other games, generally worth 100 or even 200 rupees, depending on the era. They have a metallic sheen.

A Link to the Past

Ocarina of Time

Majora's Mask

The Wind Waker

Four Swords

Twilight Princess

Spirit Tracks

Skyward Sword

RUPEE COLORS & VALUES

TITLE / VALUE	1	5	10	20	30	50	100	200	300	MECHANIC	NEGATIVE
The Legend of Zelda	Yellow	Blue									
A Link to the Past	Green	Blue		Red							
*Link's Awakening DX**	Blue	Green			Red						
Ocarina of Time	Green	Blue		Red		Purple	Gold			Silver	
Majora's Mask	Green	Blue		Red		Purple	Silver	Gold			
Oracle series	Green	Red Blue	Red	Big Blue	Big Blue	Big Red	Huge Blue				
The Wind Waker	Green	Blue	Yellow	Red		Purple	Orange	Silver			
Four Swords†	Green	Blue		Red		Big Green	Big Blue	Big Red			Rupoor
Four Swords Adventures‡	Green	Blue	Yellow	Red		Purple	Big Green				
The Minish Cap	Green	Blue		Red		Big Green	Big Blue	Big Red			
Twilight Princess	Green	Blue	Yellow	Red		Purple	Orange	Silver			
Phantom Hourglass	Green	Blue		Red			Big Green	Big Red	Big Gold		Rupoor
Spirit Tracks	Green	Blue		Red			Big Green	Big Red	Big Gold		
Skyward Sword	Green	Blue		Red			Silver		Gold		Rupoor
A Link Between Worlds	Green	Blue		Red		Purple	Silver		Gold		
Tri Force Heroes	Green	Blue		Red		Purple	Silver				

*The color is only visible in the DX version. †Four rupee shards are worth 500 rupees. ‡Rupees only appear in "Navi Trackers," which is found in the Japanese version of *Four Swords Adventures*.

Rupee values differ depending on the era. Larger rupees, like those found in Phantom Hourglass (left), tend to be worth more than their smaller counterparts of the same color. Beware the black Rupoor.

WALLETS & CARRYING LIMITS

When Link collects a rupee, it goes into his wallet. The number of rupees Link can hold depends on the size of the wallet.

The maximum number of rupees Link can carry depends on the era. In *The Legend of Zelda*, a wallet can only hold 255 rupees, while in the HD version of *Twilight Princess*, Link can hoard up to 9,999.

Upgrading a wallet will allow Link to hold more rupees.

The chart below shows several wallets and their maximum capacities.

An Ancient Gold Piece found in Spirit Tracks. They were issued by the Bank of Hyrule, but their era is unknown. Note the Triforce on its face.

Rupees are precious currency, kept safe in wallets. In the era of The Legend of Zelda, a yellow rupee is worth 1.

Ocarina of Time *Majora's Mask*	—					
Name	Wallet	Adult's Wallet	Giant's Wallet			
Amount	99	200	500			

The Wind Waker	—					
Name	Wallet	Wallet	Wallet			
Amount (GC)	200	1000	5000			
Amount (HD)	500	1000	5000			

The Minish Cap	—		—	—		
Name	Wallet	Big Wallet	Big Wallet	Big Wallet		
Amount	100	300	500	999		

Twilight Princess						
Name	Wallet	Big Wallet	Giant Wallet	Colossal Wallet *		
Amount (GC/Wii)	300	600	1000			
Amount (HD)	500	1000	2000	9999		

Skyward Sword†						
Name	Small Wallet	Medium Wallet	Big Wallet	Giant Wallet	Tycoon Wallet	Extra Wallet
Amount	300	500	1000	5000	9000	+300 ×3

Note: A dash denotes that the basic wallet is not pictured or, in the case of *The Minish Cap*, appears the same regardless of size.
*The Colossal Wallet can only be obtained in *Twilight Princess HD*.
†Up to three additional wallets can be added to the Adventure Pouch in *Skyward Sword*, allowing a maximum of 9,900 rupees if Link has the Tycoon Wallet and three Extra Wallets.

THE MAN OBSESSED WITH RUPEES

In *Twilight Princess*, a man known as Jovani sells his soul to Poes for untold riches. In exchange, he is cursed—his body turned to gold and fixed in place along with his cat, Gengle, who sits atop his head. Jovani's house is full of treasure, wealth he can't hope to spend.

MUSICAL INSTRUMENTS & MELODIES

Musical instruments in *The Legend of Zelda* do more than just make beautiful music. They may summon animals or warp Link across vast distances and even time. There are many instruments not listed here, like bells, that aid Link. Others, like pipe organs, exist entirely to play music.

Simply using certain instruments is enough to trigger their effects; others require Link to play a specific melody.

It is said that certain melodies are conversations with the goddesses, and the instruments through which they are played are sacred vessels to be preserved and treasured. These melodies awaken the power of the goddesses, making miracles with each perfect note.

HARPS

A harp is played by plucking its delicate strings. While any note played on a harp is beautiful, only certain songs will release its true power.

Goddess's Harp

A sacred treasure said to have been used by the goddess Hylia, the Goddess's Harp is passed down among the keepers of Skyloft's legends, along with lyrics that chronicle the history of the Surface world.

The power of the goddess is said to reside in the songs played with the Goddess's Harp. In *Ocarina of Time*, Princess Zelda, disguised as Sheik, uses a similar harp to teach songs to the Hero of Time.

Harp of Ages

A sacred instrument belonging to Nayru, the Oracle of Ages. Link can travel back and forth in time by playing three melodies.

The Wind Waker

The Wind Waker is a conductor's baton, used long ago to conduct the sages when performing songs to call on the goddesses. It once belonged to the king of Hyrule.

OTHER INSTRUMENTS

Other races and cultures in Hyrule have their own unique music and instruments. The Deku have their Deku Pipes; the Gorons, their Goron Drums; and the Zora, the Zora Guitar. In *Majora's Mask*, Link may don the masks of these three races in order to play their instruments.

SONGS & MELODIES

Link's Awakening

Link plays many melodies with an ocarina, as well as a special song to wake the Wind Fish with the eight Instruments of the Sirens.

♪ **Ballad of the Wind Fish**
A song to wake the sleeping Wind Fish.

♪ **Manbo's Mambo**
Enables Link to warp to Manbo's Pond, as well as to the entrance in dungeons.

♪ **Frog's Song of Soul**
This song breathes life into unliving things.

Ocarina of Time

Link plays a variety of powerful melodies with both the Fairy Ocarina and the Ocarina of Time. Playing certain songs triggers a variety of effects—as long as the musical scale matches.

♪ **Zelda's Lullaby**
A melody connected to the royal family.

♪ **Epona's Song**
A song to summon Epona.

♪ **Saria's Song**
A symbol of friendship between Link and his childhood Kokiri friend, Saria.

♪ **Sun's Song**
A song to reverse day and night.

♪ **Song of Storms**
Causes a downpour.

♪ **Scarecrow's Song**
An original composition the hero teaches to a scarecrow. Playing it in certain locations summons the scarecrow, which can be used as a Hookshot target.

♪ **Song of Time**
Opens the Door of Time.

♪ **Prelude of Light**
Warps the hero to the entrance of the Temple of Time.

♪ **Minuet of Forest**
Warps the hero to the entrance of the Forest Temple.

♪ **Bolero of Fire**
Warps the hero to the entrance of the Fire Temple.

♪ **Serenade of Water**
Warps the hero to the entrance of the Water Temple.

♪ **Nocturne of Shadow**
Warps the hero to the entrance of the Shadow Temple.

♪ **Requiem of Spirit**
Warps the hero to the entrance of the Spirit Temple.

Majora's Mask

Link uses both the Ocarina of Time and a trio of unique instruments when he dons the masks of a Goron, Deku, and Zora.

♪ **Song of Time**
Rewinds time, returning the hero to the dawn of the first day.

♪ **Inverted Song of Time**
Slows the speed at which time flows.

♪ **Song of Double Time**
Moves time forward in half-day increments (one day in the 3DS version).

♪ **Song of Healing**
Soothes the spirits of those who hear it.

♪ **Epona's Song**
A song to summon Epona.

♪ **Song of Soaring**
Enables the hero to warp to Owl Statues throughout the land.

♪ **Song of Storms**
Causes a downpour.

♪ **Sonata of Awakening**
A melody passed down among the Deku. It opens the entrance to Woodfall Temple.

♪ **Goron Lullaby**
A lullaby for Gorons. It opens the entrance to Snowhead Temple.

♪ **New Wave Bossa Nova**
A melody taught to Link by the Zora hatchlings. It awakens the Giant Turtle who guides him to the Great Bay Temple.

♪ **Elegy of Emptiness**
A song connected to the Ikana Kingdom. It solves puzzles in Stone Tower Temple and creates empty shells.

♪ **Oath to Order**
Summons the Giants.

♪ **Scarecrow's Song**
A song written by Link and taught to the scarecrow. Playing it in certain locations makes the scarecrow appear, where it acts as a Hookshot target.

OCARINAS & FLUTES

Some of the most memorable melodies ever heard in Hyrule were played on a flute or ocarina. These simple wind instruments make beautiful songs that hide great power between simple notes arranged just right.

Fairy Ocarina
Saria's ocarina, which she gives to Link.

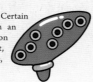

Ocarina
A type of ceramic flute. Certain melodies played on an ocarina can summon birds for transport, awaken sleeping beasts, and more.

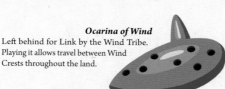

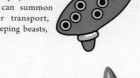

Ocarina of Wind
Left behind for Link by the Wind Tribe. Playing it allows travel between Wind Crests throughout the land.

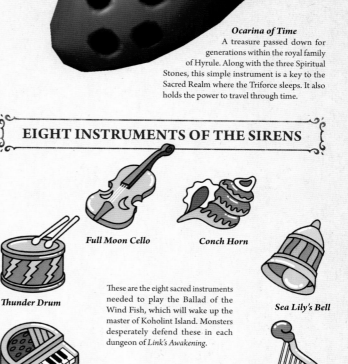

Ocarina of Time
A treasure passed down for generations within the royal family of Hyrule. Along with the three Spiritual Stones, this simple instrument is a key to the Sacred Realm where the Triforce sleeps. It also holds the power to travel through time.

Flute & Recorder
A cylindrical woodwind that can allow access to previously unaccessible areas or even warp its player across great distances.

Ricky's, Moosh's & Dimitri's Flutes
These flutes summon specific animal companions that aid Link on his quest in the *Oracle* series.

Horse Call
A hollow, ceramic pendant, shaped like a horseshoe. Much like a grass whistle, it calls horses when played.

Spirit Flute
This pan flute–like instrument, sacred to the Lokomo, is entrusted to Tetra under the condition that she and her ancestors use it to protect New Hyrule (page 40). Like other flutes and ocarinas, it makes manifest the powers of the goddesses when specific melodies are played.

EIGHT INSTRUMENTS OF THE SIRENS

Full Moon Cello

Conch Horn

Thunder Drum

These are the eight sacred instruments needed to play the Ballad of the Wind Fish, which will wake up the master of Koholint Island. Monsters desperately defend these in each dungeon of *Link's Awakening*.

Sea Lily's Bell

Organ of Evening Calm

Coral Triangle

Wind Marimba

Surf Harp

Oracle of Ages
Link plays a melody that allows him to travel between two eras of time using the Harp of Ages.

♪ **Tune of Echoes**
Awakens time portals and enables travel between the past and the present.

♪ **Tune of Currents**
Enables the hero to travel from the past to the present from any location.

♪ **Tune of Ages**
The ultimate tune that enables free movement between the past and the present.

The Wind Waker
By waving the Wind Waker wand in time with notes, Link is able to command the wind, awaken the sages, and change the time of day.

♪ **Wind's Requiem**
Changes the direction of the wind while sailing.

♪ **Ballad of Gales**
Enables the hero to warp to certain locations.

♪ **Command Melody**
Enables the hero to take control of certain characters and objects.

♪ **Earth God's Lyric**
Awakens the Rito Medli as the Sage of Earth.

♪ **Wind God's Aria**
Awakens the Korok Makar as the Sage of Wind.

♪ **Song of Passing**
Changes day to night and night to day.

Twilight Princess
By howling a memorized song in front of a Howling Stone, the Ancient Hero will appear to teach Link sword techniques.

♪ **Song of Healing**
The song howled at Death Mountain. Teaches Shield Attack.

♪ **Requiem of Spirit**
The song howled at Upper Zora's River stone. Teaches Back Slice.

♪ **Prelude of Light**
This song, howled in Faron Woods, teaches Link the Helm Splitter. Zelda's Lullaby is also howled in the Sacred Grove.

♪ **Unnamed Song 1**
Howled in Lake Hylia to teach Link Mortal Draw.

♪ **Unnamed Song 2**
Howled in Snowpeak to learn Jump Strike.

♪ **Twilight Princess (Main Theme)**
Howled in the Hidden Village to learn Great Spin.

Spirit Tracks
The Spirit Flute is moved left or right to play different notes. By playing certain melodies, the guardians of each land will restore rail lines.

♪ **Song of Awakening**
This song is able to wake a variety of sleeping things.

♪ **Song of Healing**
This song restores health. It can only be used once in each dungeon.

♪ **Song of Birds**
Summons nearby birds.

♪ **Song of Light**
Activates crystal switches.

♪ **Song of Discovery**
Reveals treasure chests buried in the ground.

♪ **Song of Restoration**
A song with sacred power, played as a duet with the Lokomo guardians.

Skyward Sword
Songs played on the Goddess's Harp in *Skyward Sword* grant passage to the Silent Realm in various regions. Link can also use it to play along with Kina's singing at the Lumpy Pumpkin.

♪ **Ballad of the Goddess**
Reveals the way to the Isle of Songs.

♪ **Farore's Courage**
Opens the way into the Silent Realm in Faron Woods.

♪ **Din's Power**
Opens the way into the Silent Realm in Eldin Volcano.

♪ **Nayru's Wisdom**
Opens the way into the Silent Realm in Lanayru Desert.

♪ **Song of the Hero**
Opens the way into the Silent Realm in Skyloft.

MONSTERS & DEMONS

For all the good created by the goddesses, there also exists a great darkness. Demons, born from the source of all evil, and monsters under the influence of dark magic, sow turmoil and bring destruction in Hyrule and its parallel worlds.

Demons desire to wrest control of the world away from those who would see it prosper—and have proven a significant threat to Hyrule and its people. Ganondorf, by his own will, became a Demon King, in order to obtain absolute power that would surpass even the goddesses', and he is not the only one with such objectives.

Beyond those who willfully serve evil are monsters corrupted by it. These may be animals or plants, or even inorganic objects manipulated in some way by darkness. While monsters may pose a formidable threat, defeated monsters may be used to create armor or medicine that ultimately helps people.

In some eras, the terms "demon" and "monster" have been used interchangeably, but in general, demons command and create evil, while monsters do its bidding.

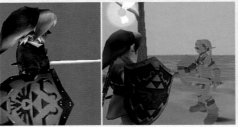

Summoning or reviving especially powerful demons requires a suitable ritual.

Dark Link is the evil reflection of a hero.

Batreaux is a friendly demon who wants to be mortal.

MONSTERS OF MANY KINDS

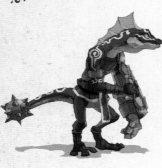

BEASTS, BIRDS & REPTILES

Most monsters are animals that have been corrupted. Moblins, crows, and Lizalfos will stalk forests, plains, and mountainsides attacking all who approach. Some do so with little purpose, while others, like Moblins and Lizalfos, are well trained and organized, like soldiers.

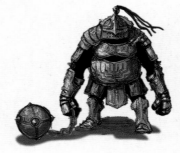

SOLDIERS & POSSESSED ARMOR

When Hylians and other races are corrupted by evil, those trained and equipped to fight prove especially dangerous. Evil spirits may also don armor without a living being inside. In some cases, it is a sacred armor, entrusted with guarding a temple, that becomes infested with evil. These soldiers and armored enemies are often specialists with a particular weapon, such as a ball and chain, which makes stopping them a formidable challenge.

PLANTS & INSECTS

The darker the world gets, the more its living things are corrupted. Plants and insects found in nature are just as susceptible to corruption as any animal. Examples include carnivorous Deku Babas and Skulltulas.

SOFT-BODIED & GELATINOUS MONSTERS

Often Link may encounter bizarre monsters that are neither plant nor animal. Some are little more than blobs or goo, while others have tentacles and are almost squid-like. Examples of these monsters include Slimes, the jelly-like Chuchus, and Like Likes.

SKELETONS, GHOSTS & CORPSES

It's said that the souls of spirits holding on to regrets when they die turn into Poes, cursed to haunt the land of the living. Dead soldiers may similarly be resurrected as the skeletal Stalfos, while Gibdos are walking mummies. Some undead possess the ability to curse those who get near them.

INORGANICS & MACHINES

Beyond the living and undead are the inanimate, possessed by evil spirits all the same and rising up as monsters of rock, earth, ice, or flame. Just as empty armor comes to life at the hands of a demon, other inorganic objects like statues and robots may also be possessed.

THE ORIGIN OF EVIL

Evil originated in ancient times, emerging from great fissures in the earth. Demons crawled up, led by the powerful Demise, carrying with them an evil in direct opposition to everything the goddesses had created. The world falling into the hands of evil would mean its destruction.

It was the goddess Hylia who sealed Demise away, but she knew the seal would not hold forever against his fearsome might. She gave up her divinity so that she might be reborn when the seal broke, and created Fi to find the chosen hero to tip the scales toward good and light. They succeeded in destroying Demise with the power of the Triforce, but his hatred and malice toward the blood of the goddess Hylia and soul of the hero became a curse that would repeat itself for all eternity.

A CYCLE OF HATRED

Demise's soul was sealed in the Master Sword and left to slowly decay, but his curse persists.

Evil finds champions in the Wind Mage Vaati, as well as the Lokomo demon Malladus, but no threat has been as persistent as the power-thirsty Ganondorf.

The sages sealing Ganondorf away (page 24) in *Ocarina of Time* is only the beginning of a cycle of evil that endures for eras. The Demon King revives repeatedly throughout history across all timelines.

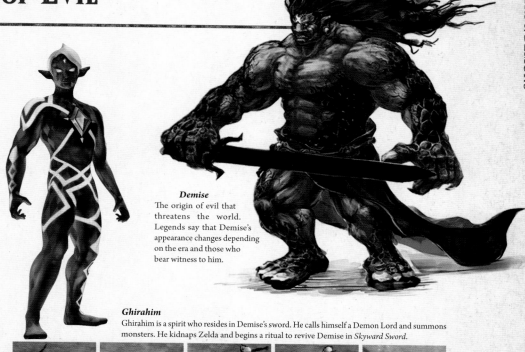

Demise
The origin of evil that threatens the world. Legends say that Demise's appearance changes depending on the era and those who bear witness to him.

Ghirahim
Ghirahim is a spirit who resides in Demise's sword. He calls himself a Demon Lord and summons monsters. He kidnaps Zelda and begins a ritual to revive Demise in *Skyward Sword*.

Ganondorf, sealed by the sages in Ocarina of Time. *His hatred of Zelda and Link, coupled with his strong will and command of the Triforce of Power, guarantees his return, thus repeating the curse of evil.*

THOSE WHO COVET MAGICAL POWER

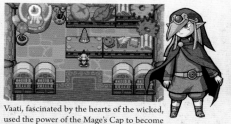

Vaati, fascinated by the hearts of the wicked, used the power of the Mage's Cap to become a demon in *The Minish Cap*. He was originally Minish, and is resurrected in *Four Swords Adventures*.

Byrne, from *Spirit Tracks*. He was originally an apprentice of Anjean, the Lokomo sage. Byrne desires power that would surpass the goddesses, and supports the revival of the Demon King Malladus.

BLINS

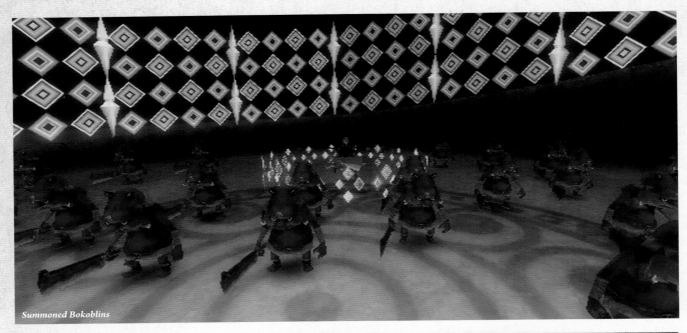

Summoned Bokoblins

Blins are demonic creatures who have existed since ancient times. They are great in numbers—greater in eras where a Demon Lord or Demon King rises or reigns—obeying those demons who wield the most power.

Blins tend to be a violent, simple sort who are quickly aggressive with just about any living thing they encounter. There are multiple kinds of Blins, starting with the smallest Miniblins, and moving up through the stronger Moblins and Big Blins.

They live and travel in groups, and follow the orders of the powerful among them.

In eras with powerful demons to lead them, they are much more active—created in especially large numbers by the Demon Lord Ghirahim and used as foot soldiers by the Demon King Ganondorf to take control of Hyrule.

A COMMUNAL LIFE

Bokoblins are dispatched to designated areas, where they build enclosed fences and watchtowers to keep lookout, sustaining themselves with rich foods cooked over fires.

They use a variety of weapons, including clubs, spears, swords, and bows. Meat eaters, Blins will hunt and attack Hylians, animals, and lesser monsters for food.

Different Blins roam Hyrule depending on the era, like forest-dwelling Moblins and Bulblins that ride boar-like Bullbo monsters.

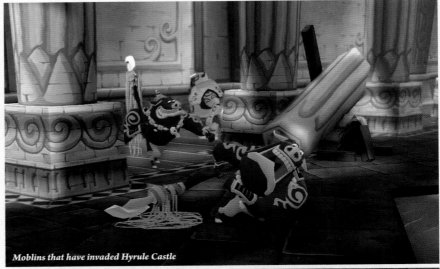

Moblins that have invaded Hyrule Castle

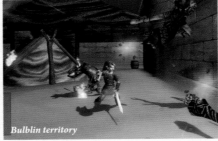

Bulblin territory

Bulblin food

Bulblins charging on Bullbos

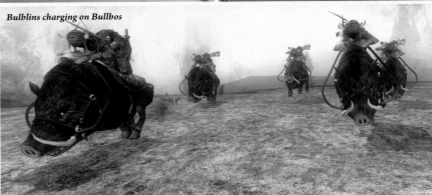

HISTORY OF THE BLINS

Ghirahim, to support the revival of Demise, creates nearly limitless Bokoblins. There is a diversity of types equipped to best suit their environments, from simple Bokoblins to enormous Moblins.

Bokoblin

Moblin

Technoblin

Cursed Bokoblin

➜ *Skyward Sword*

The Forest Temple, deep in the Lost Woods, is cursed by Ganon. Moblins and Club Moblins defend against intruders.

Moblin

Club Moblin

➜ *Ocarina of Time*

Moblins stalk the Dark World in service of the Demon King Ganon. Similar Moblins are also found in Lorule.

Moblin

Moblin

In parallel worlds, there are Blins known as Pig Warriors. In Labrynna and Holodrum, a Great Moblin sets up a keep.

Moblin

Great Moblin

➜ *A Link to the Past*
➜ *Link's Awakening*
➜ *Oracle series*
➜ *A Link Between Worlds*
➜ *Tri Force Heroes*

With Hyrule beneath the waves, smaller Miniblins thrive on the small islands that remain. The number of Bokoblins operating at sea also increases. The large-bodied Moblins are tasked with securing Ganon's base of operations, the Forsaken Fortress.

Miniblin

Bokoblin

Moblin

➜ *The Wind Waker*

Blins appear in great numbers almost instantly in the Twilight Era, stalking Hyrule as pawns of Ganon. They are led by King Bulblin and are among the most common enemies Link faces in this era. Many ride into battle on Bullbos.

Bulblin

King Bulblin

➜ *Twilight Princess*

In the Era of the Great Voyage, Miniblins move onto the open seas, acting as pirates and stalking sailors.

Miniblin *Miniblin*

➜ *Phantom Hourglass*

Moblins are always plotting the revival of the Demon King Ganon, hoping he will usher in a world ruled by demons. As Hylians look up to Link, Blins follow and even idolize Ganon and Demon Kings like him.

Moblin

Moblin

➜ *The Legend of Zelda* ➜ *The Adventure of Link*

As the land of the Lokomo fears the revival of the Demon King Malladus, Bulblins grow in number and engage in rampant thievery together with Big Blins.

Bulblin

Big Blin

➜ *Spirit Tracks*

STALS

The Stalfos skeleton soldiers who attack inside labyrinths are often soldiers who lost their lives in battle. This is different from Poes, which are spirits that become monsters due to a lingering attachment to the world of the living.

Though little more than bones, Stalfos are still soldiers. They often carry swords and shields, clubs, and other weapons and armor. There are some who maintain a kind of consciousness, even in death, throwing themselves into battle willfully and skillfully; others mindlessly attack whatever target is in front of them. Even if their skeletons are broken apart and their bones are scattered, Stalfos can often regenerate and will keep moving until they are outright shattered.

It is said that when children lose their way in the Lost Woods beyond the Kokiri Forest (page 50), they become Skull Kids, while adults will become Stalfos.

If a monster carries the name "Stal," it is undead and often little more than shambling bones. Skulls floating detached from any body are known simply as Stals, while those with bodies come in many forms, from Staltroops to Stalchildren.

TACTICS & WEAPONS

It is hard to kill something that is already dead. Even when only a skull, Stalfos and other corpses may continue to move and even attack.

If they do have a body, they may wield a variety of weapons. Without a weapon, they still find ways to fight, using their own bones or head as projectiles.

Stal

 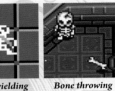

Sword & shield *Dual wielding* *Bone throwing* *Head throwing*

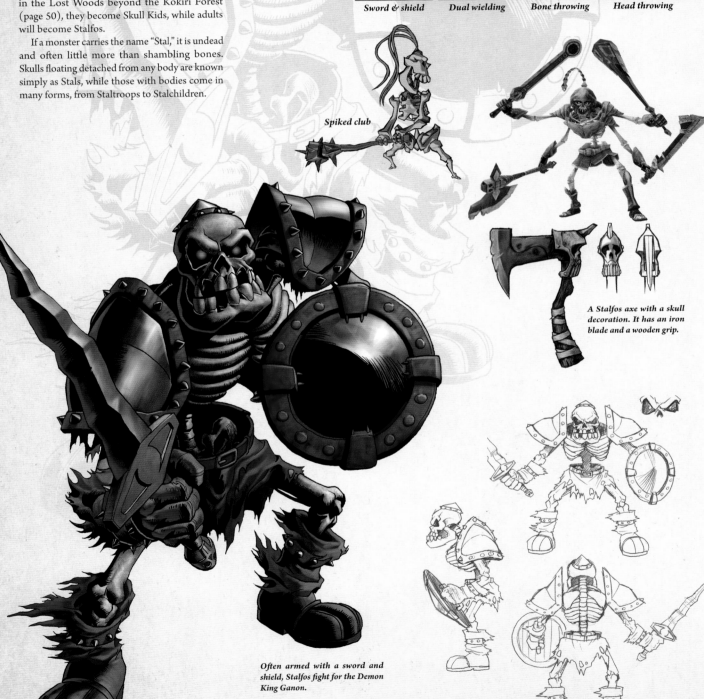

Spiked club

A Stalfos axe with a skull decoration. It has an iron blade and a wooden grip.

Often armed with a sword and shield, Stalfos fight for the Demon King Ganon.

VARIOUS STALFOS

The Stalfos that haunt Hyrule come in many shapes and sizes. A Stalchild is a smaller Stalfos, while Big Dark Stalfos are significantly larger. At times, their equipment may hint at who they were in life. The Staltroops from *Twilight Princess* are former Hylian soldiers. The latter corpses are not actually corrupted but instead under the control of the Stallord.

When a wizard returns, they often become Wizzrobes. Rarely, like in the case of the Blue Stalfos, you will see a Stalfos using magic.

Stalfos

Parutamu

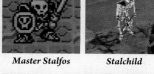

Master Stalfos

Stalchild

Staltroop

Stalfos

Big Dark Stalfos

Blue Stalfos

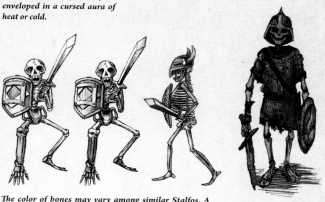

A skeleton monster known as a Bubble. Sprouting wings and flying about, they are often enveloped in a cursed aura of heat or cold.

The color of bones may vary among similar Stalfos. A Parutamu is a Stalfos that wears a helmet and is especially proficient in combat.

A common soldier, turned into a Staltroop after death. It has almost no consciousness.

STALFOS OF NOTE

Some Stalfos are still very much conscious after being revived. They may retain the personalities or even duties they held in life, despite being little more than bleached bones. This is particularly true of the resurrected king and soldiers of the cursed Ikana Kingdom, found in the Ikana Province of the parallel world Termina.

Even the Hero of Time becomes a skeleton warrior. As the Hero's Spirit, he eagerly awaits the appearance of a living hero to whom he can pass on his techniques.

Captain Keeta

King Ikana

Stalchampion

Hero's Spirit

Captain Keeta is a former soldier in the Ikana Kingdom army. Deeply trusted by the king and his subordinates, even in death he commands their loyalty. Compared to the Stalchildren under his command, he is extremely large.

Even legendary heroes must die. Regretting not having the chance to pass on his wisdom or share his heroics with the world, a remnant of the Hero of Time's eternal soul remained behind and appears as a titan of bones and armor in Twilight Princess. Even in this form, his heroic soul retains its luster, taking the form of a golden wolf (page 31).

SKELETAL BEASTS & MONSTERS

There are instances where beasts and even ancient monsters become skeletal creatures much like Hylians become Stalfos. Skullropes, Skullfish, and even Stalhounds are bony versions of once-living creatures.

It should be noted that while Skulltulas and Walltulas appear to fit this description, they are similar in appearance alone, having markings on their backs that resemble skulls.

Bagobago

Skullfish

Stalhound

Skullrope

Staldra

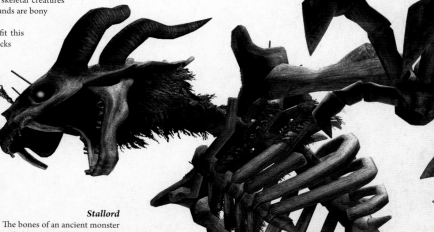

Stallord
The bones of an ancient monster sealed in the Arbiter's Grounds. Granted magical power by Zant, it goes on the rampage using Staltroops as shields.

OCTOS

Octos are monsters that spit rocks and often resemble octopuses. Of all the monsters in Hyrule and beyond, Octos come in the most varieties by far. Many live in water, while others walk on land. Some are very large, while others more closely resemble squids. Common Octoroks don't attack without provocation; they spit rocks if someone gets too near as a means of self-defense.

Octos are so ubiquitous that few fear them. Some may even end up as targets in shooting galleries.

In Lorule, humans and an Octorok run a minigame together called "Octoball Derby."

Big Octo
This especially big Octo's head is elongated, giving it the appearance of a giant squid.

Big Octorok
Since Link has shrunk in *The Minish Cap*, this normal Octorok only appears big.

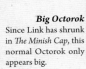

Morpheel
Though it has eight tentacles like some Octos, the Morpheel also resembles an eel.

OCTOROK VARIATIONS

An Octorok may be red, blue, or purple. It may have a plant on its head, walk on land, or even make its home in desert sand. While an Octorok may be many things over the eras, one thing never changes: it is always an octopus-like monster that shoots rocks from its mouth.

Skyward Sword

The Minish Cap

Four Swords

Ocarina of Time

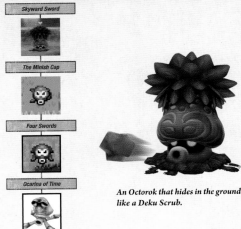

An Octorok that hides in the ground like a Deku Scrub.

A Link to the Past

Link's Awakening

Oracle series

A Link Between Worlds

Tri Force Heroes

The Legend of Zelda

The Adventure of Link

Majora's Mask

Twilight Princess

Four Swords Adventures

Purple Octoroks also appear in *Four Swords Adventures* as well, and are particularly aggressive.

The Wind Waker

Phantom Hourglass

Spirit Tracks

Octorok appearances and even names vary depending on where they are found.

An Octorok with sharp fangs.

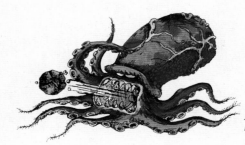

LAND OCTOROKS

Among the many variations of Octoroks are those uniquely suited to life on land. These include Octoballoons, Flying Octoroks, and even the desert-dwelling Ergtoroks.

Octorok Octoballoon Flying Octorok Ergtorok

SEA OCTOROKS

Octoroks that live in bodies of water tend to have longer tentacles than those found on land. Some may live in deeper waters, like the Ocean Octorok or Octomine. The latter is an especially dangerous creature that will explode on contact.

Octorok Ocean Octorok Ocean Octorok Octomine

CHUCHUS

A Chuchu is a jelly-like monster often depicted with big, blank eyes. They come in many colors. Some are simple jelly. Others are more complex creatures that may even don armor.

When defeated, Chuchus may leave a colorful glob of slime in their wake. This is called Chu Jelly, and it can be scooped into bottles and consumed, or used as an ingredient in potions. Some types make for a nourishing ingredient and are useful for recovering health and magical power. Types without effects do no harm but do not taste good, so there is no point in drinking them.

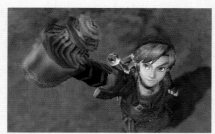

Twilight Princess
Scooping up Chu Jelly with a bottle. Rare Chu Jelly, obtained from Chuchu known as Rare Chus, is very valuable. Green Chu Jelly is also rare, obtained by merging blue and yellow together, but unfortunately it does not do much.

UNIQUE CHUCHUS

Chuchus come in a variety of colors, while some possess unique abilities. Rare Chuchus may turn into spikes to protect themselves, or even transform into metal or ice.

Spiny Chuchu

Ice Chuchu

Metal Chuchu

APPEARANCE

Having a body made of jelly has a way of leaving some Chuchus feeling vulnerable. They may don rocks or other armor in order to shield themselves from attack.

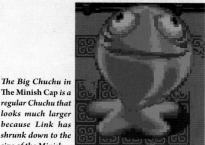

The Big Chuchu in The Minish Cap is a regular Chuchu that looks much larger because Link has shrunk down to the size of the Minish.

Big Chuchu

Rock Chuchu

Helmet Chuchu

CHUCHUS BY TYPE & TITLE

Chuchus generally come in four colors: red, green, blue, and yellow. There are rarer variants, such as the Purple Chus of *Twilight Princess* and the Dark Chuchus of *The Wind Waker*. Even Chuchus of the same color may appear quite different depending on the era.

	Majora's Mask	The Wind Waker	The Minish Cap	Twilight Princess	Phantom Hourglass	Spirit Tracks	Skyward Sword
Red	Red Chuchu	Red Chuchu	Red Chuchu	Red Chu	Red Chuchu	Red Chuchu	Red Chuchu
Green	Green Chuchu	Green Chuchu	Green Chuchu	Green Chu	Green Chuchu		Green Chuchu
Blue	Blue Chuchu	Blue Chuchu	Blue Chuchu	Blue Chu	Blue Chuchu		Blue Chuchu
Yellow	Yellow Chuchu	Yellow Chuchu		Yellow Chu	Yellow Chuchu	Yellow Chuchu	Yellow Chuchu
Purple				Purple Chu			
Dark		Dark Chuchu					
Rare				Rare Chu			

Twilight Princess
The colors of the Chuchus in *Twilight Princess* combine. Blue and yellow make green, and red and green make purple.

Majora's Mask
Chuchus in the parallel world of Termina are transparent, making it possible to see items they carry inside their bodies. Their tint changes in response. If they are carrying a heart, they are red; if they carry a magic jar, they turn green.

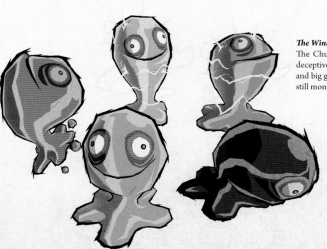

The Wind Waker
The Chuchus of *The Wind Waker* are deceptively cute, with giant round eyes and big grins. Don't be fooled. They are still monsters.

Skyward Sword
Chuchus date back to ancient eras. This one, from *Skyward Sword*, is round and red, with a massive, gaping mouth.

What follows is a comprehensive guide to key locations, items, and enemies found across every canon release in the *Legend of Zelda* series up to *Tri Force Heroes*.

Towns and dungeons in this database are grouped by release, while items and enemies are listed alphabetically. Names and details found in primary sources like the games and their manuals have been prioritized, while strategy guides and other official publications have been used to fill in the blanks (page 215). Where more than one term for a particular enemy or item is used over multiple publications or releases, the term that appears most often takes precedence.

While the initial authors largely referenced the Japanese versions of published materials, the information has been checked against English-language sources for the purposes of this translated edition.

Database

An Alphabetical Archive
of Information

TOWNS & VILLAGES

The towns and villages of Hyrule are essential hubs for those who seek refuge from the world's wilder corners—or just a good night's rest. Townspeople have a way of trading in information as well as useful items and equipment, with the information often supplied just for bothering to stop and talk. Link can learn an awful lot about a region or its people by visiting a village.

In this section, the towns, villages, and other places where people gather or live are listed in the order that the hero visits them in the story and the chronological release of the video games. Dungeons and areas occupied by enemies are omitted and included elsewhere. However, areas abandoned due to siege or periods of recession do appear here wherever relevant.

OCARINA OF TIME / 3D [1]

Beyond bustling Hyrule Castle Town and the peace of Kakariko Village, everyone from the Gerudo and Zora to the Kokiri and Gorons call their own towns and villages home. When Ganondorf takes control of Hyrule Castle, it ushers in a period of great turmoil; many towns that had been peaceful were shrouded in darkness.

▶ **Kokiri Forest** [3]

[4]

A mysterious forest where the Kokiri and fairies reside. The ancient Great Deku Tree watches over the Kokiri people. Beyond their woodland village are the Lost [5], Sacred Grove, and Forest Temple. In the Hero of Time's adult years, the forest is infested with monsters.

[1] **GAME TITLE**
Rereleases are included with the original titles.
[2] **ERA DESCRIPTION**
[3] **TOWN NAME**
[4] **SCREENSHOTS**
Images from both the original and rereleases are included.
[5] **TOWN DESCRIPTION**

THE LEGEND OF ZELDA

The kingdom of Hyrule still exists in this Era of Decline, a fraction of its former glory, but Link does not visit the castle or any towns during this particular adventure, only the wilds and dungeons of Hyrule. Any people he meets live in caves, forced into hiding by monsters.

THE ADVENTURE OF LINK

As the Era of Decline persists, towns and villages dot the expansive Eastern and Western Continents far beyond the diminished kingdom of Hyrule. In each hub, Link can learn magic from elders and receive advice from townspeople. Several of the sages in *Ocarina of Time* share their names with these towns.

▶ **Rauru Town**

A town nestled in a verdant forest. Link learns Shield, his first spell in this adventure, from the old man living here. A large boulder blocks the road leading south.

▶ **Ruto Town**

Ruto is surrounded by mountains. Taking back the trophy that was stolen by a Goriya unlocks the ability to learn Jump magic from an old man here. Without this ability, it is not possible to progress through the cave beyond Ruto.

▶ **Saria Town**

A town divided into north and south by a river. Returning a woman's lost mirror in Saria Town allows Link to learn the Life spell. Monsters disguised as Hylians lurk here.

▶ **Mido Town**

Mido is a port town on the eastern edge of the Western Continent. There is a conspicuously tall church in Mido Town, inside which Link can learn the Downthrust move from a swordsman. Giving the Water of Life to a woman with a sick daughter here also allows Link to learn the Fairy spell.

▶ **Nabooru Town**

After he crosses the sea on a raft, this town is the first that Link visits on the Eastern Continent. When Link collects water from the fountain and gives it to a thirsty woman in Nabooru Town, she will unlock a house where an old man teaches the secrets of Fire magic.

Darunia Town

A mountain town situated just past a narrow route through the mountains on the Eastern Continent. Link can learn the Jump Thrust move in the swordsman's house, which can only be accessed by a chimney. Saving a child from Maze Island allows Link to learn the Reflect spell.

Kasuto

A new town established by people who fled Old Kasuto when it was attacked by monsters. It lies hidden in a forested area beyond Old Kasuto. Link must knock down a tree with the Hammer to find it. A mysterious spell known only as "Spell" that opens doors and turns enemies into jellied Bots can be learned from an old man found behind a fireplace here.

Old Kasuto

A town full of buildings abandoned after its people fled a siege by monsters. These usually invisible monsters now roam Old Kasuto, rendering passage through the town treacherous. One old man stayed behind and teaches Link Thunder magic.

A LINK TO THE PAST

The decline of Hyrule as a result of the Imprisoning War means only one village in both the Light and Dark Worlds remains. Hyrule Castle still stands, but without much in the way of a town around it. Braver folk have set out on their own in this era, building homes along rural paths that stretch to all corners of the map, but most live in the village.

Kakariko Village

West of Hyrule Castle lies a modest settlement where people of simple means raise cuccos and sell goods. The village was home to Sahasrahla, descendant of one of the Seven Sages of the Hero of Time's era, but, according to his grandson, he has gone into hiding due to "bad people." After Princess Zelda escapes Hyrule Castle, soldiers under Agahnim's command patrol the village, searching for her and the one who freed her. It is said that the thief Blind once had a domicile here as well.

Village of Outcasts

In the Dark World, Kakariko Village becomes the Village of Outcasts. Pickpockets target anyone who happens to wander into town, but there are places here to win rupees through games as well. At its center is Thieves' Town, where ne'er-do-wells operate under the leadership of Blind, a legendary thief from the Light World who wandered into the Dark World and became a demon.

LINK'S AWAKENING / DX

The entirety of *Link's Awakening* plays out on Koholint Island, later revealed to exist only inside the dream of the Wind Fish. A relative paradise but still with its share of danger, the island has one Hylian village and another populated by animals and Zora. Outside these hubs, shops like the health spa, as well as phone booths, are scattered inland.

Mabe Village

The sole Hylian village on Koholint Island. A weather-vane stands as a landmark in the center of the village. There's also a tool shop, a library, and entertainment facilities. The village is near the ocean, and leaving it leads straight to the beach.

Animal Village

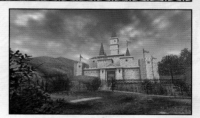

Animals have made their home in a village on the southeast corner of the island. Most animals in the village can speak, and they seem to get along well with the residents of Mabe. One Zora also lives here in secret.

OCARINA OF TIME / 3D

Beyond bustling Hyrule Castle Town and the peace of Kakariko Village, everyone from the Gerudo and Zora to the Kokiri and Gorons call their own towns and villages home. When Ganondorf takes control of Hyrule Castle, it ushers in a period of great turmoil; many towns that had been peaceful are shrouded in darkness.

Kokiri Forest

A mysterious forest where the Kokiri and fairies reside. The ancient Great Deku Tree watches over the Kokiri people. Beyond their woodland village are the Lost Woods, Sacred Grove, and Forest Temple. In the Hero of Time's adult years, the forest is infested with monsters.

Hyrule Castle & Castle Town

Castle Town thrives in the Hero of Time's youth. Merchants and travelers come from all over to trade and be entertained, while a great many call its cobblestone streets home. The Temple of Time lies just outside, a sanctuary for the weary and faithful. When Hyrule Castle falls under the control of Ganondorf and Castle Town is overrun with ReDead, most of its residents flee to Kakariko Village.

▷ Kakariko Village

Before it was opened up to outsiders looking for a safe place to call home, Kakariko Village was the domain of the secretive Sheikah. A large windmill is immediately identifiable as you enter the village. There is a path leading from the village to Death Mountain, as well as a path to the graveyard. When the Hero of Time is an adult, Kakariko is full of people who flee Castle Town amid Ganondorf's rise.

▷ Goron City

The Gorons built their city in sacred Death Mountain, carving out a labyrinth of passages deep within the rock. Among its already burly residents are the massive Medigoron and Biggoron. When Link is an adult, the city is all but deserted, and the Gorons are captured to be food for the ancient dragon Volvagia that lurks in the mountain's volcanic core.

▷ Zora's Domain

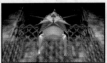

Zora's Domain is hidden at the base of Death Mountain, where the noble Zora protect the source of the kingdom's water. Pure water and energy flow freely here. Just beyond is Zora's Fountain, where Lord Jabu-Jabu lives and is worshiped as a guardian deity. As an adult, Link returns to find that the Zora and their domain are frozen in ice.

▷ Gerudo's Fortress

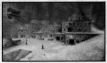

At the arid western edge of Hyrule Field, pinned between dangerous mountains and a desert, is a fortress inhabited by the Gerudo. The women warriors of the valley keep a strict watch here. Only those with their permission may travel beyond the fortress to the Haunted Wasteland and Desert Colossus still farther west.

MAJORA'S MASK / 3D

Majora's Mask takes place in the parallel world of Termina. Split into four regions, with Clock Town at its center, Termina is home to multiple villages where Hylians and other races live. Termina's regions are plagued by natural calamities, said to be omens

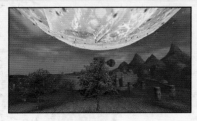

of an impending destruction by the moon, set to come crashing down in three days' time.

▷ Clock Town

A clock tower looms large over Clock Town, located in the middle of Termina Field. Residents here prepare for the Carnival of Time, a festival taking place in three days where they will pray to the gods of the four regions for a bountiful harvest.

▷ Deku Palace

Deku Palace, built from trees and other plants, occupies a corner of the swamp in Woodfall to the south of Clock Town. Entry is forbidden to all but the Deku, who are suffering from a poison that flows from Woodfall Temple, polluting the swamp.

▷ Goron Village

The Gorons of Termina live in a village high in the mountainous Snowhead region, north of Clock Town. Many call the Goron Shrine here home. A blizzard raging from Snowhead Temple means spring cannot come and the Gorons are on the verge of freezing to death.

▷ Zora Hall

The Zora of Termina live in a village on the sea in the Great Bay region, along the coast west of Clock Town. There is a large concert hall where the Zora band the Indigo-Go's perform. A mysterious murkiness has appeared in the sea amid rising water temperatures.

▷ Ikana Canyon

To the east of Clock Town is a canyon where the Ikana Kingdom once flourished. After the Stone Tower gate was opened, the region was overrun by the dead, and the people of Ikana Village fled. When Link reaches the canyon, the only people who live there are a girl named Pamela and her father, a paranormal researcher.

ORACLE OF SEASONS

A trial of the Triforce leads Link to the vibrant land of Holodrum. Its four seasons, normally in balance, are corrupted by General Onox and alternate far too rapidly. Somehow its people endure; just like the ever-sleepy Maku Tree, they remain gentle even in the wickedest storms.

▷ Horon Village

The Maku Tree, protector of Holodrum, is found in Horon Village, a central hub of Holodrum where important shops like Vasu Jewelers and the aptly named Horon Village Shop do business. Unlike in the rest of Holodrum, the seasons change without needing the Rod of Seasons here.

▷ Sunken City

A city flooded by melting ice from Mt. Cucco. Link must prove to a Master Diver that he is worthy in order to receive Zora's Flippers and dive into deep water. In the winter, Link can climb a snowdrift south of the city to buy potions from Syrup, the witch.

▷ Subrosia Village

A village in Subrosia accessible from warp zones in various regions of Holodrum. The secretive Subrosian people live here, deep underground where molten magma generates intense heat. Onox forces the Temple of Seasons to sink into Subrosia and Link must enter it to retrieve the Rod of Seasons.

ORACLE OF AGES

Labrynna, a land where people, animals, and fairies live in peace, is thrown into chaos when the Sorceress of Shadows, Veran, alters the past. The towns and villages of Labrynna are drastically changed in the present by Veran's actions in the past. Link must correct the flow of time in order to defeat Veran and return peace to the people of present-day Labrynna.

▷ Lynna City

The first city Link visits and a central hub for Labrynna. The Maku Tree grows north of the city, while the Black Tower looms in the southern reaches.

▷ Lynna Village

Centuries before Lynna was a city, it was a village ruled by a queen named Ambi. When Link visits the village, Queen Ambi is in the process of building a giant tower south of the village to guide her love home from the sea. Veran manipulates time to bring perpetual daylight and tricks Ambi into forcing her subjects to work on the tower ceaselessly.

▷ Zora Village

Link cannot enter the Zora Village in Labrynna without a Mermaid Suit. Ruled by generations of King Zoras, their guardian deity Lord Jabu-Jabu resides deep within; inside its stomach lies the Rolling Sea, an Essence of Time.

▷ Symmetry Village

 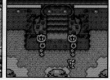

A village that mirrors itself, right down to its twin residents. Present-day Symmetry is abandoned and nearly destroyed when the village's sacred Tuni Nut is cracked, causing a volcano to erupt. Link restores the Tuni Nut, quieting the volcano and restoring the present Symmetry City.

▷ Ambi's Palace

The palace of Queen Ambi in Lynna Village is tightly guarded and Link must sneak past both guards and traps in the garden to enter. On the veranda in the back is the possessed Nayru.

THE WIND WAKER / HD

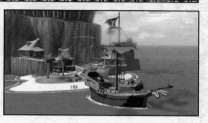

More than forty islands dot the expansive Great Sea, but settlements are limited to only a few. Many islands are strictly the domain of monsters, while pirates plague the waters in between. With few ways for the far-flung island communities of this era to keep in touch, most rely on mail delivered by the flying Rito.

▷ Outset Island

Located in the southwest and boasting beautiful beaches, Outset Island is a sparsely populated paradise where Link lives with his grandmother and his younger sister, Aryll. Inland, a forest grows above the island's high cliffs where a Great Fairy is said to reside, while a watchtower on the beach looks out over the sea for any trouble that may sail in.

▷ Windfall Island

To the north is Windfall Island, the most populated island in *The Wind Waker*. Windfall has a potion shop, a school, and a bar, among other amenities, as well as a giant windmill that turns at the center of town. Nightly auctions are held in the Hall of Wealth, where bidders can win everything from a pendant to a Piece of Heart.

▷ Dragon Roost Island

An island in the northeast protected by the spirit Valoo. The winged Rito have a village here. The heart of Dragon Roost is an enormous volcano and lava flows to a shrine where Valoo is perched. Letters sent from every which way across the sea are collected in the Rito village at the foot of the mountain. They are piled up everywhere.

FOUR SWORDS

Although the kingdom of Hyrule has bustling towns and villages during this era, Link only visits enemy-infested dungeons in *Four Swords*.

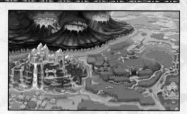

FOUR SWORDS ADVENTURES

Link visits four villages over the course of *Four Swords Adventures* in the Shadow Era. Though typically villages offer a reprieve from the dangers of greater Hyrule, hubs of this era are wrought with peril as Vaati's influence spreads.

▷ Village of the Blue Maiden

Children have been disappearing from the Village of the Blue Maiden, trapped in the Dark World, and the local Seeker's Guild investigates whether the disappearances could be connected to the arrival of mages in the village. Using a Moon Pearl will open a portal to the Dark World. This village appears in the second level of the game, "Eastern Hyrule."

▷ Kakariko Village

The once peaceful Kakariko Village is shrouded in darkness with Vaati's revival, causing its residents to lose themselves and rendering the village a dangerous place. Thieves rampage through the village with a network of hideouts underfoot. This village appears in the fifth level of the game, "The Dark World."

▷ Gerudo Village

Ganondorf's desert hometown is inhabited by the Gerudo, a tribe of women who guard ancient ruins and a sacred temple deep in the desert. This village appears in the sixth level of the game, "Desert of Doubt."

▷ Zuna Village

This oasis town in the desert, difficult to reach because of sandstorms, is inhabited by the remnants of the Zuna tribe, who built the pyramid where a dark power sleeps and pass down its legends. This village also appears in the sixth level of the game.

THE MINISH CAP

Hyrule's Castle Town is the only Hylian village that appears in *The Minish Cap*. But when Link shrinks down to the size of the sprite-like Minish people, he travels to all manner of tiny settlements, including a village in the forest and another in the mountains.

▷ Hyrule Town

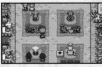 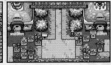 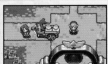

The town beyond the walls of Hyrule Castle bustles with activity as residents prepare for the annual Picori Festival, celebrating the Minish, which they call "Picori." A giant bell stands in the center of a town packed with amenities. Rows of stalls sell fruit and useful items, while other shops sell baked goods, coffee, and more. For those with the rupees to spare, Simon's Simulations offers a spooky challenge, while the Figurine Shop trades Mysterious Shells for the chance to win small statues of key figures Link meets throughout his adventure.

▷ Minish Village

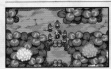

Hidden away deep in the southeastern tip of the Minish Woods is a village where forest Minish live. Using Ezlo's power, Link shrinks down and enters using a narrow passage inaccessible at Hylian size. The whole village is covered in flowers, and houses are made of Hylian shoes, books, and barrels.

TWILIGHT PRINCESS / HD

The four provinces of this era are named for the Light Spirits said to guard the land expanding out from Hyrule Castle and Castle Town. A rift between classes is increasingly apparent, as the affluent Castle Town thrives, walled

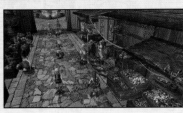

away from the self-sustaining agricultural communities who wrestle with declining populations farther afield. Monsters and beasts live in the more remote corners of Hyrule, where few dare to tread, let alone put down roots.

▷ Ordon Village

Located at the southern edge of the kingdom, just past Ordon Woods in Ordona Province, Ordon Village is a small agricultural community with a relaxed pace, famous for its pumpkins and goat milk. Crops are grown and goats are kept within the village proper.

▷ Kakariko Village

A village in the Eldin Province to the east of Castle Town at the foot of Death Mountain. Kakariko Village was once a thriving rural hub that enjoyed a friendly relationship with the Gorons up the mountain. The village has been all but deserted in the Twilight Era, with many residents turned into Shadow Beasts. Rows of quaint houses and buildings have fallen into disrepair, including a church and a hotel with open-air baths on the roof.

▷ Death Mountain

Geysers erupt throughout the Goron village on Death Mountain. A massive hot spring with a small shop partway up the mountain trail is a popular spot for the Gorons to relax after working in the nearby mines. There is also an arena for sumo, their traditional sport.

▷ Zora's Domain

The Zora live here, ruled by their queen, Rutela. The village is built into a rock basin that surrounds a lake fed by waterfalls of various heights. Reekfish can only be caught here, near a distinctive formation known as the Mother-and-Child Rocks. When taken over by Twilight, Zora's Domain and its people are frozen in ice.

▷ Hyrule Castle & Castle Town

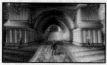

Spreading out before Hyrule Castle is the grandest city in the kingdom. Castle Town in the Twilight Era is full of life, with people coming and going at all hours. There are high-end shops and cafés in the central plaza and a bustling market to the south. Despite its grand veneer, cracks show in the town's darker corners. Cats gather in the little-traveled back alleys, while an air of loneliness unique to larger cities creeps in there.

▷ Hidden Village

The abandoned village hidden along the road connecting Eldin Province and Lanayru Province is overrun with Bulblins when Link arrives. There are many homes in the Hidden Village, but only the elderly woman Impaz lives there, waiting among the stray cats and the Cucco Leader for a hero to arrive.

▷ City in the Sky

A city floating in the sky is where the advanced Oocca live. By the Twilight Era, it is overrun with monsters. Travel to the city is made possible through the use of a Sky Cannon hidden on the surface. There is only one shop here, near the artificial pool at the entrance to the city. This city serves as the seventh dungeon of the game.

▷ Around the Palace of Twilight

The descendants of the Dark Interlopers live here after being banished from the Light World for the crime of invading the Sacred Realm in ancient times. Twili turned into beasts by Zant wander about, but they return to normal when exposed to the light of a Sol.

PHANTOM HOURGLASS

Some of the scattered islands in the four quadrants of *Phantom Hourglass* are home to thriving villages, while others support only a home or two. Central to Link's adventures in the Era of the Great Voyage is Mercay Island and its Temple of the Ocean King.

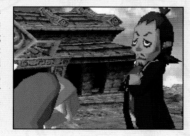

▷ Mercay Island

Link washes ashore on Mercay Island after falling in the ocean in pursuit of the Ghost Ship. The island boasts a bar and a shop, in addition to a shipyard to upgrade and maintain ships. The solemn Temple of the Ocean King rises up in the north of the island, enshrining the Ocean King, a great spirit who rules the seas.

▷ Isle of Ember

In the southwest of the Ocean Realm is an island with a volcano that belches fire. The island is famous for the fortuneteller Astrid who resides there. When the Ghost Ship arrives, Astrid flees for the safety of her basement, hiding while much of the island is set upon by monsters and destroyed. Among the casualties is Kayo, Astrid's assistant.

▷ Molida Island

Molida Island rests on the far edge of the Ocean Realm in the Southwestern Sea. A village of simple homes with straw roofs sits on the south side of the island, while a wild grove grows in the north. A man named Romanos operates a shooting gallery in the village. His father, the Old Wayfarer, found a way to get past the ocean fog of the northwest. The Temple of Courage is found here.

▷ Goron Island

The Gorons live on an island that shares their name, the biggest landmass in the Southeastern Sea. Cave-style homes make use of the layers of hard, reddish bedrock that cover the island. It is said that, long ago, the Ocean King entrusted the Gorons with the Crimsonine, one of three pure metals used to forge the Phantom Sword. The rare metal is protected by Dongorongo in the heart of the Goron Temple, just beyond the cave on the north side of the island.

▷ Isle of Frost

An intensely cold island blanketed in ice and snow in the Southeastern Sea. Though they entered into a peace agreement a hundred years ago, relations between the Anouki and the Yook who share the island remain tense. The Anouki live in the west and the Yook in the east. When Link arrives, the Yook are disguising themselves as Anouki and sneaking into their village.

SPIRIT TRACKS

The land of the Spirits of Good is divided into four realms, connected by a vast network of rail tracks, with the Tower of Spirits in the center. Trains are critical for communicating and traveling between the villages scattered across the realms, so being an engineer is considered an esteemed profession.

▷ Aboda Village

This remote village on the southern tip of the Forest Realm is tucked away where palm trees grow and a beach extends to the south. In addition to the residents who call Aboda home are friendly doves that flutter about. Alfonzo's house is the final stop on the train line, and is connected to the train storage warehouse here.

▷ Hyrule Castle & Castle Town

Castle Town is a large town near the Tower of Spirits at the center of the four realms. Just beyond is Hyrule Castle, home of Princess Zelda. There is a fountain in the center of Castle Town, where the tile patterns are bright and beautiful. In addition to a general store, there are numerous facilities, including a minigame called "Take 'Em All On!" that challenges heroes to fight monsters.

▷ Whittleton

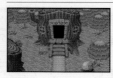

Surrounded by forests, Whittleton is a village of lumberjacks and the primary source of wood in New Hyrule. Residents make a living by growing trees, then cutting them down to sell. The villagers know everything about the forest and show Link how to get through the Lost Woods. Whittleton is notable for having a population entirely of men.

▷ Anouki Village

This village blanketed in snow is found in the northwest of the Snow Realm. The Anouki live in snow huts here, led by the long-bearded Honcho. They are fickle and blunt people who are struggling to form a patrol to deal with the nearby monsters.

▷ Papuchia Village

This island village located in the sea in the southeast of the Ocean Realm is a tropical tourist destination. Princess Zelda came here on vacation when she was a child. The great seer Wise One runs a business in the village, where the men are fishermen and the women are divers. When Link arrives, all the men have been kidnapped by pirates, leaving the women.

▷ Goron Village

In the northeast of the Fire Realm is a mountain village where the Gorons live, nestled in the rock of a volcano. The Gorons make their homes in caves dug into the cliffs. Lava flows freely and once prevented entry into the village. An elder Goron keeps the location of the Fire Sanctuary near the village a secret, and Link must first help Kagoron in order to be granted an audience.

SKYWARD SWORD

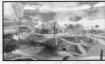

In the Sky Era, people largely live in the sky rather than on the Surface. While monsters and demons are found Surface-side, the only significant Hylian village is found on the floating island known as Skyloft. Some also make their homes on smaller sky islands like Pumpkin Landing.

▷ Skyloft

In Skyloft, a few smaller islands are connected to the large floating mass in the center. To the north, a giant statue of the goddess Hylia stands. She is said to have raised the land into the heavens. Outside the residential area is the Knight Academy, which trains knights to protect people from falling, as well as a lively shopping mall full of shops selling items, potions, and scrap.

A LINK BETWEEN WORLDS

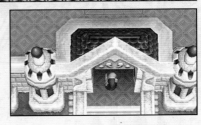

As in *A Link to the Past*, there is no Castle Town in *A Link Between Worlds*. The only place where Hylians live in significant numbers is Kakariko Village. The Zora of this era are friendlier than those found in *A Link to the Past*, but have little cause to interact with humans. In the parallel world of Lorule, Thieves' Town roughly mirrors Kakariko.

▷ Kakariko Village

Kakariko Village lies to the west of Hyrule Castle, much as it does in *A Link to the Past*. The sage Sahasrahla watches over its people. Stalls and shops sell items, equipment, and even milk at the local Milk Bar. Numerous eccentric characters hang around town, from the Stylish Woman to the Bee Guy.

▷ Zora's Domain

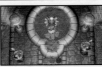

The Zora live in a village behind the waterfall in the northeast. Obstructed by the river and cliffs, Hylians are not typically able to approach the village. The village is governed by Queen Oren, one of the Seven Sages of this era.

▷ Thieves' Town

The streets are largely empty in Lorule's sole village. Homes and shops have fallen into disrepair, left to collapse in this parallel world devoid of a Triforce. Thieves lurk in a hideout underground, accessible at the feet of a fearsome bronze statue on the edge of the village.

TRI FORCE HEROES

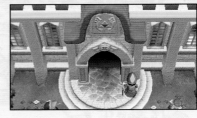

Tri Force Heroes takes place in Hytopia, a fashion-obsessed kingdom north of the kingdom of Hyrule. Here, they pass down the legend of the Tri Force Heroes: three youths who will save the kingdom in times of catastrophe. Central to Hytopia is Hytopia Castle and the Castle Town at its base.

▷ Hytopia Castle Town

Centered around a Tri Force Heroes statue, Hytopia Castle Town is a vibrant, busy hub full of shops and places to pass the time, like a photo gallery and a treasure chest game. The famous Madame Couture's shop is the premiere destination for anyone seeking fashionable and functional clothing. When they aren't shopping, residents gossip about day-to-day drama and strangers passing through town.

ITEMS

A hero of legend needs the right equipment for the job. Specially made tools to solve brain-busting puzzles, keys to explore ever deeper into perilous dungeons, life-giving potions and Heart Containers—a well-stocked inventory of items is not only advisable, it's essential.

This section collects a warehouse of gear spanning thirty years of adventures. Items are listed in alphabetical order, with details based on in-game descriptions, manuals, guides, and a variety of other official sources. Not every image is included for different item types with the same visuals. Generally, equipment like boat or machine parts is listed together.

The following are not included:
• Items only used in a specific location as part of a dungeon mechanic.
• Items that may be picked up but do not have an image.
• Living beings other than animals, fairies, and bugs. This means the Kidnapped Child from *The Adventure of Link* is not included, even though he is treated like an item in the game.

Note that items obtained only in the Palace of the Four Sword, which appeared in *A Link to the Past & Four Swords*, are considered as part of *A Link to the Past* here. Items from *Four Swords Adventures* include those obtained in "Navi Trackers," which is available only in Japanese versions of the game.

1 ITEM NAME The name of an item. Note that an item may go by multiple names depending on the era. Alternate names are accounted for below.

2 TYPE Items are divided into the following nine types: **CRITICAL:** Items that are key to progressing the story, like instruments and those that give Link new abilities or prove a dungeon has been completed. **COLLECTION:** Wallets and bags used to store other items like rupees or bombs. They are often displayed on the collection screen. **EQUIPMENT:** Weapons, clothing, and other equipment that grant Link new abilities. **TOOL:** Unique tools used for traversing the world, solving puzzles, or defeating enemies. **QUEST:** Items used to trade or give to characters, obtain information, or access an area. **CONSUMABLE:** Items that go away once used and must be replenished. This includes items that trigger an effect when picked up in the field. **DUNGEON:** Items used exclusively in a dungeon. **CREATURE:** Living creatures that can be kept in Link's inventory. **OTHER:** Items that do not fit in the above categories.

3 ALTERNATE NAMES Listed when the name of an item differs across titles. A corresponding mark is placed above an image to indicate the game where the alternate item name appears.

4 IMAGE AND GAME TITLE Unless otherwise noted, items from the rereleases of *Link's Awakening*, *Ocarina of Time*, *Majora's Mask*, *The Wind Waker*, and *Twilight Princess* take precedence visually, unless the item appears with significant differences in the original version.

5 ITEM DESCRIPTION Description of an item and its use. When an item exhibits unique properties in a particular title, that information will be included here.

COLUMN

▷ **2nd Potion** (CONSUMABLE)
See Water of Life (Red).

A COLUMN

▷ **A History of Masks** (QUEST)

The Minish Cap

A library book. Hagen, the mayor of Hyrule Town who enjoys mask making, borrows it from the library.

▷ **A Hyrulean Bestiary** (QUEST)

The Minish Cap

A library book. Julietta, a girl with a cat, borrows it to learn more about her pet.

▷ **Adult Wallet** (COLLECTION)
● Adult's Wallet

Ocarina of Time

Majora's Mask

This wallet carries more rupees than a basic one. See also page 95.

▷ **Adventure Pouch** (COLLECTION)

Skyward Sword

A pouch gifted to Link by Fledge, his classmate at the Knight Academy. It lets Link carry up to four items, including equipment and potions.

▷ **Adventure Pouch Upgrade** (COLLECTION)

Skyward Sword

Link can obtain four additional item slots for his Adventure Pouch, increasing its maximum capacity to eight slots. One is found in a treasure chest, and the others can be purchased from Beedle's Airshop.

▷ **Air Potion** (CONSUMABLE)

Skyward Sword

Drinking this potion reduces how quickly the oxygen meter depletes while diving underwater. It can be purchased at the Potion Shop, as long as Link has an empty bottle.

▷ **Air Potion+** (CONSUMABLE)

Skyward Sword

An enhanced potion made by combining ingredients provided to Bertie at the Potion Shop. Drinking this potion prevents the oxygen meter from depleting for three minutes.

▷ **Alchemy Stone** (OTHER)

Spirit Tracks

An extremely rare treasure used to upgrade Train Cars in *Spirit Tracks*. They can be won in minigames, or as a prize from the Prize Postcards.

▷ **All-Night Mask** (EQUIPMENT)

Majora's Mask

The Curiosity Shop sells this after Link saves the Old Lady. This mask keeps the wearer awake, letting him listen to Anju's Grandmother's stories without falling asleep.

▷ **All-Purpose Bait** (CONSUMABLE)

The Wind Waker

A high-quality pet food beloved by a great many creatures, from rats and pigs to Fishmen. It is mainly used to get Fishmen to fill out a portion of the Sea Chart.

▷ **Amber Relic** (OTHER)

Skyward Sword

A beautiful, amber-colored ornament. Though common, they have many applications, including upgrading items.

▷ **Amber Tablet** (CRITICAL)

Skyward Sword

One of the ancient stone tablets. It is found in the Earth Temple and has the power to open the way to grounds sealed by the goddess. Lanayru Desert becomes accessible after placing this tablet on the altar inside the Statue of the Goddess.

▷ **Ancient Circuit** (DUNGEON)

Skyward Sword

Acts as the Boss Key for the Lanayru Mining Facility. It appears to be a complex part made of gold, but its shape is a mystery. There are circuits engraved throughout the surface.

▷ **Ancient Fin** (OTHER)

Tri Force Heroes

Obtained in the Dunes. It smells heavenly when baked, but cook it too long and it hardens. Used as a material in the Dunewalker Duds and Ninja Gi.

▷ **Ancient Flower** (OTHER)

Skyward Sword

Legends say this beautiful flower flourished in the ancient Lanayru Desert. It is extinct in Link's time, and can only be obtained by shifting to the past with a Timeshift Stone.

▷ **Ancient Gold Piece** (OTHER)
● Antique Coin

Spirit Tracks

Tri Force Heroes

A highly valuable treasure used to upgrade Train Cars in *Spirit Tracks*. Pieces are used as a material for outfits in *Tri Force Heroes*.

▷ **Ancient Sea Chart** (OTHER)

Skyward Sword

An ancient map that charts the long-lost Lanayru Sand Sea. Stored in the Skipper's Retreat, home of the captain of the Sandship, it was buried in sand over many years.

▷ **Ancient Sky Book** (QUEST)

Twilight Princess

A book written in ancient Sky Writing that belongs to Impaz. There are letters missing. Finding the missing Sky Characters will restore the book. Showing the book to Shad then helps him restore power to the Dominion Rod.

▷ **Ancient Wood** (CRITICAL)

Oracle of Ages

One of the eight Essences of Time in *Oracle of Ages*. It is found in the Wing Dungeon.

▷ **Angler Key** (QUEST)

Link's Awakening

This key unlocks the seal on the entrance to the Angler's Tunnel in *Link's Awakening*.

Antique Coin (OTHER)
See Ancient Gold Piece.

Apple (CONSUMABLE)

Apples will fall to the ground if Link slams into certain trees. Eating them restores health.

A Link to the Past *A Link Between Worlds*

Aqua Crown (OTHER)

When an impure soul dons this, it evaporates. It is required to make the Torrent Robe and Linebeck's Uniform.

Tri Force Heroes

Aquanine (CRITICAL)

One of the three pure metals required to create the Phantom Sword. A treasure of Cobble Kingdom on the Isle of Ruins, it resides in the temple of King Mutoh (not to be confused with Mutoh the carpenter).

Phantom Hourglass

Armor Seed (CONSUMABLE)

A seed that increases defense when consumed, reducing damage taken from enemies. They double Link's defense and the effect persists until the end of a stage.

Four Swords

Armos Spirit (OTHER)

A spirit that dwells inside a demonic stone statue known as an Armos. When an Armos falls, its spirit remains for three days. Used as a material to make the Big Bomb Outfit and Kokiri Clothes.

Tri Force Heroes

Arrow (TOOL)

The Legend of Zelda *A Link to the Past* *Ocarina of Time* *Majora's Mask*

The Wind Waker *The Minish Cap* *Twilight Princess* *Spirit Tracks*

Phantom Hourglass *Skyward Sword*

Used with a bow to shoot distant enemies. In *The Legend of Zelda*, firing one arrow costs one rupee. See also page 89.

Ashei's Sketch (QUEST)
An image drawn by Ashei of a giant holding a red fish that is said to appear somewhere on the mountain. Showing it to the Zora garners information about the giant and the fish.

Twilight Princess

Aurora Stone (OTHER)
Obtained in the Sky Realm. A large stone with a hefty helping of aurora aura. Used as a material for the Showstopper outfit.

Tri Force Heroes

Auru's Memo (QUEST)
A memo written by Auru to Fyer at the Oasis Flight. Showing it to Fyer causes him to grant Link one free Human-cannonball Ride to the Gerudo Desert. Afterward, using the service costs money.

Twilight Princess

Azurine (CRITICAL)
One of the three pure metals required to create the Phantom Sword. It is the treasure of the tribe living on the Isle of Frost.

Phantom Hourglass

Ball and Chain (TOOL)

A heavy metal ball at the end of a chain. It is so heavy that Link cannot run while carrying it, but its weight means a single swing can destroy ice walls and send lighter enemies flying.

Twilight Princess

Balloon (CONSUMABLE)

Appears in "Navi Trackers." Balloons allow Link to warp to any of the directional warp points. They can also be used to interfere with rivals by sending them far away.

Four Swords Adventures (Japanese version only)

Bananas (QUEST)

Sale the Alligator on Toronbo Shores will give these to Link in exchange for dog food. Link can then trade the bananas to monkeys, who will in turn build a bridge to access Kanalet Castle. See also Stick.

Link's Awakening

Banded Shield (EQUIPMENT)

A Wooden Shield that Gondo upgrades at the Scrap Shop. Its durability is improved, but it retains a weakness to fire, burning to nothing with a single attack.

Skyward Sword

Bait Bag (COLLECTION)

A convenient bag that holds up to eight types of bait mainly given to animals, including All-Purpose Bait and Hyoi Pears. It can be purchased from Beedle's Shop Ship.

The Wind Waker

Bear Minimum (EQUIPMENT)

The outfit Link is wearing when he arrives in Hytopia. It doubles damage taken and reduces heart capacity by one, but acquiring enough Hero Points grants Link a higher chance of dodging attacks while wearing it.

Tri Force Heroes

Beastie Patch (OTHER)

A bandage for beasts that helps wounds heal faster. Since it looks like beast hide, it hides wounds while healing them, which is useful for monsters, but not Link. He uses it as a material for the Cheetah Costume.

Tri Force Heroes

Bedroom Key (DUNGEON)

A key for opening the bedroom doors of the yeti couple Yeto and Yeta. It serves as the Boss Key for the Snowpeak Ruins.

Twilight Princess

Bee (CREATURE)

A stinging insect that can be caught with a net. It will attack monsters when released from a bottle. See also Golden Bee.

A Link to the Past *A Link Between Worlds*

Bee Badge (TOOL)

Received for giving the Bee Guy in Kakariko Village a Golden Bee. Carrying it will stop bees from stinging Link. Instead, they will fight alongside him.

A Link Between Worlds

Bee Larvae (CREATURE)
● Bee Larva / ▲ Hornet Larvae

Twilight Princess *Spirit Tracks* *Skyward Sword*

Bee Larvae is used as bait in *Twilight Princess*, traded for Train Cars in *Spirit Tracks*, and sold to upgrade tools in *Skyward Sword*.

Beedle's Chart (OTHER)

A map that charts the locations of Beedle's Shop Ship. It is possible to shop at any of these spots, but his wares will vary slightly based on location.

The Wind Waker

Beedle's Insect Cage (QUEST)

A cage containing Beedle's precious rare insect, a Horned Colossus Beetle—a bug so rare, it drives collectors mad. Strich happens to find one.

Skyward Sword

Beetle (TOOL)

An ancient mechanical tool obtained in Skyview Temple. It can be freely controlled to aim at distant or hard-to-reach targets. Its small blades are sharp enough to cut stems and ropes.

Skyward Sword

Bell (CRITICAL)

A lovely sounding bell received from the young witch Irene. Using it outside summons her. She will then transport Link to any location with a Weather Vane.

A Link Between Worlds

Big Bomb Bag (COLLECTION)

Ocarina of Time *Majora's Mask* *The Minish Cap*

A large bag made of durable fabric. It can carry more bombs than a regular Bomb Bag. See also page 91.

Big Bomb Flower (TOOL)

A giant Bomb Flower that can be obtained at the Bomb Flower Store or in Lorule Castle. Rather than being carried, it follows Link once picked, and he must safely guide it. If an enemy touches it, it will explode. The blast is capable of breaking large, cracked rocks.

A Link Between Worlds

Big Bomb Outfit (EQUIPMENT)

When Link dons this outfit, bombs get bigger and stronger, expanding their blast radius. It works with both bombs and Bomb Flowers. See also page 90.

Tri Force Heroes

Big Bug Net (TOOL)

The enhanced version of the Bug Net, upgraded by Gondo in the Scrap Shop. The net is twice as big as before, so quick bugs become easier to catch.

Skyward Sword

Big Catch Flag (QUEST)

A flag made by a foreign fisherman. It is carried by the Traveling Merchants and can be exchanged for the Sickle Moon Flag and the Fountain Idol.

The Wind Waker

Big Catch Lure (OTHER)

This lure is obtained from the Old Wayfarer after catching and showing him a Loovar. It makes it possible to catch Rusty Swordfish.

Phantom Hourglass

Big Fairy (CONSUMABLE)

Big Fairies appear when Link plays the ocarina in certain locations. They restore eight hearts and fill Link's magic meter. Unlike regular fairies, they cannot be captured in bottles.

Ocarina of Time

Big Key (DUNGEON)
See Boss Key.

Big Poe Soul (Quest)

The bottled soul of a defeated Big Poe. It can be sold to the Poe Collector.

Big Quiver (Collection)

A size upgrade from the initial quiver, enabling Link to carry more arrows. See also page 89.

Big Sale Flag (Quest)

A flag that looks like it would be good for business. Sold by the Traveling Merchant in *The Wind Waker*, it can be traded for a Hero's Flag or a Big Catch Flag.

Big Wallet (Collection)

A wallet that can carry more rupees than a normal one. There are three upgrades in *The Minish Cap*, and each time Link obtains one, his rupee limit increases. See also page 95.

Bigger Bullet Bag (Collection)

Increases the number of Deku Seeds that Link can carry to use as ammo for his Slingshot.

Biggest Bomb Bag (Collection)

● Giant Bomb Bag

The biggest Bomb Bag available. It is made of sturdy cloth and can carry more bombs than even the Big Bomb Bag. See also page 91.

Biggest Bullet Bag (Collection)

This ammo bag can carry more Deku Seeds than even the Big Bullet Bag.

Biggest Quiver (Collection)

● Giant Quiver

A very large quiver. With it, Link can carry even more arrows than with the Big Quiver. See also page 89.

Biggoron's Sword (Equipment)

A giant, two-handed sword obtained by Link at the conclusion of *Ocarina of Time*'s trading quest. It also appears in the *Oracle* series when playing a linked game.

Bird Feather (Other)

Feathers dropped by birds living on the Surface in *Skyward Sword*. Feathers can be collected by catching birds using the Bug Net.

Bird Key (Quest)

This key unlocks the seal on the entrance to the Eagle's Tower.

Bird Statuette (Quest)

This statuette is used in the Knight Academy's Wing Ceremony to help teach students flying skills. A Golden Loftwing is released carrying the statuette and students take to the skies, vying to be the one who retrieves it. There are also larger Bird Statues in *Skyward Sword* that act as save points.

Blast Mask (Equipment)

Link receives this from the Old Lady from the Bomb Shop for stopping Sakon the thief in Clock Town. It enables the wearer to cause explosions at will.

Blessed Butterfly (Creature)

A common bug found throughout Hyrule and beyond. Blessed Butterflies are said to have the ability to sense sacred or special objects, often gathering near places where something connected to the goddesses is hidden.

Blessed Idol (Dungeon)

Shaped much like the statue enshrined in the center of the Ancient Cistern, this wooden statue looks like it is supposed to inspire gratitude. It is actually the key to the boss room for the dungeon.

Blin Bling (Other)

Only Big Blins manage to amass this kind of glitz. A material used to make Lucky Loungewear.

Blob Jelly (Other)

Blobs drop this. It is best not to ask what it is. Used as a material for Kokiri Clothes.

Blowing Wind (Critical)

One of the eight Essences of Nature in *Oracle of Seasons*. It is found in the Ancient Ruins.

Blue Bird Feather (Other)

A feather from an extremely rare blue bird that lives on the Surface. It can be obtained by using a Bug Net to catch the blue birds that sometimes appear fluttering about with other small birds.

Blue Bracelet (Equipment)

This bracelet grants the wearer increased defense. Damage taken from enemies is halved.

Blue Candle (Tool)

This candle can be used to attack enemies by firing a flame and can illuminate rooms in darker dungeons. It can also burn trees. It can only fire one flame per screen.

Blue Chu Jelly (Consumable)

The jelly that remains after defeating Blue Chuchus. In *The Wind Waker*, Blue Chu Jelly is an ingredient in Blue Potions. In *Twilight Princess*, the jelly on its own fully restores Link's health when put in a bottle and consumed.

Blue Clothes (Equipment)

See Blue Mail.

Blue Fire (Consumable)

A mysterious flame that is cold instead of hot. It melts Red Ice found inside ice caverns. A bottle is required to carry it.

Blue Mail (Equipment)

● Blue Clothes

Armor that increases defense. In the DX version of *Link's Awakening*, these are called Blue Clothes and are obtained in the Color Dungeon. See also page 86.

Blue Ore (Quest)

This special ore can be found in Subrosia. Combining it with Red Ore produces Hard Ore, which is useful for making shields.

Blue Picolyte (Consumable)

This potion makes it easier to find fairies for a short time when searching grass and other places where fairies are found. Beedle will sell it to Link in Hyrule Town if Link has an empty bottle.

Blue Potion (Consumable)

● Medicine of Life and Magic

A healing elixir that restores both health and magic power when consumed. Like most potions, it is carried around in bottles. In games without magic power status, it only restores health.

Blue Ring (Tool)

This magic ring halves the damage taken from enemies. Only certain merchants carry it.

Blue Royal Jewel (Critical)

A jewel guarded by a Blue Knight, one of the Knights of Hyrule serving the royal family. Collecting this, along with the red, green, and purple jewels, opens the path to the Palace of Winds in the Realm of the Heavens.

Boko Baba Seed (Other)

A seed obtained from defeating a Boko Baba. The Forest Potion Shop will give Link a Blue Potion in exchange for four of them.

Bomb (Tool)

The Legend of Zelda | A Link to the Past | Link's Awakening | Ocarina of Time

Majora's Mask | Oracle series | The Wind Waker | Four Swords

Four Swords Adventures | The Minish Cap | Twilight Princess | Phantom Hourglass

Spirit Tracks | Skyward Sword | A Link Between Worlds | Tri Force Heroes

A powerful item used in battle and to blast holes in certain walls. In *The Legend of Zelda*, they cannot be moved once placed, but the blast will not harm Link. In most titles, Link can pick up and throw a bomb after lighting its fuse. See also page 90.

Bomb Bag (Collection)

The Wind Waker | Spirit Tracks | Skyward Sword | Ocarina of Time

Majora's Mask | The Minish Cap | Twilight Princess | Phantom Hourglass

A bag for carrying bombs, made out of a Dodongo's stomach in *Ocarina of Time*. The bigger the bag, the more bombs Link can carry. In *The Wind Waker*, the larger bag is still called a Bomb Bag and just appears bigger. There are two versions of this item in *Phantom Hourglass*: a basic one that holds 20 and a larger one that holds 30, won in the Cannon Game. See also page 91.

Bomb Flower (Tool)

Ocarina of Time | Majora's Mask | Oracle series | The Wind Waker

Four Swords Adventures | Phantom Hourglass | Spirit Tracks | Skyward Sword

A plant resembling a bomb that grows wild throughout Hyrule. Once picked, it will start to glow and explode after a short period of time. Another Bomb Flower will grow in its place shortly after picking one.

Tri Force Heroes

Bombchu (Tool)

Ocarina of Time | Majora's Mask | Oracle series | Phantom Hourglass

A moving bomb shaped like a mouse. They run along the ground and can even travel up walls and on ceilings. Bombchus are useful for blasting targets ordinary bombs can't reach.

Bombchu Bag (Collection)

A bag that can hold up to 10 Bombchus. It is found in the Goron Temple. Two upgrades can be purchased from the Goron Island Shop or won by playing the Goron Game. Each upgrade adds 10 Bombchus for a maximum of 30. See also page 91.

Phantom Hourglass | Phantom Hourglass

Bombers' Notebook (Collection)

Link receives this notebook after being accepted into the Bombers Secret Society of Justice. It keeps track of people Link can help in Termina. In the 3DS version, Link receives it from the Happy Mask Salesman.

Majora's Mask

Bombling (Tool)

A new type of bomb developed by Barnes, only available at the Bomb Shop. It moves by itself, running forward until it explodes either by hitting an enemy or an obstacle or by running out of fuse.

Twilight Princess

Bombos Medallion (Equipment)

A medallion imbued with flame magic. Using it turns the surrounding area into a sea of flames, burning all nearby monsters.

A Link to the Past | Four Swords Adventures

Book of Magic (Tool)

A magical tome containing a spell for shooting flames. It enhances the Magical Rod by adding fire when the spell is cast. The power of the book will also illuminate dark dungeon spaces. See also Magic Book.

The Legend of Zelda

Book of Mudora (Quest)

This book is required to decipher the Ancient Hylian language used by past inhabitants of Hyrule. It allows the holder to read the writing on stone tablets.

A Link to the Past

Book of Seals (Quest)

This book is found in the Eyeglass Island Library in the present. It makes it possible to undo the seal on the library in the past.

Oracle of Ages

Boomerang (Tool)

The Legend of Zelda | A Link to the Past | Link's Awakening | Ocarina of Time

Oracle series | The Wind Waker | Four Swords | Four Swords Adventures

The Minish Cap | Phantom Hourglass | Spirit Tracks | A Link Between Worlds

An essential item in many eras, the Boomerang can stun or injure enemies, retrieve faraway items, and activate switches. In DS titles like *Phantom Hourglass*, the player can draw its path with the stylus.

Tri Force Heroes

Boomeranger (Equipment)

The outfit of a totally wild boomerang master. It makes the Boomerang bigger, increases its attack power, and lets it pass through foes. It can even transport two allies at the same time.

Tri Force Heroes

Boots (Equipment)

Mysterious boots with wings. They allow Link to walk on shallower sections of rivers and seas.

The Adventure of Link

Boss Key (Dungeon)

● Big Key / ▲ Nightmare Key

A Link to the Past | Link's Awakening | Ocarina of Time | Majora's Mask

Oracle series | The Wind Waker | The Minish Cap | Twilight Princess

Phantom Hourglass | Spirit Tracks | A Link Between Worlds

These keys open dungeon doors that Small Keys cannot—often leading to a confrontation with a boss on the other side. They can only be used in the dungeon in which they are obtained.

Boss Room Key (Dungeon)

See Boss Key.

Bottle (Tool)

See Empty Bottle.

Bottled Water (Other)

See Water.

Bow (Tool)

● Hero's Bow / ▲ Fairy Bow

The Legend of Zelda | A Link to the Past | Link's Awakening | Ocarina of Time

Majora's Mask | The Wind Waker | Four Swords | Four Swords Adventures

The Minish Cap | Twilight Princess | Phantom Hourglass | Spirit Tracks

Skyward Sword | A Link Between Worlds | Tri Force Heroes

A common bow able to attack faraway enemies and activate switches Link cannot otherwise reach. In *Twilight Princess*, Link can combine bombs with arrows to fire explosive Bomb Arrows. See also page 89.

Bow of Light (Tool)

The Minish Cap | Spirit Tracks | A Link Between Worlds

A bow filled with the power of divine light that banishes evil. It is often effective against giant demonic beings like Demon Kings. Princess Zelda sometimes carries one, depending on the title.

Bowl of Hearts (Collection)

See Heart Container.

Braced Shield (Equipment)

A further upgrade to the Banded Shield, making it the most powerful form of the Wooden Shield. It is considerably more durable, but it still has a weakness to fire.

Skyward Sword

Bremen Mask (Equipment)

Received from Guru-Guru after talking to him at night at the Laundry Pool in Clock Town, this bird mask has the power to control some animals and even speed up the aging of chicks into cuccos.

Majora's Mask

Bright Sun (CRITICAL)

One of the eight Essences of Nature in *Oracle of Seasons*. It is found in the Poison Moth's Lair.

Oracle of Seasons

Brioche (CONSUMABLE)

A rich, filling bun bought from the bakery in Hyrule Town. Eating one restores a single heart. Occasionally, there will be a Kinstone inside.

The Minish Cap

Brittle Papyrus (OTHER)

Used as paper for writing. Love letters written on these supposedly always work. Also used as a material for the Cheetah Costume.

Tri Force Heroes

Broken Giant's Knife (EQUIPMENT)

A Giant's Knife that broke while being used and has lost most of its attack power. If Link brings it to Medigoron on Death Mountain, Medigoron will fix it for a fee.

Ocarina of Time

Broken Goron's Sword (QUEST)

A broken Goron weapon. It can be traded to Biggoron for the Prescription at the summit of Death Mountain.

Ocarina of Time

Broken Picori Blade (QUEST)

An enchanted sword that has banished evil since ancient times. It is broken by Vaati at the beginning of *The Minish Cap*. It turns into the White Sword when Melari, the Minish blacksmith, repairs it.

The Minish Cap

Broken Sword (QUEST)

A trading item in *Oracle of Ages* obtained from the Old Zora. Link can give this to the guru Patch to fix. It becomes the Noble Sword.

Oracle of Ages

Broom (QUEST)

Received as thanks for giving the letter to Mr. Write at the edge of the forest. In return, he will give Link a fishing hook. See also Fishing Hook.

Link's Awakening

Brother Emblem (QUEST)

This item from *Oracle of Ages* proves that Link has become an honorary Goron. It is a reward for winning the dancing minigame. Showing the emblem to the guard grants Link passage to the summit of Rolling Ridge.

Oracle of Ages

Bug (CREATURE)

Bugs can be caught with a net or an empty bottle. They can be used to drive Gold Skulltulas out of their hiding places.

Bug Catching Net (TOOL)

● Bug Net / ▲ Net

A Link to the Past *Skyward Sword* *A Link Between Worlds*

Not only can nets catch insects like bees, they can also capture fairies and even repel some surprising things.

Bug Medal (EQUIPMENT)

One of several medals Link can acquire in *Skyward Sword* that have beneficial effects when carried. The medal reveals places on Link's map where bugs are hiding.

Skyward Sword

Bug Net (TOOL)

See Bug Catching Net.

Bullet Bag (COLLECTION)

Part of the Fairy Slingshot set. This bag holds Deku Seeds for use as ammunition with the Slingshot.

Ocarina of Time

Bunny Hood (EQUIPMENT)

Ocarina of Time *Majora's Mask*

A hood with bunny ears that sway. Wearing it in *Majora's Mask* increases movement speed.

Burning Flame (CRITICAL)

One of the eight Essences of Time in *Oracle of Ages*. It is found in the Skull Dungeon.

Oracle of Ages

C C COLUMN

Cabana Deed (QUEST)

The title deed for the cabana on the Private Oasis, received from Mrs. Marie. With it, Link can enter the cabana to find a hidden Piece of Heart.

The Wind Waker

Cacto Clothes (EQUIPMENT)

A suit modeled off a desert cactus. Its sharp spikes will damage any enemy they poke. It will not harm allies though.

Tri Force Heroes

Candle (TOOL)

An item that lights up dark caves and dungeons.

The Adventure of Link

Cane of Byrna (TOOL)

This magic staff can block enemy attacks with a barrier that envelops Link for as long as his magic power holds out.

A Link to the Past

Cane of Pacci (TOOL)

Obtained in the Cave of Flames. If light fired from the cane hits certain objects or enemies, it will flip them over. Firing it at a hole and jumping in will propel Link high into the air, making it possible to scale greater heights and hop over certain barriers.

The Minish Cap

Cane of Somaria (TOOL)

A Link to the Past *Oracle of Ages*

A staff that creates blocks for pushing switches or making platforms.

Captain's Hat (EQUIPMENT)

Received for defeating Captain Keeta. Wearing this will make Stalchildren think Link is their captain, making it possible to talk to and instruct them.

Majora's Mask

Carlov Medal (COLLECTION)

If Link collects all of the figurines from the Figurine Shop, Carlov, the owner, will present Link with this medal. The game must be completed to obtain it.

The Minish Cap

Carmine Pearl (OTHER)

A red jewel said only to be obtainable from the sky. It is also known as a sun seed. Used as a material in Robowear and Linebeck's Uniform.

Tri Force Heroes

Carrot (CONSUMABLE)

Carrots are fed to horses to give them stamina and strength. In some games, they appear automatically when Link rides a horse. In *Four Swords Adventures*, carrots can be collected from smashed Crystal Balls.

Four Swords Adventures

Carrumpkin (OTHER)

This carrot loved autumn so much, it became a pumpkin. Used as a material for the Serpent's Toga and Light Armor.

Tri Force Heroes

Carver's Statue (COLLECTION)

See Wooden Statue.

Cawlin's Letter (QUEST)

A love letter written by Cawlin for Karane. Giving it to Karane results in her rejecting him. It can also be given to the paper-seeking ghost.

Skyward Sword

Chain Chomp (TOOL)

A guest character from the *Super Mario Bros.* series. A Chain Chomp attached to a chain appears and proceeds to bite down on anything and everything nearby. It is a rare piece of equipment. Similar to the BowWow, a companion in *Link's Awakening*.

Four Swords

Changing Seasons (CRITICAL)

One of the eight Essences of Nature in *Oracle of Seasons*. It is found in the Sword & Shield Maze.

Oracle of Seasons

Charm (CRITICAL)

See Pendant of Courage.

Chateau Romani (CONSUMABLE)

Special milk obtained at the Romani Ranch. Drinking it fully restores health and magic, and will prevent Link's magic meter from decreasing until time rewinds. It can be purchased at the Milk Bar. See also Milk.

Majora's Mask

Cheer Outfit (EQUIPMENT)

A cheerleader outfit, useful for encouraging anyone within earshot. It will increase all allies' stamina meters by 50%.

Tri Force Heroes

Cheesy Mustache (QUEST)

A trading item in *Oracle of Ages* obtained from Thomas. The Lynna City Comedian is looking for just such a cheesy thing, and in return, he gives Link a Funny Joke.

Oracle of Ages

Cheetah Costume (EQUIPMENT)

A cheetah-patterned outfit that increases movement speed. It also enables its wearer to understand cats.

Tri Force Heroes

Cheval Rope (QUEST)

This special rope appears in *Oracle of Ages*. It is water resistant and therefore especially suited to building a raft. Giving it to Rafton allows him to do so.

Oracle of Ages

▷ Chill Stone (Other)

Tri Force Heroes

Guaranteed to keep its cool at all times. Used as a material in Hammerwear.

▷ Claim Check (Quest)

Ocarina of Time

A claim check for the powerful Biggoron's Sword. It is obtained by giving Biggoron the World's Finest Eye Drops for his irritated eyes.

▷ Clawshot (Tool)

Twilight Princess *Skyward Sword*

Firing this into targets or ivy allows Link to pull himself toward where it sticks. It can also pull light enemies closer. See also Double Clawshots, Hookshot.

▷ Clock (Consumable)

The Legend of Zelda

A magical clock. Picking it up stops all enemies in sight. Link will take no damage as he dispatches the frozen foes with ease.

▷ Club Card (Quest)

Spirit Tracks

Proof of membership at Beedle's Shop. Link can purchase this card for 100 rupees the first time he shops at Beedle's balloon. Once a member, Link can accumulate points that lead to discounts and other perks.

▷ Cojiro (Quest)

Ocarina of Time

An uncommon blue cucco that rarely crows. Using him to wake up Grog, who is sleeping in the Lost Woods, will help Link get the Odd Mushroom.

▷ Cold Pumpkin Soup (Consumable)

Skyward Sword

Hot Pumpkin Soup that sat in a bottle for more than five minutes and got cold. The taste is superb, but since it is cold, it only recovers half the hearts (four) it would recover if hot. See also Hot Pumpkin Soup.

▷ Colossal Wallet (Collection)

Twilight Princess HD

A wallet that can hold up to 9,999 rupees added for the HD version. To obtain it, Link must clear the Cave of Shadows. See also page 95.

▷ Compass (Dungeon)

The Legend of Zelda *A Link to the Past* *Link's Awakening* *Ocarina of Time*

Oracle series *The Wind Waker* *The Minish Cap* *Twilight Princess*

Found in dungeons, a compass reveals the location of treasure chests and bosses. In *The Legend of Zelda*, it shows the location of the Triforce.

▷ Compass of Light (Critical)

Spirit Tracks

Obtained on the twenty-fourth floor of the Tower of Spirits, this compass points in the direction where evil lies. Its power opens the path to the Dark Realm and, in turn, the Demon Train.

▷ Compliment Card (Consumable)
● Complimentary ID

The Wind Waker *Phantom Hourglass*

A special ticket received for shopping at Beedle's Shop. Beedle will compliment Link if he uses it.

▷ Complimentary Card (Consumable)

Phantom Hourglass

One of the reward cards received from Beedle's Shop Ship, which travels the open seas. Obtainable after becoming a Platinum Member. In order to obtain it, it's recommended that you compliment Beedle.

▷ Complimentary ID (Consumable)
See Compliment Card.

▷ Conch Horn (Critical)

Link's Awakening

Obtained by clearing the Bottle Grotto dungeon. One of eight instruments needed to perform the Ballad of the Wind Fish.

▷ Coral Earring (Other)

Twilight Princess

An earring made out of the precious coral in Zora's Domain. Attached to the fishing rod as a hook, it makes it possible to catch Reekfish that only live in Zora's Domain.

▷ Coral Triangle (Critical)

Link's Awakening

Obtained by clearing the Face Shrine dungeon. It is one of eight instruments needed to perform the Ballad of the Wind Fish.

▷ Couple's Mask (Equipment)

Majora's Mask

Obtained for safely reuniting Anju and Kafei on the final day. Wearing this mask will end the bickering in the Mayor's Residence.

▷ Courage Gem (Other)

Phantom Hourglass

In all, 20 of these gems exist throughout the land. Gathering and bringing them to Spirit Island will unlock the Spirit of Courage's strength, increasing the attack power of the long-range sword beam.

▷ Cozy Parka (Equipment)

Tri Force Heroes

An outfit reminiscent of some familiar ice climbers. It enables Link to walk on icy surfaces without sliding, and prevents freezing from ice attacks.

▷ Cracked Tuni Nut (Quest)

Oracle of Ages

When the Tuni Nut is cracked, it requires the restoration guru Patch to repair it. See also Tuni Nut.

▷ Crimson Shell (Other)

Tri Force Heroes

A mysterious shell that never misses a foe when thrown. This item closely resembles an item from some racing game. It is used as a material for the Hammerwear outfit.

▷ Crimsonine (Critical)

Phantom Hourglass

One of the three pure metals required to create the Phantom Sword. It is the pride of the Gorons.

▷ Croissant (Consumable)

The Minish Cap

A flaky, buttery bargain that can be purchased at the Hyrule Town bakery. Eating one restores a single heart. Occasionally there will be a Kinstone inside.

▷ Cross (Tool)

The Adventure of Link

A sacred cross that enables Link to see invisible monsters in places like Old Kasuto.

▷ Crown Key (Quest)

Oracle of Ages

This key unlocks the entrance to the Crown Dungeon in *Oracle of Ages*.

▷ Crystal (Critical)

The Adventure of Link *A Link to the Past*

The descendants of the sages are sealed within crystals in *A Link to the Past*. In *The Adventure of Link*, crystals are placed in statues inside temples.

▷ Crystal Ball (Consumable)

Four Swords Adventures

Throwing and breaking Crystal Balls will cause items like Real Bombchus, carrots, cuccos, or Heart Containers to appear. Crystal Balls are also used by fortunetellers to predict the future. In *Skyward Sword*, Sparrot the fortuneteller's Crystal Ball breaks and Link uses his Dowsing ability to find a new one at the Earth Temple.

▷ Crystal Skull (Other)

Tri Force Heroes

A glimmering skull made of beautiful crystal. The secrets this thing must hold! Used as a material in the Spin Attack Attire.

▷ Cucco (Creature)

Spirit Tracks

Chicken-like birds raised by town and farm folk alike. Usually they are not considered items. In *Spirit Tracks*, a cucco salesman raises them in Castle Town. A man in Aboda Village requires 10 birds, which Link must transport by train. Five birds are 50 rupees.

▷ Cucco Feathers (Other)

Tri Force Heroes

A common cucco feather. Cuccos regrow their feathers once per year. During that period they have no feathers and are completely exposed. Used as a material in the Robowear outfit.

▷ Cuccodex (Quest)

Oracle of Seasons

A book full of information about cuccos that Link receives from Dr. Left in *Oracle of Seasons*. If Link gives it to Malon in her home, he will be given a Lon Lon Egg in return.

▷ Cursed Medal (Equipment)

Skyward Sword

A medal received from Batreaux the friendly demon below the graveyard at Skyloft. It grants the effects of both the Rupee Medal and the Treasure Medal, but its curse disables the use of the Adventure Pouch.

▷ Cursed Tights (Equipment)

Tri Force Heroes

In exchange for doubling damage taken, Link has a high probability of dodging attacks. These tights are received as a reward for lifting Princess Styla's curse. They are technically a hand-me-down from the princess.

▷ Cyclone Slate (Critical)

Phantom Hourglass

Received from Golden Chief Cylos on the Uncharted Island. Drawing a specific shape on the touch screen will allow Link to warp to its location.

D COLUMN

Dapper Spinner (Equipment)

Tri Force Heroes

A dandy and gentlemanly thief's outfit. In addition to a regular Spin Attack, this outfit allows Link to perform a quick Spin Attack by pressing the attack button three times in a row.

Dark Ore (Other)

Spirit Tracks

One of the materials requested for transport by Linebeck III at the Trading Post. Link can buy some from the Gorons in the Dark Ore Mine. It is a mysterious element that disappears in sunlight.

Dark Pearl Loop (Other)

Phantom Hourglass Spirit Tracks

A treasured item that can be exchanged for a sizable haul of rupees. In *Spirit Tracks*, Dark Pearl Loops can also be traded for Train Cars.

Deku Hornet (Creature)

Skyward Sword

These insects are extremely wary of people and will swarm anyone who approaches their nest. The venom in their stingers smarts, and they will cling to the person they sting. Approaching a hornet nest requires caution.

Deku Leaf (Tool)

The Wind Waker

A leaf received from the Great Deku Tree in Forest Haven. It uses magic power to glide through the sky on the wind and can blow things out of the way with powerful gusts.

Deku Mask (Equipment)

Majora's Mask

When Link first follows Skull Kid into Termina, he is turned into a Deku Scrub. By playing the Song of Healing, Link breaks the curse and acquires this mask, which allows him to transform into a Deku Scrub at will.

Deku Nut (Tool)

Ocarina of Time Majora's Mask

Throwing them creates a blinding light. In *Majora's Mask*, Deku Nuts act like bombs when dropped while flying.

Deku Pipes (Critical)

Majora's Mask

When transformed into a Deku Scrub, Link can play ocarina melodies on these pipes in place of the Ocarina of Time. The instrument's use and effects are the same.

Deku Princess (Quest)

Majora's Mask

The Deku Princess is being held against her will in Woodfall Temple. Link saves the princess by clearing the temple and escorts her to the Deku Palace by carrying her in a bottle.

Deku Seed (Tool)

● Pumpkin Seed

Ocarina of Time Twilight Princess Skyward Sword

Small, light seeds used as ammunition for the slingshot. They are often dropped by plant-based monsters like Deku Babas. The slingshot in *Four Swords Adventures* also uses Deku Seeds, but it fires an unlimited amount and they do not appear as an item on their own. See also Mystery Seed.

Deku Shield (Equipment)

Ocarina of Time

A shield small enough to be carried by children. It can block attacks and repel Deku Seeds, but since it is made of wood, it will burn if exposed to fire.

Deku Stick (Tool)

Ocarina of Time Majora's Mask

A long stick taken from a Deku Baba. The tip can be set on fire. It can be used as a weapon, but breaks easily.

Delivery Bag (Collection)

The Wind Waker

A bag commonly used by the Rito. Link can obtain one from Quill on Dragon Roost Island to store items and letters received from other people.

Deluxe Picto Box (Tool)

The Wind Waker

A special version of the standard Picto Box that can capture images in color. See also Picto Box.

Demon Fossil (Other)

Spirit Tracks Tri Force Heroes

A low-value treasure used for Train Cars in *Spirit Tracks*. It is also a material in *Tri Force Heroes*.

Diamond Card (Quest)

Spirit Tracks

Proof of Diamond Membership at Beedle's Shop, obtained after accumulating 2,000 points. With this card, Link is able to purchase all items for 50% off.

Digging Mitts (Tool)

Skyward Sword

Claw-like gloves for digging into the earth. Passed down among the Mogma, they can be used to dig up items in certain locations. See also Mogma Mitts.

Dimitri's Flute (Critical)

Oracle series

A flute that summons Dimitri, a red dragon who will carry Link across water. See also Strange Flute.

Din's Charm (Equipment)

The Minish Cap

Din will place this in one of Link's bottles if he finds her a house in Hyrule Town. Using it turns Link's outfit red and temporarily boosts his attack power.

Din's Fire (Equipment)

Ocarina of Time

Fire magic that expands outward in a dome. Outside of combat, it can be used to light candles. Din is the name of the Goddess of Power, one of three goddesses who created the world. Obtained from a Great Fairy.

Din's Pearl (Critical)

The Wind Waker

A pearl given to Komali's grandmother by Valoo, the sky spirit, and held by the prince. It is one of the three Goddess Pearls necessary to make the Tower of the Gods appear.

Divine Shield (Equipment)

Skyward Sword

Gondo at the Scrap Shop upgrades the Sacred Shield upon request. It has low durability, but will cause some monsters to flee when readied. See also Goddess Shield.

Divine Whiskers (Other)

Tri Force Heroes

Whiskers from the snout of a sacred beast, grown over millennia. Beard fanatics will pay a hefty price for them. The animal-themed Cheetah Costume uses these whiskers as a material.

Dog Food (Quest)

Link's Awakening The Minish Cap

In *Link's Awakening*, Link can give it to Sale, who in turn rewards Link with a bushel of bananas. In *The Minish Cap*, Link gives dog food to Fifi the dog. It is kept in a bottle instead of a tin can.

Doggie Mask (Quest)

Oracle of Ages

Obtained from the Happy Mask Salesman. If Link gives this mask to Mamamu Yan, who wants to cover her dog's face, she will give him a Dumbbell as thanks.

Doll (Consumable)

The Adventure of Link

A doll that grants an extra life. A handful are hidden throughout Hyrule.

Dominion Rod (Tool)

Twilight Princess

Obtained in the Temple of Time, this rod can breathe life into statues, which copy the movements of the wielder. It was made by the Oocca in ancient times. See also Ancient Sky Book.

Don Gero's Mask (Equipment)

Majora's Mask

Obtained in exchange for giving a freezing Goron a Rock Sirloin. Link uses the mask to speak to frogs and unites five to form a choir, which he can then conduct for a Piece of Heart.

Double Clawshots (Tool)

Twilight Princess

When Link finds a second Clawshot in the City in the Sky, he can wield these Double Clawshots. When he wears them on both arms, they allow continuous movement between targets without touching the ground.

Dragon Key (Quest)

Oracle of Seasons

This key opens the entrance to the Dancing Dragon Dungeon in *Oracle of Seasons*.

Dragon Scale (Other)

Spirit Tracks

A reasonably valuable treasure that can be used for Train Cars. It is said that this scale came from a dragon, but no one really knows its origin.

Dragon Sculpture (Dungeon)

Skyward Sword

The Boss Key in the Earth Temple. The sculpture takes the form of a coiled dragon, made of gold with an elaborate head carving.

Dragon Tingle Statue (Other)

See Tingle Statue.

Dumbbell (Quest)

Oracle of Ages

A workout weight in *Oracle of Ages* obtained from Mamamu Yan. Thomas in Symmetry Village will give Link the Cheesy Mustache in exchange for it.

Dunewalker Duds (Equipment)

Tri Force Heroes

Clothes modeled after a king of the desert. They generate a mysterious power underfoot, allowing the wearer to move on sand without sinking.

Dungeon Map (DUNGEON)
● Map

The Legend of Zelda | A Link to the Past | Link's Awakening | Ocarina of Time

Majora's Mask | Oracle series | The Wind Waker | The Minish Cap

Twilight Princess | Skyward Sword

A map from a dungeon treasure chest. It reveals every floor and room in the dungeon where it is found. From *A Link to the Past* onward, previously visited rooms are marked with a different color.

Dusk Relic (OTHER)

Skyward Sword

A rare ornament obtained only in the Silent Realm. Similar in appearance to an Amber Relic except purple in color, it is used to improve the Sacred Shield.

E COLUMN

Earth Element (CRITICAL)

The Minish Cap

Obtained in Deepwood Shrine. It is the crystallized source for all power that rises from the earth. Required for bringing out the power of the White Sword.

Earth Tingle Statue (OTHER)

See Tingle Statue.

Echoing Howl (CRITICAL)

Oracle of Ages

One of the eight Essences of Time in *Oracle of Ages*. It is found in the Skull Dungeon.

Eldin Ore (OTHER)

Skyward Sword

An extremely hard ore excavated in Eldin Province. This ore is widely used to strengthen weapons and shields. It can even be dug up from holes in the ground.

Eldin Roller (CREATURE)

Skyward Sword

This bug rolls a round object everywhere, even while fleeing. It lives primarily underground and will hide in holes if discovered. The balls they roll are made of unidentified material.

Elixir Soup (CONSUMABLE)

The Wind Waker

Grandma's homemade soup, stored in a bottle. It fully restores health and magic upon drinking it and even doubles attack power until Link next takes damage.

Ember Seed (TOOL)

Oracle series

A seed that emits flames when touched. In *Oracle of Seasons*, using Ember Seeds to light the lamps in the biologist's house results in him giving Link the Cuccodex.

Emerald Tablet (CRITICAL)

Skyward Sword

An ancient stone tablet. It has the power to open the way to the Sealed Grounds. Faron Woods becomes accessible after placing it on the altar inside the Statue of the Goddess.

Empty Bottle (TOOL)
● Bottle

A Link to the Past | Ocarina of Time | Majora's Mask | The Wind Waker

The Minish Cap | Twilight Princess | Skyward Sword | A Link Between Worlds

A glass bottle that can carry all sorts of things inside it. The more bottles Link finds, the more he can prepare for the worst a dungeon might throw at him.

Energy Gear (EQUIPMENT)

Tri Force Heroes

An intense set of gear that increases the capacity of the stamina meter by 50%. It enables greater consecutive use of items.

Energy Potion (CONSUMABLE)

A Link Between Worlds

This potion will replenish the stamina meter when picked up. These potions can be found in pots or grasses, much like hearts or rupees.

Engine Grease (QUEST)

Oracle of Seasons

A trading item received from Tick Tock in *Oracle of Seasons*. Guru-Guru needs this grease to speed up the Windmill. In exchange for it, Guru-Guru will give Link a Phonograph.

Engineer's Clothes (EQUIPMENT)

Spirit Tracks

Link receives these after gathering 15 stamps from around Hyrule. Once they are obtained, he can change into these clothes by talking to Niko.

Eternal Spirit (CRITICAL)

Oracle of Ages

One of the eight Essences of Time in *Oracle of Ages*. It is found early in the game in the Spirit's Grave.

Ether Medallion (EQUIPMENT)

A Link to the Past

A medallion possessing lightning magic. Using it fires bright flashes of light that freeze monsters and reveal hidden floors.

Event Card (CONSUMABLE)

Four Swords Adventures
(Japanese version only)

Appears in "Navi Trackers." This card is required for participation in timed events like the bingo and quiz games.

Evil Crystal (OTHER)

Skyward Sword

Crystallized malice. Monsters with the ability to curse sometimes drop them. Despite the name, there is no harm in holding onto them.

Exotic Flower (QUEST)

The Wind Waker

This flower blossoms in regions to the south. Can be exchanged for a Sea Flower, Pinwheel, and Sickle Moon Flag. Link can get Magic Armor from Zunari once he obtains this flower.

Exquisite Lace (OTHER)

Tri Force Heroes

Obtained in the Fortress area of *Tri Force Heroes*, it is a type of lace of the finest quality. Something about it feels outdated, though. Used as a material in the Queen of Hearts outfit.

Extra Wallet (COLLECTION)

Skyward Sword

Carrying this in the Adventure Pouch will enable Link to carry up to 300 extra rupees once the main wallet is full. Up to three can be purchased from Beedle's Shop. See also page 95.

Eyeball Frog (QUEST)

Ocarina of Time

An ingredient for eye drops. Giving this to the Lake Scientist in the Lakeside Laboratory gives him what he needs to make the World's Finest Eye Drops.

F COLUMN

Fabled Butterfly (OTHER)

Tri Force Heroes

An ethereal butterfly, only visible to the valorous. Required to make the Sword Master Suit.

Face Key (QUEST)

Link's Awakening

This key unlocks the seal on the entrance to the Face Shrine.

Fairy (CONSUMABLE)

The Legend of Zelda | The Adventure of Link | A Link to the Past | Link's Awakening

Ocarina of Time | Majora's Mask | Oracle series | The Wind Waker

Four Swords | The Minish Cap | Twilight Princess | Skyward Sword

A Link Between Worlds

Interacting with a fairy restores Link's health. They can be caught and kept in bottles to revive Link when his health is depleted. The amount of health a fairy restores differs by title.

Fairy Bow (TOOL)

See Bow.

Fairy Dust (OTHER)

See Fairy Powder.

Fairy Ocarina (CRITICAL)

Ocarina of Time

A keepsake given to Link by Saria when he first leaves Kokiri Forest. Much like the Ocarina of Time, it can be used to play beautiful melodies with a variety of effects.

Fairy Powder (QUEST)
● Fairy Dust

Oracle series | Tri Force Heroes

This powder lifts the Fairy Queen's curse in *Oracle of Ages*. It is a material in *Tri Force Heroes*.

Fairy Slingshot (TOOL)

See Slingshot.

Falling Star (CRITICAL)

Oracle of Ages

One of the eight Essences of Time in *Oracle of Ages*. It is found late in the game in the Ancient Tomb.

▷ **Fancy Fabric** (Other)

Tri Force Heroes

A master artisan slaved over this for decades. It is a very pretty material used to make the elite Rupee Regalia.

▷ **Faron Grasshopper** (Creature)

Skyward Sword

This bug will jump around rapidly to escape would-be captors. Its jumping patterns are hard to anticipate. Many grasshoppers live in Faron Woods.

▷ **Farore's Charm** (Equipment)

The Minish Cap

Farore will place this in one of Link's bottles if he finds her a house in Hyrule Town. Using it temporarily boosts his defense and attack power.

▷ **Farore's Pearl** (Critical)

The Wind Waker

A pearl Link receives from the Great Deku Tree for saving Makar in the Forbidden Woods. It is one of the three Goddess Pearls and is used to make the Tower of the Gods appear.

▷ **Farore's Wind** (Equipment)

Ocarina of Time

Magic obtained from a Great Fairy that will warp Link to chosen points within dungeons. The first use creates a warp point, and the second returns Link to that location. Farore is the name of the Goddess of Courage who helped create the world.

▷ **Father's Letter** (Quest)

The Wind Waker

A letter from the leader of Dragon Roost Island to his son, Komali. Medli entrusts it to Link, and giving it to Komali makes it possible to talk to the initially hostile prince.

▷ **Fertile Soil** (Critical)

Oracle of Seasons

One of the eight Essences of Nature in *Oracle of Seasons*. It is found in the Gnarled Root Dungeon early in Link's adventure.

▷ **Fierce Deity Armor** (Equipment)

Tri Force Heroes

Armor containing power similar to the Fierce Deity's Mask in *Majora's Mask*. It increases attack power and enables the firing of beams in four directions.

▷ **Fierce Deity's Mask** (Equipment)

Majora's Mask

Earned by obtaining all the masks and then clearing the four stages inside the moon. When fighting bosses while wearing this mask, Link will transform into the Fierce Deity.

▷ **Fighter's Shield** (Equipment)
See Small Shield.

▷ **Fighter's Sword** (Equipment)
See Sword.

▷ **Figurines** (Collection)

The Wind Waker The Minish Cap

Small models of various characters that Link can collect in certain eras. In all, 136 can be purchased in exchange for Mysterious Shells in *The Minish Cap*. There are 134 in *The Wind Waker*, traded for photos from the Deluxe Picto Box at the Nintendo Gallery.

▷ **Fill-Up Coupon** (Consumable)

The Wind Waker

Giving this to Beedle will fill Link's health and magic, as well as max out his bomb and arrow supply.

▷ **Fire Arrow** (Tool)

Ocarina of Time Majora's Mask The Wind Waker

An arrow that will ignite whatever it hits. It has the power to light distant torches and melt ice.

▷ **Fire Blazer** (Equipment)

Tri Force Heroes

An outfit for heroes who wield fire. It powers up the Fire Gloves, allowing three fireballs to be fired at once. It also increases the size of the fireballs.

▷ **Fire Element** (Critical)

The Minish Cap

Obtained in the Cave of Flames, these crystallized flames bring warmth and illuminate the darkness. One of the Elements that add power to the White Sword.

▷ **Fire Gloves** (Tool)

Tri Force Heroes

These enable the wearer to shoot fireballs in the direction they are facing. They can also light candles and melt ice. The fireballs bounce when thrown and ricochet off walls.

▷ **Fire Medallion** (Critical)

Ocarina of Time

One of six medallions that grant Link the power of the sages. After clearing the Fire Temple, Darunia awakens as the Sage of Fire and presents this sacred artifact to Link to aid in the looming battle with Ganon.

▷ **Fire Rail Map** (Quest)

Spirit Tracks

A stone tablet located on the seventeenth floor of the Tower of Spirits. Obtaining it restores the Spirit Tracks in the Fire Realm.

▷ **Fire Rod** (Tool)

A Link to the Past Four Swords Adventures A Link Between Worlds

This magical staff shoots flames that can damage monsters as well as light distant lamps.

▷ **Fire Seal** (Critical)

Spirit Tracks

An item obtained as proof of repairing the barrier in the Fire Realm.

▷ **Fireshield Earrings** (Equipment)

Skyward Sword

One of the divine treasures left by the goddess for Link. Obtained by clearing Din's Silent Realm. These earrings allow the wearer to withstand high temperatures without burning.

▷ **Fish** (Creature)

Ocarina of Time Majora's Mask Oracle of Seasons Spirit Tracks

Fish can be carried in bottles in *Ocarina of Time* and *Majora's Mask*. A fish can be exchanged for the Megaphone in *Oracle of Seasons*. In *Spirit Tracks*, they are transported as freight.

▷ **Fish Journal** (Collection)

Twilight Princess

A fishing journal specifically for buoy fishing. The journal enables Link to track the types, sizes, and number of fish caught in each province.

▷ **Fishing Hole Pass** (Other)

Majora's Mask 3D

This pass allows Link free access to the Fishing Hole, added in the 3DS version. It is a prize for completing certain minigames.

▷ **Fishing Hook** (Quest)

Link's Awakening

Grandma Ulrira in Mabe Village gives this hook to Link as thanks for a broom. See also Necklace.

▷ **Fishing Rod** (Tool)

Ocarina of Time Majora's Mask Twilight Princess Phantom Hourglass

A common tool for catching fish. In *Ocarina of Time* and *Majora's Mask*, Link can rent a rod at the Fishing Pond, but he is not permitted to take it beyond the area around the pond. In *Phantom Hourglass* and *Twilight Princess*, Link can use it anywhere there are fish to catch. *Twilight Princess* has two types: Bobber and Lure. Link can also fish in a pond north of Mabe Village in *Link's Awakening*.

▷ **Flame Lantern** (Tool)
See Lantern.

▷ **Flippers** (Tool)
● Zora's Flippers

A Link to the Past Link's Awakening Oracle series The Minish Cap

A Link Between Worlds

This item allows Link to swim in water without drowning. Those received from Zora leaders are called Zora's Flippers.

▷ **Floodgate Key** (Quest)

Oracle of Seasons

A key in *Oracle of Seasons* to unlock the entrance to Poison Moth's Lair.

▷ **Fluffy Fuzz** (Other)

Tri Force Heroes

So soft, you'll want to rub your face all over it. It is very warm, so it is used as a material for the Cozy Parka and Tingle Tights.

▷ **Flute** (Critical)
● Recorder / ▲ Whistle

The Legend of Zelda The Adventure of Link

Playing this item warps Link to various places and has a variety of other effects. In *The Adventure of Link*, it has an effect on certain monsters and can even make hidden places appear. See also Ocarina.

▷ **Food** (Consumable)

The Legend of Zelda

Food beloved by certain monsters. Pulling it out will lure enemies, who can be defeated while their guard is down. It is also sometimes demanded as a toll.

▷ **Fool's Ore** (Quest)

Oracle of Seasons

Appearing in *Oracle of Seasons*, this fake ore is left behind by the Subrosian Strange Brothers in place of Roc's Feather.

▷ **Forbidden Tingle Statue** (Other)
See Tingle Statue.

Force Fairy (Consumable)

A valuable ally who will fully restore Link's health and increases the number of times he can continue after his health is depleted.

Four Swords Adventures

Force Gem (Critical)

Four Swords Adventures *Phantom Hourglass* *Spirit Tracks*

In *Four Swords Adventures*, collecting these grants the power to banish evil to the Four Sword. In *Phantom Hourglass*, they are related to a mechanic. They can also be obtained in *Spirit Tracks* by helping people.

Forest Firefly (Creature)

A firefly native to Forest Haven. It can be captured in a bottle. After becoming Lenzo's Research Assistant, Link can bring him one of these to upgrade the Picto Box to the Deluxe Picto Box.

The Wind Waker

Forest Medallion (Critical)

One of six medallions that grant Link the power of the sages. After clearing the Forest Temple, Saria awakens as the Sage of Forest and presents this sacred artifact to Link to aid in the looming battle with Ganon.

Ocarina of Time

Forest Rail Map (Critical)

A stone tablet located on the third floor of the Tower of Spirits. Obtaining it restores the Spirit Tracks in the Forest Realm.

Spirit Tracks

Forest Seal (Critical)

An item obtained as proof of repairing the barrier in the Forest Realm.

Spirit Tracks

Forest Water (Other)

Mystical water that only exists in Forest Haven. Bottling and using it to water the withered trees on eight islands restores their health. Soon after it leaves the forest, it will turn into standard water.

The Wind Waker

Forgotten Sword (Equipment)

A specially made sword forgotten at the blacksmith's by the captain of the Hyrule guard. It is not expensive, but it is comfortable to wield. Link uses this until he obtains the Master Sword.

A Link Between Worlds

Fortified Shield (Equipment)

A further upgrade to the Reinforced Shield, making it the most powerful form of the Iron Shield. It boasts the most durability of any shield in *Skyward Sword*, but electricity passes right through it.

Skyward Sword

Foul Fruit (Tool)

A mysterious fruit sold in shops around Hyrule. It can be carried in bottles, and using it will stun nearby enemies.

A Link Between Worlds

Fountain Idol (Quest)

A strange ceramic statue with a water motif. It is carried by the Traveling Merchants and can be traded for the Sickle Moon Flag or the Skull Tower Idol.

The Wind Waker

Four Sword (Equipment)

 (fourth image)

A Link to the Past *Four Swords* *Four Swords Adventures* *The Minish Cap*

A sword that can split Link into four versions of himself.

Freebie (Other)

Obtained when Link fails to win the Daily Riches game. It may come in handy one day, so don't lose it! Used as a material in the Dapper Spinner outfit.

Tri Force Heroes

Freebie Card (Consumable)

Phantom Hourglass *Spirit Tracks*

A coupon for one free item from Beedle's Shop. This is a Silver Membership perk in *Phantom Hourglass* and *Spirit Tracks*.

Freezard Water (Other)

Formerly a Freezard, now the purest of pure water. Used as a material to make the Tingle Tights and Hammerwear.

Tri Force Heroes

Fresh Kelp (Other)

Kelp found in some rivers and lakes. It grows far from the sea and is low in minerals, but it has its uses as a material in the water-themed Zora Costume and Torrent Robe.

Tri Force Heroes

Friendly Token (Other)

Received from a hero-like youth when playing with someone online for the first time. It is used as a material in the Tri Suit and Timeless Tunic.

Tri Force Heroes

Frilly Fabric (Other)

A Street Merchant exclusive. It is supposedly handmade. Used as a material for the Cheer Outfit.

Tri Force Heroes

Full Moon Cello (Critical)

Obtained by clearing the Tail Cave dungeon, this cello is one of eight instruments needed to perform the Ballad of the Wind Fish.

Link's Awakening

Funny Joke (Quest)

A quest item, depicted as a bow tie, given to Link by the Comedian. Telling this joke to the depressed boy Dekadin in Lynna Village will not make him laugh, but he does give Link a Touching Book.

Oracle of Ages

Fused Shadow (Critical)

Holds the magical power of those who threatened the Sacred Realm and were sealed away by the Light Spirits. Anyone who touches the Fused Shadow will gain dark powers and be transformed. Pieces of the shadow are in the Forest Temple, Goron Mines, and Lakebed Temple.

Twilight Princess

G G COLUMN

Gale Boomerang (Tool)

A boomerang possessed by the Fairy of Winds. It is able to create violent tornadoes when thrown, as well as spin propellers and lift light items like bombs, carrying them on the wind in its wake.

Twilight Princess

Gale Seed (Tool)

This seed allows Link to warp to locations where Mystical Trees are growing. They can be used as ammunition in the Slingshot or Seed Shooter to blow enemies away.

Oracle series

Garo's Mask (Equipment)

Majora's Mask *Majora's Mask 3D*

A mask obtained by winning a horse race against the Gorman brothers. Wearing it will make the Garo Ninjas in Ikana mistake Link for their leader and reveal themselves. It differs in appearance between the original and 3D versions.

Gasha Seed (Consumable)

Planting these in Soft Soil will produce trees with nuts that contain items. A nut's contents are random and include rings, rupees, and Magic Potions.

Oracle series

Gerudo Dragonfly (Creature)

Many of these dragonflies live in the Lanayru Desert. They fly so quickly that they are hard to catch, but it's possible if you carefully sneak up on them.

Skyward Sword

Gerudo Mask (Equipment)

A mask resembling a Gerudo, ideal for dressing like a woman. It generates some fun reactions.

Ocarina of Time

Gerudo Token (Quest)

Proof of friendship with the Gerudo. With it, Link can walk freely around their fortress and gain access to both the Haunted Wasteland and the Training Ground.

Ocarina of Time

Ghastly Doll (Quest)

A trading item received from Maple that appears in *Oracle of Seasons*. Mrs. Ruul will exchange an Iron Pot for it.

Oracle of Seasons

Ghost Key (Quest)

This key is required to save Tetra, who is imprisoned on the Ghost Ship. It is obtained after defeating the Cubus Sisters.

Phantom Hourglass

Ghost Lantern (Tool)

Appears only in *Twilight Princess HD*. This lantern reveals the locations of Poes that only appear at night. If it senses a Poe, it will light up.

Twilight Princess HD

Ghost Ship Chart (Other)

This chart shows when the Ghost Ship will appear based on the position of the moon. It enables Link to find and board the ship.

The Wind Waker

Giant Bomb Bag (Collection)

See Biggest Bomb Bag.

Giant Quiver (Collection)

See Biggest Quiver.

Giant Wallet (Collection)

A sizable wallet given to Link for showing 50 Gratitude Crystals to Batreaux. As big as its name implies. Link can stuff up to 5,000 rupees inside it. See also page 95.

Skyward Sword

Giant's Knife (Equipment)

This giant sword has double the attack power of the Master Sword, but it is fragile and likely to break. It is a two-handed sword, so it cannot be wielded with a shield.

Ocarina of Time

Column 1

▷ **Giant's Mask** (Equipment)

Majora's Mask

Obtained in the inverted Stone Tower Temple. Wearing this while battling Twinmold, the boss of Stone Tower Temple, transforms Link into a giant.

▷ **Giant's Wallet** (Collection)

● Giant Wallet

Ocarina of Time *Majora's Mask* *Twilight Princess*

A very large wallet. It can hold even more rupees than the Adult's Wallet. See also page 95.

▷ **Gibdo Bandage** (Other)

Tri Force Heroes

A bandage from a mummy-like Gibdo. Gibdos like to clean, much like cats. They are not as cute, though. Used as a material in Gust Garb and the Ninja Gi.

▷ **Gibdo Mask** (Equipment)

Majora's Mask

Healing Pamela's Father in the Music Box House grants Link this mask. Wearing it makes it possible to talk to Gibdos. It also makes ReDeads dance.

▷ **Gift of Time** (Critical)

Oracle of Seasons

One of the eight Essences of Nature in *Oracle of Seasons*. It is found in the Snake's Remains dungeon.

▷ **Gilded Sword** (Equipment)

Majora's Mask

A Razor Sword tempered with Gold Dust. The blade will never break and can be used beyond time. It has increased attack power and range.

▷ **Glittering Spores** (Consumable)

Skyward Sword

These spores can be harvested from glittering mushrooms in Faron Woods. They have a variety of effects, from stunning enemies to changing a rupee's color.

▷ **Gnarled Key** (Quest)

Oracle of Seasons

This key opens the entrance to the Gnarled Root Dungeon in *Oracle of Seasons*.

▷ **Gnat Hat** (Tool)

Four Swords

A magical hat that can shrink its wearer down to a minuscule size. It enables the use of passages and platforms that are otherwise far too small.

▷ **Goddess Longsword** (Equipment)

Skyward Sword

The upgraded Goddess Sword, reforged with Farore's Flame found in the Ancient Cistern. The blade is longer than that of the Goddess Sword, and its attack power increases.

▷ **Goddess Plume** (Other)

Skyward Sword

Rumors say this item was dropped by the goddess in a long-forgotten era. It's a legendary treasure few will ever behold!

▷ **Goddess Shield** (Equipment)

Skyward Sword

Upgrading the Divine Shield creates the Goddess Shield, which has exceedingly high durability. However, it is still more likely to break than other shields. A Blue Bird Feather is required before the shield can be upgraded.

Column 2

▷ **Goddess Sword** (Equipment)

Skyward Sword

This sword rests in the pedestal within the Goddess Statue. Only the chosen hero may draw it, and it is said he will form a pact with the spirit within it, enabling him to use the power of a goddess.

▷ **Goddess Tingle Statue** (Other)

See Tingle Statue.

▷ **Goddess White Sword** (Equipment)

Skyward Sword

The Goddess Longsword becomes this after it is forged with Nayru's Flame, an item found on the Sandship. Its dowsing abilities are enhanced.

▷ **Goddess's Harp** (Critical)

Skyward Sword

A beautiful-sounding harp said to have been used by the goddess Hylia. Zelda is in possession of it but later entrusts it to Link. Playing it provides the power to guide those who have a divine destiny.

▷ **Gohma's Eye** (Other)

Tri Force Heroes

A crafted Gohma's Eye. The eyelid is gold and the eyeball is emerald, so it is actually quite valuable. Used as a material in the Lucky Loungewear.

▷ **Goht's Remains** (Critical)

Majora's Mask

A mask left behind after defeating Goht, the mechanical creature that plagues Snowhead Temple, and freeing its spirit.

▷ **Gold Card** (Quest)

Spirit Tracks

Proof of Gold Membership at Beedle's Shop, obtained after accumulating 500 points. Link gets a 20% discount on all items and a bonus Piece of Heart.

▷ **Gold Dust** (Other)

Majora's Mask *Tri Force Heroes*

This gold powder is the prize for winning the Patriarch's Race in *Majora's Mask*, which opens when the snow melts after clearing Snowhead Temple. It is required to upgrade the Razor Sword to the Gilded Sword. In *Tri Force Heroes*, Gold Dust is used as a material for the Sword Master Suit.

▷ **Golden Bee** (Creature)

● Good Bee (Super Nintendo)

A Link to the Past *A Link Between Worlds*

A rare bee valued for its powerful sting. If Link manages to catch one, certain people are willing to buy them for a significant number of rupees. See also Bee.

▷ **Golden Bug** (Creature)

Twilight Princess

Glowing bugs found throughout Hyrule. There are 12 types, each with a male and female version. Agitha will trade them for rupees or a wallet depending on the number delivered.

▷ **Golden Carving** (Dungeon)

Skyward Sword

An item that acts as the Boss Key in Skyview Temple. This oddly shaped carving is made of gold and its surface is engraved with a mysterious pattern. Link must adjust the angle so that it fits the lock.

▷ **Golden Feather** (Other)

The Wind Waker

A Rito on Dragon Roost Island named Hoskit wants to give his girlfriend Golden Feathers. After Link gathers 20 of them, Hoskit sends him a Piece of Heart in the mail along with his thanks.

Column 3

▷ **Golden Gauntlets** (Equipment)

Ocarina of Time

Gauntlets that grant the wearer the strength to lift giant pillars that even the Silver Gauntlets could not handle.

▷ **Golden Insect** (Other)

Tri Force Heroes

A golden, glittering insect obtained in the desert. Some of these are worth more than actual gold. Used as a material in the Sword Master Suit.

▷ **Golden Leaf** (Quest)

Link's Awakening

Five of these Golden Leaves are hidden in and around Kanalet Castle. Prince Richard requests Link's help in gathering them after the prince is thrown out of the castle by rebellious servants.

▷ **Golden Scale** (Equipment)

Ocarina of Time

A Zora scale that glitters like gold. Once obtained, it allows the user to dive even farther down into water than by using the Silver Scale. It is earned by catching a record-setting fish at the Fishing Pond.

▷ **Golden Skull** (Other)

Skyward Sword

A real rarity among skull ornaments, these are occasionally dropped by Bokoblins. Though they glisten like gold, there are rumors they are not actually made of it.

▷ **Golden Skulltula Spirit** (Other)

See Token.

▷ **Good Bee** (Creature)

See Golden Bee.

▷ **Good Soup** (Consumable)

Twilight Princess

The Simple Soup made by Yeto in Snowpeak Ruins after it has been flavored with an Ordon Pumpkin. It has a sweet smell. See also Superb Soup.

▷ **Goron Amber** (Other)

Phantom Hourglass *Spirit Tracks*

A treasure that can be exchanged for rupees. In *Spirit Tracks*, it can also be exchanged for Train Cars.

▷ **Goron Drums** (Critical)

Majora's Mask

While transformed into a Goron, Link plays melodies on these drums in place of the Ocarina of Time. Though they produce a very different sound, their use and effects are no different from the ocarina.

▷ **Goron Garb** (Equipment)

Tri Force Heroes

A full-body suit that gives Link the resilience of a Goron. When wearing it, he can move around in lava without getting hurt. It also nullifies any damage from fire.

▷ **Goron Iron** (Other)

Spirit Tracks

A material requested for transport by a Lumberjack in Whittleton. Twenty pieces of Goron Iron can be purchased in Goron Village for 100 rupees.

▷ **Goron Mask** (Equipment)

Ocarina of Time *Majora's Mask*

A round and friendly looking Goron mask available for purchase in *Ocarina of Time*. It generates some fun reactions. In *Majora's Mask*, Link gets the far more powerful version after healing the spirit of Darmani the Third, hero of the Gorons at Snowhead. It enables Link to transform into a Goron when worn.

▷ **Goron Ore** (OTHER)

Tri Force Heroes

A sturdy ore resistant to flames and heat, named for its Goron-like sturdiness. And musk. It is used as a material for the Goron Garb (naturally) and the Boomer-anger outfit.

▷ **Goron Tunic** (EQUIPMENT)

Ocarina of Time

An outfit especially strong against heat. It outright nullifies damage from things like lava tiles.

▷ **Goron Vase** (QUEST)

Oracle of Seasons

Link can trade this vase to Ingo in *Oracle of Seasons* for the fish. In *Oracle of Ages*, giving it to a particular Goron yields Goronade.

▷ **Goron's Bracelet** (EQUIPMENT)

Ocarina of Time

A bracelet bearing the Goron emblem. It enables Link to pull up Bushes and Bomb Flowers. Link receives it from Darunia, the leader of the Gorons.

▷ **Goron's Ruby** (CRITICAL)

● Spiritual Stone of Fire

Ocarina of Time

A treasure passed down over generations among the Gorons. Also known as the Spiritual Stone of Fire, it is one of three jewels required to open the Door of Time. The ruby is rumored to have a sweet flavor if licked.

▷ **Goronade** (QUEST)

Oracle of Ages

An energy drink Link gives to the Goron who runs the "Big Bang Game" in *Oracle of Ages*. Winning the minigame yields the Old Mermaid Key.

▷ **Grappling Hook** (TOOL)

The Wind Waker Phantom Hourglass

The claw on the end of the rope can latch onto posts and beams, enabling Link to cross gaps between platforms. It is required for salvaging.

▷ **Gratitude Crystal** (OTHER)

Skyward Sword

Doing good deeds for people in Skyloft will cause their gratitude to materialize as crystals. These crystals can also be found around the islands, but only at night.

▷ **Graveyard Key** (QUEST)

Oracle of Ages The Minish Cap

This key opens the gate to a graveyard. Similar keys appear in both *The Minish Cap* and *Oracle of Ages*.

▷ **Great Fairy Chart** (OTHER)

The Wind Waker

A chart that reveals the locations of Great Fairies, who will increase Link's rupee and bomb limits, as well as the size of his magic meter.

▷ **Great Fairy Mask** (EQUIPMENT)

Majora's Mask

Received for helping the Great Fairy in Clock Town. Wearing it will cause Stray Fairies to approach without hesitation.

▷ **Great Fairy's Sword** (EQUIPMENT)

Majora's Mask

Collect all of the Stray Fairies in the Stone Tower Temple and return them to the Fairy's Fountain to receive this sword. It is a large, two-handed sword with the highest attack power in the game.

▷ **Great Fairy's Tears** (CONSUMABLE)

Twilight Princess

Said to be the bottled tears of a Great Fairy. They can be found in the deepest reaches of the Cave of Ordeals. Jovani also has a bottle, which he will trade for Poe Souls. Drinking them will fully restore Link's health and temporarily boost attack power.

▷ **Green Apple** (CONSUMABLE)

A Link Between Worlds

This common fruit sometimes grows on the StreetPass Tree that Gramps plants for Link in *A Link Between Worlds*. Green Apples can be carried in bottles and restore three hearts when consumed. They are not as sweet as Red Apples.

▷ **Green Chu Jelly** (CONSUMABLE)

The Wind Waker Twilight Princess

Jelly left behind by slain Green Chuchus. It is used as an ingredient in Green Potions. Drinking it in *Twilight Princess* has no effect.

▷ **Green Clothes** (EQUIPMENT)

● Green Tunic

A Link to the Past Link's Awakening A Link Between Worlds

A familiar outfit worn by Link at the beginning of his adventures.

▷ **Green Picolyte** (CONSUMABLE)

The Minish Cap

This potion makes it easier to find Mysterious Shells for a short time when searching grass and other places where shells are found. Beedle will sell it to Link in Hyrule Town if Link has an empty bottle.

▷ **Green Potion** (CONSUMABLE)

● Medicine of Magic

A Link to the Past Ocarina of Time Majora's Mask The Wind Waker

This potion can fully restore Link's magic power. It can be carried in bottles.

▷ **Green Royal Jewel** (CRITICAL)

Four Swords Adventures

A jewel guarded by a green knight, one of the Knights of Hyrule serving the royal family. Collecting this, along with the red, blue, and purple jewels, opens the path to the Palace of Winds in the Realm of the Heavens.

▷ **Green Tunic** (EQUIPMENT)

See Green Clothes.

▷ **Grip Ring** (EQUIPMENT)

The Minish Cap

This special ring can be purchased from a Business Scrub at Mount Crenel. It gives Link the ability to climb the mountain's craggiest cliff sides.

▷ **Gripshot** (TOOL)

Tri Force Heroes

Launches a chain with a robotic clamp attached to the end. Enables the user to grab onto posts or allies and pulls toward them. Can also tear away some enemies' shields. See also Hookshot.

▷ **Guard Notebook** (QUEST)

Phantom Hourglass

A notebook lost by Maritime Defense Force member Nyave. It is recovered by the Ho Ho Tribe. Link can obtain the notebook by trading it for the Kaleidoscope.

▷ **Guardian Acorn** (CONSUMABLE)

Link's Awakening

These sometimes appear after defeating enemies. They halve the damage taken by Link. The effect disappears after getting hit three times or moving to a different area.

▷ **Guardian Potion** (CONSUMABLE)

Skyward Sword

Drinking this potion halves the damage Link takes from enemies for three minutes. It can be purchased at Luv and Bertie's Potion Shop, an expensive option for increasing defense at 200 rupees.

▷ **Guardian Potion+** (CONSUMABLE)

Skyward Sword

An enhanced version made by turning in certain bugs and a Guardian Potion to Luv and Bertie's. Drinking this potion nullifies all damage from enemies for three minutes.

▷ **Gust Bellows** (TOOL)

See Gust Jar.

▷ **Gust Garb** (EQUIPMENT)

Tri Force Heroes

A magical outfit that controls the wind. It reduces the time it takes for the Gust Jar to puff out air, increasing its range by 50% and doubling the size of its puffs.

▷ **Gust Jar** (TOOL)

● Gust Bellows

The Minish Cap Skyward Sword Tri Force Heroes

This item can suck air in and blast it out. It can draw enemies and objects toward it and fire puffs of air. In *Tri Force Heroes*, the jar can also carry allies across gaps between platforms. The Air Cannons in *Four Swords Adventures* act similarly, but instead shoot air that sends Link flying.

▷ **Gyorg's Remains** (CRITICAL)

Majora's Mask

Obtained from defeating Gyorg, the boss of Great Bay Temple. This mask remains after freeing Gyorg's spirit.

H H COLUMN

▷ **Hammer** (TOOL)

● Skull Hammer

The Adventure of Link The Wind Waker Phantom Hourglass A Link Between Worlds

Tri Force Heroes

In *The Legend of Zelda*, this tool can smash rocks and knock down trees. In other games, like *The Wind Waker*, it can also smash in tall switches or posts.

▷ **Hammerwear** (EQUIPMENT)

Tri Force Heroes

An outfit that closely resembles hammer wielders from some unknown army. The outfit increases the swing speed of the Hammer, increases the shock wave's range, and doubles the attack power of hammer blows.

▷ **Handy Glove** (EQUIPMENT)

The Adventure of Link

A divine glove brimming with power. Wearing it allows Link to break blocks in palaces with his sword.

▷ **Hard Ore** (QUEST)

Oracle of Seasons

This sturdy metal ore is made by combining Red and Blue Ore. Taking it to the Subrosian Smithy will make it possible to upgrade the Wooden Shield to the Iron Shield.

▷ **Harp of Ages** (CRITICAL)

Oracle of Ages

Enables Link to travel between the past and present in *Oracle of Ages*. He can learn three songs to play on the harp, each with different effects: the Tune of Echoes, the Tune of Currents, and the Tune of Ages.

Column 1

▷ Hawkeye (Tool)

Twilight Princess

A telescope-like tool for getting a better look at faraway objects. It can be purchased at Malo Mart. When paired with the Bow, it can be used to hit distant targets.

▷ Heart (Consumable)

The Legend of Zelda · A Link to the Past · Link's Awakening · Ocarina of Time

Majora's Mask · Oracle series · The Wind Waker · Four Swords

Four Swords Adventures · The Minish Cap · Twilight Princess · Phantom Hourglass

Spirit Tracks · Skyward Sword · A Link Between Worlds · Tri Force Heroes

Hearts represent Link's life. They appear after defeating enemies, cutting grass, and breaking pots, among other things. In some titles they are also sold by merchants. The number of hearts Link has varies depending on how many containers he has found. They are sometimes called Recovery Hearts.

▷ Heart (Green) (Consumable)

Phantom Hourglass

Obtained when out at sea. It will restore the durability of the ship.

▷ Heart Container (Collection)
● Bowl of Hearts

The Legend of Zelda · The Adventure of Link · A Link to the Past · Link's Awakening

Ocarina of Time · Majora's Mask · Oracle series · The Wind Waker

Four Swords · Four Swords Adventures · The Minish Cap · Twilight Princess

Phantom Hourglass · Spirit Tracks · Skyward Sword · A Link Between Worlds

A Heart Container increases the maximum number of hearts Link can hold and also restores his health to full. They are mainly obtained by defeating a dungeon's boss, and can also be assembled by collecting four or five Pieces of Heart. This item is called Bowl of Hearts in *The Adventure of Link*.

▷ Heart Medal (Equipment)
Skyward Sword

One of several medals Link can acquire in *Skyward Sword* that have beneficial effects when carried. Holding the Heart Medal makes hearts more likely to appear. Carrying two doubles the effect.

▷ Heart Potion (Consumable)
Skyward Sword

Drinking this potion will restore eight hearts. These can be purchased from the Potion Shop in Skyloft if Link has an empty bottle to keep it in. See also Red Potion.

Column 2

▷ Heart Potion+ (Consumable)

Skyward Sword

An enhanced Heart Potion made by mixing in bugs given to Bertie at the Potion Shop. Drinking it fully restores Link's health.

▷ Heart Potion++ (Consumable)

Skyward Sword

A further enhanced Heart Potion+. Drinking it fully restores Link's health. It can be used twice.

▷ Helmaroc Plume (Other)

Phantom Hourglass

A reward from treasure boxes and mini-games. Each plume can be exchanged for rupees. It is said that they are dropped by monstrous Helmaroc birds.

▷ Hero's Bow (Tool)
See Bow.

▷ Hero's Charm (Tool)

The Wind Waker

A mysterious charm that makes it possible to see a targeted enemy's remaining health when equipped.

▷ Hero's Clothes (Equipment)

The Wind Waker · Twilight Princess

Green clothes said to have been worn by an ancient hero. Worn to celebrate coming of age in *The Wind Waker*. See also page 86.

▷ Hero's Flag (Quest)

The Wind Waker

This flag has a courageous feel to it. It can be exchanged for the Big Sale Flag, Big Catch Flag, and Postman Statue.

▷ Hero's New Clothes (Quest)

The Wind Waker · Phantom Hourglass

Invisible clothing. In *The Wind Waker*, it is exclusive to repeat play-throughs. In *Phantom Hourglass*, the outfit is received from the Man of Smiles.

▷ Hero's Shield (Equipment)

Majora's Mask · The Wind Waker

A shield Link carries at the beginning of certain adventures. In *The Wind Waker*, the shield has been passed down in Aryll and Link's family for generations. See also page 84.

▷ Hero's Sword (Equipment)

The Wind Waker

A basic sword, given to Link by Orca on Outset Island in order to rescue Tetra after she is dropped into the Fairy Woods by the Helmaroc King.

▷ Hero's Tunic (Equipment)

Tri Force Heroes

The outfit worn by Hytopian Castle soldiers and the first outfit Madame Couture makes for Link in *Tri Force Heroes*. There is nothing particularly special about it, but it gets the job done.

▷ Hibiscus (Quest)

Link's Awakening

Received from the famished Papahl in the Tal Tal Mountain Range as thanks for giving him a pineapple. It can be traded to a goat named Christine for a letter in Animal Village. See also Letter.

▷ Hint Glasses (Tool)

A Link Between Worlds

When Link dons these glasses, he can see Hint Ghosts who give him hints about his adventure and puzzles he may encounter. They provide one hint for every 3DS Play Coin.

Column 3

▷ Honeycomb (Quest)

Link's Awakening

Received in thanks for giving Tarin a stick in the Ukuku Prairie. It can be traded with Chef Bear in Animal Village for a pineapple. See also Pineapple.

▷ Hook Beetle (Tool)

Skyward Sword

An upgraded Beetle given to Link as thanks for helping an Ancient Robot in the Lanayru Desert. It has newly added scissors, which can grab objects and move them. See also Beetle.

▷ Hookshot (Tool)

A Link to the Past · Link's Awakening · Ocarina of Time · Majora's Mask

The Wind Waker · A Link Between Worlds

A weapon that enables Link to aim and fire at special targets and treasure boxes, then pull himself toward them. It is also useful in combat for stunning or injuring enemies. See also page 92, Clawshot, Gripshot, Longshot.

▷ Hornet Larvae (Creature)
See Bee Larvae.

▷ Horse Call (Critical)

Twilight Princess

A whistle made by Ilia for Link to call horses. With this item, it is possible to summon Epona even in fields without Horse Grass. See also Ilia's Charm.

▷ Hot Pumpkin Soup (Consumable)

Skyward Sword

A homemade soup cooked by the owner of the Lumpy Pumpkin. A favorite of the knight commander of the Knight Academy as well as the great spirit Levias. It can be carried around in a bottle, but will cool after five minutes. See also Cold Pumpkin Soup.

▷ Hot Spring Water (Consumable)
● Hot Springwater

Majora's Mask · Twilight Princess

Hot spring water that bubbles up throughout the realm. After a while, it cools and becomes regular water. In *Twilight Princess*, it fully recovers Link's health. See also Mt. Crenel Mineral Water.

▷ Hover Boots (Equipment)

Ocarina of Time

These boots have little traction, but they enable the wearer to walk on air for a short time.

▷ Huge Maku Seed (Critical)

Oracle of Seasons · Oracle of Ages

Received from the Maku Tree in *Oracle of Seasons* and *Oracle of Ages*. In both games, it repels evil and opens the path to the final dungeon.

▷ Hylian Shield (Equipment)

Ocarina of Time · Twilight Princess · Skyward Sword · A Link Between Worlds

A large shield carried by Hylian Knights. It is often the most powerful shield in the titles in which it appears. In *Ocarina of Time*, it is too heavy for young Link to properly carry; he can only crouch and hide under it.



▷ **Hyoi Pear** (CONSUMABLE)

Food for seagulls that fly over the sea. Feeding seagulls a pear will give Link the ability to control them. They can be used to activate hard-to-reach switches or retrieve items.

The Wind Waker

▷ **Hyper Slingshot** (TOOL)

A powerful slingshot from *Oracle of Seasons* able to fire seeds in three directions at once. Doing so only requires a single seed.

Oracle of Seasons

▷ **Hytopian Silk** (OTHER)

A popular silk for making dresses, used as a material for the Hero's Tunic worn by Hytopian soldiers. It is spun from the cocoons of rather dapper silkworms.

Tri Force Heroes

I COLUMN

▷ **Ice Arrow** (TOOL)

Ocarina of Time — *Majora's Mask* — *The Wind Waker*
An arrow that will freeze any target it hits. It can create platforms on water in *Ocarina of Time* and *Majora's Mask*, and even on magma in *The Wind Waker*.

▷ **Ice Rod** (TOOL)

A Link to the Past — *A Link Between Worlds*
A magic staff that fires ice and frigid gusts. A blast from this rod freezes monsters in their tracks.

▷ **Ice Rose** (OTHER)

This rare flower only blooms in the coldest conditions. It is an essential material for the Serpent's Toga, giving the outfit the power to freeze its wearer, so to speak.

Tri Force Heroes

▷ **Ilia's Charm** (QUEST)

A charm made by Ilia. Link receives it from Impaz in the Hidden Village. Showing this to Ilia while her memories are lost will restore them. Later it becomes the Horse Call.

Twilight Princess

▷ **IN-Credible Chart** (OTHER)

Reveals the hidden locations of Triforce Shards. It is provided by Tingle after Link returns from Hyrule Castle, frozen in time at the bottom of the sea.

The Wind Waker

▷ **Invoice** (QUEST)

After receiving Renado's Letter, Telma writes this invoice to the doctor. It lists the unbelievable bar tab the doctor has racked up. See also Wooden Statue.

Twilight Princess

▷ **Iron Boots** (EQUIPMENT)

Ocarina of Time — *The Wind Waker* — *Twilight Princess*
Donning these boots makes the wearer much heavier, allowing them to press down larger switches as well as walk in especially windy areas. They are metallic, so they can also stick to and even walk on magnetic walls and ceilings. In *Ocarina of Time*, they allow Link to walk underwater when paired with the Zora Tunic. In *The Wind Waker*, they also make it possible to walk against strong winds.

▷ **Iron Bow** (TOOL)

A Scrap Shop upgrade from a standard Wooden Bow. Metal increases the stiffness of the bow, allowing Link to charge and fire arrows with explosive power. See also Sacred Bow.

Skyward Sword

J COLUMN (middle column)

▷ **Iron Pot** (QUEST)

A cooking pot received from Mrs. Ruul in *Oracle of Seasons*. If Link gives it to the Subrosian Chef, he will make Link some Lava Soup.

Oracle of Seasons

▷ **Iron Shield** (EQUIPMENT)

Oracle series — *Skyward Sword*
A sturdy shield that defends against attacks that would burn or break a Wooden Shield. It is weak against electrical attacks in *Skyward Sword*.

▷ **Island Chart** (QUEST)

A chart in *Oracle of Ages* required to cross the sea and reach Crescent Island, where the Tokay live. Link receives it from Tingle.

Oracle of Ages

▷ **Island Hearts Chart** (OTHER)

A chart revealing the location of treasure boxes containing Pieces of Heart on every island, as well as quests that lead to still more heart pieces.

The Wind Waker

J COLUMN

▷ **Jabber Nut** (QUEST)

A mysterious nut found in the Minish Village. Eating it allows Link to understand the Minish language.

The Minish Cap

▷ **Jack of Hearts** (EQUIPMENT)

This outfit gives everyone an extra heart. It increases with the number of people wearing the outfit, so if all three heroes wear it, they all gain three hearts.

Tri Force Heroes

▷ **Jelly Blob** (OTHER)

A mysterious blob of gunk obtained from gelatinous monsters. It hardens when heated, so it is used to upgrade items like the Wooden Shield and the Slingshot.

Skyward Sword

▷ **Jewels** (QUEST)

Four crystals that can be collected in *Oracle of Seasons*, including the Pyramid Jewel, Square Jewel, X-Shaped Jewel, and Round Jewel. They are required to enter the Tarm Ruins.

Oracle of Seasons

▷ **Jolene's Letter** (QUEST)

A letter accidentally handed over by the Postman. It is actually a letter from Jolene, who dresses up like a pirate, to Joanne, her mermaid-cosplaying sister.

Phantom Hourglass

▷ **Joy Pendant** (OTHER)

A pendant that brings happiness to its wearer. Giving 20 of these to Mrs. Marie on Outset Island earns Link the Cabana Deed, while 40 yield the Hero's Charm.

The Wind Waker

K COLUMN

▷ **Kafei's Mask** (EQUIPMENT)

This mask is given to Link by Madame Aroma, who wants Link to give it to the missing Kafei. It resembles a young Kafei, and wearing it helps Link ask if anyone has seen him.

Majora's Mask

▷ **Kaleidoscope** (QUEST)
See Telescope.

K COLUMN (right column)

▷ **Kamaro's Mask** (EQUIPMENT)

Link can obtain this mask by healing the dancing master Kamaro's spirit in Termina Field at night. Wearing it allows him to do a mysterious dance.

Majora's Mask

▷ **Keaton Mask** (EQUIPMENT)

Ocarina of Time — *Majora's Mask*
A mask of the fox, Keaton, who is popular among the children of Hyrule. In *Majora's Mask*, the mask is used to seek out Keaton, who hides in the grass.

▷ **Keese Wing** (OTHER)

A wing from one of the bat-like Keese monsters. Boiling a wing and drinking it will increase willpower. Keese Wings are also used for purple dye. As such, a wing can be used as a material for the purple Energy Gear outfit.

Tri Force Heroes

▷ **Key** (DUNGEON)
See Small Key.

▷ **Key (Navi Trackers)** (OTHER)

Appears in "Navi Trackers" as a bonus item picked up during the course. Each one awards 50 points at the end. If a player gathers all three, they get 250 additional points.

Four Swords Adventures (Japanese version only)

▷ **Key Shard** (DUNGEON)
See Piece of the Key.

▷ **King's Key** (QUEST)

The key of the Cobble Kingdom. It is given to Link by the Cobble Knight Doylan on the Isle of Ruins and used in Mutoh's Temple. Once used, the water recedes and the Cobble Kingdom is revealed.

Phantom Hourglass

▷ **Kinstone** (COLLECTION)

Mysterious fragments found throughout Hyrule. Fusing them with Kinstones held by townspeople can reveal treasures or open the entrances to hidden areas, among other strange things.

The Minish Cap

▷ **Kinstone Bag** (COLLECTION)

A bag for carrying Kinstones, which are scattered in all corners of Hyrule and can be fused together. This item is received from the Hurdy-Gurdy Man in Hyrule Town.

The Minish Cap

▷ **Knight's Crest** (OTHER)

These crests are said to be obtainable by only the strongest sword masters. Gathering 10 and giving them to Orca on Outset Island will enable Link to learn the Hurricane Spin.

The Wind Waker

▷ **Kodongo Tail** (OTHER)

The fire-breathing Kodongo will drop its tail and grow a new one when it reaches adulthood. The tail is used as a material for the Energy Gear outfit.

Tri Force Heroes

▷ **Kokiri Boots** (EQUIPMENT)

Boots worn by Link at the beginning of *Ocarina of Time*. They are common boots among the Kokiri and grant no special abilities. See also page 86.

Ocarina of Time

▷ **Kokiri Clothes** (OUTFIT)

This outfit of the forest people lets Link fire three arrows with his bow. The arrows fan out as they fly.

Tri Force Heroes

▷ Kokiri Sword (Equipment)

A small sword passed down among the Kokiri. In *Ocarina of Time*, it is required before Link can meet with the Great Deku Tree.

Ocarina of Time · *Majora's Mask*

▷ Kokiri Tunic (Equipment)

A green tunic worn by Link at the outset of *Ocarina of Time*. Though iconic, the tunic is common among the Kokiri and grants Link no special abilities. See also page 86.

Ocarina of Time

▷ Kokiri's Emerald (Critical)

● Spiritual Stone of the Forest

One of the jewels necessary to open the Door of Time. It is the Spiritual Stone of the Forest, entrusted to Link by the Great Deku Tree.

Ocarina of Time

L COLUMN

▷ L-2 Power Bracelet (Equipment)

● Power Bracelet

Enables the wearer to lift objects too heavy for a basic Power Bracelet.

Link's Awakening · *Four Swords Adventures*

▷ Ladder (Equipment)

● Stepladder

A useful tool for crossing narrow waterways and rivers.

The Legend of Zelda

▷ Lady's Collar (Other)

A high-quality collar suitable for the neck of a stylish lady. Obtained after initially defeating the Fortress boss, it is required to make the Lady's Ensemble that lifts the curse on the princess.

Tri Force Heroes

▷ Lady's Ensemble (Critical)

This outfit removes Lady Maud's curse on Princess Styla. Hearts appear more frequently and an additional Heart Container appears when it is worn.

Tri Force Heroes

▷ Lady's Glasses (Other)

Sleek glasses to grace the nose of a sophisticated lady. Obtained after initially defeating the Woodlands boss, they are required to make the Lady's Ensemble that lifts the curse on the princess.

Tri Force Heroes

▷ Lady's Parasol (Other)

A fabled item, untouched by grubby hands of drab mortals. Obtained after initially defeating the Sky Realm boss, it is required to make the Lady's Ensemble that lifts the curse on the princess.

Tri Force Heroes

▷ Lamp (Tool)

See Lantern.

▷ Lanayru Ant (Creature)

These ants live in the Lanayru Desert and are often found in significant numbers. They have colonies underground, digging intricate tunnels, and can be found by looking under barrels and similar places.

Skyward Sword

▷ Land Title Deed (Quest)

● Town Title Deed (*Majora's Mask HD*)

The first of four deeds in *Majora's Mask*. Link obtains the Land Title Deed by giving a Moon's Tear to the Business Scrub in Clock Town. See also Swamp Title Deed.

Majora's Mask

▷ Lantern (Tool)

● Lamp / ▲ Flame Lantern

A Link to the Past · *Four Swords Adventures* · *The Minish Cap* · *Twilight Princess*

Illuminates dark places and lights standing lamps. In *The Minish Cap*, it is also used to melt ice. In *Twilight Princess*, using it requires Lantern Oil.

A Link Between Worlds

▷ Lantern Oil (Consumable)

Oil required to keep the Lantern lit in *Twilight Princess*. It can be carried around in a bottle to provide a refill if the Lantern runs out. Lantern Oil is sold in most shops, as well as by Coro in the Faron Woods.

Twilight Princess

▷ Large Bomb Bag (Collection)

Carries more bombs than any other Bomb Bag in these games. It can either be purchased or won in a mini-game in *Spirit Tracks*. See also page 91.

Spirit Tracks · *Skyward Sword*

▷ Large Quiver (Collection)

● Quiver

The Minish Cap · *Phantom Hourglass* · *Spirit Tracks* · *Skyward Sword*

Allows Link to carry more arrows. There are three in *The Minish Cap*, and each increases Link's arrow limit. It can be obtained in *Spirit Tracks* through minigames and stores. See also page 89.

▷ Large Seed Satchel (Collection)

A bag that allows 30 extra Deku Seeds to be carried and used as ammo for the Slingshot.

Skyward Sword

▷ Lava Drop (Other)

A fire spirit's tear, perhaps? Carrying one is good luck. Used as a material in the flaming Fire Blazer outfit.

Tri Force Heroes

▷ Lava Juice (Quest)

One of the prizes from the Goron Shooting Gallery. The Graceful Goron's friend loves it, and will give Link a Letter of Introduction in return for it.

Oracle series

▷ Lava Soup (Quest)

A trading item received from the Subrosian Chef in *Oracle of Seasons*. After trading the soup to Biggoron on Goron Mountain, he will give Link the Goron Vase.

Oracle of Seasons

▷ Legend of the Picori (Quest)

A library book. Dr. Left, a scholar researching the Minish, has borrowed this book to learn more about them.

The Minish Cap

▷ Legendary Dress (Consumable)

Bearing the symbol of the Triforce, this outfit pays homage to Princess Zelda. Wearing it increases the rate at which hearts appear when defeating enemies and breaking pots.

Tri Force Heroes

▷ Legendary Pictograph (Quest)

Valuable photographs sold by Lenzo for 50 rupees each. The image available for purchase changes depending on the day.

The Wind Waker

▷ Lens of Truth (Tool)

A magical lens made by the Sheikah that can see through illusions, revealing fake walls and hidden traps.

Ocarina of Time · *Majora's Mask*

▷ Letter (Quest)

The Legend of Zelda · *Link's Awakening* · *Ocarina of Time* · *Four Swords Adventures*

Various correspondence often delivered by a postman. In *Spirit Tracks*, letters are displayed as items, but in *Phantom Hourglass*, he will read them aloud on the spot instead. In *Link's Awakening*, a letter is received as thanks for giving hibiscus to Christine in the Animal Village. This letter can be given to Mr. Write in exchange for a broom.

Spirit Tracks

▷ Letter in a Bottle (Quest)

A bottle with a message inside. The Milk Bar Owner gives Link Premium Milk when presented with this item.

A Link Between Worlds

▷ Letter of Introduction (Quest)

This letter from *Oracle of Ages* is an invitation from a charismatic Goron who loves to dance.

Oracle of Ages

▷ Letter to Kafei (Quest)

After receiving a letter from the missing Kafei, his fiancée, Anju, replies with this letter. See also Kafei's Mask.

Majora's Mask

▷ Level 2 Sword (Equipment)

The ultimate sword in *Link's Awakening* is obtained at Seashell Mansion after gathering 20 Secret Seashells. Its attack power is double, and it can fire beams when Link is at full health. See also Sword.

Link's Awakening

▷ Library Key (Quest)

Received from King Zora in *Oracle of Ages*, this key is needed to enter the Eyeglass Island Library.

Oracle of Ages

▷ Life Medal (Equipment)

One of several medals Link can acquire in *Skyward Sword* that have beneficial effects when carried. This one increases Link's maximum number of hearts by one. It can be purchased from Beedle's Shop.

Skyward Sword

▷ Life Potion (Consumable)

See Water of Life (Blue).

▷ Life Tree Fruit (Quest)

A legendary fruit from a Tree of Life. It is said that one bite will cure any illness and that it has the power to heal the Thunder Dragon, a servant of the goddess.

Skyward Sword

▷ Life Tree Seedling (Quest)

A seedling found in Lanayru Gorge that can only grow into a Tree of Life in sacred soil. Growing the seedling into a mature tree will take a very long time.

Skyward Sword

▷ Light Armor (Equipment)

As its name suggests, this armor is made from materials that emit light, allowing the wearer to be a walking lantern of sorts. The area visible in darkness expands when worn.

Tri Force Heroes

Light Arrow (Tool)

Ocarina of Time | Majora's Mask | The Wind Waker | Twilight Princess

A powerful arrow of divine light capable of bringing down a Demon King. In *Majora's Mask*, they can also make Sun Blocks disappear. Princess Zelda uses them in both *The Wind Waker* and *Twilight Princess*.

Light Fruit (Consumable)

Skyward Sword

A mysterious fruit that appears in various places throughout the Silent Realm. Picking one up will create a pillar of light above all Tears of the Goddesses for 30 seconds.

Light Medallion (Critical)

Ocarina of Time

One of six medallions that grant Link the power of the sages. Link receives it from the Sage of Spirit, Nabooru, in the Chamber of Sages.

Light Ring Chart (Other)

The Wind Waker

A chart that shows where Rings of Light appear during a full moon. Salvaging while in a Ring of Light can yield rewards like rupees and treasure boxes.

Linebeck's Uniform (Equipment)

Tri Force Heroes

This outfit pays homage to the treasure-obsessed Linebeck. It allows the wearer to see the insides of treasure boxes. It also grants an extra 10 seconds to any mission with a time limit.

Lizard Tail (Other)

Skyward Sword

A tail dropped by lizard-like monsters like Lizalfos. The spiked ball remains attached to the end.

Lokomo Sword (Equipment)

Spirit Tracks

A sword said to have been used by the gods, received from Anjean. It contains the sacred power of the Spirit Tracks and has the power to banish evil.

Lon Lon Egg (Quest)

Oracle of Seasons

An egg received from Malon in *Oracle of Seasons*. These are popular with young women. If Link talks to Maple while carrying it, he can trade it for a Ghastly Doll.

Lon Lon Milk (Consumable)

See Milk.

Lonely Peak (Critical)

Oracle of Ages

One of the eight Essences of Time in *Oracle of Ages*. It is found in the Mermaid's Cave.

Long Hook (Tool)

Oracle of Ages

This upgrade has a longer range for swapping places with things than the normal Switch Hook. See also Switch Hook.

Longshot (Tool)

Ocarina of Time

A high-spec Hookshot with twice the firing range. See also Hookshot.

Loovar (Creature)

Phantom Hourglass

A fish that lives in the sea. It is about 1.5 to 1.8 meters long. Showing one to the Old Wayfarer allows Link to obtain the Big Catch Lure.

Lost Maiamai (Other)

A Link Between Worlds

Mother Maiamai's children are lost in the caves of both Hyrule and Lorule. There are 100 of these small creatures resembling hermit crabs in all, and finding them can yield great rewards from their mother.

Lucky Loungewear (Equipment)

Tri Force Heroes

Cheerful pajamas that sort of resemble a clown's outfit. They give the wearer a 25% dodge rate against attacks. The dodge rate is not very high, so there really is luck involved.

Lucky Star (Consumable)

Four Swords Adventures (Japanese version only)

Appears in the Japan-only "Navi Trackers" feature. When carrying one of these, the number of Pirate Medals received will match the number written on the star. The numbers range from two to five.

Lumber (Other)

Spirit Tracks

A material for transport requested by Yeko in the Anouki Village. It can be purchased in Whittleton from the Lumber Salesman.

M COLUMN

Maggie's Letter (Quest)

The Wind Waker

A letter given to Link by Maggie. It is addressed to the Moblin who helped her. After mailing it, Link later receives the Moblin's Letter.

Magic Armor (Equipment)

Twilight Princess | The Wind Waker

Gleaming, golden armor in *Twilight Princess*. Donning it costs one rupee per second. When taking damage, the wearer loses additional rupees instead of health. In *Twilight Princess*, this armor can be purchased from Chudley's Fine Goods and Fancy Trinkets Emporium after it has been taken over by Malo Mart. Magic Armor also appears in *The Wind Waker*. Taking damage does not reduce Link's life while wearing it.

Magic Bean (Consumable)

Ocarina of Time | Majora's Mask

Planting these beans as a child will result in a magic plant growing in the same spot once an adult. In *Majora's Mask*, they instantly grow into platforms.

Magic Book (Quest)

Four Swords Adventures

A book filled with suspicious magic. It belongs to the novice magician Iris in the Village of the Blue Maiden. She has trouble using magic without it. See also Book of Magic.

Magic Cape (Tool)

A Link to the Past | Four Swords Adventures

When wearing this cape, Link becomes invisible for as long as his magic power lasts. During this time, he can pass through enemies and won't take damage.

Magic Container (Collection)

The Adventure of Link

Increases Link's maximum magic power and fully restores it at the same time.

Magic Hammer (Tool)

A Link to the Past | Four Swords Adventures

Able to pound posts and similar things into the ground. In the Japanese version of *A Link to the Past*, it is abbreviated as "M.C. Hammer."

Magic Jar (Consumable)

● Magical Decanters

A Link to the Past | Ocarina of Time | Majora's Mask | The Wind Waker

This item restores magic power when picked up. There are two sizes, with the larger one restoring more magic.

Magic Jar (Blue) (Consumable)

The Adventure of Link

Restores one block of magic. Dropped by enemies and hidden in palaces.

Magic Jar (Red) (Consumable)

The Adventure of Link

Fully restores Link's magic. Dropped by enemies and hidden in palaces.

Magic Mirror (Tool)

A Link to the Past

Received from the Old Man living on Death Mountain, it enables the holder to travel between the Light and Dark Worlds instantly.

Magic Mushroom (Other)

Majora's Mask

These mushrooms grow in the woods. Putting them in bottles and taking them to the Magic Hags' Potion Shop will make it possible to buy Blue Potions. See also Mushroom.

Magic Oar (Quest)

Oracle of Ages

A trading item in *Oracle of Ages* obtained from Maple. Rafton is looking for an oar to use in a race and gives Link the Sea Ukulele in return.

Magic Potion (Consumable)

Oracle series

This potion fully restores Link's health when he runs out of hearts. It can be purchased from Syrup in the *Oracle* series. See also Secret Medicine.

Magic Powder (Tool)

A Link to the Past | Link's Awakening

A powder made from Magic Mushrooms or Sleepy Toadstools. Using Magic Powder on people and monsters can have some surprising effects.

Magic Ring (Tool)

Oracle series

Equipping one of these rings will yield a variety of effects. There are 64 in all, each with its own appearance and effect. What effect each has cannot be known until Link gets the ring appraised.

Magical Boomerang (Tool)

The Legend of Zelda | A Link to the Past | Oracle series | The Minish Cap

A boomerang imbued with magic. In *The Legend of Zelda*, it flies farther than the Boomerang. In *A Link to the Past* this is the upgrade to the Boomerang and causes more damage. It also appears in *Oracle of Seasons* and *The Minish Cap*. In the latter, it is obtained by fusing Kinstones.

DATABASE

ITEMS

▶ **Magical Clock** (Consumable)
See Clock.

▶ **Magical Decanters** (Consumable)
See Magic Jar.

▶ **Magical Key** (Dungeon)

This key is able to open all locked dungeon doors. It resembles a lion's head in *The Legend of Zelda*.

The Legend of Zelda | The Adventure of Link

▶ **Magical Powder** (Tool)
See Magic Powder.

▶ **Magical Rod** (Tool)

A magical rod able to cast spells of significant power and target distant enemies. In *Link's Awakening*, it launches a fireball straight ahead when used and is capable of both damaging monsters and melting any ice that may block Link's path.

The Legend of Zelda | Link's Awakening

▶ **Magical Shield** (Equipment)

Sturdier than Link's starting shield, it is able to block enemy spells and beams.

The Legend of Zelda | The Adventure of Link

▶ **Magical Sword** (Equipment)

A magical sword of tremendous power. Link begins *The Adventure of Link* with it in hand.

The Legend of Zelda | The Adventure of Link

▶ **Magnetic Glove** (Tool)

This magnetized glove will pull metal objects closer when worn.

Oracle of Seasons | Four Swords

▶ **Magnifying Lens** (Quest)

After inserting the scale into the Mermaid Statue in Martha's Bay, Link finds this lens: the ultimate reward for completing the trade sequence in *Link's Awakening*. It enables him to view things he otherwise cannot, like library books and, in the DX version, a friendly Zora in the Animal Village.

Link's Awakening

▶ **Maku Seed** (Critical)
See Huge Maku Seed.

▶ **Map** (Dungeon)
See Dungeon Map.

▶ **Mask of Scents** (Equipment)

Received for clearing the Deku Butler's racing minigame. Wearing it makes the scent coming from Magic Mushrooms visible.

Majora's Mask

▶ **Mask of Truth** (Equipment)

A mysterious mask that enables the wearer to hear the true thoughts of others and to listen to rumors from Gossip Stones. It can even read the hearts of animals. Obtained for clearing the Swamp Spider House in *Majora's Mask*. In the 3D version, it also makes hidden grottoes glow.

Ocarina of Time | Majora's Mask

▶ **Master Ore** (Quest)

A rich ore necessary to upgrade the Master Sword found in Lorule's dungeons. The increase in attack power from tempering by the blacksmith is tied to the Master Sword's level.

A Link Between Worlds

▶ **Master Sword** (Equipment)

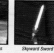

A Link to the Past | Ocarina of Time | Oracle series | The Wind Waker
Four Swords | Twilight Princess | Skyward Sword | A Link Between Worlds

The Blade of Evil's Bane that only a hero can wield. This is Link's legendary sword, a blade of great power used many times to thwart Ganon and others who seek similar power. In *Four Swords*, it is a reward for clearing the GBA version of *A Link to the Past* and can be swapped for the Four Sword. See also page 82, True Master Sword.

▶ **Master Sword Lv2** (Equipment)

The Master Sword after it is tempered by the most skilled swordsmiths in Hyrule.

A Link to the Past | A Link Between Worlds

▶ **Master Sword Lv3** (Equipment)

The ultimate form of the Master Sword after it is tempered in the Dark World or Lorule.

A Link to the Past | A Link Between Worlds

▶ **Master's Plaque** (Quest)

Link is awarded this plaque after passing the Master Diver's test. It can be exchanged for Zora's Flippers, allowing Link to swim in water without drowning.

Oracle of Seasons

▶ **Medicine of Life** (Consumable)
See Red Potion.

▶ **Medicine of Life and Magic** (Consumable)
See Blue Potion.

▶ **Medicine of Magic** (Consumable)
See Green Potion.

▶ **Medium Bomb Bag** (Collection)

Increases the number of bombs that Link can carry. Obtained through upgrades at the Scrap Shop in *Skyward Sword*. See also page 91.

Spirit Tracks | Skyward Sword

▶ **Medium Quiver** (Collection)

A supplementary quiver upgraded from a Small Quiver to hold more arrows. Carrying this quiver will increase the number of arrows the holder can carry by 10. See also page 89.

Skyward Sword

▶ **Medium Seed Satchel** (Collection)
A bag that allows 20 extra Deku Seeds to be carried and used as ammo for the Slingshot.

Skyward Sword

▶ **Medium Wallet** (Collection)
Received for presenting five Gratitude Crystals to Batreaux. It can carry up to 500 rupees, a decent amount. See also page 95.

Skyward Sword

▶ **Mega Ice** (Other)
A material for transport requested by a Goron in Goron Village. Mega Ice can be purchased from Noko at Wellspring Station, where Ferrus's house is located.

Spirit Tracks

▶ **Megaphone** (Quest)

A trading item received from the Old Man in *Oracle of Seasons*. It can be used to wake Talon, who is sleeping on Mt. Cucco. Link gets a Mushroom in return.

Oracle of Seasons

▶ **Megaton Hammer** (Tool)

The legendary hammer of the Gorons. It can break boulders and activate rusted switches.

Ocarina of Time

▶ **Member's Card** (Quest)

This special card allows Link to enter the underground floor in the Horon Village Shop.

Oracle of Seasons

▶ **Mermaid Key** (Quest)

Received from the Graceful Goron in *Oracle of Ages*, this key unlocks the entrance to the Mermaid's Cave in the present.

Oracle of Ages

▶ **Mermaid Suit** (Equipment)

This suit from *Oracle of Ages* transforms Link into a mermaid. Similar to the Flippers, it enables Link to swim in deep water. See also Flippers.

Oracle of Ages

▶ **Miiverse Stamp** (Collection)

Only appears in the HD version. Obtaining Miiverse Stamps hidden in treasure boxes throughout Hyrule makes it possible to use them in the Miiverse. There are a wide variety, including Hylian Script and Midna.

Twilight Princess HD

▶ **Milk** (Consumable)
● Lon Lon Milk / ▲ Ordon Goat Milk

Ocarina of Time | Majora's Mask | The Minish Cap | Twilight Princess

A nutritious milk that restores hearts. It can be carried in empty bottles. The milk Link drinks is often produced by cows, but in *Twilight Princess*, he drinks goat's milk. See also Chateau Romani, Premium Milk.

A Link Between Worlds

▶ **Mirror Shard** (Critical)

A fragment of the Mirror of Twilight, the entrance to the Twilight Realm. Zant destroyed the mirror and split it into four pieces, hiding one in each province of Hyrule. Those who find the shards are said to suffer misfortune, as they carry enough power to drive people mad.

Twilight Princess

▶ **Mirror Shield** (Equipment)

A Link to the Past | Link's Awakening | Oracle series | Ocarina of Time
Majora's Mask | The Wind Waker | The Minish Cap

The strongest shield in many titles, the Mirror Shield is able to guard against previously unblockable attacks like Beamos's beam. In some cases, it also reflects light. In *Majora's Mask*, it is decorated with the image of a tragic expression. In *The Minish Cap*, blocking attacks bounces a beam back at enemies.

▶ **Missed Arrow** (Tool)

An arrow fired by Link or an enemy that missed its target and is stuck in a shield or the ground. Touching one before it disappears will add it to Link's arrow supply.

Skyward Sword

Moblin's Letter (Quest)

The Moblin's response to the letter Link mailed to him from Maggie. Link gives it to her.

The Wind Waker

Mock Fairy (Other)

Threatened fairies conjure these up as decoys. This material is required to make the Showstopper outfit.

Tri Force Heroes

Mogma Mitts (Tool)

An upgrade to the Digging Mitts. With these, Hylians can burrow underground like Mogmas. They can even attack underground enemies.

Skyward Sword

Mole Mitts (Tool)

This item is obtained in the Fortress of Winds. They enable Link to dig through soft walls and find items hidden in the ground. See also Digging Mitts.

The Minish Cap

Monster Claw (Other)

These sharp talons are collected by slaying flying monsters like Keese and Guays. Their hardness makes them useful for enhancing items like shields.

Skyward Sword

Monster Guts (Other)

Monster organs. Used to make Purple Potions in *A Link Between Worlds* and as a material in *Tri Force Heroes*.

A Link Between Worlds *Tri Force Heroes*

Monster Horn (Other)

A magic potion ingredient found in Lorule in *A Link Between Worlds*. The Witch will make Yellow Potions if Link collects 10 horns. In *Skyward Sword*, they are instruments carried by Bokoblin leaders. They will blow on one to summon allies when they discover a threat. Link can steal it with the Whip and use it as a material.

Skyward Sword *A Link Between Worlds*

Monster Tail (Other)

A magic potion ingredient found in Lorule. The Witch will make Blue Potions if Link collects 10 tails.

A Link Between Worlds

Moon Pearl (Quest/Consumable)

In *A Link to the Past*, Link needs this item in order to transform into his Hylian form in the Dark World. In *Four Swords Adventures*, they open Moon Gates.

A Link to the Past *Four Swords Adventures*

Moon's Tear (Quest)

A tear from the eye of the moon. It falls to the earth when Link peers at the Clock Tower from the Astral Observatory, and can be traded for the Land Title Deed. See also Land Title Deed.

Majora's Mask

Moosh's Flute (Critical)

A flute to summon Moosh, Link's winged bear companion. Moosh can hover above the ground for short periods. See also Strange Flute.

Oracle series

Mountain Title Deed (Quest)

One of four deeds found in *Majora's Mask*. It is obtained by handing the Swamp Title Deed to the Business Scrub in Goron Village. See also Ocean Title Deed.

Majora's Mask

Mt. Crenel Mineral Water (Consumable)

Mysterious green water that bubbles up only on Mount Crenel. It can be carried in a bottle and will cause beanstalks to mature rapidly and grow leaves. See also Hot Spring Water.

The Minish Cap

Mushroom (Quest)

Found in the Lost Woods in *A Link to the Past*. Traded for the Wooden Bird in *Oracle of Seasons*.

A Link to the Past *Oracle of Seasons*

Mushroom Spores (Quest)

Powder taken from a giant mushroom. The powder is treasured for its medicinal qualities, specifically in the treatment of birds at Skyloft. It is particularly useful for healing injured Loftwings.

Skyward Sword

Mysterious Crystals (Dungeon)

This crystal formation is the key to opening the boss room in the Fire Sanctuary. It is a collection of large and small cubes, assembled in a particular order with gaps in between.

Skyward Sword

Mysterious Shell (Collection)
See Secret Seashell.

Mystery Extract (Other)

A mysterious extract found in the Ruins. No one knows what it is, which is probably for the best. Used as a material for the Serpent's Toga and Fire Blazer.

Tri Force Heroes

Mystery Jade (Other)
● Mystic Jade

A treasure made of jade that can be traded for Train Cars in *Spirit Tracks* and serves as outfit material in *Tri Force Heroes*.

Spirit Tracks *Tri Force Heroes*

Mystery Milk (Quest)

A special milk made by the elder Gorman brother, it is one of their all-time favorites. Mystery Milk spoils quickly, turning to Moldy Milk. It only appears in *Majora's Mask 3D* as part of the Fraternal Milk side quest.

Majora's Mask 3D

Mystery Seed (Tool)

Placing these seeds into an Owl Statue will reward Link with a hint. Sprinkling them on Buzzblobs will turn them into Cukemen and enable them to speak.

Oracle series

Mystic Jade (Other)
See Mystery Jade.

N COLUMN

Nasty Soup (Consumable)

Homemade soup by Coro. It can be scooped out of the pot with an empty bottle. Drinking it may restore hearts but might also deal damage.

Twilight Princess

Nayru's Charm (Equipment)

Nayru will place this in one of Link's bottles if he finds her a house in Hyrule Town. Using it turns Link's outfit blue and temporarily boosts his defense.

The Minish Cap

Nayru's Love (Tool)

This spell creates a barrier when used, temporarily blocking all enemy attacks. It is named for Nayru, the Goddess of Wisdom who helped create the world, and obtained from a Great Fairy.

Ocarina of Time

Nayru's Pearl (Critical)

One of the three Goddess Pearls necessary to make the Tower of the Gods appear. Received from the water spirit Jabun.

The Wind Waker

Necklace (Quest)

The fisherman under the bridge in Martha's Bay will give this to Link as thanks for the fishing hook. Link can then trade it to the Mermaid for the scale. See also Scale.

Link's Awakening

Neptoona (Creature)

A legendary fish resembling a swordfish caught using the Big Catch Lure. It is 5.25 meters long. Showing one to the Old Wayfarer on Bannan Island will earn Link a Piece of Heart.

Phantom Hourglass

Net (Tool)
See Bug Catching Net.

Nice Bombs (Tool)

Bombs after they have been purchased from Ravio and upgraded by Mother Maiamai. Their attack power and range double, making them capable of defeating most basic enemies in a single blast.

A Link Between Worlds

Nice Boomerang (Tool)

The Boomerang after it has been purchased from Ravio and upgraded by Mother Maiamai. The upgrade uses more stamina but allows Link to throw up to three boomerangs at a time.

A Link Between Worlds

Nice Bow (Tool)

The Bow after it has been purchased from Ravio and upgraded by Mother Maiamai. The upgraded version is able to fire up to three arrows at once, making it easier to hit targets.

A Link Between Worlds

Nice Fire Rod (Tool)

After Link purchases the Fire Rod from Ravio, Mother Maiamai will upgrade it, provided Link has collected enough Lost Maiamais. Its attack power goes up, conjuring bigger flame pillars that travel farther.

A Link Between Worlds

Nice Hammer (Tool)

The Hammer after it has been purchased from Ravio and upgraded by Mother Maiamai. The hammer itself gets a bit bigger, and its attack power and shock wave double.

A Link Between Worlds

Nice Hookshot (Tool)

The Hookshot after it has been purchased from Ravio and upgraded by Mother Maiamai. It is longer and more powerful than the regular Hookshot, allowing Link to use it more effectively as a weapon.

A Link Between Worlds

Nice Ice Rod (Tool)

After Link purchases the Ice Rod from Ravio, Mother Maiamai will upgrade it, provided Link has collected enough Lost Maiamais. The nice version creates four ice blocks when used. Its range increases and it can even hit airborne enemies.

A Link Between Worlds

Nice Sand Rod (Tool)

After Link purchases the Sand Rod from Ravio, Mother Maiamai will upgrade it, provided Link has collected enough Lost Maiamais. Any sand pillars generated will remain in place until the next ones are made.

A Link Between Worlds

Nice Tornado Rod (Tool)

After Link purchases the Tornado Rod from Ravio, Mother Maiamai will upgrade it, provided Link has collected enough Lost Maiamais. A tornado's area expands and its attack power goes up.

A Link Between Worlds

▷ **Nightmare Key** (DUNGEON)
See Boss Key.

▷ **Ninja Gi** (EQUIPMENT)

Clothing modeled off quick-moving ninjas. Dashes will occur instantly, and the damage from Dash Attacks triples.

Tri Force Heroes

▷ **Noble Sword** (EQUIPMENT)

This sword is obtained through a trading sequence and does more damage than the Wooden Sword.

Oracle series

▷ **Note to Mom** (QUEST)

A note from Baito on Dragon Roost Island to his mother. After it is mailed, his mother will send a Piece of Heart along with her thanks.

The Wind Waker

▷ **Nurturing Warmth** (CRITICAL)

One of the eight Essences of Nature in *Oracle of Seasons*. It is found in the Unicorn's Cave.

Oracle of Seasons

O COLUMN

▷ **Ocarina** (CRITICAL)
● Flute

A musical instrument used to perform songs that sometimes have magical effects. In *A Link to the Past*, it allows Link to summon a bird and warp.

A Link to the Past — *Link's Awakening*

▷ **Ocarina of Time** (CRITICAL)

A treasure that holds the power to manipulate time, entrusted to Link by Princess Zelda. Playing specific melodies has a variety of effects essential in Link's quest to thwart Ganon and save Hyrule.

Ocarina of Time — *Majora's Mask*

▷ **Ocarina of Wind** (CRITICAL)

This magical instrument was left by the Wind Tribe, who mastered the winds. It lies in the heart of the Fortress of Winds. Playing it allows Link to travel to any of the Wind Crests scattered across Hyrule in *The Minish Cap*.

The Minish Cap

▷ **Ocean Rail Map** (CRITICAL)

One of the stone tablets on the twelfth floor of the Tower of Spirits dungeon. Obtaining it causes the Ocean Realm to appear on the Rail Map.

Spirit Tracks

▷ **Ocean Seal** (CRITICAL)

Proof of clearing the Ocean Temple and restoring the barrier of the Ocean Realm.

Spirit Tracks

▷ **Ocean Title Deed** (QUEST)

The last of four deeds Link can collect and trade in *Majora's Mask*. Obtained by handing the Mountain Title Deed to the Business Scrub in Zora Hall, it can then be traded to the Business Scrub in Ikana Canyon for a golden rupee.

Majora's Mask

▷ **Octo Chart** (OTHER)

A map of the Great Sea that shows where giant, squid-like Big Octos live. The number of eyes a Big Octo has determines what Link may find by defeating it, from valuable treasure to even a Great Fairy.

The Wind Waker

▷ **Octorok Sucker** (OTHER)

An Octorok Sucker found in the Riverside area. A Drablands delicacy! Eat it raw or cook it to perfection. Used as a material in the Jack of Hearts outfit.

Tri Force Heroes

▷ **Odd Mushroom** (QUEST)

Giving this odd fungus to Granny in Kakariko Village allows her to make the Odd Potion.

Ocarina of Time

▷ **Odd Poultice** (QUEST)
See Odd Potion.

▷ **Odd Potion** (QUEST)
● Odd Poultice

Link can trade this potion, made from the Odd Mushroom, to Fado in the Lost Woods for the Poacher's Saw. It is called the Odd Poultice in the 3D version of *Ocarina of Time*.

Ocarina of Time

▷ **Odolwa's Remains** (CRITICAL)

Obtained by defeating Odolwa, the boss of Woodfall Temple. This mask remains after Odolwa's spirit is freed.

Majora's Mask

▷ **Old Mermaid Key** (QUEST)

Obtained for winning the "Big Bang Game" in *Oracle of Ages*, this key is required to enter the Mermaid's Cave in the past.

Oracle of Ages

▷ **Ooccoo** (DUNGEON)

An Oocca who lives in the City in the Sky. Link encounters Ooccoo in every *Twilight Princess* dungeon. She will take Link back to the entrance when called, no matter where he may be stuck in the dungeon. See also Ooccoo Jr.

Twilight Princess

▷ **Ooccoo Jr.** (DUNGEON)

A young Oocca who is never far from his mother, Ooccoo. Calling him will bring Link back to Ooccoo, who is waiting in the dungeon.

Twilight Princess

▷ **Orange Picolyte** (CONSUMABLE)

This potion makes it easier to find bombs and arrows for a short time when searching grass and other places where these items are found. Beedle will sell it to Link in Hyrule Town if Link has an empty bottle.

The Minish Cap

▷ **Ordon Goat Cheese** (QUEST)

Cheese made from the milk of a goat from Ordon Village, Link's hometown in the Twilight Era. Adding it to Good Soup turns it into Superb Soup.

Twilight Princess

▷ **Ordon Goat Milk** (CONSUMABLE)
See Milk.

▷ **Ordon Pumpkin** (QUEST)

A sweet and delicious pumpkin, this is Ordon Village's most famous product. Adding it to Simple Soup turns it into Good Soup.

Twilight Princess

▷ **Ordon Shield** (EQUIPMENT)

This shield has an Ordon Goat crest carved on it. Link takes it from Jaggle's house at Midna's request when he is transformed into a wolf.

Twilight Princess

▷ **Ordon Sword** (EQUIPMENT)

A gift forged by Rusl for the Hyrule royal family. Link steals it from Rusl's house at Midna's request and uses it until obtaining the Master Sword.

Twilight Princess

▷ **Organ of Evening Calm** (CRITICAL)

Obtained by clearing the Eagle's Tower dungeon. It is one of eight instruments needed to perform the Ballad of the Wind Fish.

Link's Awakening

▷ **Ornamental Skull** (OTHER)

An accessory worn by every Bokoblin. It appears to be decorative and not a real skull. It's a mystery why they choose to wear them.

Skyward Sword

▷ **Oshus's Sword** (EQUIPMENT)

A sword found inside Oshus's storehouse in *Phantom Hourglass*. Link uses this sword until he obtains the Phantom Sword.

Phantom Hourglass

P COLUMN

▷ **Palace Dish** (OTHER)

A priceless treasure that can be exchanged for Train Cars in *Spirit Tracks*.

Spirit Tracks

▷ **Palm Cone** (OTHER)

Taken from trees that can go for centuries without water. Used as a material in Dunewalker Duds.

Tri Force Heroes

▷ **Pearl Necklace** (OTHER)

A treasure that can be exchanged for rupees. In *Spirit Tracks*, it can be traded for Train Cars.

Phantom Hourglass — *Spirit Tracks*

▷ **Pegasus Boots** (EQUIPMENT)
● Pegasus Shoes

Boots that enable the wearer to dash. They allow Link to charge enemies and knock down high-up objects.

A Link to the Past — *Link's Awakening* — *Four Swords* — *Four Swords Adventures* — *The Minish Cap* — *A Link Between Worlds*

▷ **Pegasus Seed** (CONSUMABLE)

A mystical seed that enables Link to run as fast as a legendary steed.

Oracle series — *Four Swords*

▷ **Pendant of Courage** (CRITICAL)

One of three Pendants of Virtue required to wield the Master Sword. In *A Link Between Worlds*, Zelda gives this pendant to Link, initially mistaking it for a charm.

A Link to the Past — *A Link Between Worlds*

▷ **Pendant of Power** (CRITICAL)

One of three Pendants of Virtue required to wield the Master Sword.

A Link to the Past — *A Link Between Worlds*

▷ **Pendant of Memories** (QUEST)

Majora's Mask

Received from Kafei, a townsperson thought to have disappeared who has become a Skull Kid. Kafei asks Link to deliver it to Kafei's fiancée, Anju, a sign that they will meet again.

▷ **Pendant of Wisdom** (CRITICAL)

A Link to the Past *A Link Between Worlds*

One of three Pendants of Virtue required to wield the Master Sword.

▷ **Phantom Hourglass** (CRITICAL)

Phantom Hourglass

This item allows Link to progress through the Temple of the Ocean King without losing health until the sand runs out. Recovering Sand of Hours from around the world will increase the amount of time it contains.

▷ **Phantom Sword** (TOOL)

Phantom Hourglass

Forged from the three pure metals, this divine weapon is essential to defeat Bellum. Oshus uses his power to fuse the sword blade and the Phantom Hourglass to create it. This sword can even defeat Phantoms.

▷ **Phonograph** (QUEST)

Oracle of Seasons

A device for playing music obtained from Guru-Guru in *Oracle of Seasons*. Playing it next to a Deku Scrub in the Lost Woods will help Link learn the location of the Noble Sword.

▷ **Picto Box** (TOOL)
● Pictograph Box

This box, much like a camera, takes pictures. It can take one in *Majora's Mask*, three in *The Wind Waker*, and up to 12 in *The Wind Waker HD*. See also Deluxe Picto Box.

▷ **Piece of Heart** (COLLECTION)

A Link to the Past *Link's Awakening* *Ocarina of Time* *Majora's Mask*

Oracle series *The Wind Waker* *The Minish Cap* *Twilight Princess*

Skyward Sword *A Link Between Worlds*

Collecting four or five of these will increase Link's maximum health. They can be minigame prizes or hidden in unexpected locations.

▷ **Piece of Power** (CRITICAL)

Link's Awakening

These occasionally drop from defeated enemies. They double attack power and slightly increase movement speed. The effect disappears after getting hit three times or moving to a different area.

▷ **Piece of the Key** (DUNGEON)
● Key Shard

Twilight Princess *Skyward Sword*

Uniting Key Shards in the Goron Mines in *Twilight Princess* will allow Link to create a Big Key, which unlocks the boss room. In *Skyward Sword*, Pieces of the Key can be assembled to unlock the entrance to the Earth Temple.

▷ **Pineapple** (QUEST)

Link's Awakening

The bear in the Animal Village will give this spiny fruit to Link as thanks for the honeycomb. It can then be traded to Papahl for the hibiscus. See also Hibiscus.

▷ **Pink Coral** (OTHER)

Phantom Hourglass

A reward from treasure boxes and mini-games. This treasure can also be exchanged for rupees. Coral, polished to a shine, is an object to be admired.

▷ **Pinwheel** (QUEST)

The Wind Waker

Wind makes the wheel spin. It's kind of fun! The Pinwheel is carried by the Traveling Merchants and can be traded for an Exotic Flower or a Sickle Moon Flag.

▷ **Pirate Medal** (OTHER)

Four Swords Adventures (Japanese version only)

An item that Link gathers in "Navi Trackers." They are obtained by trading rupees to characters throughout the course. The player who gathers the most medals by the end wins.

▷ **Pirate Necklace** (OTHER)

Spirit Tracks

A reasonably valuable treasure that can be used for Train Cars in *Spirit Tracks*. The Big Blin, leader of the pirates, wears one as an accessory.

▷ **Pirate's Bell** (QUEST)

Oracle of Seasons

This item is a memento of the Pirate Captain and can be reforged from the Rusty Bell. Once given to the Captain, he will set out to sea.

▷ **Pirate's Charm** (EQUIPMENT)

The Wind Waker *Four Swords Adventures (Japanese version only)*

This item makes it possible to talk to and receive hints from people who are far away. It also appears in "Navi Trackers" in *Four Swords Adventures*.

▷ **Platform Chart** (OTHER)

The Wind Waker

This chart reveals the locations of Lookout Platforms throughout the Great Sea. Treasures are hidden on them.

▷ **Platinum Card** (QUEST)

Spirit Tracks

Proof of Platinum Membership at Beedle's Shop, obtained after accumulating 1,000 points. Link gets a 30% discount and a bonus Quintuple Points Card.

▷ **Poacher's Saw** (QUEST)

Ocarina of Time

A saw left behind by a poacher in the forest. Giving it to the leader of the Carpenters in Gerudo Valley yields the Broken Goron's Sword.

▷ **Pocket Cucco** (QUEST)

Ocarina of Time

This small cucco hatches from the Pocket Egg. It is required to wake up the ranch owner Talon, who is sleeping in Hyrule Castle. See also Cojiro.

▷ **Pocket Egg** (QUEST)

Ocarina of Time

Link receives this small egg from the Cucco Lady in Kakariko Village. It will hatch into a Pocket Cucco after one night.

▷ **Poe Clock** (QUEST)

Oracle of Ages

A trading item in *Oracle of Ages* obtained for helping a Poe reach the afterlife. Link can give it to the Postman in exchange for Stationery.

▷ **Poe Soul** (CREATURE)

Ocarina of Time *Majora's Mask* *Twilight Princess* *Tri Force Heroes*

The bottled-up soul of a Poe. In *Ocarina of Time* and *Majora's Mask* it will either restore or deplete Link's hearts when released. Poe Souls can also be sold to the Poe Collector. In *Tri Force Heroes*, it is used as a material in the Serpent's Toga and Light Armor. In *Twilight Princess*, they are pieces of Jovani's soul held by Poes. Defeating all 60 Poes across Hyrule and collecting their souls restores Jovani.

▷ **Postman Statue** (QUEST)

The Wind Waker

A statue of the Postman, a hero to all Rito. It is carried by the Traveling Merchants and can be exchanged for the Fountain Idol and the Shop Guru Statue.

▷ **Postman's Hat** (EQUIPMENT)

Majora's Mask

The Postman gives Link this hat after delivering Priority Mail to Madame Aroma and being told to evacuate Clock Town. When Link wears it, he can open mailboxes.

▷ **Potion Medal** (EQUIPMENT)

Skyward Sword

One of several medals Link can acquire in *Skyward Sword* that have beneficial effects when carried. With the Potion Medal, potions with lingering effects will last three times longer.

▷ **Pouch** (EQUIPMENT)

A Link Between Worlds

A pouch handmade by the blacksmith's wife. It is found lying in one of Gulley's favorite spots. Picking it up increases the number of items Link can carry.

▷ **Powder Keg** (TOOL)

Majora's Mask

A giant powder keg that only Gorons are permitted to use. Link turns into a Goron by donning the Goron Mask and uses this explosive keg to destroy a boulder blocking the road to Romani Ranch.

▷ **Power Bracelet** (EQUIPMENT)

The Legend of Zelda *Link's Awakening* *Oracle series* *The Wind Waker*

The Minish Cap

A bracelet that grants the wearer great strength. It enables them to lift heavy boulders that block paths. See also Power Glove, Titan's Mitt.

▷ **Power Gem** (OTHER)

Phantom Hourglass

Twenty of these gems exist throughout the land. Gathering and bringing them to Spirit Island will unlock the Spirit of Power's strength, increasing Link's attack power and enabling him to destroy Phantoms by attacking from behind.

▷ **Power Glove** (EQUIPMENT)

A Link to the Past *Oracle of Ages* *A Link Between Worlds*

A magical glove that allows the wearer to lift and throw rocks that are otherwise far too heavy. In *Oracle of Ages*, it is an upgrade of the Power Bracelet. See also Power Bracelet, Titan's Mitt.

▷ **Practice Sword** (EQUIPMENT)

Skyward Sword

A sword used for training at the Knight Academy. It may be for practice, but it is still a real weapon, and normally it cannot be taken out of the Sparring Hall.

Premium Milk (Consumable)

A high-priced, high-quality milk. The injured Bouldering Guy on Death Mountain wants some. Link keeps the empty bottle after giving it to him. See also Milk.

A Link Between Worlds

Prescription (Quest)

A prescription for the World's Finest Eye Drops. When Link shows this to King Zora in Zora's Domain, he informs the hero that he does not have the drops. He instead gives Link the Eyeball Frog, used to make the drops.

Ocarina of Time

Pretty Plume (Other)

A feather that charms people and beasts alike. Used as a material in the Robowear and Showstopper outfits. Found in the Sky Realm.

Tri Force Heroes

Prize Postcard (Consumable)

Postcards that can be mailed out from postboxes to potentially win a prize. They are obtained from the Man of Smiles in *Phantom Hourglass* or purchased from stores in *Spirit Tracks*.

Phantom Hourglass *Spirit Tracks*

Pumpkin Seed (Tool)

See Deku Seed.

Purple Chu Jelly (Consumable)

Jelly left behind by a defeated Purple Chuchu. It can be picked up with an empty bottle. Its effect changes randomly when consumed, from dealing damage to restoring hearts.

Twilight Princess

Purple Potion (Consumable)

Phantom Hourglass Spirit Tracks A Link Between Worlds

Drinking this potion restores eight hearts, and if carried, it will automatically heal eight hearts when Link is defeated. In *A Link Between Worlds*, it deals great damage to surrounding enemies.

Purple Royal Jewel (Critical)

A jewel guarded by a Purple Knight, one of the Knights of Hyrule serving the royal family. Collecting this, along with the red, green, and blue jewels, opens the path to the Palace of Winds in the Realm of the Heavens.

Four Swords Adventures

Pyramid Jewel (Quest)

See Jewels.

Q COLUMN

Quake Medallion (Equipment)

A Link to the Past Four Swords Adventures

A magic medallion received from the Catfish in *A Link to the Past*. It causes earthquakes that turn all nearby monsters into powerless Zols. It also appears in *Four Swords Adventures*, serving much the same purpose.

Queen of Hearts (Equipment)

A dress modeled after the Queen of Hearts. It grants Link three extra hearts. The increase is tied to the number of people wearing it. If three heroes don this dress at the same time, they all gain nine hearts.

Tri Force Heroes

Quick Beetle (Tool)

An upgrade to the Hook Beetle made by Gondo at the Scrap Shop. Link can increase its speed midflight. See also Tough Beetle.

Skyward Sword

Quintuple Points Card (Consumable)

A card that gives Link five times the points when shopping at Beedle's Shop.

Spirit Tracks

Quiver (Collection)

Ocarina of Time Majora's Mask The Wind Waker Twilight Princess

Phantom Hourglass Spirit Tracks

A cylindrical container for holding arrows. Increasing its size makes it possible to carry more arrows. See also page 89.

R COLUMN

Rabbit Net (Tool)

A net received from Bunnio in Rabbitland. Link can use it to catch rabbits out in the field without ever leaving the train.

Spirit Tracks

Raft (Critical)

The Legend of Zelda The Adventure of Link

A vessel that can be used to cross lakes and other bodies of water. In *The Adventure of Link*, it allows travel between continents.

Rainbow Coral (Other)

This coral is so beautiful that folks travel from faraway lands in search of it. It is used as a material in the Ninja Gi outfit.

Tri Force Heroes

Rare Chu Jelly (Consumable)

A jelly left after slaying a shining Rare Chu. It can be scooped up with a bottle. Drinking this jelly fully restores Link's health and temporarily boosts his attack power.

Twilight Princess

Rattle (Quest)

The favorite toy of the baby whom Bertie at the Potion Shop carries on his back. A bird stole the Rattle and took it back to its nest above the windmill.

Skyward Sword

Ravio's Bracelet (Equipment)

A bracelet received from Ravio in place of rent. This magical bracelet lets the wearer flatten against walls like a painting and move around.

A Link Between Worlds

Ravio's Bracelet (Inactive) (Equipment)

A mysterious bracelet that emits a divine feeling. Gifted by Ravio in place of paying rent when he opens his shop in Hyrule. It fits perfectly.

A Link Between Worlds

Razor Seed (Consumable)

These seeds will increase sword damage dramatically. They can increase power by up to two levels, and the effect persists until the end of the stage.

Majora's Mask

Razor Sword (Equipment)

An upgraded Kokiri Sword. After 100 uses, it dulls and must be upgraded again.

Majora's Mask

Recorder (Critical)

See Flute.

Recovery Heart (Consumable)

See Heart.

Recruit Uniform (Equipment)

The uniform of the recruited guards of Hyrule Castle. The design resembles the outfit worn by the Hero of Winds 100 years ago. See also Engineer's Clothes.

Spirit Tracks

Recruit's Sword (Equipment)

After performing the soldiers' training exercises, like the Spin Attack, at Hyrule Castle, Russell, the captain of the guard, gives Link this sword.

Spirit Tracks

Red Candle (Tool)

This candle can be used to attack enemies by firing a flame and to illuminate rooms in darker dungeons. It can also burn bushes. It has no restrictions on its use.

The Legend of Zelda

Red Chu Jelly (Consumable)

The Wind Waker Twilight Princess

The jelly that remains after defeating Red Chuchus. In *The Wind Waker*, Red Chu Jelly is an ingredient in Red Potions. In *Twilight Princess*, the jelly on its own restores eight hearts when put in a bottle and consumed.

Red Clothes (Equipment)

See Red Mail.

Red Mail (Equipment)

● Red Clothes

A Link to the Past Link's Awakening DX A Link Between Worlds

Red Mail has the highest defense of any armor in *A Link to the Past* and *A Link Between Worlds*. In *Link's Awakening DX*, a similar outfit called Red Clothes increases Link's attack power through the power of color. See also page 86.

Red Ore (Quest)

A special ore found in Subrosia. When combined with the Blue Ore also found there, it can be used to make Hard Ore.

Oracle of Seasons

Red Picolyte (Consumable)

This potion makes it easier to find hearts for a short time when searching grass and other places where hearts are found. Beedle will sell it to Link in Hyrule Town if Link has an empty bottle.

The Minish Cap

Red Potion (Consumable)

● Medicine of Life

A Link to the Past Ocarina of Time Majora's Mask The Wind Waker

 The Minish Cap Twilight Princess Phantom Hourglass Spirit Tracks

A Link Between Worlds

Drinking a Red Potion will restore a certain degree of health. It can be carried around in a bottle to be consumed when needed. See also Heart Potion, Water of Life (Red).

Red Ring (Tool)

This magic ring reduces damage taken by 75%. See also Blue Ring.

The Legend of Zelda

Red Royal Jewel (Critical)

A jewel guarded by a Red Knight, one of the Knights of Hyrule serving the royal family. Collecting this, along with the blue, green, and purple jewels, opens the path to the Palace of Winds in the Realm of the Heavens.

Four Swords Adventures

Red Shield (Equipment)

A very valuable shield. Unlike the Fighter's Shield, it can block fireballs.

A Link to the Past

Regal Necklace (Quest)

This item is required to eliminate the cyclone blocking entry into the Isle of Ruins. It can only be obtained by those recognized by Brant on the Isle of the Dead.

Phantom Hourglass

Regal Ring (Other)

A treasure that can be exchanged for rupees. In *Spirit Tracks*, it can also be exchanged for Train Cars. See also Royal Ring.

Phantom Hourglass *Spirit Tracks*

Reinforced Shield (Equipment)

An Iron Shield that has been upgraded by Gondo at the Scrap Shop. It is even harder and more durable than the Iron Shield, but electric attacks will pass right through it.

Skyward Sword

Remote Bomb (Tool)

A bomb upgrade developed by Belari the inventor. Remote Bombs can be detonated at will by pressing a button, rather than exploding automatically after a few seconds.

The Minish Cap

Renado's Letter (Quest)

A letter written by Renado, a shaman in Kakariko Village, for Telma. It contains detailed instructions on how to restore Ilia's memories.

Twilight Princess

Revitalizing Potion (Consumable)

This potion can be purchased at the Potion Shop and carried in a bottle. Using it on damaged shields will fully restore their durability. As a bonus, it also restores four hearts.

Skyward Sword

Revitalizing Potion+ (Consumable)

A Revitalizing Potion enhanced by Bertie at the Potion Shop after bringing him the required ingredients. In addition to automatically restoring a shield when it breaks, it will restore eight hearts.

Skyward Sword

Revitalizing Potion++ (Consumable)

A further enhanced version of Revitalizing Potion+. It has the same effect as the enhanced version when used, but it can be used twice.

Skyward Sword

Ribbon (Quest)

A decorative bow that Link receives in exchange for the Yoshi Doll in *Link's Awakening*. He can give the ribbon to the small Chain Chomp living in the shack next to Madam MeowMeow's. In return, the Chain Chomp will give Link a can of dog food. Giving a similar ribbon to Rosa in *Oracle of Seasons* impresses her.

Link's Awakening *Oracle of Seasons*

Ricky's Flute (Critical)

A flute to summon Ricky, a boxing kangaroo companion who can scale great heights in a single jump. See also Strange Flute.

Oracle series

Ricky's Gloves (Quest)

Ricky's favorite gloves. Finding and returning them convinces him to join Link on his *Oracle* adventure for a short time.

Oracle of Seasons

Ring Box (Collection)

A box for storing and carrying rings. Completing certain quests will increase its carrying capacity.

Oracle series

Robowear (Equipment)

An entire outfit built around a larger, more powerful Gripshot. Robowear increases the size of the clamp as well as its attack power. Range and firing speed also increase.

Tri Force Heroes

Roc's Cape (Tool)

Oracle of Seasons *Four Swords* *The Minish Cap*

Equipping this gives Link the ability to jump and glide for long distances. It is the upgraded version of Roc's Feather in *Oracle of Seasons*.

Roc's Feather (Tool)

Link's Awakening *Oracle series* *Four Swords Adventures*

A magical feather that enables Link to jump while it is equipped.

Rock Brisket (Quest)

A prize from the Goron Cart Game in *Oracle of Ages*. Giving it to the hungry Goron on guard duty will yield the Goron Vase.

Oracle of Ages

Rod of Seasons (Critical)

A mystical rod from *Oracle of Seasons* that can change the seasons of Holodrum. Changing the season will also alter the terrain.

Oracle of Seasons

Rolling Sea (Critical)

One of the eight Essences of Time in *Oracle of Ages*. It is found in Jabu-Jabu's Belly.

Oracle of Ages

Romani's Mask (Equipment)

This mask is obtained by successfully defending Cremia's cart on her delivery to Clock Town. The wearer is recognized as a member of the Milk Bar.

Majora's Mask

Room Key (Quest)

Link obtains this by donning the Goron Mask and impersonating the Goron who reserved the room. It allows Link to enter the Stock Pot Inn from the second floor, even late at night.

Majora's Mask

Round Jewel (Quest)

See Jewels.

Royal Engineer's Certificate (Quest)

Awarded by Princess Zelda, this document certifies the bearer as a Royal Engineer.

Spirit Tracks

Royal Ring (Other)

A ring with a royal legacy. Unfit for "commoner" fingers. It is used as a material for the regal Rupee Regalia as well as the Sword Suit. See also Regal Ring.

Tri Force Heroes

Ruby Tablet (Critical)

An ancient stone tablet found in Skyview Temple. It has the power to open the way to grounds sealed by the goddess. Eldin Volcano becomes accessible after placing it on the altar inside the Statue of the Goddess.

Skyward Sword

Rugged Horn (Other)

A big, impressive monster horn. It would look cool hanging above a doorway, but is also useful as a material for the Boomeranger outfit.

Tri Force Heroes

Rupee (Consumable)

The Legend of Zelda	A Link to the Past	Link's Awakening	Ocarina of Time
Majora's Mask	Oracle series	The Wind Waker	Four Swords
Four Swords Adventures	The Minish Cap	Twilight Princess	Phantom Hourglass
Spirit Tracks	Skyward Sword	A Link Between Worlds	Tri Force Heroes

Jewels used as currency in Hyrule and well beyond. Their values change with their size and color, as well as the era in which they are used. See also page 94.

Rupee Medal (Equipment)

One of several medals Link can acquire in *Skyward Sword* that have beneficial effects when carried. Carrying this makes rupees of small denominations appear more frequently.

Skyward Sword

Rupee Regalia (Equipment)

Elite clothing for elite people. Defeating enemies with this on yields more rupees. It also doubles the rupees that appear from cracking pots and defeating enemies.

Tri Force Heroes

Rupoor (Consumable)

Four Swords *Phantom Hourglass* *Skyward Sword*

Touching this black rupee will drain rupees from Link's wallet. See also page 94.

Rusty Bell (Quest)

The thoroughly rusted bell found in the Samasa Desert. It once belonged to the Pirate Captain and polishing it turns it into the Pirate's Bell.

Oracle of Seasons

Rusty Swordfish (Creature)

A rare fish that can only be caught with the Big Catch Lure. It ranges from about 3 to 4.2 meters long. Showing one to the Old Wayfarer will get him to tell Link about Neptoona.

Phantom Hourglass

Column 1

▷ **Ruto Crown** (Other)

A treasure that can be exchanged for rupees. It can be traded for Train Cars in *Spirit Tracks*.

Phantom Hourglass | Spirit Tracks

S ### S COLUMN

▷ **Sacred Bow** (Tool)

The ultimate long-range weapon, filled with sacred power after being upgraded using a Goddess Plume. It has greater attack power than any other bow.

Skyward Sword

▷ **Sacred Shield** (Equipment)

A divine blessing resides in the shield, giving it the power to repair itself over time. This shield can defend against fire, electricity, and curses, but it has low durability and is likely to break if used too frequently.

Skyward Sword

▷ **Sacred Soil** (Critical)

One of the eight Essences of Time in *Oracle of Ages*. It is found in the Crown Dungeon.

Oracle of Ages

▷ **Sacred Tears** (Quest)

Gathered in the Silent Realm during the final trial undertaken in Skyloft. Collecting all 15 scattered throughout Skyloft will complete the Spirit Vessel.

Skyward Sword

▷ **Sacred Water** (Other)

This water has powerful restorative abilities and is able to heal the wounds of great spirits. It can be bottled at the spring behind Skyview Temple.

Skyward Sword

▷ **Sail** (Critical)

Necessary to sail on the Great Sea. Opening a sail will catch the wind and propel Link's boat forward, with tailwinds increasing its speed. See also Swift Sail.

The Wind Waker

▷ **Sailcloth** (Tool)

A hand-sewn shawl given to the winner of the Wing Ceremony by Zelda. Deploying it while falling will allow Link to land safely. It also has a faint, pleasant scent to it.

Skyward Sword

▷ **Sanctuary Mask** (Other)

A mask used to ward off evil. It's seemingly ineffective. Used as a material in the Spin Attack Attire.

Tri Force Heroes

▷ **Sand Cicada** (Creature)

The Sand Cicada is a bug that is very sensitive to noise, making it perhaps the hardest bug to catch. Its rareness is spoken of among collectors, and it sells for a high price.

Skyward Sword

▷ **Sand of Hours** (Critical)

The sand within the Phantom Hourglass, made from the Force Gems of the Ocean King. They increase the time in the hourglass, enabling Link to spend longer in the Temple of the Ocean King. This sand can be found through salvaging.

Phantom Hourglass

▷ **Sand Rod** (Tool)
● Sand Wand

This rod has the power to raise up sand. It is found in the Sand Temple in *Spirit Tracks*. In *A Link Between Worlds*, it can be rented from Ravio after clearing the Thieves' Hideout.

Spirit Tracks | A Link Between Worlds

Column 2

▷ **Sand Seal** (Critical)

Proof of retrieving the Bow of Light from the Sand Temple.

Spirit Tracks

▷ **Sand Wand** (Tool)

See Sand Rod.

▷ **Sandy Ribbon** (Other)

A magic ribbon that can rouse a sandstorm when shaken. Used as a material to create the Gust Garb.

Tri Force Heroes

▷ **Scale** (Quest)

The mermaid in Martha's Bay will give Link this scale as thanks for the necklace. See also Magnifying Lens.

Link's Awakening

▷ **Scattershot** (Tool)

A Slingshot that has been improved by Gondo at the Scrap Shop. While the upgrade does not improve the Slingshot's attack power, charging it up allows Link to fire a scattering of seeds, hitting more targets at once.

Skyward Sword

▷ **Scent Seed** (Tool)

These seeds emit a weird smell when cracked open. Some enemies are attracted by the scent; others will refuse to come near it.

Oracle series

▷ **Scent Seedling** (Quest)

A young Scent Tree. Once mature, it produces Scent Seeds.

Oracle of Ages

▷ **Scoot Fruit** (Tool)

A mysterious fruit sold in shops around Hyrule. Using it in a dungeon allows Link to escape to the entrance.

A Link Between Worlds

▷ **Sea Chart** (Other)

There are four Sea Charts, all obtained in the Temple of the Ocean King (Somewhere, Southeast, Northwest, and Northeast). Link must "stamp" the third chart with a Sacred Crest by opening and closing the DS.

Phantom Hourglass

▷ **Sea Flower** (Quest)

A trading item in *The Wind Waker*. This flower from a far-off land smells of the sea. It is carried by the Traveling Merchants and can be obtained by trading a Town Flower. A Sea Flower can in turn be traded for an Exotic Flower.

The Wind Waker

▷ **Sea Hearts Chart** (Other)

This item reveals the locations of Treasure Charts, which are salvaged from the bottom of the ocean and point the way to Pieces of Heart on each island.

The Wind Waker

▷ **Sea Lily's Bell** (Critical)

Obtained by clearing the Key Cavern dungeon. This is one of the instruments needed to perform the Ballad of the Wind Fish.

Link's Awakening

▷ **Sea Ukulele** (Quest)

An instrument obtained from Rafton. Offering it to an elderly Zora, who pines for the sea on the Coast of No Return, yields the Broken Sword.

Oracle of Ages

Column 3

▷ **Seahorse** (Creature)

Obtained in exchange for a photo of a pirate from a fisherman in the Great Bay. It guides Link through the waters around Pinnacle Rock.

Majora's Mask

▷ **Secret Cave Chart** (Other)

A chart mapping secret caves that are normally difficult to find. Visiting these secret locations leads to treasure.

The Wind Waker

▷ **Secret Medicine** (Tool)

Sold at Crazy Tracy's Health Spa. With this medicine in his inventory, Link will automatically recover his health if it fully depletes. See also Magic Potion.

Link's Awakening

▷ **Secret Seashell** (Collection)
● Mysterious Shell

Link's Awakening | Four Swords Adventures (Japanese version only) | The Minish Cap

Link obtains a powerful sword for collecting enough Secret Seashells hidden around Koholint Island in *Link's Awakening*. They are required to buy figurines in *The Minish Cap* and appear in "Navi Trackers" in the Japanese version of *Four Swords Adventures*.

▷ **Seed** (Tool)

See Deku Seed.

▷ **Seed of Life** (Critical)

One of the eight Essences of Nature in *Oracle of Seasons*. It is found in the Explorer's Crypt.

Oracle of Ages

▷ **Seed Satchel** (Collection)

A bag for carrying the five types of seeds that become Mystical Trees: Ember Seeds, Scent Seeds, Pegasus Seeds, Gale Seeds, and Mystery Seeds.

Oracle series

▷ **Seed Shooter** (Tool)

It fires seeds and can hit faraway targets. This item appears only in *Oracle of Ages*. If the fired seed hits a wall, it will ricochet and change direction.

Oracle of Ages

▷ **Serpent Fangs** (Other)

Taken from a giant serpent monster, these razor-sharp fangs can pierce through anything. Used as a material in place of spikes for the Cozy Parka.

Tri Force Heroes

▷ **Serpent's Toga** (Equipment)

Inspired by the monster that can turn people to stone, this toga's effects are beneficial to its wearer. Link's body will turn to stone if he does not move for a short time, making him invincible to attacks.

Tri Force Heroes

▷ **Shadow Crystal** (Critical)

Zant forces this cursed item upon Link, who becomes unable to revert from his wolf form. After removing it, Link can use it to freely change between Hylian and wolf forms.

Twilight Princess

▷ **Shadow Medallion** (Critical)

One of six medallions that grant Link the power of the sages. After clearing the Shadow Temple, Impa awakens as the Sage of Shadow and presents this sacred artifact to Link to aid in the looming battle with Ganon.

Ocarina of Time

▷ **Shard of Agony** (OTHER)

Ocarina of Time 3D

This device will show Link hidden holes in the ground with a sound and flashing icon. In the Nintendo 64 version of *Ocarina of Time*, it is called the Stone of Agony. The Shard only appears in the 3DS version. See also Stone of Agony.

▷ **Shield** (EQUIPMENT)

The Legend of Zelda

Link's Awakening

Four Swords

Four Swords Adventures

Phantom Hourglass

Spirit Tracks

A Link Between Worlds

An essential piece of equipment used to protect oneself from enemy attacks. Link may not have a shield from the outset of an adventure, but will quickly acquire one. Basic shields tend not to withstand powerful attacks like beams, fire, or magic.

▷ **Shield of Antiquity** (EQUIPMENT)

Spirit Tracks

A shield kept by the pirate Niko and said to have been used by the Hero of Winds 100 years before the events of *Spirit Tracks*. Link receives it after gathering 10 stamps from around New Hyrule. It cannot be eaten by Like Likes.

▷ **Ship Parts** (COLLECTION)

Phantom Hourglass

Parts used to customize the appearance and upgrade the durability of Link's ship. They can be purchased in shops or found in salvaged treasure boxes. There are 72 parts in all.

▷ **Shop Guru Statue** (QUEST)

The Wind Waker

The pride and joy of all merchants. This statue can be obtained by trading in the Postman Statue. Giving it to the Merchant on Greatfish Isle yields a Piece of Heart.

▷ **Shovel** (TOOL)

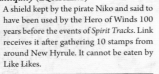

A Link to the Past · Link's Awakening · Oracle series · Four Swords Adventures

Phantom Hourglass

An essential tool that lets Link dig up items buried in the ground beneath his feet.

▷ **Showstopper** (EQUIPMENT)

Tri Force Heroes

The blindingly glorious tuxedo of a stage performer. The range for being noticed by enemies increases, so it is optimal for acting as bait.

▷ **Sickle Moon Flag** (QUEST)

The Wind Waker

A fancy flag in the shape of a crescent moon. It is carried by the Traveling Merchants and can be traded for a Fountain Idol or a Big Catch Flag.

▷ **Silver Arrow** (TOOL)

The Legend of Zelda

A sacred arrow used with the Bow. Hidden on Death Mountain, they are the key to defeating Ganon in this era.

▷ **Silver Bow and Arrow** (TOOL)

A Link to the Past

A bow and arrow enhanced by the Great Fairy in a certain spring. This weapon is essential when battling Ganon.

▷ **Silver Card** (QUEST)

Spirit Tracks

Proof of Silver Membership at Beedle's Shop, obtained after accumulating 200 points. Link gets a 10% discount and a bonus Freebie Card.

▷ **Silver Gauntlets** (EQUIPMENT)

Ocarina of Time

Gauntlets that give their wearer the strength to lift giant blocks and boulders that may block their path.

▷ **Silver Scale** (EQUIPMENT)

Ocarina of Time

A Zora scale that has a silvery glimmer. Obtaining it allows the user to dive deep underwater. Received from a Zora after winning the Diving Game.

▷ **Silver Thread** (OTHER)

Tri Force Heroes

Thread spun from glinting gossamer. Antibacterial and deodorizing, it is used as a material for the Sword Suit, since anyone wearing it is likely to break a sweat.

▷ **Simple Soup** (CONSUMABLE)

Twilight Princess

A soup that Yeto makes for his wife Yeta. Putting it in a bottle and drinking it restores two hearts. See also Good Soup.

▷ **Sinking Lure** (OTHER)

Ocarina of Time

A special lure lying around the Fishing Hole. It can catch fish living deep underwater and has a strong grip.

▷ **Skippyjack** (CREATURE)

Phantom Hourglass

A common fish found in the ocean. It is about 50 to 80 centimeters long. There is no special prize for catching this fish.

▷ **Skull Hammer** (TOOL)

See Hammer.

▷ **Skull Mask** (EQUIPMENT)

Ocarina of Time

A skull mask with horns. The Skull Kid in the Lost Woods wants it.

▷ **Skull Necklace** (OTHER)

The Wind Waker

A necklace worn by Moblins. After saving Maggie, Link can collect 20 of these necklaces and give them to Maggie's father in exchange for a Treasure Chart.

▷ **Skull Tower Idol** (QUEST)

The Wind Waker

The fossilized skulls of some strange creatures. It is carried by the Traveling Merchants and can be traded for a Big Sale Flag or a Fountain Idol.

▷ **Sky Dragon Tail** (OTHER)

Tri Force Heroes

The tail of an Aeralfo, a creature that lives in the Sky Realm. It is pliable, strong, and very rare. Used as a material in the Robowear outfit.

▷ **Sky Stag Beetle** (CREATURE)

Skyward Sword

An insect native to Skyloft with distinctive, bright blue coloring. It is always popular with children, to the point where it is said that chasing them helps them grow big and strong.

▷ **Skyloft Mantis** (CREATURE)

Skyward Sword

A bug with sharp forelimbs. They live throughout Skyloft, and often hide in the shade. They are sometimes found in surprising places.

▷ **Slate** (QUEST)

Oracle of Ages

This item appears in *Oracle of Ages*. This item is used to solve a puzzle in the Ancient Tomb.

▷ **Sleepy Toadstool** (QUEST)

Link's Awakening

Also known as a Sleepy Mushroom, this grows in the Mysterious Woods of Koholint Island. The old witch on the island will turn it into Magic Powder for Link.

▷ **Slice of Cake** (CONSUMABLE)

The Minish Cap

One of many delicacies at the Hyrule Town bakery. This cake is a moist and cream-filled bargain. Eating one restores a single heart. Occasionally, there will be a Kinstone inside.

▷ **Slice of Pie** (CONSUMABLE)

The Minish Cap

This pie can be bought at the Hyrule Town bakery. Eating a slice brings joy to one's mouth and restores one heart. Some slices have Kinstones baked inside.

▷ **Slime Key** (QUEST)

Link's Awakening

This key unlocks the entrance to the Key Cavern.

▷ **Slingshot** (TOOL)
● Fairy Slingshot

Ocarina of Time · Oracle series · Four Swords Adventures · Twilight Princess

Skyward Sword

A Slingshot fires seeds at enemies and targets, making it possible to hit things beyond the reach of a blade.

▷ **Small Bomb Bag** (COLLECTION)

Skyward Sword

A supplementary Bomb Bag that increases the number of bombs that Link can carry by five. Upgrading to Medium or Large Bomb Bag will further increase the capacity. See also page 91.

▷ **Small Key** (DUNGEON)
● Key

The Legend of Zelda · The Adventure of Link · A Link to the Past · Link's Awakening

Ocarina of Time · Majora's Mask · Oracle series · The Wind Waker

Four Swords · Four Swords Adventures · The Minish Cap · Twilight Princess

Phantom Hourglass · Spirit Tracks · Skyward Sword · A Link Between Worlds

This common key will open a single locked door in a dungeon. In *The Legend of Zelda*, they are also sold by merchants. Since *The Legend of Zelda*, these have only been usable inside the dungeon in which they are found.

Small Quiver (Collection)

A supplemental quiver that can be purchased at the Gear Shop. It increases the maximum number of arrows Link can carry by five. See also page 89.

Skyward Sword

Small Seed Satchel (Collection)

A bag that allows 10 extra Deku Seeds to be carried and used as ammo for the Slingshot.

Skyward Sword

Small Shield (Equipment)
● Fighter's Shield

A basic shield Link wields early on in some adventures. He receives this shield from his uncle in *A Link to the Past* and from Princess Zelda in *The Minish Cap*.

A Link to the Past · *The Minish Cap*

Small Wallet (Collection)

The dependable wallet that Link often starts out with. It carries a decent haul of rupees. Depending on the era, it can hold as many as 300. See also page 95.

Skyward Sword

Smith's Sword (Equipment)

A sword forged by Smith the blacksmith. Originally meant to be delivered to the castle and used as a prize, it winds up in Link's possession.

The Minish Cap

Smooth Gem (Quest)

This stone is the secret to the Zora queen Oren's beauty. It is so irresistibly smooth that it is hard to let go. Stolen by a thief, it is sold by the Kakariko Village Street Merchant.

A Link Between Worlds

Snow Rail Map (Quest)

A stone tablet located on the seventh floor of the Tower of Spirits. Obtaining it restores the Spirit Tracks in the Snow Realm.

Spirit Tracks

Snow Seal (Critical)

An item obtained as proof of repairing the barrier in the Snow Realm.

Spirit Tracks

Soothing Rain (Critical)

One of the eight Essences of Nature in *Oracle of Seasons*. It is found in the Dancing Dragon Dungeon.

Oracle of Seasons

Spare Key (Quest)

Talon, the owner of Lon Lon Ranch, loses this key. It is hidden inside a pot in the house.

The Minish Cap

Special Delivery to Mama (Quest)

A letter left behind by Kafei while in hiding on the Final Day. It is received from the man from the Curiosity Shop. Link can give it to Madame Aroma directly or send it to her via the Postman.

Majora's Mask

Spider Silk Lace (Other)

A spider silk so strong it will never break. Found in the Ruins region of *Tri Force Heroes*, it is a material used to make Light Armor.

Tri Force Heroes

Spin Attack Attire (Equipment)

An outfit for a warrior who has mastered the Spin Attack. When wearing these clothes, Spin Attacks automatically become Big Spin Attacks, and their attack power and range double.

Tri Force Heroes

Spinner (Tool)

An ancient spinning apparatus that Link can hop on and ride above the ground for a short period of time. It can also glide along rails, drive in screws, and activate certain switches.

Twilight Princess

Spirit Flute (Critical)

An instrument passed down among the royal family for ages and given to Link from Princess Zelda. The flute has multiple effects depending on the song played, including waking Gossip Stones.

Spirit Tracks

Spirit Medallion (Critical)

One of six medallions that grant Link the power of the sages. After clearing the Spirit Temple, Nabooru awakens as the Sage of Spirit and presents this sacred artifact to Link to aid in the looming battle with Ganon.

Ocarina of Time

Spirit of Courage (Critical)

The great spirit Ciela, who serves the Ocean King and lends her power to Link. She awakens as the Spirit of Courage at the Temple of Courage. Afterward, Link is able to fire beams from his sword.

Phantom Hourglass

Spirit of Power (Critical)

The great spirit Leaf, who serves the Ocean King and lends his power to Link. After Link rescues him from the Temple of Fire, he increases the damage done by Link's attacks.

Phantom Hourglass

Spirit of Wisdom (Critical)

The great spirit Neri, who serves the Ocean King and lends her power to Link after Link saves her in the Temple of Wind. By Link's side, she reduces any damage he takes.

Phantom Hourglass

Spirit Vessel (Collection)

A flower representing the spirit of the hero in the Silent Realm. It is completed by gathering all the sacred Tears of the Goddesses. Each is kept in a bulb growing off the plant's stem.

Skyward Sword

Spiritual Stone of Fire (Critical)
See Goron's Ruby.

Spiritual Stone of the Forest (Critical)
See Kokiri's Emerald.

Spiritual Stone of Water (Critical)
See Zora's Sapphire.

Spoils Bag (Collection)

A convenient bag that can carry items obtained from enemies like Chu Jelly, Joy Pendants, and Knight's Crests, among others.

The Wind Waker

Spooky Mask (Equipment)

A wooden mask with a sorrowful expression. A boy in the graveyard wants it in *Ocarina of Time*.

Ocarina of Time

Spring Banana (Quest)

Moosh, the winged bear, loves Spring Bananas and will join Link on his quest if given one.

Oracle of Seasons

Spring Water (Other)
See Water.

Square Jewel (Quest)
See Jewels.

Squid Carving (Dungeon)

This carving acts as a Boss Key, granting Link access to the control room on the Sandship. It has a squid-like design covered in suction cups that really sticks with you.

Skyward Sword

Stal Skull (Other)

A Stalfos skull. Stal bones can be used for white dye, an essential material in Dune-walker Duds and the Ninja Gi.

Tri Force Heroes

Stalfos Skull (Other)

A low-value treasure that can be combined with other items to create Skull Train Cars in *Spirit Tracks*. This artifact's eerie aura makes it the ultimate collector's item. It sells for 50 rupees.

Spirit Tracks

Stamina Fruit (Consumable)

A mysterious fruit that grows everywhere from fields to dungeons. Eating one will fully restore the stamina meter. These plants are resilient, and can even be found growing on slopes.

Skyward Sword

Stamina Potion (Consumable)

Drinking this potion temporarily reduces the rate at which stamina depletes when Link runs or otherwise exerts himself. It can be bought at a Potion Shop and carried in a bottle. Not to be confused with Green Potion, which restores magic power in other games.

Skyward Sword

Stamina Potion+ (Consumable)

An improved Stamina Potion that Bertie combines with additional ingredients at the Potion Shop. Drinking it gives Link unlimited stamina for three minutes.

Skyward Sword

Stamina Scroll (Quest)

Obtained from a treasure box in the Ice Ruins. It increases the capacity of the stamina meter by 50%.

A Link Between Worlds

Stamp Book (Collection)

A 20-page stamp book received from Niko. Depending on the number of stamps Link collects from around Hyrule, Niko will reward him with one of three valuable items.

Spirit Tracks

Star Fragment (Other)

A low-value treasure used to construct Train Cars in *Spirit Tracks*. It is also a material in *Tri Force Heroes*.

Spirit Tracks · *Tri Force Heroes*

Star-Shaped Ore (Quest)

Ore shaped like a star in *Oracle of Seasons*. It can be exchanged for a ribbon at the Subrosia Market.

Oracle of Seasons

Starry Firefly (Creature)

Appearing at night, this Skyloft insect emits a beautiful, pale light as it flies. They favor areas with water. Their light has a calming effect on people.

Skyward Sword

Stationery (Quest)

Obtained from the Postman, this Stationery can be traded to the hand in the toilet for a Stink Bag.

Oracle of Ages

DATABASE ITEMS

Steel Mask (OTHER)

The Legend of Zelda

A speck of this steel makes swords much stronger. Used as a material in the Spin Attack Attire.

Stepladder (EQUIPMENT)

See Ladder.

Stick (QUEST)

Link's Awakening

A stick left behind after Kiki the monkey and her friends build a bridge for Link near Kanalet Castle in exchange for bananas. Link can exchange it for a honeycomb. See also Honeycomb.

Stiff Puff (OTHER)

Tri Force Heroes

It looks puffy, but it is actually rock solid. Go figure! Used as a material for the Sword Suit.

Stink Bag (QUEST)

Oracle of Ages

A trading item in *Oracle of Ages* obtained from the hand in the toilet. If Link gives it to the Tokay to cure his stuffy nose, he will give Link Tasty Meat in thanks.

Stone Beak (DUNGEON)

Link's Awakening DX

Found in dungeons in the DX version of *Link's Awakening*. After acquiring one, examining a beakless Owl Statue in the same dungeon will give Link a hint. These are equivalent to the Stone Slab Fragments in the original.

Stone Mask (EQUIPMENT)

Majora's Mask

Neither people nor monsters notice the wearer of this strange mask made of rock. Shiro, a Clock Town Soldier, will trade the mask for a potion. He is found in different locations depending on the version of the game.

Stone of Agony (OTHER)

Ocarina of Time (Nintendo 64)

This item will notify the holder of holes hidden in the ground nearby by vibrating. It only appears in the original *Ocarina of Time*. In the 3DS version, it was changed to the Shard of Agony. The function is the same, but it reacts differently. See also Shard of Agony.

Stone of Trials (QUEST)

Skyward Sword

Received after completing the fourth Silent Realm. Placing it into the eye of the bird statue on Skyloft will open the way to the Sky Keep.

Stone Slab Fragment (DUNGEON)

See Stone Beak.

Stowfish (CREATURE)

Phantom Hourglass

This tiny fish, found in the ocean, has only a 5% chance of being caught. True to its name, it hitches a ride on larger fish like Loovar or Rusty Swordfish.

Strange Flute (CRITICAL)

Oracle series

A flute used to summon companions in the *Oracle* series. Its name changes based on which companion Link chooses to partner with for the remainder of his adventure. See also Dimitri's Flute, Moosh's Flute, Ricky's Flute.

Submarine Chart (OTHER)

The Wind Waker

This chart reveals where submarines appear throughout the sea. Infiltrating submarines and defeating the enemies on board yields valuable items.

Sun Key (QUEST)

Phantom Hourglass

This key opens the door for the Temple of Courage beneath Molida Island. To obtain it, Link must use the Salvage Arm in the location indicated by the Symbol of Courage.

Super Bomb (TOOL)

A Link to the Past

A large bomb sold in the Dark World. It will not fit in a bag, so Link must guide it to its destination without making it explode along the way. See also Big Bomb Flower.

Super Hammer (TOOL)

Four Swords Adventures (Japanese version only)

Appears in "Navi Trackers." Powers up the Magic Hammer just once, enabling it to cause earthquakes.

Super Lamp (TOOL)

A Link Between Worlds

Clearing the advanced course of the Treacherous Tower on Death Mountain will allow Link's Lamp to be upgraded to the Super Lamp. This increases the damage done by its flames.

Super Net (TOOL)

A Link Between Worlds

Completing the advanced course of the Treacherous Tower twice allows Link to upgrade the Bug Net. Its area of effect and swing speed are the same, but its attack power when hitting enemies is increased eightfold.

Super Warp Balloon (CONSUMABLE)

Four Swords Adventures (Japanese version only)

Appears in "Navi Trackers." Lets the user warp right in front of the next character who will award medals. Only one can be held at a time.

Superb Soup (CONSUMABLE)

Twilight Princess

A delicious and mellow soup made by adding Ordon Goat Cheese to Good Soup. Putting it into a bottle and drinking it recovers eight hearts.

Supple Leaf (OTHER)

Tri Force Heroes

A jiggly leaf brimming with collagen found in the Woodlands. It is soft and elastic, and can be used as a material in Cacto Clothes.

Surf Harp (CRITICAL)

Link's Awakening

Obtained by clearing the Angler's Tunnel dungeon. It is one of eight instruments needed to perform the Ballad of the Wind Fish.

Swamp Title Deed (QUEST)

Majora's Mask

One of four deeds in *Majora's Mask*. Obtained by handing the Land Title Deed to the Business Scrub in the Southern Swamp. See also Mountain Title Deed.

Sweet Shroom (OTHER)

Tri Force Heroes

A mushroom that emits a smell like a sweet dream. However, if eaten, it causes three days and nights of agony and suffering. It is a material for the Legendary Dress and Lucky Loungewear.

Swift Sail (OTHER)

The Wind Waker HD

An item that was added in the HD version of *The Wind Waker*. It allows Link's boat to sail at twice the normal speed with a permanent tailwind. See also Sail.

Switch Hook (TOOL)

Oracle of Ages

This tool similar to the Hookshot will swap the position of its user and whatever it hits when fired, including enemies and pots. See also Long Hook.

Sword (EQUIPMENT)

● Fighter's Sword

The Legend of Zelda / *A Link to the Past* / *Link's Awakening* / *Tri Force Heroes*

A basic weapon able to cut down both formidable foes and tall grass. In some titles, a sword fires beams when Link's life is full.

Sword Blade (QUEST)

Phantom Hourglass

A sword blade made of the three pure metals: Crimsonine, Azurine, and Aquanine. It is forged by Zauz the blacksmith on his island and required for the Phantom Sword.

Sword Master Suit (EQUIPMENT)

Clothing worn by the greatest sword masters. It doubles the wearer's attack power, extends the reach of their sword significantly, and fires a wider beam than the standard Sword Suit.

Sword Suit (EQUIPMENT)

An outfit beloved by sword masters. It doubles a sword's attack power and shoots beams when Link's hearts are full, making it possible to hit faraway enemies.

Swordsman's Scroll (QUEST)

Phantom Hourglass

A scroll imbued with great knowledge in *Phantom Hourglass*. Trading for it upgrades the Spin Attack, teaching Link the Great Spin Attack.

Swordsman's Scroll 1 (QUEST)

Spirit Tracks

Obtained by capturing 50 rabbits in *Spirit Tracks*. This scroll gives Link's sword the power to fire beams of light when he is at full health.

Swordsman's Scroll 2 (QUEST)

Spirit Tracks

Received after collecting all 20 stamps throughout Hyrule and reporting to Niko. It will enable Link to use the Great Spin Attack.

T COLUMN

Tail Key (QUEST)

Link's Awakening

This key unlocks the seal on the entrance to the Tail Cave.

Tasty Meat (QUEST)

Oracle of Ages

A trading item in *Oracle of Ages* obtained from a Tokay. The Happy Mask Salesman will give Link a Doggie Mask as thanks for letting him eat it.

Tears of Din (QUEST)

Skyward Sword

Tears gathered in the Silent Realm trial on Eldin Volcano. Collecting all 15 will complete the trial, earning Link the Fireshield Earrings.

Column 1

▷ **Tears of Farore** (Quest)

Skyward Sword

Tears gathered in the Silent Realm trial in the Faron Woods. Collecting all 15 will complete the trial and reward Link with the Water Dragon's Scale.

▷ **Tears of Light** (Quest)

Twilight Princess
Spirit Tracks

The source of the Spirits of Light's power in *Twilight Princess*. In *Spirit Tracks*, Tears of Light are used to defeat Armored Trains.

▷ **Tears of Nayru** (Quest)

Skyward Sword

Tears gathered in the Silent Realm trial in the Lanayru Desert. Collecting all 15 will complete the trial and award Link with the Clawshot.

▷ **Tektite Shell** (Other)

Tri Force Heroes

The shell of a Tektite monster. It is considered a good-luck charm . . . probably. Maybe? Used as a material in the Big Bomb Outfit and Legendary Dress.

▷ **Telescope** (Quest)

● Kaleidoscope

The Wind Waker *Four Swords Adventures (Japanese version only)* *Phantom Hourglass*

A tool for peering across great distances in *The Wind Waker*. In *Phantom Hourglass*, it is traded for the Hero's New Clothes. It is also a bonus item in the Japan-only "Navi Trackers" feature in *Four Swords Adventures*.

▷ **Thornberry** (Other)

Tri Force Heroes

A fruit covered in spikes found in Hytopia's Riverside area. The high quality of the Thornberry's fibers makes a fine fabric and it can be used as a material for Cacto Clothes.

▷ **Thunder Drum** (Critical)

Link's Awakening

Obtained by clearing the dungeon Turtle Rock. This is one of the instruments needed to perform the Ballad of the Wind Fish.

▷ **Tiger Scrolls** (Quest)

The Minish Cap

Received after training under the self-trained swordsmen throughout Hyrule. When Link learns a new skill from a swordsman, like Spin Attack or Downthrust, he is immediately able to use it in the field. These scrolls are proof that he knows how.

▷ **Timeless Tunic** (Equipment)

Tri Force Heroes

A dazzlingly nostalgic pixel-art-style outfit. It even makes the BGM sound, straight out of the good old days. Its wearer cannot become flat.

▷ **Tingle Bottle** (Other)

The Wind Waker HD

Only appears in the HD version. Miiverse messages and drawings are placed in the bottle and can be exchanged with an anonymous player. They are found along coasts and out at sea.

▷ **Tingle Statue** (Other)

The Wind Waker (1) *The Wind Waker (2)* *The Wind Waker (3)* *The Wind Waker (4)*

The Wind Waker (5)

Statues found in Wind Temple (1), Tower of the Gods (2), Forbidden Woods (3), Earth Temple (4), and Dragon Roost Cavern (5), respectively. They can be located using the Tingle Tuner in the GameCube version.

Column 2

▷ **Tingle Tights** (Equipment)

Tri Force Heroes

An homage to Tingle. Link will float back to safety if he falls where there is no platform using one of the balloons on his back. Three balloons limits this to three uses.

▷ **Tingle Trophy** (Other)

The Minish Cap

A trophy received from the Tingle Brothers after fusing all 100 Kinstones. It is proof of completing this difficult task.

▷ **Tingle Tuner** (Tool)

The Wind Waker (GameCube)

Appears only in the GameCube version. Connecting to a Game Boy Advance allows Link to use a variety of items, as well as receive the five Tingle Statues, including the Wind and Goddess Tingle Statues.

▷ **Tingle's Chart** (Other)

The Wind Waker

A chart that shows Windfall Island as well as Tingle Island, where Tingle resides. The chart's drawn by Tingle himself, who is not much of an artist.

▷ **Tiny Snowflake** (Other)

Tri Force Heroes

A fragile snow crystal that only forms at precisely -25 degrees Celsius. It is used as a material in Hammerwear and Tingle Tights.

▷ **Titan's Mitt** (Equipment)

A Link to the Past *A Link Between Worlds*

Enables the wearer to lift even heavier objects than is possible with the Power Glove. See also Power Glove.

▷ **Tokay Eyeball** (Quest)

Oracle of Ages

Placing this item into the Tokay statue on Crescent Island in *Oracle of Ages* opens the entrance to the Ancient Tomb.

▷ **Token** (Other)

● Golden Skulltula Spirit

Ocarina of Time *Majora's Mask*

A token received from defeating Gold Skulltulas found throughout Hyrule.

▷ **Toona** (Creature)

Phantom Hourglass

A fish that can be caught at sea. They range in size from 80 centimeters to 1.4 meters long.

▷ **Tornado Rod** (Tool)

A Link Between Worlds

A rod that harnesses the power of the wind. It creates small tornadoes that will lift Link up into the air. While airborne, Link can catch air currents that will carry him to spots that may be hard to reach. A burst of air from the rod can also be used to put out fires.

▷ **Torrent Robe** (Equipment)

Tri Force Heroes

A magician's robe for those who harness the power of water. The size of the water pillars created by the Water Rod roughly doubles while wearing this, making it very easy to walk across them.

▷ **Touching Book** (Quest)

Oracle of Ages

A book with a tear on the cover obtained from Dekadin when Link tells him the Funny Joke. If Link talks to Maple while carrying this book, she will offer a Magic Oar for it.

Column 3

▷ **Tough Beetle** (Tool)

Skyward Sword

Gondo at the Scrap Shop further enhances the Quick Beetle, pushing its flying time to the limit.

▷ **Town Flower** (Quest)

The Wind Waker

A little flower reminiscent of the town on Windfall Island. Can be exchanged for the Sea Flower.

▷ **Town Title Deed** (Quest)

See Land Title Deed.

▷ **Train Cars** (Collection)

Spirit Tracks

These allow Link to add to and customize the look and durability of his train. They can be obtained in exchange for treasures. There are 32 cars across all eight sets.

▷ **Train Heart** (Consumable)

Spirit Tracks

These restore power to Link's train. The train's power changes depending on the cars it is pulling, as well as their order.

▷ **Treasure Bag** (Other)

The Adventure of Link

Collecting these bags will significantly increase Link's experience points. The bags drop from defeated enemies and may also be found in palaces.

▷ **Treasure Chart** (Other)

The Wind Waker

There are many of these charts, each showing the locations of treasure boxes under the sea. Searching for salvage in these locations yields valuable rupees and Pieces of Heart.

▷ **Treasure Map** (Quest)

Oracle of Seasons *Phantom Hourglass*

In *Oracle of Seasons*, this map reveals the locations of the four Jewels. In *Phantom Hourglass*, it reveals treasures beneath the sea. See also Treasure Chart.

▷ **Treasure Medal** (Equipment)

Skyward Sword

One of several medals Link can acquire in *Skyward Sword* that have beneficial effects when carried. This one doubles the chances of a defeated monster dropping materials.

▷ **Treasure Sphere** (Consumable)

The Wind Waker

These occasionally appear when an enemy is defeated. Shatter them for a wealth of rupees or other spoils.

▷ **Tri Suit** (Equipment)

Tri Force Heroes

The effect of this suit triggers when all three Links wear it. Hearts and rupees appear more frequently, the energy meter goes up 50%, and 25% of attacks are dodged. It makes Link want to pose in it.

▷ **Triforce** ("Navi Trackers") (Critical)

Four Swords Adventures (Japanese version only)

A sacred relic with the power of the goddesses. The Triforce is able to grant any wish. Its three golden triangles represent Courage, Power, and Wisdom. It appears as an item in "Navi Trackers" in *Four Swords Adventures*. See also page 13.

▷ **Triforce Chart** (Other)

The Wind Waker

A chart detailing the locations of Triforce Shards resting on the sea floor. It cannot be read without paying Tingle to decipher it.

DATABASE · ITEMS

▷ Triforce of Courage (CRITICAL)

The Wind Waker · *Skyward Sword* · *A Link Between Worlds*

One of three pieces of the Triforce, a sacred object imbued with the powers of the goddesses. In *Skyward Sword*, it is obtained by completing trials, and in *A Link Between Worlds* by proving Link's courage by rescuing the sages. In *The Wind Waker*, it is restored by collecting Triforce Shards. See also page 13.

▷ Triforce of Power (CRITICAL)

Skyward Sword · *A Link Between Worlds*

One of three pieces of the Triforce, a sacred object imbued with the powers of the goddesses. Possessing this piece gives Ganondorf the power to take Hyrule Castle in *Ocarina of Time*. See also page 13.

▷ Triforce of Wisdom (CRITICAL)

The Legend of Zelda · *Skyward Sword* · *A Link Between Worlds*

One of three pieces of the Triforce, a sacred object imbued with the powers of the goddesses. In *The Legend of Zelda*, Link seeks to collect its fragments. In *Skyward Sword*, he obtains it by completing trials. See also page 13.

▷ Triforce Shard (CRITICAL)

The Legend of Zelda · *The Wind Waker*

Link gathers Triforce Shards to assemble the Triforce of Wisdom in *The Legend of Zelda* and the Triforce of Courage in *The Wind Waker*.

▷ Trophy (QUEST)

The Adventure of Link

The trophy from the town of Ruto, stolen by a Goriya and hidden in a cave. Retrieving it earns Link the Jump Spell as thanks.

▷ Troupe Leader's Mask (EQUIPMENT)

Majora's Mask

Obtained from the eldest Gorman brother in the Milk Bar. It makes defending Cremia's milk shipment easier and is used in the Fraternal Milk quest.

▷ True Master Sword (EQUIPMENT)

Skyward Sword

A sword that harnesses the Master Sword's true power, unlocked by Zelda's blessing at the Temple of Hylia. The ultimate sword, its Skyward Strike charges faster, does more damage, and has greater range. See also Master Sword.

▷ Tumbleweed (OTHER)

Skyward Sword

A tumbleweed that rolls around in the desert wind after its roots dry and it separates from the ground. Fragile, it will break if blown into something. It can be caught with a net.

▷ Tuni Nut (QUEST)

Oracle of Ages

This item appears in *Oracle of Ages*. The treasure of Symmetry Village, it prevents the volcano's eruption. See also Cracked Tuni Nut.

▷ Twinmold's Remains (CRITICAL)

Majora's Mask

This mask is left behind after defeating Twinmold, the boss of Stone Tower Temple, and freeing its spirit.

▷ Twisted Twig (OTHER)

Tri Force Heroes

A twig that has grown into a twisted shape. It is a highly prized talisman said to ensure marital bliss. Used as a material for the Serpent's Toga and Fire Blazer.

▷ Tycoon Wallet (COLLECTION)

Skyward Sword

Received after fulfilling Batreaux's request for 80 Gratitude Crystals and restoring his original form. It is the ultimate wallet for the wealthiest people, able to hold up to 9,000 rupees. See also page 95.

U — U COLUMN

▷ Unlucky Pot (CONSUMABLE)

Four Swords Adventures (Japanese version only)

An interference item that appears in "Navi Trackers." It places a jar over the head of the rival in the lead, stopping them in place.

V — V COLUMN

▷ Vessel (QUEST)

Spirit Tracks

Urns that can be purchased from the Wise One in Papuchia Village. When Steem wishes to redecorate the Snow Sanctuary, he asks Link to bring him one.

▷ Vessel of Light (COLLECTION)

Twilight Princess

Given to Link by the Spirits of Light, this vessel collects Tears of Light in the Twilight Realm. Filling the vessel will restore light to the land guarded by the spirits.

▷ Vibrant Brooch (OTHER)

Tri Force Heroes

With such vibrant colors, this brooch is sure to make strangers jealous. Its sparkling appearance makes it a perfect material for the Showstopper outfit.

▷ Vintage Linen (OTHER)

Tri Force Heroes

How to make this is a family secret. It is used as a material to make Gust Garb and the Ninja Gi.

▷ Volcanic Ladybug (CREATURE)

Skyward Sword

A bug that dwells in hot, volcanic areas. They often travel in groups and tend not to be wary of people, making them easy to catch.

W — W COLUMN

▷ Wake-Up Mushroom (QUEST)

The Minish Cap

This item can be bought from Syrup in the Minish Woods. It has a powerful smell that will wake up anyone immediately. It is required to wake up Rem the shoemaker.

▷ Wallet (COLLECTION)

The Wind Waker · *Twilight Princess*

A bag for holding rupees. Upgrading to a bigger wallet will allow Link to carry more money. See also page 95.

▷ Water (CONSUMABLE)
● Spring Water

Majora's Mask · *The Wind Waker* · *The Minish Cap* · *Twilight Princess*

Plain old water, scooped up with a bottle. It is mainly used to make plants grow by pouring it on them. In *Skyward Sword*, pouring water on certain switches will activate them. See also Hot Spring Water.

▷ Water Bomb (TOOL)

Twilight Princess

A bomb specially designed to explode underwater. Link can buy them at Barnes Bomb Shop or catch Bombfish to use in their place.

▷ Water Dragon's Scale (EQUIPMENT)

Skyward Sword

One of the divine treasures left for Link by the goddess. Obtained by clearing the Silent Realm in Faron Woods, its holder can swim freely underwater and even execute a spin that lets them accelerate and attack.

▷ Water Element (CRITICAL)

The Minish Cap

Obtained in the Temple of Droplets, it is the crystallized power of water, able to quench any thirst. It imbues the White Sword with greater power.

▷ Water Medallion (CRITICAL)

Ocarina of Time

One of six medallions that grant Link the power of the sages. After clearing the Water Temple, Ruto awakens as the Sage of Water and presents this sacred artifact to Link to aid in the looming battle with Ganon.

▷ Water of Life (QUEST)

The Adventure of Link

Water of Life found in the cave near Saria Town. Link is rewarded with the ability to learn Fairy Magic when he gives it to a Mido Town villager to help their sick daughter.

▷ Water of Life (Blue) (CONSUMABLE)
● Life Potion

The Legend of Zelda

Completely restores Link's life. It can only be used once. An old woman living in a cave sells it to Link. See also Blue Potion.

▷ Water of Life (Red) (CONSUMABLE)
● 2nd Potion

The Legend of Zelda

Completely restores Link's life. Using it once turns it into the blue version. An old woman living in a cave sells both varieties. See also Red Potion.

▷ Water Rod (TOOL)

Tri Force Heroes

This rod temporarily creates a pillar of water. Link can use water pillars as platforms and, by creating several, walk across them. It can be used even when no water is present.

▷ Weird Egg (QUEST)

Ocarina of Time

This egg will hatch a cucco after one night. It is given to Link by Malon, the young girl at the ranch.

▷ Whip (TOOL)

Spirit Tracks · *Skyward Sword*

The tip of this whip can latch onto and pull away enemy weapons, as well as grab onto posts, letting Link swing between platforms.

▷ Whirlwind (TOOL)

Spirit Tracks

A weapon obtained in the Forest Temple. It generates tornadoes when used and can blow away poison gas or fallen leaves, as well as spin windmills. Used by blowing into the mic in the DS.

▷ Whistle (CRITICAL)
See Flute.

White Picolyte (Consumable)

The Minish Cap

This potion makes it easier to find Kinstones for a short time when searching grass and other places where Kinstones are found. Beedle will sell it to Link in Hyrule Town if Link has an empty bottle.

White Sword (Equipment)

The Legend of Zelda The Minish Cap

In *The Legend of Zelda*, Link can obtain this powerful sword after collecting enough Heart Containers. In *The Minish Cap*, it is the name of the reforged Picori Blade.

White Sword (Two Elements) (Equipment)

The Minish Cap

The White Sword after it has been imbued with both the Earth and Fire Elements. It enables Link to split into two versions of himself by charging on glowing tiles.

White Sword (Three Elements) (Equipment)

The Minish Cap

The White Sword after gaining the Water Element and fusing it into the sword with the Earth and Fire Elements. This upgraded blade enables Link to split into three versions of himself by charging on glowing tiles.

Wind Element (Critical)

The Minish Cap

Obtained in the Palace of Winds, the Wind Element is a crystal with the power of the wind able to make flowers bloom. Required for bringing out the power of the White Sword.

Wind Marimba (Critical)

Link's Awakening

One of the instruments needed to perform the Ballad of the Wind Fish. Obtained by completing the Catfish's Maw dungeon.

Wind Tingle Statue (Other)

See Tingle Statue.

Wind Waker (Critical)

The Wind Waker

A mysterious conductor's wand said to harness the power of the gods. Long ago, the king of Hyrule used it to conduct the sages when they played their song to call upon the gods. It has many uses, and its effects depend on the song conducted.

Wisdom Gem (Other)

Phantom Hourglass

Twenty Wisdom Gems are scattered across the islands of *Phantom Hourglass*. Gathering and bringing them to Spirit Island will unlock the Spirit of Wisdom's power, reducing damage taken and granting Link the ability to better defend against special attacks.

Wood Heart (Quest)

Phantom Hourglass Spirit Tracks

This item is obtained by trading the Guard Notebook in *Phantom Hourglass* and is a low-value treasure in *Spirit Tracks*.

Wooden Bird (Quest)

Oracle of Seasons

A trading item received from Syrup that appears in *Oracle of Seasons*. Tick Tock in the Clock Shop will trade it for Engine Grease.

Wooden Bow (Tool)

Skyward Sword

A long-range weapon that can fire arrows at targets. It is obtained on the Sandship in *Skyward Sword*. Taking aim and holding the arrow back for a few seconds before firing increases its power. See also Bow.

Wooden Shield (Equipment)

Oracle series Twilight Princess Skyward Sword

A standard wooden shield useful for blocking attacks. It is weak to fire attacks, and will burn up if it catches fire in *Twilight Princess* and *Skyward Sword*.

Wooden Statue (Collection)

● Carver's Statue

A Link to the Past (1) A Link to the Past (2) A Link to the Past (3) Twilight Princess

Link is sent on a quest to recover the Wooden Statue in *Twilight Princess* to restore his childhood friend Ilia's memory. The Carver's Statues in *A Link to the Past* only appear in the GBA version and depict a cucco (1), Link (2), and Zelda (3).

Wooden Sword (Equipment)

Oracle series Twilight Princess

The first sword Link obtains in the *Oracle* series. It is a symbol of a hero that persists across many eras. In *Twilight Princess*, it is a favorite blade for practicing. It has low attack power and cannot cut since it has no edge, but it smarts if it connects. Link ends up lending it to Talo.

Woodland Rhino Beetle (Creature)

Skyward Sword

A large bug that moves slowly. Many live in Faron Woods. Woodland Rhino Beetles are often found crawling up trees looking for sap, and they can be caught barehanded using a rolling attack to knock them down.

World's Finest Eye Drops (Quest)

Ocarina of Time

This medicine heals Biggoron's eyes. In exchange, he gives Link the Claim Check.

Worm (Creature)

Twilight Princess

A bug found hidden throughout Hyrule. Putting one in a bottle lets Link take it along as bait when fishing. Bomskits, insect-like monsters that appear in the fields, drop these when defeated.

X-Shaped Jewel (Quest)

See Jewels.

Yellow Chu Jelly (Consumable)

Twilight Princess

This yellow jelly left behind by a defeated Chuchu can be scooped up with a bottle. It is very oily and acts much like Lantern Oil.

Yellow Picolyte (Consumable)

The Minish Cap

This potion makes it easier to find rupees for a short time when searching grass and other places where rupees are found. Beedle will sell it to Link in Hyrule Town if Link has an empty bottle.

Yellow Potion (Consumable)

Phantom Hourglass Spirit Tracks A Link Between Worlds

Drinking this potion fully recovers Link's health. In *A Link Between Worlds*, it will make him temporarily invincible.

Yoshi Doll (Quest)

Link's Awakening

A toy that looks a lot like a famous character from another game, offered as a prize in the Trendy Game in Mabe Village. Papahl's wife will give Link a ribbon in exchange for it.

Zelda's Letter (Quest)

Ocarina of Time

Received after Link is recognized as a messenger of the Hyrule royal family. The letter is signed by Princess Zelda herself. Link shows it to the Death Mountain Trail guard.

Zora Costume (Equipment)

Tri Force Heroes

A Zora costume that improves Link's swimming ability. It gives the wearer the power to swim against fast currents and more effectively attack enemies while in water.

Zora Egg (Quest)

Majora's Mask

The Zora named Lulu laid seven eggs that were stolen by Gerudo Pirates. Collecting and bringing them to the Marine Research Laboratory makes it possible to learn the song New Wave Bossa Nova, which will help Lulu recover her voice and, in turn, grant Link access to the Great Bay Temple.

Zora Guitar (Critical)

Majora's Mask

When transformed into a Zora, Link will play ocarina melodies on this guitar instead. Its use and effects are no different from the ocarina.

Zora Mask (Equipment)

Ocarina of Time Majora's Mask

When the Zora guitarist Mikau dies trying to recover Lulu's eggs from Gerudo Pirates, Link plays the Song of Healing on the Ocarina of Time, allowing Mikau to perform with the Indigo-Go's one last time. After Mikau fades away, he leaves behind the Zora Mask. Donning it transforms Link into a Zora. A Zora Mask also appears in *Ocarina of Time*, though it mostly just generates some fun reactions.

Zora Scale (Quest)

Oracle of Ages Phantom Hourglass Tri Force Heroes

A scale from a Zora. This item appears in *Oracle of Ages*, as well as being a type of treasure in *Phantom Hourglass* and a material in *Tri Force Heroes*.

Zora Tunic (Equipment)

● Zora Armor

Ocarina of Time Twilight Princess

A tunic passed down among the Zora that lets the wearer breathe underwater, increasing swimming ability. Can only be worn as an adult in *Ocarina of Time*.

Zora's Flippers (Tool)

See Flippers.

Zora's Sapphire (Critical)

● Spiritual Stone of Water

Ocarina of Time

The treasure of the Zora royal family, used as an engagement ring by their princesses. The sapphire is the Spiritual Stone of Water, one of three jewels required to open the Door of Time.

DUNGEONS

Caverns. Towers. Temples. Even inside monsters. Link can find himself lost in a dungeon just about anywhere. What they all have in common is peril and puzzles at every turn.

It's not a *Legend of Zelda* without at least a few labyrinths to fight through. Collected here are the primary dungeons found in each release, listed in the order of their appearance. Most are clearly dungeons in every sense: complicated layouts, valuable treasure, a boss at the end to beat. Others are less typical, but share at least some of these traits. Where relevant, dungeons added for rereleases and remakes are also included.

OCARINA OF TIME **1**

Link's first adventure on the Nintendo 64 introduces mechanics and puzzles that make ample use of all three dimensions. In addition to more traditional castles, caves, and temples, **2** are elaborate dungeons inside a giant tree and even a fish. Bosses announce their arrival though intimidating, cinematic cut scenes that highlight their strengths while hinting at weakness.

▶ *Inside the* **3** *Tree*

4
5

Deep within the Kokiri Forest, the Great Deku Tree suffers from a curse that is slowly killing him. The tree beckons Link to stop the curse. Link finds the tree overrun with monsters. Massive webs block the way forward, requiring Link to put a torch to them to proceed. After finding the Fairy Slingshot, he takes aim at the root of the curse: the spider-like boss Gohma.

1 GAME TITLE
2 INTRODUCTION
3 DUNGEON NAME
4 SCREENSHOTS
The number of screenshots varies by title. Most will show the entrance to the dungeon in addition to rooms that exemplify its challenges. When a rerelease or remake exists, screenshots are taken from those versions. However, *Ocarina of Time, Majora's Mask, The Wind Waker,* and *Twilight Princess* all include an image from their original versions in the center.
5 DUNGEON DESCRIPTION

THE LEGEND OF ZELDA

Eight fragments of the Triforce of Wisdom are hidden in the darkest corners of dungeons scattered throughout Hyrule. The entrances to each dungeon lie aboveground and lead far below where dangerous enemies lurk. Each

is broken up into rooms separated by one-way doors, traps, and mechanics unlike anything found on the surface. The difficulty increases depending on the level, while clues to their layout lie in their names, like "Eagle" and "Moon," provided to Link by Princess Zelda's nursemaid, Impa. After successfully completing all nine dungeons, Link may try his hand at the more challenging Second Quest, with new entrances and map configurations, as well as unique enemy abilities and placements.

▶ *Level 1* (EAGLE)

This initial dungeon's entrance is cut into a large tree, found by crossing a long bridge over Lake Hylia. The layout is shaped like an eagle spreading its wings. Link finds the Boomerang here after defeating a group of red Goriyas. The Bow is also found here, in a treasure room hidden below the dungeon proper. The boss of this dungeon is the dragon-like Aquamentus.

▶ *Level 2* (MOON)

The second dungeon is a crescent-shaped labyrinth located deep in the eastern woods. Link must slip past fast-moving Ropes and the red-hot beams of stone statues to reach the burly Dodongo boss far within. Cutting down a gang of powerful blue Goriyas in what might be the most perilous room in the dungeon will reward Link with the Magical Boomerang.

▶ *Level 3* (MANJI)

This dungeon at the edge of the western forest is shaped like the spiritual symbol known as a *manji*. Link can find the Raft here, but getting to it isn't easy. Darknuts, which deflect direct attacks, and Bubbles, which disable Link's sword, stand in the way, while the dangerous dungeon boss, a four-headed flower Manhandla, waits for a fight at the dungeon's heart.

▶ *Level 4* (SNAKE)

The entrance to this snake-shaped dungeon is on a small island that can only be reached by using the Raft. Several dark rooms inside require the Candle, while a two-headed Gleeok serves as dungeon boss. The Ladder, found here, gives Link the ability to cross gaps and avoid enemies.

▶ *Level 5* (LIZARD)

This dungeon is accessible by climbing the eastern mountains. It's shaped like a lizard and infested with Darknuts and Pols Voices, the latter of which are best dispatched with arrows. Link will find the Recorder in this dungeon (sometimes called the Whistle).Playing it warps Link to dungeon entrances. A Digdogger is the boss here, keeping watch with one giant eye.

▶ *Level 6* (DRAGON)

This dragon-shaped dungeon is located in the rocky area just past the Lost Woods and the Graveyard. The slew of Bubbles, Like Likes, and Wizzrobes makes this one of the hardest dungeons Link explores in the original *Legend of Zelda*. Overcoming them earns Link the Magic Rod. A fearsome Gohma acts as boss of this dungeon.

▷ Level 7 (Demon)

Playing the Recorder at the fountain in the western woods causes nearby water to dry up, revealing the entrance to this dungeon. Within lies the Red Candle, as well as a room Link cannot escape unless he gives a hungry Goriya some food. The boss is the Aquamentus much like in Level 1. His fiery breath is no less dangerous this time around.

▷ Level 8 (Lion)

Found by burning a bush on the eastern forest, this dungeon is shaped like a lion's head. It holds many treasures, including the Book of Magic and the Magical Key, but to obtain these items, Link must first face every boss that has appeared up to this point. Beyond them lies still one more challenge: a Gleeok with four heads.

▷ Level 9 (Death Mountain)

This dungeon is shaped like a skull—appropriate for a labyrinth buried deep within Death Mountain. Link will find both the Red Ring and the Silver Arrow in its expansive and complicated corridors, leading to a showdown with Ganon.

▷ Level 1 (Second Quest)

After completing his initial quest to reassemble the Triforce of Wisdom and stop Ganon, Link embarks on a Second Quest. This first dungeon lies in the same spot it was found the first time around—in a large tree on an island in the middle of Lake Hylia—but it is shaped like an E instead of an eagle. He'll meet beam firing Stalfos and other enemies that are much stronger this time around. Much like in his initial quest, Link finds the Boomerang in this dungeon and does battle with the Aquamentus.

▷ Level 2 (Second Quest)

The entrance to this dungeon is hidden by an Armos just west of Lake Hylia. Its layout is complicated and shaped like an A with locations that cannot be passed without warping or moving through walls. This time around, the Recorder is found in this dungeon, and there are far more opportunities to use it in the Second Quest. The boss is a two-headed Gleeok.

▷ Level 3 (Second Quest)

Link uncovers the entrance to this L-shaped dungeon by playing the Recorder at the fountain in the eastern forest. Though there are few rooms, it is more complicated than it appears, with scores of stronger enemies to deal with. Link can get the Magical Boomerang here by giving the hungry Goriya he met in Level 7 more food, while three Dodongos serve as bosses.

▷ Level 4 (Second Quest)

The entrance to this dungeon lies beneath a boulder in the eastern mountains. The boulder will only budge if Link has the Power Bracelet. Inside this mass of rooms, roughly shaped like the letter D, lie both the Book of Magic and the Raft. The boss is a Digdogger. To complete the dungeon, Link must pay an Old Man at the exit 50 rupees or sacrifice a Heart Container.

▷ Level 5 (Second Quest)

The entrance to the second Level 5 dungeon lies on the small island reachable only with the Raft. The Bow is inside, guarded by Keese in a treasure room. The boss of this Z-shaped labyrinth is a three-headed Gleeok. Taken together, the first five dungeons of the Second Quest spell out "ZELDA."

▷ Level 6 (Second Quest)

A particular gravestone in the Graveyard hides the entrance to this dungeon, revealed only after playing the Recorder. In order to make it through the dungeon alive, Link must press on suspicious stones and seek out warp points. He finds the Ladder here. The boss is a Gohma.

▷ Level 7 (Second Quest)

To reveal the entrance to the Level 7 dungeon in his Second Quest, Link must use the Blue Candle to burn a tree near the dead end in the eastern forest. Ample use of warping is required, making this whirlpool-shaped dungeon one of the trickiest in the game. Link must do battle with particularly powerful enemies in order to obtain the Red Candle. A four-headed Gleeok is the dungeon boss.

▷ Level 8 (Second Quest)

This dungeon is hidden in the cliffs near the waterfall in the eastern mountains, its location hinted at by an Old Man in Level 6. Similar to Level 7 (Second Quest), it resembles a whirlpool. Link will find both the Magical Rod and the Magical Key in this tangle of warps and one-way routes. A trio of Dodongos serve as bosses.

▷ Level 9 (Second Quest)

Beneath Death Mountain lies the final dungeon of *The Legend of Zelda*, a formidable cluster of puzzling rooms and powerful enemies shaped like Ganon's head. The entrance can be found by bombing a cliff in the westernmost part of Death Mountain. Similar to Level 9 the first time around, Link will find the Red Ring and the Silver Arrow here, and once again uses these items to defeat Ganon and complete the Triforce of Wisdom.

The dungeons of this action-packed, side-scrolling follow-up to the original *Legend of Zelda* throw a slew of new challenges at Link in a whole new perspective. Most are labyrinthine palaces under the control of strong guardians. Collapsing bridges, falling blocks, and more stand in Link's way, requiring a mastery of spells and great skill just to survive, let alone find the quickest routes.

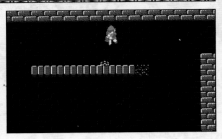

▷ Parapa Palace

A palace in the heart of Parapa Desert. While its layout is straightforward, elevators, collapsing bridges, and locked doors complicate this early dungeon. The Candle can be found here. A knight with the head of a horse, named Mazura, is the palace boss. In some texts, the boss also goes by the name Horsehead.

▷ Death Mountain

A maze of caverns and multiple routes makes exploring the depths of Death Mountain particularly perilous. While not a dungeon proper, if Link reaches Spectacle Rock, he'll receive the Hammer, essential for clearing boulders and brush. It is possible to catch a glimpse of the field from *The Legend of Zelda* by exiting the cavern and looking down toward the south.

▷ Midoro Palace

Deep within Midoro Swamp lies Midoro Palace, surrounded on three sides by mountains. Falling rocks make passage through the palace particularly treacherous, but it's worth the trouble to obtain the Power Glove. Jermafenser is the palace's boss, also known as Helmethead. His head is his weak point.

▷ Island Palace

This palace built on a small island can be reached via a cavern south of the King's Tomb. There are moments in the palace where Link can venture outside, giving him a rare opportunity to see the sky. Progressing through this dungeon requires breaking blocks with the Power Glove. Link finds the Raft here, but in order to use it, he must first defeat Rebonack, a blue Ironknuckle boss riding a levitating horse.

▷ Maze Island Palace

A palace located in the deepest part of Maze Island. Link finds the Boots at the end of a one-way falling trap within. Wizard enemies wander this palace under the command of its magic-wielding boss, Carock.

▷ Palace on the Sea

The Boots that Link finds in the Maze Island Palace allow him to reach the water-locked Palace on the Sea. The inside is expansive and full of dead ends, but there are also false walls that Link can walk through. He finds the Flute here and must do battle with Gooma, a beast swinging a ball and chain. His head is well protected, but his body is vulnerable to attacks.

▷ Three-Eye Rock Palace

Playing the Flute in the center of the three boulders in the southern region of Eastern Hyrule makes the entrance to this dungeon appear. A number of fake floors—some are invisible, others loop infinitely or require magic—force Link to watch his every step. Link must find and use the Cross to avoid these traps. At the heart of the palace, he faces the dragon Barba, who emerges from lava to spit literal fire. In some places, Barba is called Volvagia.

▷ Great Palace

A massive palace located beyond the cavern in the Valley of Death. The boss, Thunderbird, appears in the deepest chamber, which Link can reach quickly by falling through bricks concealing a stomach-churning drop. After defeating Thunderbird, Link must face his greatest challenge—himself—by battling Shadow Link, the game's final boss.

Link explores complex dungeons teeming with enemies and head-scratching puzzles across two worlds, Light and Dark, in this era. A great many tools are at his disposal, some familiar, like the Power Glove and the Boomerang, and others first seen here, like Flippers and the Hookshot. Utilizing the power of the Super Nintendo, Link is able to interact with objects like never before, pulling, lifting, and throwing objects for the first time in the series.

▷ Hyrule Castle

Using a secret passage during a heavy storm, Link sneaks into a castle patrolled by guards possessed by dark magic. Using the last of his strength, Link's uncle gives him his sword and shield, which Link uses to fight to the bowels of the castle in search of an imprisoned Princess Zelda. Along the way, he finds the Boomerang.

▷ Eastern Palace

A group of Armos Knights reign over the Light World's Eastern Palace. Its entrance overlooks ruins and crumbling statues in the rolling hills north of Lake Hylia on the map's eastern edge. Within the palace, Link must dodge iron globes and battle a particularly mean gang of Stalfos to obtain the Bow. After defeating the Armos Knights that serve as bosses for this dungeon, he receives the Pendant of Courage.

Desert Palace

Before exploring this palace in the sands of southwestern Hyrule, Link must first cross the treacherous Desert of Mystery and use the Book of Mudora to decipher an inscription set in stone at the palace entrance. Inside, enemies will leap from the sand to attack. Using the Power Glove found here, Link moves boulders to reach three burrowing Lanmolas that guard the Pendant of Power.

Mountain Cave

Near the Lost Old Man's house at the foot of the northern mountainside is a dark cave that leads up Death Mountain. The old man gives Link the Magic Mirror as a symbol of his gratitude for helping him back to his cave after he loses his lamp.

Tower of Hera

This sky-high fortress at the summit of Death Mountain becomes Ganon's Tower when Link ventures into the Dark World. Crystal and Star Switches swap the positions of blocks and holes in the floor, allowing Link to scale its many floors at his own peril. The Moon Pearl lies deep within the dungeon, giving Link the ability to keep his Hylian form in the Dark World. On a suspended platform at the top, Link must battle a writhing Moldorm for the Pendant of Wisdom, taking care not to get knocked to the floor below.

Hyrule Castle (Tower)

After pulling the Master Sword from the pedestal in the Lost Woods, Link uses the legendary blade to break the barrier on the entrance to Hyrule Castle's upper floors. He fights through narrow corridors to reach the evil wizard Agahnim, who imprisons the maiden descendants of the Seven Sages, including Princess Zelda, in the Dark World.

Palace of Darkness

After successfully navigating the eastern hedge maze, Link opens the entrance to this first Dark World dungeon with help from a monkey named Kiki. Many enemies within are immune to sword attacks, so Link must find a Magic Hammer to smash or flip them over. At the heart of this palace is the masked Helmasaur King, who protects a crystal holding the first of seven maidens that Link must rescue.

Swamp Palace

Link must enter this dungeon that exists in both the Light World and the Dark World by operating the shrine's sluice gate mechanism. Waterways run throughout the palace, which can only be successfully navigated by manipulating water levels, swimming with Zora's Flippers, and using a Hookshot found within. The boss is a one-eyed Arrghus that guards the second crystal.

Skull Woods

Skulls are strewn about in this eerie forest enveloped in fog. Multiple paths lead Link both above and below ground to clearings between the trees. A Fire Rod found here is particularly effective against the giant, hovering Mothula that serves as boss of the woods and protects a crystal.

Thieves' Town

The entrance to this underground mansion in the Dark World, built to keep out all light, is hidden under a stone gargoyle statue in the center of Thieves' Town. Link finds the Titan's Mitt here, while a girl who truly hates light seeks Link's help from the confines of a prison cell. Blind the Thief guards this dungeon's crystal.

Ice Palace

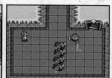

A palace surrounded by walls in the middle of the Ice Lake. True to its name, the floors are coated in ice. Between that and the dangerous spike traps, Link is wise to step carefully in this dungeon. He finds the Blue Mail here before facing the dungeon boss: a massive eyeball encased in ice dubbed Kholdstare.

Misery Mire

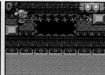

The entrance to this palace lies in the Swamp of Evil, a miserable place devoid of sunlight that endures torrential rain. Inside the expansive mire are numerous portals and well-placed holes in the floor that let Link move between rooms and floors. Lower corridors are blanketed in darkness, requiring torches to be lit, while blocks must be generated using the Cane of Somaria to activate switches in order to progress to the end. The boss of Misery Mire is Vitreous, a slime-covered cluster of eyeballs.

Turtle Rock

This dungeon hides beneath a large rock formation on Death Mountain that resembles a turtle. Warping onto the turtle's back via the Light World and using the Quake Medallion will reveal an entrance at the turtle's head. Moving platforms teeter above impossibly deep pits inside, making passage through this dungeon especially perilous. Link must put every item he has collected in his journey to use here in order to reach the boss, a stone turtle-like creature with three heads. The Mirror Shield is found here.

Ganon's Tower

An ominous tower that stands above Death Mountain in the Dark World, the final dungeon proper in *A Link to the Past*. Many of the mechanisms from earlier dungeons appear here, including the first passage, which requires light in order to see. Link finds the Red Mail here before finally cornering Agahnim on the tower's top floor.

▷ Pyramid of Power

Ganon, who had taken Agahnim's form, leaps out and opens a large hole in the top of the Pyramid of Power. Link follows him inside, where Ganon reveals his true form and the battle for the fate of Hyrule is waged.

▷ Palace of the Four Sword

This dungeon was added in the Game Boy Advance version of *A Link to the Past & Four Swords*. Only those who have cleared both games can enter it from a point in the middle of the Pyramid of Power. Four differently colored Dark Links stand guard at the back of the dungeon.

LINK'S AWAKENING

Each dungeon in Link's first island adventure is shaped like its namesake. Like the original *Legend of Zelda*, certain rooms within dungeons have a two-dimensional, side-scrolling perspective. Link's reward at the end of most levels is one of eight Instruments of the Sirens required to wake the Wind Fish. Unlike other titles, a number of characters from other

Nintendo properties appear as enemies, including Goombas and even Kirby, whose hostile alter ego Anti-Kirby appears in Eagle's Tower.

▷ Tail Cave

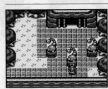

A cavern to the south of Mabe Village. It has a relatively simple layout, but there are plenty of enemies and traps to dissuade intruders. Roc's Feather is found here, while the boss is a squirming Moldorm.

▷ Bottle Grotto

The entrance to this dungeon grotto lies in the depths of the Goponga Swamp, blocked by a flower that requires the Chain Chomp to get past. Link finds the Power Bracelet inside, essential for lifting heavy pots that stand in the way of completing the dungeon. The boss is a clown-like Genie that uses his bottle to protect itself from Link's attacks.

▷ Key Cavern

The entrance to this cavern is in a pond in the Ukuku Prairie. The layout takes the shape of two keys: one large and one small. Link must use Pegasus Boots found here to dash and solve puzzles. Slime Eye is the boss here, a gooey eyeball that splits into two when struck in the middle with a well-placed dash.

▷ Angler's Tunnel

This dungeon's layout is in the shape of a fish facing the river flowing through Tal Tal Heights. More than half of the rooms have waterways, so Link must find the Flippers in order to proceed farther inside. The dungeon's Angler Fish boss fight takes place underwater.

▷ Catfish's Maw

This cavern at the center of Martha's Bay is shaped like a giant catfish with its mouth open. Link must battle Master Stalfos four times in order to obtain a Hookshot and take on the dungeon boss, a slippery Slime Eel.

▷ Southern Face Shrine (Ancient Ruins)

Ancient ruins lie north of Animal Village. While the shrine itself is relatively small, it holds big secrets. Link recovers the Face Key here, as well as information about the true nature of the island; he just has to get past a massive Armos Knight first.

▷ Face Shrine

A temple in the shape of a face, unlocked with the Face Key found at the southern shrine. There are numerous Crystal Switches to puzzle over, and Link's skill with his items is truly tested here. The L-2 Power Bracelet is found inside. Facade, a giant face that appears in the center of a room with flying tiles, stands in the way of the Coral Triangle, the sixth of eight Instruments of the Sirens.

▷ Eagle's Tower

A giant tower in Tal Tal Mountain Range. Tricky puzzles change the layout of the dungeon; at one point, smashing columns on the second floor will drop the fourth floor down a level. The Mirror Shield is found here. To make it out of the tower, Link must reach the top and do battle with the Evil Eagle.

▷ Turtle Rock

This massive cave in the Tal Tal Mountain Range is shaped like a turtle and shares its name with a dungeon in *A Link to the Past*. Piping-hot magma flows through sections of the cave, while ice blocks halt Link's progress, requiring him to melt them with flames from the Magic Rod. Link must then battle Hot Head, a sentient fireball.

▷ Color Dungeon

Appears only in *Link's Awakening DX*. The entrance to this dungeon is revealed by moving gravestones in Koholint Prairie in a specific order. There are many color-themed puzzles within, including the dungeon boss, an Evil Orb that changes color when repeatedly struck. Link will meet a Great Fairy after defeating the orb, who will give him either Red Clothes or Blue Clothes, doubling his attack damage or defense, respectively.

▷ Wind Fish's Egg

After collecting all eight Instruments of the Sirens from Koholint Island's dungeons, Link enters the giant egg at the top of Mount Tamaranch. Inside lies a maze that Link must navigate using clues from *Dark Secrets and Mysteries of Koholint*, a book found in the Mabe Village Library. Before playing the Ballad of the Wind Fish, Link must battle Nightmares that transform into powerful enemies drawn directly from his memories, including Ganon himself.

OCARINA OF TIME

Link's first adventure on the Nintendo 64 introduces mechanics and puzzles that make ample use of all three dimensions. In addition to more traditional castles, caves, and temples, there are elaborate dungeons inside a giant tree and even a fish. Bosses announce their arrival though intimidating, cinematic cut scenes that highlight their strengths while hinting at weaknesses.

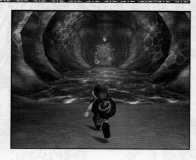

▷ Inside the Deku Tree

Deep within the Kokiri Forest, the Great Deku Tree suffers from a curse that is slowly killing him. The tree beckons Link to stop the curse. Inside, Link finds the tree overrun with monsters. Massive webs block the way forward, requiring Link to put a torch to them to proceed. After finding the Fairy Slingshot, he takes aim at the root of the curse: the spider-like boss Gohma.

▷ Dodongo's Cavern

Dodongos great and small call this massive cavern in the heart of Death Mountain home. Within the cavern, Link finds the Bomb Bag, allowing him to carry and use bombs. The cavern is the domain of the colossal King Dodongo, whose weakness is a taste for lit bombs.

▷ Inside Jabu-Jabu's Belly

Lord Jabu-Jabu, well-adorned fish deity and guardian of the Zora, is sick. He's eaten something foul. And it's led him to gobble up anything that crosses his water-bound altar, including the Zora princess, Ruto. Jabu-Jabu's mouth opens wide when Link presents a fish to him. Inside his Bari-infested body, Link finds the Boomerang and rescues Ruto from the electric Barinade that has rooted itself deep inside Jabu-Jabu's digestive system.

▷ Forest Temple

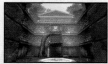 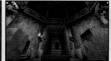

The ruins of a temple, deep within the Sacred Forest Meadow. This is the first of many dungeons Link must explore as a young adult in order to free the six sages and Princess Zelda. Memorable puzzles here involve paintings, while ancient priestesses known as the Poe Sisters stand in the way of any intruders. After obtaining the Fairy Bow, Link restores the twisted corridor and proceeds to the courtyard and a volleying fight with Phantom Ganon, who gallops out of a painting on a black steed.

▷ Fire Temple

Ganondorf has imprisoned a great many Gorons within this burning-hot temple of flowing magma in Death Mountain Crater. High temperatures mean Link cannot explore it without first donning a heat-resistant Goron Tunic. Inside the temple, Link finds the Megaton Hammer, which he uses to smash a path to Volvagia, the temple's fiery dragon boss.

▷ Ice Cavern

In Link's youth, Zora's Domain was a poolside paradise. But in the seven years since Ganondorf's rise to power, the fountain has frozen over. Frigid paths within the cavern are treacherous and covered with ice, while giant icicles frequently block the way forward. Melting Red Ice with Blue Fire can reveal paths and treasures. And if Link can get past the White Wolfos in the heart of the dungeon, he will be rewarded with Iron Boots, essential when exploring the Water Temple that follows.

▷ Water Temple

Link requires both Iron Boots and a Zora Tunic to explore this temple at the bottom of Lake Hylia. Its layout is one massive puzzle, requiring Link to adjust the water between shallow, moderate, and deep levels in order to progress. Though changes in *Ocarina of Time 3D* made for a few less headaches, this temple is notoriously challenging. Successfully navigating its many rooms will lead Link to the Longshot and the Water Medallion, but not before defeating the demon Morpha, who resides within a tentacle of water.

▷ Bottom of the Well

The magical Lens of Truth lies deep within this Kakariko Village well: a maze of underground corridors and false floors. Once Link defeats the Dead Hand and recovers the powerful Sheikah lens, it reveals eerie altars enshrining skulls and tools implying both torture and executions once took place within the well's deeper caverns. Link must collect every rupee in the lowest chamber in order to reach the exit.

▷ Shadow Temple

 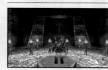

Beneath the graveyard in Kakariko Village lies the Shadow Temple. This place holds many secrets of the dark, bloodstained history of Hyrule. Challenging puzzles and horrifying monsters await Link. In order to reach the end of the dungeon and battle Bongo Bongo for the Shadow Medallion, Link must first find Hover Boots to cross the great chasm near the entrance.

▷ Spirit Temple

Beyond the Gerudo Fortress lie the ancient ruins of the Haunted Wasteland and this temple built by ancestors of the Gerudo people. Link must explore the temple as both an adult and a child. Inside, he finds both the Silver Gauntlets and the Mirror Shield, using the latter to solve puzzles of light that block his way to the heart of the dungeon and the kidnapped Gerudo sage, Nabooru. In order to save her and recover the Spirit Medallion, Link battles Koume and Kotake: sorceress sisters who raised Ganondorf and combine to form Twinrova, a powerful entity wielding both fire and ice.

▷ Ganon's Castle

 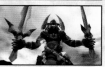

Ganondorf's seat of power looms over where Hyrule Castle once stood. Inside are six corridors, each corresponding to a freed sage, that lead to barriers that Link must destroy in order to confront Ganondorf. The King of Thieves plays a pipe organ, reveling in his power. After Link defeats him, the energy within the Triforce of Power runs wild, transforming Ganondorf into the beastly Ganon, who battles Link for the fate of Hyrule.

MAJORA'S MASK

In Termina, history has a way of repeating itself in seventy-two hour cycles. Link has three days before the moon comes crashing down—and a handful of challenging dungeons stand in the way. Using songs passed down by the Deku, Zora, and Gorons, as well as masks that grant the power to change the wearer's form to look like other people, Link must seek out temples in all corners of Termina and wake the giants there in order to stop the moon's descent.

▷ Woodfall Temple

At the center of Woodfall in the heart of Deku swampland stands a once-sacred temple now overrun with evil. Link transforms into a Deku Scrub to explore the temple, using Deku Flowers to glide over poisonous water in search of the Hero's Bow. Once Link finds this bow, he can take aim at the blade-wielding temple boss, Odolwa, and save the kidnapped Deku Princess.

▷ Snowhead Temple

To the north is a snowy mountain range, where a tower-like temple looms over the mountain village of Snowhead. The unusually frigid temperatures have frozen parts of the temple shut, requiring Link to seek out Fire Arrows to melt the way forward. When he reaches the temple boss, Goht, the mechanized beast is encased in ice. Goht must be thawed before Link can defeat him and return spring to the Goron village.

▷ Pirates' Fortress

In search of a clutch of stolen Zora Eggs, Link sneaks into this Gerudo fortress under the waves of the Great Bay Coast. Inside, the pirates keep close watch, requiring Link to dispatch them with well-placed arrows. A Hookshot hidden in a chest in the fortress allows Link to reach areas he couldn't before, including where the eggs are stashed. Between duels, Link can take the time to snap a Pictograph of one of the pirates for an interested fisherman.

▷ Great Bay Temple

Guided by the hatchlings from the Zora Eggs recovered from the fortress, Link rides a giant turtle to the entrance of Great Bay Temple, full of waterways and pipes. Link must spend much of his time here wearing the Zora Mask. Ice Arrows found here will help forge a path forward by freezing the surface of the water. Link must defeat the aquatic boss Gyorg.

▷ Beneath the Well

In the arid Ikana Canyon, there is a deep, dark well. After descending into the well, Link must navigate a maze of catacombs blocked by Gibdos, who demand various items. In the final room, Link finds a Mirror Shield.

▷ Ancient Castle of Ikana

At the other end of the well passageway in Ikana Canyon stands the Ancient Castle of Ikana. Link explores this crumbling palace inside and out, using light reflected by the Mirror Shield to defeat an army of ReDeads and lift the curse on Igos du Ikana, who teaches Link how to play the Elegy of Emptiness.

▷ Stone Tower Temple

Beyond Ikana Canyon is the Stone Tower, said to be impregnable. A curse has cast a shadow over the adjoining temple. Link explores its many rooms right side up and upside down, creating doubles of himself and using Light Arrows to flip the temple ceiling. Wearing the Giant's Mask, a supersized Link then battles the burrowing boss Twinmold and wakes the last giant.

▷ Moon Dungeons

After surviving Stone Tower Temple, Link and Tatl return to Clock Town only to be swallowed up by the moon from their perch at the top of the tower. Link finds himself lost in a strange alternate reality. At first, things seem more peaceful inside the moon. A tree grows at the center of a beautiful meadow. Link plays hide-and-seek with masked children, and must trade his masks for entry into dungeons named for the Zora, Deku, Gorons, and Link himself. After obtaining the Fierce Deity's Mask, Link does battle with three incarnations of Majora's Mask, freeing the Skull Kid from its curse.

ORACLE OF SEASONS

Each dungeon in *Oracle of Seasons* contains an Essence of Nature, essential to restore the balance of the seasons in Holodrum. Using the Rod of Seasons, Link alters the landscape to open the way to new dungeons. Many familiar puzzles and bosses from past releases appear in the *Oracle* series, with an emphasis on combat and movement by way of items like Roc's Feather and Magnetic Gloves. Mystery Seeds are also critical for overcoming the challenges presented by each dungeon.

▷ Hero's Cave

A cave on the western coast near Horon Village. Here, Link obtains the Wooden Sword as proof of his heroism. It is full of dungeon basics, such as moving rocks and using Small Keys to open locked doors.

▷ Hero's Cave (LINKED GAME)

This dungeon appears after linking *Oracle of Seasons* with a completed copy of *Oracle of Ages*. Link must use items retrieved from the first seven dungeons of both games in order to make it to the end.

▷ Gnarled Root Dungeon

The entrance to this first dungeon proper in North Horon is carved into an old tree on an island, much like the entrance to Level 1 in the original *Legend of Zelda*. Link finds the Seed Satchel here, essential for carrying the many Mystical Seeds he collects over the course of his adventure. Also like Level 1, the boss of this dungeon is the dragon-like Aquamentus.

▷ Snake's Remains

This dungeon is found within the Woods of Winter. After Link uses the Rod of Seasons to return winter to Holodrum, he grabs a shovel and clears a path to the entrance. Inside the dungeon, Link finds a Power Bracelet, allowing him to move obstacles that would otherwise block his path. Before Link can recover the second Essence of Nature here, he must do battle with a fire-breathing Dodongo.

▷ Poison Moth's Lair

Before Link can explore this Spool Swamp dungeon, laid out in the shape of a moth, he must use the Rod of Seasons to change the season to summer. Link then climbs the vines that grow in the summer heat to reach the dungeon entrance. Inside, he finds Roc's Feather, and uses it to jump over holes in the floor. Link then battles Mothula, a moth-like dungeon boss that protects the third Essence of Nature.

▷ Dancing Dragon Dungeon

Up on Mt. Cucco is a dungeon shaped like a dancing dragon. Its entrance hides behind a waterfall. Inside, Link finds the Slingshot and uses it to fire Mystical Seeds, lighting torches and flipping levers to clear the way for mine carts on the way to the dungeon boss, Gohma.

▷ Unicorn's Cave

The entrance to this cavern near Eyeglass Lake is surrounded by spiraling horns, not unlike a unicorn's. Link enters by changing the season to autumn and removing Rock Mushrooms that block access to the dungeon. Inside, Link uses Magnetic Gloves to join and separate magnetic blocks, allowing him to cross over large gaps in the floor. The boss of this cave is a Digdogger, which Link must defeat to obtain the fifth Essence of Nature.

▷ Ancient Ruins

The ancient Tarm Ruins lie just beyond the Lost Woods. In this dungeon amid the rubble, Link finds a Magic Boomerang that can be controlled in midair. It is laden with traps, including walls that close in on Link. Here he does battle with a Vire, which also appears in *Oracle of Ages'* Ancient Tomb, before taking on the dungeon boss, Manhandla, for the sixth Essence of Nature.

▷ Explorer's Crypt

Link descends into this crypt beneath the Graveyard, west of Horon Village, in search of the seventh Essence of Nature. Once inside, he must lift the curse of two Poe Sisters, Amy and Margaret, in order to proceed. Roc's Cape is found here, which allows Link to jump long distances, while the boss is a Gleeok.

▷ Sword & Shield Maze

The entrance to this penultimate dungeon is in Subrosia. It is broken up into two distinct sections. One, shaped like a sword, is full of flowing magma, while the other, shaped like a shield, is covered in ice. Link makes his way through the dungeon using Ice Crystals from the latter to cool the magma and reveal new paths. At the heart of the dungeon, Link battles a Medusa Head for the eighth and final Essence of Nature.

▷ Onox's Castle

After collecting all eight Essences of Nature and the Huge Maku Seed, Link confronts Onox, the General of Darkness, in his castle on the Northern Peak. While the dungeon itself is essentially a straight path to Onox, a small army of powerful enemies that Link faced over the course of his journey stand in the way.

ORACLE OF AGES

The dungeons of *Oracle of Ages* each contain one of eight Essences of Time, which regulate the flow of time. Using the Harp of Ages, Link travels between the past and present to open paths to their entrances. While *Oracle of Seasons* dungeons emphasize action, these emphasize puzzles using tools like the Switch Hook and Cane of Somaria. As in Holodrum, Mystical Seeds also play a key role in Link's Labrynna excursion.

▷ Hero's Cave (Linked Game)

Linking *Oracle of Ages* with a completed save file from *Oracle of Seasons* will cause this dungeon to appear. As with the *Seasons* version of the dungeon, Link will need all his gear to make it through the dungeon. Unlike the *Seasons* version, there is a greater emphasis on puzzles over combat.

▷ Spirit's Grave

On the east side of Yoll Graveyard is Spirit's Grave. As is to be expected with a dungeon in a graveyard, many ghosts, skeletons, and other undead haunt its corridors. Link must match dice to the color of the floor in order to light torches and proceed farther inside, where the menacing dungeon boss Pumpkin Head waits for a fight.

▷ Wing Dungeon

Deep in the Deku Forest, the Wing Dungeon sits in ruins. Inside, Link changes panel colors by jumping on them using Roc's Feather. Mine cart tracks, clusters of movable blocks, and Color-Changing Gels all threaten to stump Link as he makes his way to the boss, a Head Thwomp.

▷ Moonlit Grotto

Located on Crescent Island, home of the Tokay, the grotto itself is shaped like a crescent moon. Link must use a Seed Shooter here to destroy crystals inside, triggering a revolving floor that drops him to deeper levels. The grotto boss, Shadow Hag, will dispatch shadows that chase Link around the room until he can figure out a way to take aim with a Scent Seed.

▷ Skull Dungeon

Inside the volcano near Symmetry Village, everything is a mirrored version of itself. The dungeon gets its name from its skull shape. Link must travel to the past to stop the volcano from erupting, which spares the village and allows him to enter the dungeon in the present. After obtaining a Switch Hook, Link can pull himself over piping-hot magma toward a fight with the winged Eyesoar for another Essence of Time.

▷ Crown Dungeon

This crown-shaped dungeon is situated on Rolling Ridge. Inside, Link must equip the Cane of Somaria, creating and pushing blocks ahead of him to find platforms in the darkness. A plethora of Crystal Switches throw up blue and red barriers, complicating the path to Smog, a boss who breaks into smaller versions of himself. The Cane of Somaria is particularly useful in the fight.

▷ Mermaid's Cave

The Mermaid's Cave requires the mastery of travel across time, as changing the dungeon's layout in the past alters it in the present. Link finds the Mermaid Suit here, essential if Link is to swim through the deep water between himself and the tentacled dungeon boss, Octogon.

▷ Jabu-Jabu's Belly

After Link saves King Zora from an illness that otherwise claims the royal in the past, Link is given permission to enter Lord Jabu-Jabu's Belly in search of the seventh Essence of Time. Link explores the inside of this Zora deity by adjusting the water levels in winding corridors. Using the Long Switch, Link can cross between farther platforms, and switch places with the dungeon's boss Plasmarine causing him to damage himself with his own fireballs.

▷ Ancient Tomb

Reached from the Sea of No Return. Link must gather four stone tablets scattered throughout this crumbling tomb before proceeding underground. Donning the Power Glove is necessary to move giant statues that block the path to the boss room, where the laser-eyed Ramrock does his best to keep Link from retrieving the final Essence of Time necessary before confronting Veran and Dark Link in the Black Tower.

▷ Black Tower

Once Link has collected the Huge Maku Seed and eight Essences of Time, Link enters the Black Tower, now crawling with enemies, for a showdown with Veran. The evil sorceress hides beyond a maze of rooms spread over multiple floors, requiring Link to think on his feet. Only the correct path will lead Link to Veran, who takes the form of multiple beasts during an epic battle in the crumbling tower.

With the world covered by an ocean, dungeons in this era are each found on individual islands. Some require Link to work with sage characters to proceed. In addition to the major dungeons required to advance the story, there are many smaller puzzles and caves on islands that can be explored.

▷ Forsaken Fortress

This fortress island constructed by Ganondorf is fortified with batteries along high walls. Spotlights and tight security patrols make sneaking into it a challenge, and Link must avoid being seen. He visits the Forsaken Fortress twice during his adventure: once at the beginning after the avian Helmaroc King snatches away his sister, and again later on when he is ready to confront the great bird. The first time around, Link drops his sword, making engaging with enemies an exercise in futility. After obtaining the Master Sword, Link is able to explore the dungeon with a heavier hand—especially when he finds the Skull Hammer. He uses these weapons to save his sister from the winged Helmaroc King, whom he fights on the fortress roof.

▷ Dragon Roost Cavern

This cavern is located high on the northeast side of Dragon Roost Island. The sky spirit, Valoo, is rampaging at the summit, and Link follows Medli inside to investigate. Together, they aim for the summit, avoiding spouting magma by treading across rickety bridges and precarious platforms using the Grappling Hook found inside. Just below the peak, Link finds the dungeon boss, Gohma, who has been tormenting Valoo by pulling on his tail. As a reward for defeating Gohma and calming Valoo, the once skeptical Prince Komali will present Link with Din's Pearl.

▷ Forbidden Woods

The dense Forbidden Woods overwhelm an island adjacent to Forest Haven. Using a Deku Leaf, Link sails through the trees and this dungeon in search of Makar, who entered the woods and hasn't been seen since. The Boomerang found here is essential for activating distant switches, as well as cutting a path forward through tangles of thick vines. When the plant boss Kalle Demos eats Makar at the dungeon's heart, Link must avoid its spiny tendrils in order to save the grateful Korok.

▷ Tower of the Gods

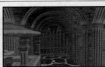

After Link gathers and places the three Goddess Pearls on their respective islands, this massive tower rises from beneath the sea. It is said to have been constructed by the gods to test a hero's courage. Link uses the Hero's Bow found here to activate distant switches and make his way up the tower. Gohdan, the arbiter, waits at the top, where ringing the bell opens the way to Hyrule Castle, held in stasis beneath the sea.

▷ Earth Temple

After returning to the Forsaken Fortress, Link travels to the Earth Temple on Headstone Island, seeking to restore the Master Sword's ability to banish evil through the prayers of Medli, the Sage of Earth, in the heart of the temple. The entrance to the island proper is blocked by a massive stone head, which Link can only move by wearing the Power Bracelets. The dungeon beyond requires the Mirror Shield found inside to reflect light and activate switches. Medli joins Link as he explores the dungeon. Certain ways are blocked until she plays her harp in time with Link's Wind Waker. Medli also helps Link cross great gaps by carrying him as she flies. The boss is a rotund Poe named Jalhalla, who only takes damage if first exposed to light.

▷ Wind Temple

This temple is found on Gale Isle. At the center is an atrium that connects the lower level to the second floor with help from the Sage of Wind, Makar, who plants trees to create platforms that Link can move between using the Hookshot. Gusts of wind blow through much of the temple, requiring Link to make frequent use of the Deku Leaf. With Makar's help, Link reaches the snake-like boss, Molgera, who slithers up from quicksand. Once Link defeats Molgera, Link uses the Wind Waker to conduct Makar, restoring true power to the Master Sword.

▷ Ganon's Castle

After Link obtains the Triforce of Courage, he uses its power to return to Old Hyrule to do battle with Ganondorf in his castle. First, however, Link faces a gauntlet of all previous dungeon bosses. After successfully navigating a maze underground and finding Light Arrows to counter Ganondorf's attacks, Link is ready to take on the King of Evil himself, first in Puppet Ganon form, then Ganondorf himself.

FOUR SWORDS

After completing the tutorial "Chambers of Insight," Link explores four dungeons in *Four Swords*. Puzzles and the strength of bosses within each dungeon change depending on the number of heroes in the party.

▷ Sea of Trees

It is said that those who set foot in this deep, dense forest never return. Though the sun makes it through the treetops, those who venture into these woods face all manner of natural obstacles. Overgrown trees, grasses, and water all obstruct a path overwhelmed by Octoroks. The giant, carnivorous plant Big Manhandla lives deep inside, serving as boss for the stage.

▷ Talus Cave

This giant cave expands into a rocky mountain covered in water and ice. Temperatures inside dip extremely low, and much of the floor is slick with ice. Dera Zol, the cave's master, forces a battle on slick, icy terrain.

▷ Death Mountain

Perpetually erupting, this mountain of flames is covered in lava that burns everything it touches. Death Mountain is so hot that flames openly burn along the path and touching them is an easy way to get hurt or worse. The mountain boss, Gouen, is a creature made of raging flames.

▷ Vaati's Palace

This castle floating high above Hyrule is the stronghold of the Wind Mage Vaati, who has kidnapped Princess Zelda. The party must gather enough rupees and be recognized by three Great Fairies who grant them the keys to take on this final challenge. Far-flung platforms require the clever use of items to cross between them, while a challenging battle with Vaati awaits only the most worthy of heroes.

FOUR SWORDS ADVENTURES

In this era, four Links set out to rescue six kidnapped maidens and Princess Zelda from all corners of Hyrule. In all, there are eight worlds in *Four Swords Adventures*, split into three stages, for a total of twenty-four stages,

with a boss at the end of each. Link may complete these adventures on his own or with up to three other heroes by his side.

▷ Cave of No Return

This massive cavern extends from Lake Hylia to just outside the grounds of Hyrule Castle. A lamp is required before the cave can be safely explored. Boulders blocking the way require at least two people to move, as well as strange rocks that can only be moved by people wearing a matching color. The cave's boss, Shadow Link, lies in wait to do battle with his doppelgängers.

▷ Hyrule Castle

Princess Zelda and six maidens have vanished, and the castle of the kingdom of Hyrule has become a den of monsters. The heroes twice visit Hyrule Castle on their journey. During the first visit, they rescue the Blue Maiden from the clutches of Phantom Ganon. The second time around, getting caught by a searchlight means being thrown in a cell. They fight through the castle to reach its powerful keeper, a Big Poe, and rescue the White Maiden.

▷ Eastern Temple

The Yellow Maiden is trapped in this temple, kept under constant watch by the giant eye of a Stone Arrghus. Portals hidden throughout the temple lead to the Dark World, while traps require traversing between Light and Dark. Bombs, the Lantern, and the Bow are necessary to make it to the Stone Arrghus and rescue the maiden.

▷ Tower of Flames

The Tower of Flames stands tall at the summit of Death Mountain, where another maiden is held captive. The party must overcome flowing magma and traps that spit flames to reach the top floor, where the Green Maiden is guarded by three Dodongos vulnerable to bombs.

▷ Temple of Darkness

This temple, shrouded in purple light, rests behind Kakariko Village. It houses the Dark Mirror, which long ago sealed away a Dark Tribe attempting to invade Hyrule. Ganondorf stole the mirror after he came to power and used it to create Shadow Links to do his bidding. Deku Scrubs now worship Ganon in the temple, even planning monuments in his image throughout. If the party reaches the heart of the temple, they do battle with Phantom Ganon, shadow of the Ganondorf who stole the mirror, and rescue the Red Maiden.

▷ Desert Temple

This temple was built to serve as a trial, keeping those with wicked hearts away from the divine Pyramid where the power of darkness was sealed. Many enemies exist within it, including living stone statues. Enemies like Shadow Links considered bosses in other dungeons fight to keep the party of heroes from completing the trial and proving themselves worthy.

▷ Pyramid

This sprawling tomb in the Desert of Doubt was built in ancient times by the ancestors of the Zuna people. The Trident, a demonic weapon born from darkness, rested here until Ganondorf violated the rules of the Gerudo and broke into the Pyramid, stealing the weapon and becoming Ganon, the King of Darkness. The party battles a Big Moldorm here, the dungeon boss, rescuing the Purple Maiden.

▷ Temple of Ice

This temple looks out onto the frozen plains, where time has stopped and winter never fades. Many of the floors are covered with ice, making them slippery to walk on. Defeating the two Ball and Chain Soldiers and proceeding to the back of the temple reveals the Four Sword Sanctuary that opens the path to the Tower of Winds.

▷ Tower of Winds

After the party has completed the other dungeons and gathered the four Royal Jewels, the six rescued maidens offer their prayers in the Four Sword Sanctuary and this tower rises into the sky. Climbing it means heading to the tallest point in all Hyrule—and perhaps even beyond. The icy gaze of the tower's boss, Frostare, awaits all challengers on the tower's top floor. Defeating him frees the captured Princess Zelda.

▷ Palace of Winds

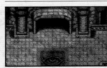

High above the kingdom of Hyrule is the castle of the Immortal Demon Vaati, hidden in a dark cloud. The party of heroes uses the four Royal Jewels to open the palace and battle their way to Vaati. Once Vaati is defeated, the palace begins to crumble. The party attempts to escape with Princess Zelda, only to be set upon by Ganon, the true source of the evil, for a final showdown.

THE MINISH CAP

Dungeons in *The Minish Cap* require Link to shrink down to Minish size and wield the power of the Elements within his sword to split into multiple versions of himself. When he's shrunk down, regular enemies become giant bosses. As Link's Minish adventure progresses, he's able to split into more and more copies of himself, though only for a short period of time.

▷ Deepwood Shrine

Behind the tiny Minish Village lies this tiny shrine, which Link explores in search of the Earth Element, the first of four Elements needed to restore the Picori Blade. A spinning barrel gives Link access to different sections of the shrine, while the Gust Jar found inside propels Link across the water on lily pads. The boss, the Big Green Chuchu, is actually just a normal Chuchu who fell into the temple.

▷ Cave of Flames

 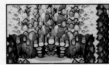

Originally a Hylian mine, cart rails still run through this cave at the summit of Mount Crenel. Link finds the Cane of Pacci here. It flips over enemies and objects with its magic, and turns holes in the ground into springboards. A hard-shelled Gleerok boss protects the Fire Element, spewing fire from its pool of magma.

▷ Fortress of Winds

The Wind Tribe, who mastered the power of the wind, long ago built this fortress beyond the Castor Wilds. Portions of the fortress are buried in dirt, but Link can use the Mole Mitts found inside to dig his way through. The seemingly impenetrable Mazaal is this dungeon's boss, protecting the Ocarina of Wind from any intruders with heavy fists and throngs of Beetles.

▷ Temple of Droplets

This tiny, frigid temple sits on Lake Hylia, accessible only by swimming out to it. The inside of this temple is frozen solid, and melting ice requires Link to expose it to sunlight or use a Flame Lantern found within. A Big Octorok is the temple boss and guardian of the Water Element. The normally typical enemy would be easy to dispatch, if only Link wasn't Minish size.

▷ Palace of Winds

This palace floats in the Cloud Tops the Wind Tribe call home. It was raised into the sky along with the tribe in ancient times. All that is visible beneath it is open sky. There are few places to walk, so Link must rely on Roc's Cape to glide through the palace on gusts of air blown by numerous fans. In order to obtain the Wind Element and upgrade his blade to the Four Sword, Link must first do battle with the Gyorg Pair, jumping between the bonded beasts in midair.

▷ Dark Hyrule Castle

Vaati's dark magic has infested Hyrule Castle, influencing the king and filling its corridors with monsters. Formidable enemies like Darknuts and Wizzrobes wander its halls, laying waste to any intruders who would challenge Vaati's power. Now wielding the Four Sword, Link is able to split into four versions of himself, an indispensable skill in this final challenge for the fate of Hyrule. To lift the curses on Princess Zelda and Ezlo, Link must defeat Vaati, who waits on the top floor of the castle.

TWILIGHT PRINCESS

The puzzles at work in the dungeons of *Twilight Princess* offer a colossal challenge, at times calling for the moving of entire rooms. Some dungeons lie in unexpected places, like ruined manors and entire cities in the sky. Link may explore dungeons in either Hylian or wolf form, and visits Hyrule Castle three times during his quest to defeat Zant and his Dark Lord, Ganondorf.

▷ Hyrule Castle

Link first visits the castle after becoming a wolf. It is engulfed by the Twilight Realm, and the spirits of Hyrulean soldiers are visible in the underground waterways. Link meets the imprisoned Princess Zelda in the farthest tower. Link returns to her in wolf form with Midna after clearing the Lakebed Temple, sneaking into her cell via the castle sewers and rooftops.

▷ Forest Temple

This temple stands at the back of Faron Woods. Monkeys are being held captive inside. Once freed, they will work with Link to solve puzzles inside the temple. The Gale Boomerang is found here, useful for triggering wind-powered switches and bridges. Link encounters the Twilit Parasite Diababa, a three-headed Deku Baba corrupted by one of four Fused Shadow shards Link must collect to stop Zant.

▷ Goron Mines

The entrance to the cavernous Goron Mines stands at the summit of Death Mountain. Magnetic platforms on the walls and ceilings require Iron Boots to walk on. Link finds the Hero's Bow here, which comes in handy when taking out distant enemies and targets. At the heart of the mines, Link must do battle with Darbus, the patriarch of the Gorons, who transformed into a fiery beast known as Fyrus after touching a Fused Shadow shard.

▷ Lakebed Temple

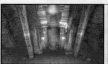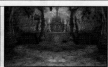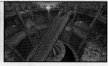

A temple at the bottom of Lake Hylia is bound to be full of water. Swimming and adjusting the water levels are necessary if Link is to make it through and recover the final Fused Shadow shard. Using the Hookshot found inside the temple, he can pull himself to previously inaccessible areas via targets and vines. It is also essential when taking on the eight flailing tentacles of the temple boss, the shadow-corrupted Morpheel.

▷ Arbiter's Grounds

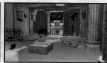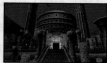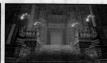

At the far end of Gerudo Desert are the execution grounds where the Mirror of Twilight is found. Invisible Poes and other ghouls hinder intruders. Link finds the Spinner here, a whirling, portable platform that rides on rails and glides across sand. The boss of the Arbiter's Grounds is the Stallord, the skeleton of a colossal beast reanimated by Zant's magic.

▷ Snowpeak Ruins

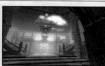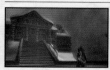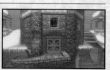

A Yeti couple, Yeto and Yeta, live in this ice-covered mansion that lies in ruins just beyond Snowpeak. A shard of the Mirror of Twilight has made Yeta ill, and Yeto sends Link all over Hyrule in search of ingredients for a soup to make her feel better. While exploring the ruins, Link finds the Ball and Chain, a powerful weapon. After finding the Bedroom Key, Yeta accompanies Link to the chamber, which contains the mirror shard. Its evil overwhelms her and she becomes Blizzeta. Link must fight Blizzeta to lift the shard's hold on her.

▷ Temple of Time

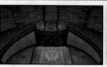

Link returns to the overgrown temple where he found the Master Sword and passes through the Door of Time, which propels him back to when the temple was intact. The temple dungeon has many floors. At the top, Link finds the Dominion Rod, which lets him move stone statues in tandem with his own steps. In order to recover a shard of the Mirror of Twilight, Link must do battle with Armogohma, a giant spider that shoots fiery lasers from an eye on its back.

▷ City in the Sky

This ancient city, built by the mystical Oocca, can only be reached using a cannon to fire Link high into the sky. The city is composed of a cluster of islands, some large and some small, and it is immediately clear that the technology required to build the city is far beyond anything on the Surface. Link finds a second Clawshot here, allowing him to wield Double Clawshots, before battling the Twilit Dragon Argorok for the fourth and final mirror shard.

▷ Palace of Twilight

The Palace of Twilight looms large in the Twilight Realm. Link reaches it after assembling and passing through the Mirror of Twilight. Dark Fog scattered throughout the palace will turn Link into a wolf upon contact. Imbuing the Master Sword with the power of the Sols—spheres of light inside the palace—enables it to cut through the fog. In the throne room at the back of the palace waits Zant, the self-proclaimed King of Twilight.

▷ Hyrule Castle

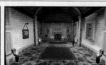

After defeating Zant, Link ventures to Hyrule Castle for the final battle with Dark Lord Ganondorf. Once a noble symbol of Princess Zelda, it has been tainted by the revived Ganondorf, who waits in the throne room.

▷ Cave of Shadows

This dungeon is only available in the HD version using the Wolf Link amiibo. Link must complete the entire dungeon in wolf form, defeating every enemy on a floor to progress to the next. If Link completes all forty floors, he will be rewarded with a wallet upgrade, enabling him to carry more rupees.

▷ Cave of Ordeals

The entrance to this optional cave of trials lies in Gerudo Mesa. Link can test his mettle by fighting his way through fifty floors of enemies. Each floor is overrun with hordes of different monsters, and Link must defeat them all in order to progress to deeper floors. The farther down Link descends, the more challenging the battles get, with mechanics that sometimes require items he will need to obtain by exploring other dungeons. Every ten floors, Link will meet the Great Fairy, who imbues a new Spirit Spring with fairies. At the bottom floor of the cave, Link will be rewarded with Great Fairy's Tears for surviving the ordeals.

PHANTOM HOURGLASS

Sixteen islands dot a vast sea split into four quadrants in the southwest, northwest, southeast, and northeast. There are eight dungeons spread across the islands. Link can chart a course to islands in each realm after finding individual Sea Charts in the Temple of the Ocean King on Mercay Island. As Link's

adventure progresses, he returns to Mercay for more. When it comes time for Link to seek out three pure metals in Mutoh's Temple, the Goron Temple, and the Temple of Ice, he can choose to explore these dungeons in any order.

▷ Temple of the Ocean King

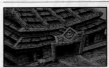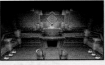

This key dungeon stands on a hill on Mercay Island. Once an important temple for people on the island, it has become infested with monsters. Invincible ghost knights and Phantoms wander the temple; what's worse, standing anywhere outside of the safe zone at the entrance will drain the life force out of even the bravest heroes unless there is sand left in the Phantom Hourglass.

▷ Temple of Fire

This temple is on the Isle of Ember, located in the southwest sea, where only the fortuneteller Astrid lives. Link must blow out the two candles that frame the entrance before he can enter. Flames roar throughout the temple, with many puzzles involving the Boomerang found here. The boss, Blaaz, is a formidable mage with the power to split into three bodies.

▷ Temple of Wind

This temple is located in the northwestern sea on the Isle of Gust, where the wind never stops blowing. Link arrives on the island to save the Spirit of Wisdom. Many mechanisms inside the temple, such as wind geysers, rely on wind to propel Link across gaps and temple platforms that would otherwise be inaccessible. Link finds the Hookshot here, and uses wind to bomb his way through to the boss, the cyclone-dropping Cyclok.

▷ Temple of Courage

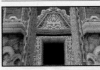

This temple is on Molida Island, home to a fishing village in the southwest sea. In order to enter the temple, Link must find the Sun Key and use it to unlock a door with a sun crest above it. Much of the temple relies on Link's adept use of the bow found inside. In order to rescue the Spirit of Courage, Link must first bring down the crab-like Crayk, who will snatch Link up in his claws and become invisible if Link gets too close.

▷ Ghost Ship

The spectral vessel emerges from the fog of the Ocean Realm in the northwest. Its spooky crew has kidnapped Tetra and has been haunting the quadrant's waters, preventing other boats from taking to sea. The power of the three spirits is required before Link can board the ship. Spirits of the dead roam its decks. Link must battle the diabolical Cubus Sisters for a Ghost Key that will unlock the quarters where Tetra was kept captive.

▷ Goron Temple

Link follows Gongoron to this temple in the northwest part of Goron Island. Inside, he uses Bombchus to blast his way through tricky switches and quicksand to reach the boss—but Link can't make it all the way there alone. With Gongoron's help, Link does battle with the temple's boss, the armored lizard Dongorongo, for the pure metal Crimsonine.

▷ Temple of Ice

This temple, located past the eastern ice field on the Isle of Frost, is as cold and ice covered as its name implies. It can be hard to stop once Link gets going on the slick ground, a problem considering all the pits Link can fall in if he's not careful. The Grappling Hook found in this dungeon helps keep Link on solid ground as he fights his way to the two-headed dragon Gleeok, who protects the pure metal Azurine.

▷ Mutoh's Temple

This temple is the resting place of Mutoh, the long-dead king of the ancient and advanced Cobbler Kingdom. Located on the northeast side of the Isle of Ruins, it is the only place on any chart known to house Aquanine. In order to obtain this pure metal, Link must use the Hammer to solve puzzles and do battle with the great stone soldier Eox, a trespasser in the temple who has disturbed Mutoh's slumber. After obtaining all three pure metals, Link can forge the Phantom Sword and return to the Temple of the Ocean King to take on the malevolent Bellum, an evil phantom that seeks Tetra for the Life Force she possesses.

SPIRIT TRACKS

All rails in New Hyrule lead to the Tower of Spirits, a high-reaching fortress where the Demon King Malladus has spent generations sealed away. Temples scattered across the four surrounding realms act as dungeons in this post–*Phantom Hourglass* era. Spirit Tracks connect the temples to the central tower, a network meant to protect the seal that keeps Malladus at bay. When the tracks disappear, it is up to Link to restore them, traveling to each temple with the help of Zelda, Lokomo, and the Spirit Train.

▷ Tower of Spirits

Long ago, war broke out between the Demon King Malladus and the Spirits of Good. The spirits erected the Tower of Spirits to seal away Malladus. Monsters and Phantoms stalk its thirty labyrinthine floors on the lookout for any intruders. Link and Zelda work together, using equipment found by exploring the temples of each realm, to clear each floor and reach the top of the tower. There, they find the Compass of Light that leads them to the Dark Realm and a final fight with Malladus.

▷ Forest Temple

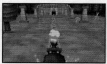

This early temple lies hidden beyond the Lost Woods of the Forest Realm. Dangerous poison gas lingers on many paths throughout the temple, and Link must use the Whirlwind to blow the gas away in order to proceed to the boss. Stagnox, a colossal, armored beetle and the apparent source of the gas, stands in the way of the first Force Gem, which returns power to the Spirit Tracks of the Forest Realm.

▷ Snow Temple

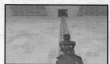

A raging blizzard in the northwest reaches of the Snow Realm conceals a snowy temple covered in ice. Link must play specific melodies on bells found inside in order to open doors. He finds the Boomerang here, and wrapping it in flames will help cool the master of icy fire, Fraaz, who guards the temple and the second Force Gem.

▷ Ocean Temple

Off the coast of the Ocean Realm, deep beneath the sea, lies this watery temple. To reach it, Link must first restore Spirit Tracks that run to the ocean floor. Deep inside the dungeon make the Whip that Link finds partway through critical, allowing him to swing between poles to avoid falling. On the top floor, Link tangles with the barbed tentacles of the temple boss, Phytops, for another Force Gem.

▷ Fire Temple

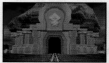

Spikes, rotating pillars of flame, and invincible enemies make exploring this Fire Realm temple particularly dangerous. After making it past the gate, Link descends multiple floors deep underground, careful not to put so much as a toe in the boiling magma that lines the path forward. The bow Link finds here can be used with Arrow Orbs to redirect arrows in the direction the orb is pointing. The temple boss, the lava lord Cragma, is a hulking rock monster who emerges from a pool of molten magma. Defeating him means another Force Gem, restoring Spirit Tracks leading from the Fire Realm to the tower.

▷ Sand Temple

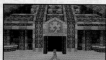 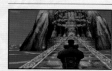

The Sand Temple lies in the desert north of the Ocean Realm. It holds the sacred Bow of Light, which Link must find if he's to stop Malladus. Sand traps and rolling boulders are meant to deter any intruders, and Link will need the Sand Wand in order to get past them. Deep within the temple, the skeletal Skeldritch rises up from the sand to stop Link from obtaining the bow.

▷ Dark Realm

Armed with the Bow of Light and the Lokomo Sword, Link enters this realm through hidden ruins on the sea in the southwestern tip of the Forest Realm. Armored trains run along tracks floating in the darkness. Link must wrap his train in the power of Tears of Light and ram them off the tracks. Eliminating the trains causes the Demon Train boss to appear, leading to a final battle with the Demon King Malladus.

SKYWARD SWORD

The temples and dungeons of this ancient era are adorned with spiritual imagery, as the events take place in a time when tales of the goddess and the creation of the world feel like more recent history. In some places, Link can travel between past and present using Timeshift Stones, learning more about his world as it changes around him.

▷ Skyview Temple

 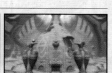

This temple was constructed deep within Faron Woods for messengers from the sky. Link enters it in pursuit of Zelda, who seeks to cleanse herself in the sacred waters of Skyview Spring in the temple's heart. Link uses a tool called a Beetle to search narrow areas and cut through anything in the way. Link is stopped before he reaches the spring by the Demon Lord Ghirahim, who challenges him to a fight. By the time the fight is over, Zelda is gone.

▷ Earth Temple

 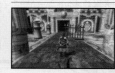

Located within Eldin Volcano, this stony temple contains another sacred spring in which Zelda wishes to cleanse herself. Rolling stone traps mean Link must tread carefully, with one large boulder he must actually ride. He receives a Bomb Bag from the Mogma Ledd here, useful for carrying bombs to blast the way forward through the rock. Ghirahim appears and awakens the temple boss, the fire monster Scaldera.

▷ Lanayru Mining Facility

Hidden beneath the Lanayru Desert, this mining facility was once run by Ancient Robots to refine ore for Timeshift Stones. The refinery is now overrun with Froaks, protecting Timeshift Stones that allow Link to shift between past and present. Here, Link also finds the Gust Bellows, useful for blowing away small enemies or sand to reveal items. After defeating the ancient scorpion Moldarach, Zelda gives Link the Goddess's Harp.

▷ Ancient Cistern

This watery dungeon is located near Lake Floria. Its upper areas are enshrined in light, a stark contrast to the dim, cursed swamp below. The Whip he finds here lets him swing to distant platforms. After Link destroys the ancient automaton Koloktos, installed to protect the dungeon from intruders, Fi uses Farore's Flame to upgrade Link's blade to the Goddess Longsword.

▷ Sandship

Lanayru Desert stretches across what was once a great sea. Using a motorboat with a built-in Timeshift Stone, Link is able to sail through the desert on the water that was once there. He finds a galleon that sailed the sea in the past, and boards it in search of Nayru's Flame. Ancient Robots once guarded the flame, but the ship has been taken over by pirates. Link finds a bow aboard and uses it to operate the ship's giant Timeshift Stone. Before he can upgrade his blade to the Goddess White Sword with the Sacred Flame, he must first do battle with a tentacle creature known as Tentalus.

▷ Fire Sanctuary

Din's Flame burns in the heart of the Fire Sanctuary at the summit of Eldin Volcano. The sanctuary is surrounded by bubbling lava. Giant trees have grown into the temple, producing Water Fruit. Link makes ample use of the Mogma Mitts he receives to dig through the earth. Ghirahim appears and faces off with Link yet again, proving himself far more dangerous this time around. After successfully fighting off Ghirahim, who has been working to free his master, the Demon King Demise, Link imbues his blade with the power of Din's Flame, creating the Master Sword.

▷ Sky Keep

A tower hidden below the Goddess Statue in Skyloft, Sky Keep holds the ultimate power of the goddesses, the Triforce. Link enters the keep using his Clawshots. Sliding panels inside alter the dungeon layout, allowing Link to explore its rooms in any order he desires. After collecting all three pieces of the Triforce, Link wishes for the destruction of Demise, who until now has assumed the monstrous form of the Imprisoned. Sky Keep collapses and Link enters the Gate of Time for a final showdown with Ghirahim and Demise.

A LINK BETWEEN WORLDS

Set in the future of the world of *A Link to the Past*, *A Link Between Worlds* shares many of the same dungeon names and locations. Some bosses emulate their predecessors in both name and appearance. Items needed to complete each dungeon are rented or purchased from Ravio's Shop; midway through the story, they can be obtained in any order.

▷ Eastern Palace

This temple stands among ruins at the top of a hill in eastern Hyrule. Link enters in search of Sahasrahla's apprentice, Osfala. A bow is required just to get through the front door and a multitude of puzzles also rely on well-placed arrows. At the end of the dungeon, Link faces Yuga, who has transformed Osfala into a painting.

▷ House of Gales

True to its name, the House of Gales floats above the center of Lake Hylia in southeastern Hyrule. Grated platforms run through the dungeon, with strong air currents blasting up at key points. The Tornado Rod's ability to create tornadoes and launch Link upward is required not only to get in the dungeon, but also to make it to the end, where Link must defeat Margomill for the Pendant of Wisdom.

▷ Tower of Hera

The entrance to the Tower of Hera is located on the western side of the enormous Death Mountain in northern Hyrule. Link uses the Hammer to slam down springs that propel him up the tower's many narrow floors. Red and blue switches alternate access to certain areas. At the top, Link fights the Moldorm for the Pendant of Power.

▷ Hyrule Castle

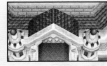

Yuga has taken over the castle and sealed the entrance. Outside, Sahasrahla informs Link that the charm Zelda gave Link is actually the Pendant of Courage. Link uses the pendants to retrieve the Master Sword and cut down the magical barrier to the dungeon's upper levels. The halls are filled with enemies. Deep within, Link faces Yuga for a second time. After beating him, Link embarks on a whole new set of trials in Lorule.

▷ Dark Palace

The Dark Palace looms east of Lorule Castle in the same spot as the Eastern Palace in Hyrule. As its name suggests, the inside is shrouded in darkness, with many puzzles involving the clever use of light. Bombs are required to activate switches. The palace's boss, the armored Gemesaur King, is weakened by lighting lanterns followed by a few well-timed sword slashes.

▷ Swamp Palace

Located to the south of Lorule Castle and flooded with water, the Swamp Palace can only be accessed by leading a Big Bomb Flower to a rock that holds all the water inside. Once the rock is destroyed, Link will need a Hookshot to control the levels and direction of the water still flowing through the temple. The Hookshot also comes in handy when fighting the boss, Arrghus, a large eye surrounded by smaller ones.

▷ Skull Woods

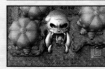

This dungeon winds through the vast forest of northwestern Lorule. Its maze-like layout requires Link to move both above and below ground. Hand-shaped Wallmasters appear seemingly out of nowhere to stop Link in his tracks and drive him out. The boss, Knucklemaster, has a massive eyeball on the back of his purple, hand-shaped body. It's pretty creepy.

▷ Thieves' Hideout

The Thieves' Hideout extends underneath Thieves' Town to the west of Lorule Castle. Link rescues a thief girl held prisoner in a cell who discovered the boss's secret, and the two of them press switches together to escape the hideout. Stalblind, the undead boss of Lorule's thieves, waits for them at the entrance, ready for a fight.

▷ Ice Ruins

Link uses mechanical lifts to scale the many floors of these ruins, seated at the summit of Death Mountain in Lorule's northern reaches. Link must tread carefully to avoid falling down to lower floors, though there are times when this is required to progress through the dungeon. The Fire Rod is required to melt ice barring entry to certain areas, as well as during the fight with Dharkstare, a dungeon boss covered in a thick layer of ice.

▷ Desert Palace

The desert in southwestern Hyrule is only accessible by first traveling there in Lorule and then returning to Hyrule. Sand has made its way inside, so exploring the palace requires the Sand Rod to conjure pillars of sand. The boss, Zaganaga, hides beyond a crack at the back of the temple. Link must make himself flat to slip through it and battle the many-eyed flower on the Lorule side.

▷ Turtle Rock

Magma flows within the turtle-shaped rock in the middle of the lake in southeastern Lorule. A mother turtle will float Link to the entrance after he saves her three missing babies. The Ice Rod is required to cross between the platforms within the dungeon. The boss is Grinexx, who resembles a turtle with a boulder for a shell.

▷ Lorule Castle

This seat of power in Lorule has been sealed to keep Yuga inside. Hilda breaks the barrier, allowing Link, now buoyed by the Triforce of Courage, to charge in after her. Invisible floors and rolling iron balls challenge Link's dexterity, while other puzzles and mechanics mimic those found in other dungeons. Link explores the castle, clears the monsters from its halls, and then confronts Yuga in the throne room.

There are eight distinct areas in the Drablands of Hytopia: Woodlands, Riverside, Volcano, Ice Cavern, Fortress, the Dunes, the Ruins, and Sky Realm. Each area has four levels with four distinct stages, making for a total 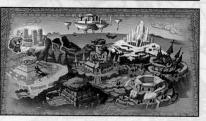 of thirty-two dungeons to fight through. Up to three heroes choose an area to explore from the lobby in Hytopia Castle and set out. A downloadable update adds yet another dungeon to the mix: the Den of Trials.

▷ Deku Forest

The first Woodlands level is a lush forest, full of rivers and waterfalls. The level serves as an introduction to using the bow, as well as totems that overcome height gaps. To beat the level, the heroes must defeat four Totem Dekus of different heights.

▷ Buzz Blob Cave

The second level of the Woodlands is in a cave full of electrified Buzz Blobs. The party of heroes must use the bow to activate armored switches to progress through the cave. They soon face the Electric Blob King, a gelatinous miniboss that shifts its shape and shoots blasts of electricity.

▷ Moblin Base

The third Woodlands level is full of Moblins, just as its name implies. There are many switches here, activated using items like bombs and arrows. The level ends with a chaotic battle against a Totem Armos and Moblins perched on watchtowers.

▷ Forest Temple

The final level of the Woodlands area, this dimly lit temple is full of traps involving arrows. The party must use their bows to light torches in order to proceed. Spiky, spinning Mini-Margos offer a considerable challenge, as they can only be defeated with bombs. The boss of the Woodlands is the much larger Margoma.

▷ Secret Fortress

The first level in the Riverside area is a fortress on a lake. Exploring the fortress is made difficult by waterways that divide the map. The party of heroes must use Water Rods to create columns on which to stand. In the last stage of this level, the heroes battle a large group of Moblins and Keeleons on narrow platforms above a giant waterfall.

▷ Abyss of Agony

In the second Riverside level, the heroes climb giant waterfalls. There are lifts throughout operated by moving waterwheels with Water Rods, while switches must be activated by shooting them with arrows in order to progress. At the top is the miniboss, the Electric Blob Queen.

▷ Cove of Transition

The third Riverside level is a canyon divided by many waterways. The Gripshot first appears here and is used throughout the level to crisscross the canyon, move rafts, and defeat the Gyorm that appears in the final stage.

Water Temple

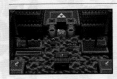

The final level in Riverside is a temple overflowing with water. The heroes must use the Gripshot to rotate valves in order to adjust the water level. The Water Rod also comes in handy here, creating platforms to move through a temple full of challenges they faced in earlier Riverside levels. The boss is an Arrghus.

Blazing Trail

The heroes climb a mountain trail surrounded by lava in the first level of the Volcano area. They must use the Boomerang while dealing with plates that sink into the lava if they stand on them for too long. In some stages, flaming rocks even rain down from above. To survive the level, the party must defeat all the enemies in the fourth stage.

Hinox Mine

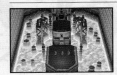

The second level of the Volcano area, Hinox Mine is nestled deep inside the volcano itself. The heroes must ride mine carts over the rails that weave throughout. The Hinox brothers, who give the cave its name, battle the heroes while riding side by side on the carts.

Den of Flames

The third level in the Volcano area sees the heroes walking over mesh and moving platforms to clear flowing magma. The air-puff-firing Gust Jar appears here. It proves very useful, allowing the heroes to put out flames and launch their allies to opposing platforms. The heroes must eliminate all the Fire Keeleons and Fire Hardhat Beetles in the final stage to complete the level.

Fire Temple

The final level in the Volcano area is a temple. It is an extremely dangerous level, with pillars of magma erupting throughout. The three heroes must work together to move a critical block. This is also the first level where each hero must use a different item to solve a puzzle and progress farther into the dungeon. The area boss is a classic one: Moldorm.

Frozen Plateau

The first Ice Cavern level has slick floors and fragile ice pillars that collapse after standing on them for too long. Fireballs from the Fire Rod will melt ice that might otherwise block the heroes' path, but not all ice here should be melted, so care is required. To finish the level, the heroes must defeat every Ice Wizzrobe in the fourth stage.

Snowball Ravine

The second level in the Ice Cavern throws giant snowballs and boulders at the heroes. They must melt the snowballs with Fire Gloves to continue up the steep cliffs' narrow paths. The giant ball of ice that is the miniboss, Freezlord, is best dealt with using these same toasty mitts.

Silver Shrine

The third level in the Ice Cavern begins covered in snow but gradually turns to slick ice. The Hammer found here can be used to smash posts and flip armored enemies. The heroes must defeat the Deadrocks in the fourth stage to complete the level.

Ice Temple

The final level in the Ice Cavern is full of ice. Thin ice. Icy breath. Giant snowballs. The battle with the area boss, Blizzagia, is the only side-scrolling section in the game.

Sealed Gateway

The first level in the Fortress built by the Lady serves as its entrance. In addition to there being many powerful, armored soldiers present, there are switches that alternatively raise and lower opposing walls. The heroes proceed by using the Gust Jar to propel allies to one side, then retrieving them with the Boomerang. They must defeat every enemy in the final stage to complete the level.

Bomb Storage

As its name implies, this section of the Fortress is filled with Bomb Flowers, while the Gust Jar can be used to launch bombs. The minibosses are the Hinox brothers, now in a group of three. The heroes battle them by throwing bombs.

Training Ground

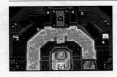

There are numerous moving stone statues called Totem Armos in the third level of the Fortress. Later in the level, the heroes will mount and ride Armos, with both heroes and enemies riding Armos in the final battle.

The Lady's Lair

This final level in the Fortress is full of difficult trials, including a Ferris wheel and a tightrope. Lady Maud, the mastermind behind everything, waits for the heroes at the end of the fourth stage. She sics her "pets" upon the heroes in three successive battles.

Infinity Dunes

The first level in the Dunes exists to introduce quicksand and sand mounds to the party of heroes. They make their way through by using the Water Rod to create platforms on the quicksand; without these platforms, the heroes will gradually sink while standing still in the sand. To complete the level, the heroes must first defeat the three-layered Hokkubokku.

Stone Corridors

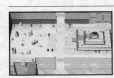

Much like other levels in the Dunes, the Stone Corridors have been built to discourage intruders. The heroes use a mysterious stone statue to solve puzzles. The miniboss, Vulture Vizier, is fought atop a large balance board, which occupies most of the stage.

Gibdo Mausoleum

The third level in the Dunes is decorated like a pyramid and has many memorable traps. The heroes will need the Fire Gloves to light the way forward and must do battle with enemies over a door key. The level ends with a mad battle with several Gibdos.

Desert Temple

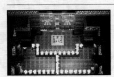

The final level in the Dunes relies heavily on the Hammer. It begins with whack-a-mole and features seesaw floor panels. The area boss is a giant Stalfos known as the Stalchampion. He challenges the heroes with weapons, area-of-effect attacks, and a variety of movements.

Illusory Mansion

The remains of a rotting mansion set the stage for the first level in the Ruins. Many of this level's mechanics rely on color, including puzzles involving colored floor tiles and Poes. To complete the level, the heroes must defeat all four Prankster Poes in the fourth stage.

▷ Palace Noir

The second level in the Ruins is an ominous building shrouded in darkness where the heroes must rely on the Fire Gloves for light. The heroes use the Gust Jar and Bow while lighting lamps and moving a key before battling the miniboss, Grim Repoe.

▷ Lone Labyrinth

There are few platforms in the third level of the Ruins, while those platforms that are present appear and vanish on a timer, creating a course where one misstep sends the heroes falling into the abyss. The fourth stage ends in a familiar battle against a group of ReDead.

▷ Grim Temple

The final level of the Ruins is full of ghoulish monsters. Colored and timed floors appear in this level to give players trouble. Waiting at the end is Prismantis and a boss battle where the players' tunic colors are key.

▷ Floating Garden

The first level of the Sky Realm is a city floating in the sky. It is a beautiful, grassy garden, but the strong winds make it difficult to keep one's footing. The heroes use cuccos to move between the floating islands. All Fire Keeleons and Helmasaurs in the fourth stage must be defeated in order to finish the level.

▷ Deception Castle

This castle in the Sky Realm serves as its second level. It is full of balance boards, gears, and other mechanical puzzles. The heroes must work their way through uncertain terrain using items that aid movement, such as the Gust Jar and Gripshot. The miniboss in the fourth stage is the floating, saucer-shaped Gigaleon.

▷ Dragon Citadel

The third level in the Sky Realm is a proving ground full of switches that control airflow. The heroes must wield the Water Rod, the Hammer, and the Boomerang in tandem before battling the dragon Aeralfos that gives the level its name.

▷ Sky Temple

Lady Maud is waiting at the final stage in the final level of the Sky Realm. In the initial stages of the temple, the heroes obtain every item appearing elsewhere in the game to assist them in the final battle for the fate of Hytopia's cursed princess.

▷ Den of Trials

This new area was added as a downloadable update to the main game. Its layout varies greatly from other areas. Instead of levels, there are eight zones divided over forty stages that the heroes must clear in a particular order. When they reach the bottom floor, they are rewarded with Fierce Deity Armor.

Enemies & Monsters

Colossal monsters. Demonic entities. Sentient slimes. Link has battled all manner of monsters across multiple eras and timelines. Some are creatures and even former allies corrupted and forced to stand against him. Many feature in multiple titles, though their appearance or properties may change depending on the era. Some are minor threats in the field or in dungeons. Others are minibosses, dungeon bosses, or even final bosses. Depending on the era, some enemies may appear in one or more of these roles.

The names and descriptions below are based on in-game descriptions, published materials, and a variety of other official documentation. In general, enemies with variations depending on the weapons they wield are grouped together and those with different armor or body colors are listed by name first followed by color—with some exceptions.

Enemies and monsters that only appear in the Palace of the Four Sword, which was added to the Game Boy Advance version of *A Link to the Past & Four Swords*, are included under *A Link to the Past*.

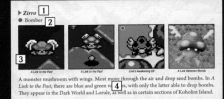

▶ Zirro ①
● Bomber ②

③ ④

A Link to the Past　　*A Link to the Past*　　*Link's Awakening DX*　　*A Link Between Worlds*

A monster mushroom with wings. Most move through the air and drop bombs. In *A Link to the Past*, there are blue and green varieties, with only the latter able to drop bombs. They appear in the Dark World and Lorule, as well as in certain sections of Koholint Island.

① **ENEMY NAME**

② **ALTERNATE NAMES** Included when the name of an enemy differs across game titles. A corresponding mark will appear with the image of any enemies with alternate names.

③ **IMAGE AND GAME TITLE** Enemy images are included from both the original and 3D/HD versions of *Ocarina of Time*, *Majora's Mask*, *The Wind Waker*, and *Twilight Princess*. When an enemy appears in both *Link's Awakening* and *Link's Awakening DX*, the DX version is used.

④ **ENEMY DESCRIPTION** Descriptions of enemy appearances, abilities, and other relevant traits. Any differences between enemies that appear across multiple titles are also detailed here.

A COLUMN

▶ Ache

The Adventure of Link

A large, bloodsucking bat. They are most often found in dark places like forests and caves. When prey wanders near, they swoop down and attack. Aches may disguise themselves as Hylians in villages like Darunia or Saria.

▶ Acheman

The Adventure of Link

A companion to the bloodsucking Ache that is cursed by Ganon's evil power. It will land on the ground, then transform into a bat-like man that walks on two legs, spitting fire from its mouth.

▶ Acro-Bandits

The Minish Cap

A team of five strange mole creatures wearing masks. Individually, they are quite small and easily defeated. Together, they form a tower five moles high that comes crashing down on Link. For all their showmanship, Acro-Bandits are cautious combatants; one will always poke its head out to see what's going on before leading its friends to the surface. If Link attacks the first mole, the other four will stay underground.

▶ Aeralfos

Twilight Princess

Twilight Princess HD

Twilight Princess

Twilight Princess HD

Tri Force Heroes

Anthropomorphic lizards similar to Lizalfos, but with wings that allow them to survey the battlefield before swooping down on their targets. Aeralfos most often carry swords and shields, making for a challenging fight. In *Tri Force Heroes*, they use their wings to create small tornadoes that blow their enemies into nearby pits. In *Twilight Princess*, Aeralfos appear as minibosses in the City in the Sky and Hyrule Castle, as well as in the Cave of Ordeals. They will deflect arrows and other long-range weapons with their shields; Link can use the Clawshot to pull them within attack range. See also Lizalfos, Super Aeralfos.

▶ Agahnim

A Link to the Past

The dark priest Agahnim awaits Link at the top of Hyrule Castle early in *A Link to the Past*. This dark wizard fires three distinct types of magical projectiles, all incredibly dangerous. Agahnim's body is protected by a barrier, making direct attacks ineffective. Link must volley Agahnim's magic back at him using the Master Sword in order to do any damage. When Link faces him for a second time in Ganon's Tower, Agahnim splits into three for his assault.

▶ Agunima

Oracle of Seasons

The miniboss of the Dancing Dragon Dungeon from *Oracle of Seasons*. A powerful wizard, Agunima shoots fireballs and can also clone himself. What's more, he cannot be attacked while the room is dark. In order to strike, Link must first light the room using Ember Seeds, then use Agunima's shadow to distinguish him from the clones.

▶ Ampilus

Skyward Sword

These monsters with ammonite-like shells and shrimp-like limbs have lived in the Lanayru Desert since ancient times. Like Thunder Keese, they possess an internal organ that generates electricity. Drawing near one will cause it to curl into its shell, shield itself in electricity, and charge any threats.

▶ Amy

Ocarina of Time

Ocarina of Time 3D

Majora's Mask

Majora's Mask HD

Oracle of Ages

The Poe named Amy is a miniboss of the Forest Temple in *Ocarina of Time*. She also appears in *Majora's Mask* as one of the Poe Sisters of Ikana Canyon, as well as in *Oracle of Seasons*, fighting alongside fellow Poe Margaret in the Explorer's Crypt. She has a childish way of speaking compared to her sisters. See also Beth, Joelle, Margaret, Meg, Poe.

▶ Aneru

The Adventure of Link

These toothy, snake-like beasts guard the halls of key palaces in *The Adventure of Link*. Blue varieties found in earlier levels spit rocks and are able to move around, while red Aneru found in the Great Palace are immobile and spit flames.

▷ Angler Fish

Link's Awakening DX

Oracle of Ages

A giant fish that lures its prey with a light attached to its head. In *Link's Awakening* and *Link's Awakening DX*, it is the boss of Angler's Tunnel. Link must fight it underwater, avoiding its dash attack. The fish will also slam its body into walls, causing rocks to fall. It is joined in battle by smaller versions of itself called Angler Fries. An Angler Fish also appears as a miniboss in Jabu-Jabu's Belly in *Oracle of Ages*. It will bounce around the room and spit bubbles at Link.

▷ Angler Fry

Link's Awakening DX

A small fish summoned by the Angler Fish serving as the boss of Angler's Tunnel. It appears much like the Angler Fish itself, only much smaller.

▷ Anti-Fairies

See Bubble.

▷ Anti-Kirby

See Kirby.

▷ Anubis

Ocarina of Time

Ocarina of Time 3D

A guardian of the Spirit Temple, this mummified, vertical figure bears the head of a beast. Its movements mirror Link's, retaliating with fire against any sword swings. Magic or fire from a torch are the only ways to do any damage.

▷ Aquamentus

The Legend of Zelda

Oracle of Seasons

A dragon with a large horn on its head. It serves as a boss in both the Level 1 and Level 7 dungeons in *The Legend of Zelda*. Though this formidable beast does not move much, it fires a tridirectional beam that can be tricky to avoid. Aquamentus also serves as boss of the Gnarled Root Dungeon in *Oracle of Seasons*.

▷ Aracha

Skyward Sword

These larval monsters live in the desert and are said to take a thousand years to mature. They hide in groups in the sand, and will leap out to attack when they sense something moving nearby. If an Aracha lives long enough, it will mature into its adult form, a Moldarach. See also Moldarach.

▷ Argorok

Twilight Princess

Twilight Princess HD

The Twilit Dragon Argorok invaded the City in the Sky, home of the Oocca, and now controls it. The power of the Mirror of Twilight has made it especially powerful and violent. Its body is covered in black armor. It becomes more agile as it takes damage, flying to greater heights.

▷ Arm-Mimic

Link's Awakening DX

Oracle series

Arm-Mimic will always move in a way that directly mirrors Link. They appear in both games in the *Oracle* series, as well as the Dream Shrine of *Link's Awakening*. See also Mask-Mimic.

▷ Armogohma

Twilight Princess (1)

Twilight Princess HD (1)

Twilight Princess (2)

Twilight Princess HD (2)

The Twilit Arachnid Armogohma is the creeping, crawling boss of the Temple of Time in *Twilight Princess*. It is a spider monster that takes time to mature, and the power of the Mirror of Twilight has both given it strength and driven it mad (1). It will drop numerous eggs upon taking damage, from which its Baby Gohmas will hatch and attack. After it emerges from its armored body (2), it will take the Baby Gohmas and try to escape. See also Baby Gohma, Gohma.

▷ Armored Train

Spirit Tracks

Encountered while driving the Spirit Train, these demonic locomotives randomly ride the Spirit Tracks. Their armor repels all cannon fire and ramming them will throw Link out of his train. They can also perform sudden U-turns on the tracks. See also Dark Train.

▷ Armos

The Legend of Zelda

A Link to the Past

Link's Awakening DX

Ocarina of Time

Ocarina of Time 3D

Majora's Mask

Majora's Mask 3D

Oracle series

The Wind Waker

The Wind Waker HD

Four Swords

Four Swords Adventures

The Minish Cap

Twilight Princess

Twilight Princess HD

Phantom Hourglass

Spirit Tracks

Skyward Sword

A Link Between Worlds

A monstrous stone statue that will lash out if approached. They carry swords and shields, and take a variety of forms, often with large heads. Bombs are typically a useful means of attacking them. Armos mainly appear within temples, ruins, and dungeons. In *The Minish Cap*, Link must shrink down and operate some from the inside in order to strategically move them. See also Death Armos, Totem Armos.

▷ Armos Knight

A Link to the Past

Link's Awakening DX

The Wind Waker

The Wind Waker HD

A rare, larger Armos that often serves as a dungeon boss. In *Link's Awakening*, a solitary Armos Knight guards the Face Key in the heart of the Southern Face Shrine, while six of them surround Link when he reaches the Eastern Palace boss room in *A Link to the Past*. In *The Wind Waker*, they are not bosses, instead appearing in several spots throughout the game.

▷ Armos Warrior

Oracle of Ages

This enemy appears as the miniboss of the Skull Dungeon in *Oracle of Ages*. A swordsman of significant skill, he pursues Link while swinging his massive blade and hiding behind a shield almost as tall as he is.

▷ Arrghus
● Wart

A Link to the Past — *Majora's Mask* — *Majora's Mask 3D* — *Tri Force Heroes*

A Link Between Worlds — *A Link Between Worlds*

A squid-like monster with a single, giant eye surrounded by floating polyps. It serves as a boss for dungeons across multiple titles, including the Water Temple in the Riverside region of *Tri Force Heroes* and the Swamp Palace in both *A Link to the Past* and *A Link Between Worlds*. In *A Link Between Worlds*, a more powerful Arrghus also appears as a miniboss in the throne room of Lorule Castle, firing rapid beams of light out of its eye. A similar creature with the name Wart, surrounded by bubbles instead of polyps, also appears in *Majora's Mask* as a miniboss of the Great Bay Temple. See also Lady's Pets, The (Arrghus), Stone Arrghus.

▷ Arrgi

A Link Between Worlds — *A Link Between Worlds*

These float around Arrghus, who serves as the boss of Hyrule's Swamp Palace and the miniboss in Lorule Castle. Link can pull the Arrgi away by targeting them with the Hookshot.

▷ Aruroda

The Adventure of Link

A breed of scorpion that lives in the desert. Instead of poison, the tip of its tail shoots fireballs. It is slow, but its carapace is thick; nothing gets through it. Its only weakness is its one open eye. A well-placed attack there is the key to defeating it.

▷ Baba Serpent

Twilight Princess — *Twilight Princess HD*

These hostile plant monsters grow in various places throughout Hyrule, devouring nearby prey with their enormous mouths. They resemble Deku Babas, but their heads will jump around, biting at enemies even after their stems are cut. See also Deku Baba.

▷ Babusu

A Link to the Past

A shadow-like monster found only in the Ice Palace of the Dark World of *A Link to the Past*. When their eyes flash, they will emerge from cracks in the dungeon walls and move rapidly for the other side of the room, ignoring Link but causing damage if he gets in their way.

▷ Baby Dodongo

Ocarina of Time — *Ocarina of Time 3D*

The offspring of Dodongos. Found in Dodongo's Cavern, they have no arms or legs and resemble tadpoles. Emerging from the ground in a cloud of dust and charging to attack, they explode after a short time after taking enough damage. See also Dodongo.

▷ Baby Gohma

Twilight Princess — *Twilight Princess HD*

Children of the Armogohma that lives in the Temple of Time, Baby Gohma crawl around the floor in large groups. Link will take damage if he comes into contact with one. Their shells have not yet hardened, so they can be easily dispatched with a sword and Clawshot. See also Armogohma, Gohma, Gohma Eggs, Young Gohma.

▷ Bad Bat

Majora's Mask — *Majora's Mask 3D*

These menacing bats are found across Termina, both outside and sometimes in the rafters of buildings. They will swoop down from above to attack passersby. Unlike their Fire Keese cousins, Bad Bats will not wrap themselves in flames to attack. In fact, fire is particularly effective when fighting them. See also Keese.

▷ Bago-Bago

The Adventure of Link

A carnivorous, skeletal fish that shoots rocks while leaping out of the water. They travel in schools to overwhelm their prey when attacking. The meat they consume simply falls through their bones, so their appetites are never sated. See also Fire Bago-Bago, Skullfish.

▷ Ball and Chain Soldier
● Ball and Chain Trooper / ▲ Ball and Chain Soldier (Grey)

A Link to the Past — *Link's Awakening DX* — *Oracle series* — *Four Swords*

Four Swords Adventures — *The Minish Cap* — *A Link Between Worlds* — *Tri Force Heroes*

These soldiers attack by swinging a spiked iron ball attached to the end of a chain. In *A Link to the Past*, they guard the captured Princess Zelda's cell. They often appear in groups, fighting together as dungeon minibosses. See also Soldier.

▷ Ball and Chain Soldier (GOLD)
● Ball and Chain Trooper (Gold) / ▲ Sky Fire Chain Soldier

A Link to the Past — *A Link Between Worlds* — *Tri Force Heroes*

A Ball and Chain Soldier covered in golden armor. They have higher health than regular Ball and Chain Soldiers. Some found in *Tri Force Heroes* increase their attack power by covering the iron ball in flames.

▷ Barba

See Volvagia.

▷ Bari

Ocarina of Time — *Ocarina of Time 3D* — *Twilight Princess* — *Twilight Princess HD*

Oracle of Ages

A jellyfish-like monster that floats off the ground, generating an electric field around itself for protection. It will shock and drain Link's health when electrified, so he must time his attacks carefully. When struck, Bari may divide into smaller Biri—or smaller Bari, depending on the game. While they most often split in two, in *Ocarina of Time* they split into three. The Bari in *Twilight Princess* do not split at all when defeated. See also Biri, Gigabari.

▷ Bari (Blue)

A Link to the Past

A Link Between Worlds

The blue Bari found in *A Link to the Past* and *A Link Between Worlds* are weaker than their red Bari counterparts, and do not split into smaller Biri when defeated. They still pack a punch if electrified though.

▷ Bari (Red)

A Link to the Past

A Link Between Worlds

Red Bari are stronger than the blue Bari that also appear in *A Link to the Past* and *A Link Between Worlds*. When struck, these Bari split into smaller versions of themselves called Biri.

▷ Bari (White)

A Link Between Worlds

A white Bari found in the Swamp Palace in Lorule. It will electrify itself at regular intervals, and attacking it in this state will shock Link. Unlike the yellow Bari found in the same dungeon, it will not split upon defeat.

▷ Bari (Yellow)

A Link Between Worlds

This rare yellow Bari is found in the Swamp Palace in Lorule. Like other color variants, it will electrify itself at regular intervals, and attacking it in this state will shock Link. It will split into two Biri upon defeat.

▷ Barinade

Ocarina of Time

Ocarina of Time 3D

The Bio-electric Anemone Barinade has wrought havoc on Lord Jabu-Jabu's belly in *Ocarina of Time*. A giant parasite with long tentacles that resembles a jellyfish, its body is covered in countless Bari. The dungeon boss fires electricity from the tips of its tentacles and spins the Bari covering its body, forcing Link to dodge them between attacks.

▷ Battle Bat

Link's Awakening DX

These bat-like monsters are summoned by the Grim Creeper in Eagle Tower. They attack in groups of six. Unlike Keese that fly near the ground, Battle Bats stay up high and can only be struck when they swoop down to attack. See also Grim Creeper, Keese.

▷ Bawb

A Link Between Worlds

A bomb possessed by the spirit of a monster. It will draw near any target it spots, turning into a lit bomb and exploding after a short time if struck. Getting caught in the blast deals a lot of damage, but they can help solve puzzles if used wisely.

▷ Bazu

See Buzz.

▷ Beamos

A Link to the Past

Link's Awakening DX

Ocarina of Time

Ocarina of Time 3D

Majora's Mask

Majora's Mask 3D

Oracle series

The Wind Waker

The Wind Waker HD

Four Swords Adventures

Twilight Princess

Twilight Princess HD

Phantom Hourglass

Skyward Sword

Tri Force Heroes

These wide-eyed statues are placed in dungeons to guard against intruders. Their heads can rotate 360 degrees, firing a powerful, sustained laser at any enemy they spot. Many Beamos will cease functioning if hit with an arrow or bomb, but some must simply be avoided. See also Giant Beamos.

▷ Bee

A Link to the Past

Four Swords Adventures

Phantom Hourglass

Spirit Tracks

A Link Between Worlds

Sometimes when Link slams into trees, a bee will buzz out and chase him. Link can also incur their wrath by attacking nests. While a bee sting certainly hurts, it doesn't do much damage. In *A Link to the Past* and *A Link Between Worlds*, bees can be caught in bottles and released to attack enemies. In *Spirit Tracks*, Link can't hit or catch them; he can only flee to the safety of water or somewhere indoors. See also page 66, Deku Hornet, Giant Bee, Hylian Hornet.

▷ Beetle
● Beetle (Black)

Link's Awakening DX

Oracle series

The Minish Cap

These insects are unearthed by digging under rocks or grass. They can't hurt Link, but if one latches on, it will render him unable to use his sword or items.

▷ Beetle (Red)

The Minish Cap

A rare species of beetle that drops from the ceiling during the boss fight with Mazaal in the Fortress of Winds. Like other beetles, it cannot hurt Link, but if it latches onto him, he will be unable to use his sword or items.

▷ Bellum

Phantom Hourglass (1)

Phantom Hourglass (2)

Phantom Hourglass (3)

The final boss in the Temple of the Ocean King, the Evil Phantom Bellum appears at first as a sea creature with eerie eyes and long, spindly tentacles. He fires acid from the water and creates Slime Minions that attack Link from above (1). He then possesses the Ghost Ship, summoning countless Slime Minions for protection (2). For his final form, he possesses Linebeck to do battle on the deck of the Ghost Ship (3). See also Phantom, Slime Minion.

▷ Beth

Ocarina of Time

Ocarina of Time 3D

Majora's Mask

Majora's Mask 3D

The second-youngest of the four Poe Sisters fought in the Spirit House in Ikana Canyon. She appears with her sister Joelle. Beth will vanish, then charge at Link to attack. See also Amy, Joelle, Margaret, Meg, Poe.

▷ Big Baba

Twilight Princess

Twilight Princess HD

This hearty plant looks like a hybrid of a Deku Baba and a Deku Like. It will regrow no matter how many times Link snips off its snapping head, regenerating as long as its base remains alive. Like similar plants, they will try to swallow up anything that gets too close. See also Deku Baba, Deku Like.

▷ Big Blin

Spirit Tracks

A big, tough Moblin. In *Spirit Tracks*, multiple Big Blins appear as pirates in the Ocean Realm, dragging their subordinates along when attacking and attempting to board the Spirit Train. See also page 100, Moblin.

▷ Big Chuchu (BLUE)

The Minish Cap

A blue Chuchu that serves as miniboss for the Temple of Droplets. It only appears big because Link has shrunk down to the size of the Minish. Using the Gust Jar to continuously pull at its base will cause it to fall over, exposing its head to attack. It is immune to this suction when electrified. See also page 105, Chuchu.

▷ Big Chuchu (GREEN)

The Minish Cap

A green-colored Chuchu that wandered into Deepwood Shrine where the Earth Element is kept. Link's Minish size turns this common enemy into a fearsome foe that serves as the boss for the shrine. Its base is narrow compared to its head. Pulling at it with the Gust Jar will cause it to lose its balance and fall over.

▷ Big Dark Stalfos

Four Swords Adventures

One of four loyal Knights of Hyrule who have been transformed into monsters by the power of Ganon's trident. One appears as a boss in Level 4, the Field, and another in Level 5, Kakariko Village. They return to normal upon defeat and grant Royal Jewels that open the way to the Tower of Winds, where Vaati waits. See also page 102, Dark Stalfos, Stalfos.

▷ Big Deku Baba

Ocarina of Time

Ocarina of Time 3D

An especially large Deku Baba found in the courtyard of the Forest Temple, among other wooded areas. It attacks by extending its stem to reach and bite anyone who gets too close. Though bigger than typical Deku Babas, their health is the same. They drop three Deku Seeds when cut down. See also Deku Baba.

▷ Big Dodongo

Four Swords Adventures

The boss of Level 8, Realm of the Heavens, this giant blue Dodongo sprays fire from its massive, horned maw. It guards the fortress in the Cloud Tops in the Realm of the Heavens at the entrance to the Palace of Winds, where Vaati resides. Link can feed the beast upgraded bombs, but it'll take multiple blasts to bring it down. See also Dodongo.

▷ Big Ice Gimos

A Link Between Worlds

A statue of ice possessed by the spirit of a demon. They are similar but much larger than standard Ice Gimos, not only closing in on their targets but leaping high into the air to slam down on them. Though Big Ice Gimos take a lot of hits, they can be melted with fire attacks. See also Gimos.

▷ Big Manhandla

Four Swords

This gnashing, multiheaded plant monster is a direct subordinate of Vaati and serves as boss in the Sea of Trees. Its three fanged flowers have different-colored petals. Targeting these flowers will reveal levers on either side that open its central flower to attacks if pulled. See also Manhandla.

▷ Big Moldorm

See Moldorm (Boss).

▷ Big Octo

Ocarina of Time

Ocarina of Time 3D

Majora's Mask

Majora's Mask 3D

The Wind Waker

The Wind Waker HD

A large Octorok that serves as a miniboss inside Jabu-Jabu's Belly in *Ocarina of Time*. They also appear in the Southern Swamp of *Majora's Mask*, where they simply block the way without moving or attacking. In *The Wind Waker*, they have many eyes and create whirlpools. See also page 104, Octorok.

▷ Big Octorok

The Minish Cap

An Octorok that was frozen in ice along with the Water Element at the back of the Temple of Droplets. It is a plain old Octorok, but it appears huge because Link is Minish size. When it is thawed out in the sunlight, it swallows the Water Element and attacks. It has fused with the parasitic plant on its back. Link must defeat the Big Octorok in order to recover the Water Element. See also page 104, Octorok.

▷ Big Pengator

A Link Between Worlds

Like its name implies, the Big Pengator is a hefty foe, several times larger than a standard Pengator. Like its smaller cousins, it is found in chillier places like the Ice Ruins. Pengators slide on their bellies with ease across icy surfaces, charging at Link bill first with all their weight. See also Pengator.

▷ Big Poe

Ocarina of Time

Ocarina of Time 3D

Majora's Mask

Majora's Mask 3D

Four Swords Adventures

A large Poe. In every game in which they appear except *Four Swords Adventures*, their souls can be scooped up in empty bottles upon defeat. In *Ocarina of Time*, ten Big Poes appear in Hyrule Field. In *Majora's Mask*, they are found in Ikana Canyon, where at least one Gibdo asks Link for a Big Poe soul. In *Four Swords Adventures*, a Big Poe serves as boss for the "Infiltration of Hyrule Castle" stage in the Swamp. A very different kind of Big Poe also serves as the ghoulish boss of the Graveyard in the same Swamp. A giant, ghostly mask attracted to the light of torches, it will grow smaller over the course of the battle, spitting out ghosts as it takes damage. See also Poe.

Big Skulltula

Ocarina of Time

Ocarina of Time 3D

A large Skulltula. Like other Skulltulas, it hangs from the ceiling, waiting for prey. Its armored, skull-shaped back repels swords and cannot be cracked. If Link gets too close, it will spin around and push him away. See also Skulltula.

Bilocyte

Skyward Sword

The Ocular Parasite Bilocyte is a boss creature with a giant eye and fins which has latched onto the great spirit of the sky, Levias, in the clouds around Skyloft. It can control its host's mind and body, causing Levias to go berserk. The Bilocyte launches slimy projectiles from its mouth at any enemy that draws near. Its eye is its weakness, but it cannot be attacked while its fins are unfurled. See also Levias.

Bio Deku Baba

Majora's Mask

Majora's Mask 3D

A Deku Baba unique to Termina that grows on the underside of a lily pad floating on ponds in secret grottoes and the Great Bay Temple. When its stem is cut, it will crawl to the bottom of the pond and wait for Link to approach. They can be defeated in a single blow by targeting their head with a ranged weapon. See also Deku Baba.

Biri
● Biri (Red)

Ocarina of Time

Ocarina of Time 3D

Oracle series

A Link Between Worlds

A small, jellyfish-like monster that hovers in the air, guarding itself against attacks with an electric barrier that must be recharged after a short time. Attempting to hit a Biri with a sword while it is electrified will shock Link. Typically smaller than Bari, multiple Biri are sometimes created when a Bari is struck. See also Bari, Gigabari.

Biri (Purple)

A Link Between Worlds

Biri that appear in Lorule Castle. The most powerful Biri in *A Link Between Worlds*, they have more health than both their red and yellow counterparts. Like other Biri, they will generate electricity, and attacking them while electrified will shock Link.

Biri (Yellow)

A Link Between Worlds

A Biri found in the Swamp Palace in the kingdom of Lorule. Defeating a yellow Bari will split it into two yellow Biri. Like other colors of Biri, it will cover itself in electricity in order to defend itself.

Bit

The Adventure of Link

A gelatinous monster found throughout Hyrule in *The Adventure of Link*. It moves by shaking its body. While Bits normally do not attack people, they are poisonous, and will deplete Link's health if touched. See also Boss Bot, Bot.

Blaaz

Phantom Hourglass

The Master of Fire, Blaaz is the robed boss of the Temple of Fire in *Phantom Hourglass*. Blaaz has the ability to split into three separate forms and burst into flames. They will also use the volcanic nature of the Isle of Ember to rain volcanic rocks down from above. When Blaaz separates into three, Link must use chain attacks on all three to force them back together. See also Fraaz.

Black Knight

The Minish Cap

Knights covered in armor encountered at the end of the Dark Hyrule Castle. These powerful enemies' heavy defenses deflect most attacks and leave few openings. Link must get behind them to hit their weak point. Three appear as the final challenge Link must face before confronting Vaati. See also Darknut.

Blaino

Link's Awakening DX

This miniboss appears in Turtle Rock on Koholint Island. He will approach nimbly like a boxer, then attack with rapid punches. Blaino signals an impending, powerful uppercut by raising his arm behind him and spinning it around. Getting hit with this punch will send Link back to the entrance of the dungeon.

Blastworm

Spirit Tracks

Vibrant blue caterpillars that crawl in the darker corners of dungeons, curling into a spiked ball and self-destructing when they feel threatened. Much like a bomb, they can be used to destroy cracked walls.

Blind the Thief

A Link to the Past

Blind the Thief became a monster when he crossed over into the Dark World in *A Link to the Past*. As boss of Thieves' Town, he attacks intruders with lasers. Later in the fight, his head will separate from his body and fly around, spitting fireballs. In the Game Boy Advance version of *A Link to the Past*, a more powerful incarnation of Blind appears in the Palace of the Four Sword. See also Stalblind.

Blizzagia

Tri Force Heroes

This giant snake with a hard shell for a helmet lurks within the heart of the Ice Temple in the Ice Cavern. It prefers narrow spaces and leaps out from tunnels to bite down on prey. The ice spike on its tail will freeze anyone who so much as grazes it. See also Volvagia.

Blizzeta

Twilight Princess

Twilight Princess HD

The Twilit Ice Mass Blizzeta is the corrupted form of Yeta, one half of a Yeti couple living in the ruins on Snowpeak. Corrupted by the power of a shard of the Mirror of Twilight, she becomes an enormous ice boss. Blizzeta uses magic to levitate, forming pillars of ice to attack Link from above.

Blob

A Link Between Worlds

Tri Force Heroes

A nonelectrified variety of the sentient globs of green jelly found across many titles in the series. Like their electric counterparts, they are mainly found in areas with a lot of greenery like forests and meadows, but attacking them directly will not shock Link. See also Buzz Blob, Cukeman.

Bloober

Link's Awakening DX

White, squid-like guest characters from the *Super Mario Bros.* series. They swim around in side-scrolling sections, moving underwater by expanding and contracting their bodies.

Blue Stalfos

Oracle of Ages

A miniboss in the Ancient Tomb of *Oracle of Ages* is called Blue Stalfos, though he looks more like a Grim Reaper than a typical skeleton warrior, wearing a hooded robe and wielding a scythe. Volleying his black projectiles back at him will turn him into a bat. See also page 102, Stalfos.

Blue Zol
See Slime.

Bob-omb

Four Swords

The Minish Cap

This walking bomb that first appeared in the *Super Mario Bros.* series has glowing red eyes. If attacked, their fuse will light and they will run around, exploding after a short time.

Boe (BLACK)

Majora's Mask

Majora's Mask 3D

A completely black, spheroid monster that lives in dark places. They hide in the shadows and attack in groups.

Boe (WHITE)

Majora's Mask

Majora's Mask 3D

A white, round monster that makes its home in the Snowhead region. It hides in the snow and attacks in groups.

Boko Baba

The Wind Waker

The Wind Waker HD

A plant-like monster that grows in forests, hiding underground before clamping its massive jaw down on prey that get too close. Upon defeat, the base of its root may leave a Baba Bud that will propel Link into the air, allowing him to reach high spots in a particular area. See also Deku Baba.

Bokoblin
● Bokoblin (Red)

The Wind Waker

The Wind Waker HD

Twilight Princess

Twilight Princess HD

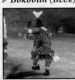
Skyward Sword

These little goblins with long, pointy ears are found in places all over Hyrule, mainly in groups. In *The Wind Waker*, some use their small stature to hide in vases. In *Twilight Princess*, they specialize in fighting with clubs and swords, while the Bokoblins in *Skyward Sword* use a variety of weapons depending on their proximity to Link. A stronger Bokoblin may serve as the leader of their group, signified by the cloth wrapped around their head. See also page 100, Cursed Bokoblin, Moblin, Technoblin.

Bokoblin (BLUE)

Skyward Sword

Small, blue-skinned Bokoblins. They attack in groups with red Bokoblins. Though fewer in number than their red counterparts, they are much stronger and better skilled with a sword. Blue Bokoblins will block with their swords and perform Jump Attacks. Like weaker Bokoblins, they have a fixation on exotic undergarments.

Bokoblin (GREEN)

A green-colored Bokoblin that wears a skull on its head and prefers to live in dark places like caves. Its skin is green because it has never been exposed to sunlight. Green Bokoblins are often found in groups and will carry both long- and short-range weapons. They have roughly the same attack power as the red Bokoblins that also appear in *Skyward Sword*, but with slightly less health.

Bomb Soldier

A Link to the Past

Four Swords Adventures

A Link Between Worlds

Tri Force Heroes

These soldiers specialize in explosives, throwing bombs at distant targets in the field, often from strategic locations like castle ramparts. They are sometimes beyond the reach of Link's sword, forcing him to hurry past or toss their bombs back at them before they explode. See also Soldier.

Bomber

See Zirro.

Bombfish

Twilight Princess

Twilight Princess HD

These fanged, round-bodied fish are found in the water of some dungeons. They carry what appear to be bombs in their mouths, and if hit with a strong blow, will swell up and explode. If Link is careful, he can catch these fish with a Fishing Rod and use them in place of Water Bombs.

Bombite

Link's Awakening DX

These bombs with feet appear in the Key Cavern on Koholint Island. They will explode if struck with a sword. They run wildly around the room until struck, then approach Link while counting down and exploding. Link can detonate Bombites instantly by using bombs on them.

Bombling

Twilight Princess

Twilight Princess HD

An insect-like monster with extremely long legs that prop up a spherical, bomb-sized body. If they extend their legs, they rival the height of some Hylians. If attacked, they will explode after a short time.

Bomskit

Twilight Princess

Twilight Princess HD

These creeping monsters appear in Hyrule Field, standing alone and keeping an eye out for travelers. If Link approaches one, it will drop bombs as it flees so quickly that Link can't possibly keep up. If Link manages to defeat one, it will release a tangle of worms living inside its body.

Bone Putter

Link's Awakening DX

These monsters with skulls only appear in the Color Dungeon added to *Link's Awakening DX.* Some Bone Putters have wings and will flap about while tossing bombs. If struck, they will lose their wings and continue to fight from the ground, while their wings continue to flutter around the battlefield.

Bongo Bongo

Ocarina of Time

Ocarina of Time 3D

The Phantom Shadow Beast Bongo Bongo was sealed at the bottom of the well in Kakariko Village until its power grew enough for it to break free. As the boss of the Shadow Temple, it cannot be seen without the Lens of Truth. Link must fight the beast, which hangs from the ceiling and attacks by striking the ground like a drum, as well as charging Link and slamming down its massive fists.

Boo Buddy

Link's Awakening DX

A ghostly guest character from the *Super Mario Bros.* series. They appear in a dark room in Bottle Grotto and move toward Link when he has his back turned. They will vanish if attacked and cannot be damaged if the room is dark. Using the Magic Powder to illuminate the room will slow their movements and make them vulnerable to sword swipes.

Boon

The Adventure of Link

A monstrous fly that buzzes around in certain regions of Hyrule. Far from a harmless housefly, it will swarm passersby without warning and drop stones from the air.

▷ **Boss Bot**

The Adventure of Link

This boss of the Great Palace in *The Adventure of Link* is a massive fusion of many Bots. When struck, it will shed Bots of considerable strength that leap at Link in attack. It is said that the Boss Bot formed from Bots living in the Great Palace for ages, absorbing its divine power. See also Bit.

▷ **Bot**

The Adventure of Link

A jelly-like monster found throughout Hyrule in *The Adventure of Link*. Similar to Bits but able to jump, these common enemies frequently drop Magic Jars. The Bots that appear in the Great Palace have especially high attack power and health, while the ones that split off from the Boss Bot in the same dungeon are even stronger. See also Bit.

▷ **Bow Soldier**

See Soldier.

▷ **Brother Goriyas**

Oracle of Seasons

These Goriya brothers appear in *Oracle of Seasons* as minibosses of the Gnarled Root Dungeon. One red, one blue, they toss a boomerang between them to cut off Link's route. See also Goriya.

▷ **Bubble**
● Anti-Fairies / ▲ Bubble (Red)

The Legend of Zelda | The Adventure of Link | A Link to the Past | Link's Awakening DX

Ocarina of Time | Ocarina of Time 3D | Majora's Mask | Majora's Mask 3D

Oracle series | The Wind Waker | The Wind Waker HD | Four Swords

Four Swords Adventures | Twilight Princess | Twilight Princess HD | Phantom Hourglass

Spirit Tracks | A Link Between Worlds

A disembodied spirit that will curse whoever it touches. Most look like skulls wrapped in flames, floating eerily in the air. Troublesome effects experienced by touching one include being unable to use a sword for a short time and losing magical energy or health. In *The Legend of Zelda*, there are red and blue versions, both of which are invincible. In all titles that follow, Bubbles can typically be defeated with items like Magic Powder or the Boomerang. See also page 102, Fire Bubble, Giant Bubble, Ice Bubble, Stalfos, Wisp.

▷ **Bubble (BLUE)**

Ocarina of Time | Ocarina of Time 3D | Majora's Mask | Majora's Mask 3D

The Wind Waker | The Wind Waker HD

A Bubble covered in blue flame. To do any damage, Link must first douse its flames. Blue Bubble attacks carry a curse that, in *Majora's Mask*, will prevent Link from using his sword. In *The Wind Waker*, this same curse renders Link unable to use any weapons at all for a short time.

▷ **Bubble (GREEN)**

Ocarina of Time | Ocarina of Time 3D

A Bubble wrapped in eerie green flames that travels along a set route. They can only be damaged when their flames are extinguished.

▷ **Bubble (WHITE)**

Ocarina of Time | Ocarina of Time 3D

Like most Bubbles, this is a skull that flies through the air. Unlike most Bubbles, it has no aura and will not attack directly.

▷ **Bulblin**

Twilight Princess | Twilight Princess HD | Spirit Tracks

These two-horned monsters wander the fields of Hyrule. In *Twilight Princess*, they wield a variety of weapons and sometimes ride Bullbos into battle. In *Spirit Tracks*, they only appear riding Bullbos while using bows. See also page 100, Bullbo, King Bulblin, Moblin, Shadow Bulblin.

▷ **Bulbul**

Four Swords

These narrow-bodied creatures are protected by an elastic, jelly-like substance that surrounds them. The jelly can be whittled down with continuous attacks, but it will regenerate quickly if left alone. The only way to defeat them is to expose and slash their heart-shaped weak point.

▷ **Bullbo**

Twilight Princess | Twilight Princess HD | Spirit Tracks

A boar ridden by Bulblins. They run at great speeds and will violently charge enemies. In *Twilight Princess*, they cannot be hurt, but Link can ride them if he first knocks off the Bulblin. Once a Bullbo starts running they have a hard time stopping. See also page 100, Bulblin.

▷ **Business Scrub**

Ocarina of Time | Ocarina of Time 3D | The Minish Cap

A type of Deku Scrub that hides in grass and shoots seeds. Using a shield to redirect their seeds back at them will stop their attack, allowing Link to speak to them and buy items. Their stock varies based on the title and the places where they appear. See also page 50, Deku Scrub.

▷ Buzz
● Bazu

A Link to the Past

These large green bugs lurk in the sunlit corridors of Thieves' Town in the Dark World. They move quickly along walls, stopping occasionally to collect themselves, behaving much like rats in the Light World.

▷ Buzz Blob

A Link to the Past

Link's Awakening DX

Oracle series

Four Swords Adventures

A Link Between Worlds

Green gelatinous monsters with bold black eyes and stubby legs. They generate a field of electricity and will shock Link in this state, depleting some of his health. Using Magic Powder or the Quake magic on Buzz Blobs in some games will turn them into Cukemen. See also Blob, Cukeman, Electric Blob King, Giant Buzz Blob.

Tri Force Heroes

▷ Byrne

Spirit Tracks

Byrne is a spirited Lokomo that Link does battle with at the top of the Tower of Spirits. He once served as an apprentice to Anjean, guardian of the Tower of Spirits. Desiring a power beyond that of the spirits, he joins the effort to revive the Demon King Malladus. Byrne later learns he is being used by Cole—a demon in chancellor's clothing—and changes sides, pledging instead to help Link.

C COLUMN

▷ Camo Goblin (BLUE)

Link's Awakening DX

This gooey goblin only appears in the Color Dungeon of *Link's Awakening DX*. It hides under floor tiles the same color as its body, stretching out and attacking Link if he gets near. There are fewer Blue Camo Goblins than other colors, and its movement is slightly faster.

▷ Camo Goblin (GREEN)

Link's Awakening DX

This gooey goblin only appears in the Color Dungeon of *Link's Awakening DX*. It hides under floor tiles the same color as its body, stretching out and attacking Link if he gets near.

▷ Camo Goblin (RED)

Link's Awakening DX

This gooey goblin only appears in the Color Dungeon of *Link's Awakening DX*. It hides under floor tiles the same color as its body, stretching out and attacking Link if he gets near.

▷ Cannon Boat

Phantom Hourglass

Spirit Tracks

These seafaring ships sport giant cannons. They appear in a fleet, firing their cannons in succession, often alongside larger Pirate Ships. Unlike the latter vessels, the crew of a Cannon Boat will not try to board Link's ship.

▷ Captain Keeta

A giant Stalfos sleeping in the Ikana Canyon graveyard. Playing the Sonata of Awakening will wake him. He will surrender if Link can defeat him before reaching the treasure box down the road. Shooting him with an arrow will cause him to stand at attention for a split second, gaining Link valuable time. See also page 102, Stalfos.

▷ Carock

The Adventure of Link

Carock is the wizard guardian of the Maze Island Palace, the fourth palace in *The Adventure of Link*. Taller than common Wizzrobes with a face obscured by a billowing red hood, he guards the palace to test the wisdom and courage of any hero brave enough to enter. Normal attacks do not work against Carock; the only way to damage him is to reflect his magic back at him with the Reflect spell. See also Wizzrobe.

▷ Chain Chomp

A Link to the Past

Four Swords Adventures

A chomping, onyx-colored ball on a heavy chain that originally appeared in the *Super Mario Bros.* series. Though invulnerable, they are thankfully held back by the chain hammered into the ground and cannot move beyond a certain range of attack. Because of this, they are not a threat if Link keeps his distance. In *A Link to the Past*, these toothy wrecking balls twice appear in Turtle Rock. They can also be found in *Link's Awakening*, but instead serve as allies to Link's cause.

▷ Chasupa

A Link to the Past

A Link Between Worlds

Tri Force Heroes

One-eyed bats that primarily live in areas without sunlight in both the Dark World and Lorule. They attack by slamming into their targets. In *A Link to the Past*, they appear on the top floors of Hyrule Castle Tower. They are also found in the Ruins of *Tri Force Heroes*. See also Eyesoar.

▷ Cheep-Cheep

Link's Awakening DX

Oracle series

Four Swords Adventures

A guest character from *Super Mario Bros.*, these puffy red fish swim the waters of side-scrolling sections in various handheld titles including *Four Swords Adventures* on the Game Boy Advance. Some Cheep-Cheeps have been known to grow roughly four times bigger than typical ones.

▷ Chief Soldier

Four Swords Adventures

Four Swords Adventures

Four Swords Adventures

Large, tough soldiers that have fallen under the spell of evil. They may command legions of smaller soldiers, ordering them to charge or retreat. See also Pack of Soldiers, Soldier.

▷ Chilfos

Twilight Princess

Twilight Princess HD

A slim-bodied soldier made of ice. They disguise themselves as icicles on the ceiling and drop down when Link draws near. Chilfos wield an icicle spear, piercing enemies that come within range and throwing it at those who keep their distance.

▷ Chu (PURPLE)

Twilight Princess

Twilight Princess HD

A Purple Chu is created when a Yellow Chu and a Blue Chu merge in the Cave of Ordeals in the GameCube and HD versions of *Twilight Princess*. Purple Chu Jelly is left behind and can be scooped into an empty bottle upon defeating these slime creatures. See also page 105, Chuchu.

▷ Chu Worm

Twilight Princess

Twilight Princess HD

These two-legged insect monsters hide inside Shell Jelly, using their protective shells to crush Link and absorb sword and arrow attacks. A Chu Worm can only be hurt by first dragging it out of the jelly or by blasting it with Bomb Arrows. See also Shell Jelly.

Chuchu (Blue)
● Chu (Blue)

Majora's Mask

Majora's Mask 3D

The Wind Waker

The Wind Waker HD

The Minish Cap

Twilight Princess

Twilight Princess HD

Phantom Hourglass

Skyward Sword

A blue-bodied slime monster. Their appearance and abilities vary significantly by title. They serve as platforms when frozen in *Majora's Mask* and will generate electricity to attack in *The Wind Waker*, *The Minish Cap*, and *Phantom Hourglass*. They are much rarer in *The Wind Waker*. See also page 105, Big Chuchu, Chu, Dark Chuchu, Helmet Chuchu, Ice Chuchu, Metal Chuchu, Rare Chu, Rock Chuchu, Spiny Chuchu.

Chuchu (Green)
● Chu (Green)

Majora's Mask

Majora's Mask 3D

The Wind Waker

The Wind Waker HD

The Minish Cap

Twilight Princess

Twilight Princess HD

Phantom Hourglass

Skyward Sword

A green-bodied slime monster that charges into its targets with abandon. Their health and attack power are low, and they often drop Magic Jars and ingredients for magic-restoring potions when defeated.

Chuchu (Red)
● Chu (Red)

Majora's Mask

Majora's Mask 3D

The Wind Waker

The Wind Waker HD

The Minish Cap

Twilight Princess

Twilight Princess HD

Phantom Hourglass

A red-bodied slime monster that charges into its targets with abandon. They often drop materials used as ingredients for recovery potions. In *Skyward Sword*, they wield fire.

Spirit Tracks

Skyward Sword

Chuchu (Yellow)
● Chu (Yellow)

Majora's Mask

Majora's Mask 3D

The Wind Waker

The Wind Waker HD

Twilight Princess

Twilight Princess HD

Phantom Hourglass

Spirit Tracks

Skyward Sword

Yellow-bodied Chuchus are often covered in electricity. Attacking one while it is electrified will shock Link. Yellow Chuchus are not electrified in *Majora's Mask*. Instead, they have arrows inside that can be gathered and used with Link's bow upon defeat. In *Twilight Princess*, this color of Chuchu is also not electrified. Defeating one will leave a gooey jelly behind that can be scooped up to use as a substitute for Lantern Oil.

Cloud Piranha

The Minish Cap

A chomping Piranha fish that lives in the clouds. Their fins stick out of the clouds like sharks in water, stalking their prey before leaping out and biting down. They can be defeated by slashing at them when they pop out of the clouds. See also Piranha.

Club Moblin

Ocarina of Time

Ocarina of Time 3D

Massive boss-level Moblins that block the path through the Sacred Forest Meadow in *Ocarina of Time*. They carry giant clubs and don spiked helmets and shoulder pads to intimidate any who trespass in the meadow. See also page 100, Moblin.

Cole

Spirit Tracks

A demon who infiltrates the Hyrule royal family as chancellor to revive the Demon King Malladus in *Spirit Tracks*. The two hats, one tall and one short, that he wears on his head strategically hide his horns. Cole is especially adept at deceiving and using people, but he is not particularly skilled in combat. His weapon of choice is a pack of Dark Rats that do his bidding. Zelda is terrified of rats, and Cole uses them to petrify and then take control of her armor.

Color-Changing Gel

Oracle of Ages

Appearing in *Oracle of Ages*, this special Color-Changing Gel is unique to the Wing Dungeon. It changes the color of its body to match the color of the floor. Link can't fight or even see it unless he uses a panel to change the color of the floor. See also Gel.

Cragma

Spirit Tracks

The Lava Lord, Cragma, is the one-eyed boss of the Fire Temple in *Spirit Tracks*. Emerging from magma, he crushes and grabs at his targets with his giant hands. Cragma's body is made of molten rock, with cracks that reveal weak points.

Cranioc

Skyward Sword

A giant fish monster that lives in Lake Floria. The size of the lump on its forehead determines its social standing among fellow Craniocs. They are extremely violent, charging at anything that moves in the water. Unable to control the speed at which they swim, they often overshoot their targets, slamming into rocks or walls and passing out.

▷ **Crayk**

Phantom Hourglass

Crayk, Bane of Courage, is a hermit crab–like boss that dwells in the Temple of Courage. It is able to make itself invisible for a short time and attacks using its massive pincers. The blue parts on the side of its shell mark its weak points, and attacking them will break apart its shell, revealing Crayk's main body. The top screen of the Nintendo DS shows Crayk's viewpoint, allowing the player to figure out where it is while invisible.

▷ **Crow**

A Link to the Past Link's Awakening DX Oracle series The Minish Cap

Phantom Hourglass Spirit Tracks A Link Between Worlds Tri Force Heroes

Hostile crows lie in wait, perched in trees to swoop down and attack passersby. They will fly away after slamming into their targets. Crows love rupees and keys; some will steal these and other shiny objects and take them to their nests. See also Takkuri.

▷ **Cubus Sisters**

Phantom Hourglass Phantom Hourglass Phantom Hourglass Phantom Hourglass

Four diabolical Cubus Sisters helm the Ghost Ship that kidnaps Tetra. They are shown here from oldest to youngest (left to right). The youngest sister is inside the Ghost Ship, paralyzed by her fear of Skulltulas. Leading the other sisters to her causes the sisters to reveal their true forms. Link volleys their attacks back at them to inflict damage in the resulting fight.

▷ **Cue Ball**

Link's Awakening DX

This octopus-like miniboss appears in the Angler's Tunnel. It charges around the room, impervious to attacks from the front. Link must find a way to strike it from behind.

▷ **Cukeman**

A Link to the Past Link's Awakening DX Oracle series

A Cukeman is a Buzz Blob after it has been exposed to Magic Powder. They are the rare monster capable of conversation, though they mainly tell lame jokes or speak incomprehensible phrases. As with a typical Buzz Blob, touching it does damage. See also Buzz Blob.

▷ **Cursed Bokoblin**

Skyward Sword

Undead Bokoblin that have been resurrected to fight another day. They are mainly found at the bottom of the Ancient Cistern and in other particularly spooky areas. Cursed Bokoblin are slow but have lots of health and attack in large groups. They are afraid of anything that gives off a divine light, like the Sacred Shield. See also page 100, Bokoblin.

▷ **Cursed Spume**

Skyward Sword

These round frog monsters live in swamps and volcanoes. They fire demonic projectiles that curse the target for a time, rendering them unable to defend themselves. Link's shield must be resistant to demons in order to block their attacks. See also Electro Spume, Magma Spume, Water Spume.

▷ **Cyclok**

Phantom Hourglass

The Stirrer of Winds, Cyclok is an octopus-like monster that surrounds itself with powerful tornadoes. Serving as boss of the Temple of Wind in *Phantom Hourglass*, it moves freely through the air, stirring wind from the sky and plummeting rapidly in an attempt to crush Link. If Link throws a bomb into a tornado, it will carry it up and explode, stunning Cyclok and dropping him within attack range. See also page 104, Octorok.

D COLUMN

▷ **Dacto**

A Link to the Past Link's Awakening DX Oracle of Seasons A Link Between Worlds

Dactos resemble flying, horned dinosaurs. They reside in the Dark World and Lorule in *A Link to the Past* and *A Link Between Worlds* respectively, acting much like crows in Hyrule: waiting in the trees when an enemy passes, then swooping down to attack. In *Link's Awakening* and *Oracle of Seasons*, they look more like birds than dinosaurs.

▷ **Daira (ORANGE)**

The Adventure of Link

Crocodilian soldiers that serve as reinforcements for Ganon's army. They are extremely aggressive, possessing incredible strength and using axes to attack. Their axes cannot be blocked with a shield.

▷ **Daira (RED)**

The Adventure of Link

Crocodilian soldiers that serve as reinforcements for Ganon's army. They are extremely aggressive, possessing great strength and brandishing axes that they sometimes throw. Their axes cannot be blocked with a shield.

▷ **Dangoro**

Twilight Princess Twilight Princess HD

The miniboss of the Goron Mines. Link fights him atop a magnetic stage, avoiding the massive Goron as he rolls into a ball attempting to crush Link. Dangoro guards a bow said to have been used by an ancient hero. Upon defeat, he will deem Link worthy of carrying the bow and open the way to him.

▷ **Dark Beast Ganon**
See Ganon.

▷ **Dark Chuchu**

The Wind Waker The Wind Waker HD

A Chuchu monster made of black jelly that prefers the darkness. It moves like other Chuchus, but will split apart to avoid sword attacks. They turn to stone when exposed to sunlight, after which they can be shattered or used as a weight. See also page 105, Chuchu.

▷ **Dark Ghini**

A Link Between Worlds Tri Force Heroes

Like regular Ghini, Dark Ghini are semi-transparent, one-eyed ghosts that lurk in the shadows. They will appear and attack Link if he draws near. In *A Link Between Worlds*, they are the opposite of Light Ghini, disappearing in the light and only visible in the darkness. See also Ghini.

▷ **Dark Keese**

Skyward Sword

A Keese made only of bones. Like regular Keese, they prefer the darker places like caves and dungeons, but these creatures will not only swoop in to attack but also curse Link, rendering him unable to use items or equipment for a time. Link's shield must be resistant to demons in order to block their attacks. See also Keese.

▷ Dark Link

A Link to the Past (1)

A Link to the Past (2)

A Link to the Past (3)

A Link to the Past (4)

Ocarina of Time

Ocarina of Time 3D

Oracle of Ages

Spirit Tracks

A dark reflection of Link that mimics not only his abilities but also his movements. In *Oracle of Ages*, four are summoned at the start of Link's fight with Veran. These incarnations of Dark Link will mirror Link's every move but will not attack on their own. Clearing both titles in *A Link to the Past* & *Four Swords* makes these four dark reflections of Link appear in the Palace of the Four Sword. Similar to the Links of *Four Swords*, they appear in four colors: green (1) red (2), blue (3), and purple (4). A Dark Link also appears in *Spirit Tracks*, serving as the boss of Level 3 in "Take 'Em All On!" in Castle Town. Like other iterations of Dark Link, he looks like a shadow of Link and will freely use his abilities, like the Spin Attack and Bombs. See also page 98, Shadow Link.

▷ Dark Lizalfos

Skyward Sword

This demonic Lizalfos emits a cursed mist from its mouth. It wears a gauntlet on its left arm that can be used to block as well as attack, and it takes a particular delight in toying with its enemies. See also Lizalfos.

▷ Dark Rat

A Link Between Worlds

A mouse-like monster similar to rats found in the dark caverns and dungeons of Lorule. Running along the floor or walls in groups, Dark Rats will attack Link if he draws too near. They are small and fast creatures, making them difficult to hit. See also Rat.

▷ Dark Stalfos

Four Swords Adventures

An armored skeletal soldier equipped with a green sword. They will raise their swords overhead when they spot a target and dash in to attack. See also page 102, Stalfos.

▷ Dark Train

Spirit Tracks

Encountered while driving the Spirit Train, these demonic trains storm down the Spirit Tracks, threatening to derail Link. They are slightly faster than the Spirit Train and will cause a massive explosion if they crash into Link. They can be temporarily stopped by cannon fire, but not destroyed outright. Several may be running around in a given area. See also Armored Train.

▷ Darkhammer

Twilight Princess

Twilight Princess HD

A reptilian miniboss that appears in the Snowpeak Ruins. Link encounters Dark-hammer in a narrow corridor, where he leaves little room to avoid his swinging ball and chain. His entire body is clad in sturdy armor, so he can only be damaged through his exposed tail.

▷ Darknut

Link's Awakening DX

Four Swords

Twilight Princess

Twilight Princess HD

A heavily armored knight equipped with a large sword and shield. Their attack and defensive power are high, making them a difficult enemy to challenge directly. See also Black Knight, Mace Darknut, Mad Bomber, Mighty Darknut.

▷ Darknut (Blue)

The Legend of Zelda

Oracle series

An armored knight equipped with heavy blue armor and a large shield. Their strength has varied by title since their introduction in *The Legend of Zelda*, where they are actually stronger than their Red Darknut counterparts.

▷ Darknut (Golden)

Oracle of Seasons

This golden-armored Darknut in *Oracle of Seasons* is far more powerful than its ordinary compatriots. Defeating all four Golden Monsters, including this Darknut, rewards Link with a Magic Ring that doubles his sword's attack power.

▷ Darknut (Green)

Twilight Princess

Twilight Princess HD

A knight wearing heavy green armor equipped with a large sword and shield. In *Twilight Princess*, the difference between these and other Darknuts is purely aesthetic.

▷ Darknut (Red)

The Legend of Zelda

Oracle series

Twilight Princess

Twilight Princess HD

The Minish Cap

An armored knight equipped with heavy red armor and a large shield. Their strength varies by title.

▷ Darknut (Silver)
● Darknut

The Wind Waker

The Wind Waker HD

The Minish Cap

A knight wearing heavy armor equipped with a large sword and shield. They have less health than other Darknuts, but their strength should not be underestimated.

▷ Dead Hand

Ocarina of Time

Ocarina of Time 3D

This toothy, long-necked abomination lurks at the bottom of the well in Kakariko Village, while another serves as a miniboss for the Shadow Temple. Their countless pale hands reach up from underground to grab at anyone daring enough to set foot in their domain. If Link is caught, Dead Hand will appear in earnest, spattered with what looks like blood. With any luck, Link can wriggle free of its grip and strike at him with his sword.

▷ Deadrock

A Link to the Past

Four Swords Adventures

A Link Between Worlds

Tri Force Heroes

A small, speedy dragon that walks on its hind legs. If attacked with a weapon or item, it will turn to stone on the spot. Link must strike the petrified monster with the Hammer to defeat it. In *A Link to the Past* and *Four Swords Adventures*, it can also be turned into a Slime.

▷ Death Armos

Majora's Mask

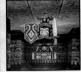

Majora's Mask 3D

Palace knights of the Stone Tower Temple, Death Armos float through the halls in search of intruders to crush. Shooting their chests with a Light Arrow will flip them, leaving them vulnerable to Link's attacks. Once defeated, they will self-destruct. See also Armos.

▷ Death Sword

Twilight Princess

Twilight Princess HD

A monstrous spirit that wields a massive sword. Link finds the sword embedded in the Arbiter's Grounds, held in place by ropes. Cutting the ropes and freeing the sword begins a battle with a spirit Link can only see by reverting to his wolf form.

▷ Deeler (Blue)

The Adventure of Link

A giant spider that makes its home in the forest. Its body has grown enormous and round from feasting on forest animals. It hangs by silken threads on tree branches, descending to the forest floor to leap at its prey.

▷ Deeler (Red)

The Adventure of Link

A giant spider that makes its home in the forest. Its body has grown enormous and round from feasting on forest animals. It hangs by silken threads on tree branches, attacking its prey from above.

▷ Deep Python

Majora's Mask

Majora's Mask 3D

A giant sea snake that lives near Pinnacle Rock, guarding a clutch of missing Zora Eggs, as well as a Seahorse. It emerges from its burrow when Link draws near, trying to get its teeth around him. The snake's weak point is just below its head.

▷ Deku Baba

Ocarina of Time

Ocarina of Time 3D

Majora's Mask

Majora's Mask 3D

Twilight Princess

Twilight Princess HD

Skyward Sword

Gnashing, plant-like monsters that grow in the greener regions of Hyrule. They hide in the ground, emerging and biting at potential prey that may step within range. A defeated Deku Baba may be harvested for Deku Sticks or Deku Seeds, and there are many subspecies, including some that grow much larger and even spit fire. See also Baba Serpent, Big Baba, Big Deku Baba, Bio Deku Baba, Boko Baba, Diababa, Fire Baba, Mini Baba, Quadro Baba, Shadow Deku Baba.

▷ Deku Hornet

Skyward Sword

Hornets that make their home in Faron Woods. They will attack in a swarm if Link approaches their nests. Deku Hornets can be caught with the Bug Net and used as ingredients in potions, as well as to upgrade items. See also page 66, Bee.

▷ Deku Like

Twilight Princess

These giant, carnivorous plants block the way through the Forest Temple. Though they stay rooted to the ground, Deku Likes will indiscriminately devour any prey that falls from above. They have sturdy outer shells, so sword attacks will not work, but their insides are delicate. See also Big Baba.

Twilight Princess HD

▷ Deku Scrub

Ocarina of Time

Ocarina of Time 3D

Oracle of Seasons

A small woodland Deku with leaves growing out of its head for camouflage. It pokes its head out of the ground and fires Deku Seeds when Link's within range. Link can use his shield to bounce the seeds back at the scrub. If hit, he will leap out of his leafy nest and run around, leaving him open to a swipe of the sword. Not all Deku Scrubs are hostile, and some can be reasoned with. See also page 50, Business Scrub, Mad Scrub, Totem Deku.

▷ Deku Toad

Twilight Princess

Twilight Princess HD

The miniboss of Lakebed Temple, it clings to the ceiling of its chamber, waiting for prey to step into range. It carries countless eggs on its back, which immediately hatch into Toados that immediately attack. It will attempt to fall onto Link, crushing him if he's not careful.

▷ Demise

Skyward Sword

The Demon King who, long ago, led an army of demons and sought to crush all life on the Surface. He was imprisoned in the Sealed Grounds after a fierce battle with the goddess Hylia. After he absorbs the spirit of Zelda, the reincarnation of the goddess, in Hylia's Realm, Demise returns. He is the origin of a cycle of conflict with beings of darkness like Ganon and Vaati that persists throughout history. See also page 99, Ghirahim, Imprisoned, The.

▷ Demon Train

Spirit Tracks

A ghastly train is used by demons to travel across the Dark Realm. It possesses a demonic will and bears a terrifying face during combat. Its three cars are armed with explosive barrels, laser cannons, and crystal pedestals. It attacks while charging along the tracks at high speed.

▷ Dera Zol

Four Swords

This giant slug monster is the boss of Talus Cave. It serves as a direct subordinate of Vaati. Able to clone and make itself invisible, Dera Zol grows smaller as it takes damage, eventually revealing four colored weak points that resemble balloons.

▷ Desbreko

Majora's Mask

Majora's Mask 3D

A skeletal fish with sharp fins and sharper fangs found in certain bodies of water. A Desbreko will often be flanked by a school of Skullfish. See also Skullfish.

▷ Devalant

A Link to the Past

Four Swords Adventures

A Link Between Worlds

A desert monster not unlike an Antlion that digs holes in the sand and waits for its prey to step close. In A Link to the Past, there are blue and red versions. The red ones shoot fireballs. In A Link Between Worlds, the Sand Rod will drive them out of their holes. In Four Swords Adventures, they are found in the Desert of Doubt and will drag the heroes into quicksand. See also Moldorm.

▷ Dexihand

Majora's Mask

Majora's Mask 3D

A blue hand on a frail, unnaturally long wrist that reaches out at Link in watery areas like the Great Bay Temple. If one gets hold of Link, it will toss him around. They won't do any damage, but that doesn't make them any less scary.

Dexivine

The Wind Waker

The Wind Waker HD

These spindly blue vines appear in areas with lots of plants like the Forbidden Woods or the Wind Temple. They squirm up from the ground and grab at the necks of intruders. Getting caught by a Dexivine won't cause any damage, but it will slowly drain Link's magic meter. Dexivines grow back quickly, even if cut down with a sword.

Dharkstare

A Link Between Worlds

This eerie ball of ink-black tentacles with a single eye serves as boss for the Ice Ruins of *A Link Between Worlds*. It protects itself by encasing its body in ice, and attacks by shooting icy projectiles in three directions. The projectiles form the points of a triangle and freeze whatever is caught inside. See also Frostare, Kholdstare.

Diababa

Twilight Princess · Twilight Princess HD

The Twilit Parasite Diababa is the boss of the Forest Temple, deep within Faron Woods. Once just another plant growing in the temple, it was transformed into a monstrous, multi-headed Baba by the dark power of a Fused Shadow. See also Deku Baba.

Digdogger

The Legend of Zelda · Oracle of Seasons

A giant sea urchin that shoots beams of energy. It splits into smaller creatures and serves as the boss of the Level 5 dungeon in *The Legend of Zelda*. It is so big that its body will collapse if it gets hit with a shock wave. A Digdogger also appears in *Oracle of Seasons* as the boss of Unicorn's Cave. See also Mini Digdogger.

Dinolfos

See Dynalfos.

Dodongo
● Dodongo Snake

The Legend of Zelda · Link's Awakening DX · Ocarina of Time · Ocarina of Time 3D

 (Four Swords Adventures)
Majora's Mask · Majora's Mask 3D · Oracle of Seasons · Four Swords Adventures

Twilight Princess · Twilight Princess HD

These stubborn lizards that resemble small dragons without wings have notoriously tough skin. Few attacks can hurt them, and Link's best strategy is to trick them into eating a bomb or three. They are typically smaller in stature, but have been known to grow to substantial sizes, such as the one serving as the boss of the Level 2 dungeon in *The Legend of Zelda*. See also Baby Dodongo, Big Dodongo, King Dodongo, Kodongo.

Dongorongo

Phantom Hourglass

The Armored Lizard Dongorongo awaits Link on the third floor of Goron Temple on Goron Island. It attacks by charging Link and breathing fire. At the start, Link tag-teams the fight with Gongoron. Dongorongo's skin is impossible to break, and the only way to hurt it is to toss a bomb into its mouth when it inhales deeply, then strike its back when it falls over. See also Dodongo.

Doomknocker

These bull-bodied warriors serve as armor-clad guardians of Hyrulean palaces in *The Adventure of Link*. They command the Parutamu and wield spiked clubs, jumping and throwing their weapons at Link when he steps beyond their reach. Their attacks cannot be blocked with a shield, making that much more difficult to fight. See also Parutamu.

The Adventure of Link

Dragonfly

Majora's Mask

Majora's Mask 3D

Giant dragonflies that live in the Southern Swamp and Stone Tower Temple of *Majora's Mask*. They hover in midair and fire electricity charged in their tails.

Dreadfuse

See LD-003D Dreadfuse.

Dynalfos
● Dinolfos

Ocarina of Time · Ocarina of Time 3D · Majora's Mask · Majora's Mask 3D

Twilight Princess · Twilight Princess HD

A highly intelligent lizard warrior. They are masters of swords and axes and can nimbly block attacks with their shields. Some even breathe fire. In *Twilight Princess*, they are smart enough to feint, breaking the hero's defense, and will counter many attacks. See also Lizalfos.

E COLUMN

Earth Guardian

Skyward Sword

Tasked by the goddesses, these armored soldiers appear in the Silent Realm carrying large, heavy blades. If Link is spotted by a Watcher or touches Waking Water, these Guardians will come alive and pursue him. Being attacked by one causes Link to fail his trial, forcing him to try again. See also Sky Guardian.

Earth Watcher

Skyward Sword

These Watchers appear in the Silent Realm, tasked by the goddesses to watch over the trial grounds. They float just above the ground, observing the area with the light in their hands. They will ring their bell and pursue any intruders they discover, as well as summon Guardians. See also Sky Watcher.

Eeno

Majora's Mask · Majora's Mask 3D

Appearing in the northern snowy sections of Termina Field and in the halls of Snowhead Temple, these snowball-like monsters have faces that resemble Gorons. They will throw snowballs if approached and are weak to fire. They come in various sizes: larger Eenos will split into smaller ones when attacked.

Electric Blob King

Tri Force Heroes

The king of the Buzz Blobs, this mighty, quivering mass of electric jelly does battle with the heroes of Hytopia in the Woodlands. It is a miniboss of the area, encountered at the end of Buzz Blob Cave. Many times the size of an ordinary Buzz Blob, it wears a crown—and not only is it covered in electricity, but it also fires bolts of it in four directions. See also Buzz Blob.

Electric Blob Queen

Tri Force Heroes

The queen of the Buzz Blobs, this electric, gelatinous royal appears in the Riverside area as a miniboss. The heroes fight her at the end of the Abyss of Agony. The Electric Blob Queen fittingly wears a crown atop her pink head and lives in water, submerging herself for a time after taking damage.

Electro Spume

Skyward Sword

A round, frog-like monster that hides in the sand of desert regions. It will show its face when it senses an enemy, firing orbs of electricity in their direction. While the orbs are quite slow, they will sometimes fire three at a time. See also Cursed Spume.

Eox

Phantom Hourglass

The Ancient Stone Soldier Eox appears in Mutoh's Temple. His weak point is his head. See also Mazaal.

Ergtorok

Spirit Tracks

A subspecies of Octorok found in the desert. It pops up from beneath the sand and spits iron balls instead of seeds or stones. See also page 104, Octorok.

Evil Eagle

Link's Awakening DX

This giant eagle is the boss of Eagle's Tower. The Grim Creeper, a monster that appears as the miniboss in the same dungeon, leaps onto its back and attacks Link from the top floor of the tower. It attacks from the left and right, flapping its wings and shooting feathers while creating powerful gusts, trying to blow Link off the tower. See also Grim Creeper.

Evil Orb

Link's Awakening DX

This boss appears in the Color Dungeon only in *Link's Awakening DX*. Its crystalline head changes color as it takes damage, and, similar to a Hardhat Beetle, it can repel enemies that attack it. It fires projectiles, and when its head turns red to indicate danger, it will summon Stalfos to attack. See also Orb Monster.

Eye Plant

Phantom Hourglass

A one-eyed monster that appears out at sea. It looks like a plant sticking out of the water and will fire projectiles at ships passing by. It takes two successful hits with the cannon to defeat one.

Eye Slug

Phantom Hourglass

These long, one-eyed slugs have sharp fangs and call the Goron Temple home. They appear in groups and will pursue their prey if spotted, but they also have little health and can be defeated with a single swing of the sword.

Eyeball Monster

Phantom Hourglass

A creepy monster that resembles a disembodied spirit with horns, most often found fluttering above the southeastern ocean waters of *Phantom Hourglass*. They will bombard Link's ship until shot down with cannon fire.

Eyeball Monster (PINK)

Phantom Hourglass

A creepy monster that resembles a disembodied spirit with horns. They form small groups and mainly fly above ocean waters to the southeast. They will try to ram Link's ship if approached and can be taken down with the cannon. Beyond their pink coloring, they are identical to other Eyeball Monsters found in *Phantom Hourglass*.

Eyegore

Majora's Mask · Majora's Mask 3D · Four Swords · Four Swords Adventures

The Minish Cap

A stone statue with a single eye possessed by a demonic spirit. Normally, its eye is closed and it stands immobile, invulnerable to any attacks. Should Link draw near, the Eyegore's eye will open and the possessed statue will stomp toward him. Link must target the opened eye with arrows in order to do any damage. Depending on the title, an Eyegore may always keep their eye open. But regardless, it will only move when Link draws near or fires an arrow.

Eyegore (BLUE)

A Link Between Worlds

A one-eyed stone statue with a blue body. Like standard Eyegores, blue variants are weak to arrows in the eye, cannot be harmed if their eye is closed, and will attack if Link draws near. They have more health than Green Eyegores and less than red ones. Unlike the others, blue Eyegores do not appear in *A Link to the Past*.

Eyegore (GREEN)

A Link to the Past · A Link Between Worlds

A one-eyed stone statue with a green body. Like other variants, a green Eyegore will keep its eye closed until Link approaches, then spot Link and attack. An Eyegore cannot be hurt when its eye is closed, but it is weak to arrows aimed at an opened eye.

Eyegore (RED)

A Link to the Past · A Link Between Worlds

A one-eyed stone statue with a red body. Like standard Eyegores, it is invincible when its eye is closed. When Link approaches, it opens its eye wide and stomps toward him. Among Eyegores, red variants have the most health.

Eyeroc

Four Swords Adventures

An eyeball with wings. In *Four Swords Adventures*, they always appear in a group of four and will vanish offscreen after a short period of time. Unless the party forms up and attacks in unison, it is impossible to defeat these monsters. Defeating the lot of them yields a large Force Gem.

Eyesoar
● Patra

The Legend of Zelda · Oracle of Seasons

A single, monstrous eye with wings, orbited by smaller Eyesoars and serving as a dungeon boss in both *The Legend of Zelda* and *Oracle of Seasons*. The Switch Hook is an effective way to take them on in the latter game. See also Chasupa.

F COLUMN

Facade

Link's Awakening DX · Oracle of Seasons

A monstrous face that appears on the floor. In *Link's Awakening*, it is the boss of the Face Shrine. It is a talkative creature that will slip clues on how to defeat it, while throwing tiles at Link that it rips from the floor. In *Oracle of Seasons*, Facade appears as a miniboss in the Snake's Remains dungeon, and will rain down both monsters and fire from above.

Fiery Moa

The Adventure of Link

A cautious, single-eyed spirit that will draw near (but not too near) if someone approaches. They appear in palaces, gently floating back and forth, dropping flames before fleeing. See also Moa.

Fire Baba

Spirit Tracks

A voracious plant monster. They spit fire from a giant mouth full of fangs and will swallow anything that gets within range, including bombs. See also Deku Baba.

Fire Bago-Bago

The Adventure of Link

A Bago-Bago found in the fiery pools of the Great Palace. They are carnivorous, skeletal fish that leap through the air while shooting fireballs. Bago-Bago form groups to attack their prey. Like their less fiery cousins, the meat these undead fish consume falls through their bones, so their appetites are never sated. See also Bago-Bago.

Fire Bubble

Twilight Princess · Twilight Princess HD

A type of Bubble covered in flames. They fly at Link to attack. If slashed, Fire Bubbles will lose their wings, fall to the ground, and start bouncing around. See also page 103, Bubble.

Fire Gimos

A Link Between Worlds

Fire Gimos are stone statues possessed by demons and covered in molten lava. Found in areas of extreme heat like Turtle Rock, they will come alive and hop toward Link if he gets too close. Their fiery state means Link will take damage if he so much as touches one. Before Link can strike at a Fire Gimos directly, he must first freeze the flames using the Ice Rod or hit it from afar with a Sword Beam. See also Gimos.

Fire Keeleon

Tri Force Heroes

A subspecies of the water-dwelling Keeleons found in hot areas like volcanoes and deserts. They float through the air while glowing red, scattering fireballs when they open their flower-like mouths. They are often high up, requiring the heroes to use platforms or form a totem in order to reach them. See also Keeleon.

Fire Keese

Ocarina of Time · Ocarina of Time 3D · Majora's Mask · Majora's Mask 3D

Oracle series · The Wind Waker · The Wind Waker HD · Twilight Princess

Twilight Princess HD · Phantom Hourglass · Spirit Tracks · Skyward Sword

Tri Force Heroes

Keese covered in flames. There are two types: Keese in flames the moment Link encounters them, and Keese that are ignited after flying through a torch or another fire source. Like regular Keese, they swoop in to attack Link. Unlike regular Keese, getting hit by Fire Keese will burn and even spread the flames, dealing more damage. They can be blocked with shields or frozen with certain items, depending on the game. See also Keese.

Fire Toadpoli

Twilight Princess · Twilight Princess HD

An amphibious monster that lives in magma, poking their heads above the surface to fire projectiles at anyone who comes near. They will not leave the safety of the magma, so Link must find a way to hit them from afar. See also Toadpoli.

Fire Wizzrobe

The Wind Waker · The Wind Waker HD · Four Swords · The Minish Cap

A Link Between Worlds

This variety of Wizzrobe specializes in fire magic. They shoot flames at Link while teleporting to avoid being hit. When a Fire Wizzrobe's magic hits Link, it sets him on fire in addition to dealing damage. While it is possible to hit them with a sword, it can be difficult to get close enough. Projectile weapons like the bow are more effective. See also Wizzrobe.

Flamola

A Link Between Worlds

Insect-like monsters with large jaws and a body made of connected, burning segments. They live in magma, swimming through it and popping out to attack Link. They are too hot to touch, so Link must first find a way to freeze one before he can strike it with his sword. See also Swamola.

Flare Dancer

Ocarina of Time · Ocarina of Time 3D

This monster wears clothing made of flame and serves as miniboss of the Fire Temple in *Ocarina of Time*. They appear from within the flames and spin around like they're dancing, attacking with fire. Tearing off its fiery protection reveals a small core, which will run around on the floor. The color of their flames will change from red to blue to green.

Flat the Younger

Ocarina of Time · Ocarina of Time 3D

The younger of a pair of ghostly brothers. Flat was a composer for the royal family of Hyrule researching the Sun's Song with his brother Sharp while alive. When Ganondorf threatened to steal the results of their research, they gave up their lives in order to protect it. He appears as a character rather than an enemy in the Ikana Graveyard in *Majora's Mask*. See also Sharp the Elder.

Floormaster

 ...

Ocarina of Time · Ocarina of Time 3D · Majora's Mask · Majora's Mask 3D

Oracle series · The Wind Waker · The Wind Waker HD · Four Swords Adventures

The Minish Cap

A giant hand that crawls along the floors of dungeons. Many resemble Wallmasters and will return Link to the dungeon entrance if they manage to grab him. Others behave quite differently, splitting into three when struck in *Ocarina of Time* or throwing nearby vases and skulls in *The Wind Waker*. See also Wallmaster.

Flying Fish

Phantom Hourglass

Hostile, downright angry fish that stalk the sea, leaping out of the water to attack any ships that get in their personal sea space. When they are above the water, they're slow to move, and a single blast from the cannon is all Link needs to stop their assault.

▷ **Fokka** (BLUE)

The Adventure of Link

Powerful soldiers bred from birds by the king of Hyrule to guard the Great Palace. They excel at swordsmanship and are skilled with a shield. They can jump high and fire both low and high beams by swinging their swords. Blue Fokka have more health than their red counterparts.

▷ **Fokka** (RED)

The Adventure of Link

Powerful soldiers bred from birds by the king of Hyrule to guard the Great Palace. They excel at swordsmanship and are skilled with a shield. They can jump high and fire both low and high beams by swinging their swords. Some appear from within stone statues.

▷ **Fokkeru**

The Adventure of Link

A bird soldier born from flame to guard the Great Palace. Its body is sheathed in fire, and it shoots fireballs from its mouth that will continue to travel toward their target even after they hit the ground.

▷ **Force Like**

Four Swords Adventures

A type of Like Like that hides in the ground, luring its prey by dangling a fake Force Gem at the end of a tentacle. When Link grabs at the Force Gem, the Like Like will leap out and steal actual Force Gems from his inventory. As with other Like Likes, they take a lot to defeat. See also Like Like.

▷ **Force Soldier**

Four Swords Adventures

A monster shaped exactly like a Force Gem. Like other enemy soldiers, they carry a sword and shield, and have similar attack patterns. They drop 100 Force Gems when defeated, but will self-destruct and only leave one gem if not defeated within a set amount of time.

▷ **Fraaz**

Spirit Tracks

The Master of Icy Fire, Fraaz is a demonic magician who wields both fire and ice magic and serves as the boss of the Snow Temple. He is exceedingly intelligent and attacks with powerful magic when his body is covered in flames or ice. After taking enough damage, he will split into two smaller versions of himself, one with fire magic and one with ice, each known as Fraaz Jr. See also Blaaz.

▷ **Fraaz Jr.**

Spirit Tracks

One of two elemental bodies of Fraaz after he splits while battling Link in the Snow Temple. Link must use the opposing power from one to defeat the other. Fraaz will return to life if only one is defeated.

▷ **Freezard**

Ocarina of Time

Ocarina of Time 3D

Majora's Mask

Majora's Mask 3D

Twilight Princess

Twilight Princess HD

Spirit Tracks

Tri Force Heroes

A monstrous ice sculpture with icy breath that freezes on contact. The Freezards that appear in *Twilight Princess* resemble dragon heads and split into Mini Freezards when hit with the Ball and Chain. In *Spirit Tracks*, they are Octoroks covered in ice. See also page 104, Mini Freezard, Octorok.

▷ **Freezlord**

Tri Force Heroes

A miniboss in the Ice Cavern that appears at the end of the Snowball Ravine. This giant ice clump rotates at the center of the battlefield while breathing ice. It begins to move around the field during the latter half of the fight, stomping the ground repeatedly and using its breath to slide around trying to hit the heroes.

▷ **Freezor**

A Link to the Past

A Link Between Worlds

A living ice carving embedded in a wall. Approaching one will cause it to leap out and chase Link. Swords do not work on them, but they are weak to fire.

▷ **Froak**

Skyward Sword

Froaks resemble pufferfish. Though they are mainly found near bodies of water, they float in the air instead of swimming. They are timid creatures covered in spines that will stick out when approached. Hitting a Froak with a sword will send it flying; it will explode the instant it hits something.

▷ **Frostare**

Four Swords Adventures

The boss of the Tower of Winds. This monster resembles a flower, with a single, giant eye. It guards the seal on Princess Zelda on the top floor of the tower, hanging from the ceiling and protecting itself by unleashing minions called Frosteyes. After its root is severed, the Frostare uses its ice petals like wings to fly around while launching ice at Link. See also Dharkstare.

▷ **Frosteye**

Four Swords Adventures

Minions of Frostare, boss of the Tower of Winds. They fly in a circle, then pour out a wave of cold. If hit by the cold, Link will freeze and be unable to move for a short period of time.

▷ **Frypolar**

Oracle of Seasons

A flaming miniboss that appears in *Oracle of Seasons* in the Sword and Shield dungeon. It has two distinct personalities: one fiery, the other ice cold, and will switch between them when hit with a Mystery Seed.

▷ **Furnix**

Skyward Sword

This monstrous but beautiful bird is a vivid red, with four wings and a long tail. Known to eat flames to sustain itself, a Furnix is exceptionally dangerous, flying through the air shooting fireballs at anything it deems a threat. The end of its tail is shaped like a ring and can be latched onto with the Whip.

▷ **Fyrus**

Twilight Princess

Twilight Princess HD

The Twilit Igniter, Fyrus is a grotesque being that was sealed deep in the Goron Mines by their elders. This boss is actually the Goron patriarch, Darbus, who was transformed by the dark magic of a Fused Shadow when he came into contact with it.

G COLUMN

▷ Ganon

The Legend of Zelda

A Link to the Past

Ocarina of Time

Ocarina of Time 3D

Oracle series

Four Swords Adventures

Twilight Princess

Twilight Princess HD

Ganon is a monstrous embodiment of evil. Ganon is typically the final boss of the final dungeon in the titles in which he appears. He frequently wields a trident and may take several forms. In some titles, a battle with Ganondorf intensifies after the Gerudo King transforms into Ganon. In *Twilight Princess*, he appears as Dark Beast Ganon. Ganon also appears in the *Oracle* series when *Oracle of Ages* and *Oracle of Seasons* are linked. See also page 20, Phantom Ganon, Puppet Ganon.

▷ Ganon (SPIRIT)

Twilight Princess

Twilight Princess HD

Ganon's powerful malice takes this form when he is plunged into the Twilight Realm. He uses the dejected Zant, who was unable to become king, by granting him dark power and manipulating him in secret. He succeeds in resurrecting his body in Hyrule Castle. See also page 20.

▷ Ganon's Puppet: Zelda

Twilight Princess

Twilight Princess HD

Following his revival and seizure of Hyrule Castle, Ganon magically takes control of Princess Zelda's body. Dark symbols cover her as she flies at great speed through the air, charging Link with magic and sword attacks and firing balls of light.

▷ Ganondorf

Ocarina of Time

Ocarina of Time 3D

The Wind Waker

The Wind Waker HD

Twilight Princess

Twilight Princess HD

Ganondorf has gone by many titles over the eras. In *Ocarina of Time*, he appears as the King of Evil. In *Twilight Princess* he is called a Dark Lord. In both titles, he transforms into the monstrous, pig-like monster, Ganon. In *The Wind Waker*, Ganondorf never takes this beastly form, fighting a final battle with Link as a Gerudo who nonetheless wields incredible power. See also page 20.

▷ Garo

Majora's Mask

Majora's Mask 3D

Also known as Garo Robes, Garo are spirits of ninjas that were sent to spy on Ikana Kingdom by an enemy nation. Wearing the Garo Mask in the Ikana Canyon when Tatl senses a "thirst for blood" causes these robed, blade-wielding enemies to appear. In death, they fulfill their duty: passing along information about the kingdom and region to Link before disappearing.

▷ Garo Master

A miniboss in Stone Tower Temple that oversees the Garo ninjas that were spying on the Ikana Kingdom. They will leave a good distance between themselves and Link before dashing forward to attack.

Majora's Mask

Majora's Mask 3D

▷ Gekko

Majora's Mask

Majora's Mask 3D

A grinning lizard that walks on two legs. They are found in temples, often in command of other creatures. One rides a Mad Jelly in the Great Bay Temple, while another fights with a Snapper in Woodfall Temple. See also Mad Jelly, Snapper (Mount).

▷ Gel

The Legend of Zelda

Oracle of Seasons

Four Swords

Phantom Hourglass

Small, gelatinous monsters that jump around inside dungeons. In *The Legend of Zelda*, slicing a Zol with a weak sword will split it into two Gels. In *Phantom Hourglass*, Gels will divide and surround the player. They also appear in *Oracle of Seasons* and *Four Swords* with similar properties. See also Color-Changing Gel, Zol.

▷ Geldarm

The Adventure of Link

Long, centipede-like monsters that live in the desert. Despite their size, they are relatively calm creatures, content to eat bugs that draw near. Attacking one will cause it to retract into the sand, making it possible to aim for its head, a weak point. Its entire body is poisonous; touching any part will hurt Link.

▷ Geldman

A Link to the Past

Four Swords Adventures

A Link Between Worlds

A Geldman is a sand monster that will spring up from the desert dunes without warning and chase Link for a short time. In *A Link Between Worlds*, Link can embarrass a Geldman by using the Sand Rod to blast it out of the sand.

▷ Gemesaur King

A Link Between Worlds

A dragon, resembling the Helmasaur King in *A Link to the Past*, that is covered in colorful scales and jewels and serves as the boss of the Dark Palace. It has eyes that can see in the darkness, and attacks its prey by charging at high speeds. There are rupees embedded in the Gemesaur King's scales and defeating it causes them to scatter everywhere. See also Helmasaur King.

▷ Genie

Link's Awakening DX

The boss of Bottle Grotto, this clown-faced Genie lives in a bottle that it finds ample use for in battle with Link. When it emerges from the bottle, the Genie breathes fire. When inside, it will leap around the room attempting to slam into Link. It is invincible when inside its bottle. Link must pick the bottle up and smash it into the walls to inflict damage.

▷ Geozard

Phantom Hourglass

Spirit Tracks

These hulking fish men wield both swords and shields, making for a tricky fight. They are quick to block direct attacks, but are vulnerable if flanked. Link can use his Boomerang to target their back, stunning them before moving in to attack.

▷ Geozard Chief

Spirit Tracks

Geozard Chiefs are especially strong Geozards that patrol some floors of the Tower of Spirits. Like other Geozards, they fight with a sword and shield. But chiefs also shoot fire from their mouths. Link can pull away their shields using the Whip.

Geru (Blue)

The Adventure of Link

Summoned from the demon realm, these lizard-like monsters are intelligent and crafty. They carry maces and shields, and will throw their maces from a distance. Their attacks cannot be blocked. Link requires the Reflect Spell to fight them. Geru heads are hard like rocks, rendering the often dependable Downthrust ineffective against them.

Geru (Red)

The Adventure of Link

Summoned from the demon realm, these lizard-like monsters are intelligent and crafty. They carry maces and shields, and will approach Link with maces swinging. Their attacks cannot be blocked. Link requires the Reflect Spell to fight them. Geru heads are hard like rocks, rendering the often dependable Downthrust ineffective against them.

Geru (Yellow)

The Adventure of Link

Summoned from the demon realm, these lizard-like monsters are intelligent and crafty. They carry spears and shields, and can attack both high and low. Link can block their spears with his shield. Geru heads are hard like rocks, rendering the often dependable Downthrust ineffective against them.

Gerudo Guard

Ocarina of Time | Ocarina of Time 3D | Majora's Mask | Majora's Mask 3D

These talented Gerudo fighters are ceaselessly on patrol. Link encounters them when he infiltrates Gerudo Fortress in *Ocarina of Time* and the Pirates' Fortress in *Majora's Mask*. If they catch Link, he will be forcibly removed from the fortress in question. He must avoid them outright or stun them with arrows to slip by. In *Majora's Mask*, Link can move through the fortress unseen if he dons the Stone Mask.

Gerudo Pirate

Majora's Mask | Majora's Mask 3D

Dual-scimitar-wielding swordswomen who guard the Pirates' Fortress in *Majora's Mask*. They stand in the way of Link's path to Zora Eggs stashed deeper in the fortress. If Link is hit with their spinning attack, he will immediately be thrown out of the fortress. Unlike Gerudo Guards, these pirates will see right through Link's Stone Mask.

Gerudo Thief

Ocarina of Time | Ocarina of Time 3D

Swift-moving Gerudo Thieves will attack Link inside the Gerudo Fortress. They wield two large, curved blades. Their spinning jump attack is especially powerful. Link will be caught and thrown out of the fortress if it connects.

Gerune

Spirit Tracks

These monsters are made entirely of sand and hide in the Sand Temple. Traditional attacks from swords and bows pass right through them until Link uses the Sand Rod to make them solid. In this state, Gerunes can also be used as weighted blocks.

Ghini
● Light Ghini

The Legend of Zelda | Link's Awakening DX | Oracle series | Four Swords

Four Swords Adventures | The Minish Cap | A Link Between Worlds | Tri Force Heroes

A Ghini is a semitransparent, one-eyed ghost that lives in spookier places like crypts and graveyards. Some appear when Link disturbs or moves a grave. Sometimes defeating one Ghini in a group will scare off the rest. In *A Link Between Worlds*, Light Ghini haunt the Dark Palace and are only visible when exposed to light. In *The Minish Cap*, Ghini will grab Link and give him a lick. The Gust Jar is particularly useful in preventing this from happening. See also Dark Ghini, Giant Ghini, Poe.

Ghirahim

Skyward Sword (1) | Skyward Sword (2) | Skyward Sword (3)

A self-proclaimed Demon Lord, Ghirahim doggedly pursues Zelda at the behest of his king, Demise. Link encounters Ghirahim three times: first in Skyview Temple (1), then in the Fire Sanctuary (2), and finally in the Sealed Grounds after traveling to the past (3). Ghirahim appears gentlemanly at first glance, but with each fight, he releases more magical power, revealing his true nature. A skilled swordsman, Ghirahim is able to block swords with his bare hands. In the final battle, Ghirahim shows his true form as Demise's sword. See also page 99, Demise.

Ghost
● They / ▲ Them

Majora's Mask | Majora's Mask 3D

Ghosts, also known as "They" and "Them," attack Romani Ranch with mysterious balls of light around 2:30 a.m. on Link's first night in Termina. They emit searchlight-like beams from their eyes and move toward the barn in groups, vanishing with the dawn. If Link cannot defeat them all, they kidnap Romani and the cows.

Ghoul Rat

Twilight Princess | Twilight Princess HD

An undead rat monster that prefers dark places and attacks in groups. They remain invisible unless Link uses his wolf senses. Unlike when they were alive, touching one does no damage, but they will slow Link's movement if they swarm him. See also Rat.

Giant Beamos

Ocarina of Time | Ocarina of Time 3D

Gigantic Beamos that appear in select locations in *Ocarina of Time*, like the Shadow and Spirit Temples. Despite their size, they attack much like regular Beamos, firing a beam of energy from their single eye when they spot an intruder. See also Beamos.

Giant Bee

Majora's Mask | Majora's Mask 3D

Rare, massive bees that swarm and attack Link after their hives have been destroyed. See also page 66, Bee.

▷ Giant Bubble

The Adventure of Link

Link's Awakening DX

When Bubbles fuse together, they form a fearsome Giant Bubble. They mainly appear in the Great Palace in *The Adventure of Link*. Slow and easy to spot, they are nonetheless challenging, as they can absorb magic. Attacking one will split it into two Bubbles. A Giant Bubble also appears in an underground passageway, the Face Shrine, in *Link's Awakening*. Unlike the ones found in *The Adventure of Link*, it cannot be defeated. See also page 103, Bubble.

▷ Giant Buzz Blob

Link's Awakening DX

A giant Buzz Blob miniboss added with the Color Dungeon in *Link's Awakening DX*. It fires bolts of electricity in four directions. Sword attacks will not work on it until Link weakens it with Magic Powder. See also Buzz Blob.

▷ Giant Eye Plant

Phantom Hourglass

This boss emerges from the sea after Link, Sun Key in hand, travels to Molida Island in search of the Temple of Courage. Link can defeat the towering plant monster by shooting its giant eye with the cannon. Every time cannon fire makes contact, it will fire three projectiles in retaliation.

▷ Giant Ghini

Link's Awakening DX

Oracle of Ages

Four Swords Adventures

Lumpy, somewhat expressive ghosts that haunt graveyards much like regular Ghini. They are also sometimes found in dungeons. In *Oracle of Ages*, a Giant Ghini serves as a miniboss. It will summon smaller Ghini and possess Link, slowing his movements and preventing him from swinging his sword. In *Four Swords Adventures*, Link must light the torches that surround Dampe's house to stop them from swarming him. See also Ghini.

▷ Giant Goponga Flower

Link's Awakening DX

A massive Goponga Flower that blocks Link's path through Goponga Swamp. Attacks from the base-level sword do nothing, but a Level 2 sword can cut the flower down. If led into the swamp, the Chain Chomp BowWow will swallow it in one gulp. See also Goponga Flower.

▷ Gibdo
● Gibdo (Blue)

The Legend of Zelda

A Link to the Past

Link's Awakening DX

Ocarina of Time

Ocarina of Time 3D

Majora's Mask

Majora's Mask 3D

Oracle series

Four Swords

Four Swords Adventures

The Minish Cap

Twilight Princess

Twilight Princess HD

A Link Between Worlds

Tri Force Heroes

Mummified monsters that appear in dungeons. They tend to be hardy foes, high in both health and attack power, but all those bandages mean a weakness to fire. Some will stare at their opponents as they draw near, freezing their prey in place and leaving them vulnerable to attack. Burning away the bandages of a Gibdo reveals the creature inside, usually a ReDead or Stalfos, depending on the title. See also ReDead, Stalfos.

▷ Gibdo (Yellow)

Four Swords Adventures

A mummy wrapped in yellowish bandages. Their attacks and weakness to fire are the same as a blue Gibdo's, but they are resurrected in the Dark World as Stalfos when defeated.

▷ Gibo

A Link to the Past

A Link Between Worlds

These floating, star-shaped jellies appear in Thieves' Town and Turtle Rock. A monster unlike any other found in Hyrule and beyond, Gibos are made from a red, gelatinous membrane protecting a darker core. This core is their weak point, and Link must cut through the membrane to damage it.

▷ Gigabari (Purple)

A Link Between Worlds

A gigantic Bari, several times the size of a normal one. This purple variant acts as a miniboss guarding a piece of the seal on the throne room in Lorule Castle. Like the yellow Gigabari, it will protect itself with a temporary shield of electricity and split into multiple Bari when defeated. See also Bari.

▷ Gigabari (Yellow)

A Link Between Worlds

A gigantic Bari, several times the size of a normal one. They electrify themselves for a short time and attacking them during this period will paralyze Link as well as hurt him. Long-range attacks are a safe alternative to getting zapped. A defeated Gigabari will split into multiple Bari.

▷ Gigaleon

Tri Force Heroes

This flower-like boss monster attacks by launching projectiles. It is big enough to stand on. Despite its size, Gigaleon can fly freely through the air. Even if knocked down, it will spray fireballs that rain down on the battlefield and burn for a time. A spot on its backside is its weakest point.

▷ **Gimos**

A Link Between Worlds

A stone statue with a demon's soul trapped inside. If Link gets too close, its glowing red eyes will open and it will start to move toward him looking for a fight. A Gimos is generally invincible when standing still. A number appear in the dungeons of Lorule. See also Big Ice Gimos, Fire Gimos, Ice Gimos.

▷ **Girubokku**

The Adventure of Link

A horrific, floating eyeball. They will appear in groups and attempt to surround Link. Encountering one can freeze a person with fear. Link must wait for a Girubokku's eye to open before striking in order to do any damage.

▷ **Gleeok**

The Legend of Zelda (1)

The Legend of Zelda (2)

The Legend of Zelda (3)

Oracle of Seasons

Phantom Hourglass

A multiheaded dragon that serves as a boss for three dungeons in *The Legend of Zelda*. In its first appearance in Level 4, the Gleeok has two heads (1). The miniboss Gleeok of Level 6 has three heads (2), while Level 8's Gleeok has four heads (3). Once severed, its heads will fly around the room. Two-headed Gleeoks also appear as bosses in *Oracle of Seasons* and *Phantom Hourglass*, in the Explorer's Crypt and Temple of Ice, respectively. In *Oracle of Seasons*, cutting off its heads turns it into a skeleton that continues to attack, while the Gleeok of *Phantom Hourglass* breathes both fire and ice, even going so far as to cause tidal waves to thwart Link.

▷ **Gleeok Head**

See Gleeok.

▷ **Gleerok**

The Minish Cap

This long-necked dragon boss waits at the end of the Cave of Flames, where it guards the Fire Element. Living in magma, it can attack using fireballs and powerful fire breath. The weak point on its back is protected by a shell of hardened magma. Hitting the shell with the magic from the Cane of Pacci will flip it over, exposing the Gleerok to attacks.

▷ **Gohdan**

The Wind Waker

The Wind Waker HD

A boss made from stone that sleeps at the top of the Tower of Spirits, waiting to test the chosen hero's strength. Gohdan stands in the way of the tower's final trial, and he will guide the hero who overcomes it to a bell that opens the way to the ancient kingdom.

▷ **Gohma**

● Gohma (Red)

The Legend of Zelda

Link's Awakening DX

Ocarina of Time

Ocarina of Time 3D

Oracle of Seasons

The Wind Waker

The Wind Waker HD

Four Swords Adventures

A Gohma is a crustaceous monster with a single eye that appears as a dungeon boss across multiple eras. Its shell is typically impenetrable, requiring Link to focus his attacks on its large, vulnerable eye. A Gohma serves as boss for the Level 6 dungeon in *The Legend of Zelda*, the Dancing Dragon Dungeon in *Oracle of Seasons*, and Dragon Roost Cavern in *The Wind Waker*. In the latter game, it torments the Spirit of the Sky, Valoo, by grabbing at the dragon's tail, causing him to go berserk. A Gohma also appears inside the Great Deku Tree in *Ocarina of Time*; dubbed a Parasitic Armored Arachnid, it proves to be the root of the sacred tree's curse. See also Armogohma, Baby Gohma, Gohma Egg, Young Gohma.

▷ **Gohma (Blue)**

The Legend of Zelda

A Gohma with particularly high health that fires energy beams. Their carapaces are so hard that no attack will penetrate them. Link must instead aim for their single, open eye with arrows. Blue Gohmas have more health than the red variety also found in *The Legend of Zelda*, requiring three hits with arrows to be defeated.

▷ **Gohma Egg**

Ocarina of Time

Ocarina of Time 3D

Twilight Princess

Twilight Princess HD

Giant eggs that a Gohma has laid in a dungeon. They can be destroyed before they hatch if Link targets them in time.

▷ **Gohma Larva**

See Young Gohma.

▷ **Goht**

Majora's Mask

Majora's Mask 3D

This masked, mechanical beast is the boss of Snowhead Temple. A mechanized monster, it charges around its circular chamber, kicking up rocks and firing lightning at Link. After Link lands a number of hits, it will start throwing bombs, shaking stalactites from the ceiling that fall to the temple floor.

▷ **Gold Skulltula**

See Skulltula.

▷ **Gomess**

Majora's Mask

Majora's Mask 3D

A miniboss that appears in the Stone Tower Temple. Several Keese surround its jet-black body, shielding it from attacks. It carries a giant scythe, swinging and throwing it to attack. Its glowing core is its weak point and can be exposed by driving off the Keese with a Light Arrow. See also Keese.

▷ **Gooma**

The Adventure of Link

Guardian of the Palace on the Sea in *The Adventure of Link*, Gooma is a hulking opponent in a horned helmet. He swings a spiked ball on the end of a long chain, protecting his vulnerable upper body from sword swings. Gooma replaces Jermafenser, who was boss of both Midoro Palace and the Palace on the Sea in the Famicom version of *The Adventure of Link*.

▷ **Goomba**

Link's Awakening DX

A guest character from the *Super Mario Bros.* series. Goombas are grinning little creatures with stubby legs that wander some side-scrolling rooms in Koholint dungeons. Link can defeat them by jumping on their heads just like in *Super Mario*.

▷ **Goponga Flower**

Link's Awakening

Oracle series

A large flower monster that hurls fireballs or seeds at Link. In *Link's Awakening*, these flowers block Link's path through Goponga Swamp unless he brings the hungry BowWow along with him. See also Giant Goponga Flower.

Goriya
- Goriya (Red)

The Legend of Zelda

The Adventure of Link

Oracle series

These devilish companions of the Moblins are masters of the boomerang, Goriyas can be found in all manner of locales, from grassy fields to deserts and caves. In *The Legend of Zelda*, a red Goriya blocks the way inside a dungeon and must be given food before Link can continue. In *The Adventure of Link*, a red Goriya can throw three boomerangs at once. See also Brother Goriyas, Moblin.

▷ Goriya (BLUE)

The Legend of Zelda

The Adventure of Link

These devilish companions of the Moblins are especially skilled with a boomerang. Blue Goriyas have higher attack power and take more hits than other Goriyas. In *The Adventure of Link*, they can toss up to four boomerangs at once. Their barrage of boomerangs can be blocked with a shield, but it's still impressive.

▷ Goriya (GREEN)

A Link to the Past

A green devil found in some Dark World and Lorule palaces. Their movements mimic Link's, but unlike their red brethren, they cannot attack and can be defeated with a sword.

▷ Goriya (ORANGE)

The Adventure of Link

These devilish companions of the Moblins are skilled with a boomerang. Orange Goriyas only appear in *The Adventure of Link* and are weaker than red and blue ones. They can throw two boomerangs at once, which Link must avoid or block with his shield.

▷ Goriya (RED)

A Link to the Past

A Link Between Worlds

These puzzling devils appear in Dark World and Lorule palaces. They mimic intruders' movements exactly. And when Link faces them head on, they will shoot projectiles that only a Mirror Shield can block. Link can target them by firing an arrow into empty space and then leading them into its path. Unlike a green Goriya, they cannot be cut down with a sword.

▷ Gouen

Four Swords

This boss of Death Mountain in *Four Swords* is a monster covered in scorching flames. It fires projectiles that match the colors of the four heroes. Gouen may look intimidating at first, but do enough damage for its flames to go out, and a small, weak creature is all that remains.

▷ Great Moblin

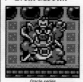
Oracle series

The Moblin that appears in both *Oracle of Ages* and *Oracle of Seasons* wears a crown and reigns over all Moblins building his keep. See also page 101, Moblin.

▷ Grim Creeper

Link's Awakening DX

A skull-faced character encountered midway through Eagle Tower who summons formations of Battle Bats with his flute. He makes the Battle Bats fight for him, keeping out of the fight himself. If Link manages to defeat all of the Grim Creeper's bats, he will retreat while cursing Link. See also Battle Bat, Evil Eagle.

▷ Grim Repoe

Tri Force Heroes

This giant, scythe-wielding miniboss appears at the end of Palace Noir in the Ruins area of *Tri Force Heroes*. It moves through the darkness, invisible and invulnerable, revealing itself only to charge the heroes while spinning its scythe around like a hurricane. As with most ghost-type monsters, it is weak to light. See also Poe.

▷ Grinexx

A Link Between Worlds

This turtle monster carries a gigantic stone shell on its back and serves as the boss of Turtle Rock in *A Link Between Worlds*. Grinexx swims around in magma, which it spews from its back like a volcano trying to incinerate everything around it. Nothing can be done about its shell, but its head is vulnerable to attack.

▷ Guard

Oracle of Ages

These enemy soldiers appear in the past in *Oracle of Ages*, guarding Queen Ambi's palace. They will rush to capture any intruders at an incredible speed.

▷ Guay

Ocarina of Time

Ocarina of Time 3D

Majora's Mask

Majora's Mask 3D

Twilight Princess

Twilight Princess HD

Skyward Sword

Guays resemble crows and live in groups in the trees. They will dive-bomb passersby one after the other. Depending on the title, they may drop rupees if the right conditions are met. In *Skyward Sword*, they just leave droppings. See also Rupee Guay.

▷ Guma

The Adventure of Link

Slow, bull-like warriors who guard palaces and swing massive chain hammers in an upward arc. In order to attack a Guma, Link must position himself inside the chain hammer's trajectory.

▷ Gyorg

Majora's Mask

Majora's Mask 3D

(The Wind Waker)

(The Wind Waker HD)

Phantom Hourglass

The boss of the Great Bay Temple in *Majora's Mask* is the gargantuan masked fish Gyorg. It leaps out of the water to snatch prey with its sharp claws, attempting to swallow its target whole. Once it has taken significant damage, it releases several small fish from its mouth that aid it in battle. In other titles, Gyorgs are more common enemies that swim in the ocean and slam into vessels. See also Malgyorg.

▷ Gyorg Female

The Minish Cap

After reaching the top of the Palace of Winds, Link rides a tornado into the Cloud Tops and does battle with this red stingray monster and its smaller partner, a Gyorg Male. Link hops between the Gyorg pair, targeting the eight eyes on the female's back, which open in specific configurations that Link must match by using foot switches to make clones of himself. She will try everything at her disposal to get Link off her back, even unleashing her green children to swarm him in midair.

▷ Gyorg Male

The Minish Cap

This blue stingray monster patrols the skies over the Palace of Winds alongside its partner, a Gyorg Female. Though much smaller than its mate, the Gyorg Male is still big enough that Link can confidently ride on its back. It can freely open and close its four eyes, waving its tail and launching projectiles to attack anything hopping on and off its back.

▷ Gyorm

A Link Between Worlds Tri Force Heroes

These hermit crab–like monsters protect themselves by donning giant shells. They appear in water-themed dungeons in both *A Link Between Worlds* and *Tri Force Heroes*. If touched, they will retreat into their shells and deflect any attacks, but they can be pulled out with the Hookshot.

H **H COLUMN**

▷ Hardhat Beetle
● Hardhat Beetle (Blue)

A Link to the Past Link's Awakening DX Oracle series Four Swords Adventures

Phantom Hourglass A Link Between Worlds Tri Force Heroes

This monster's head looks like a round helmet, with the rest resembling an octopus or squid. They live in dungeons and move about continuously trying to slam into Link. Their bouncy bodies will throw Link back if struck with a sword, but they will stop moving if hit with a bomb blast. Hardhat Beetles can be struck with the Hammer in *Phantom Hourglass*. They are invincible in *Link's Awakening* and the *Oracle* series.

▷ Hardhat Beetle (RED)

A Link to the Past Oracle of Ages A Link Between Worlds Tri Force Heroes

A red subspecies of Hardhat Beetle. In *Tri Force Heroes*, they are covered in fire. If attacked with a sword, they will retaliate with flames. Like other Hardhat Beetles, attacking it head on will knock the heroes back. Its flames can be blown out with a Gust Jar. While not on fire, Red Hardhat Beetles in *A Link to the Past* and *A Link Between Worlds* move faster and do more damage than the blue variety. A red variety also appears in *Oracle of Ages* when Patch fixes items for Link.

▷ Head Thwomp

Oracle of Ages

This boss appears in the Wing Dungeon in *Oracle of Ages*. It has four faces and unleashes a variety of attacks that correspond to the color of the visible face. It is best to attack when it shows its red face. See also Thwomp.

▷ Heatoise

Spirit Tracks

A massive turtle monster that serves as a miniboss in the Fire Temple of *Spirit Tracks*. When an enemy approaches, it will retract its limbs and charge with the full weight of its stone shell. While invulnerable to attacks inside its shell, the gem on its forehead is a worthy target when exposed. Heatoise is also particularly weak to electricity.

▷ Heedle

A Link Between Worlds

A pair of flaming lizards that stalk the House of Gales in *A Link Between Worlds*. Their body temperature is so high that even hitting them with a sword will hurt Link. They leave a trail of fire as they move around the room and can only be defeated by first extinguishing their flames with a gust of wind.

▷ Helmaroc King

The Wind Waker The Wind Waker HD Four Swords Adventures

A fearsome bird. In *The Wind Waker*, it has been aggressively kidnapping long-eared girls. It sets upon Link his second time venturing into the Forsaken Fortress. In *Four Swords Adventures*, the Helmaroc King does battle with Link from the skies over the Mountain Path on Death Mountain.

▷ Helmasaur
● Hiploop / ▲ Iron Mask

A Link to the Past Link's Awakening DX Majora's Mask Majora's Mask 3D

Oracle series Four Swords The Minish Cap Twilight Princess

Twilight Princess HD A Link Between Worlds Tri Force Heroes

Burly, lizard-like creatures that don heavy masks they use to charge at enemies. Their masks protect their heads from attacks, and Link must flank them to do any damage. In *Twilight Princess*, they leave their masks behind when defeated, which can then be used to solve puzzles. In *Majora's Mask*, the Hiploops of the Woodfall swamp do not wear masks at all.

▷ Helmasaur King

A Link to the Past

A giant monster that wears a mask. In *A Link to the Past*, it is depicted as a hulking beast with a barbed tail and sharp claws. See also Gemesaur King.

▷ Helmasaurus

Twilight Princess Twilight Princess HD

These lumpy lizards found in the City in the Sky protect themselves with hard plates fixed to their front and sides. Similar to Hiploops, their weak point is on their backs. While it's impossible to remove the plates, their size makes them quite slow.

▷ Helmet Chuchu

A Red Chuchu wearing a horned helmet that protects it against sword swings. The helmet can be removed with a whip or bombs, revealing a common Red Chuchu easily dispatched by a blade. See also page 105, Chuchu.

Spirit Tracks

▷ Helmethead
See Jermafenser.

▷ Hikkun

A single-eyed monster covered in a hard, dark shell that it closes tight to protect itself from harm. Handle-like protrusions on either side of the shell allow a Hikkun to be pulled open by two people, revealing elastic insides vulnerable to attack. See also Nokkun.

Four Swords

▷ Hinox

A Link to the Past

Link's Awakening DX

Four Swords Adventures

Phantom Hourglass

A Link Between Worlds

Tri Force Heroes

A one-eyed giant similar to a Cyclops with incredible health. While they most often throw bombs, Hinox have also been known to lift things, toss boulders, and even rush Link. While they have used bombs throughout the series, Hinox themselves are weak to bomb blasts. In *A Link Between Worlds*, some will offer rupees in exchange for sparing them. See also Lil' Hinox, Snowball Hinox, Stone Hinox.

▷ Hinox the Elder

Tri Force Heroes

A miniboss fought in both the Hinox Mine and Bomb Storage levels of *Tri Force Heroes*. He will join the fight after his older brother, Hinox the Eldest, takes damage. He acts much the same as his older brother. See also Lil' Hinox.

▷ Hinox the Eldest

Tri Force Heroes

A miniboss fought in both the Hinox Mine and Bomb Storage levels of *Tri Force Heroes*. In Hinox Mine, he rides a mine cart next to the heroes' cart, tossing bombs. In Bomb Storage, he appears from random windows, throwing bombs down onto the heroes.

▷ Hiploop

See Helmasaur.

▷ Hoarder

See Spiny Beetle.

▷ Hokkubokku

A Link to the Past

A Link Between Worlds

Tri Force Heroes

A monster with a pointy head and ears stacked on round orbs. Slashing at an orb in its torso will send the orb flying around the room. In *A Link Between Worlds*, these strange creatures appear in the Desert Palace, lying in wait in the sand. In *Tri Force Heroes*, the orbs regenerate.

▷ Horsehead

See Mazura.

▷ Hot Head

Link's Awakening DX

The boss of Turtle Rock, Hot Head is a massive flame monster that rises up from the magma to stop Link from obtaining the last Instrument of the Sirens. He will bounce off the walls attempting to burn Link, then submerge himself in magma, splashing it everywhere. Hot Head is vulnerable to blasts from the Magic Rod. After so many blasts, his flames will fade, exposing the flat, round monster underneath.

▷ Hrok

Skyward Sword

A bizarre bird with a taste for minerals found in desert stones. They store small, indigestible rocks inside stretchy, red necks, clumping the rocks together to make projectiles, which they spit at people who happen to cross their path. When not bombarding Link with rocks, they dive-bomb him from the air.

▷ Hylian Hornet

Twilight Princess

Twilight Princess HD

These buzzing hornets are commonly found in Ordon Woods. While mostly harmless, they will swarm Link if he provokes them by attacking their nests. This is not to say the nests should be ignored. Link can harvest them for Bee Larva that can be used for fishing bait or eaten to restore a bit of health. See also page 66, Bee.

▷ Hyu

A Link to the Past

A Link Between Worlds

A ghost that appears in both the Dark World and Lorule. Its body is covered in a tattered sheet with holes for its eyes and mouth, and it floats in place carrying a lantern.

▷ Ice Bubble

Twilight Princess

Twilight Princess HD

Phantom Hourglass

A Link Between Worlds

A flying skull, wrapped in freezing air. Anything they touch will take damage and freeze in place for a short time. Attacking an Ice Bubble will dispel its cold, but only temporarily. See also page 103, Bubble.

▷ Ice Chuchu

Spirit Tracks

Ice Chuchus are a rare kind of slime with a body seemingly made of ice. They live in ice and snow-covered fields, as well as in the Snow Temple. Ice Chuchus will slowly approach any enemy they spot. Attacking or just touching them will freeze Link on the spot. See also page 105, Chuchu.

▷ Ice Gimos

A Link Between Worlds

A statue of ice possessed by the spirit of a demon. Ice Gimos are found on snowy mountains and in ice temples, and will attack if Link draws near. They are a dangerous enemy, able to withstand a great many swings of the sword, but their icy bodies are weak to fire and a single blast from the Fire Rod reduces them to a puddle. See also Gimos.

▷ Ice Keese

Ocarina of Time

Ocarina of Time 3D

Majora's Mask

Majora's Mask 3D

Twilight Princess

Twilight Princess HD

Phantom Hourglass

Spirit Tracks

An icy breed of Keese, these bat-like monsters lie in wait on ceilings, then attack enemies by ramming into them. They are sheathed in cold, and often live on snowy mountains or in frigid caves. Their attacks freeze their targets in addition to dealing damage. See also Keese.

Ice Wizzrobe

Four Swords

The Minish Cap

A Link Between Worlds

Tri Force Heroes

A Wizzrobe wielding magic that freezes whatever it touches. They toy with opponents by teleporting around the battlefield. In addition to arrows and other projectiles, Ice Wizzrobes are weak to fire attacks from equipment like the Fire Rod. See also Wizzrobe.

Igos du Ikana

Majora's Mask

Majora's Mask 3D

The spirit of Ikana's long-dead king, resurrected by a curse on the kingdom. A boss of the Ancient Castle of Ikana, he will only attack after Link cuts down his two lackeys. After defeating the king, he ruminates on the destruction his wars caused and passes to the afterlife. See also page 102, King's Lackeys, Stalfos.

Immortal Demon Vaati

See Vaati.

Imp Poe

Twilight Princess

Twilight Princess HD

A type of Poe that wields a giant scythe as a weapon. Jovani, a man who sold his soul to demons for immense wealth and was turned to gold, requires souls from these Poes to lift his curse. They appear at night throughout Hyrule, and can only be seen using wolf senses. See also Poe.

Imprisoned, The

Skyward Sword (1)

Skyward Sword (2)

Skyward Sword (3)

A corrupted creature that serves as a vessel for the soul of the Demon King, Demise. Lying in wait at the bottom of the valley in the Sealed Grounds, the Imprisoned climbs out of the valley and charges toward the Sealed Temple after Link receives the Goddess's Harp (1). It sprouts arms to help it climb the ridges of the valley and once again challenges Link after the fated hero attempts to open the Gate of Time (2). Link fights the Imprisoned a third time while collecting the verses of the Song of the Hero. For this battle, it grows a tail and can use the ring on its back to fly (3). See also Demise.

In-Water Octorok

See Octorok.

Iron Knuckle

The Adventure of Link

Ocarina of Time (1)

Ocarina of Time 3D (1)

Ocarina of Time (2)

Ocarina of Time 3D (2)

Majora's Mask

Majora's Mask 3D

A knight clad in iron. In The Adventure of Link, Iron Knuckles carry a sword and shield, while they wield massive, two-handed axes in Ocarina of Time and Majora's Mask. Iron Knuckles appear in Ocarina of Time as both a standard enemy (1) and the miniboss of the Spirit Temple (2). In the latter, the Iron Knuckle that Link fights is actually Nabooru, the Gerudo thief, who dons the armor after being brainwashed by Twinrova. There are blue and red variations in The Adventure of Link. See also Rebonack.

Iron Knuckle (Blue)

The Adventure of Link

This blue version of the Iron Knuckle is the most formidable of the Iron Knuckles found in The Adventure of Link. They were originally the elite guard of the king of Hyrule, and swore an oath to continue guarding the Great Palace after the king died. They are a powerful enemy with substantial health and the ability to fire sword beams.

Iron Knuckle (Red)

The Adventure of Link

A steel-clad knight that appears in The Adventure of Link. They were originally part of the king of Hyrule's elite guard. After the founding king died, they swore an oath to forever guard the Great Palace. They are one rank above the standard Iron Knuckles, and their health, attack power, and speed are all higher.

Iron Mask

See Helmasaur.

J COLUMN

Jalhalla

The Wind Waker

The Wind Waker HD

A masked, spectral creature born from the fusion of many Poes and responsible for the death of Laruto, sage of the Earth Temple. It uses its lantern to wield fire in battle and will temporarily possess Link, causing him to lose his sense of direction. Jalhalla is weak to sunlight. See also Poe.

Javelin Soldier

See Soldier.

Jermafenser
● Helmethead

The Adventure of Link

This guardian of Midoro Palace in The Adventure of Link, also called Helmethead, is said to have been given new life by the King of Hyrule. He is a former captain of the elite royal guard and a skilled swordsman, wielding both a blade and a sturdy shield. His entire body is covered in armor, and he shoots fireballs at palace intruders. Knocking off his helmet exposes his head to attacks, but Link must then take care to avoid the helmet, which will fly around the room shooting beams of energy.

Joelle

Ocarina of Time

Ocarina of Time 3D

Majora's Mask

Majora's Mask 3D

The second oldest of the four Poe Sisters, Joelle serves as a miniboss for the Forest Temple in Ocarina of Time. Link also fights her in the Spirit House of Ikana Canyon in Majora's Mask. See also Amy, Beth, Margaret, Meg, Poe.

Jolene

Phantom Hourglass

A hostile pirate who has a history with Linebeck and in turn despises him. She sails the seas in her own unique ship and will fire torpedoes when drawing near. If she manages to get close enough, she will come aboard and challenge Link to a fight. Jolene has a younger sister, Joanne, who lives on Bannan Island and dresses like a mermaid.

K COLUMN

Kalle Demos

The Wind Waker

The Wind Waker HD

This woodland boss dwells deep within the Forbidden Woods near Forest Haven. A gigantic, plant-like monster, it sprouts from the ground and swallows Makar. Spindly stamen extend from its core and grip the ceiling, allowing it to hang freely while thrashing hefty vines at anything that threatens it.

Karat Crab

A Link Between Worlds

Tri Force Heroes

A crab-like monster found in certain fields and deserts characterized by its lopsided pincers. In A Link Between Worlds, it moves quickly left and right, but it has trouble moving forward and backward. In Tri Force Heroes, it hides in Sand Mounds. See also Sand Mound.

Kargarok
● Kargaroc

The Wind Waker

The Wind Waker HD

Twilight Princess

Twilight Princess HD

This giant bird-like monster patrols its territory from the sky, swooping down to attack any trespassers. They often appear over fields or the Great Sea, where there are wide-open skies. See also Shadow Kargarok, Twilit Carrier Kargarok.

Keaton (PURPLE)

The Minish Cap

Like more common yellow Keatons, these are fox-like monsters with an X-shaped scar on their heads. They charge forward with their daggers and can be difficult to avoid. If they connect, Link will drop several rupees. The more rupees Link is carrying, the more he will drop. Unlike their more common cousins, purple Keatons appear in groups and are only found inside Dark Hyrule Castle.

Keaton (YELLOW)

The Minish Cap

Fox-like monsters with an X-shaped scar on their heads that stalk forest clearings and other areas with easy prey. They charge forward with their daggers and can be difficult to avoid. If they connect, Link will drop several rupees. The more rupees Link is carrying, the more he will drop.

Keeleon

A Link Between Worlds

Tri Force Heroes

Keeleons primarily live in watery or icy areas. They float in the air, high above the water's surface, and spit bombs out of flower-like mouths. Swords and similar items normally cannot reach them, so Link must find a high point in order to attack with a rod or well-aimed bomb. See also Fire Keeleon.

Keese

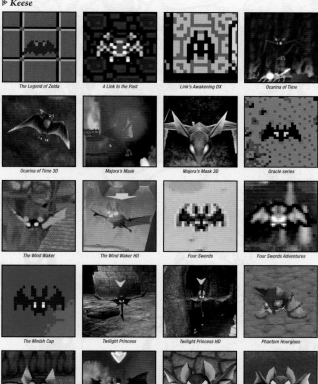

The Legend of Zelda · A Link to the Past · Link's Awakening DX · Ocarina of Time
Ocarina of Time 3D · Majora's Mask · Majora's Mask 3D · Oracle series
The Wind Waker · The Wind Waker HD · Four Swords · Four Swords Adventures
The Minish Cap · Twilight Princess · Twilight Princess HD · Phantom Hourglass
Spirit Tracks · Skyward Sword · A Link Between Worlds · Tri Force Heroes

Keese are bats that dwell in caves and other dark places. They flutter in the darkness or hang in the shadows until Link draws near. Taking flight, they swoop in and attack anyone who gets too close for their liking. Most are weak enough to be taken down in a single blow, but there are many varieties. In The Legend of Zelda, splitting a Vire will turn it into two Red Keese. See also Bad Bat, Battle Bat, Dark Keese, Fire Keese, Gomess, Ice Keese, Keese Swarm, Shadow Keese, Thunder Keese, Vire.

Keese Swarm

Four Swords Adventures

A Keese circling rapidly in a ring shape. It may look like there are several Keese in the swarm, but there is actually just one in there. Its body is darker than the others. Hitting it will cause it to drop a trove of Force Gems.

Key Bandit Poe

Tri Force Heroes

A type of Poe with a particular interest in keys. Like many ghosts, it loves the dark, and can usually be found in groups among ruins. While this type of Poe does not directly attack, it will steal keys, forcing the party to chase it down. If a hero happens to be carrying a key, all Key Bandit Poes present will rush him attempting to steal it. See also Poe.

Key Master

Spirit Tracks

A walking hand that appears in some dungeons after Link finds a Boss Key. Unsettling and purple, Key Masters see out of a single eye in their palms. Several will appear at once and attempt to take the key back. They can be defeated with bombs, but will quickly revive. See also Wallmaster.

Kholdstare

A Link to the Past

The boss of the Ice Palace in A Link to the Past resembles a cloud with a single eye. It attacks by dropping blocks of ice from the ceiling. Initially, it is wrapped in ice to protect itself and Link must use fire to melt the barrier. After the ice is melted, it will split into three and attack. See also Dharkstare.

King Bulblin

Twilight Princess

Twilight Princess HD

The powerful king of the Bulblins; all others follow his lead. Link must face him repeatedly in battle as he skillfully rides atop his Bullbo, swinging a gigantic axe. While King Bulblin says little, he understands what people say and can speak with Hylians and other races. See also page 100, Bulblin.

King Dodongo

Ocarina of Time

Ocarina of Time 3D

The fire-breathing, infernal dinosaur, King Dodongo is the boss of Dodongo's Cavern. It is a giant Dodongo said to eat anything. Though it was originally a protector of sorts for the cavern, Ganondorf's influence has caused it to go berserk. King Dodongo breathes fire after inhaling deeply, and rolls around trying to slam into Link. See also Dodongo.

King Moblin

Link's Awakening DX

In Link's Awakening, a Big Blin is the boss of Moblin Keep, a mini-dungeon. See also page 100, Moblin.

King's Lackeys

Majora's Mask

Majora's Mask 3D

Two resurrected subordinates of Igos du Ikana, fought before fighting the king himself in the Ancient Castle of Ikana. They hate light, a weakness Link can use to his benefit by reflecting rays onto them with the Mirror Shield. Neither likes the other, and they often squabble. They go to the afterlife amid reprimands from their king. See also Igos du Ikana.

Kirby
● Anti-Kirby

Link's Awakening DX

A guest character from the Kirby series, where he appears as a protagonist rather than an enemy. The Kirby of Koholint Island may look just as cute, but in typical Kirby fashion, he will suck in everything around him, including Link, when he opens his mouth. Defeating Kirby may cause fairies to appear.

▷ Knucklemaster

A Link Between Worlds

This boss of the Skull Woods is master of the Wallmasters that appear throughout the dungeon. In addition to slamming down violently, it will form a fist and attempt to punch Link. The punch is fast and follows Link so closely that it is nearly impossible to escape. See also Wallmaster.

▷ Kodongo (Green)

A Link to the Past

A Link Between Worlds

Tri Force Heroes

These small earth dragons spit fire to attack. In *A Link Between Worlds*, they only appear in the "Treacherous Tower" minigame. Kodongos spit a stream of flames from their mouths that linger for a time. While they can be difficult to fight head on, their backs are vulnerable to attack. See also Dodongo.

▷ Kodongo (Red)

These horned, reptilian creatures spit fire to attack, stalking dungeons like the Tower of Hera and the Dark Palace. Red Kodongos move faster than the green variety in *A Link to the Past*, while in *A Link Between Worlds*, they tend to keep their distance, breathing fire that lingers and prevents Link from progressing.

▷ Koloktos

Skyward Sword

The Ancient Automaton Koloktos is a mechanical guardian that protects the divine Farore's Flame from intruders deep within the Ancient Cistern. Ghirahim takes advantage of its age and wear, commanding it to destroy Link. It goes wild, swinging its giant sword and smashing down with its six massive arms.

▷ Kotake

Ocarina of Time

Ocarina of Time 3D

Oracle series

Kotake is one of Ganondorf's adoptive parents, along with her sister Koume. She specializes in ice magic. In *Ocarina of Time*, Link does battle with her and her sister as the fearsome boss Twinrova. She appears in the *Oracle* series by linking both games, as well as in *Majora's Mask* as the owner of the Magic Hag's Potion Shop rather than as an enemy. See also Twinrova.

▷ Koume

Ocarina of Time

Ocarina of Time 3D

Oracle series

Koume is one of Ganondorf's adoptive parents, along with her sister Kotake. She specializes in fire magic. In *Ocarina of Time*, Link does battle with her and her sister as the fearsome boss Twinrova. She appears in the *Oracle* series by linking both games, as well as in *Majora's Mask* as a Swamp Tour guide rather than as an enemy. See also Twinrova.

▷ Ku

A Link to the Past

A Link Between Worlds

Single-eyed aquatic monsters that appear to be Zora that wandered into the Dark World. In *A Link to the Past*, only their heads pop out of the water, but in *A Link Between Worlds*, they have nests like the Zora and walk on the ground on two legs. See also Zora.

▷ Kyameron

A Link to the Past

A Link Between Worlds

These monsters are made of water and appear in dank places like the Swamp Palace of southern Lorule and the Dark World. Water bubbles up and comes together to form this quick-moving creature. It will bounce off the walls before turning back into water. Kyamerons can be defeated, but they will never stop respawning.

▷ Kyandokyan

Oracle of Ages

These walking candle monsters appear in *Oracle of Ages*. While they cannot be damaged by normal weapons or items, they will run around frantically and explode if Link lights their wicks.

L COLUMN

▷ Lady Maud

Tri Force Heroes (1)

Tri Force Heroes (2)

Lady Maud is a flamboyant witch who cursed Princess Styla with body tights. She did so not out of spite, but simply because she thought they would look good on the princess. Maud attacks with her parasol and will fire projectiles that change between three colors (1). When cornered, she fuses with the stage and becomes a gigantic, butterfly-like creature (2). Lightning will rain down on her floating parasols.

▷ Lady's Pets, The (Arrghus)

Tri Force Heroes

One of three pet bosses, also known as Tri Furies, summoned by Lady Maud in the Lady's Lair. The last of the three the heroes must face, it resembles a mechanical Arrghus similar to the boss of the Water Temple. This Arrghus is much more colorful, and its eye is surrounded by spheres of fire and ice, rather than just regular old eyeballs. See also Arrghus.

▷ Lady's Pets, The (Margoma)

Tri Force Heroes

One of three pet bosses, also known as Tri Furies, summoned by Lady Maud in the Lady's Lair. The first of the three to appear, this one resembles a mechanical Margoma much like the boss of the Forest Temple. While its appearance is more appealing and its height only goes up to two layers, its movements remain similar to the monster fought earlier in the game. See also Margoma.

▷ Lady's Pets, The (Moldorm)

Tri Force Heroes

One of three pet bosses, also known as Tri Furies, summoned by Lady Maud in the Lady's Lair. This one appears second and is a mechanical Moldorm similar to the one that appears in the Fire Temple earlier in the game. While its movements are nearly identical, it looks much prettier and its head spews flames, making it more dangerous. See also Moldorm (Boss).

▷ Lakitu

The Minish Cap

Originally appearing in the *Super Mario Bros.* series, these odd creatures make their homes in the Cloud Tops, firing bolts of lightning instead of the spiny eggs of other incarnations. The clouds they ride can be sucked up using the Gust Jar.

▷ Lanmola
● Lanmola (Red)

The Legend of Zelda

A Link to the Past

Link's Awakening DX

Giant, centipede-like creatures that typically live in sand and areas with soft ground, crawling out to attack anyone who steps too close for their liking. In *The Legend of Zelda*, Lanmolas are typically red and are characterized by their long, segmented bodies that move at considerable speed. Three serve as the boss of the Desert Palace in *A Link to the Past*, spraying clumps of sand as they crawl up from beneath the palace floor.

Lanmola (Blue)

The Legend of Zelda

Quicker blue Lanmolas only appear in a single room in the Level 9 dungeon of Link's Second Quest in *The Legend of Zelda*. The room is not required to complete the level, so it is possible to never see these rare monsters at all. But those who have seen them are likely to remember the fight.

Lantern Poe

Tri Force Heroes

These light-carrying Poes haunt the darker corners of Hytopia, like Palace Noir. They are not technically an enemy since they cannot attack. Instead they wander the halls clutching lanterns. This can prove helpful when exploring in the darkness—but they must also be dealt with before progressing farther into the palace. Like other ghosts, Lantern Poes are weak to bright light, and will vanish if all torches in a room are lit. See also Poe.

Laser Eye

A Link to the Past

A giant eye on dungeon walls that opens and closes. There are two types: those that fire lasers when Link stands in their line of sight, and those that only fire when Link is facing them. The lasers can only be blocked by the Mirror Shield. Invulnerable to all attacks, they can only be avoided, not defeated.

LD-002G Scervo

Skyward Sword

Long ago, when the Lanayru Region was a vast sea, Scervo was an Ancient Robot pirate captain who stole a galleon guarding Nayru's Flame. Many years later, Link finds and boards this ghost ship, doing battle with Scervo on a narrow walkway at the bow. Scervo's left hand is a claw. In his right hand, he holds a gigantic, rotating sword enveloped in electricity. When it breaks, Scervo forges a shield from the raw volts.

LD-003D Dreadfuse

Skyward Sword

An Ancient Robot that appears in the Sky Keep at Skyloft. He resembles Scervo, but wears a crown and his hands are reversed: his left hand holds a sword, while his right is a hook. In addition to Dreadfuse's primary sword-thrust attacks, partway through battle he will fill his sword with electricity and guard with it.

Leever

● Leever (Orange) / ▲ Leever (Purple) / ■ Leever (Red)

The Legend of Zelda · *The Adventure of Link* · *A Link to the Past* · *Link's Awakening DX*

Ocarina of Time · *Ocarina of Time 3D* · *Majora's Mask* · *Majora's Mask 3D*

Oracle series · *Four Swords Adventures* · *The Minish Cap* · *Twilight Princess*

Twilight Princess HD · *A Link Between Worlds* · *Tri Force Heroes*

These flower-like creatures emerge from underground, move about for a short time, then dig back down. There are multiple kinds in some titles. Red Leevers are the weaker of the two types found in *The Legend of Zelda*, while purple Leevers are slightly faster than the green variety also found in *A Link to the Past*. The *Oracle* series features three kinds of Leevers: red, orange, and blue.

Leever (Blue)

The Legend of Zelda · *The Minish Cap*

Blue Leevers are harder to defeat than the standard red variety found in *The Legend of Zelda* and *The Minish Cap*. Otherwise, they behave in much the same fashion.

Leever (Green)

A Link to the Past

These creatures resemble flowers and live in sandy soil. They crawl out of the ground and slowly move toward Link for a short time before burrowing back down.

Levias

Skyward Sword

Living in the large clouds of Skyloft, this great spirit patrols the skies in service to the goddess. It understands speech and is tasked with passing down a portion of the Song of the Hero that hints at the location of the Triforce. That is, until it becomes possessed by a Bilocyte and goes berserk. See also Bilocyte.

Life Like

Tri Force Heroes

A subspecies of the all-consuming Like Like, Life Likes bury themselves underfoot and dangle a fake heart on the end of a single tentacle to lure their prey. Once caught, they will steal a hero's hearts. They are not easy to shake off and will continue to sap hearts until other heroes come to help. See also Like Like.

Light Ghini

See Ghini.

Like Like

The Legend of Zelda · *A Link to the Past (GBA)* · *Link's Awakening DX* · *Ocarina of Time*

Ocarina of Time 3D · *Majora's Mask* · *Majora's Mask 3D* · *Oracle series*

The Minish Cap · *Phantom Hourglass* · *Spirit Tracks* · *A Link Between Worlds*

A soft, thieving monster that draws in its prey, then swallows it whole. They love to eat shields, and if they swallow Link for long enough, they will consume his shield entirely, forcing him to seek out a new one. In the Game Boy Advance version of *A Link to the Past*, Like Likes appear in the Palace of the Four Sword. See also Force Like, Life Like, Pikit, Rupee Like.

Lil' Hinox

Tri Force Heroes

Unlike his older brothers, Lil' Hinox only appears in the Bomb Storage level of the Fortress in *Tri Force Heroes*. He is better at using bombs than his siblings and will lob large, powerful ones at the heroes. The bombs are so big that they can't be tossed back at him. See also Hinox, Hinox the Elder.

Link's Shadow

See Shadow Link.

Lizalfos

Ocarina of Time

Ocarina of Time 3D

Twilight Princess

Twilight Princess HD

Skyward Sword

Anthropomorphic lizards that wield swords and shields. Some equip gauntlets to efficiently block and defend against Link's attacks. They are clever creatures, often leaping around the battlefield, waiting to strike until an opening presents itself. Ranged attacks are often useless against Lizalfos, forcing Link to get up close for a sword fight. See also Aeralfos, Dark Lizalfos, Dynalfos, Super Aeralfos.

Lobarrier

Spirit Tracks

The Lobarrier uses its massive claw to block attacks from the front. Link can use the Whip or Boomerang to make the Lobarrier vulnerable to attack.

Lorule Ball and Chain Soldier

A Link Between Worlds

This elite soldier guards Lorule Castle. They differ from their ball and chain–wielding Hyrulean counterparts in appearance, as well as by having greater health and attack power. The ball on the end of their chain is covered in fire, making it especially dangerous in small rooms. See also Soldier.

Lorule Soldier

A Link Between Worlds

This elite soldier guards Lorule Castle. They differ from their Hyrulean counterparts in appearance and have greater health and attack power. Their attack methods and movements are the same, however.

Lorule Spear Soldier

A Link Between Worlds

This elite soldier guards Lorule Castle. They differ from Hyrulean Spear Soldiers in appearance, as well as by having greater health and attack power. They prefer to keep their distance, hurling spears at Link.

Lowder

The Adventure of Link

These hard-shelled beetles crawl slowly across the ground in deeper dungeons. That is, until Link steps near. Seemingly by instinct alone, they will turn and charge toward him at an impressive clip. A quick swing of the sword will take care of a Lowder, but only if Link's not caught off guard by its sudden speed.

Lynel
● Lynel (Red)

The Legend of Zelda

A Link to the Past

Oracle series

A Link Between Worlds

These strong monsters resemble centaurs with heads like lions. They can use attacks like the Sword Beam in *The Legend of Zelda* and spit fireballs in *A Link to the Past*. If possible, it's best to avoid fighting them.

Lynel (BLACK)

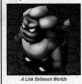

A Link Between Worlds

The strongest class of Lynel in *A Link Between Worlds* appears only within Treacherous Tower on Lorule's Death Mountain. Lynels are already strong enemies; these also have the ability to attack with fire from afar.

Lynel (BLUE)

The Legend of Zelda

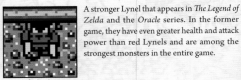

Oracle series

A stronger Lynel that appears in *The Legend of Zelda* and the *Oracle* series. In the former game, they have even greater health and attack power than red Lynels and are among the strongest monsters in the entire game.

Lynel (GOLDEN)

Oracle of Seasons

A golden Lynel appears in *Oracle of Seasons* as one of four Golden Monsters Link must defeat for a Magic Ring that doubles his sword's attack power. The fearsome, lion-like creature has a golden body and is significantly more powerful than any ordinary Lynel found in the game.

Mace Darknut

Twilight Princess

Twilight Princess HD

A Darknut with unique armor wielding a mace instead of a sword. Beyond the unique weapon, its fighting style remains largely the same. See also Darknut.

Mad Bomber

Link's Awakening DX

A soldier hiding in holes in the courtyard of Kanalet Castle. He appears from one of the six holes and throws bombs, diving back into the hole and repeating the tactic. He will drop a Golden Leaf upon defeat and never appears again. See also Darknut.

Mad Jelly

Majora's Mask

Majora's Mask 3D

This miniboss appears in the Great Bay Temple in *Majora's Mask*. It resembles an amoeba, and will split into multiple balls, drop from the ceiling, and change into a variety of forms to attack. Its weak point is the Gekko at its center. Freezing the jelly with an Ice Arrow will create an opportunity to attack the Gekko. See also Gekko.

Mad Scrub

Ocarina of Time

Ocarina of Time 3D

Majora's Mask

Majora's Mask 3D

Flame-colored leaves decorate the heads of these especially hostile Deku Scrubs. They will fire seeds at Link from afar and hide in their nests if he approaches. In *Ocarina of Time*, they fire three Deku Seeds in a row. In *Majora's Mask*, they only fire one at a time. See also page 46, Deku Scrub.

Madderpillar

The Minish Cap

Appearing in Deepwood Shrine and the Temple of Droplets, this giant caterpillar moves in a zigzag pattern. Attacking its red nose causes a weak point to appear on its tail. After the weak point vanishes, its entire body turns red, sending it into a frenzy.

Magma Spume

Skyward Sword

These round, frog-like monsters live in magma, storing the gas created by the bubbling, molten rock and firing flaming balls of the stuff at Link, trying to set him on fire. They are cowardly, and tend to hide the instant they detect any danger nearby. See also Cursed Spume.

▷ Magmanos

Skyward Sword

Dwelling in lava, these giant, hand-shaped monsters appear when intruders draw near. They are made of magma, so traditional attacks won't hurt them. Link must douse them with water, which causes them to harden temporarily, before striking and breaking them apart.

▷ Mago

The Adventure of Link

A robe-wearing magician that appears in random locations and sends flames running along the ground before vanishing. They can be attacked by jumping before they launch their flames, then using a Downthrust.

▷ Magtail

The Wind Waker The Wind Waker HD

Centipede-like monsters covered in a hard shell. They live in volcanic areas and can move through magma, rushing toward their target using pincers attached to their heads. The single eye between these pincers is their weak spot, but they will do their best to protect it, curling into a ball if injured.

▷ Magunesu

Oracle of Seasons

Magunesu live in Unicorn's Cave in *Oracle of Seasons*. These spherical monsters fire projectiles while keeping their distance and will flee if approached, so Link's best strategy is to draw them near using his Magnetic Gloves.

▷ Majora's Incarnation

Majora's Mask Majora's Mask 3D

The second form of Majora's Mask. It grows arms and legs, and begins to resemble a person. It is particularly fast in this stage of the game's final boss fight, using moves that mimic classical ballet and Ukrainian folk dancing while firing high-speed projectiles.

▷ Majora's Mask

Majora's Mask Majora's Mask 3D

The final boss of the eponymous *Majora's Mask*, fought after Link goes inside the moon. The maniacal mask grows in size during the fight, sprouting several tentacles and spinning like a disk. After Link deals enough damage, it will reanimate the corpses of the game's four dungeon bosses, all the while firing beams at Link.

▷ Majora's Wrath

Majora's Mask Majora's Mask 3D

Majora's Incarnation gains more muscle and becomes fully fleshed out. Its hands become long whips, which it swings around with great range. In this final form, it is vulnerable to Light Arrows.

▷ Malgyorg

Spirit Tracks

These shark monsters are found in groups in the Sand Realm, swimming through the sand as if it were water. They are quite ferocious, and will jump at their prey from the sand, one after the other. They hate loud noises, and blowing the train whistle will force them out of the sand. See also Gyorg.

▷ Malladus

Spirit Tracks (1) Spirit Tracks (2) Spirit Tracks (3)

A sealed Demon King who challenged the gods in an attempt to take over the world in the distant past. Revived as a spirit thanks to a scheme hatched by Byrne and Cole, Malladus seeks a host body (1). At the end of a ceremony, he possesses Princess Zelda for a fight aboard the Demon Train in the Dark Realm (2). After he leaves Princess Zelda's body and possesses Cole's body instead, Link and Zelda battle Malladus for the fate of New Hyrule (3).

▷ Manhandla

The Legend of Zelda Oracle of Seasons Four Swords Adventures

A monster with four snapping mouths pointing in each direction. Their appearance differs significantly depending on the game. A blue one serves as boss of the Level 3 dungeon in *The Legend of Zelda*, while a red and green one guards the Ancient Ruins of *Oracle of Seasons*. Each head of the Manhandla serving as boss of the coast in *Four Swords Adventures* corresponds to the colors of the heroes' tunics. See also Big Manhandla.

▷ Margaret

Oracle of Seasons

In *Oracle of Seasons*, this oldest sibling of the Poe Sisters appears as a miniboss in the Explorer's Crypt alongside Amy. Margaret's nickname is "Meg," a name she goes by in other titles. See also Amy, Beth, Joelle, Meg. See also Amy, Beth, Joelle, Meg, Poe.

▷ Margoma

Tri Force Heroes

The boss of the Forest Temple in the Woodlands is a leader of sorts for the Margomills that also appear in the temple. Spikes protrude from its circular body, and it rushes at its target while spinning like a top at high speeds. As Margoma takes damage, it will increase its number of layers, growing taller and making it harder to throw bombs into a hole that opens at its center. See also Lady's Pets, The (Margoma), Mini-Margo.

▷ Margomill

A Link Between Worlds

Dwelling in the House of Gales in Hyrule, this spinning disk with an eye in the center guards the Pendant of Wisdom. It floats and rotates by using the power of the wind, trying to push its target into the surrounding pit. Margomill's eye is its weak point; if Link strikes the eye, Margomill will increase the number of layers in its disk, attempting to protect it.

▷ Mask-Mimic

Link's Awakening DX

A guest character from the *Super Mario Bros.* series, this Shy Guy–like Mask Mimic copies Link's movements. They wear masks, guarding against direct attacks, so defeating them requires some ingenuity—like getting back to back with one and using a Spin Attack. See also Arm-Mimic.

▷ Massive Eye

Phantom Hourglass

This mysterious sea creature tries to prevent Link from reaching Goron Island in *Phantom Hourglass*. It fires projectiles and charges at the ship to attack. The three eyes on its flank are its weak points, and it can be defeated by firing at them with the cannon.

▷ Master Stalfos

Link's Awakening DX

The miniboss of the Catfish's Maw. Link fights this heavily armed Stalfos Knight four times in all. His pattern remains the same each time they fight: He crumbles apart after being hit with a sword. Then Link must light a bomb to destroy the remains. Somehow he keeps coming back for more, and after the fourth go, Link is rewarded with a Hookshot for his trouble. See also page 102, Stalfos.

▷ *Mau*

A moving statue that resembles a wolf's head. It moves slowly, changing direction perpendicularly as it moves up, then forward, then down, then forward, in that order. It will fire projectiles as it moves, and spawns endlessly, no matter how many Link has defeated. They are particularly dangerous in tight spaces where Link cannot dodge their advances by jumping out of the way.

The Adventure of Link

▷ *Mazaal*

In *The Minish Cap*, the stone statue Mazaal guards the Fortress of Winds and its Ocarina of Wind. See also Eox.

The Minish Cap

▷ *Mazura*
● Horsehead

Mazura, also known as Horsehead, is the guardian of the Parapa Palace in *The Adventure of Link*. Mazura was created from a horse by the King of Hyrule. It has the head of a horse and a massive body clad in heavy armor. It attacks by swinging a club.

The Adventure of Link

▷ *Medusa Head*

The boss of the Sword & Shield Maze in *Oracle of Seasons*, this monster of legend fires lasers from its eyes that will freeze Link in place.

Oracle of Seasons

▷ *Meg*

Ocarina of Time *Ocarina of Time 3D* *Majora's Mask* *Majora's Mask 3D*

The eldest of the four Poe Sisters. She appears as part of the miniboss in the Forest Temple in *Ocarina of Time*, cloning herself to deceive Link during the fight. Meg also appears in *Majora's Mask* alongside her sisters in the Spirit House in Ikana Canyon, and as Margaret in *Oracle of Seasons*. See also Amy, Beth, Joelle, Margaret, Poe.

▷ *Mega Thwomp*

A stern-faced, square rock wedged idly between platforms in an underground passage in the Key Cavern. Slamming into it causes it to drop to the ground with a surprised expression. See also Thwomp.

Link's Awakening DX

▷ *Megmat*

These monsters that resemble armadillos mixed with wallabies are frequently found in the southwest corners of the map. They approach by bouncing toward Link on their powerful hind legs, and can be tough to avoid.

The Adventure of Link

▷ *Metal Chuchu*

This Chuchu is unique in that it is made of a kind of liquid metal. Its body is also covered in electricity, shocking Link if he's not careful and making it one of the most troublesome Chuchus around. Bombs and bow attacks are most effective when fighting one. See also page 105, Chuchu.

Spirit Tracks

▷ **Metal Shield Moblin**
See Sword Moblin/Spear Moblin.

▷ *Mighty Darknut*

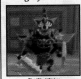

A knight wearing heavy black armor equipped with a large sword and shield. They are the commanding officers of the weaker Darknuts, and some even wear capes. To do any damage, Link must first burn their cape away. See also Darknut.

The Wind Waker *The Wind Waker HD*

▷ *Mini Baba*

A small, stemless Deku Baba. Though not a threat to Link, he can harvest Mini Babas for Deku Nuts. See also Deku Baba.

Majora's Mask *Majora's Mask 3D*

▷ *Mini Digdogger*

Appearing in *Oracle of Seasons*, these Mini Digdoggers attack Link after the large, urchin-like Digdogger has been broken apart during the boss battle for Unicorn's Cave. See also Digdogger.

Oracle of Seasons

▷ *Mini Freezard*

Twilight Princess *Twilight Princess HD* *Tri Force Heroes*

Mini Freezards form from the ice of dungeon floors and slide around if struck. In *Twilight Princess*, smashing a Freezard causes it to split into these. Depending on the title, regular Freezards may share characteristics with their smaller counterparts. See also Freezard.

▷ *Mini-Margo*

This spike-trap-shaped enemy moves along a set route while spinning at high speeds. Sword attacks do nothing, and getting too close will hurt the hero and knock him back. Despite all this, a Mini-Margo can be defeated by skillfully tossing a bomb into an opening at its center. See also Margoma.

Tri Force Heroes

▷ *Mini-Moldorm* (Purple)

A purple variety of Moldorm found in the dungeons and caves of Lorule. Like other Moldorms, their movement is erratic and difficult to predict. See also Moldorm.

A Link Between Worlds

▷ *Miniblin*
● Pirate Miniblin

The Wind Waker *The Wind Waker HD* *Phantom Hourglass* *Phantom Hourglass*

Miniblins are demonic, diminutive Moblins that always attack in groups, ceaselessly advancing on Link until they are cut down. Despite their intimidating appearance, their size makes them quite weak. In *The Wind Waker*, they make unique, song-like cries as they move along walls and try to sneak up on Link. In *Phantom Hourglass* there are seafaring Miniblin pirates who have a slightly different appearance from their land-dwelling brethren. They also appear as pirates in *Spirit Tracks*, attempting to kidnap the Spirit Train's passengers, but their appearance is identical to other Miniblins in the game. See also page 100, Moblin, Pirate Ship.

Spirit Tracks

Moa (Blue)

The Adventure of Link

Single-eyed spirits that haunt areas like Old Kasuto. Unlike the red variety, Link cannot see blue Moas without first possessing the Cross. They fly rapidly from left and right at fluctuating speeds in a pattern that covers much of the screen, making them particularly hard to hit. In addition to red and blue, purple Moas appear in Old Kasuto. See also Fiery Moa.

Moa (Red)

The Adventure of Link

Single-eyed spirits that haunt the graveyard on the southwest part of the continent. They fly rapidly from left and right at fluctuating speeds in a pattern that covers much of the screen, making them particularly hard to hit.

Moblin
● Moblin (Orange) / ▲ Spear Moblin

The Adventure of Link | *A Link to the Past* | *Link's Awakening DX* | *Ocarina of Time*
Ocarina of Time 3D | *The Wind Waker* | *The Wind Waker HD* | *Four Swords*
The Minish Cap | *A Link Between Worlds* | *Tri Force Heroes*

Moblins are beastly, pig-faced soldiers who wield either swords, spears, or bows when patrolling Hyrule at the behest of Ganon and other forces of evil. See also page 100, Big Blin, Bokoblin, Bulblin, Club Moblin, Goriya, Great Moblin, King Moblin, Miniblin, Pig Warrior, Sword Moblin/Spear Moblin.

Moblin (Blue)

The Legend of Zelda | *The Adventure of Link*

The strongest form of Moblin in *The Legend of Zelda* and *The Adventure of Link*. In the latter game, they use powerful bow attacks, and in *The Adventure of Link*, they throw spears.

Moblin (Golden)

Oracle of Seasons

Appearing in *Oracle of Seasons*, this elite, golden soldier is much stronger than typical Moblins. If Link defeats the four Golden Monsters present in the game, including this Moblin, he will receive a ring that doubles his sword's attack power.

Moblin (Red)

The Legend of Zelda | *The Adventure of Link*

This standard Moblin in *The Legend of Zelda* and *The Adventure of Link* is colored red to distinguish itself from the more powerful blue ones that appear in those titles. In the former game, they use bows, and in the latter they carry spears.

Moby

The Adventure of Link

An enemy that spawns endlessly in the fields of Hyrule, diving in at high speeds from the sky and making a 90-degree turn to charge their target once at eye level.

Moink

Spirit Tracks

These pigs with Holstein cow–like spots live in the fields near Aboda Village in the Forest Realm. They are gentle and will only attack if provoked. Groups will sometimes wander near the Spirit Tracks, and hitting them will cause the Moinks to get angry and attack. They will run off if Link uses the Spirit Train's whistle before hitting them.

Moldarach

Skyward Sword

The Thousand-Year Arachnid Moldarach is the boss of the Lanayru Mining Facility in *Skyward Sword*. This scorpion-like Aracha has lived in the mining facility for more than a thousand years, maturing into this ferocious beast. It has three eyes: one in each of its pincers and a third in its head. Attacking the central eye will destroy its pincers, causing it to scurry back into the sand and attack with the sharp spikes on its tail while it hides. See also Aracha.

Moldorm
● Mini-Moldorm

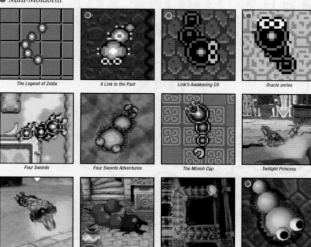
The Legend of Zelda | *A Link to the Past* | *Link's Awakening DX* | *Oracle series*
Four Swords | *Four Swords Adventures* | *The Minish Cap* | *Twilight Princess*
Twilight Princess HD | *Phantom Hourglass* | *Skyward Sword* | *A Link Between Worlds*

An unpredictable googly-eyed monster composed of three orbs joined together. Moldorms scurry around erratically, running into walls. To say this makes their movements hard to read is an understatement. Often Link can simply slash at a Moldorm when it gets near, but some require him to aim for the tail. In *The Legend of Zelda*, they appear without eyes as simple bugs made of red, spherical segments. In *Twilight Princess* these large bugs scurry through the sand, jumping out at Link to attack. When pulled out of the sand, they flop around like fish out of water. See also Devalant, Mini-Moldorm, Sandworm.

Moldorm (Boss)
● Big Moldorm

A Link to the Past | *Link's Awakening DX* | *Four Swords Adventures* | *A Link Between Worlds*

Tri Force Heroes

A Moldorm, only much bigger. It makes a lot of noise as it bounces off the walls and can only be damaged via the weak point on its tail. One appears in both *A Link to the Past* and *A Link Between Worlds* as boss of the Tower of Hera, and in *Link's Awakening* as boss of the Tail Cave. The Moldorm in *Tri Force Heroes* fires light from its eyes corresponding to the color of each hero's outfit and serves as the boss of the Fire Temple. See also Lady's Pets, The (Moldorm).

Moldorm (Purple)

A Link Between Worlds

A giant purple variety of Moldorm that serves as a miniboss guarding the seal on the throne room in Lorule Castle. Just like the Moldorm in Hyrule's Tower of Hera, its weak point is its tail and it crawls around the floor, erratically bouncing off the walls.

Moldworm

The Minish Cap

In *The Minish Cap*, these ground-dwelling monsters appear in Minish-sized areas. Being attacked by one will make Link's clothes dirty, attracting Pestos.

▷ Molgera

The Wind Waker

The Wind Waker HD

This boss entered the Wind Temple and killed the sage who was praying there. It flies through the air and digs massive sinkholes in the sand, devouring anything that falls in. Molgera will spawn larvae after taking enough damage.

▷ Molgera Larva

The Wind Waker

The Wind Waker HD

Several of these will spawn from within Molgera after the boss of the Wind Temple takes damage. They scurry through the sand, jumping out to attack. It is possible to land a blow with the sword after drawing them close with a Hookshot. When defeated, each will drop a heart.

▷ Monkey

Link's Awakening

This monkey throws coconuts at Link from the top of a coconut tree growing near Koholint Island's beach. It will also occasionally toss a bomb. Slamming into the tree using the Pegasus Boots will cause the monkey to fall down and run away. If Link brings the Chain Chomp BowWow along, it will swallow the monkey whole.

▷ Morpha

Ocarina of Time

Ocarina of Time 3D

The Giant Aquatic Amoeba Morpha serves as boss of the Water Temple in *Ocarina of Time*. All of the water present in the Boss Room of the temple is Morpha's body, which it uses to form tentacles to attack. Its main body is a small core, protected by the water around it. Link is unable to do any damage to Morpha unless he first pulls the core from the water.

▷ Morpheel

Twilight Princess

Twilight Princess HD

The boss of Lakebed Temple, the Twilit Aquatic Morpheel was an aquatic creature living in the temple until the dark power of a Shadow Crystal corrupted it. Morpheel thrashes around in the water, devouring its prey by swallowing everything around it, including the water. See also page 104.

▷ Morth

The Wind Waker

The Wind Waker HD

Tri Force Heroes

Larvae of Mothula monsters that resemble spiked orbs. They are drawn to anything that moves, and while unable to deal damage, they will slow down anything they latch onto. In *The Wind Waker*, attacking Mothula will cause it to release several Morths. See also Mothula.

▷ Moth

Majora's Mask

Majora's Mask 3D

Oracle of Ages

Oracle of Seasons

Moth creatures closely related to the larger Mothula. Moths often appear alongside bosses, including a Mothula in *Oracle of Seasons*, the Shadow Hag in *Oracle of Ages*, and Odolwa in *Majora's Mask*. Many moths are also found in Woodfall Temple in the latter game, where they will swarm Link if he lights a Deku Stick. See also Mothula.

▷ Mothula

A Link to the Past

Oracle of Seasons

The Wind Waker

The Wind Waker HD

Spirit Tracks

Mothula is a monstrous moth that has appeared as a boss and miniboss, as well as a common enemy across many titles. In *A Link to the Past*, Link battles one serving as boss of the Skull Woods. An enhanced one also appears in the Palace of the Four Sword in the Game Boy Advance version. In *The Wind Waker*, Mothula appears as both a miniboss and a common enemy. Damaging them will release Morths, which Link must also fight. Mothula is one of the more prolific enemies in the *Zelda* series, also appearing in *Oracle of Seasons*, *Spirit Tracks*, and *Majora's Mask*. See also Morth, Moth.

▷ Mothula (Wingless)

The Wind Waker

The Wind Waker HD

Knocking the wings off a Mothula in *The Wind Waker* won't necessarily defeat it. Though they cannot fly, wingless Mothula are still quick and will attack with their mandibles. When struck, they will turn around and release several Morths from their backside, complicating the fight. See also Morth.

▷ Mulldozer (Blue)

The Minish Cap

These bug-like monsters have skull-patterned shells with spikes on their backs and live in wet areas like the Castor Wilds. They move erratically in circles after spotting a target, and slashing them will only make their movements more violent. However, if Link hits one with his shield, it will stop moving and leave itself open to attack.

▷ Mulldozer (Red)

The Minish Cap

These bug-like monsters have a skull-patterned shell with spikes on their backs and live in areas rich with plant life like Deepwood Shrine. They move erratically in circles after spotting a target, and slashing them will only make their movements more violent. However, if Link hits one with his shield, it will stop moving and leave itself open to attack.

▷ Myu

The Adventure of Link

These tiny, spiked insect enemies wriggle around on the ground. They move slowly, but will sometimes jump at Link without warning. They can be handled either with a Downthrust or by avoiding them outright.

N COLUMN

▷ Nejiron

Majora's Mask

Majora's Mask 3D

These round monsters made of gunpowder appear on the road to Ikana. They pop out of the ground suddenly, roll up, and charge at Link—exploding on impact. They will not appear if Link is wearing the Stone Mask.

▷ Nocturn

Spirit Tracks

These eerie ghosts wander about in the dark. They cannot be attacked when shrouded in darkness but are weak to light.

▷ Nokkun

Four Swords

These bizarre monsters carry hard, black shells, which they use to float in the air. They will close their shell if attacked, deflecting all attacks. Picking them up and throwing them while they are in this state will force them open, making it possible to attack. See also Hikkun.

O COLUMN

▷ *Ocean Octorok*
● Octorok

| The Wind Waker | The Wind Waker HD | Phantom Hourglass | Spirit Tracks |

A subspecies of Octorok that lives in the ocean. In *The Wind Waker*, they spit bombs instead of rocks. In *Spirit Tracks*, they shoot ink. Whether encountered by ship, or in the Spirit Train along the sea floor, Ocean Octoroks are best dealt with using long-range attacks. The Ocean Octoroks found in *Phantom Hourglass* are particularly large. They circle ships before rushing in to attack and can be defeated with cannon fire. See also page 104, Octorok.

▷ *Octive*

Spirit Tracks

A subspecies of Octorok, these dopey-looking octopus-like monsters live in water, popping out when an enemy approaches and spitting projectiles at them. See also page 104.

▷ *Octoballoon*

A Link to the Past

A type of Octorok. Its head is inflated like a balloon. Popping it will scatter tiny Octoroks that swarm and attack. See also page 104.

▷ *Octogon*

Oracle of Ages

This giant, octopus-like monster that wears a shell is the boss of the Mermaid's Cave in *Oracle of Ages*. Similar to an Octorok, it fires projectiles from its mouth. It hides underwater when it senses danger. See also page 104.

▷ *Octomine*

Spirit Tracks

While this creature bears the *Octo* prefix, it looks more like a dark, spiked orb with a single eye. It simply bobs up and down near Spirit Tracks that extend from the sea floor, making it mostly harmless. See also page 104.

▷ *Octorok*
● Octorok (Red) / ▲ Water Octorok

The Legend of Zelda	The Adventure of Link	A Link to the Past	Link's Awakening DX
Ocarina of Time	Ocarina of Time 3D	Majora's Mask	Majora's Mask 3D
Oracle series	The Wind Waker	The Wind Waker HD	Four Swords
Four Swords Adventures	The Minish Cap	Phantom Hourglass	Spirit Tracks
Skyward Sword	A Link Between Worlds	Tri Force Heroes	

These octopus-like creatures fire stones from their mouths. Depending on the title, they can be found living in all manner of places, from grass to rivers and rocky hillsides. They will hide if Link draws near, preventing them from attacking. Their projectiles can also be deflected back at them. See also page 104, Big Octo, Big Octorok, Cyclok, Ergtorok, Freezard, Morpheel, Ocean Octorok, Octive, Octoballoon, Octogon, Octomine, Sky Octorok, Slarok, Winged Octorok.

▷ *Octorok* (BLUE)

| The Legend of Zelda | The Adventure of Link | Oracle series | Four Swords Adventures |

The Minish Cap

This breed of Octorok lives on land. Like more common Octoroks, it spits rocks from its mouth to protect itself. It is possible to block these rocks with even a basic shield. Blue Octoroks have slightly more health than the red variety. In *The Adventure of Link* and *Four Swords Adventures*, there are two types: those that stop in place to spit rocks, and those that move around nimbly while firing.

▷ *Octorok* (GOLDEN)

| Oracle of Seasons | The Minish Cap |

A very rare breed of Octorok. In *The Minish Cap*, fusing Kinstones will cause them to appear. Golden Octoroks drop more rupees when defeated than other varieties. They also appear in *Oracle of Seasons*.

▷ *Octorok* (PURPLE)

Four Swords Adventures

A path-blocking Octorok that appears in large groups along the coast. In groups, they will fire continuously and in unison. These coordinated assaults can be overwhelming, but their health is no different from typical Octoroks.

Odolwa

Majora's Mask

Majora's Mask 3D

The masked jungle warrior Odolwa is the boss of Woodfall Temple. He is a giant, anthropomorphic monster equipped with a sword and shield. He swings his sword and drops both blocks and insects from the ceiling to attack. He will also attack with a ring of fire.

Odolwa's Insect Minions

Majora's Mask

Majora's Mask 3D

Odolwa will call upon moths and other bugs to swarm during his battle with Link. They are attracted to fire, which Link can use to his advantage by drawing them toward lit bombs. See also Moth.

Omuai

Oracle of Seasons

Omuai is the miniboss in the Poison Moth's Lair in *Oracle of Seasons*. It lives in water and only sticks its head out to attack. Omuai typically hunt their prey in packs.

Onox

Oracle of Seasons (1)

Oracle of Seasons (2)

Onox, General of Darkness, is the final boss of *Oracle of Seasons*. Link faces him in Onox's Castle after he kidnaps Din, the Oracle of Seasons, and steals the Essences of Nature in a plot to take over Holodrum. He swings a giant, spiked ball (1) before revealing his true form: a dragon that spits flames and tears at Link with his claws (2).

Ook

Twilight Princess

Twilight Princess HD

The leader of a group of monkeys that live in the Forest Temple. Under the control of a parasite, he has captured his monkey companions and isolated them in cages. He uses the Gale Boomerang, tainted with evil power, to attack Link.

Orb Monster (BLUE)

Link's Awakening DX

Blue Orb Monsters only appear in the Color Dungeon in *Link's Awakening DX*. These one-eyed monsters carry shield-like shells in each hand. They will roll into a ball and charge when an enemy draws near. See also Evil Orb.

Orb Monster (GREEN)

Link's Awakening DX

Green Orb Monsters only appear in the Color Dungeon in *Link's Awakening DX*. These one-eyed monsters carry shield-like shells in each hand. Some puzzles in the dungeon involve throwing the Orb Monsters in a room into holes of the same color.

Orb Monster (RED)

Link's Awakening DX

Red Orb Monsters only appear in the Color Dungeon in *Link's Awakening DX*. These one-eyed monsters carry shield-like shells in each hand. They will retreat into their shells when damaged.

P | P COLUMN

Pack of Soldiers

Four Swords Adventures

In *Four Swords Adventures*, these packs of armored soldiers wield swords and shields, forming up to advance on the heroes. They deflect direct sword attacks with their extended blades. When a Chief Soldier appears alongside a Pack of Soldiers, they will attack in unison on his command. See also Chief Soldier, Soldier.

Pairodd

Link's Awakening DX

These squat birds with massive beaks are found in the Key Cavern on Koholint Island. They fire projectiles and will warp away when approached. Link requires patience when fighting a Pairodd, using long-range attacks or waiting for them to warp within reach.

Parasitic Tentacle

Ocarina of Time

Ocarina of Time 3D

Tentacles of various colors inside Lord Jabu-Jabu's Belly will reach out and attack if they detect an intruder. A tentacle's weak point, only visible when a tentacle is drawn out, is impossible to target when it retracts. In *Ocarina of Time 3D*, everything but the spiny tip of these parasites is surrounded by an electric field.

Parutamu (BLUE)

The Adventure of Link

These elite Stalfos soldiers patrol important areas in palaces throughout Hyrule. They wear horned helmets to distinguish them from weaker Stalfos and carry powerful swords. Blue Parutamu are stronger than the red versions and will repeatedly leap at Link, attacking with Downthrusts. See also Doomknocker, Stalfos.

Parutamu (RED)

The Adventure of Link

These elite Stalfos soldiers patrol important areas in palaces throughout Hyrule. They wear horned helmets to distinguish them from weaker Stalfos and carry powerful swords. Red Parutamu are weaker than blue Parutamu but still put up quite a fight. Like other Stalfos, they will only shield their upper body from attack, leaving their legs vulnerable.

Patra

See Eyesoar.

Peahat

The Legend of Zelda

Link's Awakening DX

Ocarina of Time

Ocarina of Time 3D

Majora's Mask

Majora's Mask 3D

Oracle series

The Wind Waker

The Wind Waker HD The Minish Cap Skyward Sword A Link Between Worlds

Peahats are plant- or flower-like enemies that rotate the petals and leaves on their heads to fly. Giant versions appear in *Ocarina of Time* and *Majora's Mask*. Peahats tend to have trouble staying in the air for very long before needing to land and rest: an opportune time for Link to strike. In some games, they will not attack at all, serving as obstacles, or in the case of *Skyward Sword* and *Twilight Princess*, as anchors for the Clawshot. In *A Link Between Worlds*, Peahats have cactus-like spines and are spawned by the Zaganaga desert flower. They fly around swiftly, slamming into Link and getting in the way of his fight with this Desert Palace boss. See also Seahat, Zaganaga.

Peahat (BOMB)

The Minish Cap

A blue subspecies of Peahat that only appears in *The Minish Cap*, it carries bombs as it flies around, dropping them on Link before zeroing in to attack directly.

▷ Peahat Larva

Ocarina of Time

Ocarina of Time 3D

Majora's Mask

Majora's Mask 3D

Attacking a Peahat that is sleeping in the fields at night releases a swarm of these hostile larvae instead.

▷ Pengator

A Link to the Past

Four Swords Adventures

A Link Between Worlds

A penguin-like monster that lives in caverns and colder climates. Pengators slide across icy surfaces on their stomachs to attack. While not particularly dangerous on their own, they can easily overwhelm someone when attacking in groups. See also Big Pengator.

▷ Pesto (Blue)

The Minish Cap

A fly-like monster that snatches up rocks and other objects, then drops them on their targets. See also Tiny Pesto.

▷ Pesto (Red)

The Minish Cap

A fly-like monster that charges Link from the air to deal damage. Unlike the blue variety, Red Pestos do not drop rocks.

▷ Phantom

Phantom Hourglass

Spirit Tracks

Powerful guardian warriors charged with protecting temples from would-be intruders. Their only weak point is their back, and they can only be defeated with a sacred blade. Normally, Phantoms would spare a person proven to be good, but when the Tower of Spirits is taken over in *Spirit Tracks*, they are possessed by demons and will target even heroes. See also Bellum, Swift Phantom, Torch Phantom, Warp Phantom, Wrecker Phantom.

▷ Phantom (Gold)

Phantom Hourglass

An armored soldier who searches for intruders while guarding the Temple of the Ocean King. Gold Phantoms carry axes. While slower than other Phantoms, they have the ability to teleport to Link if he is spotted by another Phantom or a Phantom Eye.

▷ Phantom Eye

Phantom Hourglass

Spirit Tracks

A small defense drone with a propeller that flies around temples, keeping watch for intruders. If they find one, they sound the alarm and try their best to keep the intruder in sight until Phantoms arrive.

▷ Phantom Ganon

Ocarina of Time

Ocarina of Time 3D

The Wind Waker

The Wind Waker HD

Four Swords Adventures

An illusory Ganon born from dark power who attacks by firing projectiles made of light. In *Ocarina of Time*, his full title is "Evil Spirit from Beyond: Phantom Ganon," the fearsome boss of the Forest Temple. In *The Wind Waker*, he is a miniboss in both Forsaken Fortress and in Ganon's Tower under the sea. In the latter fight, he will summon multiple versions of himself during the battle. Phantom Ganon is also a boss in *Four Swords Adventures*, appearing in Hyrule Castle and the Temple of Darkness. See also page 20, Ganon.

▷ Phantom Rider

Twilight Princess

Twilight Princess HD

Phantom Riders appear during the battle on horseback against the Dark Lord Ganondorf in *Twilight Princess*. When Link approaches Ganondorf's horse, Ganondorf will summon five riders to charge at Link and slow his advance. They will vanish if slashed.

▷ Phantom Zant

Twilight Princess

Twilight Princess HD

An illusory Zant fought in the eastern tower of the Palace of Twilight. He will generate enormous purple projectiles as he teleports around the tower, summoning shadow creatures and Twilight monsters. See also Zant.

▷ Phytops

Spirit Tracks

A poisonous and parasitic rose plant that serves as boss of the Ocean Temple. Its numerous tentacles covered in thorns are strong enough to break through the walls of the temple. An eye is hidden beneath a growth on its head.

▷ Pig Warrior

Link's Awakening DX

Oracle series

These monsters resemble Moblins, only more porcine. Those that carry swords will charge their enemies, while those with bows keep their distance. See also page 100, Moblin.

▷ Pikit

A Link to the Past

Pikits are similar creatures to Like Likes insofar as they lure in and swallow their prey, stealing items in the process. If they manage to swallow Link, they may steal and even destroy his shield, forcing him to find a new one. Pikits hop around to move and use their tongues to attack. See also Like Like.

▷ Pikku

A Link to the Past

Fox-like creatures that walk on two legs. They ambush Link in the Village of Outcasts in the Dark World, scattering his rupees, bombs, or arrows on the ground and stealing them. While they do not deal damage, they are also impervious to all attacks and are best avoided. Pikku are equivalent to Thieves in the Light World.

▷ Pincer

Link's Awakening DX

Oracle series

An insect with a long, narrow body and a serious set of jaws. They hide in holes in the ground, their eyes flashing the moment before they attack passersby.

▷ Piranha

Link's Awakening DX

Oracle series

Four Swords

A carnivorous Piranha fish with a giant dorsal fin on its head. It is ravenous, and will jump out of the water to attack Link. A subspecies of Piranha lives in the clouds. See also Cloud Piranha.

▷ Piranha Plant

Link's Awakening DX

A hostile plant that originally appeared in *Super Mario Bros.* Link encounters them in side-scrolling areas. Instead of pipes, they grow on pillars and platforms.

▷ Pirate Ship

Phantom Hourglass

Spirit Tracks

A sea vessel with a skull sail piloted by Miniblins. These ships appear across the open sea. In addition to firing cannons at the SS *Linebeck* from a distance, they will maneuver next to the ship so a crew of Miniblins can board. If a Pirate Ship is sunk, boat parts can be salvaged from the wreck. In *Spirit Tracks*, these special ships bearing pirate flags begin sailing the seas once the Pirate Hideout appears, battling and attempting to board the Spirit Train when Link has a passenger aboard. They attack in the same manner as Cannon Boats. If Link does not defeat one quickly enough, the ship's crew of Miniblins and Big Blins will board the passenger car. See also Big Blin, Miniblin.

▷ Pirate Tank

Spirit Tracks

Once the Pirate Hideout appears, these special tanks bearing pirate flags will appear when the hero has a passenger aboard the Spirit Train. They attack like other tanks but wave a large pirate flag to distinguish themselves. See also Big Blin, Miniblin.

▷ Pirogusu

A Link to the Past

A fish-like monster that lurks in soggy corridors of the Swamp Palace. It will drop into waterways from holes in the walls and swim straight for Link. Link must get out of the way to avoid being hit.

▷ Plasmarine

Oracle of Ages

The boss of Jabu-Jabu's Belly in *Oracle of Ages*, this giant jellyfish-like monster attacks by producing homing bubbles. Its body switches colors between red and blue when struck with the Switch Hook.

▷ Podoboo

Link's Awakening DX — *Oracle series*

A guest character from *Super Mario Bros.*, these balls of molten rock leap out of the lava in side-scrolling rooms and can only be avoided.

▷ Podoboo Tower

Oracle of Seasons

These towers of flaming Podoboo appear in Subrosia.

▷ Poe
● Poe (White)

A Link to the Past

Ocarina of Time

Ocarina of Time 3D

Majora's Mask

Majora's Mask 3D

The Wind Waker

The Wind Waker HD

Twilight Princess

Twilight Princess HD

Phantom Hourglass

A Link Between Worlds

Tri Force Heroes

The shadow of a soul that remains in the world of the living after death. They can be found floating about in graveyards and all sorts of other places. Some will leave souls behind after defeat, which can be gathered up and sold to collectors. In *Twilight Princess*, only their lantern is normally visible, and Link must use his wolf senses to see them. Poes look rather different in *Phantom Hourglass*. They haunt the decks of the Ghost Ship, where they appear seemingly out of nowhere, spouting balls of blue flame from their mouths before disappearing again. Link can hit them with his sword if he times the swings to the instant they appear. See also Amy, Beth, Big Poe, Ghini, Grim Repoe, Imp Poe, Jalhalla, Joelle, Key Bandit Poe, Lantern Poe, Margaret, Meg, Prankster Poe.

▷ Poe (BLUE)

Tri Force Heroes

A type of Poe that appears in the Ruins, abruptly disappearing and reappearing while charging the heroes. Of the three heroes, only the one who wears blue will be able to damage it with his sword.

▷ Poe (GREEN)

Tri Force Heroes

A type of Poe that appears in the Ruins, abruptly disappearing and reappearing while charging the heroes. Of the three heroes, only the one who wears green will be able to damage it with his sword.

▷ Poe (RED)

Tri Force Heroes

A type of Poe that appears in the Ruins, abruptly disappearing and reappearing while charging the heroes. Of the three heroes, only the one who wears red will be able to damage it with his sword.

▷ Poison Mite

Twilight Princess — *Twilight Princess HD*

These scattering bugs live in the Arbiter's Grounds and attack in large groups, swarming over Link when close. While they do not deal damage, they will dramatically slow Link's ability to move, making them especially dangerous when treading on quicksand.

▷ Pokey

A teetering, sentient cactus that originally appears in the *Super Mario Bros.* series. They are found in desert regions of Koholint Island and Holodrum, and can be cut down layer by layer.

Link's Awakening DX — *Oracle of Seasons*

▷ Pols Voice

The Legend of Zelda

Link's Awakening DX

Oracle series

Phantom Hourglass

These monsters have notoriously large ears. They resemble a rabbit with no arms or legs and bounce around inside the dungeons of multiple eras and timelines. They can withstand a lot of hits and are smart enough to jump out of the way of sword attacks; some are even immune to these attacks. Pols Voices are sensitive to sound and hate loud noises.

▷ Popo

A Link to the Past

Four Swords Adventures

A Link Between Worlds

A mollusk-like tentacle monster that hides in dungeons. It moves slowly toward enemies, but can take a hero by surprise by emerging suddenly from the ground. They often drop rupees upon defeat.

▷ Popo (RED)

A Link Between Worlds

A mollusk-like tentacle monster that hides in dungeons. Though capable of little more than slowly approaching a hero, it can take Link by surprise, suddenly emerging from the ground beneath his feet. Red Popo have more health and deal more damage than regular ones.

▷ Prankster Poe

Tri Force Heroes

A pale ghost with large arms and both a haircut and pointy ears that resemble the heroes'. They appear with an eerie laugh, carrying off players to toss into pits. Once grabbed, the player cannot get away on their own and need their allies' help to stop the meddlesome ghost. See also Poe.

▷ Prismantus

Tri Force Heroes

This colorful boss occupies the Grim Temple in the Ruins. The tri-colored lamps attached to its mechanical body can only be damaged by a hero of the same color. It moves about freely, sometimes flat on the ground and sometimes vertically.

▷ Puffstool

The Minish Cap

A mushroom-like monster that lives in Deepwood Shrine. It carries incredible amounts of spores and scatters them around itself for protection, releasing more every time it is struck. Areas where Puffstools live tend to be covered in spores, making it difficult to walk.

▷ Pumpkin Head

Oracle of Ages

The boss of the Spirit's Grave in *Oracle of Ages* has a jack-o'-lantern for a head. Or so it seems. Destroying his body and picking up his head reveals the small being inside who had only been masquerading as a pumpkin person.

▷ Puppet

Twilight Princess

Twilight Princess HD

A creepy puppet summoned by a Skull Kid in the Sacred Grove. They appear when he plays his flute, and will keep spawning until Link defeats the Skull Kid. The brittle puppet is made of wood and makes light clacking sounds when it moves. See also Skull Kid.

▷ Puppet Ganon

The Wind Waker

The Wind Waker HD

A bizarre puppet controlled by Ganondorf. Link must face off against this magical monstrosity as he fights his way through Ganon's Tower. It resembles the bestial form Ganondorf took in battle with the Hero of Time. Like the Ganon of that era, its weak point is its tail. After doing enough damage, Puppet Ganon transforms into a giant spider, and then a Moldorm. See also page 20, Ganon.

▷ Pyrup

Skyward Sword

A finned, fire-breathing creature commonly found in areas of extreme heat. While much larger than hermit crabs, they act much the same way, seeking out shells, holes, and even the bones of ancient creatures as homes in which to live. Pyrups are timid and hide inside their shells if Link gets too close, breathing fire to keep him away.

Q

Q COLUMN

▷ Quadro Baba

Skyward Sword

A violent plant that grows in particularly verdant regions. Quadro Babas resemble Deku Babas, but have greater attack power and health, as well as the ability to open their mouth both vertically and horizontally. The outer shells of their bulbous heads are hard, but inside they are soft and vulnerable to attack. See also Deku Baba.

R

R COLUMN

▷ Ra (BLUE)

The Adventure of Link

These stone, single-horned dragon heads appear in some palaces in *The Adventure of Link*, flying across the screen in a wave-like pattern. When Link hits one with his sword, it will be stunned for a short time, and it can be defeated with enough hits.

▷ Ra (YELLOW)

The Adventure of Link

These stony single-horned dragon heads appear in the Great Palace, the final dungeon in *The Adventure of Link*. Like the Blue Ra found in other dungeons, they move across the screen in a wave-like pattern.

▷ Ramrock

Oracle of Ages

This stony boss of the Ancient Tomb in *Oracle of Ages* floats in the air. Its giant, mechanical head is flanked by interchangeable arms that fire rocket punches and block Link's attacks while firing energy beams.

▷ Rare Chu

Twilight Princess

Twilight Princess HD

A rare, glittering Chu that leaves Rare Chu Jelly behind upon defeat. If he has an empty bottle, Link can scoop up the jelly, which has the same effect as Great Fairy's Tears. See also page 105, Chuchu.

DATABASE

ENEMIES & MONSTERS

▷ Rat

A Link to the Past | The Wind Waker | The Wind Waker HD | Four Swords Adventures

Twilight Princess | Twilight Princess HD | Phantom Hourglass | Spirit Tracks

A Link Between Worlds | Tri Force Heroes

Scurrying rodents that live primarily in darker places and often appear in groups. In *The Wind Waker*, they steal rupees by ramming into Link and biting at his heels. In *Spirit Tracks*, Princess Zelda admits that she is afraid of them. See also Dark Rat, Ghoul Rat.

▷ Rat (Blue)

A subspecies of rat that live in the Ice Cavern of *Tri Force Heroes*. They are resistant to cold and will hide inside snowballs.

Tri Force Heroes

▷ Real Bombchu

Majora's Mask | Majora's Mask 3D | The Wind Waker | The Wind Waker HD

These are not items; they are rat monsters that carry bombs. Their appearance and abilities differ by title. In *Majora's Mask*, they are rats with bombs on their tails that live in Termina Field, the road to Ikana, and in some temples. They will charge at enemies and self-destruct. In *The Wind Waker*, they are also rats, but instead of carrying the bombs on their tails, they throw them.

Four Swords Adventures

▷ Reapling

Hooded, scythe-carrying spirits of the dead who dwell in the Ghost Ship. Reaplings wander the decks, attacking anything living that wanders inside. They wield significant power and cannot be defeated, making them especially dangerous. Firing an arrow into an eye on their back will stun them.

Phantom Hourglass

▷ Rebonack

The guardian of the Island Palace who later appears as a miniboss twice in the Three-Eye Rock Palace. Rebonack, also called Guardian Iron Knuckle, is a knight selected from the kingdom's former elite corps of bodyguards. He rides a levitating metal horse that can fly, swooping in to attack with a lance in hand. After taking enough damage, he dismounts and continues the fight on foot. See also Iron Knuckle.

The Adventure of Link

▷ ReDead

Ocarina of Time | Ocarina of Time 3D | Majora's Mask | Majora's Mask 3D

The Wind Waker | The Wind Waker HD | Tri Force Heroes

These mummified corpses appear in graveyards and similarly spooky places. They stand completely still, freezing their enemies in place with a horrifying shriek, then clinging to them and biting down. The longer it takes to shake them off, the more damage they do. See also Gibdo.

▷ Remlit

Considered pets by the residents of Skyloft, these cute, furry animals are friendly during the day, but become violent at night. Though they mostly keep their four feet on the ground, they can use their ears like wings to fly for a short time.

Skyward Sword

▷ Rock Chuchu

A red Chuchu wearing a rock on its head. The rock prevents Link from using sword attacks. He must use bombs or a well-timed blow from the Hammer to smash the rock. See also page 105, Chuchu.

The Minish Cap | Phantom Hourglass

▷ Rocktite (Sand/Fire)

Two of these Rocktites serve as minibosses in *Spirit Tracks*. One is found in the Sand Realm, and serves as the first of three trials Link must overcome to reach the Sand Temple. Its entire body is covered in a hard shell, and only the eye inside its mouth can be damaged. A similar Rocktite also appears in the tunnel from the Fire Realm to the Sand Realm. Unlike the Rocktite Link fights in the Snow Realm, these creatures will close their mouths to protect the eye inside.

Spirit Tracks

▷ Rocktite (Snow)

This giant, one-eyed insect makes its home in the tunnel that connects Anouki Village to the Snow Temple and attacks the passing Spirit Train. Its entire body is covered in a hard shell, and only the eye inside its mouth can be damaged. It is akin to a miniboss, as it will doggedly pursue Link until he finishes it off.

Spirit Tracks

▷ Rolling Bones

This smiling miniboss appears in both the Tail Cave and Turtle Rock. He attacks with a rolling spike trap that spans the entire screen. Once Link jumps over the spikes, he can make short work of the relatively weak Rolling Bones.

Link's Awakening DX

▷ Rollobite

An insect-like monster that creeps along the ground. A swing of the sword won't hurt them much, but they will curl into a ball like a pillbug when struck. Rollobites fit snugly into holes in the ground, enabling Link to cross gaps and reach otherwise inaccessible areas.

The Minish Cap

Ropa

A Link to the Past

Four Swords Adventures

A Link Between Worlds

These mollusk-like monsters prefer dark, dim spaces, hence their prevalence in caves and the Dark World. They do not move much, but have more health than you might think. They occasionally appear in groups.

Rope

The Legend of Zelda

A Link to the Past

Link's Awakening DX

Oracle series

Four Swords

Four Swords Adventures

The Minish Cap

Phantom Hourglass

A Link Between Worlds

Tri Force Heroes

A monster similar to a snake found in many dungeons and caves. Ropes often appear in groups and slither around their dens with surprising speed. Alone they are relatively easy to defeat, but together, they can be overwhelming. Link may inadvertently dump a large number into a room after activating a switch, forcing a fight. See also Skullrope.

Rope (Golden)

The Minish Cap

A rare, golden type of Rope that will lunge at Link. Fusing a Kinstone will cause one to appear. Unlike their common cousins, they take more than one blow to defeat, but doing so will yield a bounty of rupees.

Rupee Guay

Skyward Sword

A rare Guay that looks like any other but flies around Skyloft carrying rupees in its talons. A nimble and highly skilled flier, the Guay will drop its rupees only if Link is able to defeat the bird within a set amount of time. Eventually, it disappears. See also Guay.

Rupee Like

● Rupee Like (Green)

Four Swords

The Minish Cap

Phantom Hourglass

A Link Between Worlds

This variety of Like Like dangles a fake rupee to lure unsuspecting victims, swallowing anyone who gets too close and stealing their hard-earned rupees. See also Like Like.

Rupee Like (Blue)

Four Swords

The Minish Cap

A Rupee Like that pretends to be a blue rupee while it lies in wait for Link. It loves rupees and uses the fake blue one on the end of its tentacle to lure and catch greedy prey. The longer it holds onto Link, the more rupees it will steal in multiples of five, making it in Link's best interest to free himself as quickly as possible.

Rupee Like (Red)

Four Swords

The Minish Cap

A Rupee Like that lures in prey by dangling a fake red rupee. When Link tries to grab it, the red Rupee Like will swallow him whole, stealing rupees in multiples of 20. The longer it holds onto Link, the more it will steal, making it in Link's best interest to free himself as quickly as possible.

S COLUMN

Sand Crab

A Link to the Past

Link's Awakening DX

Oracle series

Four Swords Adventures

A Link Between Worlds

A crab with large pincers found near bodies of water. While it moves quickly from left to right, it struggles with vertical movement. Sand Crabs do a fair amount of damage and require caution if approached, especially if Link does not yet have a ranged weapon.

Sand Mound

Tri Force Heroes

A moving mound of sand. Occasionally, Karat Crabs hide inside. The sand can be blown away using a blast from the Gust Jar. See also Karat Crab.

Sandfish

Tri Force Heroes

This subspecies of Skullfish swims through desert sand as if it was water. If approached, they will leap out to attack. See also Skullfish.

Sandworm

Phantom Hourglass

This creature lives in the sand and is sensitive to sound. See also Moldorm.

Scaldera

Skyward Sword

The Pyroclastic Fiend Scaldera is the boss of the Earth Temple in *Skyward Sword*. A giant ball of lava set as a trap in the belly of Eldin Volcano, it is transformed into a monster by Ghirahim's magic. Scaldera uses its six long arms to climb onto the bridge deep in the temple, shooting strings of giant fireballs and rolling into a ball. Its outer rock shell is hard, but its insides are vulnerable to attack.

Scervo

See LD-002G Scervo.

Scissors Beetle

The Minish Cap

The giant pincers on this beetle are almost as big as its body. They are hard as steel, and swords bounce off them with little effect. What's more, they're detachable. Scissors Beetles can actually throw their pincers like a boomerang. When they do, their bodies are left defenseless, leaving them vulnerable to attack.

▷ Sea Urchin

Link's Awakening DX Four Swords Adventures

A large sea urchin with sharp spikes. While they do not attack Link outright, they may block his path. Sea Urchins can be defeated with a single sword swing. In *Link's Awakening*, Link must push them out of the way with his shield if he isn't carrying a weapon.

▷ Seahat

The Wind Waker The Wind Waker HD

A grinning aquatic creature with propellers on its head. It flies just above the surface of the ocean, but it will still swim after Link if he cuts its propellers and it drops into the water. See also Peahat.

▷ Sentrobe

Skyward Sword

Sentrobes were built long ago exclusively to patrol the ancient Lanayru Mining Facility. They keep watch from the air, zeroing in when they spot an intruder. With both a direct projectile attack and homing bombs that fire from their sides, Sentrobes can cause a lot of damage if intruders aren't careful. They are weak to their own projectiles being volleyed back at them.

▷ Shabom

Ocarina of Time Ocarina of Time 3D

Shaboms float around the living corridors of Jabu-Jabu's Belly and resemble soap bubbles. They are easily popped with Deku Nuts.

▷ Shadow Beast

Twilight Princess Twilight Princess HD

These denizens of the Twilight Realm serve as King Zant's vanguard. Originally Twili, they have been transformed by Zant into monsters. They always appear in a group of at least three, and if even one remains, it will yell and revive its allies.

▷ Shadow Bulblin

Twilight Princess Twilight Princess HD

Shadow monsters that stalk the fields and roadways of the Twilight Realm. They will attack any enemies they see on their patrol. Some use clubs for close combat, while others keep their distance and attack with bows. See also page 100, Bulblin.

▷ Shadow Deku Baba

Twilight Princess Twilight Princess HD

These shadow monsters resembling Deku Babas appear in Twilight. They generally hide in grass and emerge when an enemy draws near. There are two types: those that die after having their stems severed, and those that live on to continue the fight when cut from the ground. See also Deku Baba.

▷ Shadow Hag

Oracle of Ages

The boss of Moonlit Grotto in *Oracle of Ages*, Shadow Hag can freely transform into a shadow and move along the ground, avoiding attacks. She will reveal herself when Link turns his back on her.

▷ Shadow Insect

Twilight Princess Twilight Princess HD

These insects born of the Twilight Realm steal the Tears of Light, which Link must collect in the Vessel of Light to revive the Spirits of Light and dispel the Twilight from Hyrule. Their true form cannot normally be seen in Twilight areas, but Wolf Link's senses can detect them. In addition to flying around, they also scurry along the ground to hide. See also Twilit Bloat.

▷ Shadow Kargarok

Twilight Princess Twilight Princess HD

Flying monsters that appear throughout the Twilight Realm. They resemble the Kargaroks found in Link's world, but instead of beaks or eyes, their faces glow red like other shadow creatures in the Twilight. Similar to Kargaroks, Shadow Kargaroks dive rapidly in attack when they spot prey. See also Kargarok.

▷ Shadow Keese

Twilight Princess Twilight Princess HD

Shadow monsters similar to a Keese that appear in the Twilight Realm and the Palace of Twilight. Like regular Keese, they typically cling to walls and ceilings, taking flight when someone gets too close. A well-timed swing of the sword or a projectile will bring them down as they move in to attack. Wolf Link can also bite them out of the air. See also Keese.

▷ Shadow Link
● Link's Shadow

The Adventure of Link Four Swords Adventures A Link Between Worlds Tri Force Heroes

A malevolent shadow of Link that possesses his abilities. In *The Adventure of Link*, this shadowy figure represents the evil within made manifest and serves as the final boss in the Valley of Death. After defeating Thunderbird, guardian of the Great Palace, Link must face himself in a final trial. Link's Shadow is quick and agile, just like Link, and shares all his attacks. In *A Link Between Worlds*, Shadow Links attack via StreetPass. A Shadow Link also appears in *Tri Force Heroes* as the final boss of the Den of Trials and in *Four Swords Adventures* as a creation of the Dark Mirror, said to be born of Ganondorf's eternal resentment at being defeated by the hero. See also page 98, Dark Link.

▷ Shadow Nightmares

Link's Awakening DX (1) Link's Awakening DX (2) Link's Awakening DX (3) Link's Awakening DX (4)

Link's Awakening DX (5) Link's Awakening DX (6)

Manifestations of the Wind Fish's nightmares that battle Link inside the Wind Fish's Egg. At first, they take the form of enemies Link faced in *A Link to the Past*, including a Bot (1), Agahnim (2), Moldorm (3), and Ganon (4). The fifth Nightmare, sometimes referred to as Lanmola (5), is a small shadow that moves in arcs and charges at Link. The final Nightmare takes a form that is harder to place. Sometimes called DethI (6), it is a menacing black mass with two spike-tipped arms and a yellow eye that occasionally opens in its center, proving to be its weak point.

▷ Shadow Vermin

Twilight Princess Twilight Princess HD

A spider-like monster that appears in areas covered in Twilight. They are often found in underground waterways. Although individually not very powerful, they pose a threat when attacking in groups, especially in narrow passages.

▷ Sharp the Elder

Ocarina of Time Ocarina of Time 3D Majora's Mask Majora's Mask 3D

A cursed, spectral conductor and half of Hyrule's Composer Brothers. In *Ocarina of Time*, this mustachioed ghost carries a lantern and a conductor's baton. He also appears in the Ikana region of *Majora's Mask*. A curse has turned Sharp violent, and he will conduct cursed songs, but he can be purified with the Song of Storms taught by his brother, Flat. See also Flat the Younger.

▷ Shell Blade

Ocarina of Time

Ocarina of Time 3D

Majora's Mask

Majora's Mask 3D

Twilight Princess

Twilight Princess HD

A clam-like creature found in aquatic areas. It will clamp down the sharp edges of its shell and lunge at Link to protect itself. The membrane inside its shell is its weak point.

▷ Shell Jelly

Twilight Princess

Twilight Princess HD

Chu-like jelly monsters that contain Chu Worms. They absorb sword and arrow attacks. Link must draw out the worm inside in order to destroy both the jelly and worm. See also Chu, Chu Worm.

▷ Shield Moblin

See Sword Moblin/Spear Moblin.

▷ Shrouded Stalfos

Link's Awakening DX

Oracle series

A skeletal monster draped in robes that appears in some dungeons. They attack by throwing spears. See also Stalfos.

▷ Shy Guy

See Mask-Mimic.

▷ Sir Frosty

Spirit Tracks

These sentient snowmen live in the Snow Realm and are often found near Spirit Tracks. They look cute at first glance, but they are fearsome enemies who will remove their own heads to lob at the Spirit Train. Another head will form after a short period of time. Unprepared for close combat, they will flee if Link approaches.

▷ Skeldritch

Spirit Tracks

The boss of the Sand Temple, where the Light Arrows needed to defeat Malladus are kept. An ancient demon, Skeldritch resembles a skull with an unnaturally long neck that pokes out of the sand. Its neck is clad in thick armor, making it that much harder to fight as it shoots rocks and fires beams at Link.

▷ Skull Kid

Ocarina of Time

Ocarina of Time 3D

Majora's Mask

Majora's Mask 3D

The monstrous form taken on by a child lost in the forest. Skull Kids hate adults and love pranks. They wander the Lost Woods of both *Twilight Princess* and *Ocarina of Time*, and will not attack Link when he is a child in the latter. In *Majora's Mask*, a Skull Kid is possessed by the mask and sows evil across Termina under its influence. See also page 102, Puppet, Stalfos.

Twilight Princess

Twilight Princess HD

▷ Skullfish

Majora's Mask

Majora's Mask 3D

Twilight Princess

Twilight Princess HD

Tri Force Heroes

These monstrous fish skeletons are found in waters across Hyrule in certain eras. They sometimes attack in groups, swarming like undead Piranhas. Link can catch Skullfish when fishing in both *Majora's Mask* and *Twilight Princess*. See also page 102, Bago-Bago, Desbreko, Fire Bago-Bago, Sandfish, Stalfos.

▷ Skullrope

A Link to the Past

A Link Between Worlds

Tri Force Heroes

These unsettling Ropes with skulls for heads reside in the Dark World of *A Link to the Past*, the Ruins of *Tri Force Heroes*, and Lorule in *A Link Between Worlds*. In certain dungeons, pulling the wrong lever can sometimes release a den of them. See also page 102, Rope, Stalfos.

▷ Skulltula

Ocarina of Time

Ocarina of Time 3D

Majora's Mask

Majora's Mask 3D

Twilight Princess

Twilight Princess HD

Phantom Hourglass

Spirit Tracks

A giant spider with a skull pattern on its body. They lie in wait for passing prey, hanging by silken thread from ceilings and trees. Skulltula come in many types, varying in size and color at times in the same game. See also Big Skulltula, Walltula.

Skyward Sword

▷ Skulltula (GOLD)

Ocarina of Time

Ocarina of Time 3D

Majora's Mask

Majora's Mask 3D

A golden, glittering Skulltula that clings to dungeon walls. Its nocturnal nature may also drive it to hide in boxes and jars. A unique noise can be heard when nearing one. Defeating them rewards Link with items that vary by title.

▷ Skulltula (RED)

Spirit Tracks

A giant breed of Skulltula that lives in forests and other places rich in plant life. They drop down from the sky to block the Spirit Train's route. If Link does not shoot them down with the cannon, they will collide with the train and deal damage. Red Skulltulas have more health than ordinary ones.

▷ Skullwalltula

See Walltula.

▷ Sky Ball and Chain Soldier

Tri Force Heroes

These elite soldiers guard the Sky Realm, where Lady Maud makes her home. They boast greater skill than the soldiers who patrol the Fortress below, swinging around iron balls attached to chains. Heroes are wise to keep their distance, especially from the Sky Soldiers that wield balls covered in flames, or they will suffer long-term consequences. See also Soldier.

▷ Sky Bomb Soldier

Tri Force Heroes

An elite soldier that guards the Sky Realm where Lady Maud makes her home. They boast greater skill than the soldiers who patrol the Fortress below, lobbing a seemingly endless stream of bombs at their enemies while moving in on them. However, a lack of sword or shield means they have trouble defending themselves in close combat. See also Soldier.

▷ Sky Fire Chain Soldier

See Ball and Chain Soldier (Gold).

▷ Sky Guardian

Skyward Sword

A Guardian of the Silent Realm that flies through the air in pursuit of all trespassers. If Link is struck by one, his spirit will shatter. Sky Guardians cannot be defeated, but they will stop moving for a time when Link finds one of the Sacred Tears scattered throughout the realm. See also Earth Guardian.

▷ Sky Octorok

Skyward Sword

A subspecies of Octorok that has grown leaves on its head. It lives on rocks floating in the sky, and will spit stones at passing Loftwings. See also page 104, Octorok.

▷ Sky Sword Soldier

Tri Force Heroes

These elite soldiers guard the Sky Realm where Lady Maud makes her home. Each one carries unique weapons and armor to stop intruders: a sword, shield, or spear. They boast greater skill than the soldiers who patrol the Fortress below. They have different colors of equipment depending on their class: sword wielders have green equipment, while shield users have blue and spear users have red. See also Soldier.

▷ Sky Watcher

Skyward Sword

These Watchers resemble spirits as they patrol the Silent Realm, illuminating the ground from the air. They follow a set route and will summon Guardians if an intruder steps into their light. See also Earth Watcher.

▷ Skytail

Skyward Sword

These flying insects have long bodies and live inside large clouds. If they spot a Loftwing, they will move behind it and attack.

▷ Slarok

A Link to the Past A Link Between Worlds

An Octorok that has wandered into the Dark World. It is also found in Lorule. Slaroks move swiftly, and much like their Light World counterparts, spit stones at anyone who gets near them. See also Octorok.

▷ Slime

● Zol (Blue)

A Link to the Past Four Swords Adventures

The form a monster is reduced to when Link uses Magic Powder or a Quake Medallion in *A Link to the Past* or *Four Swords Adventures*. The gooey mess will attempt to slam into Link, but they are slow and can be stopped in a single hit. See also Zol.

▷ Slime Eel

Link's Awakening DX

The boss of Catfish's Maw is a monstrous sea snake. It sticks its head out from holes in the walls, and attacks by swinging its tail around from a hole in the center of the room. To damage it, Link must first pull it out from the wall. Sometimes the creature will trick Link into instead pulling out an explosive.

▷ Slime Eye

Link's Awakening DX

The boss of the Key Cavern, this giant, single-eyed Zol clings to the ceiling, dropping Zols on Link. Running into the walls will knock it off the ceiling, putting it in reach of Link's sword. Repeated attacks split the Slime Eye into smaller versions of itself and shake the ground beneath Link's feet. See also Zol.

▷ Slime Minion

Phantom Hourglass

These creatures are made from slime excreted by the Evil Phantom, Bellum, during his battle with Link at the end of *Phantom Hourglass*. See also Bellum.

▷ Sluggula

A Link to the Past The Minish Cap A Link Between Worlds

In *A Link to the Past* and *A Link Between Worlds*, these slugs will drop bombs as they crawl along the ground. In *The Minish Cap*, they sometimes drop from the ceiling. Link encounters them in the latter title when he's Minish size, so they appear quite large.

▷ Smasher

Link's Awakening Oracle of Ages

These monsters resemble stingrays and throw iron balls at Link. In *Link's Awakening*, a Smasher serves as a miniboss in the Face Shrine, while a similar creature is miniboss of the Crown Dungeon in *Oracle of Ages*.

▷ Smog

Oracle of Ages

This Crown Dungeon boss in *Oracle of Ages* resembles a drifting cloud and fires lightning from its mouth. Smog will split apart and move along blocks placed around the room, preventing itself from taking damage until Link brings it back together using the blocks.

▷ Snap Dragon

A Link to the Past A Link Between Worlds

A large, walking plant with a snapping mouth. Snap Dragons patrol the Dark World in *A Link to the Past* and Lorule in *A Link Between Worlds*, moving in a diagonal pattern when enemies draw near. They do considerable damage.

Snapper

Spirit Tracks

Whip-wielding enemies that appear in the Ocean Temple and wear masks. They use their whips to bind their targets, reeling them in for a fight.

Snapper (Mount)

Majora's Mask *Majora's Mask 3D*

Not to be confused with the Snappers from *Spirit Tracks*, these turtle monsters frequently serve as mounts for Gekkos. Their shells are so strong, no attack can penetrate them, but their undersides are particularly vulnerable to attack. See also Gekko.

Snowball Hinox

A Link Between Worlds

A one-eyed giant that lives in snowy areas like Death Mountain. They make snowballs and throw them at Link. Hinox are strong and resilient, requiring a good deal of effort to defeat. Those found in colder climes are resistant to ice attacks. See also Hinox.

Snurglar

Spirit Tracks

A subspecies of Snurgle that appears along the Spirit Tracks near the temple in the Fire Realm. They resemble small red elephants and flap their ears to fly. There are three of them in all, and each carries a key to the temple. They hate the sound of the Spirit Train's whistle when it sounds a short note followed by a long one. See also Snurgle.

Snurgle

Spirit Tracks

A strange creature resembling an elephant with a round body, long nose, and giant ears. It flaps its ears to fly, and will attempt to steal materials Link is hauling in the Spirit Train. The large ears mean it hates loud noises, so blowing the Spirit Train's whistle will drive it away.

Soldier (Blue)

● Sword Soldier (Blue) / ▲ Bow Soldier (Blue) / Sword Soldier (Blue)
■ Bow Soldier (Blue) / Sword Soldier (Blue)

A Link to the Past *Four Swords Adventures* *A Link Between Worlds* *A Link Between Worlds*

Blue-armored enemy soldiers who wield swords or bows. They are more powerful than soldiers in green armor. Blue Soldiers will drop a blue rupee upon defeat. In *A Link Between Worlds*, they were originally Lorulean soldiers summoned by Yuga. Some in *Tri Force Heroes* carry large shields. See also Ball and Chain Soldier, Bomb Soldier, Chief Soldier, Lorule Ball and Chain Soldier, Pack of Soldiers, Sky Ball and Chain Soldier, Spear Soldier.

Tri Force Heroes *Tri Force Heroes*

Soldier (Green)

● Sword Soldier (Green)

A Link to the Past *Four Swords Adventures* *A Link Between Worlds* *Tri Force Heroes*

Enemy soldiers wearing green armor that carry a variety of weapons, including swords, spears, and bows. They appear in a variety of places both inside some dungeons and in the field. While they have less health than other soldiers, green Soldiers can still get the best of Link if he's not careful.

Soldier (Grey)

Four Swords Adventures

A soldier clad in armor carrying a sword and shield. Grey Soldiers are the strongest class to appear in *Four Swords Adventures*. They gradually approach with their swords extended and deflect direct attacks.

Soldier (Red)

● Spear Soldier / ▲ Spear Throwing Soldier

Four Swords Adventures *A Link Between Worlds* *Tri Force Heroes*

These red-armored enemy soldiers use spears and javelins in battle with Link. Elite soldiers, they have greater health and attack power than green or blue Soldiers. Red Soldiers often drop red rupees upon defeat.

Spark

Link's Awakening DX *Oracle series* *The Minish Cap*

These round balls of electricity move along the walls of dungeons and caverns. Striking one with the Boomerang will turn it into a fairy.

Spear Moblin

See Moblin.

Spear Soldier

● Spear Throwing Soldier

A Link to the Past *A Link Between Worlds* *Tri Force Heroes*

These enemy soldiers are clad in thick red armor and wield spears or javelins. Their health is extremely high compared to other soldiers. See also Soldier.

Spike

Ocarina of Time *Ocarina of Time 3D* *Majora's Mask* *Majora's Mask 3D*

Disguising themselves as rocks, these monsters will gradually move closer to a target, then release their spikes.

Spiked Beetle

Link's Awakening DX *Oracle series* *Four Swords* *The Minish Cap*

A spiny character that originally appeared in the *Super Mario Bros.* series. These creatures have a hard shell covered in spikes that swords cannot damage. They will charge at Link if he gets too near, but they can be flipped over by blocking their advances with a shield or by using certain equipment, exposing their weak underbelly.

Spiked Thwomp

Link's Awakening DX *Oracle series*

A stone Thwomp covered in spikes that waits amid the rocks of underground dungeon passages. Thwomps will crush anything that walks underneath them, but their tops are flat, allowing Link to step over them. See also Thwomp.

Spinut

Spirit Tracks

These small, chestnut-shaped monsters live in the Forest Realm. They wander the fields and will rush any enemies they spot, dealing damage by bumping into them. Spinuts are quite slow, so it is easy to intercept their attacks or just avoid them.

Spinut (Green)

Spirit Tracks

A subspecies of Spinut, a monster that resembles a chestnut. They behave much like regular Spinuts, but tend to be bigger and slightly tougher. They appear in groups along with Spinuts in the Forest Temple of *Spirit Tracks*.

Spiny Beetle
● Hoarder

A Link to the Past · *Link's Awakening DX* · *Oracle series* · *Four Swords*

The Minish Cap

This insect-like monster will hide under grass, rocks, and even skulls. It normally remains still, pretending to be a plant or rock, but will start moving if Link gets too close. In *A Link to the Past*, they are cowardly and will not hurt Link, but following *Link's Awakening*, they grow hostile and charge to attack.

Spiny Chuchu

The Minish Cap

A particularly spiny Chuchu made of gray jelly that will defend itself with spikes. Most attacks will have little effect when its spikes are out, but it can be stunned with a Spin Attack while its spikes are retracted, leaving it vulnerable to attack for a short time. See also page 105, Chuchu.

Squiddy

Phantom Hourglass · *Spirit Tracks* · *Tri Force Heroes*

A harmless monster shaped like a squid that drops rupees when attacked. They will split into two after enough hits and will vanish if they fall into the water. In *Tri Force Heroes*, Squiddies mainly float around the end of stages, and while they do not split, they will drop increasingly valuable rupees the more they are struck.

Stag Beetle

Phantom Hourglass

A small, spider-like monster that wears a mask, making it immune to direct attacks. Link must flank it to land a proper blow.

Stagnox

Spirit Tracks

This boss of the Forest Temple resembles a rhinoceros beetle. Known as the Armored Colossus, it flies through the air and charges Link with the giant horn on its head. It also emits a poisonous gas, making it difficult to approach.

Stal

A Link to the Past · *A Link Between Worlds*

These monsters that resemble skulls lie still on the ground, waiting for someone to approach. They will leap and gnash their teeth at anyone who disturbs them.

Stalblind

A Link Between Worlds

Stalblind is the leader of a group of thieves in the aptly named Thieves' Hideout beneath the Village of Outcasts in central Lorule. He guards the painting of the sage Osfala and imprisoned his Thief Girl subordinate because she discovered its location. In addition to wielding a giant sword and shield, Stalblind will send his head spinning around the room, spewing darkness out of his mouth. See also Blind the Thief.

Stalchampion

Tri Force Heroes

The boss of the Desert Temple in the Dunes boasts kingly stamina and strength, even among Stalfos. He freely uses his bracelets and the iron ball on his left arm to perform swift, devastating attacks, rampaging around the ring. Even if his body is destroyed, his head will keep attacking. See also page 102.

Stalchild

Ocarina of Time · *Ocarina of Time 3D* · *Majora's Mask* · *Majora's Mask 3D*

Four Swords · *Twilight Princess* · *Twilight Princess HD*

A Stalchild is a squat skeletal creature with long teeth and longer arms. It crawls up from underground at night in *Ocarina of Time* and disappears come morning, leaving behind rupees. In *Majora's Mask*, they appear as the spirits of dead soldiers from Ikana Kingdom, and carry spears in *Twilight Princess*. See also page 102.

Staldra

Skyward Sword

These Hydra-like monsters have three skulls in place of heads. When one head is cut off, it will grow back, forcing Link to find a way to destroy all three at once. Staldras are said to have existed since ancient times. See also page 102.

Stalfos

● Stalfos (Blue) / ▲ Stalfos (Orange)

The Legend of Zelda

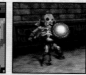
A Link to the Past

Link's Awakening DX

Ocarina of Time

Ocarina of Time 3D

Oracle series

The Wind Waker

The Wind Waker HD

Four Swords Adventures

Twilight Princess

Twilight Princess HD

Phantom Hourglass

Spirit Tracks

Skyward Sword

A Link Between Worlds

Tri Force Heroes

These skeletal warriors appear across many titles with a wide variety of skills. Many carry weapons like swords or shields. Some can dodge attacks with backward jumps, fire beams from their swords, or even throw their own heads. Stalfos can prove tricky in a fight, pretending to be ordinary skeletons and, in some cases, reassembling themselves if smashed apart. In *A Link to the Past* and the *Oracle* series, a wide variety of Stalfos appear in multiple colors. In the former game, Yellow Stalfos can throw their own heads at Link. In the latter series, Orange Stalfos can jump and toss bones, while the green variety found only in *Oracle of Seasons* will jump right on Link to attack. See also page 102, Big Dark Stalfos, Blue Stalfos, Bubble, Captain Keeta, Dark Stalfos, Gibdo, Igos du Ikana, Master Stalfos, Parutamu, Shrouded Stalfos, Skull Kid, Skullfish, Skullrope, Sword Stalfos.

Stalfos (Blue)

The Adventure of Link

Oracle series

The Minish Cap

In the *Oracle* series, these skeletal blue warriors are the least powerful of the four varieties that appear. Unlike in *The Minish Cap* they cannot jump to avoid his attacks. In *The Minish Cap*, Link can snatch their heads away with the Gust Jar, making them unable to see him.

Stalfos (Red)

The Adventure of Link

A Link to the Past

The Minish Cap

They dodge attacks by jumping backward and will go as far as to throw their own bones to attack Link. In *The Adventure of Link*, they are not skilled at defending with a shield, so their legs are exposed to attack.

Stalfos Knight

A Link to the Past

These enemies ambush Link from above, and jump to attack Link. Using a sword alone will only buy a little time. A bomb will destroy it for good.

Stalfos Warrior

A skeletal warrior equipped with a sword and helmet. They pretend to be ordinary skeletons. But when enemies step too close, they spring up and attack with everything they have—even their own heads. See also page 102.

Phantom Hourglass / *Spirit Tracks*

Stalhound

Twilight Princess / *Twilight Princess HD*

These skeletal dogs dig up from beneath the ground in Hyrule Field near the entrance to the Castle Town at night. They are often alone when Link encounters them, but some occasionally appear in packs. A pack of Stalhounds steal a Wooden Statue that Link must recover to help restore Ilia's memory.

Stallord

Twilight Princess / *Twilight Princess HD*

The Twilit Fossil Stallord is the reanimated skeleton of an ancient horned beast. Piercing its skull with Zant's sword granted it the power of shadow and returned it to being. After Link destroys Stallord's body, its head flies through the air shooting fireballs at Link. See also page 102.

Stalmaster

Skyward Sword

This skeletal commander with four arms appears as a miniboss in both Sky Keep and the Ancient Cistern. It only uses two of its arms at first, but when the fight proves serious, it goes all out and uses all four, wielding a different weapon in each. See also page 102.

Staltroop

Twilight Princess / *Twilight Princess HD*

These dead soldiers in tattered uniforms appear in the fight against Stallord in the Arbiter's Grounds. They crawl up from the sand around Stallord and stand in place, getting in the way of Link's attacks with the Spinner. See also page 102.

Star

Link's Awakening DX

A star-shaped monster that appears in Koholint dungeons. They spin at high speeds and dash around the room, but can be easily defeated with a few well-timed swings of the sword.

Stinger

Ocarina of Time / *Ocarina of Time 3D*

This stingray-like monster normally lives in water, but it will leap out and attack any passersby.

Stone Arrghus

Four Swords Adventures

In the heart of the Eastern Temple lies this giant, possessed boulder. Protected by smaller Stone Arrghus that surround its giant form, it will bounce wildly off walls, putting the party at great peril. See also Arrghus.

Stone Elevator

Link's Awakening DX

A heavy stone creature that acts as an elevator in Bottle Grotto in *Link's Awakening* and *Link's Awakening DX*. It's impossible to hurt these stubborn enemies. They block Link's path and will not descend unless he loads additional weight on their backs. See also Thwomp.

Stone Hinox

Link's Awakening DX

This miniboss appears in the Color Dungeon of *Link's Awakening DX*. Its entire body is made of rock, making its movements slow and heavy. Each hit will anger it, causing rocks to fall from above. See also Hinox.

Subterror

Oracle of Ages

The miniboss of Moonlit Grotto in *Oracle of Ages*. It is a mole-like monster, with a drill for a nose that it uses to bore through the sand and charge at Link.

Super Aeralfos

Tri Force Heroes

The final enemy to stand in the heroes' way in the Sky Temple just before the final battle with Lady Maud. They are an especially powerful breed of Aeralfos found nowhere else that breathe fire and dive from the skies clutching golden swords and shields. See also Aeralfos.

Swamola

A Link to the Past · *A Link Between Worlds*

These green, spotted bugs appear in *A Link to the Past* and *A Link Between Worlds*, leaping from the swamp to attack Link with pincers. See also Flamola.

Swift Phantom

Phantom Hourglass

This type of Phantom wears red armor and patrols the Temple of the Ocean King. It gets its name from its speed, as it is the fastest among all Phantoms. See also Phantom.

Swoop

Oracle of Ages

An airborne miniboss from the Wing Dungeon in *Oracle of Ages*. This winged dragon flies around the room, and is named for its favored tactic of diving down to attack dungeon trespassers.

Sword Moblin/Spear Moblin

● Metal Shield Moblin / ▲ Shield Moblin

Link's Awakening DX · *Oracle series* · *Skyward Sword* · *A Link Between Worlds*

These Moblins not only carry weapons but also shields to protect themselves. They cannot be damaged from the front, so Link must remove their shields or use an item like a bomb to get around it. See also page 100, Moblin.

Sword Soldier

See Soldier.

Sword Stalfos

Link's Awakening DX · *Oracle series*

A skeletal monster draped in robes that appears in some dungeons. They attack with swords, and in the case of *Link's Awakening*, a shield. See also page 102, Stalfos.

Syger

Oracle of Seasons

The tiger-like miniboss of Unicorn's Cave in *Oracle of Seasons* curls its body into a ball to attack. The red jewel at the end of its tail is its weak point.

Tailpasaran

Ocarina of Time · *Ocarina of Time 3D*

This burrowing, tapeworm-like monster emits electricity and is found living inside Lord Jabu-Jabu's Belly. Touching or slashing them will give Link a shock, making the Boomerang his best shot at defeating one without getting hurt.

Takkuri

Majora's Mask · *Majora's Mask 3D* · *The Minish Cap*

A strange bird that slams into people to steal from them. In *Majora's Mask*, it works with the Curiosity Shop, which sells the items the bird steals. In *The Minish Cap*, it resembles a red crow, scattering Link's rupees on the ground whenever it hits him. See also Crow.

Tank

Spirit Tracks

A tank with a giant gun attached. Several will pursue the Spirit Train at once, firing repeatedly and aggressively. Link can destroy one by landing two hits with the cannon.

Taros (BLUE)

A Link to the Past · *A Link Between Worlds*

These bull-like soldiers walk on two legs and appear in the Dark World and Lorule. They carry training spears and will chase after any enemy they encounter.

Taros (RED)

A Link to the Past · *A Link Between Worlds*

These bull-like soldiers walk on two legs and appear in the Dark World and Lorule. They carry tridents and will chase after any enemy they encounter.

Technoblin

Skyward Sword

A type of Bokoblin that is equipped with a mechanical mask and an electrified club said to have been fashioned by an ancient, advanced civilization. Technoblins will block Link's attacks with their clubs; striking one with a sword will both damage and shock him. Apparently, their outfit was all the rage among Bokoblins back in the day. See also page 100, Bokoblin.

Tektite

The Adventure of Link · *Link's Awakening DX* · *Oracle series* · *Four Swords*

Spirit Tracks · *Tri Force Heroes*

A bug-like monster with four legs and a single eye that leaps around wildly in a fight. Its erratic movements make it hard to read, leaving Link open to damage almost at random. It's best to take these on with sword drawn and swinging. See also Water Tektite.

Tektite (Blue)

The Legend of Zelda

A Link to the Past

Ocarina of Time

Ocarina of Time 3D

Majora's Mask

Majora's Mask 3D

Oracle series

Four Swords Adventures

The Minish Cap

Twilight Princess

Twilight Princess HD

Phantom Hourglass

A Link Between Worlds

A blue version of a leaping, bug-like Tektite. The difference in ability between this and its red-bodied counterpart varies by title. In some eras, there is no difference beyond aesthetics. In *Ocarina of Time* and *The Minish Cap*, blue ones have more health.

Tektite (Golden)

The Minish Cap

A rare, golden type of one-eyed Tektite. They jump around at random, making them difficult to attack. Fusing a Kinstone will cause these insects to appear. Defeating one yields many rupees.

Tektite (Red)

The Legend of Zelda

A Link to the Past

Ocarina of Time

Ocarina of Time 3D

Four Swords Adventures

The Minish Cap

Twilight Princess

Twilight Princess HD

A red version of a leaping, bug-like Tektite. The difference in ability between this and its blue-bodied counterpart varies by title. In some eras, there is no difference beyond aesthetics. In *A Link to the Past* and *Phantom Hourglass*, red ones have more health.

Phantom Hourglass

A Link Between Worlds

Tentalus

A giant sea monster, with sharp teeth, a single eye, and hair like tentacles, that attacks the Sandship on the Lanayru Sand Sea. This Abyssal Leviathan is said to have once controlled the ancient sea where the desert now stands, and it serves as boss for the Sandship. While its tentacles can be cut off, they will quickly grow back.

Skyward Sword

Terrorpin

A Link to the Past

Four Swords Adventures

Phantom Hourglass

A Link Between Worlds

A thick turtle shell with a pair of sinister eyes peering out of the hole where a head might normally appear. The hard shell repels most weapons, but they can be immobilized and exposed to attacks if flipped with the Hammer. In *Tri Force Heroes*, they may stack on top of each other to form totems.

Tri Force Heroes

The Imprisoned

See Imprisoned, The.

Them/They

See Ghost.

Thief

A Link to the Past

Four Swords Adventures

Thieves will target Link, running into him and scattering inventory items on the ground in an attempt to steal them. While this act won't hurt Link, it will lighten his load. What's more, thieves can't be defeated outright, only avoided. In *Four Swords Adventures*, they hide in Kakariko Village causing trouble.

Three-of-a-Kind

Link's Awakening DX

A dungeon monster with a stomach that displays playing card symbols. They will always appear in groups of three. Attacking one stops the revolving suits on its belly. The lot can only be defeated when all three have the same mark displayed. If defeated when showing hearts, they will drop hearts, while diamonds will drop rupees. Clubs and spades leave nothing.

Thunder Keese

Skyward Sword

A bat that surrounds itself in electricity produced through a unique internal organ and conducted via specifically adapted cells. Though it is generally a weak enemy, touching a Thunder Keese while it is electrified will shock Link and prevent him from moving for a short time. They can prove overwhelming in groups. See also Keese.

Thunderbird

The Adventure of Link

This powerful guardian protects the Triforce of Courage in the Great Palace. It is an artificial life form created by the king of Hyrule, flying through the air while shooting fireballs at anyone who dares challenge it. Link is unable to damage Thunderbird until he uses Thunder magic to break its barrier. The more damage it takes, the more fireballs it will unleash.

Thwomp

Link's Awakening DX

Oracle of Seasons

Four Swords Adventures

A guest character from the *Super Mario Bros.* series. They appear in the Tower of Winds, the final stage of *Four Swords Adventures*. Similar to their source, they hover in the air and slam down to crush anyone who walks underneath them. Thwomps also appear in *Link's Awakening* and *Oracle of Seasons*, though they are smaller and have only one eye. In *Link's Awakening*, Link encounters a long chain of them and must figure out a way to run through without being crushed. See also Head Thwomp, Mega Thwomp, Spiked Thwomp, Stone Elevator.

Tile Worm

Twilight Princess

Twilight Princess HD

A many-legged worm that lives underneath floor tiles in the Forest Temple and the City in the Sky. As their name implies, they make their homes underneath floor tiles, springing up and launching Link into the air when he steps on them. They leave themselves vulnerable to attack after popping up and have trouble lifting anything heavier than a person.

Tiny Pesto

The Minish Cap

These mini versions of Pestos are found on Mount Crenel where the green beanstalks grow. They are small and easily ignored when Link is his regular size, but when shrunk down, he can only dream of defeating one. See also Pesto.

Toado

Twilight Princess *Twilight Princess HD*

A small tadpole spawned by the Deku Toad miniboss during a battle in Lakebed Temple. They swim rapidly toward Link, slamming into him in groups to get in his way.

Toadpoli

Twilight Princess *Twilight Princess HD*

These tadpole-like monsters live in the more watery dungeons of *Twilight Princess*. They swim through the water, firing projectiles from their mouths to attack. Link can deflect their projectiles back at them or target them with arrows. See also Fire Toadpoli.

Toppo

A Link to the Past

These rabbit-like creatures have large ears and jump about in areas with tall grass. If Link cuts the grass around where they land, they will stop moving and begrudgingly admit defeat, leaving behind hearts or rupees before disappearing.

Torch Phantom

Spirit Tracks

This Phantom guards the Tower of Spirits wielding a flaming sword. Found patrolling pitch-black rooms, they carry their swords like torches, illuminating the corridors while keeping an eye out for intruders. Apparently, some of the Torch Phantoms are afraid of the dark; others seem to almost enjoy it. See also Phantom.

Torch Slug

Ocarina of Time *Ocarina of Time 3D* *Twilight Princess* *Twilight Princess HD*

A slug monster that generates flames. They mainly live in volcanic areas. In *Ocarina of Time*, these creatures can be flipped over using the Megaton Hammer. In *Twilight Princess*, they crawl on ceilings and will drop down onto passersby.

Totem Armos

Tri Force Heroes

A tall statue with a massive stone eye and a flat top that can be controlled if scaled. Moblins and other enemies ride these hopping totems. Defeating its pilot will cause the statue to hop around frantically and explode. If a Totem Armos has no pilot, it is possible for a hero to get on and control it. See also Armos.

Totem Deku

Tri Force Heroes

A type of Deku Scrub unique to *Tri Force Heroes*. If a hero happens by it, the Totem Deku will rise up from beneath the ground on layer upon layer of plants and fire Deku Seeds to protect itself. It is wary of close combat and will dive into the ground the instant an enemy gets too close. See also page 50, Deku Scrub.

Trinexx

A Link to the Past

This three-headed turtle monster serves as boss for Turtle Rock. Link must first target its red and blue heads, which shoot fire and ice respectively. Once dealt with, its shell will crack and the snake-like creature within will reveal itself, continuing the fight.

Turtle Rock

Link's Awakening DX

To enter Turtle Rock, Link must first take on this eponymous, crocodile-like creature. Initially immobile, it will start to move when Link plays the Frog's Song of Soul. It weaves left and right with its long neck, then snaps forward in attack. Link must dodge these advances while striking the creature with his sword.

Twilit Bloat

Twilight Princess *Twilight Princess HD*

After Link obtains all but one of the Tears of Light in Lanayru, he must face this massive Shadow Insect on Lake Hylia. A hovering electric bug with six tentacles, it holds the last Tear of Light. It shields itself with electricity and charges to attack. If Link does not finish off all its tentacles at the same time, they will regenerate. See also Shadow Insect.

Twilit Carrier Kargarok

Twilight Princess *Twilight Princess HD*

Appearing in the Twilight-covered Lake Hylia, this miniboss is a larger, more powerful Shadow Kargarok mounted by a Shadow Bulblin. It drops down from the sky upon hearing the call of a Shadow Bulblin playing a blade of Hawk Grass. The Shadow Bulblin climbs on its back and flies around, dive-bombing to attack. See also Kargarok.

Twinmold

Majora's Mask *Majora's Mask 3D*

The giant masked insects Twinmold serve as the bosses of Stone Tower Temple. This pair of giant centipedes, one red and one blue, squirm through the sand and float in the air, slamming into Link to protect their domain. In *Majora's Mask 3D*, the red one shoots flaming projectiles and spawns Moldbabies.

Twinrova

Ocarina of Time *Ocarina of Time 3D* *Oracle series*

The fused form of the twin Gerudo witches Kotake and Koume, adoptive parents to Ganondorf. In *Ocarina of Time*, they are known as the Sorceress Sisters, bosses of the Spirit Temple. In the *Oracle* series, they appear when both games are linked. See also Kotake, Koume.

V COLUMN

Vaati

Four Swords (1) *Four Swords (2)* *Four Swords Adventures* *The Minish Cap (1)*

The Minish Cap (2) *The Minish Cap (3)* *The Minish Cap (4)*

A nefarious Wind Mage who first appears in *The Minish Cap* and later in *Four Swords* and *Four Swords Adventures*. In *The Minish Cap*, Link learns that Vaati was originally a mage studying under Ezlo. After gaining the might of the Mage's Cap, he betrays his teacher, cursing him. Vaati then uses his newfound power to obtain the Light Force and becomes an Immortal Demon. In Dark Hyrule Castle, he takes three forms in battle with Link. Sealed away for countless eras, Vaati emerges from his prison and kidnaps Zelda in *Four Swords*, serving as the boss of the Vaati's Palace and taking two terrible forms. In *Four Swords Adventures*, Ganon breaks Vaati's seal and revives him to do battle in the Palace of Winds.

Vacuum Mouth

Link's Awakening DX

There are two types of this heavy-breathing monster: one that inhales its surroundings, and one that blasts out air to push it all away. They do not move, and await all comers in specific dungeon rooms. If Link is sucked in, he will be returned to the dungeon entrance. Unless he dashes with the Pegasus Boots, it is impossible to get near the type that blasts air outward.

Vengas

Spirit Tracks

A small insect that lives in the Forest Temple. They will slip through narrow cracks left by bombs in the walls. Vengas store poisonous gas in their bodies, releasing it in a toxic cloud upon defeat.

Veran

Oracle of Ages (1)

Oracle of Ages (2)

Oracle of Ages (3)

Oracle of Ages (4)

Oracle of Ages (5)

Oracle of Ages (6)

The final boss of *Oracle of Ages* is a shape-shifting sorceress (1) who possesses multiple people to change Labrynna's past for her own benefit. She possesses the body of the Oracle of Ages, Nayru, to do battle in Ambi's Palace (2). She then takes control of Queen Ambi for a final battle in the Black Tower (3). Once pulled from Ambi's body during the fight, Veran transforms into a turtle (4), a spider (5), and a bee (6), trying everything in her power to maintain her hold over Labrynna's future.

Vire

The Legend of Zelda

Link's Awakening DX

Oracle series

A winged demon with sharp fangs that will split into two Keese if attacked. In *The Legend of Zelda*, they have four eyes instead of two. In the *Oracle* series, one serves as a henchman for Twinrova. See also Keese.

Vitreous

A Link to the Past

The boss of Misery Mire, Vitreous is a giant eyeball covered in thick slime and surrounded by smaller eyeballs. It fires the smaller eyes and bolts of electricity at Link. When the smaller eyes run out, it will attempt to crush Link itself. Touching the slime hurts Link, but it can be hard to avoid it in the confined space where Vitreous lives.

Volvagia
● Barba

The Adventure of Link | Ocarina of Time | Ocarina of Time 3D

A fire-breathing dragon that has made its home in the hottest reaches of Hyrule since ancient times. In *Ocarina of Time*, it rises from the fiery depths of Death Mountain after being sealed away for ages by the ancestors of the Gorons. Volvagia emerges once more, known as Barba in *The Adventure of Link*, guarding the sixth palace in the Era of Decline. See also Blizzagia.

Vulture

A Link to the Past

Four Swords Adventures

A Link Between Worlds

Tri Force Heroes

These scavenging birds live mainly in deserts, resting on cacti and cliff sides or soaring high enough to keep out of range of any attacks. If they spot anyone brave enough to wander into the desert, they will circle overhead, swooping down to attack. In *Four Swords Adventures*, they are found on Death Mountain.

Vulture Vizier

Tri Force Heroes

This sizable Vulture Vizier is a miniboss in the Dunes, encountered at the end of the Stone Corridors. It forces the heroes to fight on an unstable, tilting platform, which it will constantly rock, using its breath to send the heroes flying. It focuses on knocking the heroes off the platform, rather than attacking them directly.

W COLUMN

Wallmaster

The Legend of Zelda

A Link to the Past

Ocarina of Time

Ocarina of Time 3D

Majora's Mask

Majora's Mask 3D

Oracle series

Four Swords Adventures

The Minish Cap

A Link Between Worlds

Tri Force Heroes

A giant hand that appears from the walls or descends from the ceiling in dungeons. In *The Legend of Zelda*, Wallmasters spawn when Link touches the walls in certain rooms. They will travel along the walls for a time before retreating back into them. In other titles, Wallmasters hide above, dropping down to grab him. It is sometimes possible to spot a Wallmaster's shadow, giving Link a chance to avoid it. If a Wallmaster catches Link, it will typically return him to the dungeon entrance. In *Tri Force Heroes*, Wallmasters slam down on their targets rather than grab them. See also Floormaster, Key Master, Knuckle-master, Zant's Hand.

Walltula
● Skullwalltula

Ocarina of Time

Ocarina of Time 3D

Majora's Mask

Majora's Mask 3D

Twilight Princess

Twilight Princess HD

Skyward Sword

A spider, smaller than a Skulltula but still quite dangerous, that clings to walls and vines. They appear in many games, and like their Skulltula cousins, have a distinctive skull pattern on their backs. The skull is hard, making it difficult to fight one without the use of a projectile. See also Skulltula.

▷ Warp Phantom

Spirit Tracks

A type of Phantom that guards the Tower of Spirits. It has the ability to warp and operates in tandem with Phantom Eyes, which keep watch for intruders. It cannot warp on its own, and will complain about the Phantom Eyes if given the opportunity. It only activates when summoned, and is normally on standby. See also Phantom.

▷ Warship

The Wind Waker

The Wind Waker HD

These small ships hang around many islands out at sea and will fire on approaching vessels. Shots from a ship's cannon will sink them.

▷ Wart

See Arrghus.

▷ Water Octorok

See Octorok.

▷ Water Spume

Skyward Sword

A round, frog-like monster that lives in the waters of the Lanayru Sand Sea in the distant past. It stores water in its body and fires it as a projectile to attack. A cowardly creature, they will hide the instant they detect any nearby danger. Water Spumes always drop a heart when defeated. See also Cursed Spume.

▷ Water Tektite

A Link to the Past

Link's Awakening DX

Oracle series

A Link Between Worlds

Tri Force Heroes

A water strider that makes its home in flooded dungeons. It uses its four limbs to glide across the water's surface. Unlike Tektites, it does not jump around and will not move in places without water. In *A Link to the Past* and *A Link Between Worlds*, their bodies are green with an almond-shaped abdomen. In *Link's Awakening* and *Oracle of Seasons*, they more closely resemble typical Tektites. See also Tektite.

▷ Whisp

See Wisp.

▷ Winder

A Link to the Past

The Minish Cap

Phantom Hourglass

Spirit Tracks

This mysterious string of electric orbs will travel on a set route in a dungeon, often along walls. Striking one with the sword will deal damage and a shock to Link. In most titles, they are invincible, and cannot even be guarded against with a shield. However, in *Spirit Tracks*, an arrow aimed to the first orb will take them out.

▷ Winged Octorok

Link's Awakening DX

A winged subspecies of Octorok. Like its flightless cousins, it spits rocks, but its wings allow it to more easily avoid attacks. Projectiles and jump attacks are particularly effective if Link encounters one. See also page 104, Octorok.

▷ Wisp (Blue)

Four Swords

The Minish Cap

Skulls surrounded by blue flames, similar in appearance to Bubbles. If Link touches one, it will latch onto him, preventing him from swinging his sword for a short period of time. See also page 103, Bubble.

▷ Wisp (Red)
● Whisp

Oracle series

Four Swords

The Minish Cap

A floating skull surrounded by flames that will slowly approach Link. While touching them does no actual damage, Link will be unable to use his sword for a short time.

▷ Wizard

The Adventure of Link

A magician that served the king of Hyrule. He was among the Wizzrobes that served the prince and were banished for putting Princess Zelda to sleep. A sword is useless against him; Link can only defeat him by using magic.

▷ Wizzrobe

A Link to the Past

Link's Awakening DX

Majora's Mask

Majora's Mask 3D

Oracle series

The Wind Waker

The Wind Waker HD

Four Swords

Four Swords Adventures

The Minish Cap

Phantom Hourglass

These magic-wielding enemies attack from afar with magical projectiles. They appear in dungeons across multiple eras and will teleport, making for a difficult fight. In *The Wind Waker* and *Phantom Hourglass*, Wizzrobes are depicted as avian. In the latter game, they guard the Temple of the Ocean King and are normally invisible, but will reveal themselves when Link's back is turned, slashing at him with scythes. If their attacks connect, they will cut down the amount of time Link has to explore the temple. See also Carock, Fire Wizzrobe, Ice Wizzrobe.

▷ Wizzrobe (Blue)

The Legend of Zelda

Oracle series

Magicians clad in robes that appear in dungeons. They fire magical projectiles while using warp magic to teleport and avoid attacks. In *The Legend of Zelda*, they move freely throughout rooms, even standing on waterways or blocks, while firing off curses. In the *Oracle* series, they can fire projectiles while moving.

▷ Wizzrobe (Miniboss)

The Wind Waker

The Wind Waker HD

This special Wizzrobe appears as a miniboss in the Wind Temple. Larger than typical Wizzrobes, they wield powerful magic and will summon other Wizzrobes to help in the fight.

▷ Wizzrobe (Purple)

A Link to the Past

Skull-faced magicians wearing hats and robes that appear in Ganon's Tower. They use warp magic and cast powerful curses. After warping, they will fire a curse and disappear, moving to a new location to repeat this tactic. No matter how many Link defeats, they will continue to appear.

▷ Wizzrobe (Red)

The Legend of Zelda

Oracle series

Magicians, clad in robes, that appear in dungeons. They fire curses at Link while using warp magic to teleport and avoid taking damage.

▷ Wolfos

Ocarina of Time

Ocarina of Time 3D

Majora's Mask

Majora's Mask 3D

A wolf monster that walks on its hind legs and attacks with razor-sharp claws. They are quick on the draw and will block weaker attacks. Target their tails. One well-placed attack to this weak point is all that is needed to defeat a Wolfos.

▷ Wolfos (White)

Ocarina of Time

Ocarina of Time 3D

Majora's Mask

Majora's Mask 3D

Twilight Princess

Twilight Princess HD

Spirit Tracks

These white, wolf-like monsters make their homes in colder climates. They walk on two legs and use their sharp fangs to attack. While they are tough enough to block all but the strongest of attacks, striking their tail just once will defeat them. In *Majora's Mask*, they turn into Wolfos in springtime.

▷ Wosu

The Adventure of Link

A dog-like palace guardian that walks on two legs, wielding a sword and wearing armor. They are found in every palace and will charge any intruders. They are easy to defeat, but spawn endlessly, attacking at varying speeds.

▷ Wrecker Phantom

Spirit Tracks

One of the Phantom guardians of the Tower of Spirits, the Wrecker appears from the eighteenth floor. It transforms into a rolling wrecking ball and plows through obstacles in an attempt to crush Link. Being hit by a Wrecker will take Link back to the entrance of the dungeon. In the Japanese version, these Phantoms end each sentence with "Goro," suggesting they may once have been Gorons. See also Phantom.

Y COLUMN

▷ Yook

A Yook is a member of a tribe of monkeys with snow-white hair that live on the Isle of Frost. They were originally kindly protectors of the pure metal entrusted to them by the Ocean King, but they fell under the power of a monster that appeared in the Temple of Ice and went berserk. As a result, they spurred a great conflict with Anouki on the same island. Later, they wish to reconcile with the warring tribe.

Phantom Hourglass

▷ Yook (Brown)

A muscular, brown-haired, ape-like monster. They carry and swing large clubs. Link can create an opportunity to attack by getting one to swallow a bomb.

Phantom Hourglass

▷ Young Gohma
● Gohma Larva

Ocarina of Time

Ocarina of Time 3D

Oracle of Seasons

Twilight Princess

Twilight Princess HD

Children of a Gohma. In *Ocarina of Time*, they emerge from eggs laid inside the Great Deku Tree. They resemble their parent and will leap at Link to attack. In *Oracle of Seasons*, Gohma will spit them at Link after he destroys her claw. In *Twilight Princess*, they are older Baby Gohma. Their shells have hardened slightly, and they bite to attack. See also Baby Gohma, Gohma, Gohma Egg.

▷ Yuga

A Link Between Worlds (1)

A Link Between Worlds (2)

An evil priest of Lorule who uses magic to transform himself and others into paintings (1). He flees after the battle in the Eastern Palace, and seals Hyrule Castle. Link challenges him again inside Hyrule Castle, only to see him retreat again, this time to his native Lorule. Yuga takes a most monstrous form after merging with Ganon and the Triforce of Power (2). As the game's final boss, he is fought in Lorule Castle after sealing Princess Hilda and obtaining the Triforce of Wisdom.

Z COLUMN

▷ Zaganaga

A many-eyed desert flower boss that Link encounters in Lorule after fighting his way through the Desert Palace. It crawls between pillars jutting from a massive pit of quicksand, spawning endless Peahats and blasting Link with sand. To reach the flower, Link must use the Sand Rod to move between the pillars and avoid falling in the quicksand. See also Peahat.

A Link Between Worlds

▷ Zant

Twilight Princess

Twilight Princess HD

Link takes on Zant, usurper king of the Twili, in the throne room of the Palace of Twilight. The newly crowned King of Shadows was once a close associate of the former king of the Twili. He was deemed too ambitious and was passed over for the crown, spurring him to ally with Ganon and use the Gerudo thief's power to take the Twili throne by force. Link's battle with Zant spans multiple locations, from a teetering platform to the ocean floor. See also Phantom Zant.

▷ Zant Mask

Twilight Princess

Twilight Princess HD

Appearing in the Palace of Twilight, these glowing monsters are giant replicas of Zant's helmet. They float in the air at stationary points, firing balls of magic from their mouths.

▷ Zant's Hand

Twilight Princess

Twilight Princess HD

These giant, hand-like monsters serve Zant, keeping watch over the Sols in the Palace of Twilight. They will float toward Link once he takes a Sol, passing through walls to try to take it back. While they cannot be defeated, Link can stun them for a short time by attacking repeatedly. See also Wallmaster.

▷ Zazak (Blue)

A Link to the Past

A Link Between Worlds

Crocodilian soldiers that don armor. They are extremely aggressive. In *A Link Between Worlds*, they patrol the Thieves' Hideout and will try to capture the Thief Girl after she escapes from her cell.

▷ Zazak (RED)

A Link to the Past

A Link Between Worlds

Armored, crocodilian soldiers that stalk some Dark World dungeons in *A Link to the Past*. Unlike their blue counterparts, they spit flames, and can withstand far more damage. In *A Link Between Worlds*, Red Zazaks only appear in the "Treacherous Tower" minigame.

▷ Zirro
● Bomber

A Link to the Past

A Link to the Past

Link's Awakening DX

A Link Between Worlds

A monster mushroom with wings. Most move through the air and drop seed bombs. In *A Link to the Past*, there are blue and green varieties, with only the latter able to drop bombs. They appear in the Dark World and Lorule, as well as in certain sections of Koholint Island.

▷ Zirro (SNOWBALL)

A Link Between Worlds

A Zirro that lives in the highest reaches of Death Mountain, where the snow piles up. Its body is a bluish color. It flutters in the air, spitting out balls of ice to protect itself and its territory.

▷ Zol
● Zol (Red) / ▲ Zol (Light-Green) / ■ Zol (Yellow)

The Legend of Zelda

A Link to the Past

A Link to the Past

A Link to the Past

Link's Awakening DX

Oracle series

Four Swords

A jelly monster that crawls and bounces around both in the field and in certain dungeons. They divide when attacked. In *The Legend of Zelda*, these divided Zols are called Gels. In *A Link to the Past*, *Link's Awakening*, and others, Link will move more slowly if covered by smaller Zols. See also Color-Changing Gel, Gel, Slime, Slime Eye.

▷ Zol (GREEN)

A Link to the Past

Link's Awakening DX

Oracle series

Four Swords Adventures

Unlike other colors, green Zols in *A Link to the Past* will not divide when cut. The unique green Zols in *Four Swords Adventures* are a type of Slime that always appears in rows of four. They leave heaps of Force Gems behind if defeated, but all four must be hit at the same time or they will flee.

▷ Zombie

Link's Awakening DX

A walking corpse that rises up out of the ground near graveyards. No matter how many Link defeats, more will always appear.

▷ Zora

The Legend of Zelda

The Adventure of Link

A Link to the Past

Link's Awakening DX

Oracle series

Four Swords Adventures

A Link Between Worlds

Members of the Zora race who have turned hostile. They pop their heads out of the water and shoot beams or fireballs at passersby. Some walk in shallow water or on land. See also page 48, Ku.

▷ Zoro

A Link to the Past

Groups of these small black orbs crawl out of holes blasted in certain walls.

SERIOUS MUSCLE BEHIND DESTRUCTIBLE ARMOR

Iron Knuckles and Darknuts are among the toughest enemies Link will face over the eras. In some cases, their armor can be broken off in battle, revealing the fighters inside. Below are examples of these enemies with and without their armor.

Iron Knuckle

Ocarina of Time 3D

Iron Knuckle (NABOORU)

Ocarina of Time 3D

These Iron Knuckles appear in the Spirit Temple, where the Gerudo have set up a base of operations. Gerudo warriors are hidden inside standard armor, while the Iron Knuckle with rose-colored gauntlets is actually Nabooru, the Gerudo sage forced to fight under the influence of magic.

Darknut (STRONG)

The Wind Waker HD

Darknut (WEAK)

The Wind Waker HD

A Darknut clad in thick armor. The monster inside resembles a jackal. Depending on where Link strikes, its shield, helmet, chest plate, or gauntlets will fall off. If it loses its sword, it will attack barehanded.

Darknut

Twilight Princess HD

A Darknut that guards the Temple of Time. When Link has dealt enough damage and removed its sword and helmet, it will pull out a slender blade to continue its assault.

BIBLIOGRAPHY

- *The Legend of Zelda: Certain Victory Strategies* (Futabasha)
- *The Legend of Zelda: Certain Victory Guide* (Shinsei Publishing Co.)
- *The Legend of Zelda: Secret Strategies Included Complete Secrets Bonus Volume* (Futami Shobo)
- *NES Certain Victory Strategy Series 33: The Adventure of Link* (Keibunsha)
- *The Adventure of Link: Complete Secrets Collection* (Futami Shobo)
- *NES Certain Victory Strategy Guides: The Adventure of Link* (Jitsugyo no Nihon Sha)
- *The Adventure of Link: Complete Certain Victory Book* (JICC Publishing)
- *Nintendo Official Guidebook: The Legend of Zelda: A Link to the Past Vol. 1 & 2* (Shogakukan)
- *The Legend of Zelda: A Link to the Past Complete Edition* (Takarajima)
- *The Legend of Zelda: A Link to the Past Certain Victory Strategy Guide* (Futabasha)
- *The Legend of Zelda: Link's Awakening Certain Victory Strategy Guide* (Futabasha)
- *Nintendo Official Guidebook—The Legend of Zelda: Link's Awakening DX* (Shogakukan)
- *The Legend of Zelda: Ocarina of Time Perfect Program* (Takahashi Shoten)
- *Nintendo Official Guidebook—The Legend of Zelda: Ocarina of Time* (Shogakukan)
- *The Legend of Zelda: Ocarina of Time GC Behind the Scenes Complete Guide* (SoftBank Publishing)
- *Nintendo Official Guidebook—The Legend of Zelda: Majora's Mask* (Shogakukan)
- *Nintendo Official Guidebook—The Legend of Zelda: Oracle of Seasons* (Shogakukan)
- *Nintendo Games Strategy Guides—The Legend of Zelda: Oracle of Seasons / Ages* (Mainichi Communications)
- *The Legend of Zelda: Oracle of Seasons Perfect Guide* (Enterbrain)
- *Nintendo Official Guidebook—The Legend of Zelda: The Wind Waker* (Shogakukan)
- *Nintendo Games Strategy Guides—The Legend of Zelda: The Wind Waker* (Mainichi Communications)
- *The Legend of Zelda: The Wind Waker Complete Guide* (Enterbrain)
- *Nintendo Official Guidebook—The Legend of Zelda: A Link to the Past & Four Swords* (Shogakukan)
- *Nintendo Games Strategy Guides—The Legend of Zelda: A Link to the Past & Four Swords* (Mainichi Communications)
- *The Legend of Zelda: A Link to the Past & Four Swords Perfect Guide* (Enterbrain)
- *Nintendo Official Guidebook—The Legend of Zelda: Four Swords Adventures* (Shogakukan)
- *Nintendo Games Strategy Guides—The Legend of Zelda: Four Swords Adventures* (Mainichi Communications)
- *The Legend of Zelda: Four Swords Adventures Perfect Guide* (Enterbrain)
- *The Legend of Zelda: Four Swords Adventures—The Hero of Hyrule Adventure Book* (Media Works)
- *Nintendo Official Guidebook—The Legend of Zelda: The Minish Cap* (Shogakukan)
- *Nintendo Games Strategy Guides—The Legend of Zelda: The Minish Cap* (Mainichi Communications)
- *The Legend of Zelda: The Minish Cap Perfect Guide* (Enterbrain)
- *Nintendo Official Guidebook—The Legend of Zelda: Twilight Princess* (Shogakukan)
- *Nintendo Games Strategy Guides—The Legend of Zelda: Twilight Princess* (Mainichi Communications)
- *The Legend of Zelda: Twilight Princess Perfect Guide* (Enterbrain)
- *The Legend of Zelda: Twilight Princess—The Complete Guide* (Media Works)
- *Nintendo Official Guidebook—The Legend of Zelda: Phantom Hourglass* (Shogakukan)
- *Nintendo Games Strategy Guides—The Legend of Zelda: Phantom Hourglass* (Mainichi Communications)
- *The Legend of Zelda: Phantom Hourglass—The Complete Guide* (Media Works)
- *Nintendo Official Guidebook—The Legend of Zelda: Spirit Tracks* (Shogakukan)
- *Nintendo Games Strategy Guides—The Legend of Zelda: Spirit Tracks* (Mainichi Communications)
- *The Legend of Zelda: Spirit Tracks Perfect Guide* (Enterbrain)
- *The Legend of Zelda: Spirit Tracks—The Complete Guide* (Media Works)
- *Nintendo Official Guidebook—The Legend of Zelda: Ocarina of Time 3D* (Shogakukan)
- *The Legend of Zelda: Ocarina of Time 3D Complete Strategy Guide* (Tokuma Shoten)
- *The Legend of Zelda: Ocarina of Time 3D Perfect Guide* (Enterbrain)
- *The Legend of Zelda: Ocarina of Time 3D—The Complete Guide* (ASCII Media Works)
- *Nintendo Official Guidebook—The Legend of Zelda: Skyward Sword* (Shogakukan)
- *The Legend of Zelda: Skyward Sword Complete Strategy Guide* (Tokuma Shoten)
- *The Legend of Zelda: Skyward Sword Perfect Guide* (Enterbrain)
- *The Legend of Zelda: Skyward Sword—The Complete Guide* (ASCII Media Works)
- *Nintendo Official Guidebook—The Legend of Zelda: The Wind Waker HD* (Shogakukan)
- *Nintendo Official Guidebook—The Legend of Zelda: A Link Between Worlds* (Shogakukan)
- *The Legend of Zelda: A Link Between Worlds Complete Strategy Guide* (Tokuma Shoten)
- *Nintendo Official Guidebook—The Legend of Zelda: Majora's Mask 3D* (Shogakukan)
- *The Legend of Zelda: Majora's Mask 3D Perfect Guide* (Kadokawa/Enterbrain)
- *Nintendo Official Guidebook—The Legend of Zelda: Tri Force Heroes* (Shogakukan)
- *The Legend of Zelda: Tri Force Heroes Complete Strategy Guide* (Tokuma Shoten)
- *Nintendo Official Guidebook—The Legend of Zelda: Twilight Princess HD* (Shogakukan)
- *Nintendo Official Guidebook: Hyrule Historia—The Legend of Zelda Complete Works* (Shogakukan)
- *The Legend of Zelda 30th Anniversary Publication, 1st Volume: The Legend of Zelda: Hyrule Graphics* (Tokuma Shoten)
- *Family Computer Magazine, 1989, No. 20, Appendix, RPG Strategies Complete Works, 1st Volume* (Tokumashoten Intermedia)
- *Family Computer Magazine, 1989, No. 21, Appendix, RPG Strategies Complete Works, 2nd Volume* (Tokumashoten Intermedia)
- *Family Computer Magazine, March 6, 1992, Appendix, RPG Strategies Complete Works, Sept. Dec., 1991, 1st Volume* (Tokumashoten Intermedia)
- *Family Computer Magazine, October 15, 1993, Appendix, RPG Strategies Complete Works, Jan. Aug., 1993, 1st Volume* (Tokumashoten Intermedia)
- *Nintendo Dream, May 6, 2004, Appendix, Zelda Collection Complete Strategy Guide* (Mainichi Communications)
- *Nintendo Dream, July 2016, Appendix, The Legend of Zelda / The Adventure of Link Reissued Complete Works* (Tokuma Shoten)
- *Nintendo Classic Mini Family Computer Magazine* (Tokuma Shoten)
- Each instruction manual and official homepage

Note: Publisher names reflect the company names at the time of release.
Works are listed in order of release.

This section charts the thirty-year history of *The Legend of Zelda* with a fond look back at the many games in the series and what made them so special.

Each entry includes a synopsis of a game's plot, world maps, and a focus on central characters, with diagrams showing how they relate to one another and character art produced around the time of release.

Also included are notes and documents from each game's development, offering fascinating details and insight into their design.

The section concludes with a summary of titles released outside the *Legend of Zelda* canon, along with promotional materials and an in-depth interview with series producer Eiji Aonuma.

Over the course of three decades, the games in this incredible series have evolved and changed, but each has retained its own kind of magic. It is our hope that these pages will inspire you to journey back and experience each wonderful adventure for yourself, whether for the first time or all over again.

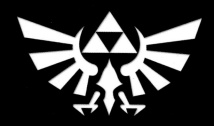

ARCHIVES

INFORMATION & NOTES
ON EACH GAME

→1986→

The Legend of ZELDA

Release Dates: August 22, 1987 | February 21, 1986 (JP)
Consoles: Nintendo Entertainment System | Famicom Disk System

Release Dates: June 2, 2004 | February 14, 2004 (JP)
Console: Game Boy Advance

The first entry in the *Legend of Zelda* series, titled *The Hyrule Fantasy: The Legend of Zelda* in Japan, was released in 1986 to coincide with the new Family Computer Disk System, a Famicom peripheral with higher storage capacity that made larger games possible.

Released a year later in North America and Europe for the Nintendo Entertainment System on a distinctive gold cartridge, the game featured Link: a fated hero charged with saving Hyrule with a sword in hand. Using equipment gathered over the course of his adventure, Link explored a vast overworld and puzzling dungeons on a quest to save Princess Zelda from Ganon.

Many aspects of the series have roots in this initial release, from lore to key sound effects and music. In 2004, it was rereleased on the Game Boy Advance as part of the Classic NES Series.

Image taken from Classic NES Series release for Game Boy Advance.

▷ PLOT

A long, long time ago the world was in an age of chaos.

An evil army led by Ganon attacked a little kingdom in the land of Hyrule. He stole the Triforce of Power—one of the powerful treasures kept in the kingdom. The Triforce had been passed down among the royal family for generations.

Zelda, princess of this kingdom, split the other powerful treasure, the Triforce of Wisdom, into eight pieces and hid them throughout the realm to keep them out of Ganon's hands.

At the same time, she sent her most trustworthy nursemaid, Impa, to find someone with the courage to defeat Ganon. Impa fled the small kingdom in secret.

Upon hearing this, Ganon grew angry and imprisoned Princess Zelda and sent out a party in search of Impa.

Impa's pursuers were quick and soon caught the elderly nursemaid. Surrounded, and at the very limit of her energy, a young lad appeared. He skillfully drove off Ganon's henchmen and saved Impa from a fate worse than death.

His name was Link and he was traveling through the area when he happened upon Impa. Impa told Link all of what was transpiring in the small kingdom.

Burning with a sense of justice, Link resolved to save Princess Zelda and defeat Ganon, but Ganon was a powerful foe. In order to fight him, Link would have to gather all of the scattered fragments of the Triforce of Wisdom and reunite them.

He prepared himself for the journey ahead and entered Hyrule.

Ganon's henchmen ran rampant throughout the small kingdom, and Link's quest to recover the fragments of the Triforce of Wisdom was long and fraught with danger. With the support of merchants and elders hiding in caves, he sought out the eight labyrinthine dungeons where the Triforce fragments were hidden.

Vicious enemies filled the dungeons, and devious traps blocked his path. It would take every ounce of Link's courage and skill to overcome these challenges.

As he journeyed, Link collected valuable items and equipment that allowed him to travel to new areas and gradually grow stronger.

As Link gained experience, he upgraded his sword and shield to the more powerful Magical Sword and Magical Shield. After gathering all eight of the Triforce fragments, Link proceeded to Spectacle Rock and its Death Mountain peak: Ganon's stronghold.

Ganon's fortress was far larger than any dungeon Link had yet explored. Its rooms seemed infinite and their connections complex. But deep within was Ganon, and with him, Princess Zelda.

Link fought his way into Ganon's lair, where the Prince of Darkness waited, formidable but weakened by the completed Triforce of Wisdom. Ganon countered Link's attacks by disappearing and lunging at great speeds. Link swiped at the air with his Magical Sword. The room was only so big, and surely a swing would hit Ganon. It was a brutal final battle, ended only by the Silver Arrow Link fired in Ganon's brief moment of weakness.

Having defeated Ganon, Link recovered the stolen Triforce of Power and safely freed the imprisoned Princess Zelda, restoring peace to the land.

In return, Zelda offered these immortal words: "Thanks, Link. You're the hero of Hyrule."

1 The legendary starting location of *The Legend of Zelda*. **2** Inside the cave near the starting location, Link receives a sword from the Old Man. **3** The Lost Hills. If Link does not follow a specific path, he will lose his way here. **4** The entrance to the Level 3 dungeon is patrolled by a Tektite. **5** Link obtains a fragment of the Triforce of Wisdom after defeating Manhandla at the end of Level 3. **6** Link finds the Red Candle in a hidden room beneath the Level 7 dungeon. **7** Link's battle with Ganon is fraught with peril, as Ganon uses magic to make himself disappear before attacking. **8** In the final moments of *The Legend of Zelda*, Link rescues the captured Princess Zelda.

◢ Main Characters

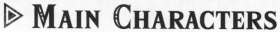

◆ Link

A young, unarmed traveler who uses his quick wits to save Impa, then takes up a sword and embarks on a quest to save Hyrule.

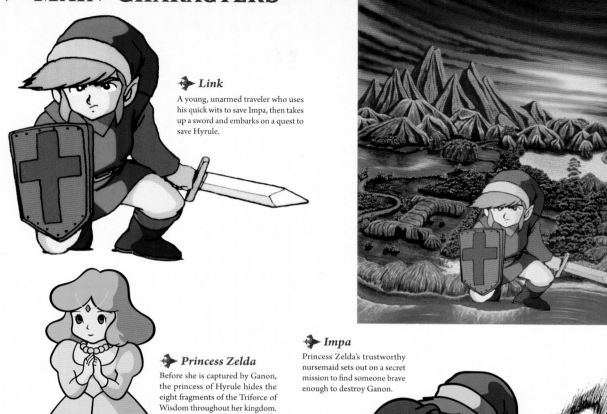

Key Art

◆ Princess Zelda

Before she is captured by Ganon, the princess of Hyrule hides the eight fragments of the Triforce of Wisdom throughout her kingdom.

◆ Impa

Princess Zelda's trustworthy nursemaid sets out on a secret mission to find someone brave enough to destroy Ganon.

◆ Ganon

Link can't know the true horror of the Prince of Darkness until he comes face to face with him atop Death Mountain.

◢ Character Relationships

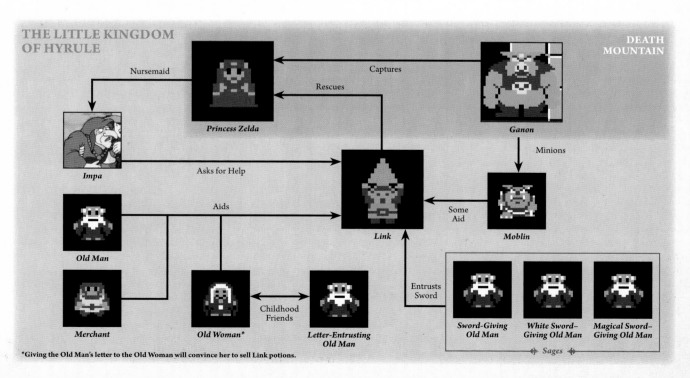

THE LITTLE KINGDOM OF HYRULE

DEATH MOUNTAIN

Nursemaid

Captures

Rescues

Princess Zelda

Ganon

Impa

Asks for Help

Minions

Old Man

Aids

Link

Some Aid

Moblin

Merchant

Old Woman*

Childhood Friends

Letter-Entrusting Old Man

Entrusts Sword

Sword-Giving Old Man

White Sword–Giving Old Man

Magical Sword–Giving Old Man

◆ Sages ◆

*Giving the Old Man's letter to the Old Woman will convince her to sell Link potions.

◁ THE WORLD

The map of Hyrule in *The Legend of Zelda* is a grid of varying terrain sixteen blocks wide by eight high. The moment Link takes his first steps in the game, it's possible to travel to nearly every corner of the expansive overworld, but Link requires special equipment found in early dungeons such as the Raft and Stepladder in order to access later dungeons and other essential areas. Some paths are further blocked by overpowered enemies that Link will have little chance of defeating without upgraded weapons and plenty of health.

Link can embark on a Second Quest after completing the game, which alters some areas of the map. The map below indicates the locations of dungeons both the first and second time around.

Hyrule

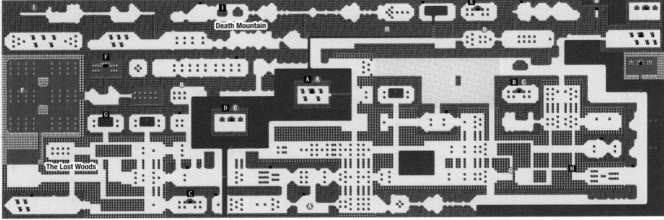

Death Mountain

The Lost Woods

A Level 1 (Eagle) **B** Level 2 (Moon) **C** Level 3 (Manji) **D** Level 4 (Snake)
E Level 5 (Lizard) **F** Level 6 (Dragon) **G** Level 7 (Demon)
H Level 8 (Lion) **I** Level 9 (Death Mountain)
Ⓐ Level 1 (Second Quest) Ⓑ Level 2 (Second Quest) Ⓒ Level 3 (Second Quest) Ⓓ Level 4 (Second Quest) Ⓔ Level 5 (Second Quest)
Ⓕ Level 6 (Second Quest) Ⓖ Level 7 (Second Quest) Ⓗ Level 8 (Second Quest) Ⓘ Level 9 (Second Quest)

Ⓐ Starting Location Ⓑ Letter-Entrusting Old Man's Cave

◁ DEVELOPMENT DOCUMENTS

◁ Map Screen Layout Draft

When Nintendo was first developing *The Legend of Zelda*, there was no system for moving around the map like in the final game. The initial design called for the player to immediately enter a dungeon from either the title screen or a menu. The image below shows a method they tested for displaying the entrance to dungeons from a three-dimensional angle.

Early Dungeon Entrance Screen

Test Screen

Using the Family BASIC, a Japan-only Nintendo product that allowed professionals and enthusiasts to program Famicom games, designers made a test screen based off the design on the left. This image is actually a photo they took of the entrance to a dungeon, displayed on a CRT monitor.

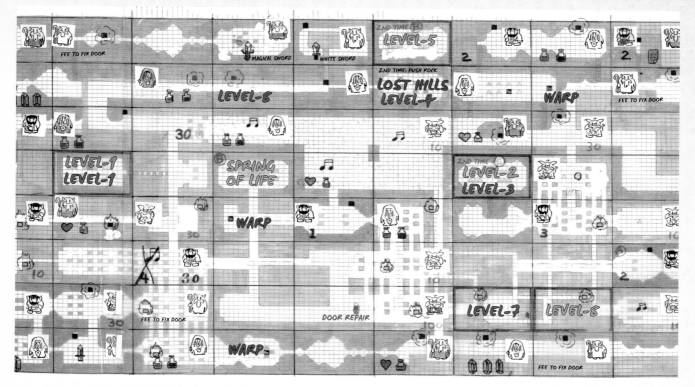

▷ Draft of Map Layout

This drawing of the overworld map implemented in the game began with hand-drawn blueprints like the image on the right. Tracing paper was then placed over the overall map's design, on which the developers sketched character illustrations and wrote notes like "Level 8" and "warp." They continuously adjusted the map as they added mechanics to certain areas, placed characters in new locations, and made other changes to improve the player experience.

Levels 1–6

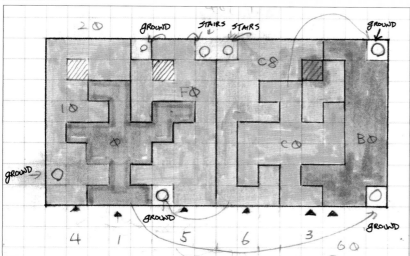

▷ Dungeon Layout

Storing the data for the game's sizable dungeon maps meant using the same sixteen-by-eight-block layout as the overworld map. For efficiency's sake, the maps for Levels 1 through 6 were designed to fit together on the same grid, almost like a puzzle, with the extra blocks used to store the data for underground areas like treasure rooms and passages connecting certain dungeon rooms.

Levels 7 through 9 are also constructed so as not to waste blocks. The mechanics and items found in each level, as well as each room's design, were all drawn and laid out separately.

❧ DEVELOPER ❧ NOTES

● **The Old Man's Letter:** Though the text does not appear in-game, the letter from the Old Man in the northeast to the Old Woman reads: "This heroic lad is an acquaintance of Impa. Please give him aid." The Old Woman is willing to sell Link potions because her child-hood friend vouches for him.

● **One Night Only:** The opening theme to *The Legend of Zelda* was originally *Boléro*, a seminal piece by the classical composer Maurice Ravel. Just before the game was completed, they realized that the music's copyright would not expire for another month. They could not delay the release, so they decided to write a new song. Composer Koji Kondo arranged a new theme in a single night that would become one of the most famous and beloved pieces of music ever written for a video game.

References
• *Family Computer Magazine*, No. 9, 1986. "The Legend of Zelda Q&A."
• "Nintendo Classic NES Series Family Computer" Release Commemorative Interview #4. "The Legend of Zelda Compilation."

1987

The Adventure of
LINK

Release Dates: December 1, 1988 | January 14, 1987 (JP)
Consoles: Nintendo Entertainment System | Famicom Disk System

Release Dates: October 25, 2004 | August 5, 2004 (JP)
Console: Game Boy Advance

Debuting roughly a year after *The Legend of Zelda*, *Zelda II: The Adventure of Link* is the only main entry in the series to feature side-scrolling as its primary perspective. The game also contains many systems seen in no other *Zelda* game, including attacks and defense that vary if Link is standing or crouching, as well as a system to gain experience and level up by defeating enemies. Though much changed in this follow-up to the original classic, it also built upon what makes the series special, expanding an overworld littered with dungeons by adding towns full of people to meet. As in any *Zelda* game, Link gains skills and equipment over the course of his adventure, giving him the strength to take on more difficult enemies and reach new areas.

The Adventure of Link was rereleased with new colors and other subtle changes in 2004 for the Game Boy Advance as part of the Classic NES Series.

This image is from the Classic NES Series version of The Adventure of Link.

▷ PLOT

Thanks to Link's valiant efforts, the little kingdom of Hyrule had recovered both the Triforce of Wisdom and the Triforce of Power. However, the evil from Ganon's vile heart still infected the kingdom, causing chaos and disorder, and the monsters who had not perished with Ganon were hunting Link. They believed that by using the hero as a sacrifice and sprinkling his blood over Ganon's ashes, their evil leader would be revived.

Meanwhile, Link was working to repair the damage done to Hyrule by Ganon, but the devastation was immense.

On his sixteenth birthday, a glowing mark appeared on the back of his left hand. Impa noticed the triangular mark and guided Link to the North Castle, where there was a sealed door called "the door that does not open."

Impa took Link's hand and pressed the back of it against the door. It slowly creaked open to reveal a beautiful woman, sleeping on an altar.

"Here lies Princess Zelda," Impa said.

The nursemaid explained that long ago, when Hyrule was a large kingdom, the king of Hyrule used the united Triforce to maintain order. With the king's passing, the prince inherited both the kingdom and the Triforce, but the sacred relic was incomplete. The Triforce of Courage was missing. A magician and close associate of the new king's offered his aid, suggesting that Princess Zelda knew where it could be found.

Despite pressure from the prince, Zelda refused to reveal the Triforce's location. Even after the magician threatened to place her under a spell of eternal sleep, Zelda remained silent. Making good on his word, the magician cursed Zelda.

The regretful prince, overcome with sorrow, placed Zelda on the altar within the North Castle. He decreed that all women born in the royal line would be named "Zelda" so this tragedy would never be forgotten.

After telling this story to Link, Impa entrusted him with a scroll and six small crystals. The scroll was written in an alphabet foreign to Link, but he instantly understood its meaning.

This scroll contained the words of the king of Hyrule:

"There are three kinds of Triforce: Power, Wisdom, and Courage," it read. "When these three are brought together, the Triforce will show its maximum power. Of the three, I have left Power and Wisdom in the kingdom. But the Triforce of Courage I have hidden for a reason.

"Not everybody can use the Triforce. It requires a strong character with no evil thoughts. But an inborn, special quality is also necessary. Unfortunately, I have not found such a person during my lifetime."

The king's scroll warned that the Triforce's misuse would produce many evils, and it foretold that a crest would appear on a young man deemed worthy. Until that time, the Triforce of Courage would be hidden in the Great Palace in the Valley of Death. To enter, Link would need to defeat the guardians of six other palaces. At the heart of each was a statue. Setting crystals in these statues would release the binding force the king had placed on the Great Palace.

Impa explained that once the three pieces of the Triforce were brought together, the ancient sleeping spell gripping Zelda could be lifted.

Just as was written on the scroll, Link discovered six palaces and placed crystals in stone statues found within them. Waiting at the heart of the Great Palace was the guardian, Thunderbird. After a vicious battle, Link found the Triforce of Courage in the room beyond, but his shadow cast on the

wall attacked! To battle oneself was the final trial for the hero who would inherit the Triforce. Link defeated his shadow and finally obtained the Triforce of Courage.

Link then returned to the North Castle. Before the altar, the three pieces of the Triforce came together and cast a sacred light. Her curse broken, Princess Zelda opened her eyes and spoke: "You saved Hyrule and you are a real hero!"

1 Princess Zelda sleeps in the North Palace. **2** Moving between towns and palaces is done in a top-down view. **3** Link can talk to townspeople to gather important information. **4** A stone statue found after defeating a palace guardian. Link places the crystal in its forehead. **5** Thunderbird, guardian of the Great Palace. Using the Thunder spell renders this boss vulnerable to sword attacks. **6** Link's Shadow separates and challenges Link to battle. **7** The three pieces of the Triforce combine, awakening Princess Zelda.

◪ MAIN CHARACTERS

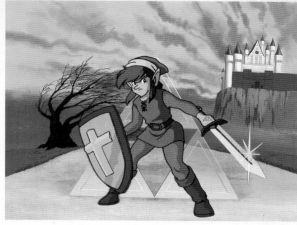

Key Art

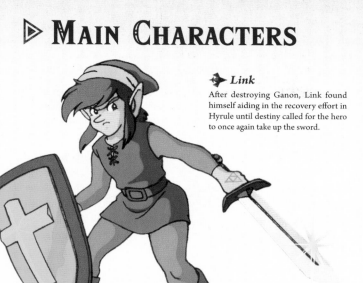

◪ Link

After destroying Ganon, Link found himself aiding in the recovery effort in Hyrule until destiny called for the hero to once again take up the sword.

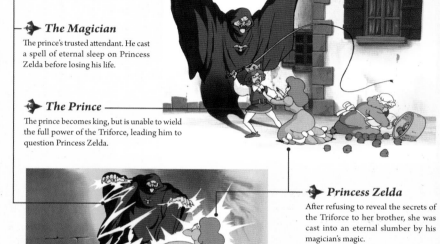

◪ The Magician

The prince's trusted attendant. He cast a spell of eternal sleep on Princess Zelda before losing his life.

◪ The Prince

The prince becomes king, but is unable to wield the full power of the Triforce, leading him to question Princess Zelda.

◪ Princess Zelda

After refusing to reveal the secrets of the Triforce to her brother, she was cast into an eternal slumber by his magician's magic.

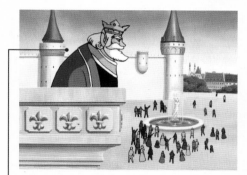

◪ The Ancient King of Hyrule

A great king who used the power of the Triforce to maintain order in the land. He cast a spell to ensure the Triforce could not be united and fall into the wrong hands.

◪ Impa

She entrusts Link with the crystals and scroll of the ancient king of Hyrule when the mark of the Triforce appears on Link's left hand.

◪ CHARACTER RELATIONSHIPS

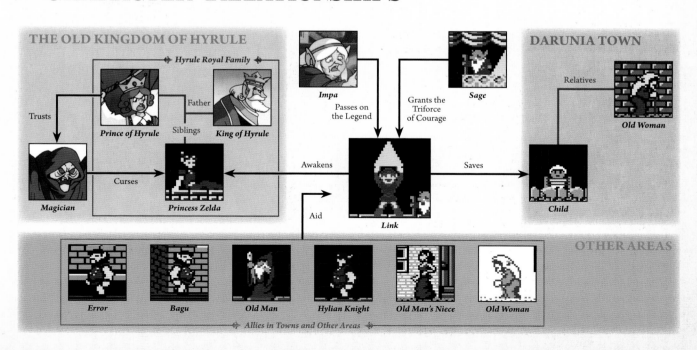

THE OLD KINGDOM OF HYRULE

◆ Hyrule Royal Family ◆

Prince of Hyrule — Father — *King of Hyrule*

Trusts

Siblings

Magician — Curses — *Princess Zelda*

Impa
Passes on the Legend

Sage
Grants the Triforce of Courage

Awakens

Aid

Saves

DARUNIA TOWN

Relatives

Old Woman

Child

Link

OTHER AREAS

| *Error* | *Bagu* | *Old Man* | *Hylian Knight* | *Old Man's Niece* | *Old Woman* |

◆ Allies in Towns and Other Areas ◆

▷ THE WORLD

Six palaces are scattered across continents to the east and west in greater Hyrule. Link must be on his guard at all times while wandering the overworld, as enemies and traps will appear seemingly out of thin air.

Link grows stronger as he fights his way through each palace. Along the way, he also learns essential magic from townspeople and finds equipment like the Raft, allowing him to reach farther-flung regions on the Eastern Continent.

Once Link has placed a crystal in every palace, it is time to venture into the Valley of Death, where the Great Palace protects the Triforce of Courage from all but a hero worthy of its power.

ARCHIVES

GAME INFORMATION & NOTES

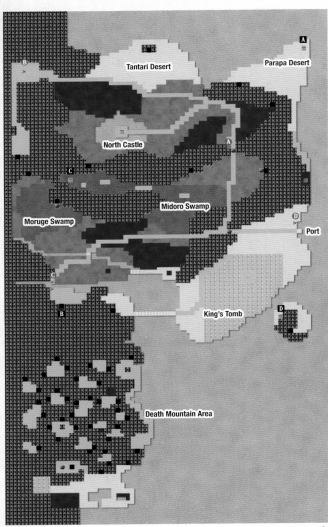

Western Hyrule

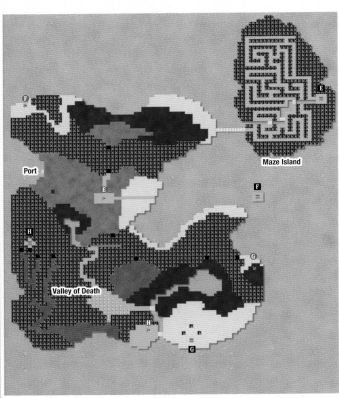

Eastern Hyrule

A Parapa Palace	Ⓐ Rauru Town
B Death Mountain	Ⓑ Ruto Town
C Midoro Palace	Ⓒ Saria Town
D Island Palace	Ⓓ Mido Town
E Maze Island Palace	Ⓔ Nabooru Town
F Palace on the Sea	Ⓕ Darunia Town
G Three-Eye Rock Palace	Ⓖ Kasuto
H Great Palace	Ⓗ Old Kasuto

VARYING TERRAIN

Link enters into battles when he encounters enemies in the field, but the stages in which those battles take place, as well as the types of enemies, change based on where Link is when he's ambushed. The enemies grow stronger the farther Link gets from North Castle.

Forests

Deserts

Grasslands

Swamps

Graveyards

◮ DEVELOPMENT DOCUMENTS

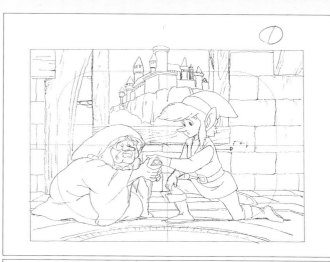

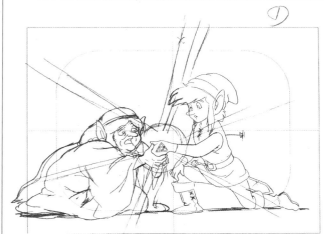

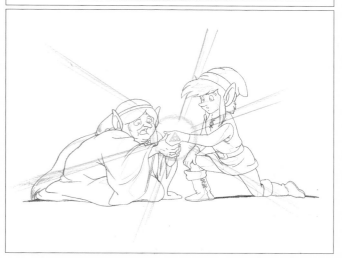

◮ *Drawing* The Adventure of Link

The prologue to *The Adventure of Link* is told over ten pages in the game's official instruction booklet. Included with the words were colorful illustrations meant to look like scenes straight out of an anime. To ensure this aesthetic, the illustrators followed a production process similar to animation. Characters and backgrounds were drawn separately, with line art drawn over the roughs and coloring notes attached.

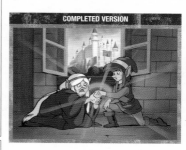

COMPLETED VERSION

COMPLETED VERSION

Standard Frame

❧ DEVELOPER ❧ NOTES

● **From Spinoff to Sequel:** Shigeru Miyamoto, the producer of the title, said that he would like to make a side-scrolling action game that divided attacking and defense into high and low planes, and this became the starting point for development. It was originally a "*gaiden*" or spinoff title, but evolved into a sequel that featured game play elements that make it a unique title within the series.

● **Leveling Up:** The leveling system was introduced as an incentive to fight multiple enemies and extend playtime as a way to get around the hardware restrictions of the time. The encounters with visible enemies roaming the world map were designed to make the map's game play engaging and introduce an element of luck.

● **Increasing the Challenge:** This game is quite difficult. The designers saw that there were a limited number of action games at the time so they wanted to make one that was playable for as long as possible. That meant they had to design a game that could not easily be beaten.

● **A Canceled Follow-Up:** There was a version of *The Adventure of Link* in development for the Super Nintendo Entertainment System, but it looked like it would not be completed until after the launch of the Nintendo 64. With the development team members being involved with *Star Fox 64*, development was ultimately canceled.

References
- Nintendo Official Home Page: Topics. "Why Did *The Adventure of Link* Not Become a Straightforward Sequel?"
- *Nintendo Official Guidebook—Star Fox 64*. "Developer Interview."

1991

Release Dates: April 13, 1992 | November 21, 1991 (JP)
Consoles: Super Nintendo Entertainment System | Super Famicom

Release Dates: December 2, 2002 | March 14, 2003 (JP)
Console: Game Boy Advance

Released nearly five years after *The Adventure of Link* and within a year of the Super Nintendo's launch, *A Link to the Past* marked a significant upgrade to everything that came before it in the series. Its mechanics, graphics, audio, and scope took full advantage of the new 16-bit console's power, while the game's story became a greater focus, unfolding in an isometric viewpoint across two worlds: one light, the other dark.

A Link to the Past became a cornerstone of the SNES library, selling in the millions. It was rereleased on the Game Boy Advance in 2002. The portable cart's screen ratio differed from the original, but was improved with a general polish and adjustments made to dialogue. Players even received new challenges in the form of the *Four Swords* expansion.

Link's home in the Game Boy Advance version of A Link to the Past.

▷ PLOT

Legends told of a golden treasure that contained an infinite amount of power that slept in a hidden land. That land was the Sacred Realm, and the entrance was discovered within Hyrule. Many entered, searching for the relic, but none returned.

One day, evil began to pour forth from the Sacred Realm and the king ordered the Seven Sages to seal the entrance in an event that came to be known as the Imprisoning War.

These events were obscured by the mists of time until a wizard known as Agahnim came to Hyrule to release the seal. He murdered the king of Hyrule, kidnapped six of the seven maidens who were descendants of the Seven Sages, and planned on kidnapping the last, Princess Zelda. With them, he could perform a rite that would break the seal to the Sacred Realm, but Zelda commanded a power that Agahnim had not anticipated. She reached out telepathically for help.

"Help me. Please help me . . . I am a prisoner in the dungeon of the castle. My name is Zelda."

Link heard these words in a dream and woke to find his uncle at the table with a sword and shield in hand.

"Link," he said. "I'm going out for a while. I'll be back by morning. Don't leave the house."

Despite his uncle's orders, Link could not ignore his dream. He left the house and headed for Hyrule Castle.

In the dungeons below, he found his uncle gravely wounded. Desperate and dying, he entrusted Link with his weaponry. "Link, you can do it! Save the princess . . ."

Link fought his way to the cells where he found Zelda locked away. Together, they escaped to a sanctuary where she would be safe.

Guided by Sahasrahla, a descendant of one of the sages, Link then set off on a journey to obtain the Master Sword to vanquish Agahnim.

The knight clan from which Link descended had protected the royal family and served as the shields of the sages during the Imprisoning War. It was prophesied that a hero would emerge from this clan. Link obtained the necessary qualities of courage, power, and wisdom in the form of pendants, and deep within the Sacred Grove, he drew the Master Sword, which recognized him as the fated hero.

In that moment, Zelda's voice echoed inside Link's head. Agahnim's henchmen had found her. Link immediately set out for Hyrule Castle. After he battled Agahnim, the seal on the Sacred Realm, which had been corrupted by evil and was now the Dark World, was shattered, and a portal opened within the castle.

Soon, Ganon, the King of Evil, would make his way into the Light World and bring it to ruin. Link had to defeat Ganon and take back the Triforce before that happened. When the seal broke, the sacrificial maidens descended from the Seven Sages were flung into the Dark World. Link traversed both the Light and Dark Worlds in search of the six maidens and Princess Zelda. Upon saving them, the barrier around Ganon's Tower was broken.

Link destroyed Agahnim in their second battle and made his way to Ganon. After a fierce battle, Link vanquished the monster and regained the Triforce. Placing his hand on the Triforce, Link wished to restore the world to its former glory.

With that, all who had fallen victim to Ganon's evil were resurrected, and Hyrule was peaceful once more. With the Triforce returned to the protection of the royal family, the Dark World born of Ganon's wicked heart gradually faded away.

1 - **4** A series of images depicting the Imprisoning War. Tales of this war were passed down to the people of this era, who considered it ancient history. **5** The remains of the king of Hyrule, still on his throne after Agahnim invaded the castle. **6** A descendant of the sages being taken away as a sacrifice. **7** Agahnim uses his magic to sacrifice the maidens who have inherited the blood of the sages. **8** Princess Zelda after taking refuge in the sanctuary. **9** Link, pulling the Master Sword from its pedestal in the Sacred Grove. **10** Cornered by Link, the wizard Agahnim challenges Link to an intense battle. **11** Link fights the King of Evil, Ganon, for the fate of Hyrule, dealing the final blow with a Silver Arrow. **12** Touching the recovered Triforce, Link wishes for things to return as they were. **13** - **17** The king of Hyrule, Link's uncle, and the flute-playing boy met during Link's journey all return to life.

▷ Main Characters

▶ Link

A descendant of the Knights of Hyrule, he possesses the qualities of a hero. He sometimes ignores what people tell him, though.

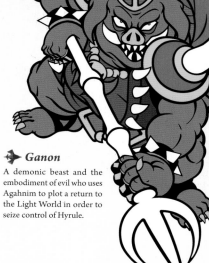

▶ Ganon

A demonic beast and the embodiment of evil who uses Agahnim to plot a return to the Light World in order to seize control of Hyrule.

▶ Princess Zelda

The princess of Hyrule and one of the maidens in the sages' bloodline. She and her fellow sage descendants possess mysterious power.

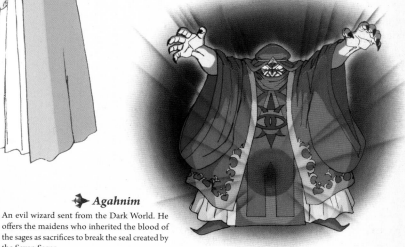

▶ Agahnim

An evil wizard sent from the Dark World. He offers the maidens who inherited the blood of the sages as sacrifices to break the seal created by the Seven Sages.

▶ Link's Uncle

Like Link, he is a descendant of the Knights of Hyrule, and lives with Link.

Key Art

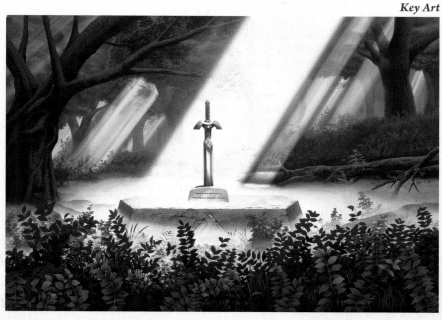

▶ Sahasrahla

The Kakariko Village elder who senses the great threat to Hyrule and travels to the Eastern Palace to investigate.

▷ Character Relationships

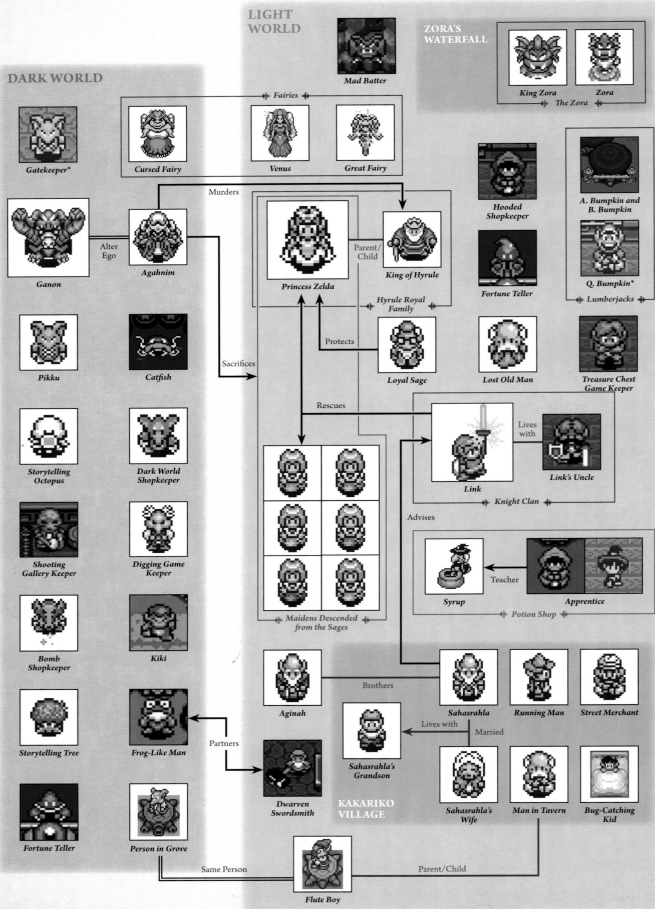

LIGHT WORLD

DARK WORLD

ZORA'S WATERFALL

Mad Batter

King Zora Zora
↔ The Zora ↔

↔ Fairies ↔

Gatekeeper*

Cursed Fairy Venus Great Fairy

Hooded Shopkeeper

A. Bumpkin and B. Bumpkin

Murders

Ganon Agahnim
Alter Ego

Princess Zelda King of Hyrule
Parent/Child

Q. Bumpkin*
↔ Lumberjacks ↔

Fortune Teller

Hyrule Royal Family

Pikku Catfish

Sacrifices

Protects

Loyal Sage Lost Old Man Treasure Chest Game Keeper

Storytelling Octopus Dark World Shopkeeper

Rescues

Lives with

Link Link's Uncle
↔ Knight Clan ↔

Shooting Gallery Keeper Digging Game Keeper

Maidens Descended from the Sages

Advises

Bomb Shopkeeper Kiki

Syrup Apprentice
Teacher
↔ Potion Shop ↔

Storytelling Tree Frog-Like Man

Aginah Sahasrahla Running Man Street Merchant
Brothers

Partners

Sahasrahla's Grandson
Lives with Married

Fortune Teller Person in Grove

Dwarven Swordsmith

KAKARIKO VILLAGE

Sahasrahla's Wife Man in Tavern Bug-Catching Kid

Same Person Flute Boy Parent/Child

*Only appears in *A Link to the Past* & *Four Swords*.

▷ THE WORLD

There are two overworlds in *A Link to the Past*. The Light World that Link calls home is a colorful and abundant place, with green forests, arid bluffs, and crystal-blue waters. In the Dark World that mirrors the Light World, the terrain is much the same, but everything is cast in a somber hue. Monsters stalk land that has withered and dried, amid putrid green lakes and swamps where only misery thrives.

LIGHT WORLD

This rich country of fair and easygoing folk is tainted by the arrival of the evil wizard Agahnim, who seizes control of Hyrule Castle and puts a bounty on Link. Soldiers begin to patrol all corners of Hyrule and will attack Link if they spot him. When portals to the Dark World begin to appear, some Light World residents wander in and go missing.

A Hyrule Castle **B** Eastern Palace
C Desert Palace **D** Mountain Cave **E** Tower of Hera
F Hyrule Castle Tower **G** Palace of Darkness
H Swamp Palace **I** Skull Woods **J** Thieves' Town
K Ice Palace **L** Misery Mire **M** Turtle Rock
N Ganon's Tower **O** Pyramid of Power
P Palace of the Four Sword (*A Link to the Past* & *Four Swords*)

Ⓐ Kakariko Village **Ⓑ** Village of Outcasts
Ⓒ Link's House **Ⓓ** Sanctuary
Ⓔ Lumberjacks' House **Ⓕ** Zora's Waterfall
Ⓖ Smithery **Ⓗ** Aginah's Dwelling

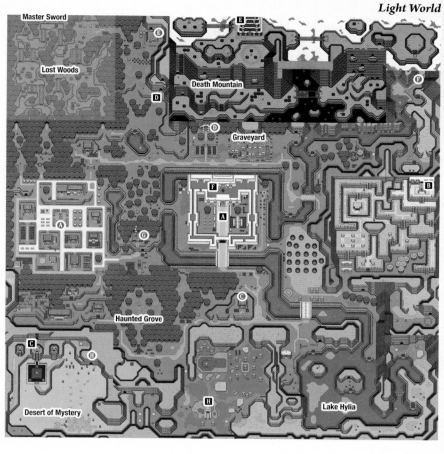

Light World

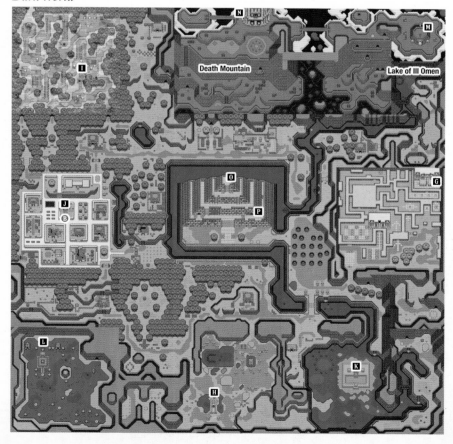

Dark World

DARK WORLD

This world of darkness was born from Ganon's wicked heart. Beings from the Light World who wander into it are transformed. The greedy become monsters; others become animals or plants. Link is a rabbit in this world until the Moon Pearl from the Tower of Hera allows him to keep his normal form. Though the Dark World is in disarray there are a few towns and shops. Terrain changes in subtle ways between the two worlds. Once Link obtains the Magic Mirror, he can enter the Dark World from any spot, which often allows him to access hard-to-reach places.

▷ DEVELOPMENT DOCUMENTS

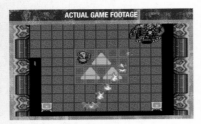

ACTUAL GAME FOOTAGE

▷ Ganon Battle

The developers of *A Link to the Past* went to great lengths to ensure the final battle with Ganon was a memorable one. This is one of the documents that detail how his attack patterns change over the course of the fight.

▷ Opening Triforce Storyboard

A Link to the Past's title screen featured the three pieces of a polygonal Triforce joining together with smooth, three-dimensional movement. This was rare on consoles at the time. The way the Triforce pieces moved and the timing with which the title was displayed were outlined using storyboards. Similar care was given to the movement and blocking of the characters in the game's preview scene.

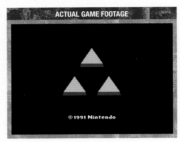

ACTUAL GAME FOOTAGE

©1991 Nintendo

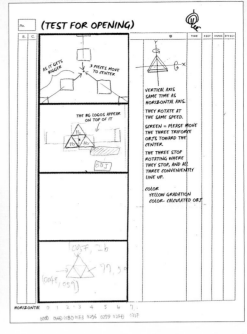

(TEST FOR OPENING)

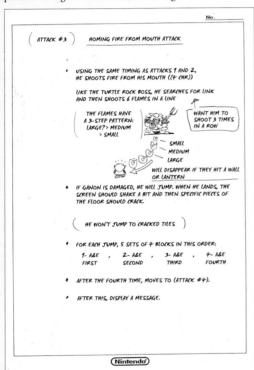

▷ Game Opening Outline

Proposals for *A Link to the Past*'s early moments differed significantly from the game's final release. This outline details how the first act could have unfolded. Columns for Country, Location, Items, Information/Events, and Notes document how the hero's health and saves would be matched to developments in the plot, like "Receives the Triforce from the princess" or "Learns 'Prayer'" at the sanctuary. While much of the content documented here was changed, the idea to have Link and Zelda escape from the castle through a secret passage was implemented.

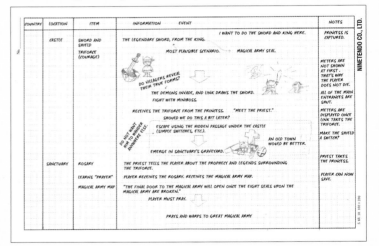

⚜ DEVELOPER NOTES ⚜

● **Three Years in the Making:** *A Link to the Past* was in development for about three years. The team began work on it long before the Super NES even launched—spending the first year on planning, the second on experimenting, and the third on actual development.

● **Too Many Worlds:** At the beginning of development, there was another world in addition to Light and Dark. Developers ultimately had to cut it, as having three risked confusing some players.

● **An Open World:** On the player's ability to explore much of the world from the start, Shigeru Miyamoto said at an event for the game, "I don't like having to progress the game along a set series of events, but if we don't make it that way, it won't work as a game. So rather than make the player an errand boy, we wanted them to think about how to proceed on their own."

● **From *Zelda* to *Mario* and Back Again:** The chains of fireballs known as Guruguru Bars were originally designed for the original *Legend of Zelda* but were deemed a better fit for *Super Mario Bros.* at the time. When they made *A Link to the Past* years later, developers felt enough time had passed that these obstacles would not be explicitly associated with Mario and they incorporated them in some dungeons.

● **Action Button:** There were designs for using the action button to do things like eat or dance, but it grew out of hand and designers opted to limit the button's use to essentials like Talk, Push/Pull, Lift/Throw, and Run.

● **Return of an Iconic Composer and Theme:** After *Super Mario World*'s development ended, Koji Kondo joined the team for this game. He managed both the music and the sound effects by himself. This was the first time Kondo ever carried forward a previous title's music to a sequel.

● **A Choral Effect:** The Super NES was capable of producing richer sound than the NES. Developers pushed it even further by running melodies on two tracks and shifting their pitches, resulting in a choral effect that matched the game's grand and heroic tone.

References
• *Nintendo Official Guidebook—The Legend of Zelda: A Link to the Past.*
• *Nintendo Dream*, February 2014. "*The Legend of Zelda: A Link Between Worlds*: This'll Make You Want to Play! Spoiler-Free Prerelease Interview."

1993

THE LEGEND OF
ZELDA
Link's Awakening™

THE LEGEND OF
ZELDA
Link's Awakening
DX™

Release Dates: August 6, 1993 | June 6, 1993 (JP)
Console: Game Boy

Release Dates: December 15, 1998 | December 12, 1998 (JP)
Console: Game Boy Color

Link's Awakening was the first title in the series to be developed for a handheld console. Its team set out to create a fully fleshed-out *The Legend of Zelda* experience, despite the compact screen. Even beyond the decision to set the game outside of Hyrule, there are other elements unique to this game, including its *Super Mario Bros.* guest characters and bittersweet story.

A remake was released in 1998 for the Game Boy Color, titled *Link's Awakening DX*, with *DX* standing for "Deluxe." Utilizing the system's ability to display multiple, vibrant colors, the core game was preserved while also adding new content like the Color Dungeon and Camera Shop. And with the Game Boy Printer, it was even possible to print photos taken in-game by Koholint's resident rodent photographer.

The black-and-white Game Boy version of Link's Awakening.

▷ PLOT

Link, having restored peace to the kingdom of Hyrule during his adventure in *A Link to the Past*, had set out on a journey to distant lands in order to train. On his way back to his beloved Hyrule, his boat was beset by a storm. Lightning struck his vessel, splitting it in two, and sending Link overboard.

When Link awoke he found himself on the beach of a strange island. A girl was standing by his side. Her name was Marin, a song-loving girl who saved him from the water. The Wind Fish, Marin explained, was asleep inside a giant egg at the highest point on the island.

Link needed time to process what had happened. What's more, his sword was missing. Shield in hand, he set out to search for the blade along the water's edge when an owl appeared before him.

"Awaken the Wind Fish and all will be answered," the owl said. Thus began a new kind of adventure: not to save Hyrule, but to figure out what the owl meant by waking the Wind Fish and how it could be done. Link cut his way through the Goponga Swamp together with a BowWow and sought aid from Prince Richard in Kanalet Castle.

The more Link came to know Marin, the more she seemed different from the other island inhabitants who believed that there was nothing beyond the sea.

"When I discovered you, Link, my heart skipped a beat! I thought, this person has come to give us a message," Marin told Link. She paused for a moment, watching the seabirds over the water. "If I was a seagull, I would fly as far as I could!" she said. "I would fly to faraway places and sing for many people!"

To wake the Wind Fish, Link sought the Instruments of the Sirens from eight dungeons on Koholint which were overrun by monsters. And on a wall in the Southern Face Shrine, he discovered the secret of the island: "The isle of Koholint is but an illusion . . . Human, monster, sea, sky . . . A scene on the lid of a sleeper's eye . . . Awake the dreamer, and Koholint will vanish much like a bubble on a needle . . . Castaway, you should know the truth!"

When Link gathered all eight instruments, stood before the Wind Fish's Egg, and played a beautiful melody, a crack appeared in the egg's shell. Dwelling within was the source of all the vile monsters: the Shadow Nightmares. They attacked Link in a variety of forms, some from Link's past, but he emerged victorious.

The owl that guided Link then revealed itself to be a part of the Wind Fish's spirit. He had been tasked with guarding this dream world while the Wind Fish slept. But Nightmares had begun to seep in through a tear in the dream and plague the island. It was then that Link arrived. When the owl first saw Link on the beach, he was convinced Link was the hero destined to end the Nightmares.

Koholint Island began to fade away when Link awakened the Wind Fish, who left Link with these words: "Someday, thou may recall this island . . . That memory must be the real dream world . . .

"Come, Link . . . Let us awaken . . . Together!"

Link awoke to find himself adrift at sea. Looking up, he saw the form of a gigantic whale soaring through the sky. It was the Wind Fish. And together with it, a single seagull flew toward the horizon.

1 The giant egg at the center of the island. **2** Marin discovers Link after he washes up on the shore. **3** The picture that the goat Christine sends to her pen pal, Mr. Write. She claims it is of her, but . . . **4** Marin and Link share a moment on the beach, discussing the gulls and her hopes for the future. **5** The Shadow Nightmares take the forms of monsters from Link's memories. **6** **7** After Link awakens, memories of Koholint Island and Marin linger in his mind.

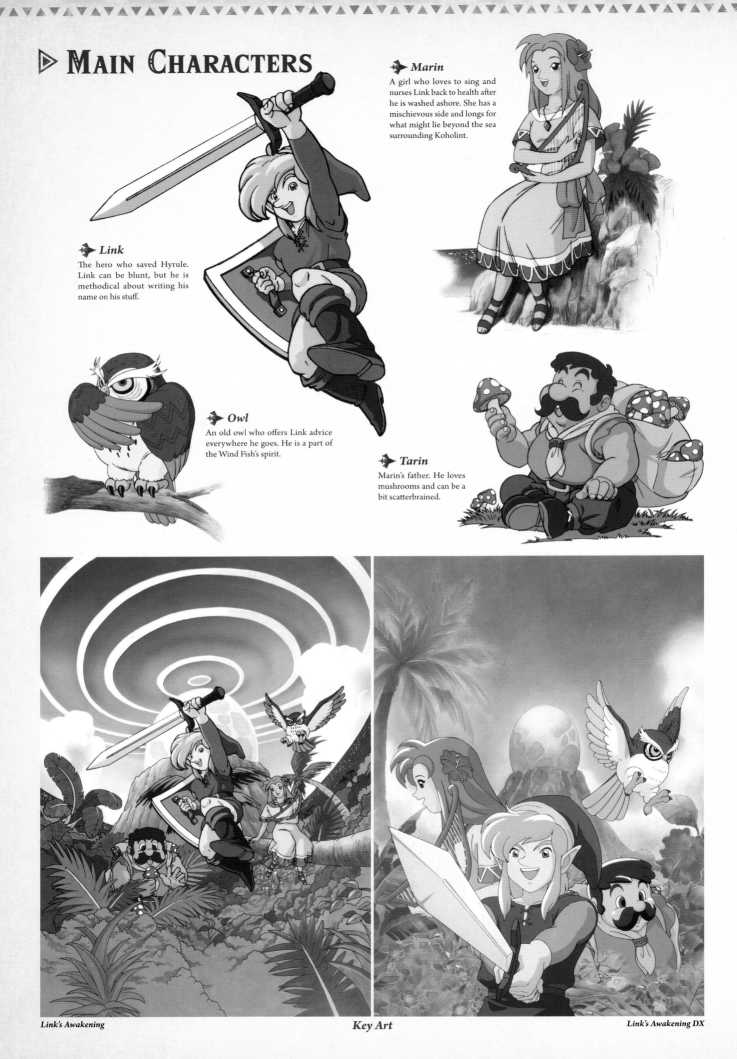

ARCHIVES

GAME INFORMATION & NOTES

▷ MAIN CHARACTERS

◈ Link

The hero who saved Hyrule. Link can be blunt, but he is methodical about writing his name on his stuff.

◈ Owl

An old owl who offers Link advice everywhere he goes. He is a part of the Wind Fish's spirit.

◈ Marin

A girl who loves to sing and nurses Link back to health after he is washed ashore. She has a mischievous side and longs for what might lie beyond the sea surrounding Koholint.

◈ Tarin

Marin's father. He loves mushrooms and can be a bit scatterbrained.

Link's Awakening

Key Art

Link's Awakening DX

▷ CHARACTER RELATIONSHIPS

Part of Its Spirit

Owl

The Wind Fish

Manbo

Guides

Awakens

Learns Songs

Mamu

Temporary Ally

Link

Interested in

Hints

YipYip

BowWow

Transformed into

Tarin

Live Together

Marin

Grandpa Ulrira

Married

Grandma Ulrira

Pet

Pet

Raccoon

Parent/Child

Quadruplets

Punishes if caught stealing

Madam MeowMeow

Papahl

Married

Quadruplets' Mother

Town Tool Shopkeeper

Trendy Game Shop Owner

Fisherman

MABE VILLAGE

Affectionate

Requests Song

OTHER AREAS

ANIMAL VILLAGE

Fisherman

Mermaid

Kiki

Walrus

Schule Donavitch

Artist and Model

Hippo Model

Ghost

Prince Richard

Cucco Keeper

Mr. Write

Pen Pals

Christine

Chef Bear

Photographer*

Item Trader

Sale

Raft Shop Keeper

Mad Batter

Syrup

Teacher

Crazy Tracy

◆ *Various Facility Operators* ◆

*Only appears in *Link's Awakening DX*.

▷ THE WORLD

The game takes place on Koholint Island, a world within the Wind Fish's dream. It takes the form of a tropical island, as lush as it is perilous. Each area has a specific name, and moving a cursor over the map screen displays the name of the region for that block. The field is large at 16 x 16 blocks, but the presence of warp holes and warping songs like Manbo's Mambo make later traversal easy.

Marin finds Link washed up on the shore.

Koholint Island

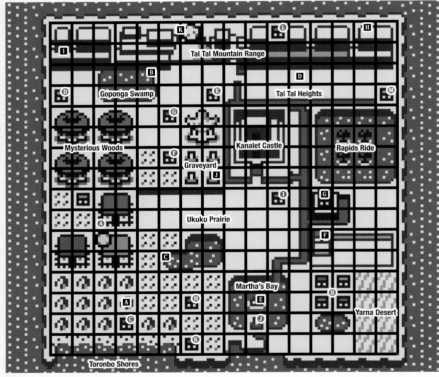

Ⓐ Level 1: Tail Cave Ⓑ Level 2: Bottle Grotto
Ⓒ Level 3: Key Cavern Ⓓ Level 4: Angler's Tunnel
Ⓔ Level 5: Catfish's Maw
Ⓕ Southern Face Shrine (Ancient Ruins)
Ⓖ Level 6: Face Shrine Ⓗ Level 7: Eagle's Tower
Ⓘ Level 8: Turtle Rock
Ⓙ Color Dungeon (Only in *Link's Awakening DX*)
Ⓚ The Wind Fish's Egg

Ⓐ Mabe Village Ⓑ Animal Village
Ⓒ Sale's House O' Bananas Ⓓ Mr. Write's House
Ⓔ Camera Shop (Only in *Link's Awakening DX*)
Ⓕ Syrup's House Ⓖ Crazy Tracy's Health Spa
Ⓗ Richard's Villa Ⓘ Seashell Mansion
Ⓙ Mermaid Statue Ⓚ Ghosts House
Ⓛ Cucco Keeper Ⓜ Rapids Ride Entrance

GUEST CHARACTERS

Dr. Wright from *Sim City* makes an appearance in this game. So do Yoshi, Kirby, and Prince Richard from the Japan-only RPG *The Frog for Whom the Bell Tolls*, and many others.

CONTENT ADDED FOR *LINK'S AWAKENING DX*

In *Link's Awakening DX*, a dungeon and new buildings were added. Under the right conditions, the photographer from the Camera Shop will appear with perfect timing to take commemorative pictures of Link and his friends. Link can view these photos whenever he wants by going to the shop. The Color Dungeon makes ample use of the new color palette, using red, blue, and green colors for puzzles. Clearing the dungeon rewards Link with a choice of Red Clothes or Blue Clothes, which improve his stats significantly.

The vibrant reds, blues, and greens of the Color Dungeon.

The photographer added for Link's Awakening DX has a knack for capturing dramatic moments and expressive poses.

▷ DEVELOPMENT DOCUMENTS

▷ Event Storyboards & Scripts

Key character moments are detailed in these storyboards, which track the flow of information and include relevant dialogue. The sheets for writing out the script contain boxes to ensure the words fit, as only a limited number of characters could be displayed on the screen at once.

SALE'S BANANA TRADING #60

(WHEN LINK DOESN'T HAVE)
DOG FOOD
MS 1C6
I WON'T GIVE YOU MY BANANAS
NO MATTER WHAT YOU DO.

IF YOU BRING ME A RARE FOOD, I
COULD GIVE YOU ONE, THOUGH.

(WHEN LINK HAS DOG FOOD)
MS 1C7
OH, THAT'S A RARE SNACK.
I'LL TRADE YOU A BANANA FOR IT

OK / NO
MS 1C9
THEN I WON'T GIVE
YOU A BANANA

MS 1C8

YOU TRADED
DOG FOOD FOR BANANA! FLAG

USE THE PEEL FOR PRANKS
AFTER YOU EAT IT!

(AFTER)
TRADING UNTIL LINK GIVES
THE BANANA TO
THE MONKEY
MS 1CA

I'VE NEVER TASTED
SOMETHING SO GOOD!

THE DOG FOOD CAN IS ON
THE TABLE

NINTENDO 1992

#60

| | | | TARIN | | | | | |

| | MABE VILLAGE | MARIN'S HOUSE | | | | | |

SRD

A Trading Event

NO DOG FOOD	MS 1C6 ①	I	S		A	N		A	R	T	I	S	T	,		S O
		I		G	U	E	S	S		S	T	R	A	N	G E	
		H	O	B	B	I	E	S		R	U	N		I	N	
	②	T	H	E		F	A	M	I	L	Y	!				
HAS DOG FOOD	MS 1C7 ①	M	A	N	,		G	I	V	E		T	H	A T		
		T	O		M	E	!	!		P	L	E	A	S	E !	
	②		G	I	V	E	/	D	O	N	'	T				
	MS 1C8 (Yes) ①	O	H		T	H	A	N	K		Y	O	U	!		
		I	'	L	L		T	A	K	E		T	H	A	T !	
	②	M	U	N	C	H		M	U	N	C	H	!	!		
					
	MS 1C9 (No) ①	I		D	O	N	'	T		S	U	P	P	O	S E	
		I	T		W	O	U	L	D		D	O		A N	Y	

()

Rescuing Marin Event

MARIN IS MISSING

#6 CLEARED.
HOWEVER, THE
BRIDGE IS BLOCKED
AND SHE IS NOT
AT #7

MS

"HELLO! IT'S ME, ULRIRA!
HMM, MARIN OFTEN
GOES TO THE WIND FISH'S
EGG TO PRAY.
CALL ME IF YOU GET LOST!
BYE! CLICK"

MS

DUNGEON
#6 CLEARED

HEY! IT'S TARIN!
MARIN IS MISSING!
I CAN'T FIND HER
ANYWHERE. MY
PRECIOUS MARIN . . .

NO NEED
TO KEEP
THIS NOTE!

TARIN IS RUNNING
ABOUT, HE SLAMS
INTO A POLE. (SCREEN)
BARRIER

Fr. out

SET AFTER CLEARING #6

NINTENDO 1992

◆ DEVELOPER ◆ NOTES

● **A Successful Experiment:** *Link's Awakening* originally started as a test to see just how much of *The Legend of Zelda* developers could re-create on the Game Boy. Because it was not an official project at first, the developers involved gathered after hours to work on it. They said it felt like being in an afterschool club, and put in self-referential jokes and ample nods to other titles during development. The director, Takashi Tezuka, said it felt like they were "making a parody of *The Legend of Zelda*."

● **David Lynch Inspires Zelda:** The setting and story of this unique title brought together wild ideas from multiple developers, including Yoshiaki Koizumi's concept of "being in a dream that may be yours, or may be someone else's," Kensuke Tanabe's vision of a world where "a giant egg sits at the summit of a mountain, and if it breaks, the world ends," and Takashi Tezuka's interest in creating "a mysterious world, like in the foreign TV series *Twin Peaks*."

References
• *Iwata Asks. "The Legend of Zelda: Spirit Tracks* Compilation of Handheld Zeldas."
• Nintendo Official Guidebook—*The Legend of Zelda: Link's Awakening.*
• Nintendo Official Guidebook—*The Legend of Zelda: Link's Awakening DX.*

-1998-

Release Dates: November 23, 1998 | November 21, 1998 (JP)
Console: Nintendo 64

Release Date: June 19, 2011 | June 16, 2011 (JP)
Console: Nintendo 3DS

Ocarina of Time brought *Legend of Zelda*–style puzzle solving and action into three dimensions. It introduced game play advancements like automatic jumping and the ability to lock onto enemies and objects by pressing Z, while the new 3D perspective allowed enhanced cut scenes and puzzle mechanics.

The game's emphasis on atmosphere and immersion in a vast world marked a turning point in the series and the games industry as a whole.

In 2011, a remake of *Ocarina of Time* was released for the Nintendo 3DS that supported 3D and had improved graphics. It also included *Ocarina of Time: Master Quest*, a version with more difficult dungeons that was previously only available with pre-orders and certain editions of *The Wind Waker.*

Link rides Epona in the Nintendo 64 version of Ocarina of Time.

▷ PLOT

The Kokiri, children of the forest, lived with the Great Deku Tree, who was the guardian spirit of that forest. Each of the children had their own guardian fairy, except one. His name was Link and he didn't quite fit in.

One day, a fairy sent by the Great Deku Tree came to him with a very important mission. The Great Deku Tree had been cursed, and needed someone with great courage to break the curse.

Guided by the fairy Navi, Link destroyed the parasitic Gohma and broke the curse on the Great Deku Tree. As thanks, the ancient tree gave Link one of three Spiritual Stones, and told Link of his origins as a Hylian. He explained that Link was fated to leave the forest and save Hyrule.

Link left the Kokiri Forest and headed for Hyrule Castle, where he met Princess Zelda. The princess had been plagued by strange visions in which a young hero much like Link surfaced to deliver Hyrule from the mysterious leader of the Gerudos, Ganondorf, who was after the power of the Triforce. Together Link and Zelda vowed to keep the Triforce from ever falling into Ganondorf's possession by getting to it before him. First, Link would need to gather the remaining Spiritual Stones to access the Temple of Time and the Sacred Realm, the sealed hiding place of the Triforce.

After completing this task, he returned to Hyrule Castle just in time to see Princess Zelda and Impa, her attendant, fleeing on horseback. Ganondorf had taken the castle. As she passed, Zelda threw Link the Ocarina of Time, a treasure of the royal family and the last element he needed to open the Door of Time.

Link rushed to the Temple of Time, and used the Spiritual Stones and the ocarina to open the doors to the Sacred Realm. Within was the Master Sword, the key to the portal between Hyrule and the Sacred Realm, which only the chosen hero could pull from its pedestal. Link drew the sword, but he was far too young to wield it. His spirit was put to sleep, to awake after seven years had passed.

In that time, Hyrule was transformed into a realm of monsters. Ganondorf had entered the Sacred Realm, obtained the Triforce of Power, and used it to become the King of Evil.

Link, at the behest of a young Sheikah named Sheik, traveled between the present and the past of seven years ago in a quest to find the six sages. After these six sages were awoken, Sheik explained that the one endowed with the Triforce of Courage sought by Ganon was none other than Link, the Hero of Time, while a seventh sage carried the Triforce of Wisdom and was destined to be the leader of all the sages. It was then that Sheik's true identity was revealed: "It is I, the princess of Hyrule, Zelda."

Zelda had disguised herself as a Sheikah in order to hide in plain sight from Ganondorf. But Ganondorf had been watching, waiting for this moment to capture Zelda. With everything at stake, Link hurried to Ganon's Castle to save Zelda and Hyrule from Ganondorf's tyranny.

In an epic battle, Link defeated Ganondorf, but this only unleashed his true power, transforming the Gerudo thief into Ganon, a hideous beast. It was only by the combined power of the Master Sword, Princess Zelda, and the six sages that Link triumphed, sealing Ganon and the Triforce of Power away in the Sacred Realm. Princess Zelda sealed the Door of Time, and the Hero of Time returned to his original era—to his true home and to his true form.

It was the dawn of a new era.

1 The guardian spirit known as the Great Deku Tree. As keeper of a Spiritual Stone, he is targeted and cursed by Ganondorf. **2** Link learns of his destiny and sets out alone on his journey beyond the Kokiri Forest. His Kokiri friend Saria catches him before he leaves and gives him her ocarina. "We'll be friends forever," she says, and soon after awakens as the Sage of the Forest. **3** Link gathers the three Spiritual Stones and places them in the Temple of Time. **4** As an adult, Link receives advice and learns magical melodies from Sheik. **5** After Princess Zelda reveals herself to be Sheik, she is captured by Ganondorf. **6** Link lands the final blow against the monstrous Ganon with the Master Sword in a battle for the future of Hyrule.

▷ MAIN CHARACTERS

◈ Link (CHILD | ADULT)

A pure-hearted Hylian boy raised among the Kokiri with a swift sword and a strong sense of justice. Traversing time itself to save Hyrule, he earns the title "Hero of Time."

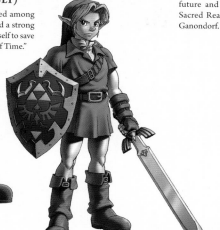

◈ Navi

A fairy tasked by the Great Deku Tree to stay by Link's side throughout his quest, providing advice and support.

◈ Princess Zelda (CHILD | ADULT)

A princess chosen by the goddesses and imbued with a sacred power. She is granted a vision of the future and fights to protect the Sacred Realm and Triforce from Ganondorf.

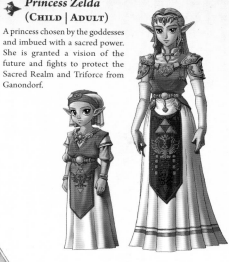

◈ Ganondorf

The first man born among the Gerudo in a century. He seeks the Spiritual Stones in order to obtain the Triforce.

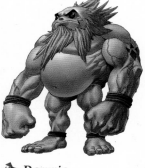

◈ Saria

A Kokiri girl and childhood friend to Link. She is kind and has many admirers. Saria later awakens as the Sage of the Forest.

◈ Rauru

Rauru constructed the Temple of Time. The ancient Sage of Light, he has since guarded the Sacred Realm from those who would seek the power of the Triforce for their own benefit. He watches over Link as Kaepora Gaebora, the owl.

◈ Impa

Princess Zelda's attendant. She knows well the legends of Hyrule. She is the last surviving member of the Sheikah and the Sage of Shadow.

◈ Sheik

When Link is an adult, he meets a young Sheikah who teaches him many songs. Behind the mask is Princess Zelda.

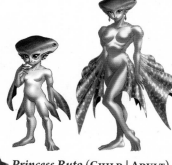

◈ Darunia

The Goron leader who awakens as the Sage of Fire. After his rescue, Darunia names his own son after Link. He sure likes to dance.

◈ Princess Ruto (CHILD | ADULT)

Princess of the Zora and Sage of Water. Ruto can be a bit selfish, and decides Link is her fiancé after she gives him Zora's Sapphire, considered to be a symbol of engagement among her people.

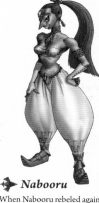

◈ Nabooru

When Nabooru rebelled against Ganondorf, Twinrova placed her under mind control and made her the leader of the Gerudo. She awakens as the Sage of Spirit.

Ocarina of Time

Key Art

Ocarina of Time 3D

Character Relationships

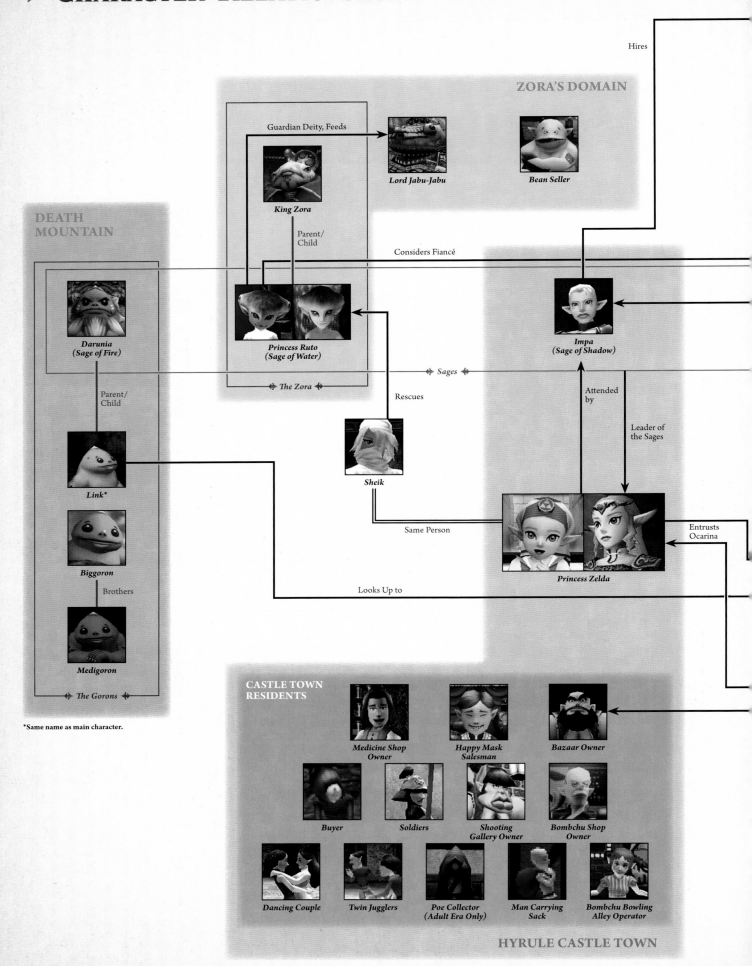

ZORA'S DOMAIN

Hires

Guardian Deity, Feeds

Lord Jabu-Jabu

Bean Seller

King Zora

DEATH MOUNTAIN

Parent/ Child

Considers Fiancé

**Darunia
(Sage of Fire)**

**Princess Ruto
(Sage of Water)**

**Impa
(Sage of Shadow)**

◆ Sages ◆

Parent/ Child

Rescues

Attended by

Link*

◆ The Zora ◆

Sheik

Leader of the Sages

Biggoron

Same Person

Entrusts Ocarina

Brothers

Princess Zelda

Medigoron

Looks Up to

◆ The Gorons ◆

*Same name as main character.

CASTLE TOWN RESIDENTS

Medicine Shop Owner

Happy Mask Salesman

Bazaar Owner

Buyer

Soldiers

Shooting Gallery Owner

Bombchu Shop Owner

Dancing Couple

Twin Jugglers

**Poe Collector
(Adult Era Only)**

Man Carrying Sack

Bombchu Bowling Alley Operator

HYRULE CASTLE TOWN

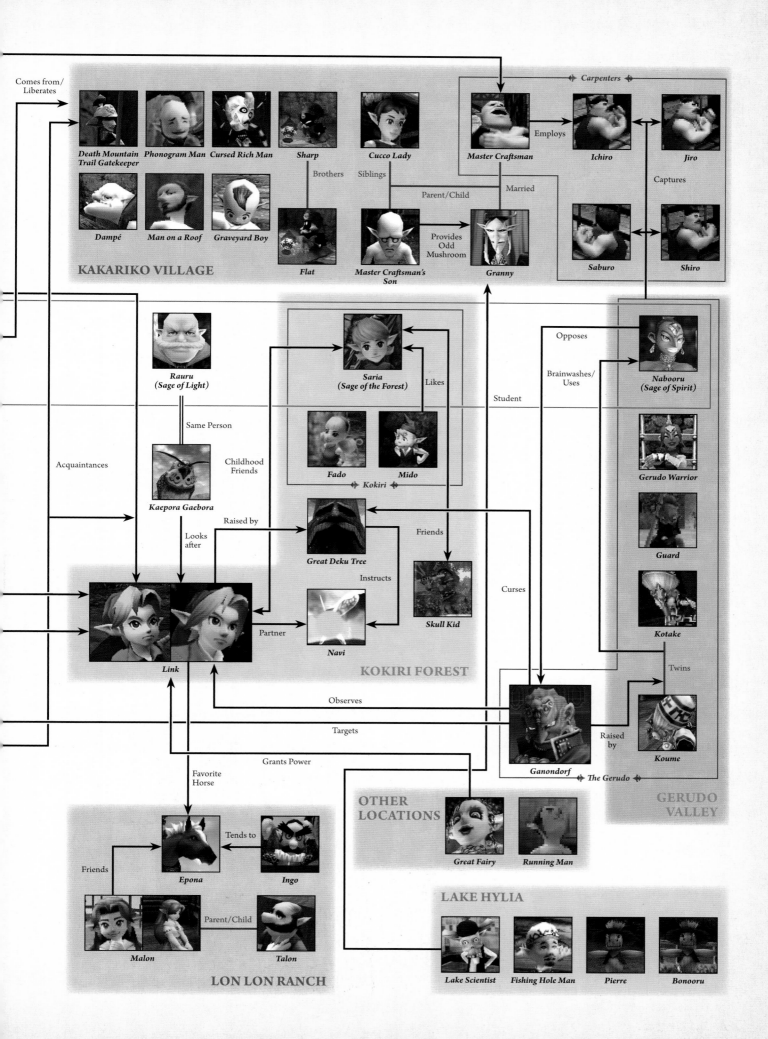

KAKARIKO VILLAGE

Death Mountain Trail Gatekeeper

Phonogram Man

Cursed Rich Man

Sharp

Cucco Lady

Master Craftsman

Ichiro

Jiro

Dampé

Man on a Roof

Graveyard Boy

Flat

Master Craftsman's Son

Granny

Saburo

Shiro

Comes from/ Liberates

Carpenters

Employs

Brothers

Siblings

Parent/Child

Married

Provides Odd Mushroom

Captures

Rauru (Sage of Light)

Saria (Sage of the Forest)

Likes

Nabooru (Sage of Spirit)

Opposes

Brainwashes/ Uses

Student

Fado

Mido

Kokiri

Gerudo Warrior

Same Person

Acquaintances

Childhood Friends

Kaepora Gaebora

Raised by

Great Deku Tree

Friends

Guard

Looks after

Instructs

Skull Kid

Kotake

Twins

Link

Partner

Navi

KOKIRI FOREST

Curses

Koume

Observes

Targets

Raised by

Ganondorf

The Gerudo

GERUDO VALLEY

Grants Power

Favorite Horse

OTHER LOCATIONS

Great Fairy

Running Man

LAKE HYLIA

Epona

Tends to

Ingo

Friends

Malon

Parent/Child

Talon

Lake Scientist

Fishing Hole Man

Pierre

Bonooru

LON LON RANCH

▷ THE WORLD

A variety of regions with vastly different climates and terrain extend off of the rolling plains of Hyrule Field. The peoples who call Hyrule home vary by region, with the Kokiri in Kokiri Forest, the Gorons on Death Mountain, the Zora in Zora's Domain, and the Gerudo in Gerudo Valley. At the heart of Hyrule are the Hylians, who make their homes on ranches and farms as well as in settlements like Kakariko Village and Hyrule Castle Town. Link journeys across two versions of Hyrule, in both the Child Era and the Adult Era, which takes place seven years later.

Hyrule

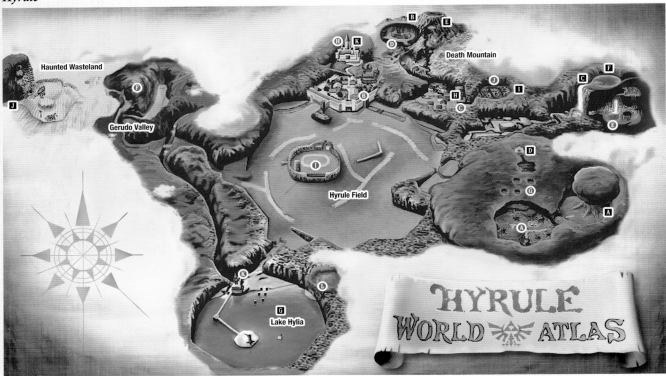

A Inside the Deku Tree	**B** Dodongo's Cavern	**C** Inside Jabu-Jabu's Belly	
D Forest Temple	**E** Fire Temple	**F** Ice Cavern	**G** Water Temple
H Bottom of the Well	**I** Shadow Temple	**J** Spirit Temple	**K** Ganon's Castle

A Kokiri Forest	**B** Hyrule Castle Town	**C** Kakariko Village	**D** Goron City
E Zora's Domain	**F** Gerudo Fortress	**G** Lost Woods	**H** Hyrule Castle
I Lon Lon Ranch	**J** Graveyard	**K** Lakeside Laboratory	**L** Fishing Hole

Castle Town

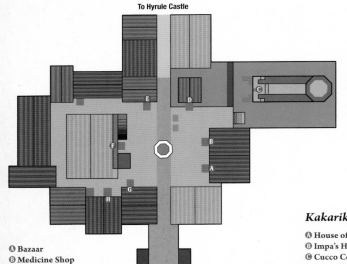

A Bazaar
B Medicine Shop
C Temple of Time
D Happy Mask Shop
E Shooting Gallery
F Bombchu Bowling Alley
G Treasure Chest Game
H Bombchu Shop

PEOPLE AND THE PASSAGE OF TIME

Seven years in the future, Ganondorf has seized control of Hyrule Castle, and the people of its Castle Town are forced to flee to Kakariko Village. The facilities at G, H, and I on the Kakariko Village map only exist in the Adult Era, and some former Castle Town residents can be seen taking refuge.

Child Era (Castle Town)

Adult Era (Kakariko Village)

Kakariko Village

A House of Skulltula
B Impa's House
C Cucco Coop
D Windmill
E To the Bottom of the Well
F Granny's Potion Shop
G Shelter
H Bazaar
I Medicine Shop

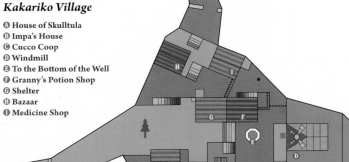

DEVELOPMENT DOCUMENTS

Link Artwork Drafts ◁

The artists working on *Ocarina of Time* used sketches to fine-tune the game's art direction while Link's in-game design was still undecided. Early versions of Navi and Ganon are illustrated along with him.

▷ Lon Lon Ranch: Rough Character Designs

These drawings, made during the design process, show that Talon and Ingo were meant to resemble Mario and Luigi, right down to their overalls.

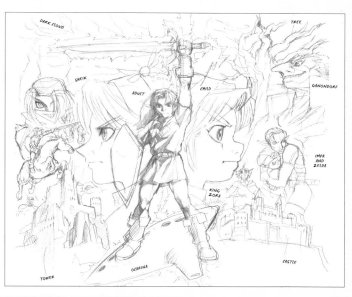

Key Art Design Proposal ◁

One of the many sketches made during *Ocarina of Time*'s development, this one encapsulates the game's key themes and characters in a single image.

DEVELOPER NOTES

● **Music as Magic:** The moment an ocarina was added to the story, producer Shigeru Miyamoto decided music would be central to the game. Songs occupied the role normally fulfilled by magic. Sound director Koji Kondo was brought in to plan how to tie music in with the story.

● **Emphasis on Swordplay:** Designers set out to make this a "*Zelda* where swordplay is possible." The development team went to the Toei Kyoto Studio Park for research. The Z-Targeting System came to them while watching the actors sword fighting. One director, Osawa Toru, pictured "two people connected by a sickle and chain, moving in circles," while another, Yoshiaki Koizumi, pushed for a system with "the main character fighting only the opponent he is focused on among a group of enemies, while the other enemies watch."

● **Navi's Name:** During the prototyping for Z-Targeting, Koizumi changed the design of the marker from something robotic to a fairy. The team started calling it the "Fairy Navigation System." Inspired by this, Osawa named the fairy "Navi." The birth of Navi was pivotal to the story, which became about "beginning the journey with meeting the fairy, and ending it when they part ways."

● **Hand-to-Hand Animation:** Beyond a portion of Link's movements that used motion capture, every animation in *Ocarina of Time* was done by hand.

● **Working with Wind:** After the completion of the game, Miyamoto said, "They gave everything they could to create a sense of wind, but the wind itself was never worked into any of the designs."

References
• "NOM Producer Shigeru Miyamoto Discussed the World of *The Legend of Zelda: Ocarina of Time*."
• Iwata Asks. "*The Legend of Zelda: Ocarina of Time* 3D Original Staff Compilation: Shigeru Miyamoto."
• *The 64 DREAM*, April 1999. "*The Legend of Zelda: Ocarina of Time*: Thank You for Your Passion! Shigeru Miyamoto Interview."

The sequel to *Ocarina of Time* built upon many of its systems and characters. The setting changed entirely, though, by transporting Link to Termina, a mysterious parallel world doomed to be destroyed in three days. This could only be prevented by rewinding time, which added a sense of tension and urgency to the game play and story. The ticking clock put a time limit on dungeons, while repeatedly meeting characters allowed them greater depth. Also introduced was a memorable mechanic that saw Link transform into Goron, Zora, and Deku versions of himself when donning the races' respective masks.

A remake was released for the Nintendo 3DS in 2015, adding fishing holes, additional plot lines, and enhanced visuals.

Link with a sleeping Captain Keeta in the Nintendo 64 version.

Release Dates: October 26, 2000 | April 27, 2000 (JP)
Console: Nintendo 64

Release Dates: February 13, 2015 | February 14, 2015 (JP)
Console: Nintendo 3DS

▷ PLOT

In the land of Hyrule, there echoes a legend of a young boy who had waged battles across time to save the world. A boy who, after the dust had settled, embarked on a personal journey to find his beloved friend, the fairy Navi, with whom he had parted ways after fulfilling his heroic destiny.

Link had wandered deep into the forest in search of Navi when Skull Kid and two fairies appeared. Skull Kid stole the Ocarina of Time and transformed Link into a Deku Scrub. As Tatl, the yellow fairy, was taunting Link, Skull Kid and Tael, the black fairy, fled into the woods. Tatl joined Link in pursuit of Skull Kid, tracking him to a clock tower in a village aptly named Clock Town.

There, a traveling merchant known as the Happy Mask Salesman called out to him. It seemed that Skull Kid had stolen a very important mask from him—something called Majora's Mask. The salesman told Link that if he recovered both the ocarina and the mask, he could restore Link to normal. Together with Tatl, Link cornered Skull Kid at the top of the clock tower. There, he learned that Skull Kid was attempting to drop the moon onto the world of Termina, destroying it. The moon loomed large in the sky. As Tatl and Tael began to panic, Link seized the moment and took back the Ocarina of Time. Playing the Song of Time, Link reversed the flow of time, finding that he had somehow returned to the moment he had first set foot in the town.

He once again visited the mask salesman in the clock tower. The salesman played a song to soothe the soul, which caused the Deku Mask to fall from Link's face, returning him to his original form. However, Skull Kid was still in possession of Majora's Mask. Link learned that it was this terrible mask that gave Skull Kid his apocalyptic power. It had to be returned as quickly as possible, but doing so was no small feat. In order to stop the moon from falling, Link first had to summon giants from the four regions of Termina.

As Link relived the same three days over and over, he gradually drew closer to the temples that housed the giants. As he did this, he helped people in need and collected a variety of other useful masks.

After a multitude of three-day cycles, Link pursued Skull Kid and played the song to summon the giants at the top of the clock tower. As he did, the four giants approaching from each region caught the moon in its descent.

Majora's Mask began to move of its own will, causing the moon to go berserk and swallow both Link and Tatl whole. Inside the moon was a wide field and a single tree. Around it were children wearing masks. The child wearing Majora's Mask asked Link if he wanted to play good guys versus bad guys. "You're the bad guy. And when you're bad, you just run. That's fine, right?"

And so the final battle began. Link defeated the deformed Majora's Mask and the moon vanished. Termina was saved. Skull Kid returned to normal, and he laughed when he saw Link. The mask salesman took back Majora's Mask and, seeing the masks Link had collected, said, "This is truly a good happiness," and left.

That day there also happened to be a massive carnival in Clock Town. But Link didn't linger long. Having restored peace to Termina, he returned to the forest and resumed his original quest.

1 Skull Kid steals the Ocarina of Time for a laugh. **2** Link hallucinates being attacked by Deku Scrubs. When he comes to, he has become one. **3** Meeting the Happy Mask Salesman in the clock tower. He begs Link to retrieve Majora's Mask, which has been stolen by Skull Kid. **4** If the moon falls after three days, it will destroy all of Termina. **5** Playing the Song of Time returns time to the dawn of the first day. **6** Another song creates an empty shell of one's self. Link is able to create one shell for each of his forms. **7 8** The citizens go about their three days like clockwork but their destinies are altered by Link's actions. Ensuring that Anju from the inn can get married requires Link's full attention for all three days.

▷ MAIN CHARACTERS

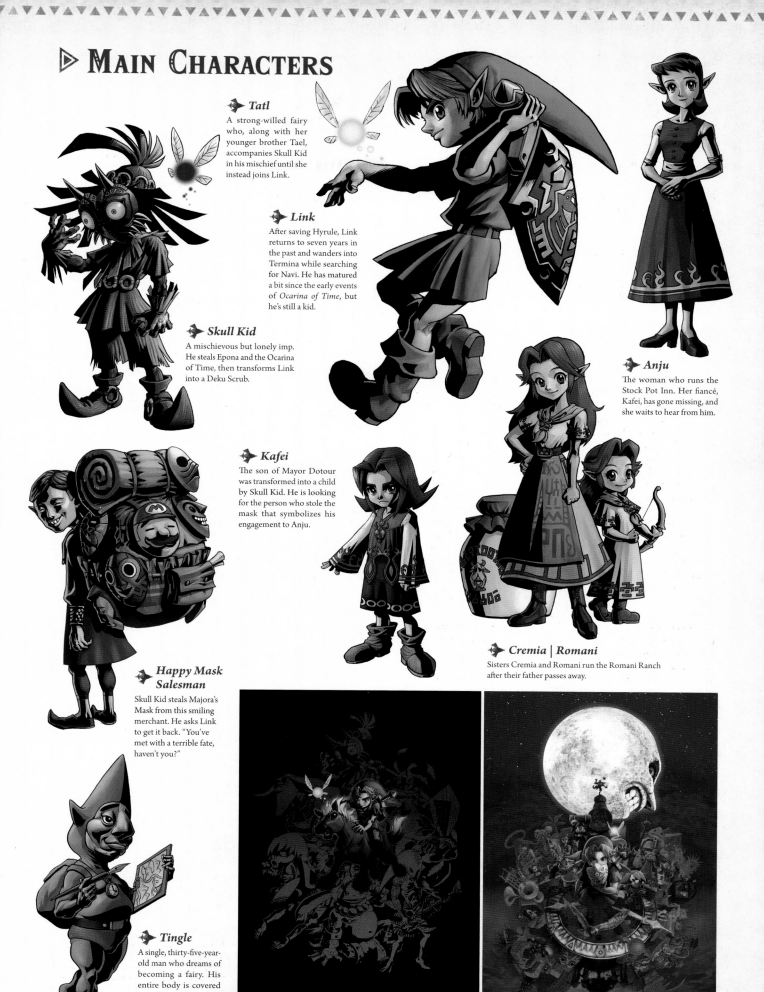

▶ Tatl
A strong-willed fairy who, along with her younger brother Tael, accompanies Skull Kid in his mischief until she instead joins Link.

▶ Link
After saving Hyrule, Link returns to seven years in the past and wanders into Termina while searching for Navi. He has matured a bit since the early events of *Ocarina of Time*, but he's still a kid.

▶ Skull Kid
A mischievous but lonely imp. He steals Epona and the Ocarina of Time, then transforms Link into a Deku Scrub.

▶ Anju
The woman who runs the Stock Pot Inn. Her fiancé, Kafei, has gone missing, and she waits to hear from him.

▶ Kafei
The son of Mayor Dotour was transformed into a child by Skull Kid. He is looking for the person who stole the mask that symbolizes his engagement to Anju.

▶ Happy Mask Salesman
Skull Kid steals Majora's Mask from this smiling merchant. He asks Link to get it back. "You've met with a terrible fate, haven't you?"

▶ Cremia | Romani
Sisters Cremia and Romani run the Romani Ranch after their father passes away.

▶ Tingle
A single, thirty-five-year-old man who dreams of becoming a fairy. His entire body is covered in green tights, and his father feels ashamed and wants him to stop.

Majora's Mask

Key Art

Majora's Mask 3D

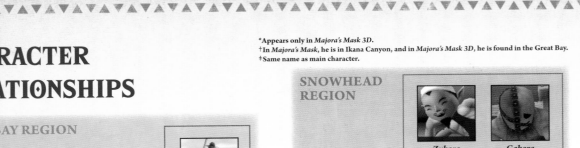

*Appears only in *Majora's Mask 3D*.
†In *Majora's Mask*, he is in Ikana Canyon, and in *Majora's Mask 3D*, he is found in the Great Bay.
‡Same name as main character.

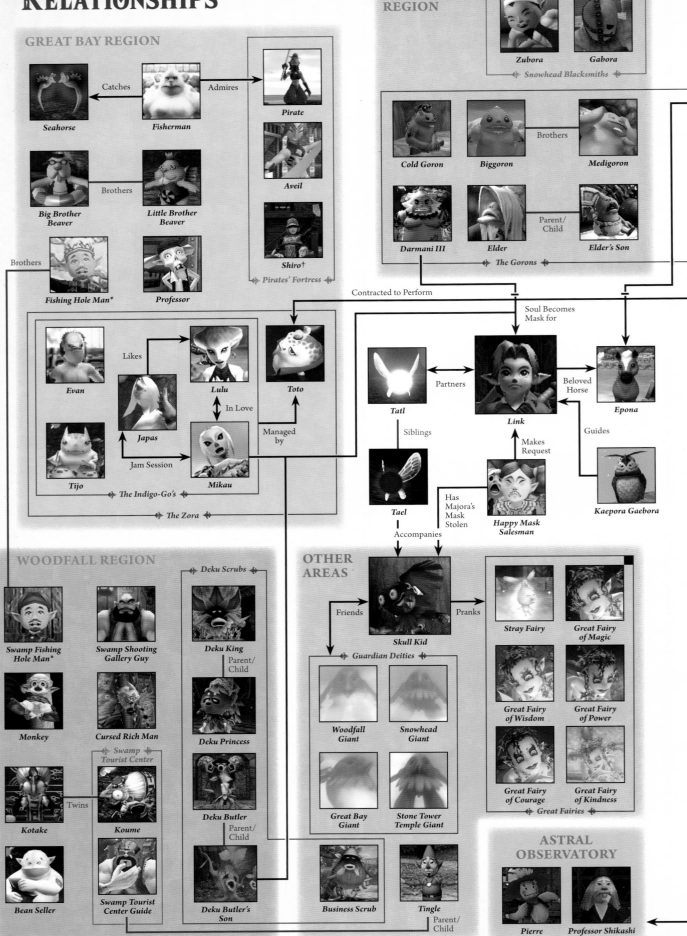

GREAT BAY REGION

Seahorse ← Catches — Fisherman — Admires → Pirate

Aveil

Shiro†

▶ Pirates' Fortress ◀

Big Brother Beaver — Brothers — Little Brother Beaver

Fishing Hole Man* Professor

Brothers

The Indigo-Go's

Evan — Likes → Lulu — In Love → Mikau — Managed by → Toto

Japas — Jam Session →

Tijo

Lulu — In Love ↕ — Mikau

▶ The Zora ◀

SNOWHEAD REGION

Zubora Gabora

▶ Snowhead Blacksmiths ◀

Cold Goron Biggoron — Brothers — Medigoron

Darmani III Elder — Parent/Child — Elder's Son

▶ The Gorons ◀

Contracted to Perform

Soul Becomes Mask for

Tatl — Partners → Link — Beloved Horse → Epona

Tatl — Siblings — Tael

Tael — Accompanies →

Makes Request → Link

Happy Mask Salesman — Has Majora's Mask Stolen

Kaepora Gaebora — Guides →

WOODFALL REGION

Swamp Fishing Hole Man* Swamp Shooting Gallery Guy

▶ Deku Scrubs ◀

Deku King — Parent/Child — Deku Princess

Monkey Cursed Rich Man

Swamp Tourist Center

Kotake — Twins — Koume

Bean Seller Swamp Tourist Center Guide

Deku Butler — Parent/Child — Deku Butler's Son

OTHER AREAS

Friends ← Skull Kid → Pranks

▶ Guardian Deities ◀

Woodfall Giant Snowhead Giant

Great Bay Giant Stone Tower Temple Giant

Business Scrub Tingle — Parent/Child

Stray Fairy Great Fairy of Magic

Great Fairy of Wisdom Great Fairy of Power

Great Fairy of Courage Great Fairy of Kindness

▶ Great Fairies ◀

ASTRAL OBSERVATORY

Pierre Professor Shikashi

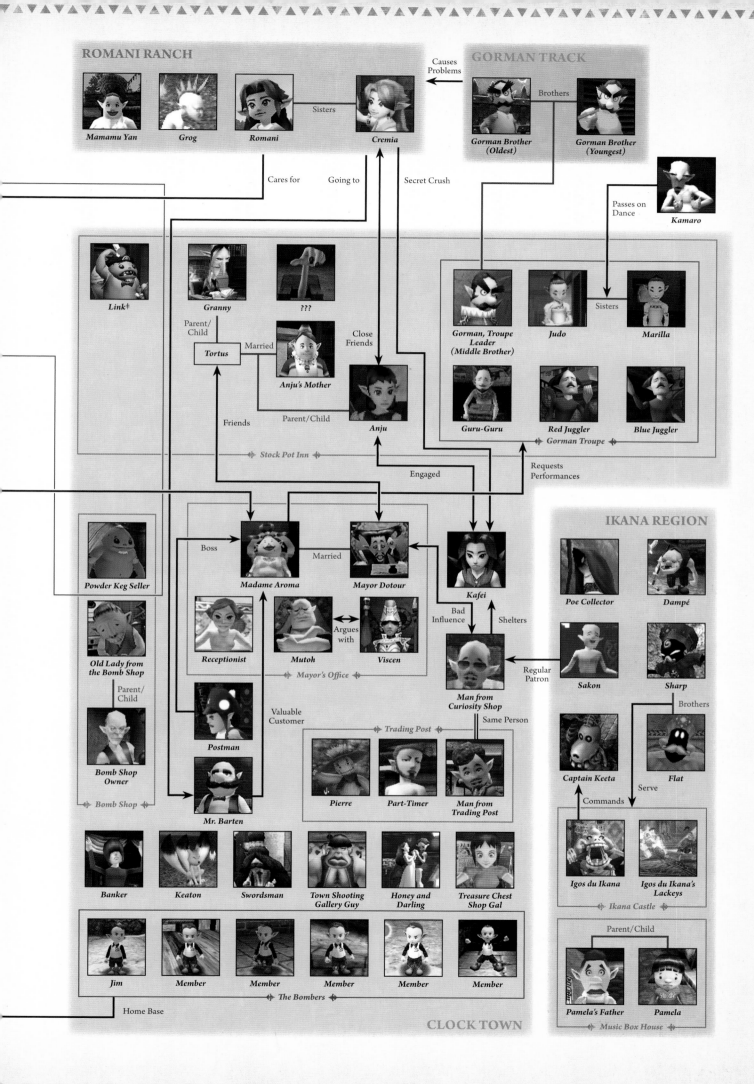

ROMANI RANCH

Mamamu Yan

Grog

Romani — Sisters — **Cremia**

GORMAN TRACK

Gorman Brother (Oldest) — Brothers — **Gorman Brother (Youngest)**

Causes Problems

Passes on Dance

Kamaro

Cares for

Going to

Secret Crush

Link‡

Granny

???

Parent/Child

Tortus — Married — **Anju's Mother**

Friends

Parent/Child

Close Friends

Anju

Gorman, Troupe Leader (Middle Brother)

Judo — Sisters — **Marilla**

Guru-Guru

Red Juggler

Blue Juggler

Gorman Troupe

Stock Pot Inn

Engaged

Requests Performances

IKANA REGION

Powder Keg Seller

Old Lady from the Bomb Shop

Parent/Child

Bomb Shop Owner

Bomb Shop

Boss

Married

Madame Aroma — Married — **Mayor Dotour**

Kafei

Poe Collector

Dampé

Receptionist

Mutoh ↔ **Viscen**

Argues with

Mayor's Office

Bad Influence

Shelters

Man from Curiosity Shop

Regular Patron

Sakon

Sharp

Brothers

Valuable Customer

Postman

Same Person

Trading Post

Pierre

Part-Timer

Man from Trading Post

Captain Keeta

Flat

Serve

Commands

Mr. Barten

Banker

Keaton

Swordsman

Town Shooting Gallery Guy

Honey and Darling

Treasure Chest Shop Gal

Igos du Ikana

Igos du Ikana's Lackeys

Ikana Castle

Parent/Child

Jim

Member

Member

Member

Member

Member

The Bombers

Home Base

Pamela's Father

Pamela

Music Box House

CLOCK TOWN

ᐅ THE WORLD

Termina Field expands outward from Clock Town, which is located at the field's center. The world itself is broadly divided into four regions—the swamp, the mountain, the ocean, and the canyon, with different races living in each area. Additionally, there is an Astral Observatory with a giant telescope in Termina Field, as well as the pastures of Romani Ranch to the southwest.

Swamp: Woodfall Region
A large swamp covers this region. The Deku Princess has gone missing and the king is interrogating a monkey hoping to learn where she is being kept.

Mountains: Snowhead Region
The region normally has a warm climate, but something strange has caused the temperature to fall rapidly. The mountains are covered in ice and snow, and the Gorons who live here are suffering from the cold.

Ocean: Great Bay Region
This massive bay is lined by a large beach on the coast. The aquatic Zora are found in Zora Hall here, while pirates make their home in a nearby fortress. Something is making it impossible to fish . . .

Canyon: Ikana Region
The land where the ancient Ikana Kingdom once stood. Something has resurrected the dead and the people living in Ikana Village have fled. Now, only ghost researchers and a gravekeeper remain.

Termina

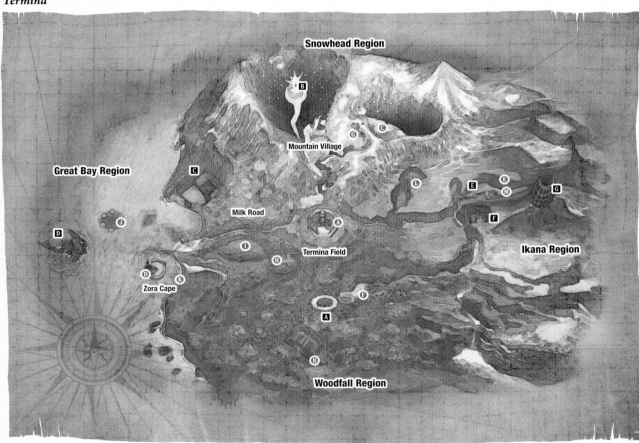

A Woodfall Temple **B** Snowhead Temple
C Pirates' Fortress **D** Great Bay Temple **E** Beneath the Well
F Ancient Castle of Ikana **G** Stone Tower Temple

Ⓐ Clock Town **Ⓓ** Deku Palace **Ⓖ** Goron Village **Ⓓ** Zora Hall **Ⓘ** Ikana Canyon
Ⓕ Swamp Fishing Hole* **Ⓖ** Goron Racetrack **Ⓗ** Gorman Track **Ⓘ** Romani Ranch
Ⓙ Pinnacle Rock **Ⓚ** Ocean Fishing Hole* **Ⓛ** Graveyard **Ⓜ** Music Box House *Only in *Majora's Mask 3D*.

THE MOON OVER CLOCK TOWN

Clock Town, the biggest town in Termina, is normally busier as the Carnival of Time approaches, but concern that the moon might fall casts a shadow over the excitement. As the first and second days come and go, the residents become more uneasy, with some fleeing and some preparing for the festival. Just past midnight at the end of the third day, the top of the clock tower becomes accessible, and the carnival fireworks are set off.

First Day

Second Day

Third Day Morning

People are concerned that the moon will fall, but do not fully believe it. They argue over whether to continue preparing for the carnival or evacuate the town.

The clouds gather and it rains that afternoon. Earthly tremors grow larger, as does the moon as it nears the surface. The people's unease increases.

By the afternoon of the third day, most residents have fled and the town is basically empty. The sky turns to an eerie mix of red and yellow, and it seems the end is near.

◢ DEVELOPMENT DOCUMENTS

▷ *Kafei Design Proposals*

Kafei plays a critical role in the events recorded in the Bombers' Notebook. These sketches show the character in various poses, including his adult form, which is not seen in the game.

▷ Majora's Mask 3D *Sketches*

Rosa Sisters

COMPLETED VERSION

Fierce Deity Link

COMPLETED VERSION

◅ DEVELOPER ► NOTES

● **Time Bears Down:** Much like the plot of *Majora's Mask*, developers were given a relatively short period of time to complete the game: a single year. They accomplished this by making the most of *Ocarina of Time*'s assets while focusing effort on designing a new game structure. The initial development team members were organized as a perfect split between rookies and developers of *Ocarina of Time*. Later, as the moon bore down on development, more original members were brought on,

making for a team of about 70 percent *Ocarina of Time* veterans.

● **"Do whatever you can!":** Yoshiaki Koizumi, codirector on the title, was brought on after a project he was really excited about was canceled. *Majora's Mask* producer Shigeru Miyamoto told Koizumi, "Do whatever you can!" He worked in a number of elements from the canceled project, which led to the Bombers' Notebook quests. Koizumi said of the intricate relationships he dreamed up: "I threw in everything I had experienced over thirty-odd years."

● **"What the heck is this?!":** During development of *Majora's Mask 3D*, Eiji Aonuma played

through every inch of the original N64 version that he helped direct. Points that stuck out while he played went onto a "What the heck is this?!" list. The team then took any elements from the original game that they deemed unfair to the player and resolved them in the remastered version. Aonuma said that he thinks the game no longer feels as unreasonable as it once did. The studio in charge of developing the remake, Grezzo, added in even more material.

References
• *The 64 DREAM*, June 2000. "Nintendo Double-Header Interview: 1st Match."
• *Hobo Nikkan Itoi Shinbun Treetop Hideout*. "The Legend of Zelda: Majora's Mask ~Let's Discuss the New Zelda~"
• *Iwata Asks*. "The Legend of Zelda: Majora's Mask 3D."

← 2001 →

THE LEGEND OF ZELDA ORACLE OF SEASONS

Release Dates: May 14, 2001 | February 27, 2001 (JP)
Console: Game Boy Color

The *Oracle* series marked the first time canon *Zelda* titles were developed by a company other than Nintendo. Capcom's two portable adventures transported Link to new worlds and could be linked for more content. Both featured a guardian Maku Tree as a central character and emphasized collecting mysterious seeds with a variety of effects, giving the pair its Japanese title: *Fruit of the Mysterious Tree.*

In *Oracle of Seasons*, Link explores Holodrum, a world plagued by extreme changes in climate. To save Din, the Oracle of Seasons, and restore order to Holodrum by deposing the renegade Onox, General of Darkness, Link must first seek the Rod of Seasons, which will allow him to change the seasons at will. Color graphics showed the effects of each season on Holodrum, while the game emphasized action, contrasting with the puzzle-friendly *Oracle of Ages.*

A variety of colors shows the change of seasons.

▷ PLOT

As Link rode his horse across Hyrule, he felt a strange beckoning. He found himself deep within Hyrule Castle, where he found the Triforce resting.

"Link . . . Link . . . Accept the quest of the Triforce!"

There was a flash of light and Link vanished, transported to the land of Holodrum, where he lay unconscious and taken care of by a woman named Din. Din was a dancer in a troupe of performers, and when Link awoke, she invited him to dance with her. It was then she noticed the triangular mark on the back of his hand. "That is a sacred mark in Hyrule. If it's the true symbol, then you are a hero with a special fate, Link."

As the troupe were enjoying themselves the sky grew dark. A voice from a man calling himself Onox, General of Darkness, called out, "I've found you, Din, Oracle of Seasons!" With that, a tornado appeared, enveloped Din, and left with her, casting Link aside and rendering him unconscious.

One of the troupe's members found Link and roused him. It was Zelda's nurse Impa in disguise. Zelda had sensed a darkness following Din, and sent Impa to escort her to Hyrule, but Impa was wounded in the attack and could not travel. She understood Link's importance and sent him to the guardian of Holodrum, the Maku Tree, who directed him in his quest to save Holodrum and told him to seek the Rod of Seasons, which had the ability to control the four seasons.

Onox imprisoned Din, the Oracle of Seasons, and buried the Temple of Seasons, where the season spirits resided, under the earth. This caused the seasons of Holodrum to become chaotic. The fruit of the earth rotted, and the land began to perish.

The Temple of Seasons had come to rest in Subrosia, a subterranean world far below Holodrum. Link reached the temple and recovered the Rod of Seasons from within, but it wasn't functional. Link would need to meet the spirits in the temple's four towers to reclaim its power—and then gather the eight Essences of Nature scattered across Holodrum in order to save Din.

Link traveled between the surface and Subrosia, gathering the essences and regaining the powers of the seasons, one by one. With the power of the four seasons restored to the rod, Link was able to open new ways forward.

After Link gathered all eight essences, the Maku Tree granted him a Huge Maku Seed. It allowed Link to access Onox's Castle and confront Onox, the General of Darkness. Faced with such worthy opposition, Onox revealed his true form: a dark dragon summoned from the Dark Realm by the witches, Twinrova.

Link defeated Onox and broke the seal on Din. With that, the four seasons of Holodrum slowly returned to their normal order.

With peace returned, Din and the others returned to Horon Village, Holodrum's central hub.

However, Onox's true goal had been to cause enough damage to Holodrum to light the Flame of Destruction, and that flame had already been lit next to an altar where a certain rite was to be performed.

Link had successfully saved Holodrum. The triangular mark on the back of his hand was surely the mark of a hero, but Link wouldn't have time to rest. Impa received a message from Hyrule that turned her face pale. She set out for the land of Labrynna immediately.

Link's next trial was already beginning . . .

1 Link enters Hyrule Castle as if drawn there by some unknown force in this opening scene of both *Oracle of Seasons* and *Oracle of Ages*. **2** The troupe of performers. The dancer Din is strong-willed but kind. Zelda's attendant, Impa, is disguised as their cook. **3** The Rod of Seasons, obtained in the Temple of Seasons. **4** Maple, an apprentice witch, flies about and may bump into Link, triggering a battle to pick up everything that scatters. **5** A date with a Subrosian named Rosa. **6** The heroic Noble Sword, waiting in its pedestal in a secret location. **7** The true form of Onox, the General of Darkness: a dark dragon summoned by Twinrova (the twin witches Kotake and Koume).

▶ MAIN CHARACTERS

Key Art

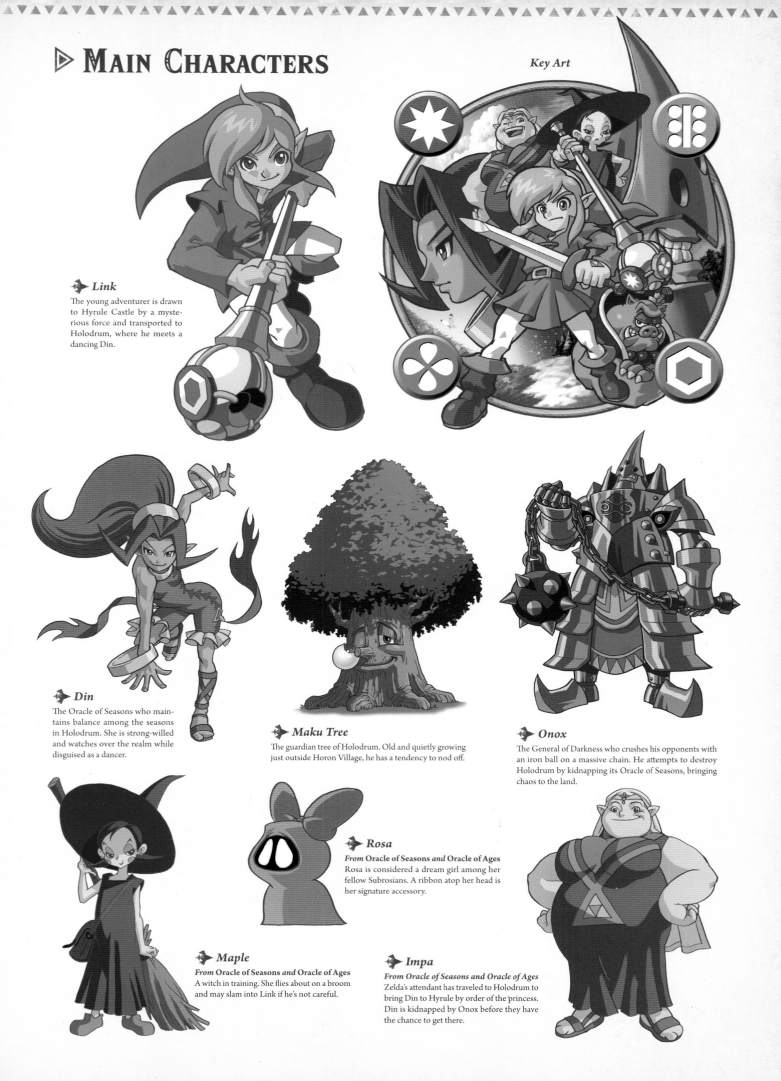

▶ Link

The young adventurer is drawn to Hyrule Castle by a mysterious force and transported to Holodrum, where he meets a dancing Din.

▶ Din

The Oracle of Seasons who maintains balance among the seasons in Holodrum. She is strong-willed and watches over the realm while disguised as a dancer.

▶ Maku Tree

The guardian tree of Holodrum. Old and quietly growing just outside Horon Village, he has a tendency to nod off.

▶ Onox

The General of Darkness who crushes his opponents with an iron ball on a massive chain. He attempts to destroy Holodrum by kidnapping its Oracle of Seasons, bringing chaos to the land.

▶ Rosa

From **Oracle of Seasons** *and* **Oracle of Ages**
Rosa is considered a dream girl among her fellow Subrosians. A ribbon atop her head is her signature accessory.

▶ Maple

From **Oracle of Seasons** *and* **Oracle of Ages**
A witch in training. She flies about on a broom and may slam into Link if he's not careful.

▶ Impa

From **Oracle of Seasons** *and* **Oracle of Ages**
Zelda's attendant has traveled to Holodrum to bring Din to Hyrule by order of the princess. Din is kidnapped by Onox before they have the chance to get there.

CHARACTER RELATIONSHIPS

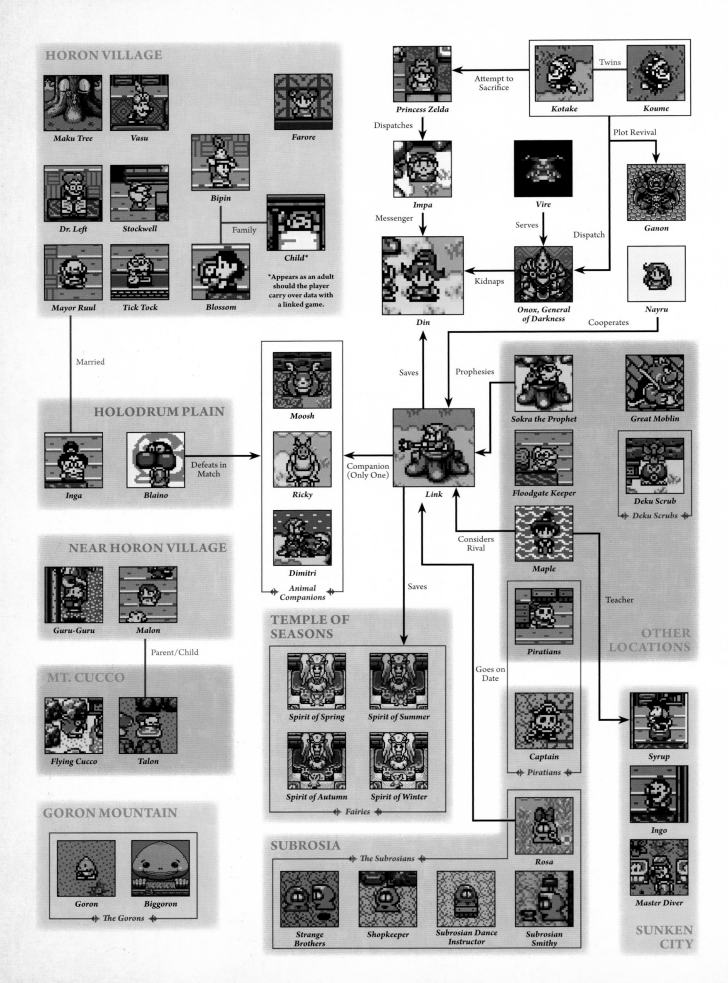

HORON VILLAGE

Maku Tree

Vasu

Farore

Dr. Left

Stockwell

Bipin

Mayor Ruul

Tick Tock

Blossom

Child*

*Appears as an adult should the player carry over data with a linked game.

Family

HOLODRUM PLAIN

Inga

Blaino

Defeats in Match

Moosh

Ricky

Dimitri

Animal Companions

Companion (Only One)

NEAR HORON VILLAGE

Guru-Guru

Malon

Parent/Child

MT. CUCCO

Flying Cucco

Talon

GORON MOUNTAIN

Goron

Biggoron

The Gorons

Married

TEMPLE OF SEASONS

Spirit of Spring

Spirit of Summer

Spirit of Autumn

Spirit of Winter

Fairies

SUBROSIA

The Subrosians

Strange Brothers

Shopkeeper

Subrosian Dance Instructor

Subrosian Smithy

Princess Zelda

Dispatches

Impa

Messenger

Din

Attempt to Sacrifice

Twins

Kotake

Koume

Plot Revival

Ganon

Vire

Serves

Dispatch

Onox, General of Darkness

Kidnaps

Nayru

Cooperates

Saves

Prophesies

Sokra the Prophet

Great Moblin

Floodgate Keeper

Deku Scrub

Deku Scrubs

Link

Considers Rival

Maple

Saves

Goes on Date

Piratians

Teacher

Captain

Piratians

Rosa

Syrup

Ingo

Master Diver

OTHER LOCATIONS

SUNKEN CITY

▷ THE WORLD

At the heart of Holodrum is its guardian spirit, the Maku Tree. Beneath lies Subrosia, into which the Temple of Seasons falls. Where the towers of the four seasons once stood are now ruins. One dungeon lies in Subrosia, with the rest scattered across Holodrum. The map changes based on Link's animal companion, most notably in the Natzu region, which becomes a river, prairie, or wasteland.

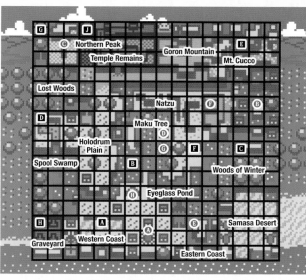

Holodrum
With Moosh as companion

Ⓐ Hero's Cave
Ⓑ Level 1: Gnarled Root Dungeon
Ⓒ Level 2: Snake's Remains
Ⓓ Level 3: Poison Moth's Lair
Ⓔ Level 4: Dancing Dragon Dungeon
Ⓕ Level 5: Unicorn's Cave
Ⓖ Level 6: Ancient Ruins
Ⓗ Level 7: Explorer's Crypt
Ⓘ Level 8: Sword & Shield Maze
Ⓙ Onox's Castle

[Holodrum]
Ⓐ Horon Village
Ⓑ Sunken City
Ⓒ Tarm Ruins
Ⓓ Blaino's Gym
Ⓔ Windmill
Ⓕ Moblin's Keep
Ⓖ Talon & Malon's House
Ⓗ Impa's Hiding Place

[Subrosia]
Ⓘ Subrosia Village
Ⓙ Subrosian Wilds
Ⓚ Treasure Grove
Ⓛ Subrosia Cemetery
Ⓜ Lava Lake
Ⓝ Temple of Seasons
Ⓞ Tower of Spring
Ⓟ Tower of Summer
Ⓠ Tower of Autumn
Ⓡ Tower of Winter

Subrosia

SUBROSIA

Subrosia is an underground region beneath Holodrum. Rivers of magma flow through Subrosia from subterranean volcanoes, and ore is used in place of rupees. Subrosians smith, use furnaces to melt metal, and run hot springs to put their piping-hot home to clever use.

CHANGING SEASONS

Locations in Holodrum may vary significantly depending on the season. When spring comes, flowers bloom. Entering summer causes some water to dry up and ivy to climb. In autumn, the leaves cover up holes, while Rock Mushrooms ripen and are ready to pick. Water sources freeze in winter, allowing people to walk on top.

Spring **Summer**

Autumn **Winter**

▷ DEVELOPMENT DOCUMENTS

▷ Maple Artwork Drafts

▷ Rod of Seasons Design Sheet

The Rod of Seasons allows Link to change the weather by standing on top of a stump and waving it. It was designed around a four-season motif.

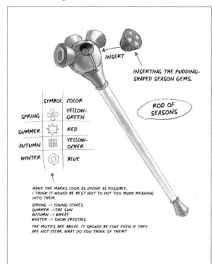

INSERT

INSERTING THE PUDDING-SHAPED SEASON GEMS.

ROD OF SEASONS

	SYMBOL	COLOR
SPRING		YELLOW-GREEN
SUMMER		RED
AUTUMN		YELLOW-OCHER
WINTER		BLUE

MAKE THE MARKS LOOK AS DIVINE AS POSSIBLE.
I THINK IT WOULD BE BEST NOT TO PUT TOO MUCH MEANING INTO THEM.
SPRING → YOUNG LEAVES
SUMMER → THE SUN
AUTUMN → WHEAT
WINTER → SNOW CRYSTALS
THE MOTIFS ARE ABOVE. IT SHOULD BE FINE EVEN IF THEY ARE NOT CLEAR. WHAT DO YOU THINK OF THEM?

▷ Cut-In Visual

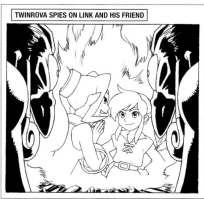

TWINROVA SPIES ON LINK AND HIS FRIEND

These images were used for cutaways in the opening and ending of the game. The artist would start from a draft of the image or a rough sketch and then create the in-game visual.

ACTUAL GAME IMAGE

2001

THE LEGEND OF
ZELDA
ORACLE OF
AGES

Released alongside *Oracle of Seasons*, *Oracle of Ages* featured additional content if linked with its sister release, including different endings depending on which game was first completed. As in *Oracle of Seasons*, Link could recruit one of three potential animal companions, altering parts of the map in the process.

Oracle of Ages is set in Labrynna, a land suffering in the present for the events of the past. Link must seek out the Harp of Ages to allow him to travel between time periods and solve problems in the past to change the present. *Oracle of Ages'* game play prioritizes puzzles over swordplay, contrasting with the action focus of *Oracle of Seasons*.

Link with Ralph, Nayru's guardian and friend.

Release Dates: May 14, 2001 | February 27, 2001 (JP)
Console: Game Boy Color

▷ PLOT

Link was transported to the land of Labrynna by the Triforce and found Impa under attack by Octoroks. After frightening them off, Impa and Link set off to find a singer named Nayru. They happened upon a stone with the same triangular mark on it as the one on the back of Link's hand. At Impa's behest, Link moved the stone, and they found Nayru singing to a group of animals.

It was here that the Sorceress of Shadows, Veran, revealed herself. Veran had possessed Impa in order to trick Link into moving the barrier rock. Veran possessed Nayru, the Oracle of Ages, and using Nayru's ability to manipulate time, disappeared into the past. Suddenly, bizarre events started occurring throughout Labrynna.

No longer possessed, but not yet fully recovered, Impa told Link to meet with the land's guardian spirit, the Maku Tree, but the Maku Tree had vanished. Link headed into a time portal to several hundred years in the past along with a young, would-be hero, Ralph, Nayru's childhood friend.

In the past, construction on Ambi's Tower had commenced. The tower was being built so that Queen Ambi's lover, who had gone missing at sea, would someday find his way home by seeing this tower. However, time had stopped without anyone noticing. Daylight was never ending and as long as it was day, the once-kind queen had her people working themselves ragged. People had taken to calling her structure the Black Tower.

Link saved the young Maku Tree of the past, and, upon returning to the present, found her alive. After locating the Harp of Ages in Nayru's home, which allowed Link to warp between the past and present, Link returned to the past to rescue the oracle, only for Veran to take control of Queen Ambi instead.

Thus began a dark age when the people of Labrynna suffered mightily from the past through to the present. Link traveled between time periods, collecting the eight Essences of Time required to defeat Veran. By the time he'd collected them all, her Black Tower reached the heavens and Veran had obtained power that allowed her to throw the flow of time in Labrynna into true chaos. The misery of the people had lit the Flame of Sorrow on the altar for a kind of strange ceremony. This had been Veran's true goal.

After gathering the essences, the Maku Tree gave Link a Huge Maku Seed, which Link used to enter the Black Tower. Just then, Ralph charged in ahead of Link. He intended to slay Queen Ambi with Veran in her body and return the world to normal. He left Link with these parting words: "Umm . . . Link . . . Don't forget me." Ralph was the descendant of the queen. By eliminating her, he would disappear. Ralph was unsuccessful and Link himself had to battle Queen Ambi, still possessed by Veran, at the top of the tower. Expelling Veran from Ambi's body and defeating her, the young hero restored peace to the realm and its people.

But this was not the end of his adventure. The Flame of Destruction and the Flame of Sorrow were both lit, and by kidnapping Princess Zelda, a symbol of hope, Twinrova succeeded in lighting the Flame of Despair. With these three flames burning, all that was needed to revive the evil king Ganon was to sacrifice the princess.

Borrowing the powers of Din, the Oracle of Seasons, and Nayru, the Oracle of Ages, Link entered the Room of Rites. After defeating Twinrova, they offered their own bodies as a sacrifice to revive Ganon. Link stopped the rampaging Ganon and escaped with the aid of the Maku Tree. The world had narrowly avoided catastrophe.

The hero Link then boarded his boat and set out to a new land to train.

1 The singer Nayru and her friends. **2 3** The Maku Tree, saved by Link in the past, waits several hundred years for a reunion. **4** Expelled from Nayru's body, Veran takes control of Queen Ambi. **5** Ralph attempts to slay Veran, within Queen Ambi, to free the people from her cruelty. **6** Princess Zelda is kidnapped by Twinrova (the twin witches, Kotake and Koume). **7** Twinrova revives Ganon. Since the ritual is incomplete, he appears as a mindless raging beast. **8** Link after saving Labrynna, Holodrum, and Princess Zelda.

◢ MAIN CHARACTERS

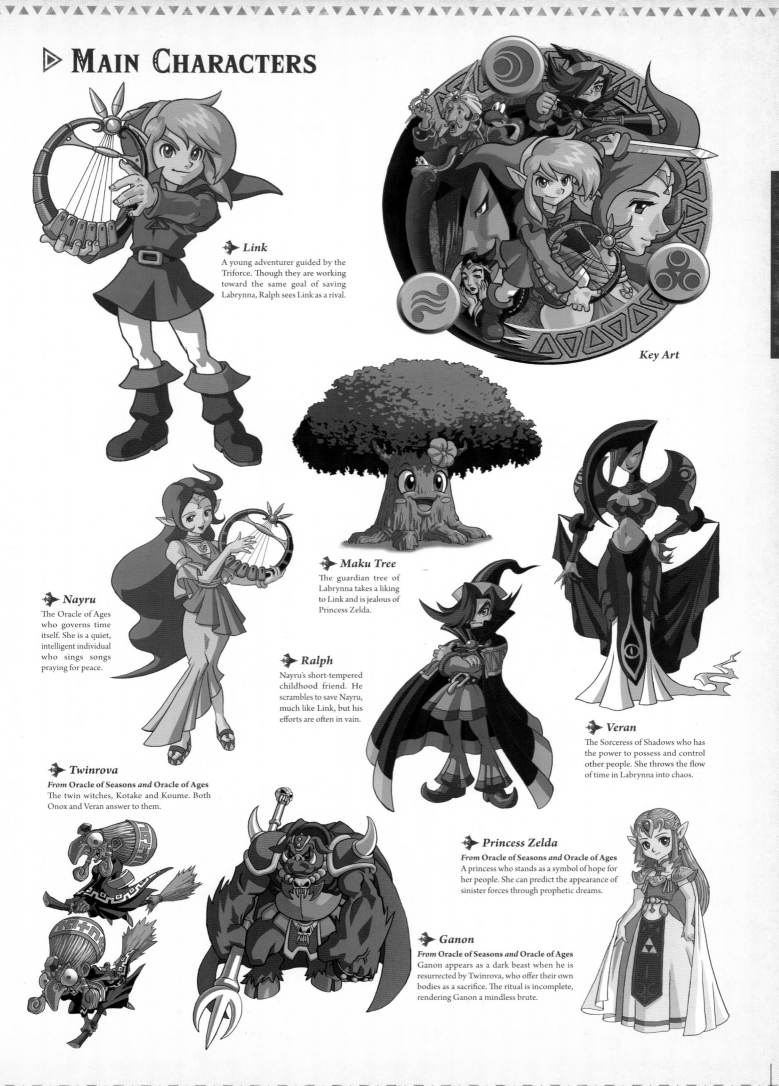

◆ Link

A young adventurer guided by the Triforce. Though they are working toward the same goal of saving Labrynna, Ralph sees Link as a rival.

Key Art

◆ Nayru

The Oracle of Ages who governs time itself. She is a quiet, intelligent individual who sings songs praying for peace.

◆ Maku Tree

The guardian tree of Labrynna takes a liking to Link and is jealous of Princess Zelda.

◆ Ralph

Nayru's short-tempered childhood friend. He scrambles to save Nayru, much like Link, but his efforts are often in vain.

◆ Veran

The Sorceress of Shadows who has the power to possess and control other people. She throws the flow of time in Labrynna into chaos.

◆ Twinrova

From Oracle of Seasons and Oracle of Ages
The twin witches, Kotake and Koume. Both Onox and Veran answer to them.

◆ Princess Zelda

From Oracle of Seasons and Oracle of Ages
A princess who stands as a symbol of hope for her people. She can predict the appearance of sinister forces through prophetic dreams.

◆ Ganon

From Oracle of Seasons and Oracle of Ages
Ganon appears as a dark beast when he is resurrected by Twinrova, who offer their own bodies as a sacrifice. The ritual is incomplete, rendering Ganon a mindless brute.

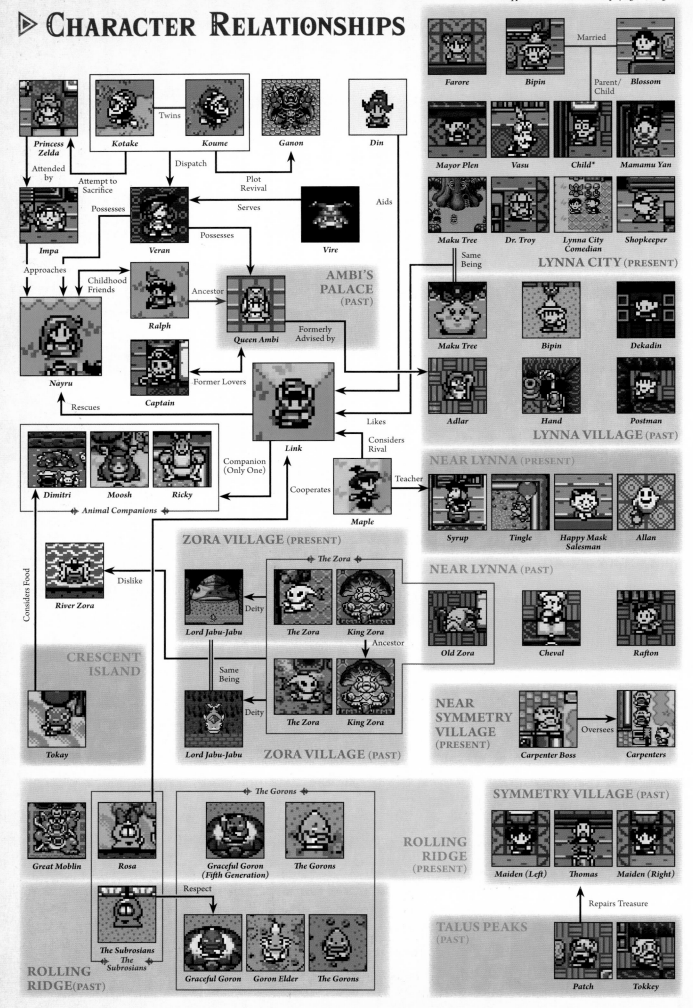

▷ CHARACTER RELATIONSHIPS

Princess Zelda

Kotake — Twins — Koume

Ganon

Din

Attended by

Attempt to Sacrifice

Dispatch

Plot Revival

Aids

Impa

Possesses

Serves

Veran

Possesses

Vire

Approaches

Childhood Friends

Ancestor

Queen Ambi

Formerly Advised by

AMBI'S PALACE (PAST)

Ralph

Nayru

Rescues

Former Lovers

Captain

Link

Considers Rival

Likes

Cooperates

Teacher

Maple

LYNNA CITY (PRESENT)

Farore — Bipin — Married — Blossom

Parent/Child

Mayor Plen

Vasu

Child*

Mamamu Yan

Maku Tree

Same Being

Dr. Troy

Lynna City Comedian

Shopkeeper

Maku Tree

Bipin

Dekadin

Adlar

Hand

Postman

LYNNA VILLAGE (PAST)

NEAR LYNNA (PRESENT)

Syrup

Tingle

Happy Mask Salesman

Allan

Companion (Only One)

Dimitri **Moosh** **Ricky**

Animal Companions

NEAR LYNNA (PAST)

Considers Food

River Zora

Dislike

ZORA VILLAGE (PRESENT)

The Zora

Deity

Lord Jabu-Jabu

The Zora

King Zora

Ancestor

Old Zora

Cheval

Rafton

CRESCENT ISLAND

Same Being

Deity

The Zora

King Zora

NEAR SYMMETRY VILLAGE (PRESENT)

Oversees

Tokay

Lord Jabu-Jabu

ZORA VILLAGE (PAST)

Carpenter Boss

Carpenters

The Gorons

SYMMETRY VILLAGE (PAST)

Great Moblin

Rosa

Graceful Goron (Fifth Generation)

The Gorons

ROLLING RIDGE (PRESENT)

Maiden (Left)

Thomas

Maiden (Right)

The Subrosians

The Subrosians

Respect

Repairs Treasure

ROLLING RIDGE(PAST)

Graceful Goron

Goron Elder

The Gorons

TALUS PEAKS (PAST)

Patch

Tokkey

▷ THE WORLD

In *Oracle of Ages*, Veran has disrupted time in the past, which influences events in the present. Link must travel between present-day Labrynna and the Labrynna of several hundred years in the past, changing aspects of the present through his actions in the past. For example, the ocean was polluted in the past, making King Zora ill. If Link does not clean up the pollution in the past, King Zora will not survive to see the present. As in Holodrum, Labrynna's map changes based on Link's choice of animal companion.

Labrynna (Present)

With Moosh as companion

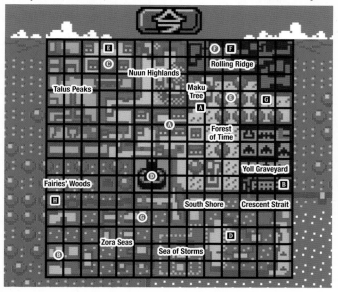

Labrynna (Past)

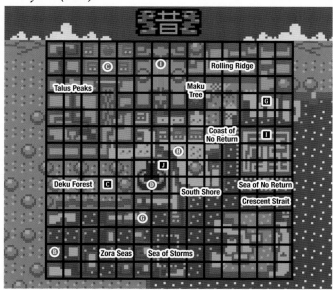

THE PRESENT

The Maku Tree watches over the land. Nayru, whose singing is adored by all, is actually the Oracle of Ages.

THE PAST

With time running amok, the world is stuck in endless daylight. The people are forced to work on the tower without end, resulting in an age of misery.

A LAND OF MANY RACES

The Goron Dance is quite popular among Gorons as well as Subrosians. Reptilian Tokay on Crescent Island are prone to stealing Link's stuff and may even try to eat Dimitri. There are also Zora living in the southern seas, leaderless in the present, because King Zora fell ill in the past.

Ⓐ Hero's Cave (Linked Game)
Ⓑ Level 1: Spirit's Grave
Ⓒ Level 2: Wing Dungeon
Ⓓ Level 3: Moonlit Grotto
Ⓔ Level 4: Skull Dungeon
Ⓕ Level 5: Crown Dungeon
Ⓖ Level 6: Mermaid's Cave
Ⓗ Level 7: Jabu-Jabu's Belly
Ⓘ Level 8: Ancient Tomb
Ⓙ The Black Tower

Ⓐ Lynna City (Present)
Ⓑ Zora Village (Present/Past)
Ⓒ Symmetry City (Present/Past)
Ⓓ The Black Tower (Present/Past)
Ⓔ Nayru's House (Present)
Ⓕ Great Moblin's Keep (Present)
Ⓖ Eyeglass Island Library (Present/Past)
Ⓗ Lynna Village (Past)
Ⓘ Ambi's Palace (Past)

✦ DEVELOPER ✦ NOTES

● **Zelda for a New Generation:** The *Oracle* series came about after Capcom developer Yoshiki Okamoto approached Shigeru Miyamoto and said that he wanted to try making a *Zelda* game at Capcom. The pitch was to "convey the quality of the NES *Zelda* titles to the current generation of kids." The games were released two years later.

● **Power, Courage, Wisdom:** At one point, there were plans for three games: *Oracle of Power*, *Oracle of Wisdom*, and *Oracle of Courage*. *Oracle of Power* was similar to what became *Oracle of Ages*, except Zelda, who gets kidnapped, controlled the four seasons and Link would travel between Hyrule and Subrosia on his quest.

● **Enough Content for Multiple Games:** The final version of the game ended up being about ten times the amount of content originally planned. It gradually grew larger as development continued, resulting in a unique title.

● **First Comes the Story:** The development team at Capcom started making the maps only after the story was nearly complete. After that came characters. They would adjust the levels as they went, with the world map changing almost daily.

● **A Kinder Way to Make Games:** In the middle of development, Nintendo's Yoichi Yamada joined as a supervisor. He worked to introduce more "Zeldaness" and "Nintendoness" to the games, like having players practice ways to use a newly obtained item after acquiring it. The Capcom development team has said that it felt like Mr. Yamada and his team were teaching them a "kinder way to make games" with advice like, "It's a good idea to name the characters" and other practices they weren't used to.

● **Nayru Takes Ages:** Nintendo's Yusuke Nakano was in charge of character illustrations. He would listen to how the development team envisioned the sprites and their impressions of the characters, then expand on these notes and turn them into illustrations. Finalizing Nayru in *Oracle of Ages* took half a year. Her design called for a "wise, beautiful, older sister–type woman," and Nakano struggled to express these traits in just the right way.

References
• "Nintendo Space World '99 Venue Bulletin."
• *NOM* No. 30. "*The Legend of Zelda: Oracle Series* Special Feature."
• *Nintendo Dream*, December 6, 2004. "*The Legend of Zelda: Oracle Series* Commemorative Release Interview."

2002

Release Dates: March 24, 2003 | December 13, 2002 (JP)
Console: Nintendo GameCube

Release Dates: September 20, 2013 | September 26, 2013 (JP)
Console: Wii U

Designed around the concept of creating a playable cartoon, *The Wind Waker* used cel shading to bring a completely new look and feel to the series. It introduced many new mechanics, including sailing and the Tingle Tuner, which gave players control of Tingle if they hooked up their Game Boy Advance to a GameCube.

A remastered version was released in 2013. Beyond enhanced visuals, game play in *The Wind Waker HD* was adjusted to improve the experience.

The unique visuals of *The Wind Waker* sparked a variety of reactions when it was first announced. Its version of Link, later called Toon Link, has appeared in subsequent titles like *Phantom Hourglass* and *Tri Force Heroes* alongside more realistic depictions of the fated hero found in games like *Twilight Princess* and *Breath of the Wild*.

Link as seen in the GameCube version of The Wind Waker.

▷ PLOT

Long ago, the power of the goddesses was stolen by a man of great evil, but a young hero wearing green defeated him and sealed him away. The battle between the dark one and the Hero of Time faded into legend, but the King of Evil eventually returned. This time, a hero did not appear, and the people could only pray to the goddesses for deliverance. The story of what happened to that kingdom was lost to time.

Many years later, on tiny Outset Island on the Great Sea, a tradition based on this legend persisted where boys donned green clothes to celebrate their coming of age. It was the twelfth birthday of an island boy named Link, and he was given these Hero's Clothes by his grandmother.

Link promptly put them to use as he happened upon the pirate captain Tetra, the target of a kidnapping by a monstrous bird known as the Helmaroc King. Link saved Tetra, only for his sister Aryll to be kidnapped instead.

He boarded Tetra's ship on a quest to save Aryll, imprisoned in the Forsaken Fortress. Link found Aryll locked away with other girls in the belly of the fortress. Before Link could rescue them, the Helmaroc King descended and tossed Link into the sea. Link was rescued by a strange talking boat that called itself the King of Red Lions. The boat told Link of how the King of Evil, Ganondorf, had returned and was using the Helmaroc King to kidnap girls who might be Princess Zelda.

Before returning to take on the Helmaroc King, Link set about gathering the Goddess Pearls and overcoming the perils of the Tower of the Gods in order to wield the Wind Waker, a conductor's wand with the power to create wind. Link then headed for a mysterious castle, frozen in time beneath the sea. In the castle, he found the Master Sword and pulled it from its pedestal.

With this legendary blade in hand, Link was ready to set out for the Forsaken Fortress to save his sister. There, he met Ganondorf; though Link fought

valiantly, he could not land a single blow against him. Even when Tetra rushed in to aid Link, the two were unable to stand against his powerful magic. They were saved at the last moment by the sky spirit.

Link and Tetra headed back to the room that contained the Master Sword in the castle. The ancient king of Hyrule, true form of the King of Red Lions, stood before them. He revealed that Tetra was Princess Zelda, inheritor of the Triforce of Wisdom, and explained how Ganondorf returned long ago, but a hero never appeared. As Hyrule fell under Ganondorf's fist, its people prayed to the gods, who sealed their kingdom under the Great Sea.

The ancient king of Hyrule beseeched Link to return power to the Master Sword with the aid of the sages, and seek out the fragments of the Triforce of Courage scattered across the sea. When Link found that Ganondorf had slain the sages, he searched for descendants like Medli, who carried the blood of the Sage of Earth, and the forest spirit Makar, who descended from the Sage of Wind. After restoring power to the Master Sword and uniting the Triforce of Courage, Link broke the seal on Hyrule Castle.

It was then that Ganondorf, possessor of the Triforce of Power, captured Zelda. Link chased him and with Zelda, Link, and Ganondorf all within close proximity, the Triforces of Wisdom, Courage, and Power within them combined to resurrect the legendary power of the goddesses.

Ganondorf desired to restore Hyrule in order to rule it. But before he could place his hand on the Triforce to wish for this, the king of Hyrule intervened and touched it first, crying out to the Triforce to wash away Hyrule and bring hope to the world.

A final battle ensued. Ganondorf rushed toward Link, but could not withstand the power of the Master Sword and the barrage of Zelda's Light Arrows.

Pierced through by Link, Ganondorf entered a peaceful sleep. As Link and Zelda floated to the surface of the sea, Link extended his hand to the king of Hyrule, but the king chose instead to sink to the bottom of the sea along with his kingdom. Ganondorf was vanquished, and the realm of Hyrule, the site of so many adventures past, now lay beneath the waves.

Link, now the Hero of Winds, and Tetra, who'd resumed her role as pirate captain, bid farewell to Outset Island and set out in search of a new land.

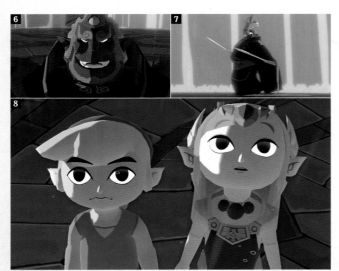

1 Aryll is kidnapped by the Helmaroc King on Ganondorf's orders. **2** Link sets out on a journey with Tetra in order to save Aryll. **3** Link pulls the Master Sword from its pedestal. **4** Medli and the ancient sage Laruto. **5** Makar and the ancient sage Fado. **6** The King of Evil, Ganondorf, grins. **7** Link defeats him with Princess Zelda's help. **8** "It will be *your* land!" The king of Hyrule entrusts the future to Zelda and Link.

▷ Main Characters

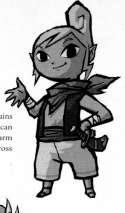

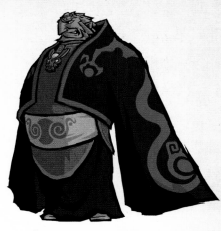

⚜ King of Red Lions

A mysterious boat that can talk. He joins Link on his quest, ferrying him between islands and dispensing advice until his true identity as the ancient king of Hyrule is revealed.

⚜ Tetra

A spirited young woman who captains a crew of eccentric pirates. Tetra can use the power of her Pirate's Charm to communicate with people across great distances.

⚜ Princess Zelda

Tetra, after she awakens with the power of the Triforce of Wisdom. After she and Link defeat Ganondorf, she returns to her life as a pirate, keeping the name Tetra.

⚜ Ganondorf

The King of Evil, sealed along with the kingdom of Hyrule under the sea long ago. Once revived, he searches for Princess Zelda in order to obtain the Triforce of Wisdom.

⚜ Link

A twelve-year-old boy who lives on Outset Island. The King of Red Lions stakes the future of Hyrule on the courage of this child, who is trying to save his sister.

⚜ Helmaroc King

A monstrous bird loyal to Ganondorf. On his master's orders, he kidnaps young girls with long ears who resemble Princess Zelda and brings them to the Forsaken Fortress.

⚜ Aryll

Link's younger sister. She is kidnapped by the Helmaroc King on her brother's birthday and locked away in the Forbidden Fortress.

⚜ Grandma

Link and Aryll's grandmother. She worries terribly about both her grandchildren and is particularly good at making soup.

⚜ Medli

A Rito maiden with the blood of a sage coursing through her veins. She attends to Valoo, the sky spirit, and encourages Prince Komali to aid in Link's quest.

⚜ Makar

A Korok who performs at the annual gathering of his people. He later shows himself to be the descendant of a sage.

The Wind Waker　　　　　　　　*Key Art*　　　　　　　　*The Wind Waker HD*

▷ CHARACTER RELATIONSHIPS

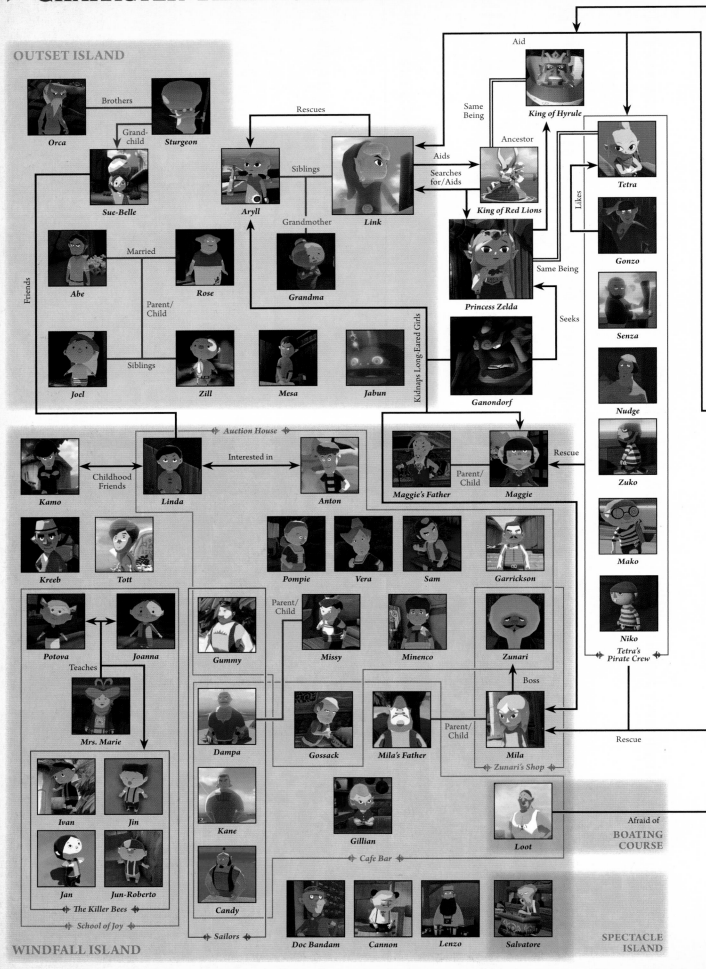

OUTSET ISLAND

Orca — Brothers — Sturgeon

Orca — Grand-child → Sue-Belle

Rescues

Aryll — Siblings — Link

Abe — Married — Rose

Friends

Abe — Parent/Child — Joel

Joel — Siblings — Zill

Grandmother

Grandma

Aryll

Zill Mesa Jabun

Kidnaps Long-Eared Girls

Ganondorf

Aid

King of Hyrule

Same Being

Aids

Searches for/Aids

Ancestor

King of Red Lions

Same Being

Princess Zelda

Seeks

Likes

Tetra

Gonzo

Senza

Nudge

Zuko

Mako

Niko
Tetra's Pirate Crew

◀ Auction House ▶

Kamo — Childhood Friends — Linda — Interested in — Anton

Maggie's Father — Parent/Child — Maggie — Rescue

Kreeb Tott

Pompie Vera Sam Garrickson

Potova ↔ Joanna

Teaches

Mrs. Marie

Gummy

Parent/Child

Missy Minenco Zunari

Boss

Dampa Gossack Mila's Father — Parent/Child — Mila

◀ Zunari's Shop ▶

Rescue

Ivan Jin

Jan Jun-Roberto

◀ The Killer Bees ▶

◀ School of Joy ▶

Kane

Gillian

Loot — Afraid of

BOATING COURSE

◀ Cafe Bar ▶

Candy

◀ Sailors ▶

Doc Bandam Cannon Lenzo Salvatore

SPECTACLE ISLAND

WINDFALL ISLAND

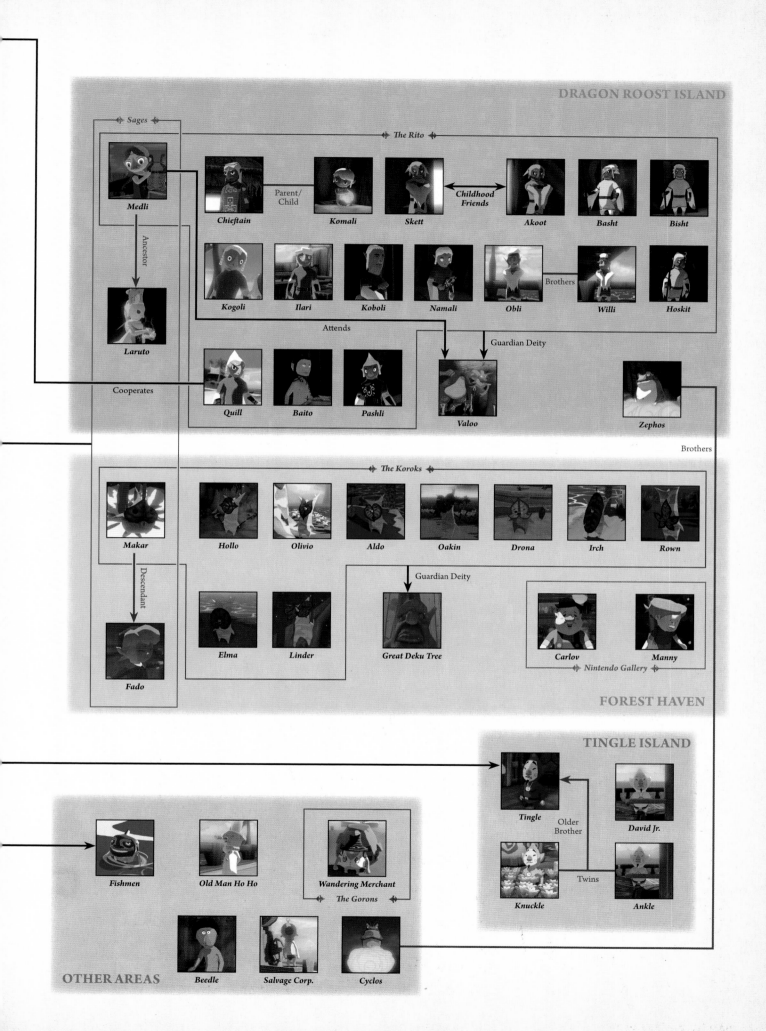

DRAGON ROOST ISLAND

Sages

Medli

The Rito

Chieftain — Parent/Child — Komali — Skett — Childhood Friends — Akoot — Basht — Bisht

Ancestor

Kogoli — Ilari — Koboli — Namali — Obli — Brothers — Willi — Hoskit

Laruto

Attends

Cooperates

Quill — Baito — Pashli — Valoo — Guardian Deity

Zephos

Brothers

The Koroks

Makar — Hollo — Olivio — Aldo — Oakin — Drona — Irch — Rown

Descendant

Guardian Deity

Elma — Linder — Great Deku Tree — Carlov — Manny

Fado

Nintendo Gallery

FOREST HAVEN

TINGLE ISLAND

Tingle — Older Brother — David Jr.

Knuckle — Twins — Ankle

Fishmen — Old Man Ho Ho — Wandering Merchant

The Gorons

OTHER AREAS Beedle — Salvage Corp. — Cyclos

▷ The World

The Wind Waker takes place on a sea dotted with forty-nine islands both large and small. Some of these islands hold dungeons, while others are home to people.

Care was taken in design to show distance, with islands gradually growing larger as Link draws near and makes landfall.

Waterspouts, ghost ships, and sea creatures like Big Octos make sea travel at times perilous. The sea is vast and it takes time to move between islands. This is made easier once Link learns the Ballad of Gales, a song that warps him to specific points.

The Swift Sail, added for The Wind Waker HD, also helped, enabling Link to sail twice as fast as in the GameCube version.

Windfall Island boasts the largest population.

TIME AND WEATHER AT SEA

Morning Day Evening Night

Daytime Rain Daytime Storm Evening before a Storm Night Rain

A volcanic island before extinguishing it with an Ice Arrow.

THE FORTY-NINE ISLANDS OF THE GREAT SEA

[A-1] Forsaken Fortress [A-2] Star Island [A-3] Northern Fairy Island [A-4] Gale Isle [A-5] Crescent Moon Island [A-6] Seven-Star Isles [A-7] Overlook Island [B-1] Four-Eye Reef [B-2] Mother and Child Isles [B-3] Spectacle Island [B-4] Windfall Island [B-5] Pawprint Isle [B-6] Dragon Roost Island [B-7] Flight Control Platform [C-1] Western Fairy Island [C-2] Rock Spire Isle [C-3] Tingle Island [C-4] Northern Triangle Isle [C-5] Eastern Fairy Island [C-6] Fire Mountain [C-7] Star Belt Archipelago [D-1] Three-Eye Reef [D-2] Greatfish Isle [D-3] Cyclops Reef [D-4] Six-Eye Reef [D-5] Tower of the Gods [D-6] Eastern Triangle Island [D-7] Thorned Fairy Island [E-1] Needle Rock Isle [E-2] Islet of Steel [E-3] Stone Watcher Island [E-4] Southern Triangle Island [E-5] Private Oasis [E-6] Bomb Island [E-7] Bird's Peak Rock [F-1] Diamond Steppe Island [F-2] Five-Eye Reef [F-3] Shark Island [F-4] Southern Fairy Island [F-5] Ice Ring Isle [F-6] Forest Haven [F-7] Cliff Plateau Isles [G-1] Horseshoe Island [G-2] Outset Island [G-3] Headstone Island [G-4] Two-Eye Reef [G-5] Angular Isles [G-6] Boating Course [G-7] Five-Star Isles

▷ DEVELOPMENT DOCUMENTS

Artwork Draft ◁

COMPLETED VERSION

▷ Iterations of Key Art for **The Wind Waker HD**

❧ DEVELOPER ❧ NOTES

● **Steering Away from Realism:** At the time of *The Wind Waker*'s release, most video games were moving toward visual styles more closely resembling reality. The *Zelda* team turned their rudder the other way, moving from the realistic look of *Ocarina of Time* to a simpler art style where personality could be communicated at a glance.

● **The Faces of Link:** The development team wanted to create a Link that players would connect with emotionally, and created his large, black eyes to be as expressive as possible. Early test players from Europe requested that some color be added to his eyes, so red and blue gradations were attempted, but ultimately they settled on black eyes with black eyelashes.

● **Sailing Tricks:** To make transitions seamless between sailing and landfall, developers experimented with the sizes of both islands and the sea itself. The GameCube would not load fast enough if the islands were too large, placed too close together, or if Link approached them too quickly. The Wii U's improved hardware allowed the team to increase sailing speed with the Swift Sail.

● **The Wind in *The Wind Waker*:** The game's themes of wind, control, and the sea were incorporated in a variety of ways. Thought had gone into expressing a sense of wind in past games but *The Wind Waker* required it. Developers used white lines to show where the wind was blowing. The theme of control pops up in everything from the Deku Leaf's fan to the puppets in the Tower of the Gods, and even being able to control seagulls, while the Wind Waker wand merged wind and control into one waving action. Before the team decided on a conductor's wand, they considered giving Link an instrument like a theremin instead, which can make sounds without being touched.

● **Unraveling Strings:** From the ropes on suspension bridges to the strands hanging from Moblin spears, strings feature heavily in *The Wind Waker*. It can be tricky to make strings behave with realistic physics in games, and their functionality was brought over by a *Majora's Mask* programmer in charge of Majora's Wrath, an enemy who used whips.

● **A New Style of Game Play:** As with past titles, developers focused on memorable, innovative game play. Steering away from the kinds of worlds they built on the Nintendo 64, it was decided that the game would be set at sea, with sailing as a central mechanic. Hyrule was sunk before players even started the game. With the world in place, designers turned to how they'd make sure players cared about Link's quest. On top of the urgency that comes with saving the world, they added the kidnapping of Link's sister for more personal stakes.

● **Variations on a Theme:** The world of *Ocarina of Time* is submerged beneath the sea in *The Wind Waker*, and the music was designed to reflect this, returning to many of the same melodies first used in the Nintendo 64 classic. All music was composed on computers, with an emphasis placed on *Zelda*-style interactivity. Though a song will keep playing when a situation changes, its arrangement and tempo will respond to Link's status. This even extends to the sound made when Link attacks, which was made with a program that incorporates the sound effect into the background music.

● **Elephants and Chips:** The sounds of seagull cries in the game were processed elephant cries, while the sound of walking through a desert was made using potato chips.

● **The First High-Definition *Zelda*:** *The Wind Waker HD* was released eleven years after the original version, after Nintendo began testing upgraded visuals for *Skyward Sword*. *The Wind Waker* was chosen because of demand, as well as the speed at which its cel-shaded visuals could be upgraded to high definition.

References
• *Hobo Nikkan Itoi Shinbun Treetop Hideout.* "Zelda Is Finally Here!"
• *Nintendo Dream,* December 21, 2002/January 6, 2003. "Wind Interview, First Half/Second Half."
• *Nintendo Online Magazine NOM.* "Zelda and the World of Sound (No. 54)."
• *Iwata Asks.* "The Legend of Zelda: The Wind Waker HD."

When *A Link to the Past* was rereleased on the Game Boy Advance, it included a brand-new adventure called *Four Swords*. It was the first title in the series where multiplayer was possible, and production was handled by Capcom following *Oracle of Ages* and *Oracle of Seasons*.

Four Swords supported two to four players, who worked together as green, blue, red, and purple Links to clear stages full of puzzles and swarms of enemies.

Each stage was made up of multiple maps, chosen at random with each play-through, giving the game significant replay value.

In 2011, *The Legend of Zelda: Four Swords Anniversary Edition* was released for a limited time as a DSiWare remaster. This version added a single-player mode and new stages based off previous titles in the *Legend of Zelda* series.

Release Dates: December 2, 2002 | March 14, 2003 (JP)
Console: Game Boy Advance

▷ PLOT

Legend has it that long ago, in the kingdom of Hyrule, there appeared a wind sorcerer named Vaati who occupied the Palace of Winds suspended high in the sky. Vaati terrorized the villages of Hyrule and kidnapped any beautiful girls who caught his fancy. It was then that a hero appeared wielding a sword that could divide his body into four, and those four heroes worked together to defeat Vaati. The hero used the Four Sword, as it came to be called, to seal Vaati, and the sword was placed in a pedestal in the forest.

Generations watched over the Four Sword, but, eventually, the seal began to weaken. Princess Zelda, the guardian of this era, sensed something was wrong and went to check on the seal, but it was too late. Vaati had broken free. Zelda was carried away to Vaati's Palace. Link witnessed the kidnapping and, as instructed by fairies, took hold of the Four Sword and split into four.

To save Zelda meant having to prove their courage to the three Great Fairies by gathering rupees. The four Links defeated countless monsters in search of rupees, and were rewarded by the Great Fairies with the key to access Vaati's Palace.

Deep within the palace, the four Links defeated Vaati, rescued Princess Zelda, and once again sealed the sorcerer within the Four Sword. Link returned the sword to its pedestal and became whole again.

1 Princess Zelda speaks of the legend of the Four Sword, standing before it in the Four Sword Sanctuary. **2** Vaati revives before them. He cries out that Princess Zelda will be his bride as he captures her. **3 4** Link is split into four bodies upon extracting the Four Sword. **5** Vaati is defeated by Link and is once again sealed inside the Four Sword. **6** Princess Zelda is saved after Vaati's defeat. Link returns to his original form.

▷ MAIN CHARACTERS

Key Art

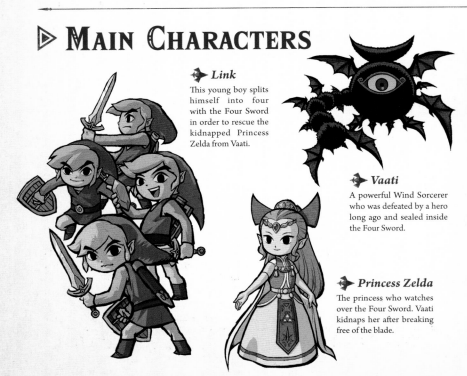

◆ Link
This young boy splits himself into four with the Four Sword in order to rescue the kidnapped Princess Zelda from Vaati.

◆ Vaati
A powerful Wind Sorcerer who was defeated by a hero long ago and sealed inside the Four Sword.

◆ Princess Zelda
The princess who watches over the Four Sword. Vaati kidnaps her after breaking free of the blade.

CHARACTER RELATIONSHIPS

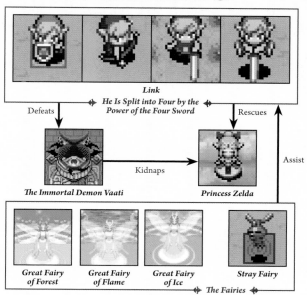

Link

He Is Split into Four by the Power of the Four Sword

Defeats

Rescues

Assist

The Immortal Demon Vaati → Kidnaps → **Princess Zelda**

Great Fairy of Forest **Great Fairy of Flame** **Great Fairy of Ice** **Stray Fairy**

◄ *The Fairies* ►

THE WORLD

THE THREE TRIALS AND VAATI'S PALACE

Link, split in four, ventures across Hyrule, exploring dense forest in the Sea of Trees, a volcano in Death Mountain, and the frigid Talus Cave. Completing these trials will cause Vaati's Palace to appear.

A Sea of Trees **B** Talus Cave **C** Death Mountain **D** Vaati's Palace

DEVELOPMENT DOCUMENTS

▷ Roc's Cape Rough

This concept art depicts Roc's Cape, an item that enables Link to jump great distances and glide through the air.

▷ Map Screen Design Concept

This drawing showed one way to display the game's map screen, using a variety of icons to mark important spots and cloud cover that would part once an area was accessible.

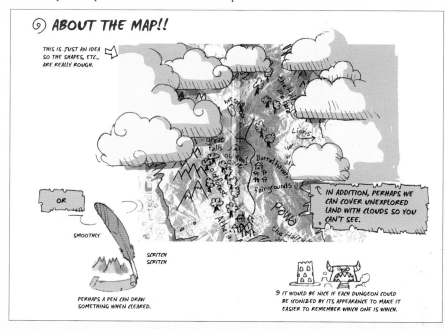

ABOUT THE MAP!!

THIS IS JUST AN IDEA SO THE SHAPES, ETC., ARE REALLY ROUGH.

OR

SMOOTHLY

SCRITCH SCRITCH

PERHAPS A PEN CAN DRAW SOMETHING WHEN CLEARED.

IN ADDITION, PERHAPS WE CAN COVER UNEXPLORED LAND WITH CLOUDS SO YOU CAN'T SEE.

IT WOULD BE NICE IF EACH DUNGEON COULD BE ICONIZED BY ITS APPEARANCE TO MAKE IT EASIER TO REMEMBER WHICH ONE IS WHICH.

▷ Four Sword Sanctuary Concept

Capcom produced a number of storyboards and concept art for ideas that did not appear in the final game. The Four Sword's resting place was drawn at the start of development. There is no flowing water in the final game, but the stones positioned in a circle, the presence of fairies, and sunlight through the trees were incorporated.

DEVELOPER NOTES

● **Gnat Hat:** Director Hidemaro Fujibayashi dreamed up the Gnat Hat after Shigeru Miyamoto said he "wanted to play with getting inside treasure chests and make mischief." Fujibayashi wondered, "What about an item that makes Link small?"

● **Four Swords, Four Colors:** The colors for the four Links were decided based on a proposal from the Capcom development team.

References
• *Nintendo Dream*, December 6, 2004. "The Legend of Zelda: The Minish Cap Commemorative Release Interview."
• *Nintendo Dream*, April 21, 2004. "The Legend of Zelda: Four Swords Adventures Producer + Double Directors Commemorative Release Interview."

+2004+

THE LEGEND OF ZELDA
FOUR SWORDS ADVENTURES

Release Dates: June 7, 2004 | March 3, 2004 (JP)
Console: Nintendo GameCube

Link once again wielded the power of the Four Sword in *Four Swords Adventures*. The game allowed up to four players in cooperative and competitive play. Using Game Boy Advance Link Cables to connect their Game Boy Advances to a GameCube, individual players used both the TV and handheld screens during game play. The principal game mode called "Hyrulean Adventure" was an epic journey over eight stages to reclaim the Dark Mirror and stop both Vaati and Ganon from taking Hyrule for themselves. Players embarked on this quest alone or with their friends. An additional multiplayer battle mode called "Shadow Battle" pitted up to four Links against each other.

An image from the Japanese-only "Navi Trackers" mode.

▷ PLOT

The story of *Four Swords Adventures* takes place long after the tale from *Four Swords* has faded into legend.

Swiftly and suddenly, dark clouds covered all of Hyrule, bringing a heavy rain and filling its people with fear. Princess Zelda summoned Link to Hyrule Castle, sensing that this could be the work of the Wind Sorcerer Vaati, who was supposed to be sealed inside the legendary Four Sword. Zelda offered her prayers with the six maidens and opened the way to the Four Sword Sanctuary. The light leading to the sanctuary darkened and a black shadow stepped forth.

"Y-you're . . . Link?!" Zelda said, unsure as she spoke. This Shadow Link, who looked exactly like the real adventurer, captured Princess Zelda and the maidens.

Link pursued them into the Four Sword Sanctuary and extracted the blade. As the legend foretold, Link was divided into four; but pulling this sword from its pedestal also freed Vaati. The Four Sword was devoid of its Light Force, the source of the blade's ability to repel evil. The Links set out to replenish it by saving the people of Hyrule from the chaos wrought by Vaati's return. Over the course of their journey, the Links also reclaimed the Dark Mirror, causing the Shadow Links it created to disappear.

After rescuing the six maidens and Princess Zelda, the Links fought Vaati in a climactic battle in the Palace of Winds. Their victory caused the palace to fall apart around them. The Links and Zelda fell into the bowels of the palace, where the King of Darkness, Ganon, was waiting. "You so-called heroes do not stand even a gnat's chance of harming me! Even if you worms attack in a group, I will skewer the lot of you on my Trident!!"

Ganondorf, a Gerudo thief, had broken the taboos of his village and had gained possession of the Trident. Wielding the Trident gave him great power, but the King of Darkness still desired more. Using the Shadow Links, he'd orchestrated Vaati's resurrection and brought a great darkness to Hyrule.

A battle with Ganon ensued, but with the Four Sword in hand and the help of both Princess Zelda and the maidens, the Links succeeded in sealing Ganon away.

They then returned the Four Sword to its sanctuary, making Link whole once more and restoring peace in Hyrule.

All the while, the crest of the Triforce in Hyrule Castle continued to shine.

1 Link is summoned to Hyrule Castle by Princess Zelda on a rainy night. **2** Without the six maidens and Princess Zelda, the door to the Four Sword Sanctuary will not open. **3** Princess Zelda and the maidens are captured after the sudden appearance of Shadow Link. **4** Extracting the sword frees Vaati. Link is prepared and pulls out the sword, splitting into four. **5** A shadow emerges from the pedestal of the Four Sword. Vaati has returned. **6** The Dark Mirror, which created the Shadow Links, is taken back thanks to Princess Zelda's power. **7** The Links defeat Vaati and escape from the crumbling castle with the princess. **8** The Links emerge victorious in a final battle against Ganon, sealing the King of Darkness away with the aid of the maidens.

▷ MAIN CHARACTERS

↣ Link
The young adventurer takes up the Four Sword in exchange for reviving Vaati so that he can save Princess Zelda. The power of the blade splits him into four versions of himself.

Key Art

Four Swords Adventures' main campaign, called "Hyrulean Adventure," challenges players to complete eight levels, each set in its own distinct area. The levels are broken down into three stages that players must complete. Beyond the bad guys, the party encounters dozens of interesting characters along the way. This page charts the relationships of characters encountered through Level 4.

L1 WHEREABOUTS OF THE WIND

LAKE HYLIA

Formation Old-Timer

Formation Sisters

Locked-Up Old Woman

Man in Garden

HYRULE CASTLE

Green Maiden

Blue Maiden

Great Fairy

Maiden

L3 DEATH MOUNTAIN

THE MOUNTAIN PATH

Child Goron

Goron

The Gorons

DEATH MOUNTAIN FOOTHILLS

Old-Timer in Moving House

TOWER OF FLAMES

L4 NEAR THE FIELDS

THE FIELD

Blue Knight

Knights of Hyrule

Parent/Child

Malon

Talon

White Maiden

Yellow Maiden

HYRULE CASTLE

EASTERN TEMPLE

THE COAST

Husband — *Married* — Stubborn Wife

L2 EASTERN HYRULE

Horse

THE SWAMP

Dampé

Rides

Mage

Lonely Old Man

Kaepora Gaebora

OTHER LOCATIONS

Guides

Fairies

Force Fairy

Great Fairy

Assist

VILLAGE OF THE BLUE MAIDEN

Old Man

Red Girl

Don't Get Along?

Blue Girl

Old Woman

Treasure Chest Shopkeeper

Iris

Shopkeeper

The Leader

Hide-and-Seek Boy

Man Who Lost His House

In Relationship

He Is Split into Four by the Power of the Four Sword

Link

Steals Force Gems

Tingle

Secret Agent One

Secret Agent Two

Secret Agent Three

Secret Agent Four

Secret Agent

Sweetie

Attacks

Shadow Link

Goes to Defeat

Vaati

Kidnaps

Princess Zelda

Old Woman

▷ CHARACTER RELATIONSHIPS: LEVELS 5-8

The chart below shows the relationships between characters who appear from Level 5 through Level 8. The connections for Princess Zelda's rescue, Link and Shadow Link, Vaati, and more change as players progress. All characters are sorted by the area and stage in which they appear.

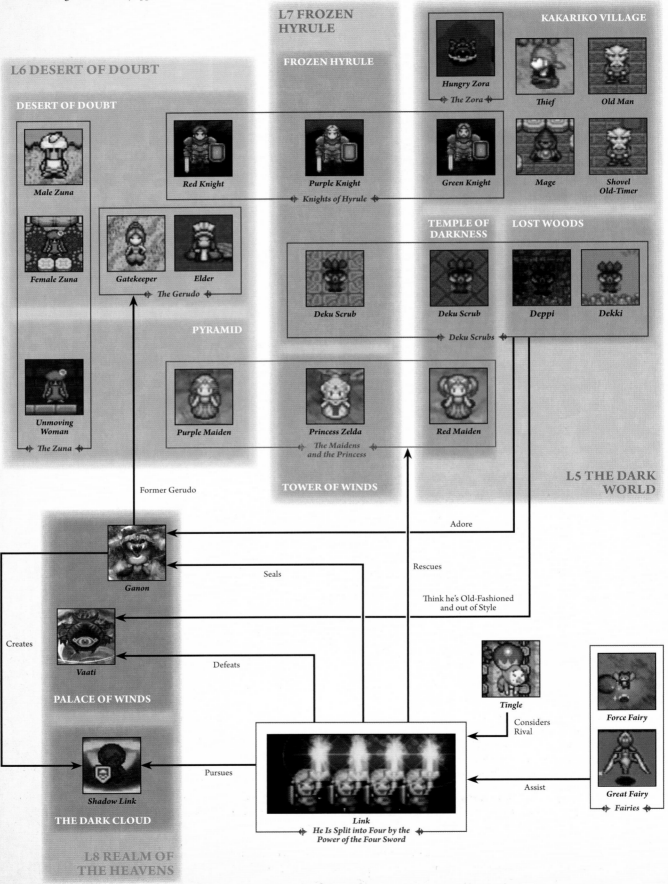

L7 FROZEN HYRULE

FROZEN HYRULE

KAKARIKO VILLAGE

Hungry Zora
◆ The Zora ◆

Thief

Old Man

L6 DESERT OF DOUBT

DESERT OF DOUBT

Male Zuna

Red Knight

Purple Knight

Green Knight

Mage

Shovel Old-Timer

◆ Knights of Hyrule ◆

Female Zuna

Gatekeeper

Elder

◆ The Gerudo ◆

TEMPLE OF DARKNESS

LOST WOODS

Deku Scrub

Deku Scrub

Deppi

Dekki

◆ Deku Scrubs ◆

PYRAMID

Unmoving Woman

◆ The Zuna ◆

Purple Maiden

Princess Zelda

Red Maiden

◆ The Maidens and the Princess ◆

TOWER OF WINDS

L5 THE DARK WORLD

Former Gerudo

Adore

Rescues

Ganon

Seals

Think he's Old-Fashioned and out of Style

Creates

Defeats

Vaati

PALACE OF WINDS

Tingle

Considers Rival

Force Fairy

Pursues

Shadow Link

THE DARK CLOUD

L8 REALM OF THE HEAVENS

Link
He Is Split into Four by the Power of the Four Sword
◆ ◆

Assist

Great Fairy
◆ Fairies ◆

THE WORLD

The world of *Four Swords Adventures* is vast and varied, stretching from Death Mountain to the Desert of Doubt, and even the Dark World.

Every time the Links save a maiden, a new area opens up, marking a linear progression of numbered stages rarely seen in the *Zelda* series.

A Cave of No Return **B** Hyrule Castle
C Eastern Temple **D** Tower of Flames
E Temple of Darkness **F** Desert Temple
G Pyramid **H** Temple of Ice
I Tower of Winds **J** Palace of Winds

Ⓐ Village of the Blue Maiden
Ⓑ Kakariko Village
Ⓒ Gerudo Village **Ⓓ** Zuna Village

Map labels: J L8 Realm of the Heavens · D · L3 Death Mountain · L5 The Dark World Ⓑ · L1 Whereabouts of the Wind · E · I · B · A · F · G · H · L4 Near the Fields · L6 Desert of Doubt · Ⓒ · L7 Frozen Hyrule · Ⓐ · L2 Eastern Hyrule

DEVELOPMENT DOCUMENTS

▷ Artwork Sketches

Cloth… Mmm, not quite there… Nakano, you can handle this in whatever way you think would look best.

The horn decoration looks good simple.

I don't like this either, so it's fine to improve it so it doesn't stand out. (Additional armor?)

Was that shield made official anywhere? (It's easy to fix, too.)

SCREENSHOT

▷ Green Soldier Concept Sketch

This soldier was drawn to explore what soldiers usually seen in pixels would look like in the style used for the game's key art, as seen on page 264).

Feedback notes are included from team members who were trying to make the soldier's armor look as impressive as possible with this level of detail.

▷ Artwork Drafts

The Japanese-only game mode known as "Navi Trackers" was originally called "Tetra Trackers" and the rules focused on collecting stamps. It ultimately became medal collecting.

COMPLETED VERSION

⚔ DEVELOPER ⚔ NOTES

● **Passing the Torch:** Before *Four Swords Adventures*, longtime director and designer Eiji Aonuma told Shigeru Miyamoto that he was no longer interested in working on the *Zelda* series. Miyamoto proposed that he become the producer instead, urging him to try looking at the series with a bit of distance. "As you watch talented new people make a *Zelda* game, revisit what you think *Zelda* is," Miyamoto said. Other than a stint directing *Twilight Princess*, Aonuma has been a producer on every principal *Zelda* title since.

● **Evolution of Adventure:** "Hyrulean Adventure" was originally a competitive title focused around gathering rupees. From there, it transitioned to a game with a solid amount of puzzle solving, and then to being about gathering Force Gems to obtain the Master Sword. The 2D design of the game made changing focus like this possible. Changes of a similar scale in 3D would have been much more difficult.

● **Four Links with a Single Player:** "Hyrulean Adventure" was initially created as a multiplayer game. It wasn't until later that the single-player mode was added as a bonus. About two months before release, Miyamoto advised director Toshiaki Suzuki: "If you're going to have single player, make sure you do it properly. A single-player *Zelda* that isn't interesting as a game is no good." Though it would delay the game's release, they spent the next month essentially redoing the way the game played with a stronger focus on the single-player side.

● **Like Pieces of Power:** The idea for the Force Gems in "Hyrulean Adventure" came from the Pieces of Power that appeared in *Link's Awakening*—items that occasionally dropped after defeating enemies and temporarily boosted attack power.

● **Twenty-Four Dungeons:** The evaluation upon clearing a level in "Hyrulean Adventure" was inspired by *Super Mario Bros.* Since each level was completely independent of the others, some staff felt it was like making twenty-four dungeons.

References
• *Nintendo Dream*, April 21, 2004. "The Legend of Zelda: Four Swords Adventures Producer + Double Directors Commemorative Release Interview."

2004

THE LEGEND OF
ZELDA
The Minish Cap

Release Dates: January 10, 2005 | November 4, 2004 (JP)
Console: Game Boy Advance

Like *Oracle of Ages*, *Oracle of Seasons*, and *Four Swords*, *The Minish Cap* was developed jointly with Capcom. It tells the origin story of the sacred Four Sword, as well as the Wind Sorcerer Vaati, which both previously appeared in *Four Swords*.

Like previous games featuring the blade, Link is able to split into multiple versions of himself to solve certain puzzles and aid in combat. It also took the Gnat Hat that allowed Link to shrink and seek out new paths in *Four Swords* and made it a central mechanic. Link used Ezlo, the Minish Cap, to travel between the Hyrulean world and the tiny world of the Minish hidden in its cracks and quiet corners.

In 2011, *The Minish Cap* was distributed as one of several free bonus titles in the Ambassador Program for those who preordered a Nintendo 3DS.

▷ Plot

Long ago, evil spirits descended on the land of Hyrule. Just when it seemed their world would be cast into darkness, the tiny Picori descended from the skies and entrusted a shining golden light and a single sword to a courageous hero. The hero fought off the demons and restored peace. The people were so grateful for the Picori's help that they created the Picori Festival to honor them.

Many years later, Link, a young apprentice blacksmith, was invited to the Picori Festival by his childhood friend, Princess Zelda. It was said that every one hundred years, a mystic doorway between Hyrule and the Picori world would open, and this festival marked one hundred years to the day.

Link headed for Hyrule Castle with Zelda, where they would first present the winner of the sword-fighting tournament with his prize. The ceremony began in the presence of the Picori Blade, plunged into a locked chest full of evil monsters, sealing them there. The mysterious victor, Vaati, approached, only to shatter the Picori Blade and release the monsters it kept at bay. Knocking Link aside, Vaati turned Zelda, who showed a glimpse of her sacred power, into stone. When Vaati realized what he sought was not inside the chest, he vanished.

The only way to free Zelda from her curse was to ask the Picori to restore the shattered blade. According to the king of Hyrule, the Picori were not a legend, but actually existed. However, only children could see them, and so Link was tasked with heading into the forest to find them. Along the way, he encountered a mysterious talking hat named Ezlo who was in peril. In exchange for saving him, Ezlo guided Link to the Minish Village in the forest.

In the tiny village, Link met with the Minish elder. Link learned that "Picori" was a name Hyruleans had given the Minish people. The elder said that before engaging Vaati, Link would need to reforge the Picori Blade to make a more powerful White Sword, then seek out the four Elements hidden throughout

the realm to truly restore the blade's power as the Four Sword. Link and Ezlo headed for the temples the elder spoke of and collected the Elements. As they did, Ezlo revealed that he was originally a Minish sage. Vaati had been his apprentice, before he betrayed Ezlo and stole a Mage's Cap that granted the wishes of its wearer. With the Mage's Cap, Vaati became a formidable sorcerer. Still not content, he sought the greater power of a "Light Force," bestowed by the heavens long ago. Vaati just didn't know where to find it.

With the Elements in hand, Link and Ezlo traveled to the Elemental Sanctuary at the center of Hyrule and fused them with the White Sword, completing the Four Sword. As they did, the door behind opened, and they headed through it, learning that the Light Force lies within the princess of each generation of the royal family.

It was then that Vaati appeared. He had been following Link and Ezlo in order to learn more about the Light Force. Vaati snatched away Zelda, who was still frozen in stone, and took her to the castle roof, where he began to extract the Light Force from her body in a ceremony that would turn him into a demon. Although Link and Ezlo stopped the ritual, it was too late. Vaati had enough Light Force to change into a hideous, one-eyed demon. Link battled this demon Vaati, splitting into four using the Four Sword. After cutting Vaati down, he sealed the wicked sorcerer away within the sword.

Though Vaati's curses on both Zelda and Ezlo were lifted, the kingdom had suffered greatly. Ezlo placed the Mage's Cap that Vaati had stolen atop Zelda's head. She had but one wish. Using the traces of Light Force remaining within her, she wished to restore Hyrule to its peaceful former state.

It was then that the door to the Minish world began to close. Ezlo, once again Minish, thanked Link and gave him a green hat that looked much like he did before the curse was lifted.

"Heh . . . You know, I've never actually seen you wearing a cap until now!" Ezlo said. "It suits you, little hero."

1 Link and Princess Zelda enjoy the Picori Festival together. **2** Vaati opens the chest sealed by the Picori Blade then turns Princess Zelda to stone. **3** Ezlo jumps onto Link's head. He gives Link all sorts of advice, but he's a little self-important while he does it. **4** Ezlo shrinks Link down at the entrance to the Minish Village. **5 6** Vaati breaks into Hyrule Castle and attacks King Daltus. He locks the king in the dungeon, takes on his appearance, and commands the soldiers to search for the Light Force. **7** The writings left at the Fortress of Winds tell of the Wind Tribe and how they left for the skies with their Element. **8** Link and Ezlo search the tiny world inside the village to find a way to reach the temple where the Wind Element rests. **9** Vaati, having seized most of Princess Zelda's Light Force and made it his own, transforms into a raging demon. **10** The sage Ezlo returns to the land of the Minish. He gives Link a green cap as a parting gift.

▷ MAIN CHARACTERS

◣ Link

An apprentice of a blacksmith known as Smith. Traveling with Ezlo atop his head, Link makes himself small so he can enter the world of the Minish.

◣ Ezlo

This bird-like cap works together with Link to stop Vaati, his former apprentice. Ezlo was a Minish sage until Vaati used magic to turn him into a hat.

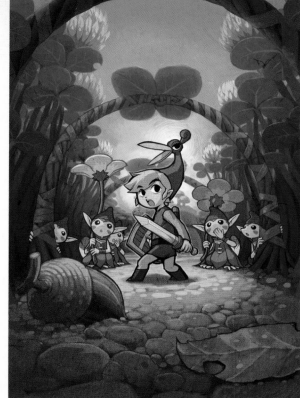

Key Art

◣ Princess Zelda

The princess of Hyrule and Link's childhood friend. Vaati turns her to stone at the Picori Festival and later seeks to drain the Light Force that flows through her.

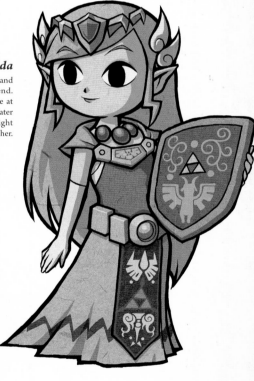

◣ Vaati

An evil sorcerer who seeks the Light Force. Vaati was Ezlo's assistant until he stole the powerful Mage's Cap and betrayed his master.

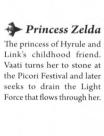

◣ The Minish

A tiny race of people, known to Hylians as Picori. They are thought to be a legend, but they actually live throughout Hyrule. Only children can see them.

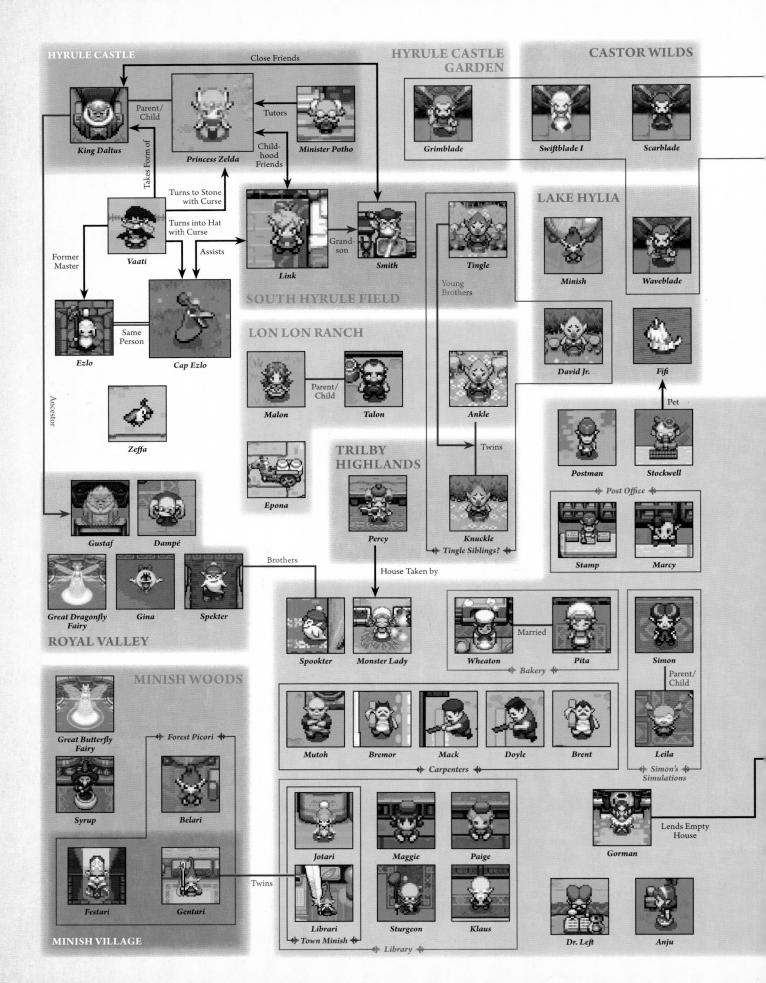

HYRULE CASTLE

King Daltus

Princess Zelda

Minister Potho

Close Friends

Parent/Child

Tutors

Childhood Friends

Takes Form of

Turns to Stone with Curse

Turns into Hat with Curse

Assists

Vaati

Former Master

Ancestor

Ezlo

Same Person

Cap Ezlo

Zeffa

HYRULE CASTLE GARDEN

Grimblade

CASTOR WILDS

Swiftblade I

Scarblade

SOUTH HYRULE FIELD

Link

Grandson

Smith

LAKE HYLIA

Minish

Waveblade

LON LON RANCH

Malon

Parent/Child

Talon

Epona

Tingle

Young Brothers

Ankle

David Jr.

Fifi

Twins

Pet

TRILBY HIGHLANDS

Percy

Knuckle

Tingle Siblings?

Postman

Stockwell

Post Office

Stamp

Marcy

Gustaf

Dampé

Great Dragonfly Fairy

Gina

Spekter

Brothers

House Taken by

Spookter

Monster Lady

Wheaton

Married

Pita

Simon

Parent/Child

Leila

Simon's Simulations

ROYAL VALLEY

MINISH WOODS

Great Butterfly Fairy

Forest Picori

Syrup

Belari

Mutoh

Bremor

Mack

Doyle

Brent

Carpenters

Gorman

Lends Empty House

Festari

Gentari

Twins

Jotari

Maggie

Paige

Librari

Town Minish

Sturgeon

Klaus

Dr. Left

Anju

MINISH VILLAGE

Library

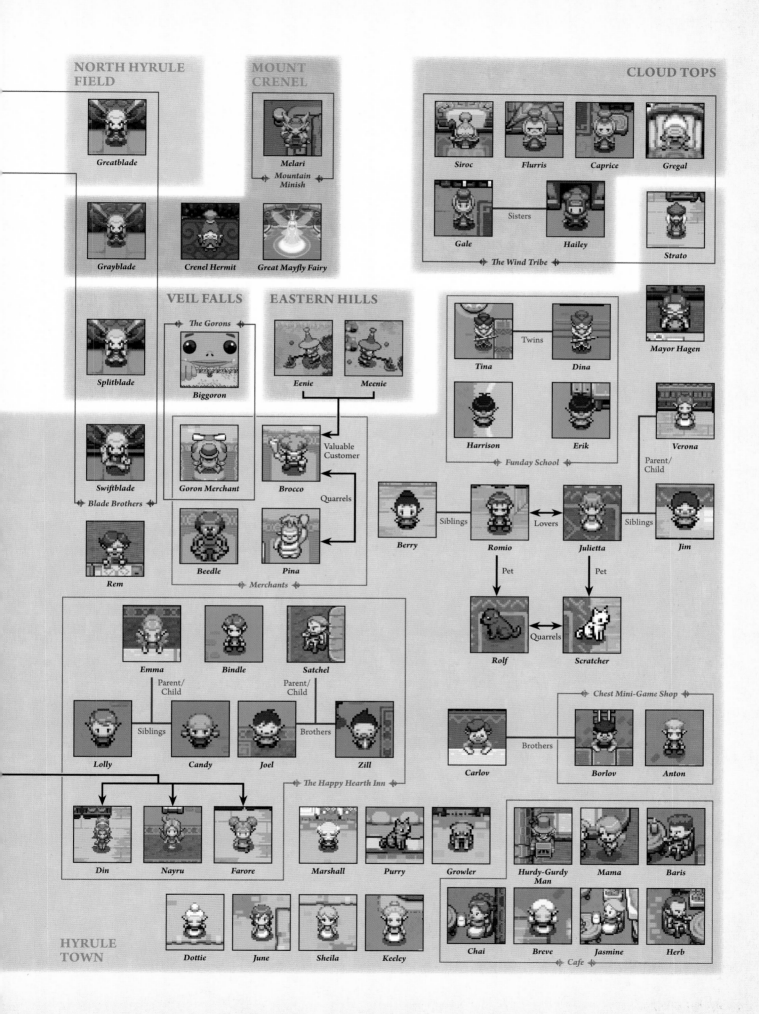

NORTH HYRULE FIELD

Greatblade

Grayblade

Splitblade

Swiftblade

↤ *Blade Brothers* ↦

Rem

MOUNT CRENEL

Melari

↤ *Mountain Minish*

Crenel Hermit

Great Mayfly Fairy

VEIL FALLS

↤ *The Gorons* ↦

Biggoron

Goron Merchant

Beedle

Pina

↤ *Merchants* ↦

EASTERN HILLS

Eenie

Meenie

Valuable Customer

Brocco

Quarrels

CLOUD TOPS

Siroc

Flurris

Caprice

Gregal

Gale — Sisters — *Hailey*

Strato

↤ *The Wind Tribe* ↦

Tina — Twins — *Dina*

Harrison

Erik

↤ *Funday School* ↦

Mayor Hagen

Verona

Parent/Child

Berry — Siblings — *Romio* ↔ Lovers ↔ *Julietta* — Siblings — *Jim*

Pet ↓

Rolf ↔ Quarrels ↔ *Scratcher*

Pet ↓

HYRULE TOWN

Emma

Bindle

Satchel

Parent/Child

Parent/Child

Lolly — Siblings — *Candy*

Joel — Brothers — *Zill*

↤ *The Happy Hearth Inn* ↦

Din

Nayru

Farore

Marshall

Purry

Growler

Carlov — Brothers — *Borlov*

↤ *Chest Mini-Game Shop* ↦

Anton

Hurdy-Gurdy Man

Mama

Baris

Dottie

June

Sheila

Keeley

Chai

Breve

Jasmine

Herb

↤ *Cafe* ↦

271

▷ THE WORLD

Forests, mountains, and marshes spread out from Hyrule Castle and Hyrule Town. The kingdom is divided into seventeen regions, each dotted with hidden caves, paths, and more that are revealed upon fusing Kinstones with the residents of each area. By using Minish Portals, Link can also shrink down to Minish size and explore parts of the world in miniature.

The Kingdom of Hyrule

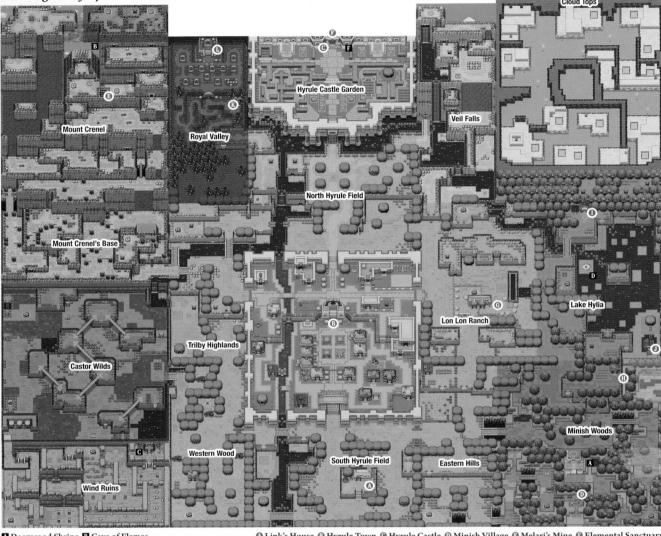

Cloud Tops
Mount Crenel
Royal Valley
Hyrule Castle Garden
Veil Falls
North Hyrule Field
Mount Crenel's Base
Lake Hylia
Lon Lon Ranch
Trilby Highlands
Castor Wilds
Minish Woods
Western Wood
South Hyrule Field
Eastern Hills
Wind Ruins

A Deepwood Shrine **B** Cave of Flames
C Fortress of Winds **D** Temple of Droplets
E Palace of Winds **F** Dark Hyrule Castle

Ⓐ Link's House **Ⓑ** Hyrule Town **Ⓒ** Hyrule Castle **Ⓓ** Minish Village **Ⓔ** Melari's Mine **Ⓕ** Elemental Sanctuary
Ⓖ Talon and Malon's House **Ⓗ** Witch's Hut **Ⓘ** Stockwell's House **Ⓙ** Mayor Hagen's Lakeside Cabin
Ⓚ Dampé's Shack **Ⓛ** Royal Crypt **Ⓜ** Home of the Wind Tribe

A NEW PERSPECTIVE

Minish homes are hidden in places that appear normal at first. Many live in secluded forests and hilltops, but a brave few hide in busy Hyrule Town.

Hyrule Town **Minish Perspective**

Minish Woods Minish Perspective

Lake Hylia Minish Perspective

Mount Crenel Minish Perspective

MINISH HOMES

The Minish live in all sorts of places from mushrooms and boots to tin cans. They decorate their homes using oversized items in surprising ways.

DEVELOPMENT DOCUMENTS

The World of the Minish Concept Art ◁

These images were drawn to show how and where the Minish live. At the start of development, the game's director, Hidemaro Fujibayashi, asked for a large number of storyboards and environmental concept art.

The design for the minuscule race was mostly complete from the initial sketches, but the name of the race was not decided until later, with early ideas floating about like "Chilorians" or "Tiny People."

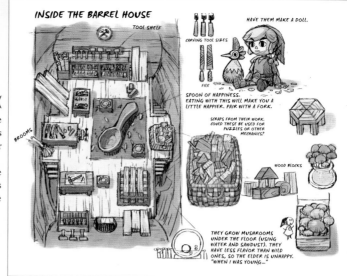

▷ Ezlo Design Concepts

These images were used to help define the relationship between Link and Ezlo, the snarky hat Link dons for this adventure. The drawings illustrate Ezlo's sometimes obnoxious personality, as well as his unique range of movement. There are a couple of surprising references in these sketches. In one image, Ezlo makes a reference to Navi, and in another, he mentions Ganon.

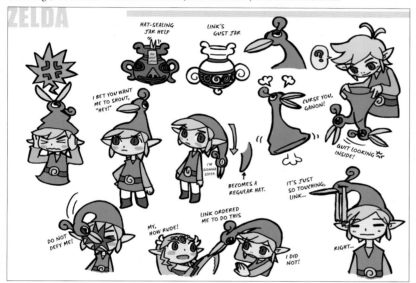

DEVELOPER NOTES

● **A New Perspective:** When developing *Zelda* games, director Hidemaro Fujibayashi thinks about the main hook of the game play before digging deeper into how it will play out in combat or puzzles. He steers away from game play that doesn't feel "*Zelda*-like," instead asking how that game play can provide a fresh perspective on the familiar and beloved world of Hyrule. In *The Minish Cap*, the act of shrinking and growing allowed designers to show Link's world in an entirely new way without ever taking them out of it.

● **A Hat That Shrinks Link:** The idea for a hat that shrinks Link came from the Gnat Hat in *Four Swords*, which itself was an idea Shigeru Miyamoto had during production of that game. The team on *Four Swords* thought Link's shrunken appearance was funny and wanted to use it again. They filed the idea away until *The Minish Cap*, where it

evolved from a minor item to something central to the game's design—changing size to explore different corners of the world.

● **Showing the Way:** When the team worked on the *Oracle* series, they struggled to find ways to direct the player without a character to guide them. For *The Minish Cap*, they decided to make a partner for Link right from the start. Around the same time, they were brainstorming signature items Link could wear, including masks and hats. The designers combined the two ideas and gave Link a talking hat, thus leading to the prototype for Ezlo.

● **Gust Jar's Inspiration:** When Fujibayashi thinks of ideas for new items, he pulls concepts from sources as disparate as fairy tales and science experiments. The idea for the new Gust Jar item in *The Minish Cap* came from a gourd that can suck up anything in the sixteenth-century Chinese novel *Journey to the West*.

● **Tiny Link, Big World:** In some cases, the world gets bigger as Link shrinks down. Other

times, Link shrinks down but the world appears the same. In these latter cases, Link appears as a tiny dot, moving around the same area he did while regular sized. The designers did this to give Link a sense of scale while also keeping players oriented to their surroundings. Producer Eiji Aonuma felt the 2D perspective of the game helped accomplish this effect, which challenged players to notice subtle details like mouse holes to find new paths and progress the story.

● **A Town That Feels Alive:** Fujibayashi set out to make the central hub of the game feel lived in, packing the town with details and people going about their lives. By adding hidden paths and puzzles, accessed by shrinking, Hyrule Town also took on the feel of a dungeon—something *Zelda* developers hadn't really attempted before. When the game was finished, Aonuma had high praise for the depth his team gave Hyrule Town, saying it exceeded even Clock Town in *Majora's Mask*.

References
• *Nintendo Dream*, December 6, 2004. "*The Legend of Zelda: The Minish Cap* Commemorative Release Interview."

THE LEGEND OF **ZELDA**
Twilight Princess

THE LEGEND OF **ZELDA**
Twilight Princess HD

Released simultaneously for the Wii and GameCube, *Twilight Princess* marked a series return to more realistic graphics, with a darker tone and game play never before seen in a *Zelda* game, notably Link's ability to transform from Hylian to wolf at will.

The GameCube and Wii versions were set in worlds that mirrored each other from left to right, and together they broke the series' record for sales, with 8.85 million copies sold worldwide as of February 2017.

A Wii U remake was released in 2016. In addition to enhanced visuals, it included convenient features like using the GamePad to display the map and change items, as well as a new area called the Cave of Shadows, accessible using the simultaneously released Wolf Link amiibo.

Release Dates: November 19, 2006 (Wii) | December 11, 2006 (GC)
December 2, 2006 (JP)
Consoles: Nintendo GameCube | Wii

Release Dates: March 4, 2016 | March 10, 2016 (JP)
Console: Wii U

Link attacks on horseback in the Wii version of Twilight Princess.

▷ PLOT

Link, a ranch hand and skilled rider, lived in Ordon Village, a small agricultural town at the southern edge of the kingdom of Hyrule.

One day, Link was on an errand for the village swordsman when tragedy struck. Monsters abducted his childhood friend Ilia and a group of village children. Link hurriedly pursued them into the forest, a place of peace now shrouded in eerie shadows. Link was dragged into the shadows, where he was transformed into a black wolf and lost consciousness.

Link awoke in his beastly form in a castle dungeon with a mysterious imp calling herself Midna before him. Midna agreed to help Wolf Link escape, and with her guidance, they reached the top of the castle. There they found Princess Zelda. The princess explained that Hyrule Castle had been overtaken by the Twilight Realm and invaded by Zant, the King of Twilight, who commanded the shadow beasts Link saw in the forest. Zelda explained that soon all Hyrule would be shrouded in Twilight.

Link returned to his village and saved a Spirit of Light, who restored his Hylian form. But Ilia and the children were still missing. Link and Midna then began a journey to collect three Fused Shadows, which possessed the power to oppose Zant, and saved the rest of the Spirits of Light, returning the regions of Hyrule invaded by the Twilight Realm to normal in the process.

When Link collected the last Fused Shadow, Zant launched a surprise attack and once again turned Link into a wolf. Midna was gravely injured in Zant's assault.

1 In the Twilight Realm, Hylians turn into spirits, but Link, chosen by the gods, turns into a wolf. **2** King Bulblin, who kidnaps Ilia and the village children. Link crosses blades with him countless times during his journey. **3** Link, assaulted by Zant, turns into a wolf, while Midna is on the verge of death. **4** Princess Zelda saves Midna by sacrificing herself. **5** The Shadow Crystal that comes out of Link's body when he draws the Master Sword. Following this, Link becomes able to freely shift between his Hylian and wolf forms. **6** The Mirror of Twilight that connects to the Twilight Realm is in pieces, but the usurper king Zant was unable to fully destroy it. Fragments are scattered throughout the land, which Link and Midna must collect to reassemble the mirror. **7** There is incredible power within the Fused Shadows. **8** The fated battle against Ganondorf, who was behind everything. **9** Midna, in her true form, destroys the Mirror of Twilight and returns to the Twilight Realm.

Wolf Link petitioned Zelda for aid. Zelda told Link that the Master Sword could break Zant's curse, and, realizing the role Midna was fated to play in stopping Zant, saved Midna's life by pouring all of her soul into the imp's body.

Following Zelda's directions, Link and Midna journeyed to the Sacred Grove, where Link obtained the Master Sword, once again lifting his beastly curse. Link and Midna were now ready to put an end to Zant.

To defeat Zant in the Twilight Realm, Link and Midna had to pass through the only connection between the Light and Twilight Realms: the Mirror of Twilight. As they headed for the Mirror Chamber, they met ancient sages, who told them of the evil thief Ganondorf. Though blessed by the power of the goddesses, the Gerudo sought more power and plotted to conquer the world and was thus banished by the sages to the Twilight Realm, where his malice was able to manipulate Zant and destabilize the Twili. The sages also revealed that Midna was the true ruler of the Twilight Realm, usurped and turned into an imp by Zant. The sages apologized for putting Midna's people in danger by banishing Ganondorf to her realm.

Zant knew the power of the Mirror of Twilight and shattered it. Together, Link and Midna gathered its pieces from across the realm, restored it, and used it to enter the Palace of Twilight. There, with the aid of the Fused Shadows, Midna defeated Zant.

Link and Midna then set off for Hyrule Castle to vanquish Ganondorf. Fighting alongside Princess Zelda, who was revived thanks to Midna, they defeated Ganondorf in battle. The mark of the goddesses' power within Ganondorf vanished, and Midna returned to her true form.

In order to prevent a tragedy like this from occurring ever again, Midna shattered the Mirror of Twilight. "Never forget that there's another world bound to this one," she said, and with those parting words, Midna returned to the Twilight Realm.

Link returned to Ordon Village, bathed again in the blessing of the Spirits of Light, along with those who had been abducted.

▷ MAIN CHARACTERS

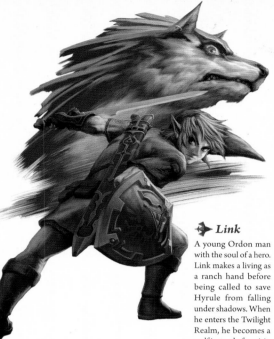

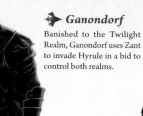

◆ Ganondorf

Banished to the Twilight Realm, Ganondorf uses Zant to invade Hyrule in a bid to control both realms.

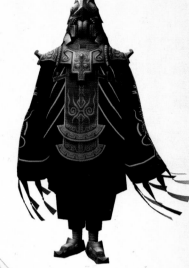

◆ Link

A young Ordon man with the soul of a hero. Link makes a living as a ranch hand before being called to save Hyrule from falling under shadows. When he enters the Twilight Realm, he becomes a wolf instead of a spirit.

◆ Ilia

Link's childhood friend and the daughter of Ordon Village's Mayor Bo. Ilia suffers through many hardships.

◆ Zant

Passed over as leader of the Twilight Realm, Zant uses Ganondorf's power to drive Midna away and claim the throne by force.

◆ Princess Zelda

The princess of Hyrule surrendered to Zant when he invaded her kingdom. After this, she dons black to symbolize her mourning.

◆ Midna

Midna first meets Link in his wolf form and becomes his partner. Together they fight to save their respective realms. Midna is actually the Twilight Princess, transformed by Zant.

◆ Telma

Telma, owner of a bar in Castle Town, collaborates with the Resistance investigating disturbances throughout Hyrule.

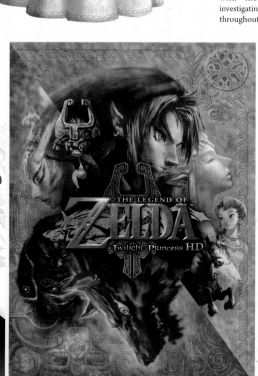

◆ Agitha

A young girl who proclaims herself to be the "princess of the insect kingdom." She has invited the Golden Bugs to come to her ball.

Twilight Princess

Key Art

Twilight Princess HD

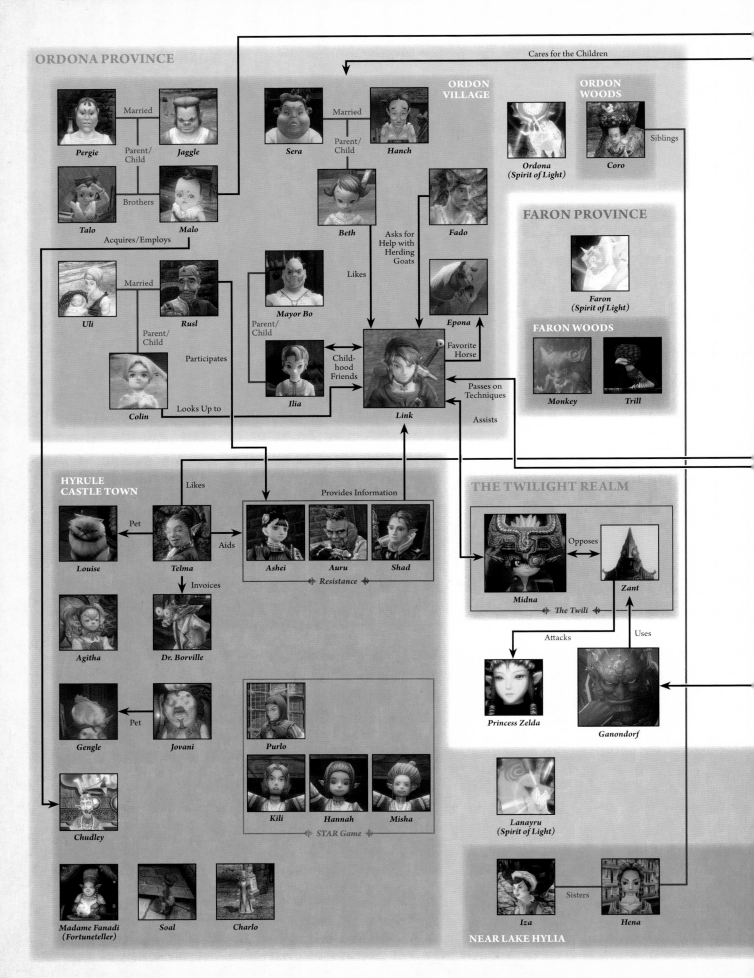

ORDONA PROVINCE

Pergie — Married — Jaggle

Parent/Child

Talo — Brothers — Malo

Acquires/Employs

Uli — Married — Rusl

Parent/Child

Colin

Participates

Looks Up to

Mayor Bo

Parent/Child

Ilia

ORDON VILLAGE

Sera — Married — Hanch

Parent/Child

Beth

Likes

Asks for Help with Herding Goats

Fado

Epona

Favorite Horse

Childhood Friends

Link

Cares for the Children

ORDON WOODS

Ordona (Spirit of Light)

Coro — Siblings

FARON PROVINCE

Faron (Spirit of Light)

FARON WOODS

Monkey Trill

Passes on Techniques

Assists

HYRULE CASTLE TOWN

Likes

Louise — Pet — Telma — Aids —

Invoices

Provides Information

Ashei Auru Shad

◀ Resistance ▶

Agitha Dr. Borville

Gengle — Pet — Jovani

Purlo

Chudley

Kili Hannah Misha

◀ STAR Game ▶

Madame Fanadi (Fortuneteller) Soal Charlo

THE TWILIGHT REALM

Midna — Opposes — Zant

◀ The Twili ▶

Attacks Uses

Princess Zelda Ganondorf

Lanayru (Spirit of Light)

Iza — Sisters — Hena

NEAR LAKE HYLIA

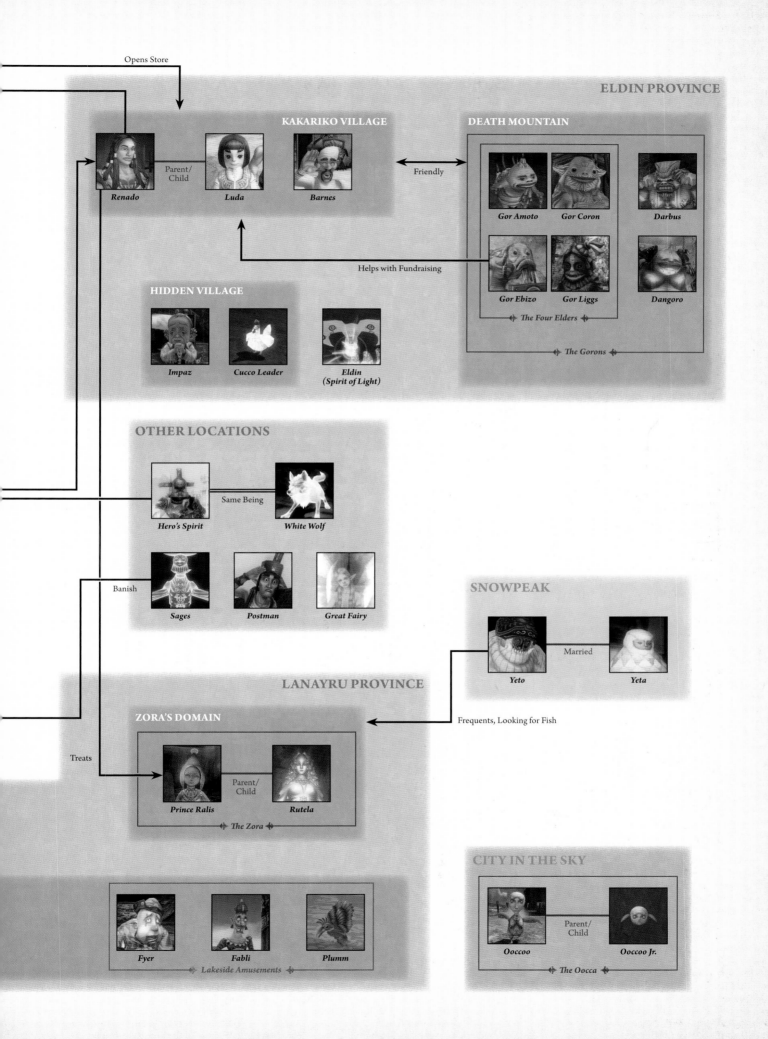

ELDIN PROVINCE

Opens Store

KAKARIKO VILLAGE

Renado — Parent/Child — **Luda** — **Barnes**

DEATH MOUNTAIN

Friendly

Gor Amoto **Gor Coron** **Darbus**

Gor Ebizo **Gor Liggs** **Dangoro**

◆ The Four Elders ◆

◆ The Gorons ◆

Helps with Fundraising

HIDDEN VILLAGE

Impaz **Cucco Leader** **Eldin (Spirit of Light)**

OTHER LOCATIONS

Hero's Spirit — Same Being — **White Wolf**

Banish

Sages **Postman** **Great Fairy**

SNOWPEAK

Yeto — Married — **Yeta**

LANAYRU PROVINCE

Frequents, Looking for Fish

ZORA'S DOMAIN

Treats

Prince Ralis — Parent/Child — **Rutela**

◆ The Zora ◆

CITY IN THE SKY

Ooccoo — Parent/Child — **Ooccoo Jr.**

◆ The Oocca ◆

Fyer **Fabli** **Plumm**

◆ Lakeside Amusements ◆

▷ THE WORLD

A field surrounds Hyrule Castle, spreading outward in all directions, beyond which lie volcanoes, forests, and other disparate regions broadly divided into four provinces.

Beyond these are more remote places like deserts and snowy mountains. These harsher environments are home to few if any people, but beasts and monsters suited to their extreme temperatures survive or even thrive there.

In the skies above Lake Hylia floats a City in the Sky, built and inhabited by the advanced Oocca, former residents of this land who escaped to the clouds in ages past.

Note: This world map is from the GameCube and Wii U versions.

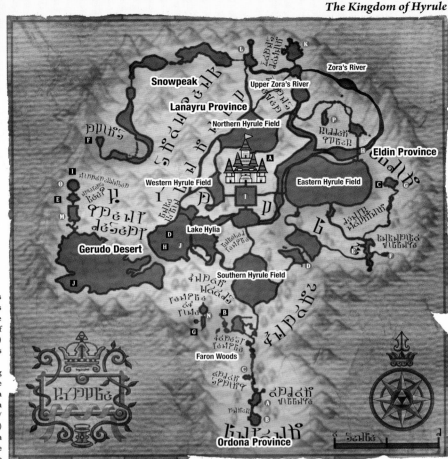

The Kingdom of Hyrule

Snowpeak

Upper Zora's River

Zora's River

Lanayru Province

^Northern Hyrule Field

Eldin Province

Western Hyrule Field

Eastern Hyrule Field

Lake Hylia

Gerudo Desert

Southern Hyrule Field

Faron Woods

Faron Woods

Ordona Province

Ⓐ Hyrule Castle Ⓑ Forest Temple Ⓒ Goron Mines
Ⓓ Lakebed Temple Ⓔ Arbiter's Grounds
Ⓕ Snowpeak Ruins Ⓖ Temple of Time
Ⓗ City in the Sky (Placed at Location of Sky Cannon Needed to Get There)
Ⓘ Palace of Twilight Ⓙ Cave of Ordeals

Ⓐ Ordon Village Ⓑ Ordon Ranch Ⓒ Ordon Spring
Ⓓ Kakariko Gorge Ⓔ Kakariko Village
Ⓕ Graveyard Ⓖ Death Mountain
Ⓗ Bridge of Eldin Ⓘ Hyrule Castle Town
Ⓙ Lakeside Amusements (Cannon Rides/ Flight by Fowl)
Ⓚ Fishing Hole Ⓛ Zora's Domain
Ⓜ Desert Caravan Ⓝ Sacred Grove
Ⓞ Mirror Chamber Ⓟ Hidden Village

THE FOUR PROVINCES

The four provinces of Hyrule are watched over by four Spirits of Light, each of which resembles an animal. These provinces, once abundant with natural beauty, are overtaken by the Twilight Realm, transforming them into shadowy, dangerous places. Even when the light is restored in the provinces, areas of darkness remain.

Ordona Province

The smallest province of the kingdom, Ordona Province is home to Ordon Village and its woods. The province is the only one to escape the Twilight. Its spirit takes the form of a goat, which is also the symbol of the village.

Faron Province

Faron is a lush, heavily forested province. After being covered in Twilight, a portion of the forest is overwhelmed with poisonous gas. The spirit of this province is a monkey.

Eldin Province

Eldin Province is full of jagged rock formations and volcanoes. Kakariko Village lies at its heart, beyond a gorge that shares its name. Encroaching Twilight causes volcanoes in Eldin to grow more active. The province's spirit is a hawk.

Lanayru Province

Lanayru is the largest province and the source of most of Hyrule's water, which flows from Zora's River into Lake Hylia. Twilight freezes Lanayru's waterways, causing a water shortage. The province's spirit is a snake.

Hyrule Castle Town

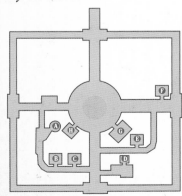

Ⓐ STAR Tent Ⓑ Agitha's Castle
Ⓒ Fanadi's Palace Ⓓ Telma's Bar
Ⓔ Jovani's House Ⓕ Medical Clinic
Ⓖ Chudley's Fine Goods and Fancy Trinkets Emporium/Malo Mart Castle Branch
Ⓗ Observation Deck

Central Square

South Road

WEALTH DISPARITIES

The larger population of Hyrule Castle Town compared to provincial villages has greatly increased the cost of even essential goods there, meaning only the wealthy can afford anything. When Malo Mart moves in, prices drop significantly. Soon, citizens are walking around town with smiles and full shopping bags.

A Shop for the Wealthy, Renovated for the People

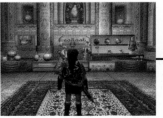

Chudley's is an upper-class shop that requires customers to shine their boots before entering. They sell items at much higher prices than other shops, so there are few customers inside.

After Chudley's is acquired by Malo Mart, the prices, look, and even background music become far more welcoming.

▷ DEVELOPMENT DOCUMENTS

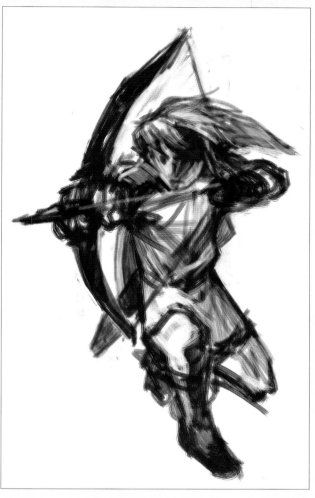

▷ Twilight Princess HD Artwork Drafts

New illustrations for Link, Ganondorf, Zelda, and other key characters were produced during the development of *Twilight Princess HD*. The completed versions are on page 275. These drafts show their evolution. The rough sketch of Link shows how he might wield a bow in the heat of battle.

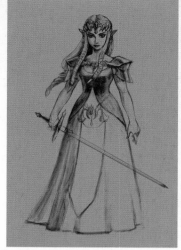

◄ DEVELOPER ► NOTES

● **A Darker Zelda:** After the cartoon style of *The Wind Waker*, developers worked to make *Twilight Princess* a more grown-up experience. This started with Link, who was older and drawn more realistically. The visuals around him followed, with designers developing more sophisticated controls and adding darker elements that had not been present in the series until this title, like children being kidnapped.

● **Right-Handed Swordplay:** Originally, the Wii and GameCube versions both used the B button to swing Link's sword in his traditional left hand. Wii players at E3 unconsciously swung the Wii remote in combat. With their feedback, developers tied swinging the sword to player motions. The B button was repurposed to instead fire arrows, leading to what the developers felt were more intuitive controls. To match players holding the remote in their right hand, the Wii version put the sword in Link's right hand and mirrored the world to compensate.

● **Link-canthropy:** The idea for Link to turn into a wolf came from producer Eiji Aonuma. On a business trip overseas early in development, the *Zelda* veteran dreamed he was a wolf locked in a cell; when he woke up, he didn't know where he was. They originally intended to have Link be a wolf from the very start of *Twilight Princess*, a stark departure from what would be expected of a spiritual sequel to *Ocarina of Time*. After some discussion, developers opted for a more traditional beginning for the sake of new players, introducing Link as a Hylian in Ordon Village before he is captured and transformed into a wolf.

● **A Dungeon Overworld:** Every *Zelda* game up to this point was clearly divided between an overworld and dungeons. Developers wondered what combining the two would look like, resulting in Link's quest to collect Tears of Light across provinces. While care was given to make the encroaching Twilight Realm feel uncomfortable to motivate players, developers made sure not to make it so unpleasant that players would stop playing. Sound was key to achieving this balance. "Make the music so you don't like it," Aonuma said, "but not too unpleasant, more 'I've got to do something!' Make sure it has a sense of atmosphere."

● **Realistic Horse Riding:** Great care was taken in *Twilight Princess* to incorporate battle on horseback and improve the realism of horse riding. Keisuke Nishimori, who was in charge of character design, decided to ride a horse himself to experience what it was actually like. What Nishimori learned from the ride, and how big a horse actually feels when standing next to one, helped bring a greater sense of realism to horses in the game.

● **Finding the Right Balance:** Making an HD version allowed developers to enhance puzzle mechanics and display distant backgrounds more clearly. Australian development company Tantalus Media, which handled the HD version, worked hard to balance the clarity HD allowed with the feeling of a "soft, blurred atmosphere" so characteristic of *Twilight Princess*.

References
- *Iwata Asks Wii Project, Vol. 5. "The Legend of Zelda: Twilight Princess Compilation."*
- *Nintendo Dream*, February 2007. "*The Legend of Zelda: Twilight Princess Giant Feature: Interview with Producer Eiji Aonuma.*"
- *Miiverse Developer's Room Miiting #6. "The Legend of Zelda: Twilight Princess HD."*

2007

THE LEGEND OF ZELDA: Phantom Hourglass

Release Dates: October 1, 2007 | June 23, 2007 (JP)
Console: Nintendo DS

As the popularity of the Nintendo DS exploded in Japan and beyond thanks to games like *Brain Age*, an entirely new kind of *Zelda* experience was developed for the dual-screen, touch-sensitive console.

All of Link's actions, from movement to combat, were done with touch controls, and many puzzles utilized features unique to the DS. This new way to play *The Legend of Zelda* proved a success, as *Phantom Hourglass* became the first title since *Ocarina of Time* to sell one million units domestically in Japan.

▷ PLOT

A few months after their adventures in *The Wind Waker*, Tetra's pirate crew reached the domain of the Ocean King. There, an eerie Ghost Ship appeared in the fog, sailing away with Tetra after she boarded it. Link tried to jump aboard to save her, but fell one step short and dropped into the sea.

Link washed up on the shores of Mercay Island and was rescued by a fairy named Ciela who'd lost her memories, and a mysterious old man named Oshus. Link needed a vessel to pursue the Ghost Ship, and his search led him to the treasure-seeking Captain Linebeck. The two set out in search of the Ghost Ship in an aptly named ship, the SS *Linebeck*.

Link obtained a sea chart from the Temple of the Ocean King, a place patrolled by illusory knights known as Phantoms. The temple had an aura that drained Link's life just by setting foot inside, making it impossible to go any farther.

A fortuneteller named Astrid advised Link to seek out the Spirits of Power, Wisdom, and Courage in order to find the Ghost Ship. To do so he obtained a powerful item, the Phantom Hourglass, which allowed him to control time within the Temple of the Ocean King and venture farther within to gain more sea charts.

He traveled to numerous islands, and after rescuing the Spirits of Power and Wisdom, Oshus revealed that Ciela was the Spirit of Courage. The fairy's memories returned and she regained her sacred power.

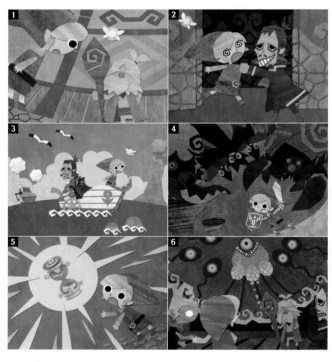

1 Link falls into the sea while pursuing Tetra, then washes up on Mercay Island, where he meets Oshus and Ciela. **2** Linebeck has been sneaking into the Temple of the Ocean King to find clues related to the Ghost Ship's treasure. Link saves him after he falls into a trap and is unable to move. **3** Since they share the same goal, the pair set sail on the SS *Linebeck*. **4** They visit temples throughout the land on their journey to find the three spirits. **5** The power of the Phantom Hourglass is restored by obtaining Sand of Hours. **6** Link finds Tetra turned to stone on the Ghost Ship, then learns the truth about Bellum from Oshus. **7** He sets sail once more in search of three pure metals to forge the Phantom Blade. **8** Link collects Crimsonine, Azurine, and Aquanine, and Oshus combines the completed Phantom Blade and Phantom Hourglass into the Phantom Sword. **9** Bellum possesses Linebeck and the final battle ensues. **10** Peace returns to the ocean and Oshus becomes the Ocean King once more. Link and Tetra return to their original world, where only ten minutes have passed since Link fell into the ocean. However, the Phantom Hourglass is still in Link's hand.

With the spirits gathered, Link boarded the Ghost Ship. Inside, Link found that Tetra's Life Force had been stolen, turning her to stone.

Oshus appeared and revealed that he was the Ocean King and that the demon Bellum was loose, consuming Life Force like Tetra's. To defeat Bellum, Link would need the Phantom Sword, a sacred blade forged from three pure metals.

Oshus recognized Link as a true hero for saving the spirits, and implored him to now seek out the pure metals and stop Bellum.

Waiting in farther-flung corners of the map were peoples guarding these pure metals. Link earned the trust of the Gorons, Anouki, and Yook, and proved his wisdom and courage to the Cobble Kingdom. With each bond, Link was granted a pure metal, and together they were forged into a blade. The Ocean King then fused the blade with the power of the Phantom Hourglass, completing the Phantom Sword.

Link reached the deepest part of the Temple of the Ocean King, where he found the demon. During the battle that followed, Ciela regained her ability to stop time as the Spirit of Time, and together, Link and the fairy vanquished Bellum and restored Tetra's Life Force.

But Bellum wasn't finished. He emerged from beneath the sea and sank the SS *Linebeck*. Bellum possessed Linebeck, forcing Link to fight his friend. Link defeated Bellum once more while sparing Linebeck. In victory, the sailor always so obsessed with treasure wished only for his sunken vessel to return to him.

Link and Tetra awoke on their ship. The pirates insisted only ten minutes had passed and they must have dreamed the whole adventure. That's when Link spotted the SS *Linebeck* in the distance.

Link and Tetra bid farewell to the realm of the Ocean King and resumed their journey to seek out a new land. A new Hyrule.

◈ Ciela

A fairy with no memories of the past who finds Link washed up on the shores of Mercay Island.

◈ Linebeck

This cowardly captain seeks the Ghost Ship, said to be full of treasure. He journeys with Link on the SS *Linebeck*, a modest vessel that shares his name.

Key Art

◈ Link

The Hero of Winds who saved Hyrule. He can be a bit careless but will do whatever it takes to save Tetra.

◈ Phantom

Knights created by Bellum that patrol the Temple of the Ocean King. They are invulnerable to attacks from the front.

◈ Tetra

A pirate captain who also happens to be Princess Zelda. She believes the Ghost Ship that sails the waters of the Ocean King must actually be helmed by pirates, and is eager to teach them a lesson.

◈ Bellum

A demon that devours Life Force. It steals Tetra's Life Force, turning her to stone.

◈ Oshus

Oshus lives with Ciela. Together they find Link after he washes up on the beach. Oshus acts as a guide throughout Link's adventure, lending advice and support. Later, his true form as the Ocean King is revealed.

▷ CHARACTER RELATIONSHIPS

NORTHWESTERN SEA

Golden Chief Cylos
UNCHARTED ISLAND

Zauz
ZAUZ'S ISLAND

Purifies the Sword's Blade

Linebeck ← Cooperates → **Link**
◄ SS Linebeck ►
Rescues

Cooperates

BANNAN ISLAND

Nyeve

Salvatore

Old Wayfarer

Joanne — Sisters — **Jolene**

Pursues

Assists

Live Together

Ciela

Brothers

Married

Son

Tells Fortune

Master

Nyave

Romanos

Maronie

Chaco

Oshus ← Disguised as → **Ocean King**

Potato

Ocara

Mai

MOLIDA ISLAND

Phantom

Swift Phantom

Gold Phantom

◄ Temple of the Ocean King Guardians ►

Sells Cannon

Ojibe

Treasure Teller

Gazpacho

Fuzo ← Assisted by — **Eddo**
◄ Eddo's Garage ►
CANNON ISLAND

Freedle

Fuchiko

Doudo

Saya

Midori

Maltza — Married — **Tuzi**

◄ Bar ►

ISLE OF EMBER

Kayo — Serves → **Astrid**

Ai

Lapelli — Married — **Apricot**

MERCAY ISLAND

SOUTHWESTERN SEA

Three Sisters

ARCHIVES

GAME INFORMATION & NOTES

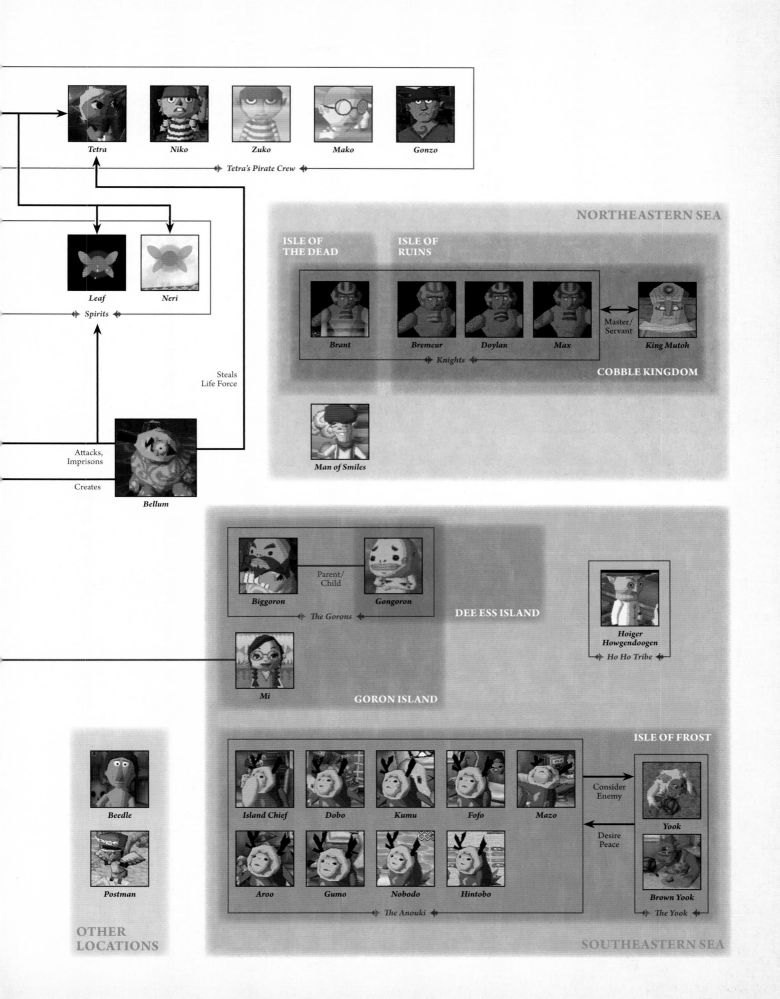

Tetra Niko Zuko Mako Gonzo

◆ Tetra's Pirate Crew ◆

Leaf Neri

◆ Spirits ◆

Attacks,
Imprisons

Creates

Bellum

Steals
Life Force

NORTHEASTERN SEA

ISLE OF
THE DEAD

ISLE OF
RUINS

Brant Bremeur Doylan Max

◆ Knights ◆

Master/
Servant

King Mutoh

COBBLE KINGDOM

Man of Smiles

Biggoron Gongoron

Parent/
Child

◆ The Gorons ◆

DEE ESS ISLAND

Hoiger
Howgendoogen

◆ Ho Ho Tribe ◆

Mi

GORON ISLAND

ISLE OF FROST

Beedle

Island Chief Dobo Kumu Fofo Mazo

Consider
Enemy

Yook

Desire
Peace

Postman

Aroo Gumo Nobodo Hintobo

◆ The Anouki ◆

Brown Yook

◆ The Yook ◆

OTHER
LOCATIONS

SOUTHEASTERN SEA

▷ THE WORLD

The world of *Phantom Hourglass* is governed by the great spirit known as the Ocean King. Said to be the next ocean over from where *The Wind Waker* took place, it also seems to exist somewhere far beyond. Its map depicts a vast ocean dotted with islands in four quadrants. In all, there are sixteen islands Link and Linebeck can visit. On some, people make their homes. Others may be home to only a single minigame. Sea charts found in the Temple of the Ocean King open new areas to explore. Sea travel takes place in the SS *Linebeck*, but Link can also warp across the map using Cyclone Slates.

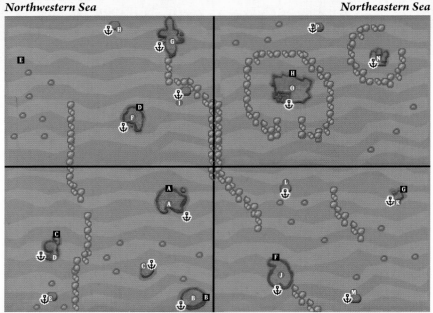

Northwestern Sea

Northeastern Sea

Southwestern Sea

Southeastern Sea

A Temple of the Ocean King B Temple of Fire
C Temple of Courage D Temple of Wind
E Ghost Ship F Goron Temple
G Temple of Ice H Mutoh's Temple

Ⓐ Mercay Island Ⓑ Isle of Ember Ⓒ Cannon Island
Ⓓ Molida Island Ⓔ Spirit Island Ⓕ Isle of Gust
Ⓖ Bannan Island Ⓗ Zauz's Island Ⓘ Uncharted Island
Ⓙ Goron Island Ⓚ Isle of Frost Ⓛ Harrow Island
Ⓜ Dee Ess Island Ⓝ Isle of the Dead Ⓞ Isle of Ruins
Ⓟ Maze Island

SEEN FROM THE SEA

Mercay Island

Isle of Ember

Cannon Island

Molida Island

Spirit Island

Isle of Gust

Bannan Island

Zauz's Island

Uncharted Island

Goron Island

Isle of Frost

Harrow Island

Dee Ess Island

Isle of the Dead

Isle of Ruins

Maze Island

SS *LINEBECK*: LINK'S VESSEL ON THE HIGH SEAS

The SS *Linebeck* is a capable if humble vessel helmed by the reedy Captain Linebeck. Players can collect and swap out ship parts for the SS *Linebeck*, giving it a variety of appearances.

Captain Linebeck pierces Bellum in the climactic battle with the aquatic demon.

SS Linebeck

Bright Ship

Iron Ship

Stone Ship

Vintage Ship

Demon Ship

Tropical Ship

Dignified Ship

Golden Ship

ISLAND PLANTS

A great many plants grow in *Phantom Hourglass* and vary depending on the island.

Bomb Flower

Item Flower

Flutter Grass

Spike Grass

Tufted Grass

Flower Grass

Tree

Fellable Tree

Palm Tree

Molida Island Tree

Isle of the Dead Tree

▷ DEVELOPMENT DOCUMENTS

▷ Concept Art

The sketch below is quite close to the image used as cover art for the Japanese version of *Phantom Hourglass*. Its composition is reversed, however, with Linebeck striking a decidedly more relaxed pose when compared to the finished drawing.

COMPLETED VERSION

Anouki
Rough Design ◁

ANOUKI (GENERAL)

MAN OF SMILES

COMPLETED VERSION

▷ **Man of Smiles**
Rough Design

ARCHIVES

GAME INFORMATION & NOTES

❧ DEVELOPER ❧ NOTES

● **Three Years in the Making:** Development on *Phantom Hourglass* began soon after *Four Swords Adventures*, with much the same team investigating what would be possible with the Nintendo DS's dual screens and stylus. Since the portable console had not yet been released, this early work was done on a prototype unit. At first, the team was keen to create a direct follow-up to *Four Swords Adventures* with Game Boy Advance–style visuals on two screens. Partway through, they shifted focus to a game that would set the standard for the new console's unique control options. This led to game play dependent on the stylus.

● **Goodbye, Buttons:** The team was initially worried about controlling everything with the stylus, so they left in button controls. It was when the Boomerang was introduced, which had players draw its path before throwing it, that they were convinced using the stylus for all other actions would be fine.

● **Returning to the Temple:** The Temple of the Ocean King was created as developers searched for a progress mechanic beyond simply acquiring hearts. Repeatedly exploring the temple and getting a little farther each time

would give players an immediate sense of accomplishment. They then added enemies that could not be defeated (Phantoms), followed by a time limit to up the tension.

● **Sand in the Hourglass:** *Phantom Hourglass* wasn't the first *Zelda* game where a time limit played a central role. The development team studied how *Majora's Mask* used time and applied it to the Temple of the Ocean King in a way that better suited dungeon game play. The idea to apply this mechanic to an hourglass actually came in the final stages of development. The hourglass was incorporated into the story, and ultimately combined with the concept of Phantoms for the game's title.

● **A New Kind of Zelda:** From cute box art designed to appeal to new players, to an emphasis on stylus controls, this first *Zelda* title on the DS attempted to evolve the series in bold new ways. Mechanics central to previous games like collecting bottles and upgrading wallets were removed, while Pieces of Heart were replaced with whole Heart Containers.

● **Two Screens, Two Perspectives:** Developers also focused on ways to use both screens to their advantage in game play. The boss fight against Crayk in the Temple of Courage shows the battle from the boss's viewpoint, which is only possible due to the hardware having two screens.

● **All the Names:** The names of the ghosts who haunt the Cobble Kingdom come from carpenters who appear in *Ocarina of Time*, *Majora's Mask*, and other games in the *Zelda* series. King Mutoh is the leader of the Cobble Knights in *Phantom Hourglass*, much like Mutoh leads the carpenters of other titles. Mutoh's carpenter apprentices also have similar names to Cobble Knights, like Brent and Brant, respectively. And the names of Mercay and Molida Islands come from Mercator and Mollweide projection, techniques for displaying maps in the real world.

● **Composing Linebeck's Theme:** The first attempt by composer Toru Minegishi to write "Linebeck's Theme" was rejected by producer Eiji Aonuma, who said he "felt the grief and sorrow of a middle-aged man" in the piece. Aonuma asked Minegishi to steer the music toward a style found in traditional Japanese narrative singing known as *naniwabushi*.

References
• *Nintendo Dream*, September 2007. "The Legend of Zelda: Phantom Hourglass Development Team Interview."
• *Nintendo Dream*, March 2010. "Developer Chat: Interesting Stories from *Spirit Tracks*."
• *Nintendo Game Strategy Guide*. "The Legend of Zelda: Phantom Hourglass."
• *Iwata Asks*. "The Legend of Zelda: Spirit Tracks Development Team Compilation."

2009

THE LEGEND OF ZELDA™ Spirit Tracks

The second *Zelda* game released for the Nintendo DS refined the touch controls and mechanics of *Phantom Hourglass*. *Spirit Tracks* was a direct follow-up to *Phantom Hourglass*, which was itself a sequel to *The Wind Waker*. Past games like *Link's Awakening* and *Majora's Mask* continued the stories of their predecessors, but never to this degree. Several years after the release of *Spirit Tracks*, an official timeline was released, charting the three games on their own branch following the successful sealing of Ganondorf at the end of *Ocarina of Time*. Unlike the past two installments, which were set primarily at sea, *Spirit Tracks* returned Link to land. Much of the overworld travel was done by train across a vast new Hyrule forged in the land of the Spirits of Good. For the first time, Zelda joined Link as a full-fledged companion.

Release Dates: December 7, 2009 | December 23, 2009 (JP)
Console: Nintendo DS

▷ PLOT

Many years after Tetra and the Hero of Winds made landfall in the lands of the Lokomo Tribe, the Spirit Tracks crisscrossing the realms were disappearing. Princess Zelda called upon a young engineer in training named Link to help her learn why.

Together they traveled to the source of the tracks: the Tower of Spirits, which had broken apart as the Spirit Tracks disappeared. Chancellor Cole arrived in a Demon Train, revealing that he was a demon working to revive his lord, Malladus. Cole's henchman, a mysterious man named Byrne, helped Cole separate Zelda's spirit from her body, and together they stole her body.

Link and the spirit of the princess hurried to the Lokomo Anjean, protector of the tower. She told them that Zelda's body was to be used as a vessel for reviving Malladus, the Demon King sealed inside the tower. The only way to stop Malladus from breaking free was to collect Rail Maps from the tower, now shrouded in evil, and restore the Spirit Tracks, long ago built to be his shackles.

Link and Zelda's spirit made their way up the tower to obtain their first map. This was no easy feat. Phantom guardians possessed by demons were on patrol. When one attacked Link, Zelda came to his aid, expelling the demon and taking control of the Phantom's body—a power that would prove useful. After, Link and Phantom Zelda recovered the first Rail Map. An impressed Anjean granted them use of the Spirit Train, an ancient locomotive once helmed by the Spirits of Good. Thus began the long journey of Link and Phantom Zelda across all corners of land and sea.

They met the residents of Whittleton and headed for the Forest Sanctuary beyond the Lost Woods. Using the Spirit Flute given to him by Princess Zelda, Link played the Song of Restoration with the sage Gage, amplifying the power

of the Rail Map. The Spirit Tracks to the Forest Temple returned. As they restored the temple's barrier, a portion of the divided Tower of Spirits returned to normal, enabling them to ascend farther up the tower. They obtained the second Rail Map from within it and headed for the next realm.

At the heart of each realm's temple, Link played the Song of Restoration on the Spirit Flute, restoring the region's connection to the tower and allowing passage farther up the tower.

After recovering the Fire Realm's Rail Map, Byrne appeared before Link and Zelda. Anjean tried to stop him from interfering, revealing that Byrne was once Anjean's apprentice. Byrne had betrayed her, desiring power to surpass the Spirits of Good by reviving Malladus.

As Anjean and Byrne battled, Anjean warped Link and Zelda to the Fire Realm, urging them to hurry.

After restoring the final barrier, Link and Zelda returned to the tower. They reached the top only to find that Cole had already revived Malladus and escaped. To defeat the Demon King, they would need the Bow of Light, which rested within the Sand Temple.

Together with Anjean and Byrne, who had realized the error of his ways, they set out for the Sand Realm and secured the Bow of Light.

From the top of the Tower of Spirits, the Compass of Light then pointed Link and his allies to the Dark Realm and the Demon Train, where Cole and Malladus would be found.

In an epic battle for the fate of the realm, Link shot Malladus with the Bow of Light and Zelda took back her body, but Byrne lost his life. Holding back tears, Zelda used her sacred power, and together with Link's courage, destroyed the Demon King.

Realizing that the Spirit Tracks and the people of this land no longer needed Lokomo protection, Anjean told Zelda to watch over the land and that Link must help her, then departed.

1 Link arrives to be certified as an engineer. **2** The Tower of Spirits is split apart. **3** Byrne defeats Alfonzo. **4** Princess Zelda becomes a spirit. **5 6** Zelda saves Link by possessing a Phantom. **7** Link receives the Spirit Train from Anjean and departs for the four realms. **8 9** Zelda and Link obtain Rail Maps as they travel the four realms, overcoming many challenges along the way. **10** Princess Zelda finally regains her body with Byrne's help. **11** Zelda's singing, filled with sacred power, increases the power of the Lokomo instruments. **12** The final battle against the Demon King Malladus, who has possessed Cole. Link fires the Bow of Light, and together with Princess Zelda, he defeats him. **13** Anjean, along with the other Lokomo sages, entrusts the world to Link and Princess Zelda and returns to the sky. There are multiple endings depending on what Link does moving forward, as decided by the player.

▷ MAIN CHARACTERS

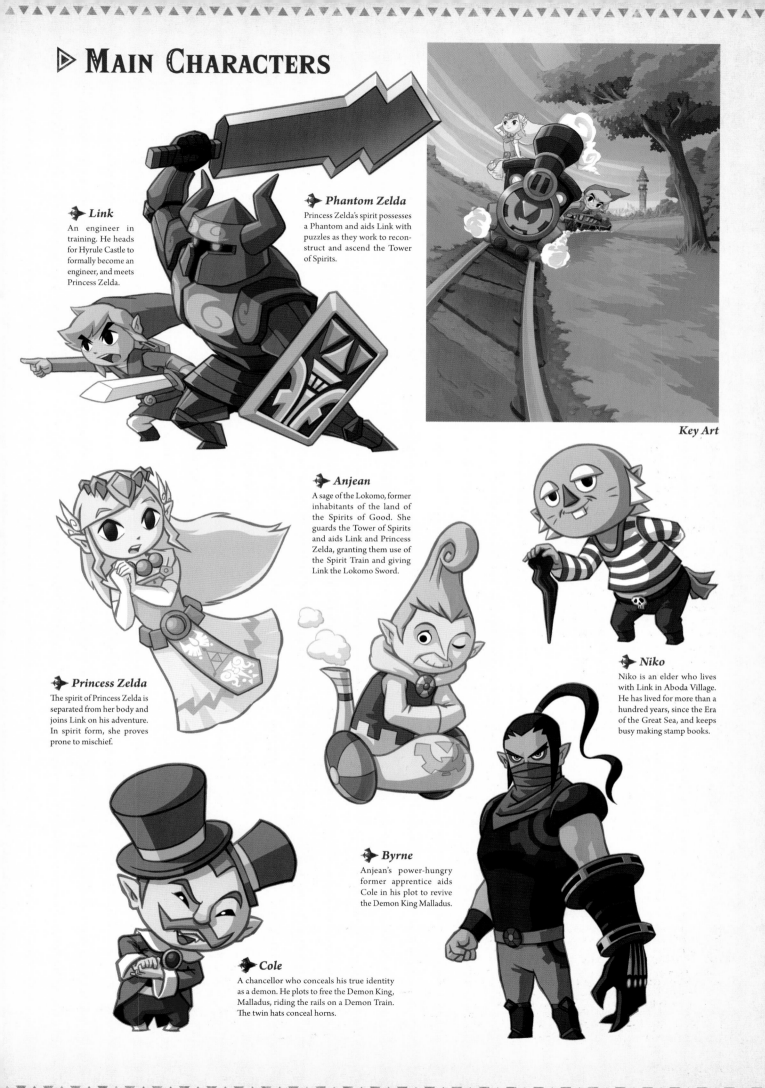

◆ Link

An engineer in training. He heads for Hyrule Castle to formally become an engineer, and meets Princess Zelda.

◆ Phantom Zelda

Princess Zelda's spirit possesses a Phantom and aids Link with puzzles as they work to reconstruct and ascend the Tower of Spirits.

Key Art

◆ Anjean

A sage of the Lokomo, former inhabitants of the land of the Spirits of Good. She guards the Tower of Spirits and aids Link and Princess Zelda, granting them use of the Spirit Train and giving Link the Lokomo Sword.

◆ Princess Zelda

The spirit of Princess Zelda is separated from her body and joins Link on his adventure. In spirit form, she proves prone to mischief.

◆ Niko

Niko is an elder who lives with Link in Aboda Village. He has lived for more than a hundred years, since the Era of the Great Sea, and keeps busy making stamp books.

◆ Byrne

Anjean's power-hungry former apprentice aids Cole in his plot to revive the Demon King Malladus.

◆ Cole

A chancellor who conceals his true identity as a demon. He plots to free the Demon King, Malladus, riding the rails on a Demon Train. The twin hats conceal horns.

CHARACTER RELATIONSHIPS

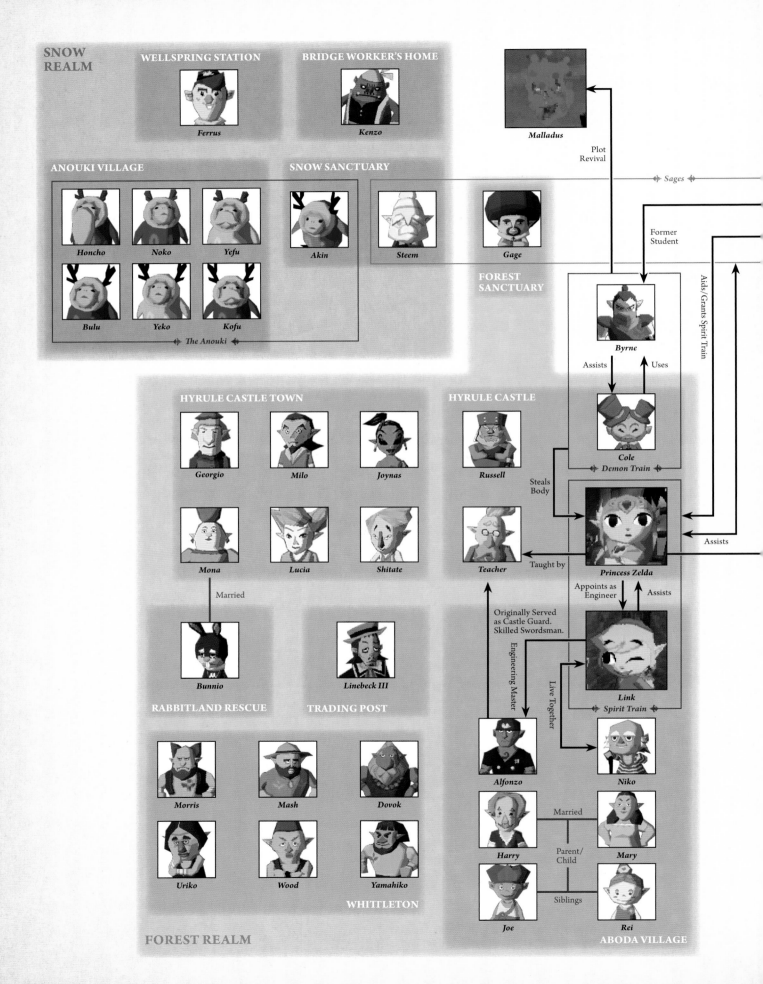

SNOW REALM

WELLSPRING STATION
Ferrus

BRIDGE WORKER'S HOME
Kenzo

Malladus

Plot
Revival

ANOUKI VILLAGE
Honcho
Noko
Yefu
Bulu
Yeko
Kofu
◆ The Anouki ◆

SNOW SANCTUARY
Akin

Steem

Gage

◆ Sages ◆

Former
Student

**FOREST
SANCTUARY**

Byrne

Assists Uses

Aids/Grants Spirit Train

HYRULE CASTLE TOWN
Georgio
Milo
Joynas

Mona
Lucia
Shitate

Married

Bunnio
RABBITLAND RESCUE

Linebeck III
TRADING POST

HYRULE CASTLE
Russell

Teacher

Cole
◆ Demon Train ◆

Steals
Body

Princess Zelda

Taught by

Appoints as Assists
Engineer

Assists

Originally Served
as Castle Guard.
Skilled Swordsman.

Link
◆ Spirit Train ◆

Engineering Master Live Together

Alfonzo

Niko

WHITTLETON
Morris
Mash
Dovok

Uriko
Wood
Yamahiko

FOREST REALM

Harry Married Mary

Parent/
Child

Joe Siblings Rei

ABODA VILLAGE

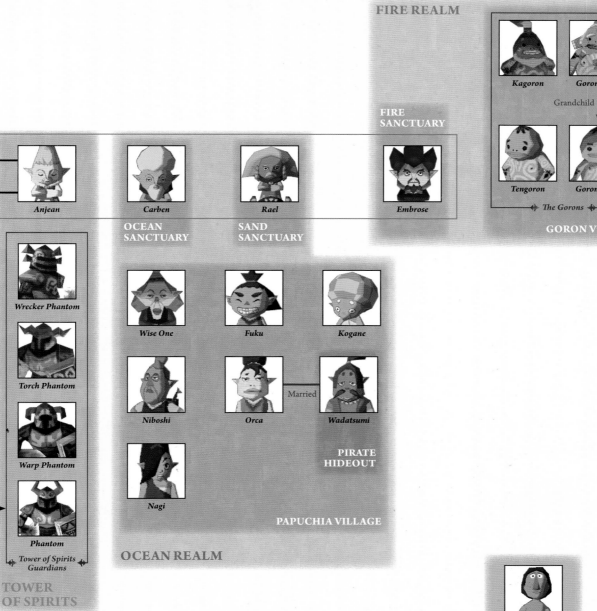

FIRE REALM

Kagoron

Goron Elder

Grandchild

Tengoron

Goron Child

↤ The Gorons ↦

GORON VILLAGE

**FIRE
SANCTUARY**

Embrose

Anjean

**OCEAN
SANCTUARY**

Carben

**SAND
SANCTUARY**

Rael

Wrecker Phantom

Torch Phantom

Warp Phantom

Possesses

Phantom

↤ Tower of Spirits
Guardians ↦

**TOWER
OF SPIRITS**

Wise One

Fuku

Kogane

Niboshi

Orca

Married

Wadatsumi

Nagi

**PIRATE
HIDEOUT**

PAPUCHIA VILLAGE

OCEAN REALM

Beedle

Postman

**OTHER
LOCATIONS**

▷ THE WORLD

Spirit Tracks is set on the Lokomo continent that Tetra and her pirates ended up finding after their adventure in *Phantom Hourglass*. They name the continent Hyrule. A network of Spirit Tracks run across mountains, forests, deserts, and even under the sea, all leading to the Tower of Spirits via twenty-two train stations, not including temples.

Snow Realm

True to its name, the Snow Realm is covered in ice and snow. It is extremely cold, so there are few settlements beyond the Anouki Village. One of the "trainiac" Ferrus's photography spots is located here.

Forest Realm

A land of lush forests where the adventure begins. Hyrule Castle was built at the foot of the Tower of Spirits and has several stations. It is in many ways the cultural center of the continent.

Fire Realm

Volcanic projectiles rain down on this scorching-hot realm, while piping-hot lava and magma run right next to the tracks. Not many people live in this realm, but the Gorons find it more than hospitable, even running a target range here.

Ocean Realm

Tracks run over and under the sea in this tropical region bordered by the Sand Realm. Islands hold everything from Papuchia Village to a Pirate Hideout near the Tower of Spirits.

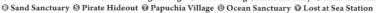

Photo Spot

Tunnel

Ocean Floor Entrance

Lost Woods

A Tower of Spirits **B** Forest Temple
C Snow Temple **D** Ocean Temple
E Fire Temple **F** Sand Temple
G Dark Realm

A Snowdrift Station **B** Slippery Station **C** Snow Sanctuary **D** Anouki Village **E** Wellspring Station **F** Worker's Home
G Rabbitland Rescue **H** Hyrule Castle/Castle Town **I** Forest Sanctuary **J** Whittleton **K** Aboda Village **L** Trading Post
M Disorientation Station **N** Goron Target Range **O** Goron Village/Fire Sanctuary **P** Ends of the Earth Station **Q** Dark Ore Mine
R Sand Sanctuary **S** Pirate Hideout **T** Papuchia Village **U** Ocean Sanctuary **V** Lost at Sea Station

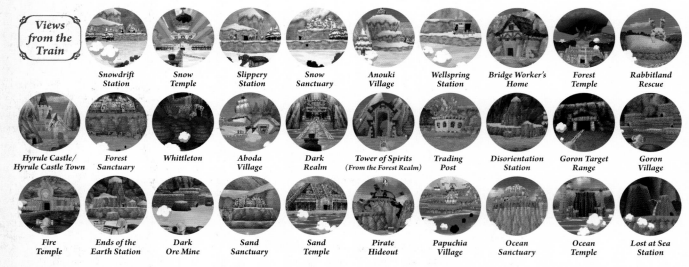

Views from the Train

Snowdrift Station	Snow Temple	Slippery Station

Snowdrift Station · Snow Temple · Slippery Station · Snow Sanctuary · Anouki Village · Wellspring Station · Bridge Worker's Home · Forest Temple · Rabbitland Rescue

Hyrule Castle/Hyrule Castle Town · Forest Sanctuary · Whittleton · Aboda Village · Dark Realm · Tower of Spirits (From the Forest Realm) · Trading Post · Disorientation Station · Goron Target Range · Goron Village

Fire Temple · Ends of the Earth Station · Dark Ore Mine · Sand Sanctuary · Sand Temple · Pirate Hideout · Papuchia Village · Ocean Sanctuary · Ocean Temple · Lost at Sea Station

THE SPIRIT TRAIN

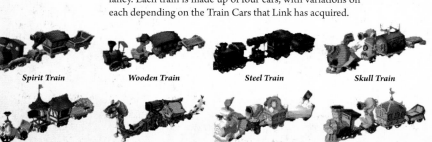

The Spirit Train is entrusted to Link and Zelda by Anjean. This ancient locomotive is essential for long journeys to distant corners of the map. Over time, Link may find enough treasure to trade for Train Cars at the Linebeck Trading Company, allowing him to customize the look of the train to suit his fancy. Each train is made up of four cars, with variations on each depending on the Train Cars that Link has acquired.

Inside the Passenger Car

Spirit Train · Wooden Train · Steel Train · Skull Train

Stagecoach Train · Dragonhead Train · Sweet Train · Golden Train

LIFE ON THE RAILS

In this world where trains have become the main form of transportation, features have been developed to make travel both easier and safer for everyone on the rails. Engineers rely on these to keep things running smoothly.

Spacetime Gate

These magical gates work in pairs. Activating one and passing through it will warp the train to a distant land elsewhere on the map.

Signs

Signs alongside the tracks let engineers know when to slow down or stop. It means a safer trip for all involved.

Begin Slowdown · End Slowdown

Whistle · Stop

DEVELOPMENT DOCUMENTS

▷ Artwork Sketches ◁

As part of the design process, concept artists sketched Link in a variety of poses before fine-tuning and finishing a select few, as seen below.

COMPLETED VERSION

LIFE FORCE EMISSIONS

A STEAM TRAIN THAT RUNS ON LIFE FORCE ENERGY IT RECEIVES FROM THE TRACKS

▷ Spirit Train Design Proposals

In the story, the Spirit Train's power source is the Life Force it obtains from the Spirit Tracks. This was planned early on in development, while many other aspects of the game's design were still being worked out.

PHANTOM VARIATIONS

NORMAL TORCH WARP WRECKER

▷ Phantoms Concept Art

New Phantoms were added for *Spirit Tracks*, with variations if they were possessed by Zelda. If the player talks to the Phantoms during the game, they will mutter and complain. The developers channeled some of their own frustrations into these Phantom grumblings.

☙ DEVELOPER NOTES ❧

● **The *Majora's Mask* of *Phantom Hourglass*:** Just as *Majora's Mask* is based on the world, characters, and style of *Ocarina of Time* with a twist, so too does *Spirit Tracks* grow from and reimagine core elements of *Phantom Hourglass*. Developers decided early on to base much of the game play around controlling Phantoms via Zelda's spirit, taking inspiration from the section of *Phantom Hourglass* where players switched between controlling Gongoron and Link.

● **Zelda as a Companion:** Developers wanted to ensure that Link's companion in this installment was a girl, and they had already featured Tetra in past titles. Since the series is called *The Legend of Zelda*, they felt it was long overdue to have Zelda join Link for an adventure.

● **All Aboard:** The idea to base the game around trains was inspired by a picture book that producer Eiji Aonuma was reading to his kids. Initially, the team planned to let players draw the tracks themselves, embracing the pioneering spirit that has long

informed the *Zelda* series. Development on this style of game lasted a year before the idea proved too difficult to implement with a relatively linear story. As a result, fixed tracks were laid that vanish at the beginning of the game and must be restored.

● **More Zelda, Less Princess:** Developers felt that it was important for the Princess Zelda of *Spirit Tracks* to contradict what players might expect from royalty, and purposefully wrote her to act more like any girl her age might. The game's cut scene designers had plenty of fun with this idea, especially in the early scenes when Zelda, driven out of her body, is still getting used to being a spirit.

● **Gaining Levels:** The scene where Link ascends the spiral staircase in the Tower of Spirits was not originally in the game, but was added near the end of development after a comment from Aonuma. "The player has repaired it and can now climb higher," he said, "but just going in and out of doors will never create the feeling of climbing a tower."

● **Linebeck's Return:** Director Daiki Iwamoto grew very attached to Linebeck in *Phantom Hourglass*, leading to his descendant's appearance in the follow-up as a secondary character. Though his role running a trading post is hardly

as important as the one he played in *Phantom Hourglass*, Linebeck III is the only character aside from Link and Zelda in *Spirit Tracks* to have a voice. "Eeeya-hah!"

● **Musical Training:** The sound of the Spirit Train's whistle reminded lead composer Toru Minegishi of a pan flute, so he used the instrument in background music that plays while Link is riding the rails. This choice was in keeping with other folk instruments that had been a critical component of each game's sound since *The Wind Waker*. Developers again wrote music that changed depending on the action and even specific player movements. The speed of the song playing when the Spirit Train is moving, for instance, changes depending on the speed of the train, with its "choo-choo" blasting in time with the music.

References
• *Iwata Asks*. "The Legend of Zelda: Spirit Tracks."
• *Nintendo Game Strategy Guide*. "The Legend of Zelda: Spirit Tracks."
• *Nintendo Dream*, March 2010. "Developer Chat: Interesting Stories from Spirit Tracks."

2011

THE LEGEND OF ZELDA Skyward Sword

The release of the epic Nintendo Wii adventure *Skyward Sword* coincided with the twenty-fifth anniversary of the *Legend of Zelda* series. The series' second game on the Wii introduced players to a time before Hyrule, during a period of ancient history that saw many legends born, including the creation of the Master Sword. This made it an ideal release to mark the series' quarter century in development.

Skyward Sword focused much of its game play on the Wii MotionPlus, which could detect much subtler movements than the original Wii Remote. Link could closely match the player's motions with the remote sensing direction, angle, and swing speed. Many puzzles utilized these systems, which created a sense of unity not found in previous games.

Release Dates: November 20, 2011 | November 23, 2011 (JP)
Console: Wii

▷ PLOT

One dark, fateful day, the earth cracked wide and malevolent forces rushed forth from the fissure. They sought the power of the Triforce, the power of the goddesses that grants the wish of the one who touches it. The goddess Hylia, protector of the land and Triforce, took the surviving members of the race that would later become Hylians, and sent them skyward, putting them and the power of the Triforce out of evil's reach. Then, she and the rest of the Surface-dwelling races fought back the monsters, sealing their leader, Demise, away. She knew that the seal would not hold, and only the Triforce had the power to combat him, so she put plans in motion to stop him when the time came.

Years passed, and the goddess and the Surface became the things of legend. The story of *Skyward Sword* began in Skyloft, the largest of the islands floating in the sky. Link, a student of the Knight Academy, completed the Wing Ceremony and was enjoying a flight through the sky atop his Loftwing with his childhood friend, Zelda. Suddenly, a dark tornado attacked the two, and Zelda fell below the clouds. That night, a mysterious voice guided Link to the goddess statue, where he found the Goddess Sword placed in a pedestal. Together with Fi, the spirit of the sword, Link dove beneath the clouds and landed on the Surface to begin searching for Zelda.

Link and Fi's search led them to the Temple of Time in the Lanayru Desert, where their reunion with Zelda was cut short by an ambush by Ghirahim, a lord of the lower lands plotting the revival of Demise.

Zelda, who was with her bodyguard Impa, then passed through a Gate of Time to the distant past. Impa destroyed it behind them, so that Ghirahim could not follow. In order to pursue Zelda, Link took on the trials that would

1 Zelda and Link, childhood friends, riding on Loftwings. **2** Ghirahim. He doggedly pursues Zelda and crosses blades with Link many times. **3** Groose, a young man at Skyloft. He descends to the Surface and realizes his powerlessness, but finds his own way of fighting. **4** In the Silent Realm, tests from the goddess try the strength of Link's spirit. **5** Absorbing Zelda's power, Demise is fully resurrected. Link and Demise do battle in a hyperspace controlled by evil power. **6** Link parts with Fi after all they shared together. Though Fi is not supposed to have emotions, she expresses gratitude and thanks Link.

turn the Goddess Sword into the Master Sword, granting him the power to open a second door in the Sealed Temple deep in Faron Woods. He tempered the sword with three Sacred Flames hidden throughout the land and used the power of its Skyward Strike to restore the temple's Gate of Time. When Link passed through the gate, he found Zelda on the other side: in the Sealed Grounds of the ancient past, just moments after Skyloft separated from the Surface. Zelda then told him what she had learned. Though the Triforce is the legacy of the goddesses, their kin cannot use it. The goddess Hylia abandoned her divine form so that her soul might be reincarnated in a mortal body to protect the world.

This incarnation of the goddess Hylia was none other than Zelda herself. Zelda apologized for involving Link in such a heavy destiny. She strengthened the seal upon Demise and, to stabilize it through millennia, entered a deep, deep sleep that would last for thousands of years. "Ever since we were kids, I'd always be the one to wake you up when you slept in," she said. "But this time, when all of this is over, will you come to wake me up?"

Link returned to the present and sought the legendary Triforce within Skyloft. Using its awesome power, he eliminated the Imprisoned, a twisted form of Demise who had broken the seal. Having fulfilled her task, Zelda awoke in the present. It was then that Ghirahim appeared and dragged Zelda back into the world of the past. He intended to perform the rites that would successfully revive Demise, who still lived in the past. Link pursued Ghirahim and vanquished him, but the ceremony was completed. Demise was revived.

Armed with the Master Sword, Link faced Demise and won—the demon's pure malice sealed away inside the Master Sword. Fi, having completed her duty, returned to the Sealed Temple and went to sleep inside the Master Sword as well. Impa saw Link and Zelda off to the present, where, as an old woman, she completed her role of guarding the seal and quietly faded away.

The threat of the demons receded from the Surface and all was at peace once more. Link and Zelda decided to give up their lives in the sky, choosing instead to live on the Surface and protect the Triforce.

◁ MAIN CHARACTERS

◈ Zelda

Daughter of Gaepora, the headmaster at the Knight Academy. She later faces her destiny to be awakened as the goddess Hylia.

◈ Link

A young graduate of the Knight Academy who rides a legendary red Loftwing. He descends to the Surface in search of Zelda, his childhood friend.

◈ Fi

A sword spirit created by the goddess Hylia. She resides inside the Goddess Sword, and calls Link "Master" after he pulls the blade from its pedestal.

◈ Impa

A Sheikah charged in ages past with guarding the Sealed Temple, Impa serves as Zelda's protector on the Surface.

◈ Ghirahim

A self-proclaimed Demon Lord who plots the revival of his master, Demise.

Key Art

◈ Groose

Link's classmate at the academy. He has feelings for Zelda and antagonizes Link. He later becomes an ally who fights alongside Link and Fi on the Surface.

◈ The Imprisoned (DEMISE)

Sealed by the goddess Hylia, Demise revives twice in *Skyward Sword*. The first time, he returns as a twisted, incomplete monster known as the Imprisoned. He later shows his true form, as a fiery-haired Demon King.

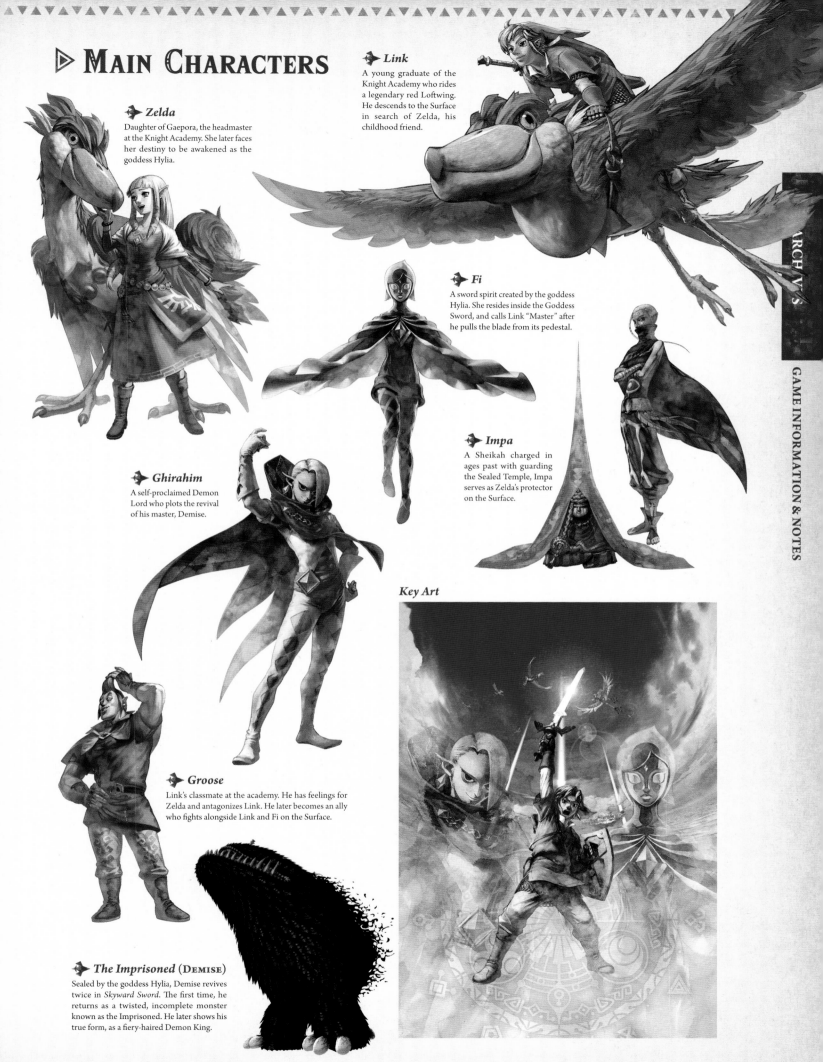

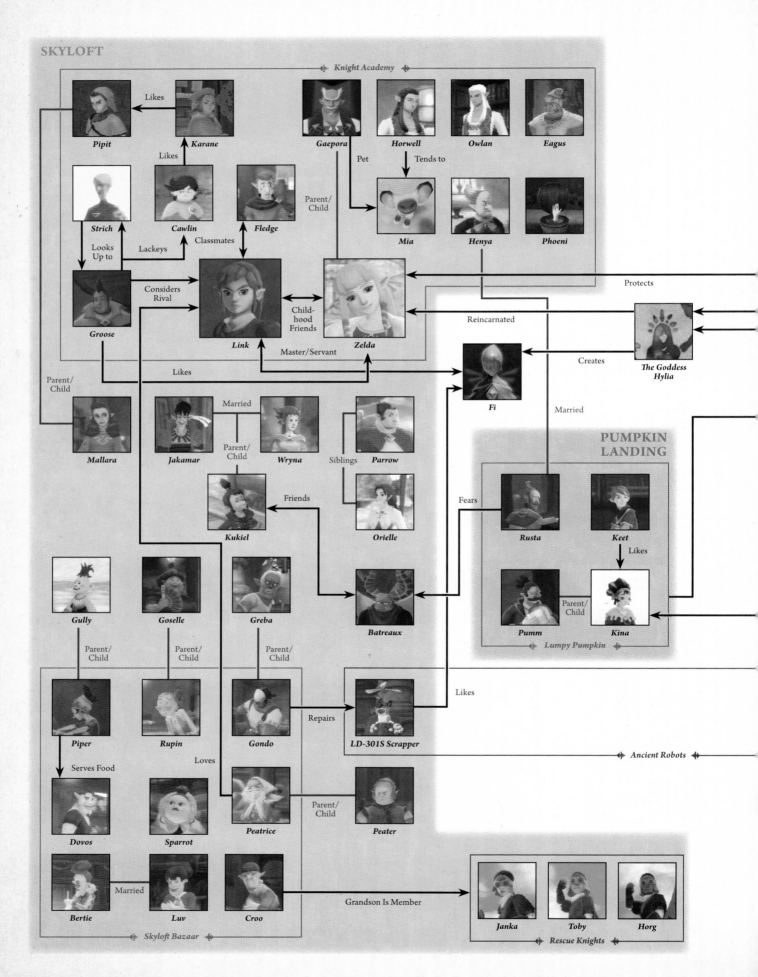

SKYLOFT

Knight Academy

Pipit — Likes → Karane

Gaepora — Pet → Mia

Horwell — Tends to → Mia

Owlan

Eagus

Henya

Phoeni

Karane — Likes → Cawlin

Fledge

Strich — Looks Up to / Lackeys → Groose

Cawlin — Classmates → Link

Groose — Considers Rival → Link

Link — Childhood Friends → Zelda

Link — Master/Servant → Fi

Zelda — Reincarnated → Fi

The Goddess Hylia — Creates → Fi

The Goddess Hylia — Protects → Zelda

Likes

Mallara

Parent/Child

Jakamar — Married → Wryna

Jakamar / Wryna — Parent/Child → Kukiel

Parrow — Siblings → Orielle

Kukiel — Friends

PUMPKIN LANDING

Rusta — Fears → Batreaux

Keet — Likes → Kina

Pumm — Parent/Child → Kina

Married

Lumpy Pumpkin

Gully — Parent/Child → Piper

Goselle — Parent/Child → Rupin

Greba — Parent/Child → Gondo

Batreaux

Gondo — Repairs → LD-301S Scrapper

LD-301S Scrapper — Likes

Ancient Robots

Piper — Serves Food → Dovos

Rupin

Gondo — Loves → Peatrice

Sparrot

Peatrice — Parent/Child → Peater

Bertie — Married → Luv

Croo — Grandson Is Member →

Janka

Toby

Horg

Rescue Knights

Skyloft Bazaar

FARON WOODS AREA

THE SEALED GROUNDS

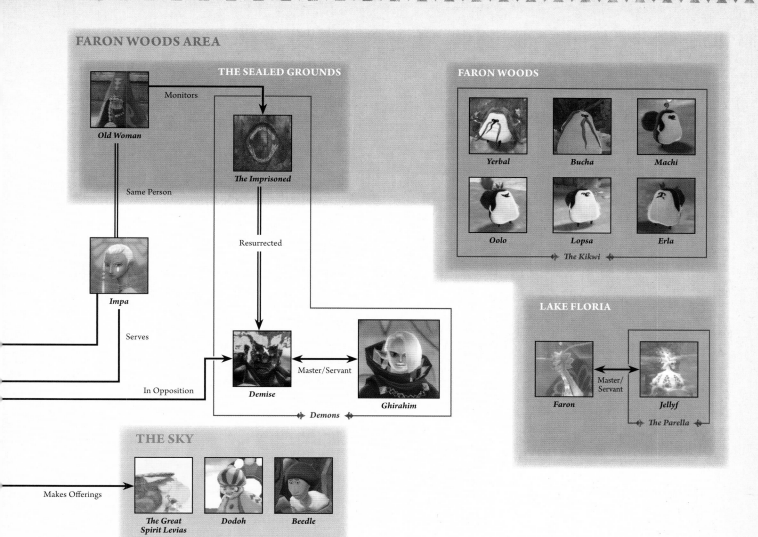

Old Woman — Monitors → **The Imprisoned**

Same Person

Impa

Serves

In Opposition

Resurrected

Demise ←Master/Servant→ **Ghirahim**

◆ Demons ◆

FARON WOODS

Yerbal **Bucha** **Machi**

Oolo **Lopsa** **Erla**

◆ The Kikwi ◆

LAKE FLORIA

Faron ←Master/Servant→ **Jellyf**

◆ The Parella ◆

THE SKY

Makes Offerings →

The Great Spirit Levias **Dodoh** **Beedle**

LANAYRU DESERT AREA

LANAYRU GORGE

Lanayru

Manages

LANAYRU SAND SEA

LD-301N Skipper **Gortram**

ELDIN VOLCANO AREA

ELDIN VOLCANO

Eldin

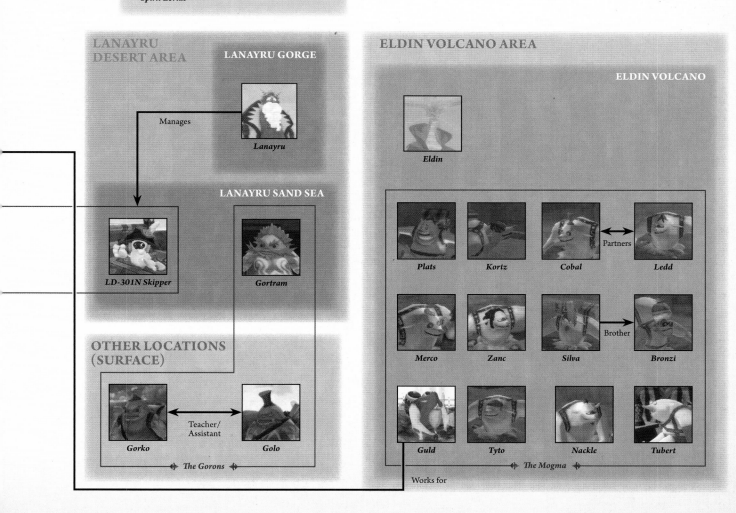

Plats **Kortz** **Cobal** ←Partners→ **Ledd**

Merco **Zanc** **Silva** —Brother→ **Bronzi**

Guld **Tyto** **Nackle** **Tubert**

◆ The Mogma ◆

OTHER LOCATIONS (SURFACE)

Gorko ←Teacher/Assistant→ **Golo**

◆ The Gorons ◆

Works for

▷ THE WORLD

The world of *Skyward Sword* is divided into two areas: the sky and the Surface. Skyloftians live in the sky and a variety of other races live on the Surface.

The Surface can be broadly divided into three areas. Faron Woods, Eldin Volcano, and Lanayru Desert are each protected by a dragon, whose name they share with the land they watch over.

The World Map (Surface)

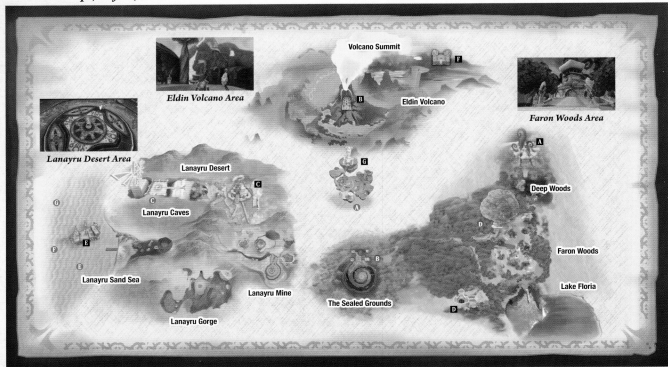

Volcano Summit

F

Eldin Volcano Area

B

Eldin Volcano

Faron Woods Area

Lanayru Desert Area

A

G

Deep Woods

Lanayru Desert

C

A

G

Lanayru Caves

D

Faron Woods

E

F

Lanayru Sand Sea

E

Lanayru Mine

B

Lake Floria

Lanayru Gorge

The Sealed Grounds

D

A Skyview Temple **B** Earth Temple **C** Lanayru Mining Facility **D** Ancient Cistern
E Sandship **F** Fire Sanctuary **G** Sky Keep

A Skyloft **B** Sealed Temple **C** Temple of Time **D** Inside the Great Tree
E Skipper's Retreat **F** Lanayru Shipyard **G** Pirate Stronghold

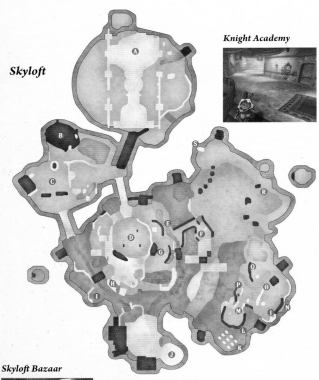

Skyloft

Knight Academy

Skyloft Bazaar

A Statue of the Goddess **B** Sparring Hall
C Knight Academy **D** Skyloft Bazaar **E** Piper's House
F Jakamar's House **G** Peatrice's House
H Parrow and Orielle's House **I** Windmill
J Light Tower **K** Graveyard **L** Entrance to Batreaux's House
M Rupin's House **N** Sparrot's House
O Gondo's House **P** Pipit's House **Q** Bertie's House
R Entrance to Waterfall Cave **S** Bird Statue

ISLANDS IN THE SKY

Many islands dot the skies. Some play roles in the story, while others are home to key characters or minigames. Some have names that hint at their purpose.

Pumpkin Landing

Bamboo Island

Fun Fun Island

Isle of Songs

Bug Rock

EVOLVING TERRAIN

Both Faron Woods and Eldin Volcano will change depending on when Link descends to the Surface. The forest waters rise. The volcano erupts. And the techniques Link uses to explore these regions change, from swimming to sneaking around without weapons trying to avoid detection by enemies.

Top: The water dragon Faron submerges all of Faron Woods.
Bottom: The fire dragon Eldin causes the volcano to erupt.

DEVELOPMENT DOCUMENTS

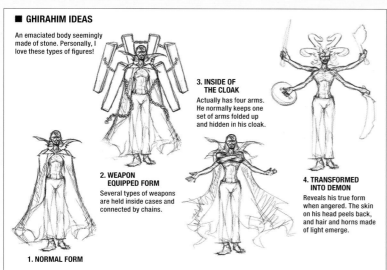

■ GHIRAHIM IDEAS

An emaciated body seemingly made of stone. Personally, I love these types of figures!

3. INSIDE OF THE CLOAK
Actually has four arms. He normally keeps one set of arms folded up and hidden in his cloak.

2. WEAPON EQUIPPED FORM
Several types of weapons are held inside cases and connected by chains.

4. TRANSFORMED INTO DEMON
Reveals his true form when angered. The skin on his head peels back, and hair and horns made of light emerge.

1. NORMAL FORM

▷ *Ghirahim Concept Art*

The design for the self-proclaimed Demon Lord, Ghirahim, went through many revisions before his final look was decided upon. What ties each iteration of Ghirahim's look together is an emphasis on "different." Unlike other characters in the series, Ghirahim gradually reveals his true form as the spirit of an evil sword in opposition to Fi. The sketches to the left show one way his appearance could have evolved over the course of the story.

The origin of Ghirahim's name comes from "Ghira," a name which sounded villainous to designers, and the evil wizard Agahnim from *A Link to the Past*.

Zelda Artwork Drafts ◁

Artists explored how Zelda might look when reacting to a variety of situations, as *Skyward Sword*'s cinematic systems allowed characters to express more subtle and detailed emotions.

The final version of the sketch shown here sees Zelda playing with a Loftwing (see page 293) in nearly the same pose, but in this sketch, she is instead smiling at a small bird.

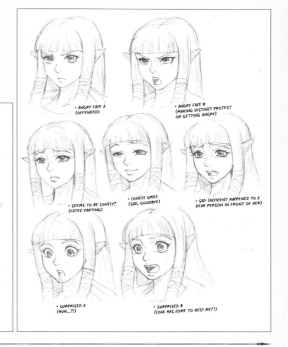

❧ DEVELOPER ❧ NOTES

● **A Guided Tour of the Surface:** While themes of discovery and exploration were central to *Skyward Sword*'s design, director Hidemaro Fujibayashi had his team ensure players would not get lost while exploring the three realms of the Surface world. To help keep players oriented, the team added beacons and the dowsing mechanic. They also took care to show the map and Link's place in it when Link first reached the Surface, making it clear where he was and where he needed to go.

● **Inventory Worthy of a High-Five:** Ideas like the pointer controls for the Gust Bellows and rolling bombs came out of a broader challenge to utilize the Wii MotionPlus as much as possible. During development, the team looked into systems for changing items without having to rely on a selection screen, trying instead to use the position of the remote. They then adopted a round selection menu, allowing the player to tilt the Wii MotionPlus to choose an item. Shigeru Miyamoto loved this system, since players could swap items without looking at the screen. After hearing this, Fujibayashi high-fived Ryo Tanaka, the head of UI design. Miyamoto enjoyed the feeling of the

system so much that he was bragging about it to Nintendo's president at the time, Satoru Iwata, as soon as it was finished.

● **Why There Isn't a Boomerang:** Though the Boomerang does not appear in *Skyward Sword*, a "Remote Boomerang" was considered. There was even a period when the team tested a system where the player could freely control its trajectory, Link could grab onto it to fly, then drop down wherever the player wanted. After a fair amount of work, the system was abandoned because it would lead to players missing key objects and paths. Later, a Rocket Punch was also proposed for grabbing objects, which led to the Beetle. This is why the Beetle fires from Link's wrist.

● **Link's Friend Fi:** One designer on the project was responsible for writing all of Fi's explanation text, giving her a distinct, singular voice throughout the game. During development, the team brainstormed ways for Fi to also assist in game play, including giving Link a lift in place of the Sailcloth and appearing when Link's sword was thrown in combat.

● **Zelda's Second Quest:** During development, the team considered turning Zelda's adventure after she landed on the Surface into a fully playable "Second Quest." It never became reality, but the setting of that story was used in the cinematic shown after the game's ending.

● **A Variety of Emotions:** In-game character expressions began by drawing them out in rough sketches, ensuring the emotions required in key moments were expressed in just the right way. Designers then set to work making facial animations based on the sketches, using a technique where a bone structure is set inside the face and manipulated for detailed movement. Director Fujibayashi's highest-priority expression was for "the scene where Zelda turns around and shows her face for the first time."

● **Break Room Brainstorming:** Director Fujibayashi requested that Ghirahim's resurrection ceremony be "an extremely creepy dance," leading the cutscene staff to create frame-by-frame storyboards. The storyboards were then left in the break room where other team members could review them and write comments. Character artists studied the images to make sure Ghirahim's in-game model was able to move in line with the storyboards. The process turned the break room into a forum for collaboration.

References
• Iwata Asks. "The Legend of Zelda: Skyward Sword."
• Nintendo Dream, February 2012. "Asking the Developers: Skyward Sword Power and Courage? Interview."

2013

THE LEGEND OF ZELDA
A LINK BETWEEN WORLDS

Release Dates: November 22, 2013 | December 26, 2013 (JP)
Console: Nintendo 3DS

The Japanese subtitle for *A Link to the Past* was *Triforce of the Gods*. *A Link Between Worlds* was titled *Triforce of the Gods 2* in Japan, which makes it the first title in the *Legend of Zelda* series to use a subtitle and attach a number to indicate that it is a sequel.

A Link Between Worlds shares many similarities with *A Link to the Past*, but *A Link Between Worlds* was very much its own game, making ample use of the 3DS's 3D perspective when Link flattened into a painting, allowing players to see and do things they couldn't in the familiar top-down view. Producer Eiji Aonuma also reimagined the way equipment worked so that players had more freedom to choose the order in which they completed dungeons. In *A Link to the Past* players found most items in a particular order. Here, Link could rent equipment from Ravio using rupees collected over the course of the adventure. This added a layer of strategy for players exploring certain dungeons and forced them to keep a close eye on rupees.

▷ PLOT

Long ago, Ganon used the power of the Triforce to attack the kingdom of Hyrule. A hero wielding the Master Sword sealed Ganon away with the help of the Seven Sages. Following the sealing, the Triforce divided into three and came to rest in different parts of the kingdom—one within the sealed Ganon, one with the royal family of Hyrule, and one within the spirit of the hero.

Many years later, a young apprentice blacksmith named Link set out for Hyrule's sanctuary to deliver a sword. Inside, he encountered a terrible scene. An evil sorcerer, Yuga, had invaded this sacred place and accosted the priest. His daughter, Seres, lay cowering before the altar as Yuga, seeking "perfection," turned her into a painting. Yuga turned to discover Link had witnessed the whole thing and used his magic to render Link unconscious.

Link awoke in his own home with a stranger named Ravio, who claimed to have rescued him. The bunny-eared traveler gave Link an old bracelet as a symbol of their new friendship, and with urgency, Link headed for Hyrule Castle to report what he had seen at the sanctuary.

Greatly concerned, Princess Zelda ordered Link to investigate. Link tracked Yuga to the Eastern Palace, where he learned that the sorcerer was targeting the descendants of the Seven Sages and turning them all into paintings. Link challenged Yuga and was struck by Yuga's magic and turned into a painting. After Yuga departed, the bracelet Ravio had given Link began to glow. Link found he could change from a painting into his normal form at will, enabling him to move along walls and slip through cracks.

After turning the other sages into paintings, Yuga headed for Hyrule Castle to capture Impa and Princess Zelda, bearer of the Triforce of Wisdom, so that he could revive Ganon. He surrounded the castle with a barrier to keep Link out. To break the barrier, Link would require the Master Sword. After collecting the Pendants of Virtue needed to wield the blade, Link made his way through the Lost Woods and retrieved the legendary sword.

By the time Link reached the princess, he was too late. Yuga had turned Zelda into a painting.

1 Link witnesses Seres, the daughter of the sanctuary priest, being turned into a painting. She is the descendant of one of the sages. **2** Link is turned into a painting. Yuga's curse backfires as Link is able to use Ravio's Bracelet to flatten himself at will. **3** Link draws the Master Sword from its pedestal. **4** Princess Hilda holds a transformed Yuga with a magical barrier. **5 6** Hilda reveals her true plan to steal the Triforce from Hyrule. Yuga, fused with Ganon, betrays her and runs wild. **7** Ravio arrives to stop Hilda, convincing her to reconsider. **8** Link and Zelda share the same wish for light to return to Lorule.

Pursuing the fleeing Yuga, Link turned himself into a painting and slipped through a crack in the wall, entering the parallel world known as Lorule.

Yuga was waiting for him on the other side, having already revived Ganon and fused with him. Hilda, princess of Lorule, came to the rescue just as Link was overwhelmed by Yuga's new power. Hilda was able to keep Yuga at bay, but only for a short time.

During that time, Link set out to reverse the magic that had turned the Seven Sages into paintings and obtain the Triforce of Courage, thus gaining the power to defeat Yuga. He traversed both Hyrule and Lorule, exploring dungeons and freeing each sage. Then, with the Triforce of Courage in hand, he once again headed for Lorule Castle.

It was there that Princess Hilda revealed that she intended to keep the Triforce for herself to save her kingdom. Lorule once had a Triforce of its own, but the ceaseless conflicts over its possession led her ancestors to destroy it. This was a mistake. The Triforce proved the very foundation of the realm, and without it, Lorule was fated to degrade and destroy itself.

Princess Hilda had ordered her subordinate, Yuga, to capture the Seven Sages of Hyrule and steal Princess Zelda's Triforce of Wisdom. When Yuga fused with Ganon, he also gained the Triforce of Power. All that was left was Link's Triforce of Courage.

Yuga betrayed Hilda, stealing her Triforce of Wisdom, and turned her into a painting. Wielding the Bow of Light, Link vanquished Yuga and recovered all three Triforce pieces.

Princess Zelda and Princess Hilda both returned to their original forms. Still, Hilda would not relent in her quest for the Triforce. Too strong was her will to save her own kingdom, even if Hyrule would suffer in the process. It took Ravio of all people to intervene and persuade her to stop. When Hilda's plan was first put into place, Ravio had been unable to stop her, so he ventured to Hyrule to enlist the help of Link. Inspired by Link's heroism, Ravio pleaded with his princess to reconsider.

With Ravio's words, Hilda decided to accept her kingdom's fate. Using the last of her power, she turned Princess Zelda and Link into paintings and sent them back to their world. As they parted, Ravio shook Link's hand and spoke. "Maybe some of your courage rubbed off on me," he said. "So thanks, Link."

Back in Hyrule, Link and Princess Zelda placed their hands on the Triforce and wished for Lorule to be spared its fate. Though they had brought trouble to Hyrule, they had done so out of desperation, not malice.

With this wish, the darkness that plagued Lorule lifted as its long-destroyed Triforce returned, and Lorule was saved.

▷ MAIN CHARACTERS

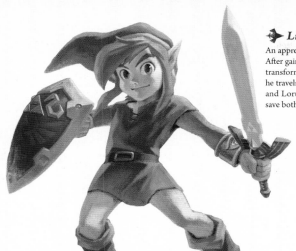

◈ Link

An apprentice blacksmith. After gaining the ability to transform into a painting, he travels between Hyrule and Lorule on a quest to save both worlds.

Key Art

◈ Yuga

A Lorulean sorcerer and artist with the power to turn people into paintings. He hunts down and transforms the Seven Sages of Hyrule.

◈ Princess Hilda

The princess of Lorule. Saddened by the slow destruction of her world, she secretly plots to steal the Triforce of Hyrule.

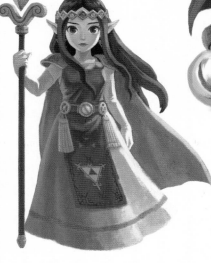

◈ Princess Zelda

The kindhearted princess of Hyrule. She foresees the danger approaching Hyrule and gives Link a charm passed down through many generations.

◈ Ravio

He remodels Link's home and opens an item rental shop with his partner Sheerow.

◈ Irene

One of the Seven Sages. Irene is a witch's apprentice who aids Link after a fortune-teller urges her to "take care of green." If Link summons Irene using the bell she gives him, she will transport him to any Weather Vane.

◈ Gulley

Gulley is the son of the blacksmith. He also happens to be a sage. His job is to wake Link up in the mornings, as even heroes tend to oversleep.

◈ Seres

A kind nun of the sanctuary and daughter of the priest. She is revealed to be one of the Seven Sages and is turned into a painting by Yuga when Link first meets the Lorulean sorcerer.

◈ Impa

Princess Zelda's nursemaid serves as one of the Seven Sages. She grants Link an audience with Princess Zelda at the start of the story.

◈ Osfala

Osfala is one of the Seven Sages. He is dedicated to the pursuit of knowledge, and studies under the elder Sahasrahla. Osfala is brimming with confidence and believes that he is the hero who will save the world.

◈ Oren

A Zora queen who is one of the Seven Sages. She is transformed when her Smooth Gem is stolen.

◈ Rosso

This sage makes a living mining ore on Death Mountain. Rosso is a familiar face at the blacksmith's home where Link works.

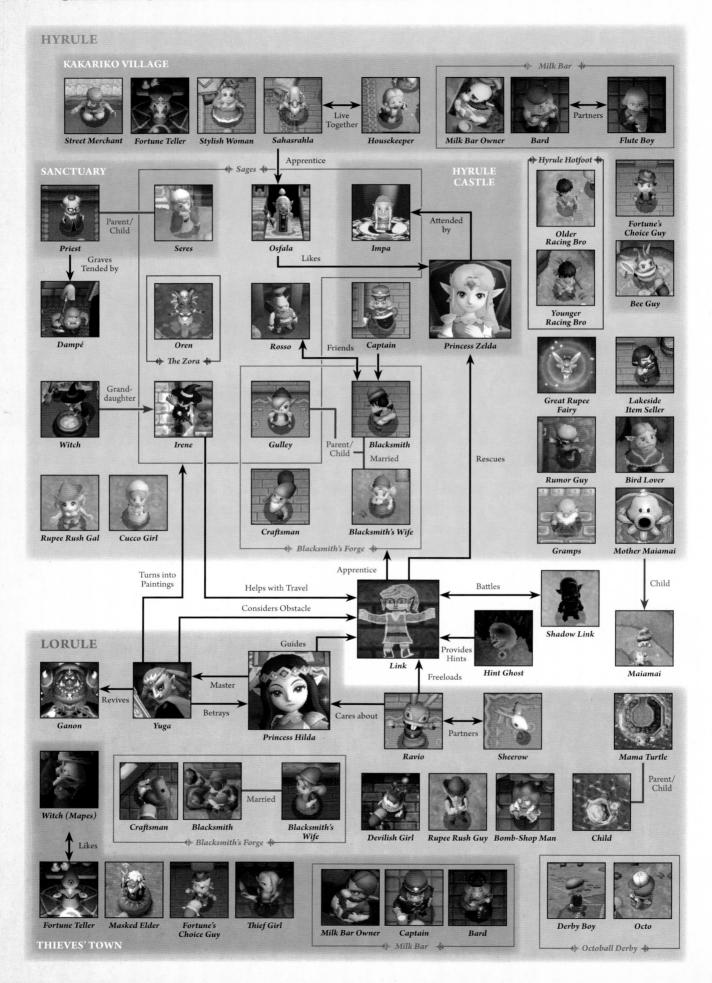

HYRULE

KAKARIKO VILLAGE

Street Merchant · Fortune Teller · Stylish Woman · Sahasrahla — Live Together → Housekeeper

Milk Bar: Milk Bar Owner · Bard — Partners → Flute Boy

SANCTUARY — Sages — Apprentice → · HYRULE CASTLE

Priest — Parent/Child → Seres · Osfala — Likes → Impa — Attended by → Princess Zelda

Priest — Graves Tended by → Dampé

Oren (The Zora)

Rosso · Captain — Friends — Princess Zelda

Witch — Granddaughter → Irene

Gulley · Blacksmith — Married — Blacksmith's Wife

Craftsman

Rupee Rush Gal · Cucco Girl

Blacksmith's Forge

Hyrule Hotfoot: Older Racing Bro · Younger Racing Bro · Fortune's Choice Guy · Bee Guy

Great Rupee Fairy · Lakeside Item Seller · Rumor Guy · Bird Lover · Gramps · Mother Maiamai

Rescues

Apprentice → · Battles → Shadow Link · Child → Maiamai

Link — Provides Hints — Hint Ghost

Turns into Paintings · Helps with Travel · Considers Obstacle · Guides · Freeloads

LORULE

Ganon — Revives — Yuga — Master / Betrays → Princess Hilda — Cares about → Ravio — Partners — Sheerow

Mama Turtle — Parent/Child → Child

Witch (Mapes) — Likes

Craftsman · Blacksmith — Married — Blacksmith's Wife
Blacksmith's Forge

Devilish Girl · Rupee Rush Guy · Bomb-Shop Man · Child

Fortune Teller · Masked Elder · Fortune's Choice Guy · Thief Girl

Milk Bar: Milk Bar Owner · Captain · Bard

Octoball Derby: Derby Boy · Octo

THIEVES' TOWN

▷ THE WORLD

Hyrule Castle stands in the center of the kingdom of Hyrule, surrounded by a rich and diverse world of forests, mountains, and desert. The terrain strongly resembles the period from *A Link to the Past*. When Link travels to the decaying land of Lorule, the map stays much the same. But like the Dark World of his earlier adventure, everything parallel in Lorule has a darker air about it, with perilous new dungeons and legions of monsters to fight or avoid.

The Kingdom of Hyrule

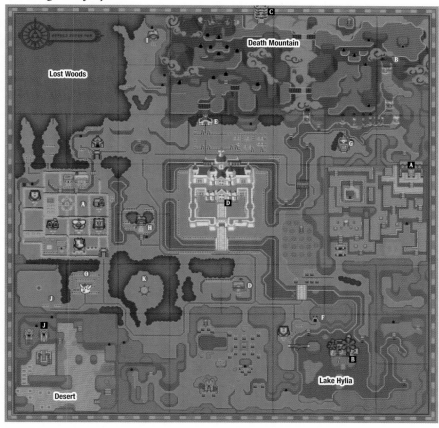

🅐 Eastern Palace 🅑 House of Gales
🅒 Tower of Hera 🅓 Hyrule Castle
🅔 Dark Palace 🅕 Swamp Palace 🅖 Skull Woods
🅗 Thieves' Hideout 🅘 Ice Ruins 🅙 Desert Palace
🅚 Turtle Rock 🅛 Lorule Castle

🅐 Kakariko Village 🅑 Zora's Domain 🅒 Thieves' Town
🅓 Link's House/Ravio's Shop 🅔 Sanctuary
🅕 Maiamai Cave 🅖 Witch's House
🅗 Blacksmith's Forge 🅘 Rosso's Ore Mine
🅙 Rupee Rush 🅚 Haunted Grove 🅛 Octoball Derby
🅜 Bomb Flower Store 🅝 Vacant House
🅞 Cucco Ranch 🅟 Treacherous Tower

The Kingdom of Lorule

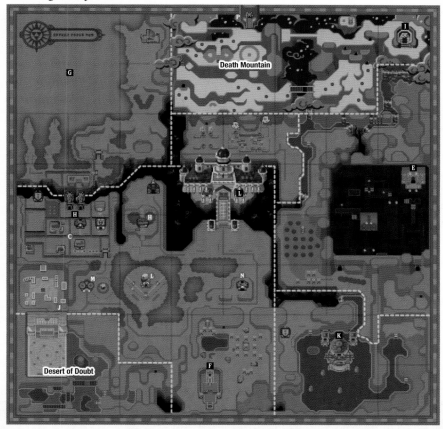

HYRULE AND LORULE

By transforming into a flattened painting, Link is able to squeeze through numerous cracks found across Hyrule into the shadows of parallel Lorule. The places he ends up in Lorule are eerily similar to his home realm, but darker and in a state of decay.

Traveling between the worlds is a rare feat, and though the worlds have existed in parallel for untold eras, it is impossible to cross between them without powerful magic.

Hyrule	Lorule

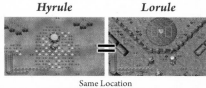

Same Location

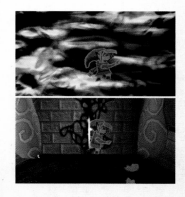

▷ DEVELOPMENT DOCUMENTS

WIND WAKER STYLE CUTE-EYED GRAFFITI

FAUVISM POP ART?

COMPLETED VERSION

▷ Painting Link Design Concepts

The in-game mechanic of flattening Link into a painting gave artists a lot of room to experiment with different styles, including graffiti, pop art, and fauvism, all seen above. Game play requirements for Link to move along the wall and slip between cracks prompted the artists to switch from a more straightforward perspective to a side view that emphasized the direction Link was traveling.

COME PAINTERLY STUBBORN SLIGHTLY DARK

SLIGHTLY POLITICAL AND NARCISSISTIC ART IS MY INSPIRATION!

JESTER-LIKE

▷ Yuga Concept Art

The Lorulean sorcerer who transforms Link and the Seven Sages into paintings had many appearances over the course of development. Yuga's name originates from *yuga*, or "oil painting" in Japanese. Early concepts had him wielding a paintbrush, which evolved into a staff with a colorful, brush-like flame on one end.

STRAIGHT HAIR BLUE DRESS VER STRAIGHT HAIR SIMILAR TO PAST STYLE

OCARINA OF TIME STYLE CURLING HAIR IS ONE OF HER CHARACTERISTICS, SO I'D LIKE TO LEAVE IT... SOME OF HER HAIR IS GATHERED IN THE BACK. IT MIGHT CURL EVEN WHEN PULLED BACK NEW HAIR-STYLE

▷ Princess Zelda Design Concepts

Concept art of Princess Zelda drawn for *A Link Between Worlds* incorporated elements of her past designs. Artists tried multiple variations before deciding on her look for the game, resulting in numerous versions of the character with new hairstyles, dresses, eyes, and even heights.

▷ Princess Hilda Design Concepts

Princess Hilda's design specifically contrasted Zelda's, drawing on a darker palette and a litany of morose or flat expressions.

▷ Ravio Concept Art

Ravio's design hints at how Link turned into a rabbit when he entered the Dark World in *A Link to the Past*. This led to the idea of Ravio being the Hero of Lorule, a cowardly mirror image of the brave Hero of Hyrule who crosses over and asks for Link's help.

⚔ DEVELOPER ⚔ NOTES

● **Inspired by Phantom Ganondorf:** Early in development, producer Eiji Aonuma was haunted by memories of Phantom Ganon's ability to enter walls through paintings in *Ocarina of Time*. He mused, "It would be fun if the player got to do that this time," leading to Link becoming a painting himself.

● **Initially a Skeleton Crew:** The initial design document for *A Link Between Worlds* was written shortly after *Spirit Tracks* was finished. *Skyward Sword* was already well into development and most of the team was needed there. This left three

developers to start work on what would be the first 3DS *Zelda* game: director Hiromasa Shikata, lead programmer/subdirector Shiro Mouri, and a third programmer. For nearly a year, the three brainstormed and refined the game's vision. It was during this time that Shikata brought the concept of Link entering walls to his teammates.

● **One Canvas, Many Styles:** Deciding the style Link would be painted in proved difficult. The game's artists experimented with a wide range of techniques. A toon-style Link was considered, similar to *The Wind Waker* but flattened. This didn't mesh with the rest of the game's art, though. Other styles were explored, from a child's scribbles to line drawings. After they decided on a style, the question became why he would turn into a painting. This is how Yuga was born: a crazed painter who could turn people into art using magic.

● **More Than a Sequel:** While *A Link Between Worlds* began as a direct sequel to *A Link to the Past*, its story and design evolved as development progressed. Its initial team found new ways to use the classic map and expand on ideas that showed potential in the original. The direction "If it can be changed, it is okay to change it" let them tell a story set in the same world as *A Link to the Past* that at the same time felt fresh.

References
• Iwata Asks. "The Legend of Zelda: A Link Between Worlds."
• *Nintendo Dream*, February 2014. "*A Link Between Worlds*: This'll Make You Want to Play! Spoiler-Free Prerelease Interview."
• *Nintendo Dream*, March 2014. "Making the Second Time Around Even More Fun: The Legend of Zelda: A Link Between Worlds—Drawing Out Development Stories to Make It More Fun."

THE LEGEND OF
ZELDA
Tri Force Heroes

The first multiplayer-focused *Zelda* since *Four Swords Adventures* introduced players to an entirely new kingdom known as Hytopia. Up to three players could take control of heroes, working together to fight enemies and solve puzzles using unique mechanics, including the Totem system that allowed players to stand on top of each other to reach higher-up areas. The game was the first in the series to support online cooperative play.

A free demo of *Tri Force Heroes* was made available for download on October 7, 2015, just before the game's worldwide release. It allowed three players to try the game out together for an online event that even saw producer Eiji Aonuma participating.

Release Dates: October 23, 2015 | October 22, 2015 (JP)
Console: Nintendo 3DS

▷ PLOT

Once upon a time there was a kingdom called Hytopia, and the thing that the people who lived there loved more than anything else was being fashionable. Princess Styla, the most stylish of this style-obsessed kingdom, was adored by her people. Well . . . adored by all but one person.

One day, Princess Styla received a gift. It was a mysterious package; it did not say who it was from, but the box was so beautifully wrapped that the princess could not help herself and opened it. This was a mistake. As she opened the box, a strange cloud of smoke enveloped the princess. When the smoke cleared, she was wearing an embarrassingly ugly full-body jumpsuit that she could not remove.

"A perfect outfit for a perfect princess."

The words of the Drablands Witch, Lady Maud, echoed in the princess's head. Princess Styla was so miserable that she locked herself in her room, and the people, no longer able to see her stylish beauty, fell into despair.

The most distraught was her father, King Tuft. The only way to remove the curse on Princess Styla was to defeat the witch who cast the spell. However, the land where the witch lived was very dangerous, and only heroes could enter. Thus the king sent out a call for heroes.

A young traveler visiting Hytopia happened to spot the king's plea, posted on the notice board in the town plaza: "WANTED: TRI FORCE HEROES!! Do you have pointed ears, truly epic sideburns, and side-parted hair? If so, YOU may be a Tri Force Hero! Our kingdom needs such heroes to defeat the evil witch and lift the curse placed on Princess Styla. Whoever succeeds in this most noble of tasks will be rewarded to the fullest extent of my extensive power. So sayeth King Tuft, ruler of Hytopia!"

The young man matched the description of a Tri Force Hero. His name was Link, the hero who saved Hyrule.

Madame Couture of the Castle Town tailor shop made a heroic outfit for Link, and he was granted permission to enter the Drablands. In order to take on the Drablands, he would need to cooperate with two other heroes. The three were able to form the legendary Totem, a vertically connected formation they used to overcome countless traps and enemies.

Together, they pressed farther into the Drablands, over snowy mountains and through rocky passes. Back in the castle, Princess Styla had become more comfortable with her tights-bound appearance, but she grew tired of waiting. More than anything, she wanted to wear frilly dresses again.

The heroes' wardrobe grew as their adventure continued, until they arrived at the home of Lady Maud. Maud, the Drablands Witch, donned an enormous outfit both gaudy and overstated, and attacked with fury. But the combined power of the Tri Force Heroes, their natural courage, and their teamwork drove her back. Lady Maud relented.

"You and the princess deserve each other," she said. "You're all unfashionable, ungrateful cretins."

She used her magic to vanish, and the heroes were able to save Princess Styla from her humiliatingly drab appearance. The kingdom of Hytopia erupted with joy. The return of the beautiful Princess Styla brought happiness back to the people, and the three heroes were celebrated for their brave feat. As for the reward that the heroes were to be granted, they were given the Cursed Tights as Princess Styla's hand-me-down.

It's not like she needed them or anything.

1 2 The box Princess Styla receives is so beautiful that she cannot help but open it. Surrounded by smoke, she is trapped in the Cursed Tights and looks in the mirror in horror. **3** The Drablands Witch who casts the spell roars with laughter. **4** The king is unable to hold back his tears at his daughter's fate. **5** The heroes make outfits out of the materials they find in the Drablands, giving them new abilities. **6** The three heroes passing through the castle's Triforce Gateway. **7** Lady Maud is utterly unfazed. **8** The people welcome and congratulate the heroes on their success in defeating Lady Maud and returning their princess's wardrobe.

◢ MAIN CHARACTERS

◆ Link

The hero who saved both Hyrule and Lorule ventures to Hytopia for a new adventure. All three are heroes in their own right and together serve as the main characters.

◆ King Tuft

The king of Hytopia and father of Princess Styla, who summons heroes from across the world to save his daughter from embarrassment.

◆ Princess Styla

The fashionable and overly curious princess of Hytopia. A curse from the Drablands witch, Lady Maud, traps her in plain brown tights she cannot change out of.

◆ Madame Couture

A famous designer who runs a fabulous tailor shop in Castle Town. Her love for cats is unequaled. She happens to be Lady Maud's sister.

◆ Sir Combsly

Commander of the Witch-Hunting Brigade. Sir Combsly burns with a passion for justice. He used to have a slicked-back hairstyle. Now it is parted down the middle.

Key Art

◆ Lady Maud

The Drablands witch and a fashion designer with a rather unique eye who covers herself in the gaudiest outfits imaginable. She sends Princess Styla a gift of cursed tights, but her taste is such that it's possible she actually thinks they look good.

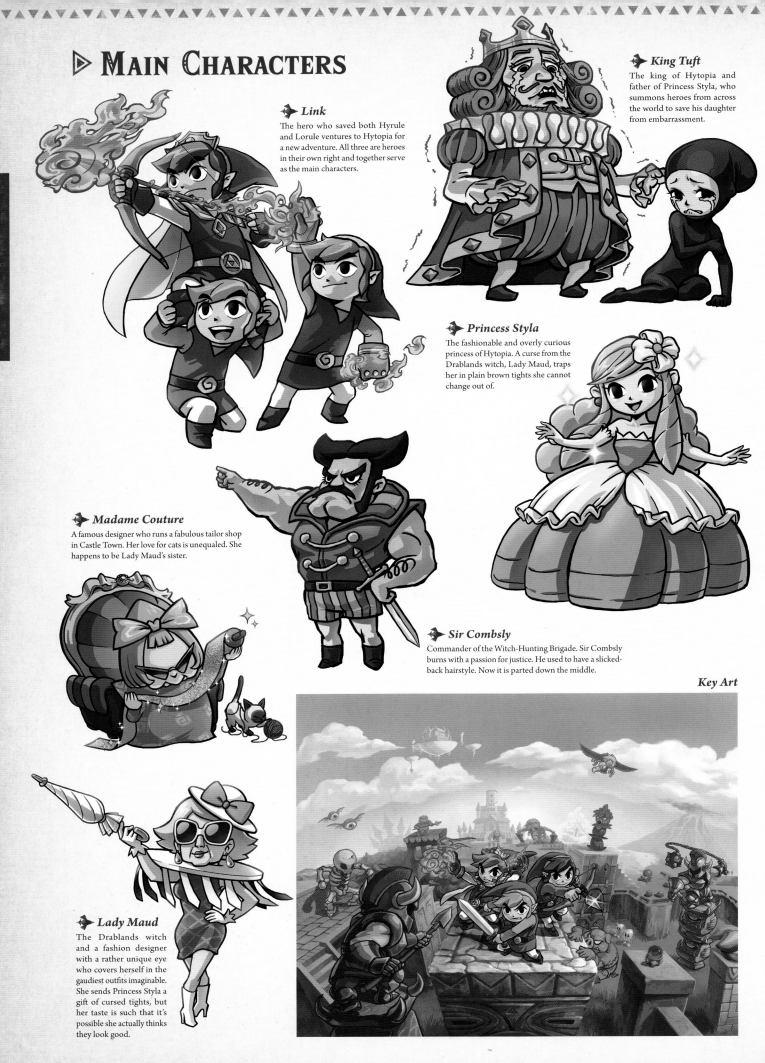

▷ CHARACTER RELATIONSHIPS

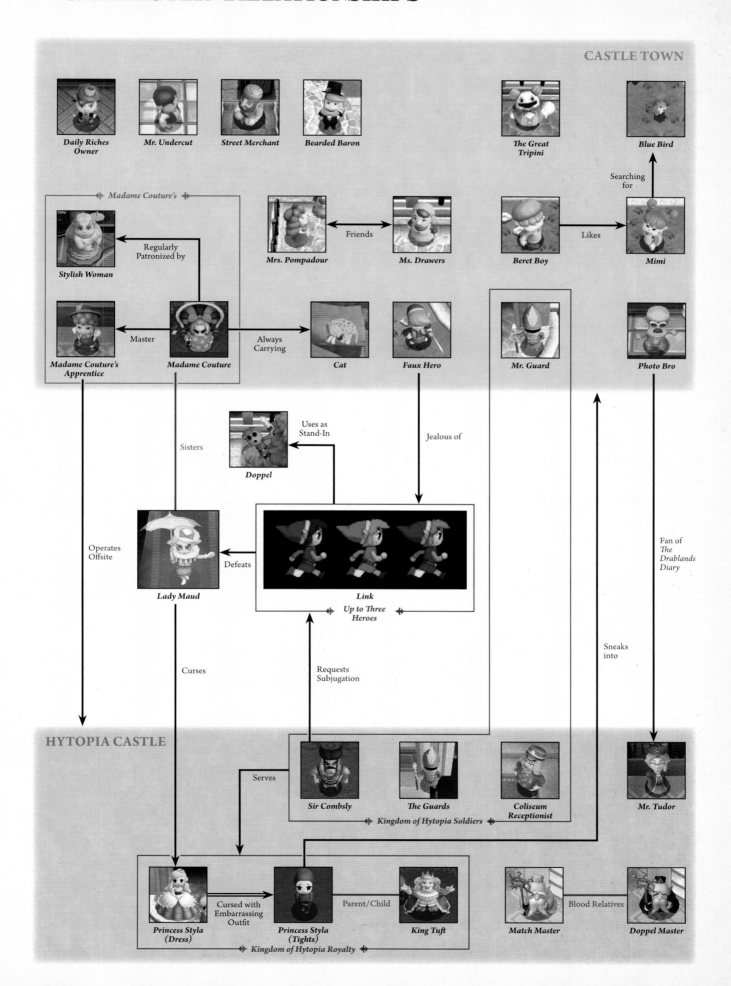

CASTLE TOWN

Daily Riches Owner

Mr. Undercut

Street Merchant

Bearded Baron

The Great Tripini

Blue Bird

Madame Couture's

Stylish Woman

Regularly Patronized by

Mrs. Pompadour ←Friends→ **Ms. Drawers**

Beret Boy —Likes→ **Mimi**

Searching for ↑

Madame Couture's Apprentice ←Master— **Madame Couture** —Always Carrying→ **Cat**

Faux Hero

Mr. Guard

Photo Bro

Uses as Stand-In

Doppel

Jealous of

Sisters

Lady Maud ←Defeats— **Link** *Up to Three Heroes*

Operates Offsite

Fan of *The Drablands Diary*

Curses

Requests Subjugation

Sneaks into

HYTOPIA CASTLE

Serves

Sir Combsly

The Guards

Coliseum Receptionist

Kingdom of Hytopia Soldiers

Mr. Tudor

Princess Styla (Dress) —Cursed with Embarrassing Outfit→ **Princess Styla (Tights)** —Parent/Child→ **King Tuft**

Match Master —Blood Relatives→ **Doppel Master**

Kingdom of Hytopia Royalty

▷ THE WORLD

The three chosen heroes set out through the Triforce Gateway in Hytopia Castle into the perilous Drablands. These lands are broadly divided into nine regions, and excluding the Den of Trials, each is separated into four stages the heroes must complete to advance. In all, Link and his two friends also named Link will venture into ruins atop snowy mountains, deep within forests and volcanoes, and even high in the sky in a floating city.

And after all that, the Den of Trials still awaits, with the heroes descending forty floors below the surface to battle increasingly challenging enemies over eight unique zones inspired by past stages.

The Drablands

A Woodlands **B** Riverside **C** Volcano **D** Ice Cavern **E** Fortress **F** The Dunes **G** The Ruins **H** Sky Realm **I** Den of Trials (Added with Update)

TROUBLE IN HYTOPIA

Link arrives in the kingdom of Hytopia, a land famous for its stylish citizenry. But something is wrong. Lady Maud's curse upon Princess Styla has caused the people, who so carefully followed Styla's lead, to live only a moderately stylish lifestyle. Only the Tri Force Heroes can save the day; those bearing the three features characteristic of true heroism—pointy ears, side-parted hair, and truly epic sideburns.

Conditions for Being a Tri Force Hero

③ *Side-Parted Hair*

① *Pointy Ears*

② *Truly Epic Sideburns*

STOCK CHANGES DAILY

The kingdom of Hytopia's style may be in a slump, but that doesn't mean they've lost interest. Although the number of customers at Madame Couture's has fallen somewhat, her regular customers are always visiting the shop. And the Street Merchant has different materials for sale daily.

Link can also find materials in Daily Riches' treasure chests or by exploring the many regions of the Drablands.

CASTLE TOWN

Hytopia's Castle Town feels different from Hyrule's. It's brighter. There are birds and cats everywhere. And it changes as the heroes make their way through the Drablands.

Link can find broken Doppels, Princess Styla sneaking around, and even empty cicada shells around town.

At Madame Couture's, there is a cat that can only be seen when looking into a mirror.

Mimi looks for a blue bird, which is said to bring happiness to anyone who finds it.

▷ DEVELOPMENT DOCUMENTS

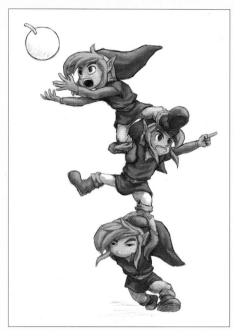

▷ Link Concept Art

Because *Tri Force Heroes* features the Link from *A Link Between Worlds*, designers initially drew versions of him faithful to the previous game. Then producer Eiji Aonuma stepped in and insisted they instead use Toon Link. Variations based on the colors of their tunics and hats led the heroes to take on a look that, while clearly Link, was not quite like he'd ever been seen in past titles.

▷ *Princess Styla's Tights* ◁

The team brainstormed numerous ideas for Styla's cursed tights, attempting to make it clear that she was still a princess in spite of her unfashionable appearance.

▷ *Madame Couture Design Concepts*

Madame Couture's look went through many revisions. She was drawn younger and as a man before an older look was chosen to show experience. One of the unused concepts for Madame Couture (center) became the basis for Lady Maud.

▷ *Multiplayer Lobby Model Sheet*

Hytopia's castle and Castle Town, as well as every building and piece of terrain in the Drablands, were designed using detailed model sheets like the one below. There were also design sheets for individual objects like bronze statues and trees.

▷ *Lady Maud Design Concepts*

Lady Maud's concepts initially ranged in age. Once Madame Couture was finalized, a senior Lady Maud was chosen to match her sister.

❧ DEVELOPER ❧ NOTES

● **Three Become One:** *Tri Force Heroes* did not initially have a single-player mode, as director Hiromasa Shikata felt its multiplayer was fun enough to stand on its own. The means to play solo was implemented after producer Eiji Aonuma requested it. Shikata later said that the result was better than he ever thought possible.

● **Link at a Minimum:** Link's initial Bear Minimum outfit design came from lead designer Keisuke Umeda. "If the green part of Link's hero outfit was a tunic and he took it off," Umeda asked, "wouldn't there only be a brownish undershirt and white tights left?"

● **A Story with Multiple Links:** Story progression proved tricky in a game where three Links appear simultaneously. Rather than make one Link the leader of two non-Link hero candidates, the team decided that each player would be the same Link from their *A Link Between Worlds* adventures—on a visit to Hytopia Castle. This would give each player confidence that their Link was truly a hero, as he'd already proven himself.

● **A Timeless Theme:** Wearing the Timeless Tunic changes all of the game's music to mimic the 8-bit sound of an NES. This music was originally added to the game as a way to compress data when transferring the game to another 3DS unit for Download Play. The Timeless Tunic was created so that players could hear the tune whenever they wanted.

References
• *Nintendo Dream*, December 2015. "The Legend of Zelda: Tri Force Heroes Tri Hero + One Interview."
• Miiverse Developer's Room Miiting #4. "The Legend of Zelda: Tri Force Heroes."

STILL MORE LEGENDS

Legends grow. Legends last. And few in the gaming world have lasted longer and grown more than *The Legend of Zelda*. Link has embarked on a litany of adventures outside of the core *Zelda* titles discussed at length in this book. There are spinoff games set in the *Zelda* universe. Games set in other universes in which Link, Zelda, and others appear as guest characters. Link and others have appeared in racing games. Fighting games. Even alongside Sonic the Hedgehog.

This section shines a light on the dozens of other titles on which *The Legend of Zelda* has left its mark.

SPINOFF TITLES

From special editions to spinoffs, this section collects *Zelda* releases that do not necessarily have a place on the core timeline but are still set in the same world.

▷ **Release Date: August 26, 1989**
Console: Game & Watch

ZELDA

Released for that great-grandparent of all Nintendo handhelds, the Game & Watch, this 1989 release, simply titled *Zelda*, is the only *The Legend of Zelda* title to never be released in Japan. The game was played using two screens, rare among Game & Watch titles. The Tomahawk was the ultimate weapon, rather than the Master Sword. Link used it to battle dragons, among other enemies that appear nowhere else in the series.

Zelda was later included in *Game & Watch Gallery 4* for the Game Boy Advance, but this too was not released in Japan. Japanese audiences were only able to play the Game & Watch *Zelda* in 2016, when it was released on the Wii U's Virtual Console.

The Game & Watch's two-screen unit and its box, depicting the eight pieces of the Triforce.

These screenshots are from the Virtual Console version. The two screens were combined to play on a television.

CHARACTERS

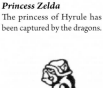

Link
Link faces goblins, ghosts, and Stalfos as he fights his way to save Princess Zelda.

Princess Zelda
The princess of Hyrule has been captured by the dragons.

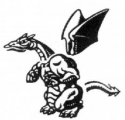

Ghost
These spectral enemies attack from behind and cannot be harmed.

Stalfos
Several of these skeletal warriors appear in each room. They are invulnerable to attack.

Goblin
A dungeon miniboss. Link cannot progress until the goblin is defeated.

Dragons
The bosses of each dungeon. They breathe fire and attack with their tails.

The game was also released in a smaller keychain version.

copyright line below
©1989 Nintendo ©1980-2003 Nintendo ©Nintendo

SPECIAL EDITIONS AND RERELEASES

▷ **Release Dates: February 17, 2003 | November 28, 2002 (JP)**
Console: Nintendo GameCube

OCARINA OF TIME & MASTER QUEST

Ocarina of Time was made available for the GameCube, bundled with the never-before-released *Master Quest*, for those who preordered *The Wind Waker*. *Master Quest* was originally developed for the N64's 64DD peripheral, but this was its first release. It is also playable in *Ocarina of Time 3D* for the 3DS.

©1998-2002 Nintendo

▷ **Release Dates: November 17, 2003 | November 7, 2003 (JP)**
Console: Nintendo GameCube

THE LEGEND OF ZELDA: COLLECTOR'S EDITION

This GameCube collection was released through Club Nintendo in Japan, and in a GameCube bundle or as a subscription incentive to *Nintendo Power* in North America. The disc contains four titles: *The Legend of Zelda*, *The Adventure of Link*, *Ocarina of Time*, and *Majora's Mask*. It also includes clips of and a demo for *The Wind Waker*.

©2004 Nintendo

left side vertical and footer

BS THE LEGEND OF ZELDA SERIES

The "BS" in the title stands for "Broadcast Satellite." These two *Legend of Zelda* games were released exclusively in Japan and utilized a satellite modem peripheral for the Super Famicom. They were only playable during predetermined broadcasting times.

Since they are played through the BS-X, the console's menu system, the character the player utilizes in the games is their menu avatar instead of Link.

Two titles with four episodes were broadcast and the nature of their release means it is no longer possible to play these games.

▷ 1997 (JP): Super Famicom Satellaview

BS THE LEGEND OF ZELDA: ANCIENT STONE TABLETS

The second BS *The Legend of Zelda* was far closer to *A Link to the Past* in its visuals, right down to the menus. The story took place six years after Link defeated Ganon, in a Hyrule where monsters were once again appearing. After Sahasrahla left on a journey to find Link, the sage's younger brother Aginah, along with Princess Zelda, discovered a mysterious youth inside a ball of light. This was the player.

▷ 1995–1996 (JP): Super Famicom Satellaview

BS THE LEGEND OF ZELDA

These games were notable for their SoundLink narration, which allowed for voice acting to be streamed during the game. The game itself resembled a version of the first *The Legend of Zelda* with upgraded graphics, using the 16-bit hardware of the Super Famicom. However, the story covered during the prologue is the same as the Imprisoning War from *A Link to the Past*.

Players all over Japan played at the same time, and top performers were awarded an 8M Memory Pack of the game with the transmitted game data stored once the broadcast was over.

©1995 Nintendo

▷ Release Dates: November 19, 2007 | May 1, 2008 (JP)
Console: Wii

LINK'S CROSSBOW TRAINING

This on-rails shooter had players combine a Wii Remote and Nunchuk in the Wii Zapper accessory to serve as a crossbow. The game was set in the world of *Twilight Princess*.

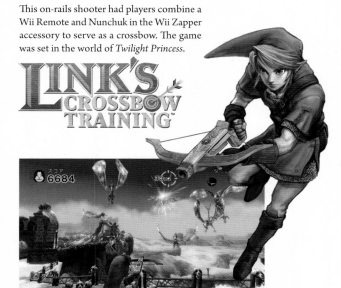

©2007-2008 Nintendo

AMIIBO

Characters from *The Legend of Zelda* have been featured in three sets of amiibo figures to date: *Super Smash Bros.*, *Breath of the Wild*, and a wide-ranging *The Legend of Zelda* series depicting variations of Link and Zelda over the last thirty years. Each amiibo unlocks exclusive game content when tapped while playing certain Wii U or Switch games.

Link	Zelda	Sheik	Toon Link	Ganondorf
Wolf Link	Link *Ocarina of Time*	Link *The Legend of Zelda*	Toon Link *The Wind Waker*	Zelda *The Wind Waker*
Link (Archer)	Link (Rider)	Zelda	Bokoblin	Guardian

©Nintendo

▷ Release Date: Setember 28, 2011
Console: DSiWare

THE LEGEND OF ZELDA: FOUR SWORDS ANNIVERSARY EDITION

This exclusive, download-only version of *Four Swords* included a new single-player mode. It was released for free between September 28, 2011, and February 20, 2012, to commemorate the twenty-fifth anniversary of the series. The *Anniversary Edition* also added new stages themed around classic titles including *Link's Awakening*, *A Link to the Past*, and the original *The Legend of Zelda*.

©2002-2011 Nintendo

▷ Release Dates: March 31, 2016 | March 17, 2016 (JP)
Console: Nintendo 3DS (DLC)

MY NINTENDO PICROSS: THE LEGEND OF ZELDA: TWILIGHT PRINCESS

A *Zelda*-themed Picross puzzle game where the player uncovers a hidden image by filling in numbered rows and columns. This downloadable title contained forty-five challenges, all based on *Twilight Princess*. Players could exchange their My Nintendo points to download it.

©2016 Nintendo ©2016 Jupiter

APPEARANCES IN OTHER GAMES

Zelda characters, items, and worlds appear in all sorts of titles. Link in particular has shown up in everything from fighting to racing games.

SUPER SMASH BROS.

▷ **Release Dates: April 26, 1999 | January 21, 1999 (JP)**
Console: Nintendo 64

SUPER SMASH BROS.

© 1999 Nintendo/HAL Laboratory, Inc. Character © Nintendo/HAL Laboratory, Inc./Creatures Inc./ GAME FREAK inc.

The first *Super Smash Bros.* brought together characters from Nintendo classics as far afield as *F-Zero*, *Star Fox*, and *EarthBound*. It was only natural that Link joined the fight too. Hyrule Castle served as a stage in the game, with Heart Containers appearing as items. Released in 1999 for the Nintendo 64, *Super Smash Bros.* established the frenetic, four-player action that became a franchise staple. Though Link appears in his adult form from *Ocarina of Time*, he is a mere puppet in series mythology, controlled by the giant Master Hand.

▷ **Release Dates: December 3, 2001 | November 21, 2001 (JP)**
Console: Nintendo GameCube

SUPER SMASH BROS. MELEE

© 2001 Nintendo/HAL Laboratory, Inc. Characters © Nintendo/HAL Laboratory, Inc./Creatures Inc./ GAME FREAK inc./APE./INTELLIGENT SYSTEMS

The second *Super Smash Bros.* was a colossal hit, selling over seven million copies worldwide. The number of characters expanded dramatically. Link, Zelda (Sheik), Young Link, and Ganondorf were all playable, while Tingle appeared as one of the many *Zelda*-themed trophies that had a cameo in the Great Bay stage. In addition to the return of Heart Containers, the Bunny Hood was added as an item. Enemies from the *Zelda* universe like ReDeads, Like Likes, and Octoroks showed up in "Adventure Mode."

▷ **Release Dates: March 9, 2008 | January 31, 2008 (JP)**
Console: Wii

SUPER SMASH BROS. BRAWL

© 2008 Nintendo/HAL Laboratory, Inc. Characters ©Nintendo/HAL Laboratory, Inc./Pokémon./Creatures Inc./GAME FREAK inc./SHIGESATO ITOI/APE inc./INTELLIGENT SYSTEMS/ Konami Digital Entertainment Co., Ltd./SEGA

The third release in the *Super Smash Bros.* series added scores of characters and multiple new ways to play. It included a side-scrolling action mode called "The Subspace Emissary," and used the Wii's Wi-Fi capabilities to enable online battles (no longer in service). On the game play side, *Brawl* also introduced Assist Trophies and the Smash Ball, among a plethora of new items. The appearance of Sonic and Solid Snake as third-party characters also marked a series first. From the *Legend of Zelda* series, Link, Zelda (Sheik), Ganondorf, and Toon Link appeared as playable characters, while Tingle returned as an Assist Trophy.

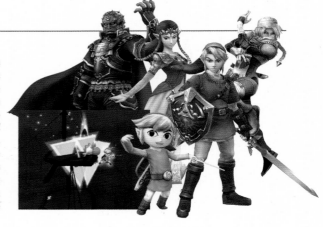

▷ **Release Dates: October 3, 2014 | September 13, 2014 (JP)**
Console: Nintendo 3DS

Release Dates: November 21, 2014 | December 6, 2014 (JP)
Console: Wii U

SUPER SMASH BROS. FOR NINTENDO 3DS/WII U

©2014 NintendoOriginal Game ©Nintendo/HAL Laboratory, Inc.Characters: ©Nintendo/HAL Laboratory, Inc./ Pokémon./Creatures Inc./GAME FREAK inc./SHIGESATO ITOI/APE inc./INTELLIGENT SYSTEMS/SEGA/CAPCOM CO., LTD./BANDAI NAMCO Games Inc./MONOLITHSOFT/CAPCOM U.S.A., INC./SQUARE ENIX CO., LTD.

The first multiplatform title in the *Super Smash Bros.* series. Though they bore many similarities, each had its own game play style and features. Playable characters from the *Zelda* series included Link, Zelda, Sheik, Toon Link, and Ganondorf. Zelda and Sheik were treated as separate characters for the first time. Tingle, Skull Kid, Midna, and Ghirahim also appeared as Assist Trophies. The Wii U version supported eight-player battles.

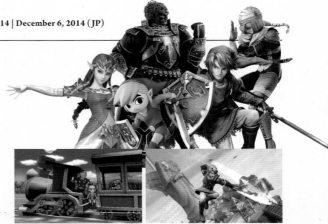

▷ **Release Dates: August 27, 2003 | March 27, 2003 (JP)**
Console: Nintendo GameCube

SOULCALIBUR II

This legendary fighting game was released by Namco (now Bandai Namco Entertainment) on multiple platforms. Each version featured a different playable bonus character, and on the GameCube that character was Link. He took up the Master Sword and traveled to a parallel world in order to destroy the evil sword known as Soul Edge, which threatened Hyrule. Many of Link's abilities and equipment in the game were borrowed from the *Zelda* series, including his bow and bombs.

©2003 BANDAI NAMCO Entertainment Inc.
"The Legend of Zelda": ©1986-2003 Nintendo
"NECRID": Character ©2003 BANDAI NAMCO Entertainment Inc./Illustration ©2003 TMP, Inc.

▷ **Release Dates: October 29, 2013 | October 24, 2013 (JP)**
Console: Wii U

SONIC LOST WORLD

This high-speed 3D action game was released by Sega (now Sega Games) for Wii U and 3DS, as well as the PC. The third piece of downloadable content released for the Wii U version was *The Legend of Zelda Zone*. Sonic donned Link's signature green cap and tunic for an adventure through the world of *The Legend of Zelda*. The Link from *Skyward Sword* and his Loftwing also appeared.

©SEGA ©2012 NINTENDO

▷ **Release Dates: May 30, 2014 | May 29, 2014 (JP)** **Release Date: April 28, 2017**
Console: Wii U **Console: Nintendo Switch**

MARIO KART 8 | MARIO KART 8 DELUXE

The eighth installment of the *Mario Kart* series included downloadable content adding Link as a playable character. The Hero of Hyrule mounted the gold-trimmed Master Cycle to race the game's already massive roster across multiple courses, including the brand-new Hyrule Circuit. As a fun bonus, coins become rupees in Hyrule Circuit. The same content was also included in the deluxe version of the game released on the Nintendo Switch.

©2014 Nintendo
Note: The images are from the Wii U version.

HYRULE WARRIORS

▷ **Release Dates:** September 26, 2014 | August 14, 2014 (JP)
Console: Wii U

HYRULE WARRIORS

Hyrule Warriors combined the game play of Koei Tecmo's flagship action series *Dynasty Warriors* with the characters and setting of *The Legend of Zelda*. The game thrust Link and his allies into intense hack-and-slash action in the worlds of *Ocarina of Time*, *Twilight Princess*, and *Skyward Sword*. In addition to playing as Link and some original characters, Impa, Zelda, Sheik, Darunia, Ruto, Midna, Agitha, Fi, Zant, Ghirahim, and Ganondorf all made appearances.

▷ **Release Dates:** March 25, 2016 | January 21, 2016 (JP)
Console: Nintendo 3DS

HYRULE WARRIORS LEGENDS

The handheld version of the original *Hyrule Warriors* included new content, notably the debut of a female player character named Linkle. The number of playable characters increased dramatically overall, and included those available on the Wii U only as downloadable content. Twili Midna, Young Link, Skull Kid, Medli, Marin, Toon Zelda, Ravio, and Yuga were all introduced in *Legends* and could be transferred to the Wii U version via a download code.

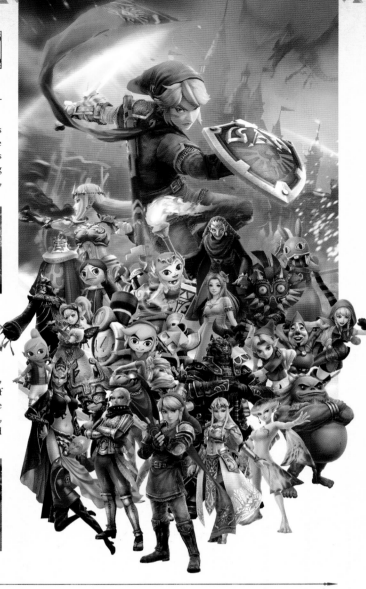

THE TINGLE SERIES

Everyone's favorite aging fairy wannabe has shown up in *Zelda* titles ever since *Majora's Mask*. But in Japan, Tingle has his own series of games.

▷ **Release Dates:** September 2, 2006 (JP)
September 14, 2007 (EU) | **Console:** Nintendo DS

FRESHLY-PICKED TINGLE'S ROSY RUPEELAND

Tingle, a thirty-five-year-old bachelor, sets out on a journey in his very own RPG. Lured in by Uncle Rupee's cajolery, he earns rupees and aims to enter the fabled paradise of "Rupeeland." The game centers around the collecting of rupees—everything, from Tingle's health to moving forward, requires them. True to its main character, it is an eccentric title to be sure. *Rosy Rupeeland* was released in Europe as well as Japan, making it the only Tingle game to date to be released outside of Japan.

▷ **Release Date:** August 6, 2009 (JP)
Console: Nintendo DS

RIPENED TINGLE'S BALLOON TRIP OF LOVE

Tingle's second title was an adventure game. In *Balloon Trip of Love*, a single thirty-five-year-old person is sucked into a book, where he becomes Tingle. To escape the book, the titular character must dance with the princess at the city ball. He works to reach the city, meeting all manner of beautiful women along the way, with three familiar companions: Kakashi, a scarecrow who wants to gain wisdom; a kindhearted tin woman named Buriki; and a cowardly lion, aptly named Lion.

▷ **Release Date:** April 12, 2007 (JP)
Console: Nintendo DS

TINGLE'S BALLOON FIGHT DS

Tingle's Balloon Fight DS was a Platinum Member bonus for Japanese Club Nintendo (no longer in service) members in 2006. It replaced the characters of the NES classic *Balloon Fight* with Tingle.

▷ **Release Date:** June 24, 2009 (JP)
Console: Nintendo DSiWare

TOO MUCH TINGLE PACK

For players who couldn't get enough Tingle, there was the *Too Much Tingle Pack*: a small collection of applications including a fortuneteller, a calculator, a timer, and weirder things all said to be made by Tingle himself.

Even More Games

Elements of *The Legend of Zelda* have appeared in scores of other games to date. A wide catalog of games have featured outfits, weapons, characters, and even *Zelda*-themed minigames over the years. This list collects the rest of these titles to date, in order of appearance.

▷ 2.3.1991
10.10.1991 (EU)
11.9.1990 (JP) · GB · *F-1 Race*

Link cheers for the player if they win the Grand Prix.

▷ 11.20.1995
12.14.1995 (EU)
11.21.1995 (JP) · SNES · *Donkey Kong Country 2: Diddy's Kong Quest*

Link appears as one of Cranky Kong's Video Game Heroes.

▷ 5.13.1996
3.9.1996 (JP) · SNES · *Super Mario RPG*

After defeating Bowser, Link will be sleeping in the Rose Town inn if the player stays overnight.

▷ 9.20.1996
1.23.1997 (EU)
3.21.1996 (JP) · SNES · *Kirby Super Star*

The Triforce appears as treasure in the Great Cave Offensive.

▷ 12.1.1999 (JP) · SNES · *Picross NP Vol. 5*

Part of a series of Japan-only *Picross* titles from *Nintendo Power*. Characters from *The Legend of Zelda* appeared in the "Character Mode" puzzles.

▷ 12.11.1999 (JP) · 64DD · *Mario Artist: Paint Studio*

This Japan-only successor of sorts to *Mario Paint* includes stamps of Link and Zelda from *Ocarina of Time*.

▷ 9.15.2002
9.24.2004 (EU)
2.11.2001 (JP) · GC · *Animal Crossing*

The Master Sword with pedestal can be purchased from Tom Nook while the original *The Legend of Zelda* appears as a hidden NES game.

▷ 5.26.2003
5.23.2003 (EU)
3.21.2003 (JP) · GBA · *WarioWare, Inc.: Mega Microgames!*

A short bit of game play from *The Legend of Zelda* appears as a microgame.

▷ 6.27.2003 (JP) · GC · *Animal Forest e+*

A Hero's Outfit appears via an e-reader card in this Japan-only update to the original *Animal Forest*, known as *Animal Crossing* outside of Japan.

▷ 4.5.2004
9.3.2004 (EU)
10.17.2003 (JP) · GC · *WarioWare, Inc.: Mega Party Game$!*

As in the Game Boy Advance version, there is a *The Legend of Zelda* 9-Volt microgame.

▷ 5.9.2005
6.3.2005 (EU)
7.1.2004 (JP) · GC · *Donkey Konga 2*

One of the songs included in the Japanese version of this rhythm-action title is the *Legend of Zelda* theme.

▷ 11.15.2004
6.25.2004 (EU)
7.1.2004 (JP) · GBA · *Donkey Kong Country 2*

This GBA port of the SNES original also includes Link among Cranky's Video Game Heroes.

▷ 5.23.2005
10.14.2004 (JP) · GBA · *WarioWare: Twisted!*

The NES microgames once again include *The Legend of Zelda* in this installment of *WarioWare*.

▷ 2.14.2005
3.11.2005 (EU)
12.2.2004 (JP) · DS · *WarioWare: Touched!*

The Legend of Zelda appears as a microgame in this one too. Wario has his favorites, it seems.

▷ 2.2.2004 (JP) · DS · *Daigasso! Band Brothers*

A music game for the Nintendo DS only released in Japan. One of the songs is "The Legend of Zelda Medley."

▷ 3.17.2005 (JP) · GC · *Donkey Konga 3*

One of the tracks in the NES section of this third, Japan-only installment of *Donkey Konga* is "The Legend of Zelda."

▷ 12.5.2005
3.31.2006 (EU)
11.23.2005 (JP) · DS · *Animal Crossing: Wild World*

Zelda-themed furniture appears in this follow-up to the original *Animal Crossing*.

▷ 1.15.2007
1.12.2007 (EU)
12.2.2006 (JP) · Wii · *WarioWare: Smooth Moves*

The first *WarioWare* on the Wii featured a *Wind Waker* stage.

▷ 6.26.2008 (JP) · DS · *Daigasso! Band Brothers DX*

Additional *Zelda* songs could be downloaded via Wi-Fi connection in this *DX* version of the Japan-only music game.

▷ 8.28.2008 (JP) · Wii · *Captain Rainbow*

This unique "actionventure" only released in Japan featured a collection of Nintendo characters. Tracy from *Link's Awakening* made an appearance. She has a picture of Link in her room.

▷ 9.22.2008
9.18.2009 (EU)
11.6.2008 (JP) · DS · *Kirby Super Star Ultra*

As in the original, the Triforce is a treasure in the Great Cave Offensive.

▷ 11.16.2008
12.5.2008 (EU)
11.20.2008 (JP) · Wii · *Animal Crossing: City Folk*

Animal Crossing on the Wii also features *Zelda*-themed furniture.

These abbreviations indicate the hardware the relevant title was released on, as well as its release format.
GB: Game Boy | SNES: Super Nintendo Entertainment System | GC: Nintendo GameCube | GBA: Game Boy Advance | DS: Nintendo DS | 3DS: Nintendo 3DS
3DS DL: Nintendo 3DS Downloadable Software | Wii U DL: Wii U Downloadable Software | iOS/Android: Smartphones

▷ **11.10.2009**
4.12.2010 (EU)
12.25.2008 (JP) | DS | *Phantasy Star 0*

The Hylian Shield appears in this RPG released by Sega.

▷ **3.28.2010**
4.30.2010 (EU)
4.29.2009 (JP) | DS | *WarioWare: DIY*

9-Volt loves *Zelda* and includes it yet again in his Nintendo collection.

▷ **3.28.2010**
4.30.2010 (EU)
4.29.2009 (JP) | WiiWare | *WarioWare: DIY Showcase*

In addition to the *Zelda* content in the DS version, there is a game in the *DIY Showcase* based on *The Adventure of Link*.

▷ **3.27.2011**
3.25.2011 (EU)
2.26.2011 (JP) | 3DS DL | *StreetPass Mii Plaza*

Mii Plaza comes bundled with every 3DS. *The Legend of Zelda* content plays a role in multiple minigames, including *Zelda*-themed puzzles in *Puzzle Swap* as well as hats and outfits in *Find Mii*.

▷ **3.25.2011 (NA/EU)**
2.26.2011 (JP) | 3DS | *AR Games*

This software was also bundled with every 3DS. Link is in one of the physical AR cards included with the console. By viewing the card, it is possible to photograph him.

▷ **12.8.2011 (NA/EU)**
10.5.2011 (JP) | 3DS DL | *Pushmo*

Puzzles related to the series appear in this cute puzzle-action game.

▷ **12.22.2011 (NA/EU)**
12.21.2011 (JP) | 3DS DL | *Swapnote*

Zelda stationery is available in this software that lets users write and exchange messages.

▷ **12.27.2011 (JP)** | 3DS DL | *Tobidasu Purikura: Kira Deko Revolution*

This software only released in Japan let users put decorations on 2D pictures. Link was one of the stamps.

▷ **4.26.2012 (JP)** | 3DS | *Dynasty Warriors VS*

This Japan-only installment of the prolific hack-and-slash action game was released by Koei Tecmo and featured Link's outfit from *Skyward Sword*.

▷ **9.13.2012 (JP)** | 3DS DL | *Club Nintendo Picross*

This downloadable Picross game featured Nintendo-themed puzzles, including *The Legend of Zelda*.

▷ **11.13.2012 (JP)** | WiiU | *Scribblenauts Unlimited*

Multiple characters and items, including Navi and the Master Sword, appear.

▷ **6.9.2013**
6.14.2013 (EU)
11.8.2012 (JP) | 3DS | *Animal Crossing: New Leaf*

Series-themed furniture and outfits also appeared in this edition of *Animal Crossing* for the 3DS.

▷ **11.18.2012**
11.30.2012 (EU)
12.8.2012 (JP) | Wii U | *Nintendo Land*

One of the attractions in *Nintendo Land* is "*The Legend of Zelda*: Battle Quest."

▷ **9.14.2013 (JP)** | 3DS | *Monster Hunter 4*

Zelda-themed outfits and more appeared in this action RPG made by Capcom.

▷ **11.14.2013 (JP)** | 3DS | *Daigasso! Band Brothers P*

Songs, outfits, and playable videos related to the *Zelda* series appeared in this Japan-only follow-up to the DS rhythm and music-making game.

▷ **11.21.2013 (JP)** | Wii U | *Taiko no Tatsujin: Wii U Version*

A Japan-only rhythm game played with drumsticks. The *Legend of Zelda* theme is included as part of the Famicom DLC pack.

▷ **12.18.2013 (NA/EU)**
12.19.2013 (JP) | Wii U DL | *NES Remix*

A compilation of popular NES titles. It includes *The Legend of Zelda*.

▷ **12.5.2014 (NA/EU)**
4.24.2014 (JP) | Wii U | *NES Remix Pack*

A packaged version of the two *NES Remix* games that contains both *The Legend of Zelda* and *The Adventure of Link*.

▷ **4.25.2014 (NA/EU)**
4.24.2014 (JP) | Wii U DL | *NES Remix 2*

This downloadable compilation of popular NES titles included *The Adventure of Link*.

▷ **10.24.2014 (NA/EU)**
9.20.2014 (JP) | Wii U | *Bayonetta 2*

A special "Hero of Hyrule" costume is found in *Bayonetta*, which was included with the release of *Bayonetta 2* on the Wii U.

▷ **10.9.2014 (JP)** | 3DS DL | *Club Nintendo Picross Plus*

This expanded version of *Club Nintendo Picross* also included *Zelda*-themed puzzles.

▷ **2.13.2015 (NA/EU)**
10.11.2014 (JP) | 3DS | *Monster Hunter 4 Ultimate*

This ultimate version of the action RPG by Capcom featured downloadable clothing and weapons, including Link's iconic cap and tunic.

▷ **11.13.2014 (JP)** | 3DS | *One Piece: Super Grand Battle! X*

An action game released by Bandai Namco Entertainment and based on the popular manga/anime. Zoro gets a Link outfit if players tap the Link amiibo.

▷ **11.10.2015**
11.13.2015 (EU)
12.17.2014 (JP) | 3DS DL | *Nintendo Badge Arcade*

Zelda badges appeared periodically in this downloadable title for the 3DS.

▷ **2.10.2015**
2.13.2015 (EU)
1.29.2015 (JP) | 3DS | *Ace Combat 3D: Assault Horizon Legacy +*

Link and Zelda amiibo unlock special aircraft named for the characters in this action flight simulator by Bandai Namco Entertainment.

▷ **4.30.2015** | Wii U DL | *amiibo Tap: Nintendo's Greatest Bits*

A free piece of software that let players tap various amiibo to try classic Nintendo games, including *The Legend of Zelda*, *The Adventure of Link*, and *A Link to the Past*.

▷ **5.13.2015 (JP)** | 3DS DL | *Pushmo: Hippa Land*

This pixel-puzzle game released only in Japan features *Zelda* content in Grandpa's NES Park.

▷ 10.16.2015 6.26.2015 (EU) 7.16.2015 (JP)	Wii U	*Yoshi's Woolly World*

Yoshi will dress up in the costumes of various amiibo characters when tapped, including ones from the *Legend of Zelda* series.

▷ 7.22.2015 (JP)	3DS DL	*Daigasso! Band Brothers P Debut*

The smaller, downloadable version of *Daigasso! Band Brothers P* also included *Zelda* content.

▷ 9.25.2015 10.2.2015 (EU) 7.30.2015 (JP)	3DS	*Animal Crossing: Happy Home Designer*

Items related to the *Zelda* series including the Hero's Clothes appear in *Happy Home Designer*.

▷ 12.5.2015 11.7.2015 (EU) 8.27.2015 (JP)	3DS	*Ultimate NES Remix*

The 3DS version of this Wii U title also includes *The Legend of Zelda* and *The Adventure of Link*.

▷ 9.11.2015 (NA/EU) 9.10.2015 (JP)	Wii U	*Super Mario Maker*

Tapping a *Legend of Zelda* amiibo will turn Mario into a pixel version of that character in this side-scrolling level-building game.

▷ 9.1.2016 12.2.2016 (EU) 10.1.2015 (JP)	3DS	*Picross 3D: Round 2*

Tapping an amiibo unlocks a special puzzle for that character in this three-dimensional *Picross* for the 3DS.

▷ 7.15.2016 (NA/EU) 11.28.2015 (JP)	3DS	*Monster Hunter Generations*

A Link outfit based on his appearance in *The Wind Waker* was included along with weapons for Felyne companions in this version of *Monster Hunter*.

▷ 3.31.2016 3.17.2016 (JP)	iOS/ Android	*Miitomo*

Zelda-themed items occasionally appear in this mobile title, including outfits and wigs for dressing up players' Miis.

▷ 6.10.2016 (NA/EU) 4.28.2016 (JP)	3DS	*Kirby: Planet Robobot*

Tapping a compatible *Legend of Zelda* amiibo will unlock a unique look or special Copy Ability.

▷ 8.19.2016 11.20.2016 (EU) 8.19.2016 (JP)	3DS	*Style Savvy: Fashion Forward*

Tapping a *Zelda* amiibo will unlock unique items.

▷ 9.8.2017 (NA/EU) 10.8.2016 (JP)	3DS	*Monster Hunter Stories*

In this action RPG by Capcom, *Zelda*-themed equipment is included, as well as an Epona companion monster and a Skull Kid Mask for Navirou.

▷ 11.17.2016 (NA/EU) 11.22.2016 (JP)	3DS DL	*Swapdoodle*

Zelda-themed illustrations and stickers appear in this game that centers around exchanging pictures.

▷ 12.2.2016 11.25.2016 (EU) 11.23.2016 (JP)	3DS	*Animal Crossing: New Leaf— Welcome amiibo*

Zelda-themed furniture from previous *Animal Crossing* titles returns in this installment.

▷ 7.28.2017 (NA/EU) 12.8.2016 (JP)	3DS	*Miitopia*

Players battle their Miis in this strategy game set in a fantasy world. Tapping amiibo will give Miis new outfits, including many from the *Legend of Zelda* series.

▷ 4.26.2017 (JP)	Arcade	*Taiko no Tatujin*

A *Breath of the Wild* medley was added to the arcade version of the popular Japanese drum game.

▷ 10.27.2017	Switch	*Super Mario Odyssey*

Tapping compatible *Legend of Zelda* amiibo unlock helpful assists and even outfits.

▷ 11.11.2017	Switch	*The Elder Scrolls V: Skyrim*

The Master Sword, Hylian Shield, and Link's signature green tunic appear when players tap compatible amiibo.

PROMOTIONAL MATERIALS

This section contains several in-store leaflets and magazine advertisements created to promote the *Legend of Zelda* series in Japan. Taken together, these campaigns show an evolution in the series' tone and art style, specifically in the design of key characters like Link and Zelda.

1986 *The Legend of Zelda*

1994 *The Legend of Zelda*

1987 *The Adventure of Link*

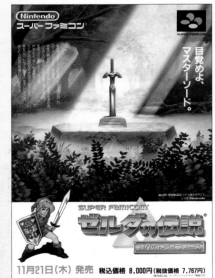

1991 *The Legend of Zelda: A Link to the Past*

1993 *The Legend of Zelda: Link's Awakening*

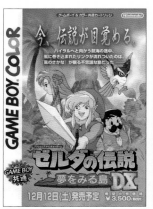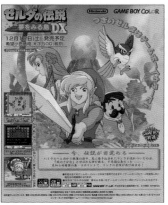

1998 *The Legend of Zelda: Link's Awakening DX* 1995 *BS The Legend of Zelda*

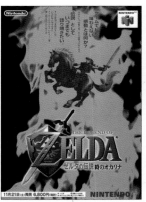

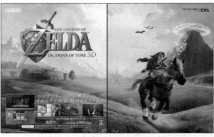

1998 *The Legend of Zelda: Ocarina of Time* 2011 *The Legend of Zelda: Ocarina of Time 3D*

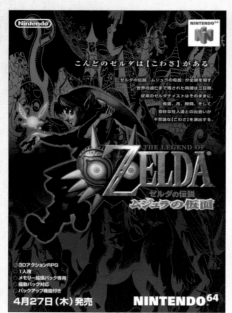

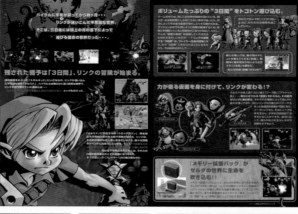

2000 *The Legend of Zelda: Majora's Mask*

2015 *The Legend of Zelda: Majora's Mask 3D*

2001 *The Legend of Zelda: Oracle of Seasons/Oracle of Ages*

2002 *The Legend of Zelda: The Wind Waker*

2013 *The Legend of Zelda: The Wind Waker HD*

2003 *The Legend of Zelda*
A Link to the Past & Four Swords

2004 *The Legend of Zelda: The Minish Cap*

2004 *The Legend of Zelda: Four Swords Adventures*

2006 *The Legend of Zelda:*
Twilight Princess

2016 *The Legend of Zelda:*
Twilight Princess HD

2007 *The Legend of Zelda: Phantom Hourglass*

2008 *Link's Crossbow Training*

2009 *The Legend of Zelda: Spirit Tracks*

2011 *The Legend of Zelda: Skyward Sword*

2011 *The Legend of Zelda 25th Anniversary*

2013 *The Legend of Zelda: A Link Between Worlds*

2015 *The Legend of Zelda: Tri Force Heroes*

REVISING EXPECTATIONS IN THE LEGEND OF ZELDA

Series producer Eiji Aonuma has lived and breathed *The Legend of Zelda* for more than twenty years, playing a key role in the development of every release since first joining the team on *Ocarina of Time*. During his tenure, the veteran Nintendo developer has overseen the series' evolution and reinvention through generations of home and handheld consoles.

In this interview, recorded in December 2016 at Nintendo Headquarters' Development Building, Aonuma reflects on the series' growth and player expectations over a storied history more than three decades long. We ask what defines a *Zelda* game and how the series' legacy was incorporated into *Breath of the Wild*, released four months later (March 3, 2017) for the Nintendo Switch and Wii U.

The interview was conducted in Japanese and has been translated into English exclusively for this edition.

青沼英二
EIJI AONUMA

Eiji Aonuma was born in Nagano Prefecture in 1963. After directing the Japan-only RPG *Marvelous: Another Treasure Island* for the Super Famicom, Aonuma joined *Ocarina of Time*'s development team. He has since worked as a director or producer on every principal release in the *Legend of Zelda* series.

A THOUSAND DEVELOPERS

Congratulations on receiving the Lifetime Achievement Award at the Golden Joystick Awards[1] in England.

AONUMA: Thank you very much.

In the video message to commemorate receiving the award, you spoke about how "over one-thousand people have been involved in developing the Zelda series." Just looking at the great number of characters, items, and dungeons that appear in The Legend of Zelda: Encyclopedia, *it's easy to understand just how many people must have been involved with the series.*

AONUMA: That is very true. Looking at this book, I'd like for fans to feel nostalgic, and I hope that the people involved in the development of *Zelda* can look at it and think, "I made this!"

ELEMENTS OF A DUNGEON

With the latest entry in the Legend of Zelda *series,* Breath of the Wild,[2] *the main focus of development was to revise expectations for* Zelda *games.*

AONUMA: Indeed.

On that subject, what do you think are the expectations for a Zelda game?

AONUMA: When I first got involved with *Ocarina of Time*, which was my first time on the series, there was already a set of expectations. And we were going to translate them to 3D with *Ocarina of Time*.

I see.

AONUMA: At the time, I was in charge of planning out the dungeons.

You were the dungeon designer, correct?

AONUMA: Yes. However, if you're making a *Zelda* game for the first time, that means it's your first time making the dungeons, so I started by asking myself: "Just what makes a dungeon?"

So what did you interpret a dungeon to be?

AONUMA: The main structure of a *Zelda* title is to start from a village and then dive into the dungeons. Clearing them means increasing what you can do as the player, enabling you to go to the next area, where a new dungeon will be waiting for you.

Right.

AONUMA: Then, inside the dungeon is a miniboss, and defeating them yields an item. You then use that to do something you couldn't before, and also to beat the boss. That's the basic setup.

In other words, the player uses the items they obtain right away, and then again to beat the boss, which is an expectation of a Zelda title, correct?

AONUMA: That is correct. The player defeats the miniboss and uses the item to learn the basics, and after that comes the section where they apply that.

A section to apply what they've learned . . . in other words, a puzzle that can only be solved if they put their knowledge to use?

AONUMA: Yes. As they try out various uses, they learn what is possible and then apply that to beat the boss, then by advancing to the next dungeon—

—they get hit with another puzzle. [laughs]

1. The Golden Joystick Awards are a storied British video game award program that celebrated its thirty-fourth year in 2016. The categories are divided into themes like Ultimate Game of the Year and Best Original Game, with some awards granted to individuals in the game development community. In 2016, Eiji Aonuma was awarded a Lifetime Achievement Award.

2. *The Legend of Zelda: Breath of the Wild* was released on March 3, 2017. In the expansive adventure, Link's first on the Nintendo Switch, players can move seamlessly across vast and varied terrain. Where Link goes and how the story progresses is very much up to the player. As of publication, *Breath of the Wild* is the largest-scale *Zelda* game in the series' history.

AONUMA: And that is the structure. However, that sort of approach can lead to problems.

THE EXPECTATION OF A STRAIGHT PATH

What sort of problems?

AONUMA: The players had to receive the items in the order we decided.

Otherwise the game would be unbalanced, correct?

AONUMA: Indeed. So it was always a straight path.

So even if players could freely travel the 3D worlds you made . . . in reality, it was a linear journey, right?

AONUMA: Structurally speaking, yes.

Even if the path is straight, because the game is in 3D, players will still sometimes get lost.

AONUMA: That is why we worked to minimize how much players would feel lost. For example, we would place numerous landmarks so that players could follow them, and so on.

Like sending up flares. [laughs]

AONUMA: Indeed. [*laughs*] We did things like that to ensure that players wouldn't get lost. But thinking critically, making a game in which players never get lost is like the development team saying that it's actually just linear.

Ah, yes, that's true.

AONUMA: When making a *Zelda* with that structure, and then examining it from a distance, it starts to feel like, "Is this really interesting?"

I see.

AONUMA: On top of that, when we've debugged *Zelda* titles in the past, we would get reports saying, "Doing this thing lets me jump straight to this point, but is that OK?" If we allowed such shortcuts, it would mean that everything we made in between those points would be in vain . . .

It would just end up being skipped.

AONUMA: So, we would tell them that it was a problem, and then spend a lot of time plugging up shortcuts.

Dropping in boulders, for example. [laughs]

AONUMA: Right. [*laughs*] For the new title, *Breath of the Wild*, we allowed things like that instead of "fixing" them.

You reworked the expected linear structure.

AONUMA: That's right. After all, isn't finding a shortcut yourself and reaching a completely new area the peak of fun? "I did it! I found a new path!" [*laughs*]

Very true. [laughs]

AONUMA: Development on *Breath of the Wild* started with the decision not to steal that fun away.

And that's why you decided to make an open world?

AONUMA: Yes. That's why. This time, when reports would come from the people handling the debugging that they found a shortcut, we would

tell them, "That's by design," and send it back. [*laughs*]

"COULD THIS TAKE ME TO THE ENDS OF THE EARTH?"

In Breath of the Wild, *the ability to climb rocks is a critical new action.*

AONUMA: Being able to climb anything is a very important part of the game, and when you reach the top, you find a completely new space spreading out before you.

In A Link to the Past, *obtaining the Hookshot lets the player cross over to the other side of the river to find a completely new area waiting for them.*

AONUMA: In that game, it isn't possible to reach that space without first obtaining the Hookshot. But in *Breath of the Wild*, if the player wants to go there right from the start, they can reach that new location. If they climb part of the way up and realize they cannot go any farther, they can use the paraglider to descend right away. Then, by looking at the terrain they just climbed from where they landed—

—they can spot a better route leading up the mountain.

AONUMA: That's right. By realizing that they should be able to climb using that other route, they try again and make progress, which is part of the fun.

I see.

AONUMA: When they get higher up, they can survey from there, and may spot something that looks like a hole and decide to check it out,

which is another way to have fun, and I think that epitomizes what is possible in an open-world game.

By the way, does looking out from high places have any connection to the fact that you grew up surrounded by mountains in Nagano Prefecture?

AONUMA: It has absolutely nothing to do with it. When I was in elementary and middle school, we would go climb mountains for school activities, but I hated it. [*laughs*]

[**laughs**]

AONUMA: There is actually a more accurate reason as to why we did it. In *Skyward Sword*, when Link ate Stamina Fruit—

—he was able to dash forward and run up steep slopes.

AONUMA: When dashing toward a wall, it didn't feel right to suddenly just stick to it. The climbing came from a conversation about how it would be more fun to have Link be able to climb without any external factors. At the time, though, we couldn't fully implement it. It wasn't a world where you could go wherever you wanted, after all. [*laughs*]

There are places you don't want people to go. [laughs]

AONUMA: Indeed. [*laughs*] It would completely break the game. But in an open world, climbing means that the player can go wherever they want. And I know I said that I hate mountain climbing a little earlier, but there was a period where I was utterly hooked on motorcycles.

When was that?

AONUMA: It was when I was a student. When I got my license,

I would ride all over, wondering, "Could this take me to the ends of the earth?" Motorcycles are good for driving down narrow alleys, and I had fun getting lost in those places. I feel like that sort of feeling is clearly present in *Breath of the Wild*.

I see.

AONUMA: And that's why horses are so important in the game. Of course, the player can control them directly, but the horse will run on its own volition, so players can look around while riding. It's a lot of fun. We've made horses many times before, but these are the best horses we've ever made.

AN OPEN WORLD FULL OF "I CAN DO THAT TOO?!"

I'd like to get back to what we were discussing a little while ago. Aside from straight paths, what other expectations are there for a Zelda game?

AONUMA: This is a bit conventional, but if the player gets a Game Over inside a dungeon, they are returned to the entrance, right?

Right. Starting over from the entrance is a little frustrating. [laughs]

AONUMA: It's terrible. I think it would be fine to revive the player where they were defeated, even if it is close to an enemy; however, starting over from the entrance can lead to new discoveries.

You do sometimes find things that you didn't notice when you first entered.

AONUMA: Right. That system is sometimes necessary for the puzzle

solving in *Zelda* titles. But as the series progressed, the dungeons got bigger and bigger. [*laughs*]

That's very true. [laughs]

AONUMA: And since being returned to the entrance is not enjoyable, we reworked that with *Breath of the Wild*.

Cutting grass and defeating enemies to find rupees and hearts is also one of the expectations in a Zelda game, isn't it?

AONUMA: That is correct. But rupees appearing when the player cuts grass turned into questions such as, "Is the grass growing rupee fruit?" or "Who hid the rupees there?" Most important though was: "Is it heroic to go around cutting grass to try to gather money?"

[*laughs*]

AONUMA: Of course, you can still cut the grass in *Breath of the Wild*.

But no rupees appear from it, right?

AONUMA: It's a more realistic game, so bugs come out. You can use those bugs in all sorts of interesting recipes.

I see. I suppose that being able to cut grass and shake trees is expected of Zelda game play. Players could cut the signs in **Ocarina of Time,** *after all.*

AONUMA: At first, I didn't understand what about that was entertaining at all. When we were making *Ocarina of Time*, I was solely focused on the structure of the dungeons. At one point, I was getting exhausted, and Miyamoto-san came over and said: "What if we made it so the signs could be cut in

the direction of the sword swing?" My mouth fell open, and I said, "What?" [laughs]

[laughs]

AONUMA: "What's the point of doing that?" After that, a programmer told me, "I made it so the cut sign pieces float on the water." I thought, "What in the world are these people doing?" [laughs] These were things that were totally unrelated to beating the game.

From your perspective, focusing on building the dungeons, you must have thought that they were simply goofing off.

AONUMA: You're right. I think people can only build that sort of game play if they have some room in their heart for it.

And you didn't have that room at the time, did you?

AONUMA: When you really think about it, it's having the world of *Zelda* react in some small way to the actions that you yourself have taken. That is what surprises players. When you experience one thing, you want to see what else you can do, and all sorts of mechanics develop from there.

Are there mechanics like that in Breath of the Wild as well?

AONUMA: There are many. I once asked a member of the development team what happened after they burst out laughing while playing the game, and they said, "Look at what happens when I do this."

There must be a lot of fun things in there that even you don't know about.

AONUMA: You're right. The team came up with all sorts of tricks,

and there were a lot that surprised me. That's why this game is such an endless march of "I can do that too?!"

So you had some room in your heart this time then. [laughs]

AONUMA: The team did a tremendous job with that. Far more than I did! [laughs]

SOME THINGS SHOULD NEVER CHANGE

What about expectations related to Link's appearance?

AONUMA: Depending on the title, he will wear green clothes, red clothes, blue clothes, four different-colored outfits . . . But he always wears the same kind of hat. We've made the games assuming that it was fine to expect that, or that it was a given. But thinking about it dispassionately, we ended up wondering, "Are a green outfit and hat really that cool looking?"

But those green clothes are sort of special. They create the feeling that once he's wearing them, the fight has begun.

AONUMA: Link was originally a normal boy who would get caught up in some sort of destiny, put on the green outfit, and awaken to something.

When players wear that outfit, they can stand up taller and feel really cool.

AONUMA: That's because the designers worked incredibly hard to make sure they looked cool. [laughs]

I suppose you're right. [laughs]

AONUMA: In *Breath of the Wild*, we decided to start thinking more closely about what appearance for Link would make players happy. Wondering if we were tied to something just because it was expected was the core reason for revisiting expectations with this title. It challenged us to think about what sort of new worlds we'd come up with when we were released from that spell.

I see. Link being left-handed was a given as well, until the release of Twilight Princess for the Wii.

AONUMA: Even if that was also a tradition, there were a lot of opinions about it, and I still don't know what the truth of it is. However, by asking, "Why does *Zelda* have to be this way?" we find a reason to change things if we can't come up with a specific answer.

And so that's why Link appears in this game without a hat, wearing a blue outfit, and even right-handed. As you were revisiting these expectations, what things did you decide you would not change?

AONUMA: The element of growth.

The player growing alongside Link?

AONUMA: Yes. As I said before, as the player gradually becomes able to do more things, they experience many things; when they reach the next level, I want them to enjoy the sense of accomplishment that comes with expanding your capabilities until the very end. That's why having not only Link but the player grow is the most important aspect of *Zelda*—and I think that is an element we should never change.

ALL BECAUSE
OF THE FANS

Aonuma-san, since you joined the development team on Ocarina of Time, *you've been involved with* Zelda *for about twenty years, correct?*

AONUMA: That is correct.

I imagine that it is extremely rare, even within Nintendo, to only work on Zelda *and not be involved with any other titles.*

AONUMA: That's why I received a Lifetime Achievement Award. [*laughs*]

[**laughs**] *How have you been able to continue working on the same series for so long?*

AONUMA: You know, that's a mystery to me. The truth is, I get bored with things very quickly.

So, you get tired of things. [*laughs*]

AONUMA: There are very few things that I can continue to do for a long time. I was hooked on fishing for a while, but once I had done it enough to get a real feel for it, I immediately became tired of it.

But there are things you don't get bored with?

AONUMA: Yes. There are three things that I've always been able to keep doing. One of those is *Zelda*, one is the company wind instrument club, and the other is cooking.

Cooking.

AONUMA: I love to cook. [*laughs*] I recently finally understood what it is that allows me to keep doing

those three things. The thing that all three share is that there is someone to play the game, someone to come listen to us perform, and someone to eat the food.

If you were fishing, it's not like someone would watch you, I suppose. In other words, it's important to be able to see someone enjoying it?

AONUMA: You're right. That is true, but then it could be said that the game does not necessarily have to be *Zelda*.

Ah, yes, you're right.

AONUMA: When cooking, you can only serve the food to people you know well, right? Similarly, when the wind instrument club holds a performance, there are people who come every time to hear us. Then, when the concert is over, we can chat about whether they enjoyed the performance this time.

If you cooked, someone could say, "Well done as always, Aonuma. This is really good."

AONUMA: [*laughs*] And with *Zelda*, since there are people who have been playing the games for years, I can see how they react to our new releases . . .

That must be exciting.

AONUMA: Yes. I get really excited about it. Though it makes me really nervous too. [*laughs*]

Even with that to look forward to, it's incredible that you've been able to continue working on a single series for twenty years.

AONUMA: I think a major part of that is how flexible *Zelda* is as a series. For example, you can try some baseball-like moves. Even fight like you're having a tennis match . . .

You've even done sumo. [*laughs*]

AONUMA: That we put so many elements into these worlds may just be what makes it *Zelda*. Even in *Breath of the Wild*, you can do all sorts of ridiculous things. There are times when you'll be surprised at what you can make happen using different elements.

I see.

AONUMA: Also, my individual development history may be twenty years, but *The Legend of Zelda* has thirty years of history. This encyclopedia is the fruit of all our labors, showcasing how we have taken on all sorts of challenges. Of course, the reason that we're able to publish this sort of a book, or even make *Breath of the Wild*, is because of the fans who have supported us. I'd like to thank all of them from the bottom of my heart.

Enjoy!

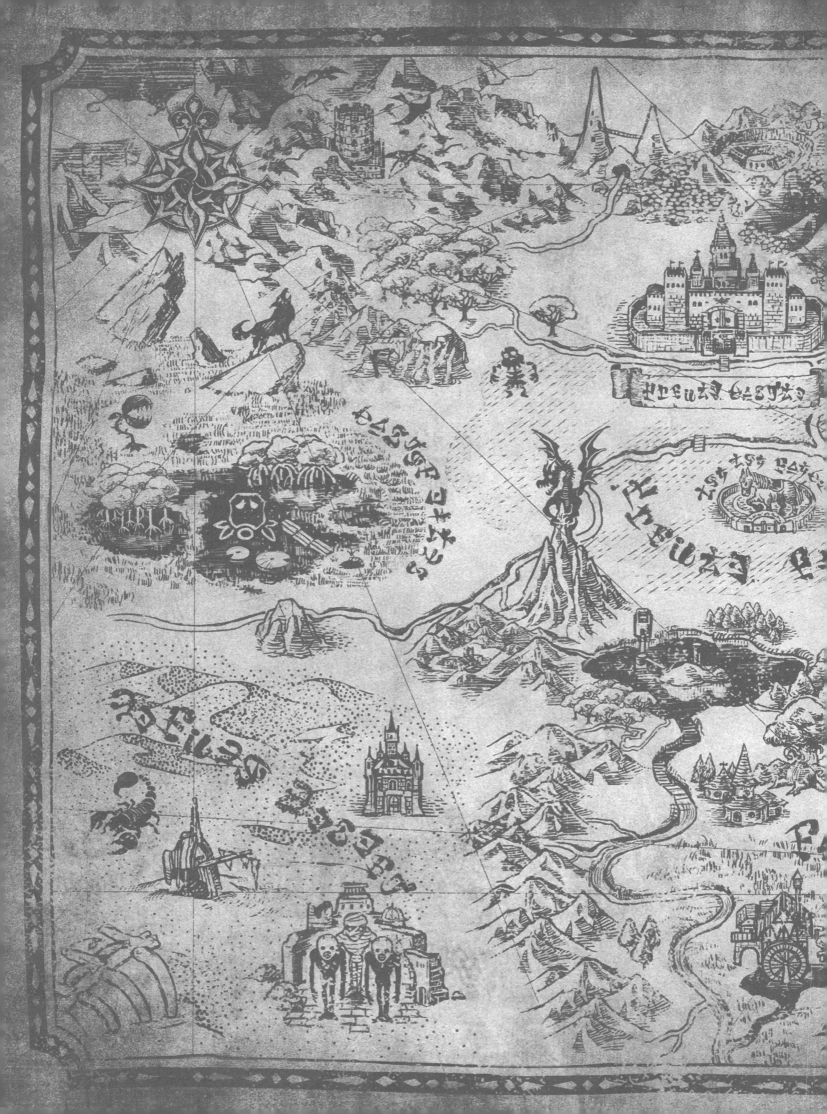